To Barb

May there be

a road

Steven E. Anway

In Love With Freedom

The True Story of a Remarkable Woman

A Novel

By

Steven E. Aavang

authorHOUSE®

AuthorHouse™
1663 Liberty Drive
Bloomington, IN 47403
www.authorhouse.com
Phone: 1-800-839-8640

First published by AuthorHouse 3/30/2011

ISBN: 978-1-4567-1547-2 (sc)
ISBN: 978-1-4567-1548-9 (e)
ISBN: 978-1-4567-1549-6 (dj)

Library of Congress Control Number: 2010919216

Printed in the United States of America

TABLE OF CONTENTS

AUTHOR'S NOTES

The telling of this story was literally 100 years in the creation and twenty years in the composition. I am chagrined to say it was not for lack of attempts, nor was it due to the copious amounts of research on my part. I lament that so many sources of information are forever buried - in the souls of the many lives that Princess Catherine touched in some way... so many orphans for which she cared, the 'boys' who fell into her country during WWII, patients in emergency hospitals she worked in, refugees from a devastating earthquake that she helped in relief efforts, country-man she helped to inspire during war, Nazi occupation, and under the dark cloak of communism.

For all these years since I first met the Princess and learned her amazing story I have had a little bird sitting on my shoulder whispering into my ear, not letting me forget. Now those everyday interruptions of work and life have been settling down (even though I still have a teenager at home and off to college). I can now try to be more in control of my time and not let time be in control of me (another wish). I made time to write.

Events in the not so distant past, however, have made the life and words of Catherine so relevant and universal. Without casting a political opinion I site the events of 9/11; a brave man standing his ground in front of a tank in China, bombings in England and Spain; the perpetual turmoil of the Middle East; the horror of Chad and Sudan; defiance in the aftermath of Iranian elections, the repression of North Korea - the list unfortunately can go on. We cannot forget the admonitions of Catherine to not let down our guard, that freedom is not free, our work is not finished.

Princess Catherine admired the Founding Fathers and their ability to create a new government that has been enduring — not because of power, personality, or economics, but because it is based upon the basic and universal human desire for freedom. Her one hundred years of life and experience in the matters of freedom gave her a wisdom and insight into this basic human need so many of us take for granted. There are

and always will be forces in this world who because of greed and the desire for power will usurp individual freedom. The zealots of causes that have no tolerance will succeed only when there is a vacuum from a dearth of freedom. The 'Free World' should not be a reference to a part of the world but be a standard for all to live up to and preserve, protect and defend. Freedom is both precious and fragile and is desired by all, yet endowed to none.

Twenty years ago I was the Executive Director of an association of municipalities. The organization's President was Mayor Joseph Devlin of Roselle, Illinois. He was a distinguished, tough, but fair-minded man. We would meet regularly to prepare for our board meetings, and I had noticed on a wall of his office a large print of WWII bombers flying on a mission. I grew up in a patriotic family — my father a Marine in WWII and my mother an immigrant from England who had survived the Blitz. The picture begged to me to ask the question... "Joe, you must have been a pilot in WWII?"

Joe was all business and matter of fact, "Navigator. The plane, there, in the formation was mine." That was it, no more comment. As I had found with so many vets, they seldom talked of their experiences, and they certainly did not toot there horn about it, but my curiosity pushed me forward. I told Joe I'd love to hear more about his experiences... after all I had been a history teacher at one time. That day was for business, however, perhaps some other time he said. Believe me, it was tough waiting, but knowing Joe I was not going to push it, so I bided my time. One day he asked me to come to his office — business I presumed. When I entered his board room, however, I was surprised to find newspaper clippings, photos, souvenirs, and other paraphernalia including a 'survivor's kit'.

Joe told me his story. He had been a navigator and so skilled at it that he had been assigned to a top secret radar system, he had been shot down over the Romanian oil fields, and survived a good part of a year of captivity as a POW. Joe had an unusual gate to his walk. As it turned out this was because he had bailed out of his flaming plane and as he was descending his parachute became tangled in a tree and he fell the final 50 feet breaking his leg. He had to set the leg himself while in captivity, using tree branches for splints. He lost about a third of his body weight in the prison —'containment camp'. Near the end of the war he was part of one of the largest prison escapes in military history.

As I was absorbing all of this I kept asking questions and become so taken with what he was telling me that I said to Joe... "This needs to be made into a book!" At that point Joe said what to me at the time seemed a curious thing. "No, if you want a *real* story, a *real* hero — you need to meet the Princess! Now *there's* a story!"

How could a story be more compelling than the one I was hearing? Who was this Princess and how could I meet her? It turned out there was a reunion of the air group that had flown in the campaign over Romania. Joe was in a family wedding and could not attend, but if I wanted he would let me go in his stead. They would be dedicating a monument to that campaign at the Air Force Museum in Dayton, Ohio. The Princess would be there to speak at the dedication and Joe would attempt to arrange for a meeting with myself and the Princess.

And so it began my saga of meeting and befriending this amazing woman. When we met she was obliging to me and generous with her time. She had a story to tell and indeed felt it was her life's mission to tell the story. She in fact was working on her autobiography and had a ghost writer helping her, but she was unsatisfied with the results. I offered to help, but this independent woman had already determined that only she could tell her story the way she wanted it told and she would to do it herself. She said she would send me a copy for my book. Still, she was happy to share her story with me in an extraordinary interview that lasted several days and continued via correspondence, the results of which follow. She finished her memoir and I did get a copy and it proved invaluable in helping complete this work. She remained in touch with me during her remaining days — she was ninety-five when we met.

I was honored to have privilege to know her and was not disappointed by her story. Joe was right! I wonder now in retrospect, did this wise and insightful woman know she was planting a seed that would eventually become this effort you are about to read. A generation after her departure she might still be on the circuit beseeching Americans and free people everywhere to hold fast, to preserve their freedom, and to in fact work to expand freedom to the unprotected. It is my wish that Princess Catherine's story will move and inspire you and others to appreciate, to work, to sacrifice so that all mankind could enjoy that precious and fragile... freedom... and the hope it conjures.

I hope that you are all, indeed, in love with freedom.

ACKNOWLEDGEMENTS

The compilation, typing, editing, and general overall total efforts needed to transform an idea into a finished tome would have not been possible without a number of special people. First to my wife Linda who allowed an indulgence for her husband to zip off for a weekend to meet "*A Princess!*"; followed by listening for over twenty-five years to my ruminations about "*a book?*"; and culminated by over a year's hiatus from normal life while I composed this work.

It was when my eldest daughter Corey headed off to the U of I that I decided my life was indeed evolving and I had better get started on that book so I let her drive and wrote the outline. Ten years later the typing of my barely legible handwritten manuscript was the primary task of my youngest daughter Gracie Aavang. She was ably assisted after she departed for college by her classmate, teammate, and friend and one of my former players in many seasons of basketball and softball Tiffany Chamberland. My wife pitched in to finish the rough draft after Tiffany too departed for school. Middle daughter LynnAnn kindly aided her techno-challenged Dad through the digital imaging process for all the images in the book.

The painstaking task of initial proof reading (two and three readings) fell to my chief cheerleader and fellow storyteller and author, my mother Joy Aavang. My wife again was a valuable extra pair of 'English Minor' proofing eyes. The final polish went to a dear friend and neighbor Kathelene Spaltro who is a professional proof reader and editor by trade, as well as an author herself, but who offered herself as a neighborly proof reader during her commute on the train to her real job.

I had many other advisors whose many thoughts and observations were incorporated into the final product that the agencies and publishers were to see. They include my grand dame mother-in-law who defies the common definition. Lorraine North's many years of reading and crosswords puzzle conquering made her insights and corrections invaluable. Great friends added unique perspectives that rounded out the effort. They include: Scott Brunswick — teacher, administrator, and historian; Cheryl

Wormley - newspaper editor and columnist; Mike Hellyer — editor, confidant and alter ego; Lynn Belcher — a lifelong friend who builds fighter jets and reads and reads and reads; Sue Kazlusky — a former teaching-mate and English instructor extradinaire, and Donna Schroeder a former student and fellow writer. My sincere thanks to these friends for their efforts, comments, and suggestions which helped make this a better book.

I also remind the reader that while based upon as much fact achieved by years of research, it is still a work of fiction. Most conversations within this tome aside from those by me with Catherine and Joe are literary devices. Many characters are real though some are solely of my imagination with any resemblance unintentional. Some real characters may have been placed into situations that did not occur and some fictional characters may have been used in situations that really did occur. It was entirely my judgment to do so in an effort to allow the story to flow as I desired. No slight or misrepresentation was intended.

DEDICATION

I would have never considered such an undertaking without the lifelong encouragement and guidance of my late father Irvin E. Aavang and mother Joy Aavang. Their appreciation of history and patriotism certainly lead to my own interests in the same which brought me to this journey.

This book would have not been possible without an introduction to the Princess by Joe Devlin — a true American hero. His downplay of his remarkable story in deference to the 'Princess' certainly got my attention.

Finally, of course, there is the Princess, my 'Princess' the remarkable Catherine Cantacuzene Caradja who I hope will continue to be an example and inspiration to the cause of freedom for all of mankind.

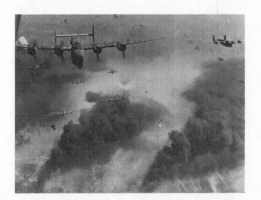

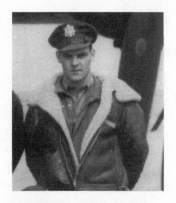

A formation of B-24 Liberators over the oil fields of Ploesti. The picture that started this journey Photo courtesy of US Air Force

Joseph Devlin of Roselle as a nineteen year old officer in the Army Air Corps

Joseph Devlin of Roselle retired but still active as
Director of Roselle Historical Foundation

In Love With Freedom

A Novel

By

Steven E. Aavang

ALL TYRANNY NEEDS
TO GAIN A FOOTHOLD
IS FOR PEOPLE OF GOOD CONSCIENCE
TO REMAIN SILENT

Thomas Jefferson

REBELLION AGAINST TYRANNY
IS OBEDIENCE TO GOD

Benjamin Franklin

LIBERTY WHEN IT TAKES ROOT
IS A PLANT OF RAPID GROWTH

George Washington

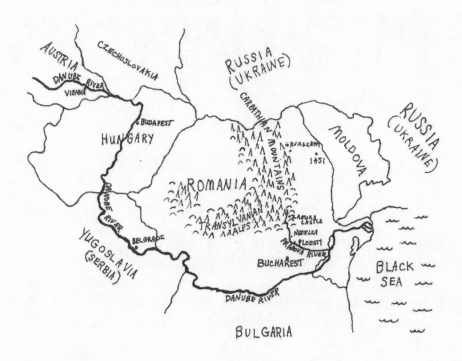

Map of Romania that includes sites noted in the book

Their Selfless Courage Lives On

August 28, 1987. Dayton, Ohio

"I am... in love... with freedom."

The old woman looked out the window to some distant place and slowly returned a steadfast gaze at me. *"Yes, this is what served me through starvation, freezing, bombs, and all of the death and maiming I have witnessed. It is what brought me to your land. It is what has consoled me in my times of personal travail. It is what has given me my strength and will to go on against so many obstacles. Yes, indeed that is the reason."*

She spoke with a hint of an accent — proper British mixed with an eastern European clip. Her words were loud — as spoken by one with long term hearing problems, yet there was no mistaking those words were also spoken straight from the heart, with conviction, with passion.

The ninety-five-year old woman standing before me moved slowly across the hotel room. She appeared to be on the edge of frail; her stature was withered under a shrunken frame. Her skin was wrinkled and mottled. Her eyes were a bit swollen and watery and had a cloudy appearance not unlike those who have lost sight. There was never a doubt, though, this was a proud woman who carried her brittle bones with as much dignity and elegance as her years would allow. Without question she had once been a robust and vigorous individual. She quickly left the impression she was still in possession of a bright and vibrant mind and spirit.

I had been told stories of her boundless energy and her fearlessness that at times could be confused with boldness, stubbornness, foolhardiness... perhaps even a bit of self-righteousness thrown in as well. Despite the physical infirmities within this aged woman was a force that had moved men and nations, and indeed she had done it long before it was deemed politically correct for a woman to be heard, much less heeded. My goal was

1

to find out what motivated, no, what had driven this woman throughout her long life.

Characteristically, as I had been forewarned to expect, she was simple, direct, and to the point. My opening question to her was very broad, a conversation starter for two complete strangers..." Why have you done this for over thirty years?" In that briefly uttered one sentence she had summed up her life's long struggle, a fight and quest for an ideal perilously fragile for so many in this tumultuous world. An ideal taken for granted by so many who have been cushioned and comforted by its pervasive embrace — indeed those most empowered to insure and protect this basic human right. It was obvious from the very start this woman had a message and I was going to get it whether or not I asked for it! Of course I craved to hear it, but little did I realize what a journey she was about to take me on or how profoundly she would affect me.

The subject of my study — this Princess — had often been denied this most precious of human rights, yet had always coveted and cherished it for as long as her many memories could conjure up the images. As our conversation continued I could see beyond that bent countenance and beneath those dimmed eyes. I could feel the fire that still glowed brightly within her. It was stoked by her indomitable spirit which had carried her these many years, across so many miles, through so many tragedies and travails. It was that ideal, one as frail as her body, but also insatiable and cherished. I knew in those opening few moments she was of strong conviction and of an inspiring personality. I knew too that as natural as breathing, indeed as life itself, was her desire for the gift of freedom to be given to others.

Earlier that same day Catherine Caradja had risen early from her bed in a plain attic suite in the Armour Pensioners Home in Kansas City, Missouri. The elderly woman hummed merrily to herself as she donned her favorite navy blue dress, the one that was sprinkled lightly with a simple pattern of white polka dots. She covered it with a dark blue overcoat and looked at herself for a moment in the mirror mounted atop the dresser. Squinting a bit to gain focus, then happily resuming her humming — satisfied that she was properly put together for the big day... and perhaps just as happy that she couldn't see all of the details reflected in the glass before her. The phone rang loudly as it had been adjusted to allow for her poor hearing. However, it was the red flashing light for the hearing impaired on the phone's base that actually caught her attention

in the mirror's reflection. As she turned to answer it she looked out the window from her aerie and saw the hazy yellow image of the waiting taxi below in the circle drive.

"Yes, yes, of course I'm ready!" she responded loudly and abruptly into the phone.

Shortly there was a knock at the door. An elderly slightly bent gentleman in a well used, powder blue cardigan sweater picked up Catherine's worn suitcases and followed her through the labyrinths of the pensioners' home. It had been Catherine's home of sorts for over a decade, though she was considered more like a regular visitor than a resident.

Despite her age the spunky lady was taking this trip free because of her frequent flyer's program.

"Morning, Catherine."

"Thank you, Charles, and the same to you. Thanks for helping me with the bags," Catherine replied as she strolled down the stairs a bit too fast for the younger octogenarian carrying her things.

She quickly turned from the stairway to the dimly lit hallway; her arthritis limited her movements but did not slow the pace. Charles and Catherine moved at a comical clip down the wide hallway, she in an arthritic hurry, and he in a bent shuffle. Overstuffed chairs and wooden rockers lined the hall and several were occupied by the early risers. One of the residents, a woman older than Catherine named Loraine, raised a thin frail hand and waved slightly as Catherine walked by. She patted the resident's knee as she passed.

A female orderly offered a cheery sing-song, "Good morning," which Catherine acknowledged with a wink and a smiling nod. "Morning, Lucy."

"Hey, Princess!" an old timer in a wheel chair said enthusiastically.

Charles struggled with the suitcases to keep up. Catherine stopped abruptly and cast a mock evil glance in the direction of the old WWI vet, who was in his nineties. Bill Morrison got the desired attention he sought when Catherine wagged her finger at him as if to scold a child.

He raised his hands in surrender, "Have a nice trip... *Catherine*," he mocked back at her sarcastically, knowing she did not like formality or titles in the home.

With a quickening step Catherine strode through the lobby, a very formal and richly appointed entrance to the stately brick and columned building that had been a gift to the elderly poor by the wealthy Armour family of Kansas City meat-packing fame. At the front desk a nurse

and administrator with green name tag badges on their blouses greeted Catherine, "Well, I see you're off again. Safe trip, Mrs. Caradja. Will we see you on... Thursday?" the administrator Janet Douglass asked looking down at her clipboard of notes. Though she was not one of their charges, the staff always kept a watchful eye over their unique guest.

Stopping suddenly at the question Catherine smiled back at the pleasant ladies, "No, I'll be gone an extra week. I just received an invitation to spend a week in Cincinnati with one of my 'boys' after the dedication ceremony."

" Keep us updated," Nurse Lucy called after Catherine who was already passing through the double doors at the entrance. Catherine waved back over her head in both acknowledgement and goodbye.

The seasoned traveler settled back into her taxi seat and double-checked her purse for the plane boarding pass. Mrs. Caradja did not like to travel by plane, but found, as her age was catching up to her, it was easier on her backside, as she would say, to fly rather than take the long bus rides. She had become quite familiar with Kansas City International Airport. Her destination of Dayton, Ohio, would only take a couple of hours. There she would be speaking at the dedication of a memorial to her 'boys', the American pilots who had devastated her homeland in a rain of deadly bombs the second "Great War".

Upon arrival at Dayton, Catherine was met at the terminal by one of her 'boys', Dick Britt. After a joyous greeting and hug for his 'Princess' he gathered her bags and drove her to the Air Force Museum at Wright Patterson AFB. As she passed through the gates at the entrance, the huge tail of a B-52 Bomber was visible outside near the three hangers that served as the museum. The retired leviathan of the air was there on display with many other military aircraft. It was too large to fit inside the converted hanger and dwarfing the B-24s that had been used in the skies over Romania forty-five years earlier. If the huge contemporary bomber were an eagle, then the stubby B-24 would have been a crow, Catherine thought to herself as they approached the museum.

Catherine's thoughts were wandering to the days when the B-24s first appeared to drop their deadly tons of explosive payload on her estates. She felt inside the rumble of explosions and the shaking ground as the planes disgorged their deadly cargo upon her beloved land. Across the seat Britt was quiet as well and likely was having similar flashbacks, but

4

from a different vantage point of an airman looking down from many thousand feet above.

The car came to a halt and Britt announced, "We're here," gently prodding his passenger back to the present.

"Oh, why yes, Dick. Thank you." Catherine said as she turned her thoughts back to the reunion and dedication ceremony. Pressing her tightly curled hair, making sure it was in place, and brushing the front of her blue dress to removed any remnants of her morning's travel she left the sedan.

Inside the military hanger turned museum was an array of airplanes representing different eras of flight and war. The Enola Gay, a reminder of the explosive end to the war with Japan, shined in its stainless steel skin. There was an old Army green dirigible hanging from wires near the top of the ceiling. It had been used in WWI as a spotter over the killing fields of France. An early jet from the Korean conflict was parked at an angle in a corner of the building. Britt led Catherine towards an EMPLOYEE ONLY entrance, away from the bustle of the crowd already assembled.

Inside the huge hall was stuffed not just with mechanical war memorabilia, but on this day with human war memorabilia. The general public was not being allowed in during the dedication program. There was a smattering of reporters and camera men from the media and Air Force and a generous sprinkling of military officers uniforms, mostly Air Force. Their chests were weighted by rows of colorful ribbons and medals representing various campaigns and accomplishments.

The crowded floor, though, was composed mostly of hundreds of men and woman in their sixties and seventies, perhaps several in their eighties. Many of the men were dressed in the conservative grey, blue and brown suits of the day. A number wore an assortment of military caps adorned with more service ribbons and medals. They also wore VFW, American Legion, POW, and other military caps with insignia and adornments. The women who accompanied these former warriors were equally conservative — mostly wearing 'reunion' dresses, mid-calved in length with more color and patterns than the men's suits... happier than one would find at a funeral, but not as formal as would be found at a wedding.

There was a cacophony of noise; backslaps, handshakes, hugs, greetings, and jokes. Tall tales were being repeated, boisterous laughter echoed and hardy hailing from opposite ends of the hall as old buddies found one another and gathered. Of course there were the sober moments

as news of yet another passing was repeated, but the predominant feeling was one of celebration and joy, glad to be among those recognized and not just remembered. It was an eclectic gathering as well — with very successful company presidents, clasping onto war comrades who were happy just having a job on a factory line someplace — perhaps a job given to them by one of those company presidents in that very room.

Many of the throng were already retired and enjoying the fruits of their labors. Others were missing limbs and were aided by canes or wheel chairs. A number were haunted by memories of a distant but unrelenting past that occurred forty-five years earlier, yet kept returning to their thoughts day after day. Most kept those thoughts to themselves. All the veterans were survivors. They had been in the service of their country during WWII and had flown over the angry skies of Romania in 1943-44 as part of the Allied attack on Germany's precious oil fields and bread basket... land actually owned by their guest of honor for the ceremony about to begin.

Catherine was greeted in a dimly lit hallway away from the crowds by several officers, Air Force Museum staff, and political dignitaries. Everyone was spit polished and decked out for a big occasion. They greeted Catherine with great deference and respect. The group proceeded down the long hallway of offices behind frost-windowed doors on each side of the hallway. They were painted in drab military grey, accented solely by a plastic name identification name plate with titles only the military could conjure, such as *"Chief Adjutant Officer, Museum Specialist, Research Division {non-combat}"*.

The raucous noise from inside the large hanger was muted by the long hallway, but it was growing in volume as Catherine and her entourage approached the backdoor entry. In consideration of her age and in deference to her stature as the guest of honor, museum officials afforded Catherine the discretion to enter from the side without having to proceed through the long lines. They knew she would not have wanted to cut in front of any of her 'boys' still waiting in line to get into the event. A side or backdoor route had been her choice for the past several years when she attended large events.

As the doors swung open the noise within spilled out and served to drown out the meaningless small talk with which the escorts had engaged Catherine. She was well versed from her many years as a Royal;

6

indeed trained to engage in such prattle, but it was not her style and she was relieved to leave it behind her in the hallway. Inside the cavernous museum Catherine simply and naturally moved to the fore of the phalanx, piercing the crowd. As she entered she immediately spied a familiar face and opened her arms to offer her embrace in greeting one of her 'boys'.

"Adam, you're looking so good! Your surgery went well?" she offered to the surprised vet.

As he returned the greeting with a single word exclamation, "Princess!" the hall noise dropped almost immediately to a murmuring din. All eyes seemed to turn in the direction of the diminutive lady. Then like a fire spreading across a dry prairie the single word in the crowd was "Princess". Many began to call out her name hoping she would recognize them, or nod knowingly to a companion and mention something of a personal occurrence or experience he had remembered regarding the lady of their attention.

The hall then broke into spontaneous applause and someone led the gathering in three rousing, "hip, hip, Hoorays!" to which the Princess smiled and waved off the attention in which she unabashedly found delight. Then it was like a parting of the sea as she advanced to greet as many as she could reach and wave acknowledgement to those she could not. Inching forward she grasped hands, giving warm hugs, and reached out just to touch the hand of an old airman who could not get close enough for a personal greeting. Occasionally, Catherine would stop to have a brief chat with someone. She was greeted by a single lady who whispered into her ear. The two shared a brief tearful hug, as Catherine learned she had lost another of her 'boys'. The widow had made a long trip to share just that lingering moment in memory of her late husband.

But there were too many people to greet. She had seen too many die and heard of so many who had passed during the course of her long life. A moment of thought, remembrance, a word of encouragement, and a blessing; then Catherine moved ahead; always moving forward. The Princess worked the crowd like a political candidate, though she was treated more like a rock star as she meandered through the adoring crowd. It was a mutual admiration, they were her 'boys', and she was their 'Princess', their heroine, their 'angel'.

Catherine Olympia Caradja was indeed a princess — in fact — not just in the eyes and minds of her grateful 'boys'. She was born to royalty as the

daughter of the Cantacuzene family on her mother Princess Irene's side and through the Kretulesco family by her father Prince Radu. Catherine subsequently married into the royal Caradja family by her husband Prince Constantine. This background gave Catherine blue-blood lines that originated during the ancient Byzantine Empire throughout Romania and much of Europe.

Catherine's affiliation with the U.S. airmen came, ironically, out of the Allied raids of her homeland as they sought to destroy the source of Hitler's oil and much of his food. Those fields had been the source of Catherine's family's great wealth. Yet despite the Allied efforts to destroy her source of wealth, Catherine respected and admired these airmen. She had put her own life on the line to protect and nurture the men who fell out of the sky. The Princess knew that at the time her country was under a form of serfdom or as the Nazi had called it 'a protectorate nation'. Indeed it was an intolerable and brutal form of foreign occupation. These brave young men from America were unleashing their bombs on her land, destroying it, and killing many of its citizens, yet they too were on a mission to liberate her beloved country and indeed the world of a despicable dictator.

Those airmen were a God fearing force of freedom fighters as she saw it, and freedom often comes at a price, a heavy price at times. These men began to fall from the skies and into her country as she knew they would. Hitler had assembled his heaviest concentration of anti-aircraft defenses there to protect the black lifeline of oil his military craved. Catherine felt a duty to the Americans to bury the dead, heal the wounded, and most importantly care for the prisoners of the conflict as Romanian prisoners, not prisoners of Germany. Catherine provided for these prisoners as best as she could within the limitations that the war had placed on the resources of her own country. Most accounts suggest that fully one half of all the Allied POWs in Romania would have perished where it not for her efforts. Many of the men in the hall that afternoon owed Catherine more than their gratitude, and they knew it. This instilled the lifelong bond and indeed the worship they had with her.

These heroes Catherine gathered amongst who had fallen from the sky over her country were not viewed as much as ex-POWS. In her mind they were more akin to the thousands of orphans she had spent so much of her life tending to and nurturing in Romania. She had been like a mother to her many Romanian orphans, and she had seen herself as an adoptive mother to these, her 'boys', when they had been shot down.

Her tenderness and caring had not only repaired many bodies, it had also spared many a soul and mind. This matron had indeed been their 'angel' on earth and she was fittingly called by them and historians the 'Angel of Ploesti'.

Over the loudspeaker system was heard the call for everyone to go to the memorial courtyard outside and west of the museum. As she was leaving for the dedication, saying more hellos to those who worked their way over to her, Catherine remembered a promise she had made. A note of regret had been sent to her by one of her 'boys' who would not be able to attend. He had asked a favor. Would she meet with a young man who had an interest in history — used to teach it in fact — and who had a strong sense of patriotism? The lad did some writing and maybe he could help her in some way, but at least an introduction would be most appreciated. Catherine could not rely on her eyesight, and she asked Britt to scan the crowd for a 30 year old man with red hair and a mustache. Britt knew such a person would be very obvious in this silver haired gathering; in fact he thought he may have already noticed someone that met the description standing off to the side by a B-24 Liberator parked inside the hanger.

Britt's recollection was correct, and he brought the young man over to the smiling little lady, still engrossed in a conversation with an airman she had not seen in a long while. She noticed their approach and immediately turned and extended a hand, "Pleased to meet you. Steve, isn't it? I am Catherine. Your friend, Joe, told me to expect you. I'm so glad you could make it. Would you be so kind as to stay with my little group here? Oh, I see you have a beautiful camera. Could you take some pictures for me of the event? Perhaps later we can talk. Right now, well you see I have many 'boys' and friends to visit. I don't get around as much as I used to."

The young man eagerly agreed, a little dumbstruck and taken by the command of the stooped grandmotherly figure.

The group was slowly moving out of the doors towards the memorial gardens. Steve overheard Catherine speaking to another distinguished looking man with a name tag that read 'Col. Gunn'. "So how is Frank Shaw?"

There was obvious sadness as Gunn responded, "I'm afraid not too good, Ma'am. He's confined to a VA facility back in Minneapolis."

"So many of you carry so many scars inside. It's a shame." Catherine

added shaking her head in the negative. "You have holes in your bodies and carry German metal in your bones and flesh. Those wounds you carry so gracefully, minimizing the difficulties I'm sure you have from time to time. Some of you limp or carry artificial limbs, and modify your lifestyle to meet your hardships without complaining. But in all of my experiences, it is the wounds of the heart and mind that have taken the greatest toll. That demon within is an intruder that haunts so many. I swear many of those poor souls have given up more than if they had laid down their life on the battlefield. It often takes more courage to live than to die."

With that Catherine went quiet as she entered the memorial garden walkway that led to the new canvas draped stone monument that was about to be dedicated. It would have been impossible to not be touched by the woman's compassion for her 'boys'. Her newly appointed cameraman followed; respectfully several steps behind.

Catherine moved with the shuffling crowd across the expanse of grass and monuments. There were many pedestals, statues of airmen and planes, and sculpted art of varying forms honoring individuals or complete flying corps for their contributions to aviation, military campaigns and other acts of heroism. Catherine was led to a podium with the shroud covered monument where she was joined by other active and retired military. At the scheduled time the monument was unveiled to show a beautiful sleek black marble memorial. On its face was an etched picture depicting various profiles of the famed B24 'Liberator Bomber' used almost exclusively in the US Operations into Romania. The sides and benches that flanked the centerpiece identified the various wing groups involved and the campaigns within the mission. It was duly noted that 286 bombers were lost in the campaign and that there had been 2,829 casualties. As this grim fact was revealed a moment of silence was asked for by the master of ceremonies.

Retired Col. Gunn had been the final commander of the POWs in Bucharest. Now he commanded the podium. He read the dedication, "For all airmen who flew combat missions over Romania and in memory of our many comrades who endured all and gave all that mankind might live in freedom and in peace, we dedicate this memorial."

Gunn then read the poem inscribed on the marker.

> *"Harken you who in spirit soar,*
> *To the echo of thundering wings,*
> *Theirs was the sky, the high frontier,*

Where courage and valor reign,
Though fate of man has stilled their wings,
And quieted their thunderous song,
In those who streak the beckoning blue,
Their selfless courage lives on."

As if on cue, a loud rumble was heard overhead. Everyone looked up. The airmen in the crowd knew... they recognized the familiar drone of those engines from within the recesses of memories of bygone days. A lone B-24 escorted by three vintage P-38 fighters flew across the sky. All heads craned skyward to follow the formation as it moved across the blue expanse. Most veterans saluted, many with tears in their eyes shed in thoughts of the past As the old planes disappeared, from a crossing direction came a formation of three screaming F-16 fighter jets racing low over the airfield. As they crossed overhead, the jet on the outside right peeled upwards straight towards the heavens, in tribute to fallen comrades. It was not just the noise or sheared airwaves that stirred the bodies in the memorial garden to their inner core.

Col. Gunn paused a little longer to let the moment settle. "Ladies and gentlemen, let me conclude with one of the highest honors that can be bestowed upon a former POW from the Raids over Romania, and that is to introduce and turn the stage over to our very own Florence Nightingale, our guardian angel, *the* Angel of Ploesti — we are so pleased that at the age of ninety-five she can still fly across the country to have a *free* dinner with us."

Gunn paused for the interruption of laughter and sprinkling of applause. He continued, tongue in cheek, "Ladies and gentlemen, most of us have broken bread with this lady before — but I can promise you... there will be no sawdust in the bread, no goat meat, and no eyeball stew this evening!" He paused for more laughter. "Without further delay, we have saved the best for last, Princess Catherine!"

Cameras flashed and auto rewinds whirled as Catherine rose slowly, but gracefully, and moved to the center of the podium while the warm and prolonged applause continued. She raised her arthritic arms stiffly, her palms up, not quite to the height of her shoulders. In Catherine's way it was a silent command for her audience to be quiet and listen and they obeyed. Before she began she turned to the monument and stroked the etched words of dedication gently. Pausing, she dabbed the moisture welling in her left eye she patted the monument again, not unlike the mothers and wives who do the same at the coffin of a loved one. Letting

her hand rest on the black monument she chose to speak there rather than using the pedestal and microphone.

"Please forgive me if you cannot hear me," Catherine began in a voice that could have been heard over a bombing, a voice that seemed much stronger than her age and condition might suggest. Then with a brief twinkle in her glistening eyes she added, "That's seldom been a problem for me!" The assembled crowd laughed, breaking the deafening silence that accompanied her command. Soon they quieted again as Catherine prepared to speak.

"I was never blessed with a male child and yet since 1944 I will forever have so many sons!

"As you know," she began and paused before continuing to speak. She had no notes... then she cleared what certainly was a lump of emotion from her throat, "I am known to say little, but speak my mind." A few chuckles sprinkled the crowd and were quickly stifled as she spoke again. "I believe I have become a very popular speaker lately... likely it's the 'saying little part' of course! As I've gotten older my speeches have gotten much shorter... bladder issues you know!"

Her self-deprecating humor was not lost on this gathering. It was obvious she had spent decades as a public speaker and knew her audience. She turned again to the monument and patted it as the chortling crowd grew respectfully silent.

"This is especially dedicated to those who are **not** present this day, so we and others never forget what they sacrificed for freedom." Catherine looked back to the inscription under her hand. "In Freedom and in Peace." She reiterated, "If you don't mind my back to you I feel closer to **them** as I touch these words. Yes, **they** gave their all. Now forty years later we have the privilege and God's good graces to be here enjoying **glorious** freedom! But around this world there are many — too many who have no freedom. We must take our **gift** and work to spread it to those not as fortunate. Do you know that in the Arctic the Eskimos have over 200 words to describe snow? Well, of course... they have a lot of it! Yet, some countries don't have **one** word for **freedom**.

"Your **comrades**, and my 'boys' — **not** here — gave their all. We cannot let them down! You, my 'boys' out there — you offered your all at one time — so long ago. God chose not to call you then. He gave you a purpose, and I believe part of your purpose is to remain vigilant to the cause of **freedom!** You must also spread the word, don't let our leaders in government, in schools, in business become complacent. We have

much work to do! We have many miles to traverse, many words to be spoken." A right hand with crooked fingers extended upwards to the sky. "Please be as fearless today as you were those days when you flew over my homeland. ***The cause of freedom and peace requires it!***" Then she closed quietly, "God bless each and every one of you." Catherine turned to the monument and gently kissed the shiny black memorial.

<center>*****</center>

Later that evening at the banquet room of the Dayton Marriott dinner had been served and the reunited airmen and their wives were really beginning to get loose. The Big Band orchestra was belting out some Glenn Miller tunes, and the bars had been catering for several hours. Catherine had been invigorated by the day's activities and by visiting with so many of her 'boys'. But it was time for her room and some quiet.

"I just can't keep up with all you youngsters," she joked to her host, Col. Gunn, at the head table.

As she was leaving the banquet hall she asked Col. Gunn again to contact the young man she had met earlier at the museum. The young writer was not a part of the reunion banquet and was anxiously waiting in his room for the phone to ring. "Mr. Aavang, Princess Catherine will see you in her room 712 in fifteen minutes, 8 pm. She's very tired — a very long day, but I'm sure she'll visit with you for a few minutes."

<center>*******</center>

August 28, 1987. Dayton, Ohio

I knocked at precisely 8 pm. "Holy Cow!" was my first thought — "I'm interviewing a princess! Best be prompt. Can't be late, don't want to rush her." My Midwest farm town upbringing instilled respect for elders, and I guessed royalty would have to be up a notch from that! My palms were sweating.

The door was answered by Col. Gunn. "Mr. Aavang thanks for your interest in the Princess. I'll be getting back to the banquet now. Just don't linger. She'll let you know when it's time to go. She's rather blunt."

I nodded in acknowledgement, anxious to see how this anticipated meeting would play out, be it ever so brief. As Catherine looked up a slight smile of greeting creased her lips. "Please, Steve? Please sit here, Steve," she commanded pointing to the table across the room by the window with two empty cushioned chairs next to it. She noticed the folder with paper and pen I carried with me, "If you want to write it will be easier here." She walked slowly to the table.

I began a nervous rapid-fire prattle of words, thinking I was making

<center>13</center>

interesting conversation. "Princess Catherine... I've heard so much about you. I so admire your drive, your stamina. My mother lived through the Blitz in London, and I've been told many things about war. I think I understand a little of what you've been through. My dad was a Marine in WWII, in Asia. My brother was in the Army, Germany in the 70's. I was 4F... poor eye sight and a high lottery number. I once met the King of Norway — Olav — back in 1981..."

The Princess held up her hand. She appeared quite tired. "So do you want to talk... or listen? What are they... your questions for me?"

I realized that in my pent up anxiety over meeting a princess I had been chattering... yammering. I opened my notebook and clicked open my pen. "Princess Catherine, what is the reason... for what it is you do?"

So began an odyssey I did not expect. She talked... and I listened for three hours that evening, ending, I believe when her eyes simply became too irritated. It had been a day of travel, much activity at the dedication and finally conversation and too much smoke at the banquet. Catherine's eyes appeared swollen and red and watered often during the late evening and when her tissue package emptied she surrendered, asking me to return in nine hours.

*Standing immediately I walked to the door and let myself out. My mind was swimming with the story that was unfolding before me. When I finally settled in my room I was mentally exhausted. I know I fell asleep at some point in the wee hours of the morning. It seemed like just a flash of time had passed when the hotel alarm buzzed me from my slumber at 7:15 the next morning. I spent those quiet early morning moments with my mind racing — rethinking the unbelievable story being unveiled, and anxiously anticipating what she would impart shortly. I had literally become fatigued writing notes the previous evening as she talked and would have never asked Catherine to stop, but I needed the break at least as much as she. In four more hours that morning she completed her story, answered my many questions, and left me with a promise to stay in touch. Though I knew nearly immediately upon seeing this amazing person in her element among her 'boys', I had absolutely no doubt, just as she had stated in the first moments of our meeting... Princess Catherine was indeed... **in love with freedom**.*

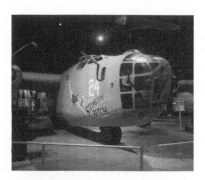

US Air Force Museum, Wright-Patterson Air Force
Base, Dayton, Ohio. Side view of a B-24 Liberator.

Nose view of Strawberry Bitch flown in
combat with J. Devlin as navigator

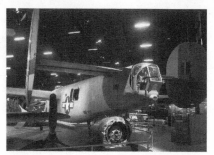

Side gunner position and tail gunner position under
the unique twin fin tail of the Liberator bomber.

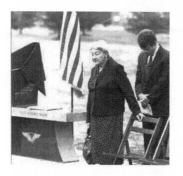

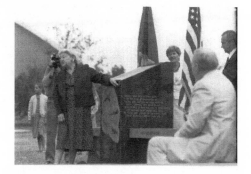

Heads bowed in prayer at the opening of the
dedication held at the museum

Princess Catherine Caradja , a commanding and polished
orator, speaking at the dedication

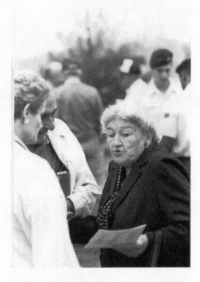

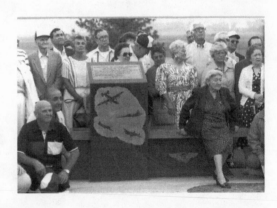

Princess Catherine Caradja sharing memories and tender moments after the dedication

Bargain with a Scoundrel

August 28, 1987. Dayton, Ohio

As I reflected on my notes scribbled across the pad before me I knew those many nuggets garnered from my encounter with Princess Catherine had provided me with an enduring story of love — full of passion and dedication — not to a person, but to a cadre of American servicemen, to two countries, and to the cause of freedom.

Catherine continued, "Romania is an isolated country, caught between Asia and Europe yet not belonging to either. It's bounded by the Black Sea to the east; the Danube snakes from Europe along the southern border, the sinister Russia tries to envelope it from the north and east. The other orphan countries of eastern Europe— Hungary, Yugoslavia, and Bulgaria — are restless neighbors on the north and west.

"The Transylvanian Alps, the Carpathian Mountains, arc through the country, effectively separating the east from the west and the south from the north. They are at once beautiful yet dark and mysterious, the source of much legend and isolation. It is a very rugged land and sparsely populated."

Princess Catherine gazed outside the hotel room window, but I sensed she was looking off to the misty mountains of her homeland. "Below this craggy mountain crescent lays the bread basket, our fertile plains which also are the source of our greatest resource — rich oil fields."

She paused for a minute to dab her eyes, still stinging from the previous evening's smoke, I imagined. "We have been crisscrossed for centuries, by invaders — not so intent on our land as much as a means to get from one conquest to another — but none has spared us the plundering and pillaging — the Vikings, Cossacks, Attila the Hun... even Alexander the Great left his mark. He died while returning from his conquests to the east. His generals squabbled and plundered the riches he had been taking back;

and the Indian carriage drivers they commanded fled into the mountains of Romania and formed the corps of wandering gypsies of which we have been credited.

"Gypsies and Dracula, no wonder civilized Europe has looked down on us," she said with a shrug of acceptance. "As geographically isolated and divided, as torn and sundered, as so often overrun — we became a splintered, fractional, feudal land. We had no national religion or culture, rather sectarianism and rivalries. In the 19th century as a small nation under the shadow of Germany, France, England, and always under the desirous longing stare of Russia — Romania struggled for respectability and acceptance; for security and safety. We were viewed as a nation with a chip on its shoulder. Kind of like your Chicago always being a second city to New York City.

"To gain respectability we determined a need to adopt the European model of a democratic monarchy. We even brought in a member of the German nobility to create a line of monarchy that would be respected by the rest of Europe. We strode to create more of a sense of nationality by arranging marriages between our own nobility — affairs of the pocketbook and political alliances — not for the heart. Such was the case of the Cantacuzene and Kretulesco families in the 1890's, and my own marriage later.

"On my mother's side was the Cantacuzene family which was a respected and prominent family from Bucharest. My father's family was the Kretulescos are of a lesser connected royal family of north central Romania. One son, my father Radu was dashing and handsome; my mother Irene was young and wanting in the worst way to be a mother. After a wistful courtship, brief honeymoon, and consummation their union quickly resulted in a child. For her the baby was a dream come true...for him it was merely cementing the deal.

"I was that child.

"I have no recollection of those first couple of years of course, though there are pictures of me at play with my father. Alas, though they show us happily at play, maybe those pictures were only as you say 'a Kodak moment,' done for the benefits of the camera. Bitterness, greed, and mistrust broke the marriage. The young Prince was a flamboyant playboy — you'd call him a gold-digger. He was not interested in a job, a wife, a family — he had no ambition or resources. He wanted his wife's fortune to sponsor his philandering. Knowing that his strong willed wife would not tolerate such a marriage or drain on the family wealth — the schemer Radu wanted to secure his desired lifestyle anyway he could. When the Princess requested

a divorce and split from the imprudent Prince, he exploded with rage and vowed his revenge.

"My mother, the Princess Irene, took refuge within her family. She traveled with her mother, father, and nanny to France with me, just a toddler. I was then three. The young Prince followed the family proclaiming there would be no divorce, that they could not take his child away from him, that he would not leave without a dowry. I think you would call him a 'stalker' today. He convinced my mother he should be entitled to spend time with their child. She in a moment of weakness agreed to such a visitation, though only in the company of the child's nanny. This created the opportunity the deranged man sought."

Paris, 1896, was a destination Irene's father Prince George Cantacuzene felt would be a pleasant distraction for his distraught daughter who still reeled from the emotions of the pending divorce. The Cantacuzene family was traveling to the playground of the royals and rich; its shops and restaurants were the Mecca of the civilized world. Princess Irene enjoyed the company of her family — and the escape from the failed marriage to Prince Radu Kretulesco. Her happy precious daughter Catherine was constantly at her side. The family was staying in a beautiful, ornately decorated hotel along the Champs-Elysee.

Prince George was an impressive man. He always seemed to stand erect; he was broad of shoulders; with impressive white hair and a grand mustache that mingled with bushy sideburns ending at the side of his chin. Prince Cantacuzene was highly respected in both financial and political circles and often mentioned as a potential leader of Romania. He spent his days in Paris having business lunches, being courted by the who's who of France and the European diplomatic corps. He could spend hours in stately rooms filled with the pungent odor of large Cuban cigars, sampling some of Europe's finest cognac.

The wife of Prince George, Caterina, and their daughter Irene, with child in-tow and nanny trailing, on the other hand preferred to sample the dress, hat, and shoe stores and pause for hour long teas — often with just their own company; but occasionally as hostesses or as guests at formal gatherings in grand homes or hotels with the noblesse of Europe then gathered in Paris.

Princess Caterina, for whom her granddaughter, the young daughter of Irene was named, played the roles of both wealthy and nobility well.

The grandmother had a quick smile and smart wit that made her a popular conversationalist. Her gray hair was long but usually pulled back into a fashionable and convenient bun. She was short and full figured. Her daughter Irene was taller with luxurious wavy dark hair and a shapely body kept modest by appropriate attire. Though Princess Caterina excelled in her role as the wife of a prominent royal and one of Europe's wealthiest she preferred the private time spent with her daughter and adorable granddaughter.

As they prepared to enter a social gathering they were hosting in the hotel, a concierge quietly and discretely slipped a note to Princess Irene. The socialite glanced at it in a private moment.

I would like to spend an hour with my daughter... Perhaps while you're at your event this afternoon. Can we discuss this in the lobby? I await.

Radu...

"Mother, could you excuse me for just a moment?" Princess Catherine was about to greet a guest, "Oh, but hurry, dear, our guests are beginning to arrive!" Her glance and nod at her daughter shifted to a smile as the wife of a German banker extended a hand. Princess Irene gracefully parted and hurried toward the lobby. On her face was a scowl of anger. *How could he be so bold and ill timed! Yet he was the child's father.* Her expression softened to an anxious worry, and she bit on her lower lip — a nervous habit.

"Darling?" a voice arose from behind a column in the lobby.

"Please, Radu! Let's not delude ourselves!" Irene countered immediately.

Radu was attired impeccably — formally — as befitting royalty in such a setting. He did cut a dashing figure. Slim, though not tall, he had dark wavy hair parted down the middle. His broad thick handlebar mustache curled up high towards his brown eyes which were large and expressive. On this afternoon the eyes were bright and smiling. Irene remembered mostly their fury and deceit.

"You're so right, Irene," Radu agreed somewhat stiffly. "But I've not spent any time with little Catherine. Might I spend just an hour or two with her on such a glorious day as this?" He pleaded as he gestured towards the sunny day just beyond the doors.

A nervous Irene began to shake her head no and raised her hands as if to push away. Radu persisted before she could speak. "Irene, if I could

occasionally have some time like this... with little Catie... it might make the future a bit more tolerable... for both of us."

The last comment was more like the Radu she knew — always a condition, a lightly veiled threat — charm with a dagger! He had been making demands for a huge settlement dowry before agreeing to a divorce. The family knew Radu would not go away quietly, but her father Prince George felt the demands were excessive. He would agree to a "reasonable settlement" — not an uncommon occurrence among royals to "keep the peace". He would not, however, be looked upon by others as having been weak or submitting to extortion.

Hoping to be a peacemaker Irene felt if she could somehow intercede, if she could somehow pacify Radu, perhaps he and her father would become more amicable and a reasonable agreement could be reached, despite her father's caution, "You cannot bargain with a scoundrel."

Finally relenting, Irene relaxed her body language and clutched her hands and pressed them against her breast in an almost playful pose and forced a restrained smile trying to be pleasant and accommodating. "Our tea will end at 4 p.m. Nanny Jeanne will accompany you... of course, and be advised that Catherine must be up in our suite by the time Mother and I return. That should allow you a good two hours."

Radu beamed, "Oh that is most gracious of you! I think if we can both be reasonable — everything can be worked out."

Satisfied Irene left for the suite and told the nanny of the arrangement. She rejoined the tea and told her mother of the encounter with Radu.

Still in the receiving line, Princess Caterina was taken aback. "Gracious, Irene!" she gasped in a whisper, clutching the broach at her throat.

She managed a smile, "Oh, Madame Cheverene, how nice of you to come." Then quickly Princess Caterina turned back to her daughter. "Child, you must leave these matters to your Father! You cannot trust Radu; he's an *evil* man. Well, let's just focus on our event now." She shook her head wondering what her daughter was thinking.

"Good afternoon, Mrs. Naylor, how are your houses in the Dales and London?"

"Bonjour, Nanny Jeanne. I've arranged for this carriage to take us to the Promenade under the Eiffel Tower. I think Catherine would enjoy this beautiful day in the park!" Radu loaded the push chair and had

Nanny Jeanne sit next to the vivacious child who was perhaps a tad too rambunctious for him. He didn't have much practice with or patience for children.

It was a long ride from the Champs-Elysee to the tall piercing iron landmark. Radu often ordered the carriage driver to turn down a street, across a strange boulevard, around a fountain. The carriage driver occasionally looked puzzled or just shrugged after each request from Radu... it certainly was a roundabout way. Once he offered a suggestion, but Radu quickly flared up. "I'm paying by the hour!" Then just as quickly he turned and smiled at his young child Catherine and looked over to the nanny, "Our little Princess seems to enjoy the ride."

At long last they arrived under the shadow of the famed metal spire. Radu ordered the driver to continue on to the far end of the park, suggesting a leisure walk up the Promenade would be delightful. As they neared the end Radu saw a vender selling roasted nuts, "Nanny Jeanne, here's a Franc. Let's get a bag."

Jeanne took the coin and lowered herself from the carriage. With bag in hand she gave the vendor the coin, and as she did she heard the clatter of hooves on cobblestone. She looked back to see the carriage bolt down the street and around a corner and let out a guttural scream. A crowd gathered, but she only spoke Romanian. The frantic woman had no money, she had no idea where she was, and all she had was a bag of roasted nuts and the haunting image of a little girl's smile as she looked out the carriage at her nanny.

After the highly successful tea Princess Catherine and Irene retired to their suite. There was no bouncing toddler to greet them, no nanny, no note. It was half past four. Irene expected everyone to be back to the suite by that time. Calling out for the nanny and Catherine, she knew they weren't there; Catherine was too energetic to be sitting quietly when her mother returned. She paced nervously for a brief moment and then went to the balcony to peer up and down the boulevard in the vain hope she would see the nanny and child perhaps wandering in the sidewalk. As she stared futilely outside Irene at last admitted, "Oh Mother, I'm upset! That Radu!" Irene, again chewing her lower lip fought off tears of desperation and fear.

"I'm angry, my dear," Princess Caterina responded. "He's likely being late on purpose — just to worry us *and* to spite us! This will not

sit well with your father! But let's just sit and wait him out. Your father should be back by five."

At last Prince George arrive, just ahead of the hour, but not the nanny and child. He initially took the calm approach agreeing with his wife's assessment. But his pacing and gazing from the balcony, scanning up and down the broad boulevard revealed his inner turmoil. Suddenly, he bolted from the balcony with a command to wait for his return. He had seen a police buggy with several Gendarmes and he recognized Nanny Jeanne, sobbing and alone.

"Where is my Granddaughter!" he commanded in French and then again in Romanian to the Gendarmes and the nanny collectively, as he reached the lobby. The group had just entered from the hotel entrance. The people in the lobby area hushed and looked at the commanding man — not used to such commotion in the otherwise genteel and sedate surroundings.

One of the officers looked up and asked politely, "You must be Prince Cantacuzene? Your nanny has only been able to convey your name and this hotel to us. She's been making gestures but I'm afraid we have no one who can understand her."

Prince George took the sobbing nanny's chin in his hand and directed her eyes to his. His voice boomed, "Tell me! What has happened?"

The great political influence and wealth of Prince George Cantacuzene was marshaled to its fullest extent. The Paris police force, even units of the French army and navy were alerted to the kidnapping. Pictures of the three year old child were posted and distributed throughout France. The youngster had been posed for pictures in some of her newly bought Paris fashions, complete with an exquisite white beret. They were delivered to the hotel two days after the abduction and used in the posters.

All of Romania was alerted in the event Radu would seek refuge in a familiar land, though Prince George knew the radical prince would not go to Romania. Radu had more enemies than friends there, and the Cantacuzene family was too respected to allow such a heinous crime's perpetrator to go unreported. Even the Kretulesco family, in shame, vowed to help in the matter. A note arrived and was handed to Prince George by the same concierge who had handed the first note to Irene. Prince George read it and crumpled it in his fist.

Catherine is well hidden. If you want to see her again you

23

will accede to my original request... but it must now be <u>tripled</u>.
The payment must of course be directed to my Swiss account as
set up originally for the divorce proceeds. When the money is
deposited you will be contacted about the release of the child.

<div align="center">

Radu

</div>

After waiting two more weeks in the unlikely event the young princess or her abductors were found, the Cantacuzene entourage began its mournful journey home. When they at last headed back to Romania Prince George went out of the way stopping in Rome to seek and get the assistance of another with whom he had influence, the Pope. Notice was sent to many of the other Royals throughout Europe. Once hope was lost of an early recovery and as officials became less specific about their efforts, Prince George hired private detectives to scour Europe in an effort to find the kidnapped princess.

The search failed. The family did not quit, however. Relatives, business and government contacts of Prince George were always reminded and kept mindful of the kidnapped child, the princess, the lost daughter and granddaughter. Private detectives continued to be hired to track down all leads. As the months wore on the official efforts by the French and Romanian governments were drawn away to more pressing and immediate needs.

A final communiqué from the chief of police in Paris came one year after the kidnapping..."We regret to inform you that despite heroic efforts on the behalf of my staff and in the course of following up on hundreds of leads provided by both our investigation and from sources you have provided — we have been unable to find any substantive trace of your kidnapped daughter/granddaughter, Princess Catherine Cantacuzene. While we will not close this file, we must redirect our limited resources, for more viable and pressing investigations. We wish you the best in your continuing efforts."

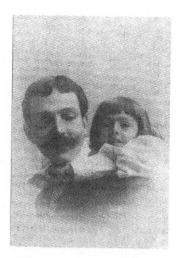

Princess Catherine approximately two
years old with Prince Radu

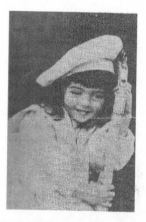

Princess Catherine in a portrait photo taken
days before her kidnapping. The picture
was used in posters distributed after her
abduction

Princess Catherine at approximately age nine;
one of the annual pictures taken of her by Radu
to enclose with his renewed ransom demands

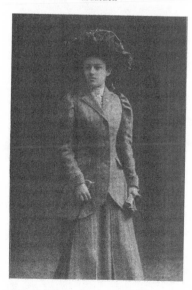

Princess Catherine at age seventeen dressed in
her Paris fashions after her safe return to Bu-
charest and the Cantacuzene family

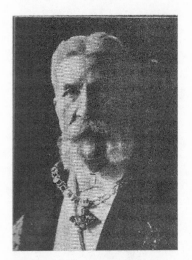

Prince George Cantacuzene (Grandpapa)

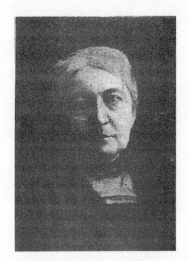

Princess Caterina Cantacuzene (Granny)

Princess Irene Kretelusco (Mother)

Prince Rudolph (Radu) Kretelusco (Father)

CHAPTER 3

The Unruly Child

Radu had a well planned abduction. He had even enlisted accomplices from another errant aberration in his younger life. As a young man Radu ran away from home when his father refused the ranting juvenile's demand for an apartment such as the one his older brother had been granted when he went to the University. Radu had not earned such a privilege, in fact had no interest in pursuing an education, but could not stand to be denied such a perk if his brother had received one. He joined the French Foreign Legion... which was not at the time very selective in its recruitment process. He was immediately shipped to an outpost in Algiers. Needless to say this was all more romantic on the recruitment posters than in the sands of Algiers. Radu posted his father to bail him out – it was neither the first nor the last time.

Brief as the stint was, however, the clever Radu had found time to charm and cajole several low-life comrades into being accomplices for future escapades. His promises of riches in his scheme to kidnap the princess convinced one such crony and the man's gullible wife to meet him on the northern outskirts of Paris and transfer his 'package' to be delivered to an address in London. Radu thought correctly that a child with a 'mother' would not attract suspicion the way a young man with a toddler might — especially when it would be obvious he did not have any experience with or interest in handling a small child. Sadly Radu did not even view the child as being of his own blood... only as a pawn, chattel, in a high stakes game he planned on winning.

Traveling alone Radu immediately made for the coast and was across the channel arriving in London by noon the day after the kidnapping. The rendezvous with his accomplices and their 'package' went as arranged that evening at the Gate of the Duchess of Leeds Orphanage operated by

the Sisters of the Holy Child Jesus. The nun received her 'commission' and the child was enrolled as an orphan whose parents, she was told, had both tragically died in a train accident. Radu registered as the child's guardian under an alias of Francois Garnier leaving the scared and confused child in the arms of the nun without a second glance. The child's name was given as Jeanne Bardin. With an ironic twist Radu had chosen to rename the young princess using a combination of the nanny's name and the street of the child's abduction.

Too young to understand what was happening to her the young girl quickly adjusted to her new surroundings. She did not understand the disappearance of her loving family which was replaced by the cold black shrouded nuns of the orphanage. Strange voices were accompanied by unfamiliar with the new words being spoken to her, yet quickly gained an understanding of the English she heard spoken by the adults and other children the surrounded her daily. Her new life seemed crowded, regimented, and strict compared to the majestic and leisure life of her previous existence, but that past world was quickly forgotten. There was a hollow memory of love and affection which faded but never vanished. The long days of fright and confusion turned to months of adjustment and acclimation. The months became years and the young heiress had slid into a meaningless existence as an unclaimed orphan struggling like the runt of the litter for survival in a stone block existence that was her new life. Soon she knew only her life as it was revealed to her each day cloistered as it were from the rest of the real world within the walls of the orphanage.

By the time the precocious child turned six she was showing a very independent streak — one which would both hinder and help her throughout her life. The little girl called Jeanne questioned the nuns often about why so much was different in her situation. Why was she so much younger than the other girls; why didn't relatives come to visit her; or why was she never was able to leave on holiday with family like the other children did? Why did she always sleep alone and not in a dorm with the other girls? The nuns could only explain her tragic circumstances and assure her this was the best situation she could expect.

Jeanne was often alone — the older girls of the orphanage had no time for her. To entertain herself the young child would often run off to the woods of the estate to play alone among the trees, flowers, and grass.

Jeanne would search the ground for shimmering rocks that she would pretend were fine jewels and add them to a collection she kept in a box under her bed. Jeanne thought it was because she was so much younger than the other orphans who typically were aged ten to thirteen, that she was kept in a separate room a floor above the girls' dorms, not knowing it was because of the orders of her guardian. Her room was adjacent to the quarters of the nuns servicing the orphanage and on an upper floor to discourage any attempts at fleeing. When her room was locked at night the young girl was told it was for her own safety.

The isolation did serve Jeanne well in a couple of ways. She developed a very active imagination and had pretend playmates and created her own family with whom she would travel widely to unknown places. She also grew to be very stubborn and independent, not learning the compromise and the give and take that comes with living in a group setting. This independent spirit was especially difficult on the nuns, for their little charge would not be ordered, nor would she quietly acquiesce to punishment if *she* did not agree with either the premise of the offense or prescribed penance.

There was one such occurrence Jeanne remembered proudly. She was eight by the time of this event. The kitchen garden had produced an abundance of spinach and the meals were found to include dozens of ways to foist this abundant crop on the young lady charges. After several weeks of this Jeanne had enough and gathered daisies from the garden and sprinkled them secretly on several nearby plates and proclaimed, "They think we are goats!"

The girls looked at their plates and screamed hysterically, several vomited in revulsion at the thought of being fed like farm animals. Another fainted. In unison the contents were swept off all the plates by the hysterical girls and on to the floor. Spinach was quickly removed from the menu. Jeanne got a whipping — as expected. She accepted the punishment with a smile — she had won — despite some pain! Jeanne did not, however, agree with the "act of contrition" that was expected of a repentant misbehaver. The nuns determined their smiling impish deviant should kiss the foot of the mother superior. Jeanne was ushered into the chambers of the Mother Superior — already sitting with her foot extended.

"I won't do this! Give me more lashes!" Jeanne protested.

The sisters were adamant and pushed the young girl to her knees. One very large nun took Jeanne by the nape of her neck and forced her

head down nearer to the foot, Jeanne resisting all the way. Then, in a flash of 'divine' inspiration Jeanne opened her mouth and clamped her bared teeth across the top of the unsuspecting Mother Superior's ankle. The confusion and uproar was only supplanted by the bloodcurdling scream of Mother Superior. Several days of cleaning chore details followed. But Jeanne was never again asked for 'contrition'.

There were other punishments. One was called 'isolation' and girls were placed in the punishment room. This again did little to Jeanne as she was used to being alone in her attic room. Isolation was just an escape for her imagination. She did, however, feign fear of the punishment so that the nuns would continue to use it. Yet again, the young girl would claim a private victory every time the 'isolation' punishment was employed.

Little Jeanne had a few pleasures during her time at the orphanage. One was tending to the farm animals. Most of the girls did not like those chores. They didn't like getting dirty and they especially abhorred enduring the smells and dealing with manure. Jeanne often volunteered for that chore and enjoyed the company of Sister Grace who tended the barn and livestock. The nun took a liking to Jeanne and tutored her little charge in the ways of the farm beasts. Soon Jeanne looked forward to the smell of manure as it meant time with the animals and away from the older children. It also meant time with the kind nun to whom she took a shine. Her time with Sister Grace gave Jeanne a strange emotion, a sense of love and affection she could not grasp in her consciousness as that which she had enjoyed constantly when she was known as Catherine.

Another enjoyment was the rock cakes, the hard candy the sisters would sell to the girls exchanging it with coins from the orphan's small allowances. Most of the girls would eat their sweets in minutes. Jeanne would smash hers into tiny pieces and wrap them into a hanky. She would then sneak away to one of her many hideaways inside the orphanage or outside to the woods, and pick out one piece at a time, savoring the candy — by licking it instead of putting it in her mouth. Jeanne's imagination went to work then by smelling the candy's aroma, breathing in deeply the sweet essences of oranges, apples, and pears. Closing her eyes she imagined she was on a boat bringing in a cargo of the precious fruit, or in a foreign market place bartering for a case of succulent juicy, tangy exotic fruits.

The orphanage provided much training that as it turned out would be very useful in Jeanne's adult life. The primary function of the training at the orphanage was to provide the highly regarded English Nanny. As

such, training in the care of infants and toddlers and in food preparation, sewing and proper manners were emphasized. The girls were also trained in the French and German languages since nannies were very popular in those countries. Other countries would seek out the nannies and one could get by if they had a working knowledge of those three different languages. Jeanne could only speak English by that stage of her training because she had been immersed in it when she came to the orphanage and never used the Romanian language she had once heard and used sparingly as a toddler.

Jeanne saw her guardian just once a year. Mr. Garnier always arrived with a photographer and had a picture taken of his young and innocent charge. The nuns knew to prepare Jeanne in a pretty dress and spent extra time curling her thick black hair. Jeanne enjoyed the attention and relished the brief time she was able to spend in the fancy borrowed clothing. Her guardian it seemed was never friendly nor attentive. Francois was always in a hurry and had little time or patience for the young girl. He spent more time talking with the sisters and Mother Superior than he did with the little girl. Jeanne had no idea that the pictures were being sent by post back to Romania along with renewed threats and increased demands for ransom.

The clever Radu knew that Prince George was using all of his resources to find his stolen granddaughter so he always took care to mail each letter from a different county so no postmark or trace of either the girl's or his location could be determined. Each year the letters became more strident and the price for the release of the child grew. Each year his temperament seemed darker and more strained. Each year the young girl became an increasing source of his venom, not knowing why, but knowing inside that this sinister man had no real connection with her.

As the years went on and Jeanne became more responsible she was given more freedom within the orphanage, and was allowed to join classes with the older girls for she had an inquisitive mind and asked intelligent questions. A great privilege was being allowed to go on outings to London and the seashore. Those were wonderful times for the lonely little girl who seemed to thrive on isolation. In reality she craved the attention and affection she was denied, and did not enjoy her loneliness. Rather she tolerated it and found ways to use it to her advantage. The trips were a delightful divergence.

Oftentimes to make her solitary existence more exciting, Jeanne would create an adventure. It might mean sneaking outside the orphanage

31

building to play in the nearby woods. Sneaking around was difficult as the sisters were many and always seemed to be about. To avoid detection and perhaps to heighten the thrill Jeanne added danger. From her lofty third floor perch that was her room, whenever the woods beckoned, she would slip out of her window in the rear of the building facing her beloved woods. Jeanne would shuffle on a narrow ledge to the corner of the building, grab the downspout to swing around the edge and lower herself to a window below that was always left open — the opening was to allow fresh air in the water closet! From there she would tip-toe down the back staircase, out the back door and on to her green sanctuary.

Time passed slowly for the orphan child. Jeanne was growing from childhood into adolescence. Precocious was a word heard to describe the young girl, and though she didn't know the word, she gathered by the context it meant troublesome. One day as she passed the open door of Mother Superior Jeanne noticed an older couple talking with the institution's Head Mistress. Though all the girls in the orphanage knew they were too old to be adopted, they all always held out hope. Jeanne was no different. She looked up and down the corridor and did not see anyone so she decided to eavesdrop. The conversation seemed strained, the voices hushed, French was being spoken in poor accents so Jeanne figured the adults could be neither French nor English.

"No, no, there is no one here by that name and we have no parent or guardian with that name either," Mother Superior answered a query.

"Do you have anyone here that is from Romania?" the man asked.

"No, all of our girls are French or English." Mother Superior replied, and then added a bit more stridently, "We are a church run home, and as such we don't support criminal activities!"

The strange woman sat at the edge of her chair and waved her hands nervously, "No, of course not! We didn't mean to suggest anything like that. It's just that her father is so clever and sly, so corrupt. He's evaded us for nearly 10 years!" After a pause she added, "There is a sizeable reward."

At that moment a group of nuns entered the building's main doorway, returning from Mass. Jeanne quickly left her spying from behind the door and walked past the nuns in the hallway. She was intrigued, but had no idea that she had stood just 10 feet away from an aunt and uncle, relatives who could have taken her away had they discovered who she was.

Within a week Jeanne found herself being removed from the orphanage to another, further away from London. Her guardian, Francois was very agitated and paced nervously. He clearly was not happy to be there.

"Can't you pack any faster than that!" he scolded. Jeanne cried at his anger, and, though she had never grown fond of the orphanage, yet it was the only home she could remember.

"Why am I leaving?" she pleaded between sobs. She was never been comfortable in the company of her guardian. As she grew older she now added a sense of fear and mistrust of him.

"It is just time to get you better training!" was his terse reply. Then looking at her with a sneer added. "Besides, you have no say in the matter."

The young girl was being moved because Radu, upon being advised about the couple from Romania who had been asking questions, feared the Cantacuzene family was getting too close to finding the child. He still coveted a huge ransom so he would move the girl to a different location.

The new home was not as large and also not as well appointed. Jeanne arrived and was disappointed. There were no woods that surrounded the grounds as at the previous orphanage. Her new institution was not an orphanage either, but rather a school attended by French girls from wealthy families who wanted their daughters to learn English and manners. Jeanne only had her bags of clothes from the orphanage, drab blue dresses, black stockings, and square toed, heavy service boots, such as the nuns wore. She was the laughingstock of the rich French girls, who also intensified Jeanne's resentment of her station in life; being poor, when they were rich — they had families — she had none. It was confusing, disheartening, and once again a lonely place for a young girl despite being surrounded by others. Though closer in age with the new girls, as an orphan Jeanne was not of the status and standing of the other boarders, and she could feel their animosity. She was also still kept out of the dorms and in a separate room, an attic, this time with no windows that could open.

Just a month after she moved, the school adjourned for the week of Christmas. All the girls left excited for holidays with friends or family — all but Jeanne. In a fit of anger Jeanne found a hide-away under the stage, crawled in, and hid for three days. Despite the desperate callings and searching by the staff, Jeanne refused to show herself. Each night

33

she would sneak out to drink water and relieve herself, but had no food as the kitchen was next to the nuns' living quarters, and she feared they would find her.

To her surprise Jeanne found her new quarters under the stage much larger than she first envisioned, as it was hollow under the entire performance area. Props and boxes of wardrobes filled much of the space, so she made piles and shoved boxes around and made several cubby holes to fill the time. Old costumes made wonderful mattress and great imaginary nightgowns. Jeanne was used to making her own fun and using her imagination. She often moved the piles and boxes and made new rooms in her pretend suite pretending she too was on a vacation of her own making away from the institution.

There were cracks of light around parts of the stage where the aged wood had split, warped, or shrunk. There was enough light when the eyes adjusted to see all around her domain — in muted and shadowy half-tones. Occasionally someone would walk into the auditorium and Jeanne would hold still. She laughed quietly to herself when she heard nuns walking through the area calling out her name and fretting about the missing child. To Jeanne's delight there was even enough light to read! Jeanne had come across a box of old hymnals and pulled one out to read... song after song, singing just in her mind to herself, passing hours away.

There was one thing, however, that made her ruse less adventuresome and more of a self inflicted torture. As evening came the dim light slipping through the cracks disappeared. There was nothing but black, total darkness. Jeanne began to experience panic! In the absence of light one loses all sense of space and spatial relations; even gravity could not guarantee up from down to her confused brain. Jeanne was experiencing claustrophobia.

Her first sense was fear, but her rational mind fought back. There were no wolves, thieves, or snakes in the old orphanages, despite the images running through her mind's eye, so they couldn't possibly be hiding under the stage waiting to get her! Still — the fear of darkness and entrapment was almost overwhelming. However, as she had already learned at her tender age, Jeanne knew if she occupied herself, kept her mind on other things, her bad feelings, the disorientation, the panic diminished. She also moved to near the entrance to the stage storage door when night approached and a nearness to a potential escape reassured her.

The hymnals served the purpose of occupying her mind after that first night. She repeated in her mind as many verses of as many hymns as she could remember. During the second day she looked up the hymns to make sure she was correct. Then she added new ones — first reading, then repeating the song in her head, then reading them again. It became her mission for the next few days to help her through the long sightless nights. At last, hunger from fasting caught up to Jeanne after three days of hiding. The hunger was getting to her occupying her mind and she became careless. As she crawled into her cubbyhole she forgot to close the door entirely, fell asleep and was discovered by the furious and frantic nuns. They stood her up before the Mother Superior for a scolding. Still weak Jeanne fainted from her hunger, adding to the nuns' hostility.

It was a dreary rainy spring morning in Paris. Out from an apartment building along the exclusive Champs-Elysee stepped a slender good-looking man. His large black eyes shifted left to right beneath the black, wide brimmed fedora. A greased handlebar mustache seemed to twitch under nervous glances. Radu would again become Francois Garnier that day, guardian to a girl in a boarding school in England. But first he had to get there alone and not followed. The man across the street, a short broadly built fellow, was reading the newspaper under the awning. To his left, the vendor was sweeping the sidewalk. Across the boulevard there were people walking to their jobs. Anyone, perhaps all could be detectives under the hire of Prince George Cantacuzene. Radu's apartment in Paris was known by them — he was certain. He was sure he had been followed too often for it not to be known. His whereabouts often were tracked by these private soldiers in the Cantacuzene army in their efforts to find their stolen granddaughter Catherine.

After a quick glance up and down the busy avenue Radu walked briskly up the Des Champs-Elysee in the direction of the Arc De Triomphe then turned a corner at Rue Des Ecole. He flipped up the collar on his dark gray Chesterfield coat and pulled the hat brim lower over his forehead. A carriage taxi was waiting for him there as he had pre-arranged the day before. As the carriage bounced off down the street Radu looked back through the rear window and saw the man with a newspaper round the corner. Seeing the carriage and not his quarry, the frustrated detective threw the newspaper in disgust into the street gutter. Watching from inside the carriage Radu smiled at his cleverness.

The carriage ride was brief; Radu got off after it crossed the Seine River. He went down a stairway next to the bridge leading to a dock and boarded a crowded river ferry for an uncomfortable thirty minute ride to St. Denis on the outskirts of Paris. He watched to see if anyone followed him off the ferry and was satisfied he would need no further diversions. From there he took a train to the English Channel, to a coastal village called Cayneux sur-Mer. It was in this town that his kidnapping partners lived, running a small fishing boat for charter. The channel crossing was much rougher than one would find on the main Calais to Dover ferries, but Radu enjoyed the sea, and, for him, the rare companionship of a friend. He could leisurely enjoy sharing a bottle of hearty red burgundy wine and a wedge of aged Gouda cheese.

As a precaution Radu never went through the Paris or London central train stations or the Calais or Dover docks for fear of discovery by Cantacuzene's detectives. He imagined they were everywhere and perhaps that anxiety was good for he was never careless in his travels. The surreptitious routes often caused his trips to and from London to double and even triple in time, but after 10 years of hostage tending he was not about to lead them to their little princess. Little princess... if they only knew!

The reason for this trip, however, was unwittingly going to lead them to her. He had grown tired of the long trips to England to tend to his troublesome hostage. He would bring her closer, to the outskirts of Paris. As the unruly child was becoming more aggravating, and the trips more arduous, Radu had decided to enroll Jeanne in a French boarding school he had found in Fontainebleau just south of Paris. It was known for being very private and tight-lipped. Many a young French lady of aristocratic bearing had been enrolled in Madame Jullian's School for Young Ladies during the year in which they carried and bore an illegitimate child. It was indeed a 'finishing' school. Others were brought there because they were an embarrassment to their wealthy parents — some handicapped, deformed, or with abnormal behavior. Money bought discretion at Madame Jullian's.

The fishing boat put in at the harbor of Hastings, the English town of the famous conquest by William the Conqueror. Radu boarded a train for London, getting off at Weybridge, where he hired a carriage for the final leg of his trip to fetch his waif. Radu was furious that Jeanne kept causing him the trouble and expense of repeated return trips to England. He had a temper that could snap on the finest of days at the slightest of

provocations. The temper became a broiling cauldron of venom if he had several days to brood on the cause of his aggravation.

It was after those several days Jeanne found herself facing an enraged Francois. The school had called him as guardian asking for the naughty girl to be transferred yet again. Upon entering the facility Radu was rude and seethed with anger as the nuns led him to Jeanne's room. Jeanne looked blankly out the room's window as the angry man threw her clothes into a suitcase and berated her for all the trouble she caused him. The nuns stood by, perhaps sensing his fit of rage mixed with the young lady's righteousness could become an unpleasant, perhaps explosive, mix. They could not tolerate another embarrassment.

"You fool!" was Radu's first greeting to the surprised Jeanne who was not aware of his coming nor her pending move — as usual.

"You are impossible!" he ranted. "Do you know the trouble you cause? Not to these fools." He looked back over his shoulder at the nuns. "To me! It takes me a day of travel each way when I have to come to tend to matters such as this!"

"I was mad! All the girls just left for vacation with their families. I have no one to talk to about my concerns, no friends...no family!" Jeanne pleaded, wanting to cry, but defiantly determined not to in front of this demon.

His large brown eyes narrowed as Radu glared at Jeanne contemptuously. "You *do* have family!" he blurted. "*I* am your *family! I am your father* — your mother *abandoned* you — and me as well! You are not Jeanne Bardin. Your birth name was Catherine Kretulesco and I am Prince Radu Kretulesco of Romania! It is I who have cared for you all these years!

The young girl's eyes widened in disbelief, her head was spinning — those people in the Mother Superior's office had mentioned Romania; she was a Romanian? It was a country she did not know. She was not French; her name was Catherine — not Jeanne; and she was... a Princess? "I do not believe you! Must you destroy all I know, all I am?"

Barely containing himself Radu's eyes bulged, his nostrils flared, the veins on his forehead and neck bulged and throbbed. "And *you*... are a fool! An *insolent* one at that! I have protected you all these years from your evil family! I tried to get you trained for your place in life! And this is what you do — call your father a liar! Here read this."

He tossed a red leather bound book on her bed. Hesitantly, Jeanne looked at the book, a family history of the Kretulesco family. A trembling

hand reached down and opened the heavy cover. As she turned the first page — she vowed to herself, if what he said was true, to become this Catherine, Princess Catherine Kretulesco! She did not care what her 'father' said or planned to call her, Jeanne was now a name from the past and in her mind she would always be Catherine. For the last twelve years the young girl knew something was missing. She had always yearned to have a family, to belong, to be loved. It would never be with the despicable man in the room with her at that moment, but it would happen — someday, somehow. This sudden turn of events, these revelations by the lunatic and madman had given the young lady a new hope.

Radu looked contemptibly at the teenage girl pouring earnestly through the pages of the red book and clenched his jaws in anger. She caused him so much aggravation, so much expense, so much wasted time! He could no longer tolerate looking at her. He left the room. It was time to complete the paperwork the nuns required. Catherine had not noticed his departure; he did not exist to her anymore. She studied the pages trying to make sense of the book... and of her life.

No one returned to her room that evening and Catherine was just fine with that for she needed the time — alone. Alone again. It seemed as life altering and radical of a changed that she bore witness to that afternoon, some things did not change.

With arrangements complete Radu returned the next morning, much more composed. "You will leave tomorrow morning. You will be given a chain to wear around your neck with your destination and tickets. A nun will accompany you by carriage to London and then by train to Dover. You will cross the channel by ferry and a nun will meet you on the docks in Calais. She will escort you to your new school in Paris."

"When will I go to Romania? When will I meet my mother? " Catherine questioned.

Radu sneered — it was a nasty devilish smile as he crossed his arms over his chest. "First, your mother is *dead*." he said flatly. Catherine looked stunned, yet she had learned not to believe anything the man before said.

Continuing he added, "It's just as well you will never meet her. Secondly, your name shall remain Jeanne Bardin; for the same reason it may be years before you see Romania. You see Catherine is a name on your mother's side and I shall *never* refer to you by a name given in

remembrance of your evil mother and grandparents. Besides, it is not safe for your identity to be known or for you to return to Romania until matters are settled there. If your grandparents capture you — your inheritance and future are lost. You are only safe if you remain unknown, undiscovered. You are in danger if you are found. Perhaps now you will have some respect for me... some understanding of the travails you have caused me and the precautions I must take for your well being!"

Despite her newfound information Catherine abhorred the man in front of her, the man who claimed now to be her father. He would never be her father! Such thoughts made him seem all the more repulsive to her. She remembered Nun Grace in the barn telling her about animals — dogs especially. They could sense or smell or somehow know whether a person was a friend or meant ill, and she was beginning to understand now that she too had the same uncanny sense for herself. She smiled inwardly when she found herself thinking of snarling and biting this man's leg, like the barnyard dog had done one day back at the first orphanage in England to the hacker man who had just slaughtered a sick cow.

He may have said he was her father but she would not believe it even if it were somehow true. He never treated her the way she had seen other fathers treat their daughters when they came to the school to see their children. Catherine was developing a keen inner sense of human nature and she did not believe for a minute his story. Surely even if his story had any truth to it she still would not treat him as her father. He had not earned such a distinction. Catherine did not know how, but she was determined to find out the truth. For the time being she would have to satisfy her curiosity by studying all she could about a place called Romania.

Catherine's new home was a boarding school for girls, a finishing school for the wealthy. It was appointed much more exquisitely...suitably for its clientele. Her plain clothes, however, were even more noticeably unacceptable. The embarrassment and humiliation was not soothed by the horrible treatment she received from the spoiled girls that resided there. Her initial claims that she was a princess were scoffed at... how could she, dressed like she was! They laughed all the more haughtily at her.

Catherine was by that time entering the teen years and her tormentors were just slightly older. It was an awkward age when girls were about to become women, and the dramatic changes in their bodies were only matched by the mercurial swings in moods and personality. If anyone

felt unsure it was always easy to pick on the new girl, the younger one, the one with the baggy orphan clothes, the misfit who stayed alone in the attic — the belfry, the bat cave. She was still called Jeanne in the new school though she stubbornly refused to respond to either staff or the other girls unless they called her Catherine. By this time in her life she had developed a mature understanding of the snobbery, the pranks, the meanness shown to her by her contemporaries. It no longer bothered her — at least that she would show her antagonists for she had also developed fierceness and a look that meant business that the other girls were reluctant to challenge.

Again she was isolated from the others, alone and singled out. It no longer seemed a coincidence that she was being ostracized, isolated, and looked down upon in confinement. Catherine, as she had become older, had grown more self-reliant, self-assured, and confident because of and not despite her tormentors. She had many long hours to ponder her thoughts and come up with her own answers. Perhaps her upbringing among the nuns — though not cherished — had given her a faith in something better outside the walls of the institutions within which she constantly found herself held almost as a captive. It provided her an inner strength far beyond her years to cope inside those often cruel walls.

CHAPTER 4

May There Be a Road

The finishing school was just another stop on the way to nowhere. Catherine's new school was so much like the others she had always known. Large, drafty, stony cold, echoing, just nicer furnishings private rooms for the girls which she was used to, it was just that the other girls were all on the second floor and Catherine again was be herself in the highest room — the attic. The building was full of women orderlies instead of the nuns she was accustomed to, but they too met very nearly met the same description as the building... large and stony cold.

It was difficult at first to communicate because the language switched from English to French. Catherine had learned the language from the lessons and the French girls in her last school in England, but it did not compare to the total immersion in the 'language of love' in which she now found herself existing. She was also taking more lessons in German — the language of the large brooding country to the west. By the middle of her fifteenth year, Catherine was becoming fluent in three languages and her knowledge of math exceeded her teacher's. Much of her library time studying what she could about Romania, though there was little to be found.

The months passed slowly and in the middle of June as the school emptied of its students for summer holidays, Catherine found herself — as she had every summer — without anywhere to go and without anyone to go with; yet she was content reading books. Not interested in romance novels, she was fascinated by books about the wild and rugged country — America. The 'Land of the Free' was a place she would go one day. Lost in a book she was startled when an orderly knocked on her door and asked Catherine to accompany her to the main office. Catherine closed her eyes and took a deep breath. Here we go again! She had been at Madame

Jullian's school for nearly a year, and she had not seen the madman 'her father' once, but she also had not caused any big problems either. Still could only imagine what might be in store on this sunny day.

To Catherine's surprise, instead of the brooding or raging Radu, a little old lady sat quietly in the room. The head mistress stood and introduced Catherine to the woman. As per her instructions from Radu the head mistress, in fact the entire staff still referred to the girl by the name still logged on their paperwork. "Jeanne, please meet Madame Lahovary — your paternal grandmother. I'll leave you two here if you'd like, I have to tend to some banking and will be away for several hours."

Catherine smiled hesitantly, and Madame Lahovary tipped her head politely, saying simply to the head mistress, "Thank you."

Sitting down on the soft cushioned couch next to Madame Lahovary, Catherine had heard the old woman being described as her grandmother, yet she would not given in to any emotional commitment just yet. There had been too many cruel turns in her young life to give in to such a temptation as a family member coming to see her. She studied the lined face of the stranger before her.

The grandmother clasped the girl's hands before she said a word and then spoke very deliberately. "Let me explain some things... *Catherine.*"

This was the first time someone addressed Catherine by her given name — and it came from the mother of her source of anguish, Radu. "Your father does *not* know I've come by. And if you don't mind I shall address you by the only name of which I have ever known you. I have paid Madame Jullian well for the right to meet with you and for this privacy. Your father has done a horrible thing"

The two talked for the full time they had been given. It seems that Radu's ego or brashness or anger had caused him to slip up. He boasted to his sister that he had brought his charge to Paris and his life would be easier because of it. His sister as did all the family disapproved of the situation her brother was responsible for and the shame it caused the family, yet she as did the entire family also feared Radu. Still she told her mother of her brother's boast. Madame Lahovary was not without her own resources and quickly but quietly set about upon her own mission of discovery which led her to Madame Jullian's school.

Catherine confirmed for the first time that what she had been told by Radu was actually true! She wanted to believe she was part of a family yet never fully believe it was as Radu said. She asked all she could about

a life she could not even imagine, about her family, and her country Romania. Her newly found grandmother responded by painting a beautiful picture of a mountainous land traversed by the slow winding waterway connecting Europe to the Middle East, the Danube. Catherine soaked up every word like a fresh sponge, fascinated by the first-hand reports by her sincere grandmother. As she looked at the old woman, Catherine could see no connection to the man who claimed to be her father — perhaps physically in the cheeks and jaws, but nothing within.

Catherine yearned to know about her family. "Grandmother," the word came out haltingly, as strange as a new word in her German lessons. "Please..." She was almost afraid to ask. "What about my mother, my family?"

Madame Lahovary paused in her travelogue abruptly. She grasped both of Catherine's hands. She looked for a moment into the eager eyes of the young lady before her. Then as Madame Lahovary's countenance changed, Catherine's reliable 'animal instincts' kicked in; and she sensed fear coming over the old woman's being.

"My dear, I must go soon. But I am very ashamed and fearful of my son... for both you and myself. You deserve to see your home, meet your other family, and **NOT** under Radu's terms. You will continue to be a prisoner of his will. You have missed your childhood because of my son — I cannot stand by and watch you miss out on the rest of your life and the truth — as you become a woman.

"I am sorry to say you will never meet your mother. What he has said in that count was sadly true... she died just recently, within the past year. That was when he felt he could bring you back to France and try to gain legal rights to you — well, to your wealth. I know not what your father told you — I'm sure lies — but she was a caring woman who missed you everyday you've been gone. I dare say she died of a broken heart. But her mother and father — George and Caterina Cantacuzene are among the most respected people in all of Romania. They too, as I, grow older and deserve to have the company of their granddaughter — their own daughter's child."

Sitting on the edge of the couch Catherine found herself gripping the elderly woman's hands so tightly she surely must have been hurting the old bones within. She relaxed her grip. Madame Lahovary noticed and a slight smile crossed her lips and she continued. "My dear, I cannot take you from here, and I am relying on the graces of Madame Jullian to keep this visit from Radu for I fear the wrath of my own son — his mind

is so bent with anger, so cluttered with schemes. Well, I just pray for his forgiveness when his day comes."

The tiny grandmother paused to collect her thoughts. "You must find a way to leave the school, to escape. This school is paid handsomely for your enrollment and you will not be allowed to walk away." Madame Lahovary pulled a slip of paper from beneath her sleeve's cuff and pressed it into Catherine's palm. "Here is the address to the Romanian Embassy in Paris. Your Grandfather Kretulesco — my divorced husband — is dying of cancer, but he is still well enough to travel. He wishes to end his days in his homeland —Romania, and I have extracted from him a promise — one last action of kindness and contrition in his life. Perhaps he can make up in a small part to our Lord for how our son Radu has turned out. He will take you with him — back to Bucharest. But you must hurry! Your Grandfather Cantacuzene is a very influential man. While our son is not worth redemption, we will return you to Prince George in exchange for the pardoning Radu. Your grandfather — Prince George — is a man of great power and influence and can see to this. You must not breathe a word of this to anyone here. Do you *understand?*" she asked firmly.

Catherine emphatically nodded her head in affirmation — her eyes wide with excitement, yet with tears welled in the corners. Madame Lahovary's smile returned as if a burden had been lifted, a mission accomplished. Her eyes too were glistening. She wrapped her arms around Catherine in a warm hug; and as she relaxed her embrace her hands grasped Catherine's arms, "Remember, not a word, and you cannot tarry — you must leave this school somehow in the next several days! Grandfather Kretulesco has begun his decline; he wishes to leave within the week. And I fear too that word of our meeting here today could reach Radu. I am sure of Madame Jullian's confidence, but I have not paid every soul that works here. Talk is always available when there is money involved and Radu has always been the master of finding things out. So you must get away quickly before word reaches Radu."

With her mind spinning Catherine thought back on her adventures into the woods and the dark stony corners of the institutions — the orphanages and boarding schools that had been the only life that she could remember. Those dalliances would pale to this grand escape! This time it was for real! The walls of the orphanages and schools had been her prison for nearly thirteen years — yet they had also been her sanctuary.

She had perhaps never known love within them, but she had always felt safe and secure.

About to set off to find her way through a strange city, travel a thousand miles to a country she only knew through the pages of books, where the people talked in a language she did not know, to meet a family she could not remember gave Catherine pause. To get there she was going to have to put her trust in an old dying man whom she had never met and who was the father of her life's tormentor — the despicable Radu. In all of her imaginary games and dreams she had never come close to such an adventure.

It was more than she could comprehend, but she was determined to carry out an escape. First things first... Catherine focused on the issue of how to get out of the school. She had learned in her life of isolation to be self-reliant, and to breakdown big problems into smaller, manageable parts — and deal with each as it came. It was a skill she would come to use throughout her long days.

From past conversations with other girls in the school Catherine knew that whenever a girl needed medical attention, one of the assistants — Madame Marie — would accompany the ailing girl to the medical offices the school always used. Madame Marie would use the waiting time as an opportunity to rendezvous with a boyfriend who worked in the area. The girls always speculated, as young teen girls would, as to what occurred, since they sometimes would end up waiting at the office lobby after their appointments for Madame Marie's return. Catherine hoped there was some truth to the chattering gossip of the girls — for she was relying on their gossip for her escape.

A visit to the dentist would be the easiest for her to fake, and that very night Catherine began to create her case for emergency dental attention. To do so she needed to break a splinter of wood from a window ledge in her room. Having 'borrowed' a butter knife from the evening's meal to probe the window's casings, she found some loose wood where the bars had been added to the window's frame. It had been a special accommodation for Catherine's entrance into the school. The piece would not break off. Retrieving a book to act as a tool to pound against the knife, she laughed at the irony, for she would read anything she could find about Romania. The book that would help her in her escape was <u>Dracula</u>, by Bram Stoker, Romania's most notorious literary character. This heavy tome had provided a scary escape from reality for many

readers. On this occasion it was to help provide an escape into reality for its young reader.

Several firm whacks of the book against the knife produced the wedge of wood she needed. Catherine then rubbed the splintered wood in her mouth against the outside of the front molars to irritate and redden the gum. The act was painful and bloody, but that did not deter the determined escapee. It was a sleepless night for the young teenager, and as the sun rose Catherine peered out the dew draped window, smudged, dirty and shadowed by the bars — for a last look at the day-yard of the school below. The sun was rising, glowing a warm yellow and pink across the scarlet sky above. A new day was dawning as was a new life for Catherine.

Her reflection was brief. There was action to be taken. Catherine rubbed the wood across her gum again, it hurt — it was already very tender and puffy from the previous night's efforts. It bled at the irritation of the stick. Then she used the vampire horror volume again, this time to slap herself against the cheek, repeatedly, until it reddened and swelled. Her looks were quite convincing to the staff when she appeared moaning at the breakfast call. They called upon Madame Marie to take the pained student to the dentist immediately.

It was a brisk morning and Catherine wore a loose overcoat into which she stuffed one change of undergarments and socks. The loose fitting, bulky uniform dresses she had been required to wear at the school now served a purpose as did Catherine's changing body shape for she was able to wrap a blouse inside the flimsy cheap bra she wore and then tie the legs of the pantaloons the girls wore in recreational exercises, below her waist across her expanding hips. She laughed at her image in the mirror of the bathroom. It reminded her she was not heading for Romania to be fashionable; just to be free and reunited with a real family!

Madame Marie acted perturbed to have to go out to the medical clinic so early. The girls of the school rolled their eyes knowing that was not true. Catherine by this time had been examined by the staff and had a towel wrapped around her head to hold a bag of ice next to her red swollen jaw. A carriage was hailed and the two were off to the dentist. Once there Catherine took a seat in the waiting room as Marie talked to the nurse about her charge. The two nodded together in agreement.

"I have errands to run for the school now, Jeanne. You do exactly as asked in there and wait here for my return! Adieu." she concluded sternly.

Catherine knew it would be the last time she was ever to be addressed by that false name and hoped she was concealing on her face the joy she was feeling inside. She was afraid the great pounding of her heart would be seen or heard in the waiting room. She was clutching her head and bending over her lap feigning great pain to disguise the exhilaration that was overcoming her. Goose bumps of excitement rush over all her skin — she thought her arms looked like the skin of a plucked chicken.

Surveying the waiting room as the door closed behind Madame Marie Catherine looked for an opening. Beyond the office of the receptionist she could see the dentist working on another patient. The receptionist rose from her squeaky wooden swivel chair and left for another room carrying an arm full of files. Catherine did not hesitate, she was out the door in such a hurry, she didn't even close it behind her as she ran down the corridor of the clinic, sliding on the slick tiled floors to turn the corner at the exit. The two doors to the street flung open against her crashing impact.

The sun was bright and glaring after the dim corridor of the clinic. Catherine stopped abruptly as her eyes adjusted then looked up and down the street busy with the early morning traffic — a mix of pedestrians, bikers, horses, carriages, and several noisy lorries rumbling down the cobblestone street, honking horns. A trolley coursed the middle of the boulevard, its bells clanging at every stop and intersection. Catherine was frozen amidst the cacophony. She realized she had no idea how to get to Paris, much less to the Embassy — whose address she clutched in her hand, but that would not stop the determined teen about to embark on the journey of the rest of her real life.

Still the question persisted in her mind... now what? Catherine, for such a young girl, already had an uncommon maturity and resilience. It was forged from spending so much of her isolated childhood with nuns and other adults working at the orphanage and boarding schools. She was also honing another of her life's skills — thinking quickly under duress.

One of the noisy lorries had stopped nearby to make a delivery. Across the canvas side-panel of the cargo hold was the name of the company — *Les Petite Rouge Potage*, below it an address — ending in *Paris*. She approached the delivery truck. It carried fresh produce to local restaurants; the back end was nearly empty. Catherine surmised it was nearing 10 AM and the cafes and restaurants need their goods before the

lunch time meal. The driver only had a few more stops before he would be empty — AND THEN HE WOULD RETURN TO PARIS!

Paris! That was where she needed to go, but Catherine was too naïve to realize how large the city was. Would the delivery man give her a ride? To where? Even if the driver's warehouse was in the center of the city — where would that be in relation to the Romanian Embassy? But it was a start; first things first, get to the city, then find the Embassy.

"Bon jour, monsieur," Catherine said politely in her obviously learned and broken French she would fool no one as a native.

The driver looked up surprised from his clipboard full of bills of lading and delivery instructions. The girl before him was dressed like a street urchin, except the clothes and girl were too clean to actually be one. The towel and ice bag added to the young lady's most unusual appearance. "Etse-vous bien... Mademoiselle?" he said in a mix of concern and humor and then in English, guessing that was her native language. "Your injury?"

Blushing, Catherine realized that in her haste to escape the medical clinic she had forgotten to remove the towel and ice bag which she did while she continued to talk to the driver, "Well, as you can tell by my poor excuse for French. I am not from around here, and I've injured my mouth." She was relieved he spoke English as she found it much harder to concentrate on the foreign language outside the classroom which was so unlike this real setting on the street. With the towel and bag removed she opened her mouth to show the man who with obligingly curiosity peered down into her open jaw.

Catherine continued very nervously switching languages hoping this stranger would understand her mumbles with her mouth still badly swollen. Her heart still pounded as she stuttered nervously, "I have lost my way to le dentiste. I'm supposed to visit, vous comprend? I'm attending a les ecole here," she looked down at her clothes, "it's a boarding ecole for orphans, these ugly uniforms, vous voit? My parents — ont tue, mort — killed in a train crash and my guardian was so kind to put me in this school to be trained as a nanny, vous voit... so I can support myself later, you see?" Catherine felt rather smug using the story she had been told by her father to hopefully help her escape from him.

"I speak your English well enough, I understand what you say," the burly man stated flatly as he scratched his dark rough beard.

The delivery man straightened up and frowned, then furrowed his brow, and crossed his arms. Catherine sensed he was unsure of what to

do, though she was sure her charms were winning him over. She didn't wait for him to decline assistance and thrust the address on the paper she held in her hand up to his face. "This is where I'm supposed to go — but I have no idea where I am... and I have no money for a carriage... could I just ride in the back with the produce? If you're going back to Paris that is... I won't be any trouble... promise!" Catherine tried a friendly smile, but painfully realized how good a job she had done on her fake tooth problem. Her puffed cheek and gums could only muster a crooked little smile, but that was enough for the kind and amused driver.

He laughed out loud at her as he took her note. "Girl, with your accent, your clothes, and your lopsided face — you *need* help. I have another stop to make, but I'll nearly go right past this address back in Paris. Go ahead and hop inside the cab. We'll be there in several hours."

"Oh, excuse me," Catherine held out her hand formally. "My name is *Catherine*... and thank you so much!"

The driver shook her hand and with a big smile said, "And mine is Pierre. Pleased to meet you... I think!

Climbing aboard and gripping the seat tightly, Catherine prepared to go on her first ride in one of those new horseless carriages she had read about. She hoped it would not explode or catch fire remembering from her reading vehicles operated by burning gasoline in many small explosions!

The truck lurched off as the driver traded the clutch for the gas pedal. A frightened Catherine found herself gripping the seat so tightly that her knuckles were turning white. The little cargo truck turned and bounced down a narrow street, turned again on to a larger avenue and veered over to the sidewalk.

"Well, Catherine, I have one more stop at the café up ahead," he said nodding over to the green awning building ahead, the Café d'Amore spelled out on the canvas.

As the truck slowed to a stop, the brakes made a loud long screech. Catherine smiled at the man — it was only just one block and she was already enjoying this excursion. Pierre picked up his clipboard with the invoice and bill of lading to take in to the café proprietor.

Looking through the windshield at the life bustling about the busy street Catherine's eyes glanced up the sidewalk in front of the truck and then turned to the right as she watched a pair of women walking arm in arm down the street heading towards the truck. She followed them past

the truck and was looking directly out her side door window. What then caught her eye took her breath away — she gasped.

There in the sidewalk portion of the café sat Madame Marie, snuggling up to her boyfriend. Catherine's eyes bugged wide as Marie said something to the young man. He laughed and leaned over placing a light kiss on a blushing Marie. Catherine did a backward summersault into the cargo bay of the lorry just as the driver opened the rear door. She picked up the crate of produce and handed it over.

"Why thank you, young lady!" he was genuinely surprised and happy not to have to jump up one more time into the cargo hold.

"Just repaying your kindness," Catherine replied, noticing her hands quivering with nervousness. She was hoping Madame Marie had not noticed her as she peeked through the corner flaps of the truck's canvass covering. The young couple was too enraptured in their own little world to have even noticed the truck right across from them.

Pierre was back in a couple of minutes, "Here, hop aboard, we're on our way!" Catherine peered subtly through the crack at Marie, "No... I mean..." she said hesitantly, "Can I ride back here for a bit?" Then adding with a more playful, childish-like glee, "I want to pretend I'm a cabbage — oh please, can I, for a little bit? I've never been in a motored carriage before!"

"Suit yourself, hang on though — I don't want you to roll out the back like a loose head of cabbage!" Pierre said with a laugh. He popped the clutch again and the truck back-fired loudly frightening Catherine. It was a good thing she had stayed in the back. With the loud bang the two seated at the café table were also startled and looked directly into the truck's window.

The driver waved and shrugged apologetically to the couple as the truck staggered into the street. They were on their way to Paris. Catherine couldn't help stealing a peek outside the truck's back flap. As the truck lurched and rumbled forward, Catherine looked back at her life as an orphan one last time. Madame Marie and her boyfriend had already forgotten their momentary scare at the backfire and were laughing merrily at each other. Marie picked up her coffee cup and sipped — she would never give the vegetable truck another thought. Catherine on the other hand would always remember that image — a couple at the sidewalk café on the outskirts of Paris — for it marked her first moments of her road to freedom.

It was a long bumpy ride, nearly two hours. Catherine had kept a conversation going the entire way. Pierre enjoyed her company, laughing often at the young girl's many questions. Some seemed initially quite naive — it was like this girl had never been out into the real world, he thought, never imagining how correct he was. The route to the Romanian Embassy took them up the broad Champ-Elyse, right past Radu's apartment, he could have even been sitting at one of the sidewalk cafes watching people, perhaps even a produce truck pass by, though Catherine had no way of knowing.

They coursed along the promenade park near the Eiffel Tower — the very place nearly thirteen years earlier where she had been kidnapped. Catherine was blithely ignorant of the fact that she was crossing paths of her own history. The lorry came to a stuttering stop on the cobblestone avenue. Pierre had gone quite a bit out of his way to take the young passenger directly to the address she had given him. Catherine looked out at a grand stone building, three stories tall, and balconies of wrought iron on the second floor. Two brightly uniformed soldiers stood guard at the entrance which was two huge wooden doors standing perhaps ten feet tall with large brass door knobs.

"Here you are, Catherine." Pierre said, actually a bit sad that he would be losing his animated companion. Then he looked out at the Embassy building. "Looks like quite a dentist office!"

Catherine had a gift of being ready with a quick response. "I'm sure it must be around the corner somewhere. Oh, Pierre, you have been so kind — I shall always remember you... and this ride!"

Pierre laughed, "My, my, this ride was nothing special... to me, save your delightful company. I've enjoyed your companionship! And the practice of my English! Adieu, my dear." He held out his hand to shake hers.

Taking the man's large grimy paw with both of hers, Catherine leaned over and placed a kiss on his cheek. "Pierre, you have *no* idea how *special* this ride has been! Adieu."

Pierre blushed, "Well young lady, there's an old gypsy saying I shall leave you with as my parting wish. 'May there be a road!' I've a sense you shall heed it well."

Catherine smiled and looked into the eyes of the kind man one final time, then scooted from the boxy bouncy vehicle. She stood there waving good-bye as the truck grinded into gear and rumbled off down the street.

"May there be a road?" Catherine pondered the expression of departure, knowing not how many roads she was yet to travel.

The lorry turned a corner at the first block and disappeared. Catherine spun immediately back to the edifice and looked over the building. Ever so conscious of her poor appearance, swollen face, and her mode of delivery she walked slowly to the front door.

The guard to the right stepped forward, his fancy gold braids shimmering against the bold red uniform. "Your business, mademoiselle!"

CHAPTER 5

Your Last Christian Act

The young girl stood alone before the commanding figure of the tall uniformed guard holding a gaudy long spear. The ride to the Embassy had already been an adventure for the naive sixteen year old who had been sheltered so much of her life. The reality of being on her own now came over Catherine like a bucket of cold water and she was taken aback. The request from the guard was more a command than a question. She pulled the paper from her pocket on which her grandmother had written the Embassy address. The note had been written on family letterhead and her Grandmother had signed it.

The guard took the paper and examined it briefly. As a guard he would not recognize a signature, or the name. "Wait here." was his stern, brief reply. He turned and went inside the cavernous room beyond the two huge doors.

The wait of several minutes seemed an eternity. What if the note meant nothing to those inside? What if her father had heard of the escape and notified the embassy? Would they be sending for him? She would flee from him. To live in the streets would be better. The oak door creaked and swung slowly to the inside. The guard stepped outside and did not speak. Catherine looked up questioningly. Then a man dressed in a finely cut and tailored gray suit with silver pinstripes and tails peered from behind the open door. "Mademoiselle Catherine? This way please." he beckoned in impeccable English.

The young girl didn't wait for a second invitation and rushed past the guards and the surprised butler and without knowing it left her childhood behind. As she entered into an ornate foyer, complete with huge flowered arrangements, fancy vases, plush couches, and several larger than life portraits of what were obviously historic royal figures, the man behind

the door closed it and stepped forward extending a white gloved hand in greeting. "Pleased to meet you, mademoiselle. I have been instructed by the Ambassador to make you comfortable. We have contacted Madame Lahovary who will be here soon. Please come with me."

Relief swept over the young lady. For the first time she felt like she might indeed be a princess and not an orphan. The butler led Catherine into another even more ornate receiving room. Many pedestals with more vases, more flowers, and busts sculptured in bronze and marble surrounded a room that spanned about 30 feet by 30 feet. There were a number of upholstered couches and high backed leathered arm chairs scattered about in clustered arrangements.

"Mademoiselle Catherine, you'll find the necessary room beyond that white door over to your right. I shall be back with a tray of cheese, biscuits, and fruit. Would you prefer tea, coffee... perhaps wine?" Catherine wondered if her mouth gaped open too far and hopefully she wasn't drooling. Looking back to the butler, not fully registering her new surroundings, nor her elevated station in life — she had *never* been referred to as 'Mademoiselle'. Holding her hand up to her mouth and coughed politely, she realized her jaw was still a bit swollen and her gums were raw from her self-inflicted injury. "Could I just have water please?"

The butler closed his eyes and smiled as he nodded in the affirmative and quietly glided out of the room.

<p align="center">*******</p>

Grandmother Lahovary arrived within the hour accompanied by an exquisitely dressed middle aged woman. "Catherine — I'm so glad you are here! This is your Aunt Anne, your father's sister — she's not like him at all — she was anxious to meet you."

Looking over to the other lady Catherine could see a resemblance to her father — his dark hair and high cheek bones. The middle aged, but beautiful woman too, had large brown eyes, but they seemed to smile at her — not like the fierce anger that usually glared from her father's eyes. Hesitantly Catherine held out a hand. Anne instead grasped the young girl by the shoulder and engaged her in an embrace. "My poor darling. I cannot believe what Radu has done to you! You must be returned to your mother's parents." There were tears freely flowing down her cheeks. "I've brought you a suitcase with several changes of clothes — mother described your size to me and I think you'll closely match my own daughter's size."

Madame Lahovary joined in, "Your grandfather will die soon of his cancer, he has a short time left of healthy life. I have insisted that he do this one last Christian act — rescue you from your monster of a father. With some reluctance he has agreed. Always remember your grandfather as a truly courageous man."

Looking into the grandmother's eyes Catherine could see they were swollen with tears. She knew the Kretulesco family — save her very own father — felt a tremendous burden of guilt and sorrow for her treatment, and the loss of a childhood. "I will remember — and I do appreciate his help — and yours — and yours too Aunt Anne."

The three then collapsed into a brief tearful huddle of hugs. Catherine suddenly thought of her father's recent declaration to her. "My father has said, 'You'll never be able to leave without me! You have no papers — you are nobody!' Is that true?" Madame Lahovary reassured her dubious granddaughter, "My dear Catherine, don't worry. Remember — you are here — at the Embassy of your own country, and we do have influence, despite your father. All families have black sheep! It does not make everyone bad. We have added your name to your grandfather's diplomatic passport. It has been properly stamped here in this very building. It will get you through."

The inexperienced traveler was now trying to think through her coming journey. There seemed to be so many ways the trip could end as a disaster. "Oh Grandmother, are you sure Grandfather can make such a trip with his health? What if he gets ill? How could I care for him or complete my journey? Who would know me in Romania?"

Anne interceded, "Catherine, we feel Grandfather is well enough for this trip, so don't worry. And I will spend the next several days to prepare you while he makes arrangements for the trip. I will give you a crash course on our country; I have a book here that is English to Romanian translation. We will prepare maps and directions to your grandparents who are very prominent and well known in Bucharest. You will have official letters of introduction. Already a cable has been sent ahead to Romania and the proper people and your family know of your pending arrival. Besides, my dear, from what I've seen, I think if I gave you a compass and said go east, you would find your way!"

Anne's words were very reassuring. Catherine thought of her time hiding under the stage and the hymns she was able to memorize to calm her fears. If she had moments of doubt she would call again on those hymns. She clutched the small black leather translation book from her

Aunt Anne. It would not leave her possession as she would embrace the book and its words — her new language, her fourth — and memorize its contents. The maps of her homeland would be carried under her blouse — next to her heart. She would learn the roads, the rivers, the mountains and absorb all that she could of Romania. Catherine was not unlike the starving urchin brought to a royal feast.

Hardly containing her excitement, Catherine could only temper it by the anxiety of uncertainty. Yet to meet her grandfather she pondered her fate. What if he changed his mind? What if he notified his son Radu? That man was evil, resourceful and perhaps insane, or if not, then driven by rage and revenge. He would never be outside her mind. Her thoughts still were flooded with doubts.

The embassy butler had become her new best friend. Catherine seemed to have a gift for being viewed by others almost immediately as a long trusted friend. Perhaps it was her openness, her quick intelligence —and she remembered names remarkably. Her constant inquisitiveness had a way of making anyone in a conversation feel that what they had to say to her was significant and important, indeed an endearing quality.

There was a crisp knock at the door followed the friendly familiar voice, "Catherine, your grandfather has arrived. Shall I take your bag?"

"Yes, Jean-Paul, I'm ready." Catherine responded.

"Of course you are, Mademoiselle," Jean-Paul added knowingly.

Catherine left the suite on the third floor of the Embassy that had been provided for the newly found young princess. Immediately it was discovered that the lifestyle of a princess far exceeded that of an orphan. She could not even imagine what her new life as a royal would be like. Her experience as an orphan had given her little reference to the opulence she surely would enjoy. Life in the Embassy certainly did as she already had quickly formed an opinion of institutional food she had grown up with versus the Embassy 'cuisine' she was enjoying.

The princess to be ran down the stairway in front of the butler. At the foyer she halted abruptly. An old bearded man stood inside the huge doors. His color was ashen and flesh on his face sagged from sudden weight loss. His clothing hung loosely, but his voice was strong. "The carriage is waiting outside. We must hurry. I don't want to delay. I fear

your father may get suspicious, or perhaps he has heard from the school you so suddenly left. He lives here, in this city!"

"Grandfather," Catherine held out a polite hand in greeting. Though she had never met her grandfather Kretulesco, she was surprised that he was so different than the gentle and kind Grandmother Lahovary. She was taken aback by his appearance and his curt pronouncements. Not even a word of greeting. It was troubling. The knowledge her father lived within Paris was downright terrifying, but she wouldn't let on her feelings. Instantly there was a sense that she could not fully trust her grandfather, the kinship of the father with the son crossed.

"I don't think the school will have said anything yet," she said to reassure the old man. "I left a note in my room that I was running off to the Mardi Gras Celebration — I said I would be back in several days and accept my punishment. The school is as discreet with its own foul-ups as it is with the affairs of its clients. I doubt that they will contact my father until they are certain I am not returning. I think it should be a week before he knows I am missing, and even then he would likely search the brothels of Paris before he would suspect that I would be in Romania."

"My dear, forgive me." He took her hand and weakly shook it. No hug was offered. "I have not acted properly. My greetings, but your father — my son — makes me nervous. You, I see now, have perhaps inherited some of his cunning and resourcefulness. But that, too, is why I am so nervous; for he may well have had your grandmother or me under observation since he moved you here to the Paris area. You, my dear are viewed as his greatest resource, his perceived future endowment. He knows he cannot come into the Embassy for you. I'm sure he would be arrested. But I fear he may be waiting outside these doors for us!"

Shuddering at the thought Catherine did know for certain, however, that she was young, agile and fit. If Radu were outside he would have the race of his life to capture her — and the fight of his life if he thought she would go quietly with him. The teenager was just beginning to learning what freedom was and she would not easily let go of that feeling... not for anyone. And she knew too that she would be willing to struggle to the end of her days to keep that feeling.

They left the sanctuary of the Embassy and boarded the carriage without incident. On the carriage ride Catherine looked down every side street expecting to see the haunting image of the slightly built man with greased handlebar mustache and large brown, sinister eyes... in her own mind she refused to acknowledge this persona of such revile as her father.

It was disturbing to notice her grandfather also looking uncomfortably from side to side and behind the carriage.

The train station bustled as no other place Catherine had ever been before. The intoxicating aura of movement and human energy was matched by the huge loud steam locomotives squeaking steel on steel to a halt while others pulled out chugging, hissing steam and belching acrid black smoke against the weight of their loads. Catherine had been on several trains before, but they were meant for utility — wooden bench seats in open passenger cars, usually very crowded, smelly, and noisy. The Orient Express was meant for luxury. The floors were carpeted; the seats were more like cushioned couches, not benches. Paintings adorned walls giving one the sense of being in a chamber room. The train was destined for Istanbul, just an amazingly short 3 ½ day's journey. They had just settled in when the train vibrated, then lunged in a series of jerks and finally into forward motion. Bucharest, Romania was a little beyond the half-way point of the train's route. Catherine was two days away from her destination... and her new life

Taking the initial moments of the ride to reflect, Catherine had no idea she was embarking on a journey, not of two days, rather one of a lifetime stretching into the new century nine decades into the future. At this moment she was only concerned with the immediate, the next day, and then the next week.

She did not know the Romanian language; she had no idea of the customs, the clothing, the money of her homeland. Catherine, in fact, was still not sure she would even reach the land of her ancestors. Doubts, always nagging doubts. Was this elderly man she had never met before leading her straight to his son Radu? Even if her newly found grandfather was sincere, his failing health would surely not be able to resist her madman father if he somehow was able to intercept them along the route. Her mind raced with thoughts of running down the train's corridors, jumping off the barreling chain of passenger cars to escape the madman's clutches. She forced her thoughts to other questions though they seemed almost as troubling.

Once in Romania what would her mother's father and mother be like? Would they like her? Would she be accepted as their granddaughter? Would she meet their expectations? What would it be like — to live as a princess? Would her lack of interest in the lessons of manners at her recent schools, once again, make her an outcast to be scorned and made fun of by peers? Her head was spinning and Catherine began to feel

panic. Closing her eyes and breathing in slowly several times to collect herself she looked out the window and tried to just watch the countryside fly by.

Several hours passed. When at last it was time for lunch, Catherine accompanied her grandfather to the dining car. As they sat down to white linens and crystal glasses she watched his every move. Copying his manners as she had not before eaten in such refined circumstances the unsure royal admitted she should have been more attentive in her etiquette courses. After spreading her napkin across her lap Catherine looked out the window. "Where are we now, Grandfather?"

He looked out the window after her. "We'll pass through Nancy, France, soon and cross into Germany by bedtime. By the time we eat breakfast we will be in Bavaria. The mountains are covered with snow now and are beautiful. Then on to Munich, Germany, Linz and Vienna, Austria. After that we have Budapest, Hungary, and then finally, our own Bucharest, Romania."

The old man had the heavy weight of guilt on his shrunken hunkered shoulders. "Your father is one of my two sons. My eldest son married well, is successful and wealthy. Your father married well — quite well! Your mother was a wonderful woman, her family one of the foremost of our country. But Radu was a fool.

"I'm very ashamed of Radu. He always wanted more, he always felt he was inferior, yet entitled and would do anything to get ahead. His problem, basically – was laziness. He did not want to work or earn his station and would lie, cheat, connive, use any means to get ahead. When he used his charm and guile to win over your mother, he was not satisfied. He needed mistresses, so he lived multiple secret lives to fool your mother and his other women. He outsmarted everyone for a while, but soon all became suspicious. You cannot live a lie forever.

"Your Grandfather Cantacuzene hired detectives and soon knew the truth. Your mother moved back with her parents — you were already in your second year. Your mother's divorce was of course expedited — the Cantacuzene family is very powerful. Your father was extremely bitter but also desperate. His source of money was gone. He could have had a great settlement, but he was greedy and wanted much more. That led to his plot to kidnap you and seek a huge ransom."

Understanding the reason for her circumstances Catherine still did

not fully realize its impact on her. She had known no life other than the isolation of the orphanages and private finishing schools. As she learned more and more of what she had been deprived, the demonizing of her father grew in her own thoughts.

The first meal on the train was a new experience to Catherine. Obviously it was standard fare for her grandpapa. The number of eating utensils was confusing and though she watched closely, Catherine knew she messed up several times. One time Grandpapa noticed and quietly shook his head and pointed to a different spoon.

"Your father I think soon realized his ransom would not be paid. However, by then it had become a contest of wills, egos, perhaps one of revenge. If he could not get his money, she — your mother — would not get her daughter — you. We did not have any idea as to your whereabouts until after your mother died. Radu thought he could claim guardianship and gain your inheritance from your mother's estate. It was obvious his original plan of ransom was not going to work. That is why he changed his strategy. That was why he told you of your family and brought you back to France.

"Your Grandfather Cantacuzene, however, would not let that happen either. Radu brought you to Paris because he felt he no longer needed to hide you. With your mother's passing he was going to try to establish legal guardianship of you in France and petition the courts for your inheritance. It was a new scheme. He has become desperate for cash to pay for all of his shenanigans and bad habits. That's when Grandmama and Aunt Anne first learned you were in Paris. We then tracked you down and here we are. We did not want to chance the French courts nor any other fraud or ruse Radu might attempt. We knew we had to get you to Romania."

When they returned to their compartment the sitting room had been transformed into a sleeping suite. Grandpapa excused himself leaving for a smoke on his pipe. Catherine went to her suitcase and found a luxurious silk nightgown — something she had never known much less ever experienced its cool smooth touch against her skin. Carefully she slid into the crisp clean linens on the bed and felt extremely pampered against the smooth material. Opening her translation book to memorize more words and await her grandfather's return, she soon fell asleep.

When he returned, he startled the sleeping Catherine awake. There

was a worried look on his face that alarmed Catherine. He cleared his throat. "Catherine, I've been thinking... I am not sure it is the right thing I am doing... you *are* a Kretulesco... Radu *is* your legal father... I have a responsibility for you."

Sitting upright in her bed, Catherine stared incredulously at the old man before her. The worn leather book she studied slipped off the smooth linens and fell open on the carpet. Her heart was pounding rapidly and her cheeks felt flushed. "What do you mean? We are halfway there now!"

"Let me explain myself. The train will next stop at Vienna. It is a two hour loop around the city. I often get off on the west side, take a taxi to a fine restaurant for a meal and then rejoin the train at the east end. I think we could perhaps even stay in a hotel. I could telegraph my other son Emmanuel who will be meeting us in Bucharest. I shall ask his advice. I am an old and sick man, my dear. I am not sure I am thinking this through."

In a panic Catherine wondered... what was he doing? This couldn't be happening. This was a trap — her father was in Vienna! "No!" she blurted out — her defiant side in full evidence. "I will *not* get off this train!"

"Now, now, my dear, you are still a child; this is a legal matter for adults to consider. Perhaps we shall put you in a school in Switzerland until we properly get your custody into the Cantacuzene family."

She sensed he was just offering suggestions and he really did not have a real plan. Or perhaps he was as much a con man as her father and was going to sell her out to Radu. Catherine's greatest concern was that if she was not in Romania her father would find her and he would have papers to force her to go with him. There were no official papers to carry on her person. Grandfather Kretulesco carried on his person the only document mentioning Catherine's name... giving her a status... a chance. If she was separated from him or stolen away again by Radu she would have no proof. Radu would surely have false papers as he had threatened. That could not be allowed to happen! In Romania she had a chance that the influence of her maternal family would prevent her father from taking her. There was no other option; she had to make it into Romania!

"No! You cannot change our plan! You made a promise to your wife and daughter — to God! This was your *last Christian Act!*"

The old man crumpled into a heap at the end of the bed. He was not used to such defiance from a child... a woman, and he was too ill to deal

with confrontation. "Let's just sleep on this tonight. I will discuss it with you again in the morning."

Her mind was confused and thoughts ran afoul of each other. Catherine was scared and she could not sleep for she had no money, no official papers, and was now in a country where she did not know the language nor did she have any family or allies. Was the old man's health causing him to not think clearly? Was he caving in again to his evil, but persuasive son? She tossed without sleep that night fearful of who might appear... either in her dreams or in person.

A knock on the door by the porter signaled breakfast time. Grandfather Kretulesco tapped on the painted bamboo screening that separated the compartment into two bedrooms. "Catherine, are you ready to go to the dining car?" He peered around to the young girl. He saw the drawn look, her eyes puffy from little sleep and much crying. "I really want to return you to Bucharest. It's just we must do it right. Do you understand?"

There were no doubts and Catherine expressed herself so that there would be no misunderstanding. "No! I do not understand *you*! But you must understand *me*. I am one day away from my new life. I will not go to another school — another institution where I am a nameless waif! Where my evil father might again kidnap me again! You say that I am a princess! This is not how you treat a princess!"

"My father once threatened me when we moved to Paris saying if I ever ran away, he would find me. He would put me in an asylum! He said he had papers, signed by doctors, stating that I had suffered a bout of meningitis and had such a high fever that I had brain damage, that I was delusional! That would explain any story I may have given to someone trying to help me. Oh Grandpapa, if he ever were to find me again I know I'd become berserk, I *would* look like a crazy person!"

Her grandfather did not know this girl well, but he did know his son. Radu the schemer, yes he would have such a doctor's letter.

"I have been in institutions all my life... that I can remember. I would rather jump from this train and die than go to another school!"

Grandpapa took, for him, the best course of non-argument — he refused to speak further. The conversation was over. They had a silent breakfast and lunch. He read newspapers; she studied the translation book. By mid-afternoon Catherine was becoming very tired following her sleepless night. She curled on the sofa and dozed. Grandpapa left the room to smoke a cigar and perhaps stop for a glass of scotch.

The shrill whistle of the locomotive awoke Catherine with a start. As

she looked up at the ceiling a thought of desperation crossed her mind. On an earlier smoke break by her grandfather Catherine took the liberty to rummage through his suitcase and briefcase. She hoped to find papers she might steal away to prove her identify if her grandfather actually carried out his thoughts of leaving the train and delaying her return to Romania.

There was a small pearl handled pistol in her grandfather's briefcase, and she had been taught how to shoot at the English finishing school. Hunting was a gentleman's sport, and refined ladies needed to be familiar with guns either to participate or as a safety precaution if firearms were to be in the home. Some even suggested woman carry small pistols in their purses when traveling as protection from robbers. Being trained to be a nanny for such gentry a nanny needed to be familiar with their guns. Catherine reached into the unlocked case and slipped the miniature handgun into her own suitcase.

Dinner had come and gone without further word about stopping, or schools in Switzerland. Grandpapa spoke of little other than what news the papers told that he thought might be of interest to a young princess. Catherine responded politely. Upon returning to their room — by then again a bedroom — they both quietly read. As darkness shrouded the compartment Catherine found she could not keep her eyes open. She slipped between the fine bed linens and quickly fell into a sound asleep. When she awoke it was already light outside and to her horror she was surprised to see Grandpapa dressed and sitting in her chamber.

He had a stern look about him. "Why did you take my pistol?"

Noticing her suitcase opened Catherine had no defense; she was caught red-handed, so she took the offensive. "I want to be able to protect myself from my father! I would shoot either him or myself!" she added in defiance. "My father will find me if I don't go to Bucharest! I will not be safe! If you take me from this train I will lock myself in a bathroom and shove the soap down my throat and choke to death! I will run in front of a train! It would be *your* fault!"

The thought of this determined young girl actually acting in such desperation had convinced the tired and sick old man to do what he knew was right in his own mind — even if it was not legal. He realized too that in his condition there would be nothing that his son, Radu, could do to him that would cause any harm.

"Do not be so afraid, my dear. You have won. We will go on to Bucharest."

CHAPTER 6

The Declaration

Miles and miles were passing by as the train continued on its eastward journey to a strange land, new language, and unknown people. Catherine looked out of the window of the compartment watching the countryside become mountainous. They were on the fringe of the Transylvanian Alps. She was in Romania! The senior Kretulesco said it was time for breakfast. They entered a crowded dining car and found a table. The young lady had mixed emotions. Relieved that her grandfather had given up thoughts of taking her from the train; excited to now be inside the country of her family, her homeland, yet her thoughts were pervaded with anxiety. What would this new world hold?

After enjoying a bowl of porridge and goat's cheese on flat bread Catherine put a glass of milk up to her lips. She noticed for the third time a man sitting at the far end of the dining car peering at her from behind a newspaper she was sure was not being read. "Grandpapa, I think we are being watched. There's a man over there, in a brown suit, reading a paper. I'm sure he's spying on us! Might he be an agent of a government or a detective working for my father?"

"Oh no, my dear," he replied with a chuckle. "Your imagination runs rampant. As we talked earlier, I don't think your father even knows you've left the school yet. And besides, you are an attractive young lady! You will become accustomed to the stares of men. It is a natural thing you have yet to experience."

Accepting the explanation, Catherine looked back to the seat and the brown suited man was gone. She was not so sure of her Grandfather's conclusion and was learning to trust her own instincts. He sensed her uneasiness.

"Let me tell you more of your country's history. Romania has been

a civilized society for a long time. It was once on the edge of the Greek settlements. They, of course, were the epitome of most civilized peoples. They were succeeded by the Legions of the Roman Empire who followed the Danube River to the Black Sea. The Romans allowed their soldiers to remain in a conquered land at the end of their service if they had served twenty-five years, and they would be granted twenty-five acres within an occupied territory. Such settlement helped to establish Roman rule and order. Many enjoyed the good wines and beautiful woman of our country and chose to stay. We became an island of Latin influence within the Slavic peoples. It is how our country got its name." Catherine was spellbound as the story continued while they finished their breakfast.

"We have a country blessed in many ways... oil, gold, fertile soils. Yet that too has been our curse. We have been the victims of many greedy tyrants, the Vikings, the Goths, the Mongols under the infamous Attila the Hun, the Russians and their Cossacks. Ah, the Russians, they have *long* coveted us!"

With an obvious great admiration of his homeland, Grandfather Kretulesco readily passed this love on to his eager pupil. Catherine was still not sure of his loyalty towards *her*, but she was certain of his loyalty and love of his Romania. His nostalgic review of his country's heritage would likely be his last such oratory, as he knew his cancer would soon to make him one with the soil of his beloved homeland. During his monologue Catherine watched the mountains give way to level plains being turned by farmers from their winter respite in preparation for sowing a wheat crop.

Grandfather Kretulesco watched her gaze out the window. "Your family owns much of the land you're looking at — in fact it may be yours someday."

Catherine looked out the window even more intently, lost in her thoughts.

The farmland suddenly changed to endless rows of stone buildings. The thatched roofs on the farmhouses in the country were replaced by tiled roofs. The muddy lanes of farm wagons had transformed to cobble streets and horse drawn carriages which were mixed with Lorries and other horseless conveyances.

The buildings in the city resembled those of the other capital cities Catherine had seen in London, Paris, and Vienna, except for the unusual

round turrets and curved domes that adorned the large structures. Catherine could feel her pulse quickening as the train was noticeably slowing. She followed her grandfather's lead and gathered her things, cinching the straps of the luggage and placing them outside the compartment for the porter to carry off the train then grasped the old man's hand, both to accept his guidance and to help steady him off the train.

As they moved to the corridor she saw the 'agent' again. "Grandfather, the *same man*, in the brown suite... he's following us!"

"My dear, he's not even paying attention to us. He's talking to people on the platform. Let's move along, now."

Looking back and then out to the platform Catherine saw a man with the woman he had been talking to move away from the platform. Her eyes widened. Though she had only seen them for several minutes at the school, she was sure it was the couple she had seen talking with the head mistress about a girl from Romania. Perhaps she was mistaken. Were they agents of her father? He would hire someone to do his dirty work here. What would meet her now she was in Romania, her once lost and now found homeland?

They were met at the central train station by Emmanuel and Tincouline Kretulesco, Catherine's Uncle and Aunt, her father's brother and his wife. Emmanuel was taller and heavier than Radu. His hair was receding and graying at the edges and he was dressed in a business suit appearing very conservative and successful as her grandfather had described. He also appeared very agitated and not pleased to be there. There had been an animated conversation between the couple as Catherine was getting off the train. There was a frown on his face when the discussion stopped as the grandfather joined the group on the platform. She had a worried look that turned to a sympathetic smile towards Catherine as the young lady approached the pair.

The father and son shook hands briefly and formally. Catherine did not think it an appropriate way to greet one's dying father. The son turned, choosing to ignore the young lady stranger. Aunt Tincouline, however, greeted Catherine with an open embrace and in French offered, "We're your aunt and uncle and you will come home with us for a while Catherine. There is business regarding your legal standing to be tended to. Until that is sorted you may be our guest!"

The newfound aunt seemed polite, sincere and genuinely concerned

about her new charge. Uncle Emmanuel on the other hand was simply rude and acted as if Catherine did not even exist. He was appearing to be more and more like his younger brother. The carriage ride to their home was an uncomfortable awkward arrangement for Catherine at best. Grandfather sat in the front seat with Emmanuel and the two argued in Romanian which Catherine did not yet understand. Aunt Tincouline made small talk to Catherine in French and acted as a town guide.

At one point the men arguing in the front became quite strident and Aunt Tincouline leaned over and whispered in explanation and apology, "Your father is viewed by his brother as a very evil and dangerous man. He truly fears retribution from Radu if he finds out we are complicit in any way."

They lived in a beautiful huge stone home with balconies and a stately iron fence surrounding landscaped grounds. The senior Kretulesco had indeed been accurate in his bragging about his successful first son. At the front door a girl bounced out through the doors in greeting. Aunt Tincouline introduced her, "This is my daughter, Drina. Drina, please see Catherine to your room."

Drina seemed to favor her mother's pleasant personality. The young girl was about ten and full of energy. Her golden hair bounced in a series of ringlets falling from the top of her constantly moving head. "Come, let's play with my dolls!"

"Drina, why don't you let Catherine take a bath and rest from her trip, you can play after supper," Tincouline admonished her enthusiastic daughter.

Drina placed a big frown on her face for effect — then quickly smiled back at Catherine, "Come, I'll show you your room!"

Catherine was not used to such freedom or opulence. Her new companion was like a long-lost friend. A relative, something she had not found in the previous years of her life. Despite her young age Drina was very precocious and open. Catherine had not enjoyed any friends among the girls she had encountered at the orphanages and schools. She had either been too young or of a different, lower social class.

The younger Drina's questions were like a barrage... "Did your father *really* kidnap you? What was the orphanage like? Were the nuns mean? How did you escape from Paris? What was the food like? I don't think I have ever met my Uncle Radu. Do you *hate* your father?"

Laughing with Drina as any girl would with a close playmate, Catherine answered most of Drina's questions, choosing, however, to

diplomatically avoid the personal questions and references to her father. Not fully assured that she was in friendly surroundings — she would remain cautious.

Dinner was an educational experience for Catherine. She had never tasted Romanian cuisine, nor was she used to such well prepared food. It was a far cry from cafeterias at schools and orphanages. There were vegetables in wine sauces, soups made from tubers she had not heard of before, minced meat wrapped in grape leaves and topped with luscious sour cream, and a local favorite corn meal mush called mamaliga. The dessert was fresh fruit topped with walnuts in a rich creamy sauce.

After the meal Catherine and Drina went upstairs to play with Drina's dolls, a joy she had never known. While at play Drina continued with her questions, although Catherine was now asking as many questions about Drina's life and family. Drina confided that there had been many arguments in the house lately about Radu. Her parents feared the evil man's return in search of his possession, his daughter. They feared the wrath of the '*crazy man*' as he was referred to in the household! Catherine empathized with her hosts' concerns.

In a sense Catherine felt as if she was on one of the holidays with family that so many of the children in the schools experienced during vacations. Uncle Emmanuel was gone during the entire day at his work and dinners were more formal than social — at least when he was present. Catherine felt he resented her being there for the repercussions his family may have to endure from his evil brother Radu. He was very pleased to announce that Catherine would be leaving after the third day. A cousin on the Cantacuzene side would escort Catherine to the Ministry of the Attorney General for purposes of identification.

At the very ornate office of the Attorney General a man in a black business suit stood and greeted Catherine. Several other people stood when she arrived. They were dressed in white smocks as doctors would be.

"Good morning, Madame, I am Bruno Janclesusco. I am the Deputy Attorney General. This is Dr. Pada. He was, if you are Catherine Cantacuzene Kretulesco, the doctor who delivered you and attended to you and your mother. This is the nurse who also attended to your mother when you were born."

With great anxiety and apprehension Catherine extended a nervous hand in greeting the strangers. She felt a strange connection with these

two who participated in her birth. They were the first people she had met who had a direct link to her mother. Catherine felt a chill perhaps sensing that her mother was present with her at that moment. Yet there was also fear. If what was about to happen either proved nothing or worse proved that she was not who she thought she was — what would be her situation! If she was not Catherine — then who might she be? What would Radu attempt? Would these wonderful people she had met as Catherine, then ignore her and cast her off? Would she truly be an orphan?

"Young lady," the official continued. "Your mother was very wise and after you – well, um — her daughter was abducted she met with these two witnesses, to provide a document within this sealed envelope that contains twelve identifying marks to be used in your identification. We did not think you would be lost so long. I hope your growth and development has not altered or, eliminated those marks. They will take you into the adjoining room for the examination."

The doctor had a very kind and understanding look behind his wire rimmed spectacles. He was a short balding man with unruly white hair. As an educated man he knew some English and French and acted as best he could as an interpreter. The Deputy Attorney General slipped his hand under the envelop flap and while all watched, broke the red wax seal that had kept the contents private for nearly thirteen years. The doctor took the paper and examined it and passed it to his nurse Nadia.

She looked at the paper briefly and handed it back to the doctor with a nod, "This is the list we compiled, Doctor. Shall we begin the process?"

The Deputy Attorney General nodded quietly in affirmation.

The doctor took Catherine by the hand and led her into the side office. As he did so he clutched her hand firmly and added reassuringly, "Catherine — you *are* Catherine — I see your mother's eyes in you. But we must be official. Please, you must remove your clothes for examination."

The process was very embarrassing and uncomfortable for a teenage girl of sixteen; but Catherine held fast to the thought that when this was done she would know for sure who she was, and her new life could begin. These few moments of pure embarrassment could not compare with years of anguish and uncertainty.

It was not the typical examination with Catherine standing in the middle of the room and feeling very self conscious as a developing young lady. The nurse read an item off the list and the doctor examined her

arm, legs, behind her neck, and under her hair. Catherine knew what "Da, da," and "Nu, nu" meant in the search process, and she had heard an equal number of both. The doctor of course acted in a very polite and clinical matter of fact way, but that did not help Catherine when he had to examine the area around the nipple of her right breast. He was saying "Nu, nu, nu."

Catherine's eyes moved towards the ceiling and away from the probing hands and bulging eyes of the elderly doctor. The process was so embarrassing, so demeaning, yet Catherine was learning at an early age to do whatever it took to achieve something important. The doctor seemed anxious and almost frantic, his nose nearly touched her skin as he peered and moved the breast as he looked. Then Nadia looked back at the list and realized the error. She blurted out in a language unfamiliar to Catherine, but she easily comprehended the new Romanian words, "Left, not right!"

The doctor immediately shifted his hands and quickly pronounced, "Da! Da!" as he triumphantly acknowledged the freckle shaped like a snowman. The doctor pinched the skin together and Nadia smiled and nodded. As Catherine had matured the skin stretched with the breast's development. The doctor was satisfied and Nadia said, "*Seven!* Young lady, you may get dressed. We are done!"

Dressing quickly Catherine was happy to be finished, but curious about, 'seven'. She adjusted her clothing and entered the main office, seeing all smiling faces. The Deputy Attorney General had an envelope in his hand, "*Catherine*," he said definitively. "I have signed the enclosed letter including a copy to the courts and of course the King. Your examiners have confirmed and witnessed that you have seven and one-half of the twelve identifying marks — a majority; and you, my dear *Catherine*, have been found! You are the daughter of Princess Irene! You are home."

Little Drina was atwitter with excitement for Catherine. Fortunately, Emmanuel had been gone overnight on business and that evening's dinner was like a birthday party with laughter, stories and extra desert. Aunt Tincouline enjoyed the celebration for Catherine. "My goodness, your life will now be so wonderful! I am so excited for you!"

Drina enthusiastically interrupted. "Yes, and they live in a huge Palace! You'll have butlers and maids and castles in the mountains!"

Catherine smiled and was joyous with them, such grand things to

look forward to, almost incomprehensible. Her excitement though was tempered by the sobering thoughts of how she would be received into a new family, one that had existed without her for so many years. How would she know how to act? All she had known were orphanages and boarding schools where the pupils and staff alike had always treated her as second class at best. Sadly too it was also now confirmed that she would never be able to know her mother except through the memories of others.

The night dragged on for a sleepless Catherine — so much excitement, so much anxiety mixed along with so many doubts, fears, hopes, and dreams. As the new day dawned Catherine had her lone suitcase packed as she paced nervously throughout the huge house waiting for Drina and Aunt Tincouline to come down for breakfast. When the carriage arrived Catherine bade hasty farewells and boarded, realizing she could not even remember what she had just eaten for breakfast!

The ride took Catherine deeper and deeper into a bustling city. Lawns and grand homes quickly gave way to row homes with little flower gardens, and then to apartment buildings with an occasional flower box bursting with bright flowers. The style of the buildings seemed to be remarkably similar to those in Paris, but the people seemed more akin to peasantry and working class, the streets more plebian and utilitarian. They were not as alive and gaily festooned with cafes, colorful awnings and young lovers walking arm in arm. There were more horse drawn carts, carriages and wagons but fewer automobiles or lorries.

As the trip progressed Catherine sensed she was nearing the city center. Several train tracks had been crossed that angled like spokes on a wheel to a hub. Adjacent to the tracks were old factory buildings. There were more shops and businesses, more massive buildings that must have contained many offices. The carriage turned off the main boulevard and traveled for several blocks along a quieter street. It turned suddenly and passed through tall imposing iron gates enclosing a courtyard. Catherine was nearly half outside the carriage straining to see a massive four story stone edifice with a pair of massive cement lions guarding an archway atop a rise of marble steps. Above the arches on the third floor were ornate wrought iron enclosed balconies with huge glass doors. Above it all were two flagpoles with the Romanian flag and a family crest. Gargoyles and pillars decorated the fourth level flanked by uniquely Romanian curved peaks.

The carriage halted abruptly and Catherine lost her balance, nearly

being thrown to the crushed stone driveway. Now that would have been an inglorious grand entrance she thought with a twinkle of delight. A formally dressed elderly man walked very slowly from the top of the stairway and opened the door, "Mademoiselle Catherine, we've been expecting you."

It was the first time Catherine would be referred to with such deference in her native tongue which she was quickly mastering. Languages seemed to be very easy for her to grasp. She quickly brushed her blouse and skirt of the dust from the ride before accepting the man's outstretched hand as she stepped as gracefully as she could out of the carriage. At the top of the stairs were two large wooden doors, ornately carved glass etched with vines and flowers. Catherine entered the palace of her own family for the first time. It was a glorious feeling!

Inside was a foyer that opened to a large main hall with two sweeping staircases leading to the upper floors. There, dressed in a black dress was a short plump woman with silver hair rolled into a bun. She seemed all the smaller framed as she was between the massive stairways, but her smile radiated. Catherine paused sensing — knowing — that this woman was her mother's mother.

The woman turned for a moment and called out to a side room. "George... she's here!" She held up both arms as Catherine raced and threw herself into the arms of a longing grandmother. They clung to each other as if neither were willing to ever let go.

There was a noise, repeated again more loudly. It was a cough, a throat clearing, a polite request for attention. The grandmother conceded and turned the still clutching girl towards her grandfather. He was a distinguished, broad man, rather rotund in his senior years, with a long prominent nose and great bushy white sideburns that plunged down his cheeks and curved up to meet a broad mustache. The man surely must have been an imposing figure to most, but the joy in his eyes were all that Catherine noticed as she bounced into her grandfather's embrace. He patted the sobbing girl on the top of her head.

The three shared the reunion moment, and then each grandparent took a hand and led Catherine into a finely upholstered and appointed drawing room. As they all sat on a couch several servants appeared with little cakes and cups of tea.

Granny began, "Catherine, I am sorry we were not up to meeting you sooner. We have had so much disappointment and treachery from

the hands of... well... we could not stand to chance more disappointment until we were sure of your identity."

Grandfather George added, "We have actually had detectives follow you on the train all the way from Paris, and even had some stationed around your Uncle's home. We would not chance another intervention by your father. The next several days will be busy with governmental and legal requirements. I will assume your legal guardianship, for your father is actually a wanted man in this country and would be arrested and jailed for life for your kidnapping; but I would still not put it past him to try something desperate. Once I become your guardian you will become a member of a proud family, and we will begin your training."

Catherine looked puzzled. What training? Was she to be a nanny after all? Were her newly found grandparents going to ship her off to a school, another institution?

Grandfather Cantacuzene perceived the girl's doubts, and threw his head back, letting out a roar of laughter, "My dear... you must be *trained* to be a *Princess*."

The next day Catherine appeared before a judge. Grandfather Kretulesco actually filed the petition requesting Prince George Cantacuzene be legal guardian. It had been arranged that way to avoid any appearance that the Cantacuzene family might be kidnapping or stealing Catherine from her father, a member of the Kretulesco lineage. Such caution and attention to image and perception was very important with circles of royalty. And as was customary in such dealings Grandfather Kretulesco would also be adding a comfortable recompense to his estate for his day in court — courtesy of the Cantacuzene family.

Asked to rise Catherine approached the judge. She was still a 'Doubting Nellie'. She had all the faith in the world that her Grandfather Cantacuzene was indeed a great potentate within Romania, yet the turmoil of her entire life as she could remember it painted a picture dominated by an evil force — her father. Her thoughts were always dogged by a nagging fear that this new life, this dream, was just a warm beautiful image within the reaches of her mind and grasp to be abruptly sundered by those angry brown eyes of Radu glaring at her while he was shaking her violently from her blissful wandering sleep.

"Ah-hem. Madame Catherine!"

Catherine looked up, realizing she had become lost in her anguished thoughts and that the judges had just repeated her name. "Yes sir."

"Your age?"

"Sixteen, sir. Well, almost sixteen."

"How long has it been since you were in Romania?"

"Nearly thirteen years, your Honor, I mean I was too young to be aware of things when I was last here, but what I was told by the nuns who cared for me was that I was three when my guardian brought me to the orphanage."

"And why were you in the care of nuns?"

"I was in a catholic orphanage, sir."

"Where was your father?" the judge asked incredulously.

"I don't know. In fact I did not know I had a father till the year before last. The man who said he was my guardian was actually my father. He told me... and all of the orphanages and schools did likewise... that both of my parents had been killed in a train crash."

The judge furrowed his brow and sighed loudly, "Did you ever spend time with your guardian — err, father?"

"Yes sir, every year he would come for a day to where I stayed and take a picture with me."

"Is that all? What about holidays, birthdays?"

"No, your honor. I actually didn't know my birth date. My guardian — father — never said anything to me about a birthday... in any event, we never celebrated it."

The judge's eyes widened and he looked up from his notes to the girl before him. "How then did you spend your holidays?"

"I was not allowed to leave the orphanage. At the boarding schools, the girls usually left on holidays with families. I would have the run of the entire place!"

"That must have been a joy." The judge intoned sarcastically, not knowing that Catherine actually did enjoy the solitude, despite envying the other children's time with their families.

"Did you have an allowance?"

"Oh yes, I would get a farthing each week!"

The judge scratched his chin, and then incredulously exploded, "A penny each month! A penny?" He was shocked. Before him stood the granddaughter of one of Romania's wealthiest families, a royal, a former *Prime Minister*! "This is shameful!" was his retort with a stare focused on the elder Kretulesco, who shuffled nervously.

74

"Your honor, as the paternal grandparent I submit to you that I, too, am ashamed. I cannot call this girl's father my son. He is no longer of my family. I have a letter here that absolves our family of any and all claims to Catherine from this day forward." With that he handed the letter to the judge.

As if that were the last piece to the puzzle, the judge rapped his mallet and ordered custody and legal guardianship of Catherine to Prince George Cantacuzene.

The ways of laws were very confusing to the new young princess. Her Cantacuzene grandparents had not gone to court as a matter of protocol. Her Grandfather George as the former Premier was obligated to work within the courts and laws, yet actually appearing in a courtroom setting were too plebian for someone of his stature. The most difficult thing for Catherine, however, was an automatic 60 day waiting period before the court's decree would go into place — an appeal period! It would still be inappropriate for the Cantacuzene family to take the Kretulesco daughter into their household.

Uncle Emmanuel seemed very bitter and claimed he would not stop Radu if he came forward. He was nervous and upset that his family had been drawn into the mess with his bad seed brother. It had been a hard enough legacy to live down in Romania. Because of the stature of Prince George the kidnapping was an event that anyone in a position of influence would be aware of and it cast a pall over Emmanuel's own good work. It seemed his younger brother always somehow got the attention, the free pass, a reward for his bad behavior while the good son had to bear the burden of guilt by association. He also feared having a raging Radu reappear into his life as he was only just learning to be comfortable living down his underling's reputation.

Emmanuel refused when Aunt Tincouline offered to keep Catherine during the waiting period. Catherine was just as happy not to be in the house with Emmanuel's ranting, and besides, he might just cooperate with another attempt by Radu to reclaim his 'possession' just to be rid of the evil man. She felt more like a piece of chattel, a part of someone's estate, than a daughter or a niece — or *a princess*!

Aunt Tincouline packed Catherine's lone suitcase — the one she had bought from Paris. The young girl now had more than the one change of clothes originally packed for the ride on the Orient Express though

75

such a scant wardrobe was not befitting a young princess. Yet Catherine was content if not happy. The clothes Aunt Tincouline had packed were a vast improvement over the uniforms she had worn in the orphanages and boarding schools. Another Aunt, Paula, met her at the train station. She was a member of the Cantacuzene family and so the transition began away from the Kretulesco family.

A six hour ride to a mountainous region was the beginning of Catherine's training to be a royal. Aunt Paula pointed with pride to vast reaches of farmland outside Bucharest owned by the Cantacuzene family. The mountainous region was unlike anything Catherine had experienced in the relative flatness of England and France. The trip through the mountains in the train with her Grandfather Kretulesco had been during the night. On the ride huge dark evergreens created a dense forest over craggy mountains. Wonderful rapidly flowing rivulets of whitewater raced alongside the train's path through the valleys. Frequent tunnels chopped through the mountain slopes putting the train into near total darkness. It was a thrilling adventure for the young heiress.

The train slowed once again at one of the many villages along its path. This was the town of Roman — harkening to ancient past history. "It will be where we get off and begin a long carriage ride, Catherine."

The young Catherine continued her enthusiastic questioning of her new mentor. "Tell me more about your time in England."

Aunt Paula's time in England had predated Catherine's by some twenty years though her visit was in sharp contrast. She had lived in England for nearly ten years while her grandfather had been Romania's Ambassador to the Court of St. James. During that period she had attended finishing schools not unlike those Catherine had been placed in just prior to the move to France. Aunt Paula, of course, had been one of the privileged 'spoiled' girls who had beautiful clothes and wonderful holidays with her family. She assured young Catherine that *her* time was arriving — starting with this glorious holiday in the mountains.

"Here we are," she said at last. The carriage halted before what looked like a miniature of a medieval castle — a square stone building with turrets on the corners and parapets surrounding the roof. Catherine was stunned that it was not a regular residence, rather a summer home, a hunting lodge, or family retreat, a part of the convenience of belonging to the Cantacuzene family.

"This will be a wonderful place for me to tutor you in Romanian language and history!" Aunt Paula began. "You are so bright, I am sure

76

you will be ready to assume an active role in the royal society back in Bucharest when we return."

"Why so long? Catherine queried, and then quickly answered her own often asked question, "I know, it's the *LAW*. But is there another reason we are so far from the city?"

"If you've noticed, this home is built like a fortress — one very thick stout entrance; tall and narrow windows that start high off the ground, and a wide expanse of open fields surrounding the home. This home was built many years ago as an outpost and a safe-house. It was often used as an escape from more than the rigors of everyday life. More than once have your ancestors needed to escape angry mobs. Being of power and prestige and control can also put one in unpopular positions in the view of the masses. And there have also always been the scourge of robbers — highway men — who would, of course, target the wealthy. Nobody can approach the house unseen across these open fields and up the steep hill. The servants have been ordered not to allow any strangers in and to tell us if anyone tries."

Being a perceptive young lady Catherine asked, "It's my father, isn't it? That is why we are at such a remote 'safe-house' isn't it?"

Aunt Paula looked young Catherine in the eyes. She could see anger and fear in the widening pupils. "My dear, this is a precaution. Your Grandfather was informed by the police that a known criminal was seen and stopped for questioning. The man indicated that he had been approached to kidnap a young girl of royal standing. A large amount of money was offered, though the man had never seen any proof of funds. The highwayman would not identify either who was making the offer, or who was the target. But, dear, the coincidences were too obvious.

"I think your grandfather has done the best thing. He also advised the local authorities and assigned several of his most trusted detectives to protect us. One will stay here at the home and act as a manservant; one will scout the nearby countryside and check the grounds regularly. He will visit nearby villages keeping an ear to ground, looking for anything suspicious. And Catherine, they are *armed*, and will shoot to kill! They both have already been with you for weeks — since you left Paris on the train — though I doubt that you have known it."

Catherine smiled. Her instincts had been correct. The man in the brown suit, the searching eyes behind unread newspapers. She was proud of her powers of observation.

77

The two months at the fortress were spent with Catherine alternating intensive studies with long walks through the wooded mountains. They were always accompanied on their walks and trips to the villages by the detectives off in the distance, yet within shouting range. Always feeling secure with them nearby, she was painfully aware that danger could lurk anywhere and strike anytime.

Aunt Paula diligently instructed her niece in the ways of royalty — duties, expectations, etiquette, and manners that were obliged with the title. She used charts, diagrams and family photo albums to help her eager student absorb the legions of relatives and of unrelated royals who dominated the business and governance of Romania's local and national scenes. There was a large library in the hunting lodge which Catherine combed through and read extensively.

Language lessons were exciting. The teacher and the student shared English as a common language. Catherine knew French and Aunt Paula had a working knowledge of German. They traded lessons in the different languages with each other. Catherine found her existing grasp of two languages made it easier to pick up the new Romanian language. Learning what she considered her native tongue was a privilege and a joy. At long last she was somebody, belonged to someone, and was a part of a larger existence. Romania and her family were at the core of a new sense of being; something that for her once was only a far-fetched dream, a bleak hope, and fantasy in a boarding school. Now being part of a family was becoming a reality.

CHAPTER 7

From a Mother Who Lost a Child

The lessons in the mountains were absorbed by the eager student anxious to learn as much as she could. Catherine had a lot to catch up on, but her tutor was excellent. The sixty day waiting period seemed at first to be an eternity, but Aunt Paula was so engaging as a teacher and the lodge in the mountains was such a lovely retreat, Catherine was not even aware that the day for departure had arrived.

"Catherine, are your bags packed?"

"Oh my gosh! It's time to return to Bucharest?" Catherine asked, nearly choking on the glass of milk she was drinking. As she dabbed her chin of spilt milk with the linen napkin she asked, "Will I be returning to my Grandfather and Grandmother's home?"

"Yes, they are now your legal guardians. Their home is your home. Catherine, now you are truly a Princess!" Aunt Paula said with a broad smile.

"Princess Catherine? Princess! Oh yes! Princess! Princess! Princess Catherine!" the young heiress proclaimed at the top of her voice, bouncing and jumping around the dining hall like a young colt just let out of the stable.

"Oh my, now remember your standing in society!" Aunt Paula taunted, wagging a finger at the young princess.

Putting her hands up to her mouth in mock anguish, Catherine drew her feet together and gave a gracious prolonged curtsey to her aunt. Then she bounced out the room and raced up the stairs to pack — all the time singing out, "I'm a princess, *a princess!*"

Within minutes Catherine was packed. She actually had added several touring outfits that Aunt Paula provided for the hikes through the

mountains. Hiking boots, scarves, blouses, overcoats — it was so wonderful to both need and have so many kinds of clothes. Just two months prior she had but the clothes on her back and one change wrapped around her waist, hidden under her blouse. Aunt Paula also had graciously allowed Catherine to pack boxes of books and the family charts she had been using in her training, though her skills of memorization had rendered them unnecessary.

It had been a long trip from the city to the mountains. Catherine had been saving some questions for her aunt and she would waste no time asking them on their return journey. The carriage was loaded and tied down by Uri, the manservant and bodyguard. He would drive the carriage and along with Sergi, the guard on the exterior of the castle would accompany the two royals back to the city. The two professional bodyguards would be the princess's shadow for the next six years and friends for life. Prince George would never leave his granddaughter unprotected under his guardianship.

As the carriage rocked and swayed down the mountain lane Catherine asked, "Aunty, I've so many questions about my mother, but I know Granny did not want to talk about her... not yet anyway."

"Yes, I understand. I have been waiting for you to ask. Your mother was the dearest lady and very close to your grandparents. She was the eldest daughter in their household and always carried a position of favor and the responsibility that went with being the eldest, like a little mother to her younger siblings. Even though she was not yet an adult herself, she took to nurturing and caring for children. I think that may have been part of the reason she wanted to start her own family so badly, and why she turned to creating an orphanage when you were taken from her."

Catherine grabbed Aunt Paula's arm and asked, "What orphanage?" Catherine was aghast. The very word carried such negative connotations for Catherine.

"Well, I think your Grandmother will have more to say about that. Suffice it to say there is an orphanage that bears *your* name." Catherine sat back to contemplate such as ironic twist to her disappearance and her mother's life within that period of her absence.

Aunt Paula continued, "Your mother actually pushed your grandparents into arranging a courtship with Radu before they wanted. She was persistent — I think you may have inherited some of that from her. Well, it was hard to know at first, but Radu was a poor choice. His family was wonderful, and his older brother was already making a name for himself

as a young attaché. Emmanuel as you know eventually became a diplomat and successful businessman. Radu, well, you know what he's become. I think he was doted on as a child and wanted everything the easy way. Even before the marriage Radu was asking for a substantial dowry. Prince George laughed and politely declined. Your Granny, however, I think sensed the evil in the man and convinced your Grandfather to accept the demand, hoping to get the marriage off on a good note, hoping things would work out, hoping, just hoping.

"Of course there was never enough money. Radu spent lavishly on fancy carriages, horses, a huge home — all things *he* said were befitting his *wife*. In reality he was puffing his own oversized ego and went gallivanting on adventures with other woman, gambling excursions with a group of rowdies, all in the name of business ventures that stretched from Istanbul, Berlin, Paris, London, Rome, and many others. It was quite a life he led, and soon your mother saw through the lies and deceptions. When you were born he did not settle down as your mother hoped. In fact, and I'm sorry to tell you this, but you were more of a distraction to him — a bother. Irene tried her best to make it work, to accept his lies, if only he would act like a father to you. After nearly three years, she realized that aside from you she was wasting her life staying within the relationship. One day she just put you in a carriage, left the house behind with all her belongings, and never looked back. She returned to her parent's palace and filed for divorce.

"I'll bet that Radu went into a rage!" Catherine said, adding, "He's used to having his way!"

"He was maniacal! His dowry was gone. He had no other means of support. He lost his house and had no money for his womanizing and gambling. He demanded a huge settlement for the divorce, far above the accepted norms. Grandpa George refused."

"Irene would not see him — he even promised to change his ways if she would have him back. Fortunately, your mother had learned of his lying ways all too well and knew it was only insincere efforts to regain an allowance. His plot to kidnap you I think was fed by two desires. One was the money he hoped to get, and secondly, revenge. He wanted to punish your mother and grandparents for his humiliation. It was more than his ego could take. That is why I think he continued to withhold you from them long after it was obvious he was not going to get his ransom."

"He also added to the Cantacuzene family's anguish with several cruel ploys. At one point he informed your family that you were close to

death. If Irene would come to Brussels, she could see her daughter, or at least he would not bury the body until she viewed it, if she brought half of the demanded ransom and came alone. Your mother came at once, but your Grandfather would not let her go alone. Uri and Sergi were in his employ already and were sent with her. Radu, of course, suspected she would not be alone and when she arrived at the prearranged hotel, the clerk passed her a note that simply read...

Sorry for the inconvenience, your daughter is alive and I will require payment in full; please remit as previously instructed into my Swiss bank account.

Radu.

Sergi and Uri offered to ferret out the rat and bring — literally — his hide to Irene, and you should be aware, Catherine, that they are very capable of doing just such a thing. Irene knew she couldn't let that happen for then she surely would not ever find her daughter. She returned to Bucharest a brokenhearted mother, and I think she was never able to recover. Your Granny sympathized with her daughter, but felt Irene needed to be active for fear of falling into a melancholy. Together they founded an orphanage. Catherine pleaded with Aunt Paula, "*Please*, tell me more about this orphanage!"

"It is in Ploesti, a city west of Bucharest. It bears your name. **St. Catherine's Crib**. It has a special motto: *"From a mother who lost a child, for children who have lost their mothers."*

When Catherine arrived she bade her heartfelt gratitude and a good-bye to Aunt Paula. She was escorted to the palace by Granny. As she unpacked, Granny shook her head in disgust. "Child, tomorrow we shall go to some shops to get you some respectable clothes. These were adequate for the mountains, but around here you'll have to meet a higher standard. We will pick up some clothes for you tomorrow... then next week we are off to Paris!"

Princess Catherine's royal education was beginning and this part of it did not involve a text book. She learned that to buy a fine dress, you couldn't get it at a local shop, you couldn't even find one in the best stores in your country's grandest city. You had to go to the finest stores in the fashion capital of the world, Paris! Granny taught Catherine how to spend more on one piece of fine chocolate than she had spent on all her favorite rock candy from the orphanage, for the entire time she had

been there! Catherine discovered that truly good food was not determined by its portion, its smell, or even its taste, rather by its presentation, and that an umbrella with a gold handle was *not* meant to be taken out in the rain. It was indeed an education!

The formal schooling of a princess was surely different than the boarding schools. Young Catherine had always been in awe of the young ladies of privilege attending the finishing and boarding schools — the ones she had attended in England and France. They had all seemed to take such pains to look down at the 'orphan'. Catherine at that time could not feel jealous, because in her opinion a person needed a sense of being able to achieve a level or station in life to able to covet it. Since she felt there was no such chance for her, no hope she could ever be like them, she only felt self-pity, a sense of forlorn, and of being even more alone in her isolated world.

The meanness most had shown towards her in the orphanages and boarding schools was something the girl would never understand. It was something she would not duplicate and her entire life was marked more by empathy, of helping the underdog. It was apparent she had learned more at the boarding schools from those experiences than from all their lessons of instruction.

Learning she would not live in the palace itself for despite its huge size, most of the space was dedicated to formal gatherings, offices, and servant quarters initially surprised Catherine. Twenty-four servants were needed to run the palace and grounds. There was an apartment in the palace for the Prince and Princess, but it did not contain another suite suitable for another young princess. Instead it was felt that the young lady would have a better opportunity to a more gradual transition back into royal society if she had her own space without all the carrying on of the main palace. Catherine was given the entire adjoining guest house. It was huge and lavish compared to most homes, though modest next to the ornate palace. Its three bedrooms would be occupied by Catherine, by her full time personal maid, and by Uri and Sergi who shared quarters.

Both the servant and bodyguards would take some getting used to; in fact they were treated more as companions and confidants than as employees at her beck and call. While Catherine did not feel she was being left out, removed as she was from the palace, she felt as if she had been given responsibility with her own household to run, and she had the company of Sergi, Uri, and her maid and first best friend Bella. She did appreciate the arrangement. Since her entire life to that point had been

one of isolation and separation, Catherine was more comfortable having her own space. Though she would often find herself alone, loneliness would never be an affliction Catherine felt throughout her life.

Even though Catherine attended a private school, the head teacher picked her up every day — along with either Uri or Sergi. The tutor stayed for the extra tutoring Catherine needed to become proficient in the languages. She would become fluent in English, French, German, and Dutch along with a working understanding of Russian for Grandpapa insisted that she be able to communicate with the big brooding neighbor to the north. Of course she eagerly assimilated immediately into her native Romanian language and culture as if she had never been gone. There was a beautiful ebony baby grand piano moved into her house for she would also be expected to be musically proficient to a level of performing recitals. Math and science were not considered necessary subjects for a woman of royalty to master, however, Catherine insisted they be taught as she was fascinated by both and an astute student of each subject.

The new world Catherine lived in was like a fantasy. Meal time in the palace exceeded that of most fine restaurants in terms of fare, service, and appointments. Getting dressed each day was an adventure — so many things to wear — a huge change from her orphanage and boarding school uniforms. There were servants to do her every bidding — things once part of her own everyday chores. The most challenging for her to accept was the grandeur and opulence that surrounded her, all of which seemed so normal and expected by her new family.

Grandpapa George enjoyed tours of the palace with Catherine, and retelling the family history. "I always have enjoyed this building, but here, I'm afraid I overdid it!" he said as they entered the Grand Ballroom.

The ceiling was thirty feet high and framed with a gilded cornice and crown moldings. There was a balcony along the entire outer wall which was lined with huge mirrors reflecting back into the huge space making it seem even larger. There was an immense sparkling crystal chandelier as a centerpiece. The floor was cut marble that shone like glass. Huge heavy double doors, intricately carved with scenes from the mountains separated the ballroom from a very ornate dining room lined with huge oil paintings of landscapes and portraits. Grandfather boasted that 60 people had often been seated comfortably at a 'U'-shaped table arrangement that allowed for easy servicing and a quartette or harp could reside in the center and play chamber music during the meal.

From the dining room guests could retreat to the music parlor. It

had a raised platform for the performers and a beautiful wood parquet flooring of different types of woods and stains which in the center of the room formed the family crest. There was a single glass door that led out to a balcony overlooking an inner courtyard of the grounds. Several small but lavishly appointed sitting rooms allowed guests to retreat for a private conversation or to perhaps steal a kiss from a dance partner.

Though all of the grandeur was breathtaking to Catherine, it held no life. She was starved for family and her Grandfather enjoyed regaling her with as much as he could in his regular talks with the eager young heiress, and she looked forward to the day when she would find happiness and a meaningful life along with the comforts great wealth provided. For now she was content to learn and looked forward to each day under the care and love of her family.

Prince George loved to share his family's history and often told Catherine, "Who we are, is who we were, and if we can remember our ancestors, it is like they never left us." The family patriarch seemed to play a similar role with his Romania countrymen. With an immense intellect he was considered wise as to the point of being among the intellectuals of the country's elite.

He was born into royalty which provided him with access to a fine education. He studied economics and business and had been exposed to the theories of Karl Marx and **The Communist Manifesto**. It certainly was a theory that seemed to him to be contrary to human instincts; and although he conceded it was sympathetic to the human condition, it gave false hope to the poor. Grandpapa George often let his talk slip into a one-sided political debate with Catherine his captive audience. His skills as a debater had already been firmly established in his country's Senate and later as its Prime Minister. The talks did shape the impressionable young teen in her political views. However, it was the ability to persuade and control a discussion through verbal tenacity and conviction that would later become a hallmark of Catherine as a woman in a very cruel and dangerous world.

Catherine learned many business skills by listening intently to her wise and tested grandfather. Prince George was royalty, yet the family into which he was born was not wealthy. He did, however, attribute a trait of his father that the Prince felt had served him well. He said that although his father was not wealthy he was a man of high integrity and

honesty. Nothing was a bargain if one had to give away part of his soul to get it. Their life was comfortable, make no mistake, but the riches and opulence that Catherine was enjoying was through the fruits of his business acumen, not inherited wealth. The value of hard and intelligent work was impressed upon her.

As was the custom of royals in Europe Prince George's first marriage was a royal merger and at a young age though not unacceptable for the period. He was twenty, she was seventeen. She became pregnant but suffered a difficult birth. The child died at eight days old and his wife's demise sadly followed shortly. Though he was not obligated to do so, the grieving prince returned the dowry to his deceased wife's family.

It was several years later and the young bereaved prince was found to be still in a period of melancholy. He had no drive or ambition for work or for more schooling. He was at best standing in place when, as he said, his guardian angel appeared in the form of Caterina. She was younger and full of life and vitality. Her family had some land holdings and hoped to find someone who could advise them in the most productive use of their acreage. Prince George had already established his credentials throughout the country as a brilliant mind in the area of agriculture. Fortunately, he said this vivacious daughter was given the task of showing him around the estates.

Caterina was just what George needed because not only was this young woman attractive and energetic, she shared his love of the land and pushed him both intellectually and in his business, always telling him he had great potential to do well, not just for himself but for his countrymen as well for she too had a strong sense of connection with her country and its people. She encouraged and challenged George to try new things and take chances. Grandfather admitted to his granddaughter that without her steady and encouraging hand and entrepreneurial spirit he would not have taken the risk he did with a young and growing family. There were times when he was not sure he would survive the risks of his early investments.

Prince George had secured his own farm along the Danube and by using his intellect and industrious work habits, came upon a strain of winter wheat which produced a fine grade of flour instrumental to the introduction of white bread to the region. It was in great demand as purer and healthier bread than the black, brown, and grey breads most common in Romania. His vision and boldness as a businessman led Prince George to borrow heavily, investing in farmland for production, mills for grinding

wheat to flour, and barges for transporting the flour to cities where the markets existed. Later he added bakeries that produced the bread. He, in essence, created a bread basket monopoly similar to Rockefeller's model for the great oil monopoly in America. Prince George's intuitions were correct and soon he too accumulated vast wealth.

The Industrial Revolution was well underway as the 19th century ebbed toward the next millennium. The new machinery demanded oil initially for lubrication, and then more as a fuel source to drive the industrialization. Grandfather admitted to some luck in his next endeavor, but took credit for skillful management and stewardship to develop his most lucrative enterprise.

His connection to Rockefeller and oil was deeper than a business plan for wheat production. It turned out the farmland Prince George had acquired in the tens of thousands of acres providently sat upon the richest oil reserves in Europe. Standard Oil, Rockefeller's company, had become global; there was speculation that vast stores of oil were buried in sand deposits several hundred feet below the roots of Prince George's winter wheat fields. After consultation with geologists from Standard Oil the young entrepreneur bravely invested in a drilling program with his American partner.

It was primitive at first. The oil did not gush to the surface as it did in America. It was a thick material imbedded in sand much like buried tar pits. Shafts similar to those used in mines were built several hundred feet below the surface. A man would lower himself down the shaft and fill leather pouches with the tar which were hoisted to the surface. Prince George studied the reports of the American geologists and determined that another bold gamble was worth the risk.

Romanian bankers thought the businessman had gone a bit daft, and the European capital markets were not familiar enough with oil production and not as inclined to risk the vast amount of money the young Prince said was necessary — especially to be invested in the rather primitive and remote Romania. However, New York banks that had benefited greatly from Mr. Rockefeller had a keen ear to the oil baron's recommendations and loaned the necessary money to Prince George. Arrangements were quickly negotiated for drilling, extraction and refining. Soon Prince George was sitting upon one of the world's greatest oil production centers, and he again was in a monopolistic position. Even if oil was drilled for on someone else's property Prince George's equipment and company would extract, refine, and transport the oil.

Grandpapa George imparted the value of integrity, fairness, and business ethics to young Catherine. He had become one of the wealthiest, if not the wealthiest industrialist of Romania, indeed of Europe. Yet there was an occasion when one of his oil wells spilled crude into a tributary of the Danube. Many fisherman and farmers lost their livelihood for the year and filed a class action suit against his company. The judge declared the oil spill an 'Act of God' and not intentional or by fault since there existed no technology to mitigate the issue. Prince George accepted the innocent verdict on behalf of his shareholders and bankers. Then in an astounding move after the innocent findings he still paid out of his personal wealth all the claims of the fishermen.

As he explained this act to his granddaughter... it was the *right* thing to do. He protected his company and investors; he kept whole the affected fishermen and farmers who were his neighbors; and then invested more money into research to prevent further spills. And for doing the right thing, his investors felt rewarded and confident in him and continue to invest in his businesses. Many of the farmers eventually sold their land or oil rights to a man they could trust, Prince George.

The research resulted in reclamation and preventative measures that ended up saving him many-fold the money through oil recovery than he paid out in claims. He pointed out to Catherine that enormous wealth carries enormous responsibilities. There is a temptation to use money to get one's way such as Radu did, to live the high life, or to avoid difficulties, and to ignore the needs of society for one's for personal gain. One must resist this and seek to benefit society, and always, *do the right thing*.

Often Granny would interrupt his discourses late into the evening and chastise Catherine to go off to bed. Grandfather and grandchild would acquiesce agreeing the young girl and old man both needed their sleep, but often as not another subject of grave import would arise and the two would talk on until another hour had passed as he escorted her from his office to the house across the courtyard that was her residence.

Granny's life was much different to the political and business driven worlds of Grandpapa, though just as interesting to Catherine. She was ten years younger than Grandpapa when they married. His busiest and most challenging and riskiest periods of business paralleled her life as a mother, bearing eight children, though two were lost to diphtheria — both sadly on the same day as well. Diseases were common in those days and

ravaged all levels of society. Even the best doctors and care were primitive and could not overcome some of the scourges of mankind.

Granny was philosophical and matter of fact about her losses. "Such things were common and expected," she explained. "It was part of the reason many people had such large families. We missed those two children dearly and mourned our loss, but we were grateful for those who survived."

The singular trait of Granny which served Catherine later in life was when traumas and discouragement seemed to envelope life, she threw herself into work for the benefit of others. Upon the loss of her children Grandmother devoted not only great financial resources, but also much of her personal time towards the Red Cross, a new international organization that assisted in disasters. War, disease, and earthquakes were the primary sources of the Red Cross efforts in the late 1800's. Her efforts were both in fund raising and in humanitarian assistance. She felt the presence of herself, a Royal, at a time and place where people were in need would provide inspiration for others to help and perhaps make those less fortunate feel their plight was indeed being noticed. There was always service to one's country. A responsibility that came with a title... but also expected was participation as a member of a culture, a society, and a common people.

"It is your duty!" she reminded Catherine over and over again.

The time had come for Granny to delve into the matter of the life of Irene, Catherine's mother. The young Catherine had spent several months learning of her new family and new country. She had been to Paris and Brussels on shopping excursions; she had spent time in her first true holiday such as her more fortunate schoolmates from her 'other life' had often regaled her. Her holiday had consisted of a visit to the family's castle in the mountains, a remote area called Zamora. This was followed by a slow cruise down the Danube in a barge upon which a grand 'house' was built with many of the comforts of a landed house. The barge docked at the mouth of the Black Sea where the Grandparents, Catherine, and several favorite servants and the ever present Sergi and Uri, enjoyed a week of sand castles, swimming, and a cuisine that combined the fresh fish of the sea with the spice of the Turkish influence that lay on the other end of the Black Sea.

Grandpapa always had an entourage of business advisors, associates,

solicitors, investors, and admirers that seemed to appear wherever he went — even on holiday. Granny on the other hand could gather her granddaughter up and go off on an adventure. They were enjoying a long walk on the beaches of the great sea and an exploration of an estuary by the point of entry of a small tributary emptying into the Black Sea, "Your mother loved this place," she said to Catherine quietly. It was the first time Granny had mentioned Catherine's mother — her eldest beloved daughter.

Catherine paused. She longed to know more of the mother she never knew. "Did you come here often with her?"

Longing to speak of her daughter to Catherine, Granny always found it to be too painful. She knew it was unfair to her new found granddaughter to not tell her all she could — the poor child was so young when she was stolen away from her mother.

"Irene was as beautiful a person on the inside as she was a woman on the outside. She was an adorable child, and a great help to me as our family grew. She never acted as if caring for her siblings was a chore, more an opportunity to be helpful to me — though I suspect she also saw it was an opportunity to practice being a mother. That, my dear, is what she felt her calling was and why the loss of you was so devastating to her."

Granny spent the rest of the afternoon telling Catherine about her mother, as a child, as a young princess, and as a mother. Several times the memories became too much and Granny was overwhelmed. Both shed tears.

Listening intently Catherine found the story of her mother was like an oral scrapbook. For Granny it was a catharsis. Since the illness and tragic passing of Irene, Granny had coped with her sorrow silently. Catherine provided her a sounding board for a long held grief, and it helped Granny in her own healing. The day ended with a story that raised the horrid specter of Radu and a promise by Granny to Catherine's dying mother. It was time for Granny to take Catherine to the orphanage.

Granny brought up the story that Aunt Paula had relayed to Catherine earlier. When Princess Irene returned from Brussels after the cruel deception by Radu, she was mired in her pity, distraught about the fate of her daughter. Her mother counseled her to find meaningful work to recreate a passion that had been lost in the abduction of her little daughter. It was an easy choice for Irene to establish the orphanage.

Her father built the initial structures on land he also donated for what was envisioned as an innovative showcase facility. As the buildings absorbed the orphan children Irene did find a new passion. It did not fill the void from her missing daughter, but it did fill the time, and gave her a reason to go on living and doing her good work. She was responsible for several hundred children who were without parents and family just as her stolen daughter had been. Irene had no control over the whereabouts of her daughter or how she was faring. She could, however, control the circumstances of her new orphaned children — the children of the home she called **St. Catherine's Crib**.

The concept they employed which was so radical for the opening of the Twentieth Century was to create a facility that would be capable of handling a large number of orphans, yet be a place that treated the children in a more family and home-like setting — in other words to not be so institutional. The living quarters were spread out among smaller buildings resembling cottages, not the standard large dormitories, each with house parents for supervision. All the children had age appropriate schooling and chores that taught responsibility. They were given allowances, as well, that they could use to learn the value of work and money.

Prince George gave a farm complete with animals and a factory equipped with tools for a number of trades making the orphanage capable of producing food and products for its own consumption and also able to teach many skills and trades to allow the children to find good jobs when they came of age. It was Irene's pride and joy and one of the best facilities of its kind in the world. Catherine found herself, ironically, anxious to visit an orphanage — the kind of place that she thought under her new circumstances she would never visit again!

The week following their return from holiday Granny and Catherine took a train ride to Ploesti. They were met by a carriage dispatched from **St. Catherine's Crib**. It was a ride of several miles from the train station in the small city. It was a pleasant ride through a bucolic countryside of many small farms lining the country lane interspersed with several grain storage and mill operations. Granny pointed them out to Catherine noting they were owned by the Cantacuzene family. The carriage turned up a long tree-lined lane and came to a stop alongside a gate with an arching canopy over it that bore the name of the facility... **St. Catherine's Crib**

91

and its poignant motto. Catherine's heart pounded. For the first time she really felt her mother's presence.

The compound resembled a quaint little village. Crushed stone lanes created a network of paths throughout the facility. The main road led from the entrance to a barn structure at the end of the campus. The lanes were lined with whitewashed rocks and manicured lawns fronted the buildings. There were several three story structures that were the schools. From Granny's previous description Catherine recognized the cottages that housed the children of different ages. There was a lot of activity along the paths as children passed along in small groups some carrying books, others kicking balls. Catherine noticed the children seemed happy and virtually unsupervised though adults were present. The most noticeable difference that struck Catherine immediately was that there were no uniforms! The children wore normal clothing. She thought back to the stigma she associated with the clothing she had worn.

The administrative building was stucco with a red tiled roof. The main entrance doors were heavy wooden works of art. An Angel with outstretched arms was carved on each door and leaded windows transoms surrounded the gracefully curved entry. Above the leaded stained windows of the transom was the inscription **'LEACANUL S'ECATERINA'** (ST. CATHERINE'S CRIB). To one side was a gracefully curved turret with five arched windows. A beautiful stone braid circle above the windows and was topped by what might appear to some as a clamshell. Beauty and elegance seemed to be purposefully incorporated into the facility. As she crossed the threshold Catherine felt she was in a sacred place like entering a church. She saw a huge portrait in a lobby.

"Catherine... that is a painting of your mother. *You* are the child in her arms. I had the painting commissioned after your mother passed."

The teenage girl looked up to the portrait, glancing at her own image as a two year old, but focusing on her mother's image. The photographs of her mother were flat black and white photographic images. The oil painting had been painted thickly and with vivid colors. It seemed to have a depth that brought it to life for Catherine. It only confirmed her sense she was imbued with for the entire tour of **St. Catherine's Crib**. There was a feeling within her that this place was calling to her, beckoning her to stay.

On the trip back to Bucharest, Granny spoke solemnly to her granddaughter, "Catherine, not many people have an institution dedicated to them while they are alive. This is *your* monument, and now not just to

you, as it is for your mother. It is now for you to honor your mother and her memory — some day *you* will have to live up to it."

Before her Grandmother spoke, Catherine had been quiet, contemplative, trying to comprehend all that she had seen. She laid her hand upon her grandmother's shoulder. Her response was simple, "Granny, I will. I feel as if I have now found my life's work."

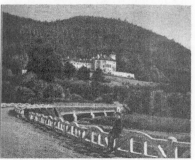

The Cantacuzene Palace, Bucharest, Romania. Close examination shows a touring car by the entrance for scale

The beloved Zamora Castle in the mountains

An enlargement of the doorway entrance St. Catherine's Crib

A gathering at the dedication of St. Catherine's Crib Orphanage. Front left, Queen Elizabeth, Rom.; Front center, Crown Princess Marie; Princess Caterina behind the queen; Princess Irene, back row center

CHAPTER 8

Admiration and Respect

Even though he was not present, the trip by Catherine to the orphanage was a catharsis for Prince George as much as an introduction for his granddaughter. He was relieved and delighted to hear afterward from his wife Caterina of Catherine's enthusiasm for the orphanage. There was a concerned that because of her early years of growing up in an orphanage, Catherine might be repulsed by the idea of any involvement her mother's facility. He had always admired his daughter Irene's commitment to **St. Catherine's Crib** and felt now her legacy would be carried on by his granddaughter.

Catherine had pleased her grandfather in so many ways since they had been reunited. She was a wonderful student and eagerly learned not only her school lessons, but his lessons to her of life as well. Prince George felt the country and family history and lessons in the ways of the family business would serve her well in her future life. He took great joy in his regular sessions with Catherine.

Having the attention of her adoring Grandpapa pleased Catherine; her young life had been so void of positive male influence. She had little experience with boys or men in the orphanages and boarding schools. They were run and serviced by nuns or other women of service. Her limited contact with her guardian-turned-father left her lacking trust and naturally uncomfortable with men. Grandfather had quickly become her ideal of what a man should be. He was not only her mentor, he was the role model — caring, but strong and protective; smart in the ways of the world and business, yet understanding of the minds of children; a loving father figure and a fine example of a devoted husband.

Awe best described Catherine's ongoing sense of her surroundings, the life she was then leading, and her Grandfather Cantacuzene's great

95

wealth and power. Her curiosity always led her to ask people about her mother, the family, the country's history, and the circumstances behind her own kidnapping and ransom demand. Catherine was a sponge for all she was told. Of course she loved her grandfather, but she sensed so many of the people she came in contact with not only respected him but had a feeling of admiration, perhaps, even loved him. This seemed obvious when so many described his service. They explained all the high governmental offices he had held and there was a general consensus he had always acted in the best interests of the country and its people above his own. Above all he had been principled. His career included being the Minister of Education, leader of both the Chamber and the Senate, and finally he capped his political career as Prime Minister.

One evening Grandfather had settled into his library to read, smoke his favorite pipe and of course answer questions from Catherine who would join him, ostensibly to read, yet invariably to talk with her Grandfather.

"Grandfather, have other relatives been in government?"

"Sure, my dear," he replied as he put his pipe down and folded his newspaper. "It's in our blood, you might say. One of our ancestors was the Emperor of the Byzantine Empire, back in 1633. Another ancestor invented the maize plant — that miniature corn plant — one of our staple foods. Several have served as governors of various principalities."

"Grandpapa, why did you leave government?"

"Well you don't serve forever, I believe it corrupts one to be in power too long — you forget you're there to serve the people, and begin to feel entitled, that the people owe you! However, in my particular case I removed myself from office."

"It was a time of high emotion in the country. The Communists were trying to spread their gospel throughout Europe. As you know I have always been very opposed to that philosophy. There had been several revolts in our country, in the more remote areas to the north — of course closer to Russia where the Communists infiltrated hooligans across our borders. They committed atrocities against landowners and were holding up in several villages. Our army wanted to bomb the villages. I refused. We do not condone capital punishment for our criminals and to bomb them would have been no more than a duplication of their crimes. We would have damaged the property of Romanians and could have caused harm to innocents as well.

"There was popular sentiment to act aggressively because we have always been in the shadows of Russia — the great angry bear to the

north. The cabinet wanted a show of force. I would not commit an act of war against civil disobedience, much as I abhorred their activities and their philosophies.

"My cabinet resigned in opposition to me, and by law, the government was dissolved. I viewed it as my time to return to private life. As it turned out, in the interim the troublemakers and hooligans realized they had not found comfort or acceptance within our borders and retreated back to Russia before the government reorganized.

"I do not miss it, for I did not seek the offices for the power they afforded. Perhaps that is a blessing of our personal wealth. There is nothing I covet that I cannot achieve by my own means. I do not need to pilfer the public purse to satiate a personal need."

The year was a busy one for Catherine with school, tutoring to accelerate or catch her up in certain areas, and private lessons in music, art, and royal manners — etiquette. Those late into the evening lessons by Grandfather fostered her interests in history, culture, and business, and more importantly a deep love of their country — Romania.

When summer arrived it was Granny's turn to shine. The agenda was social gatherings, royal duties, and, of course, shopping and touring the Continent. Europe was indeed a playground for the royals of every cut. Brussels for jewelry, Paris for gourmet dinner and fancy shops, London had its fine china, Amsterdam fine art, and Switzerland had the breathtaking Alps. It was also known for its famous secret banks used by the wealthy for the depositing of heirlooms, money, and secrets. It was to a Swiss account that Radu had directed his ransom demands.

Excursions would take them from city to city, country to country, mountain to seashore. When Granny could not travel, Catherine toured in the accompaniment of her personal teacher Mademoiselle Cardinesco and of course her discreet shadows, Sergi and Uri. Catherine exuded energy and excitement when she traveled.

Having her teacher along as a companion was wonderful for the precocious princess. The two had developed a relationship far beyond that normally associated with a teacher and pupil. Mademoiselle Cardinesco was young and unmarried. In her late twenties she had been a brilliant student who was well schooled and had earned, through academic endeavors, the opportunity to be trained as an elite teacher at many fine

institutions throughout Europe. It was the intention of the young lady to be a personal instructor for upper classes, the noblesse.

In Catherine Mademoiselle Cardinesco found a wonderful match for her skills. Catherine was an eager student — a far cry from the many spoiled royals she had tutored who were not focused on schooling — instead wanting to spread their wings socially. Catherine was a quick learner and had a very inquiring mind. She also did not hesitate to challenge her instructor, not just in accuracy, but in philosophical matters, in the realm of interpretation, and in speculative matters — in short Catherine kept her teacher on her toes. Mademoiselle for her part was a blend of respected teacher, trusted mentor, and perhaps a surrogate big sister. Catherine could not have been more fortunate, given the absence of friends in her childhood.

The tours across Europe were a feast for the eye and mind — as well as the palette. Museums, galleries, landmarks, cathedrals, palaces, ruins, and monuments were among the sites. The finest restaurants, galas and banquets as guests of royalty and elite across the continent, were nearly daily occurrences. Conversations with the intellectually elite including university professors, royalty, clergy, gifted performers and artists, and business leaders were all part of the tutorial agenda of Mademoiselle Cardinesco. Catherine also was expected to become well versed if not fluent in the languages of French, English, Russian, German, and Dutch. The Russian language being her sixth language was the most difficult. It did not have the common threads of Latin that was found in most of Europe. These were the only languages her tutor would speak to her on given days. Her grandparents insisted that she be able to communicate with people from neighboring countries and with those most influential to her homeland and of course with the common languages of business on the Continent.

Occasionally, there were adventures. Getting lost in strange cities with foreign tongues occurred regularly to Catherine's delight. She found extreme joy in solving such dilemmas before Sergi and Uri could. Her constant traveling companions were both fun and comforting. They too were having a grand time touring Europe with the two young ladies even though there were times the two bodyguards did not have entry to events. They did, however, always remain faithful to their charge by Prince George... "not to let anything happen to Catherine!" They would scout out venues in advance. Then they would pace restlessly outside events until Catherine emerged, constantly checking all entrances for anyone or

anything suspicious. Although to a bystander they may have appeared to be no more than carriage drivers or escorts, Sergi and Uri were always armed and prepared to protect their charge at all costs.

The two alternated the night watches. Always one stayed awake through the night sitting in front of the door to the room shared by Catherine and Mademoiselle Cardinesco, or patrolling the corridors of the hotel, pacing the street below their windows, climbing fire escapes to check roofs. Any person that claimed dual titles of nobility and wealth as did Catherine could be a target for deception, robbery, or worse. Of course Radu was always a prime concern.

Unfortunately for Catherine she always had the added danger and lingering nightmare of her deranged father who had never been brought to justice. His only known crime was in Romania so he roamed not only Europe, but America as well. Radu was well known as a gigolo, preying with his charm on unsuspecting and lonely women of wealth. The witty, dashing prince from the mysterious Transylvania would lure ladies into webs of lies and deception and live grandly from their purse till he became tired of the game or was caught up in other philandering mischief. He often had several consorts ongoing in different countries at the same time — with 'business needs' calling him away for weeks or months at a time allowing him to simultaneously carry out his mischief with the gullible and unsuspecting but needy women.

Prince George was generally aware of Radu's goings on from a network of detectives and police connections he maintained solely for the purpose of protecting his granddaughter from further harm by the psychopathic Radu. Catherine's itinerary had been altered on several occasions because of suspicion or knowledge that Radu was in a city or country nearby. The worry, no, the threat of an act against Catherine was always considered by Prince George as an imminent danger, such was the reputation of the seemingly deranged man who was Catherine's father. Those fears included not just kidnapping but the even more heinous specter of the ultimate revenge that could be extracted against the Cantacuzene family — murder. Sergi and Uri both knew implicitly though not directly that Radu's presence, should it ever occur, was to be dealt with quickly, discreetly — "and with a degree of *finality*" — as Prince George ordered.

Neither Catherine nor Mademoiselle Cardinesco was ever aware of all the precautions the bodyguards executed sublimely. However, Uri and Sergi both suffered Catherine's wrath on several occasions when

her schedule had been suddenly changed for no apparent reason. They both were masters at discretion and diversion with ample excuses for necessary changes. Catherine of course was insightful enough to be aware of their duty and would acquiesce to their apologetic "requests for alternative scheduling." At times she even turned such occasions into playful matches using their excuses with her piercing questioning to seek a justification or alternative venue — and they would oblige her to make up for her disappointment the change brought about. They seldom failed or disappointed.

Catherine had not been fully aware of her guardians' unique range of skills until one humid evening in Amsterdam in the summer of 1912. The evening had been a fun-filled tour of several art museums with receptions after each guided tour. It was a highly anticipated event that featured the work of contemporary artists under the backdrop of the masters. Art connoisseurs and wealthy patrons of the art viewed the evening as the event of the year. Catherine was decked out in the latest Paris fashions and wore several pieces of precious family jewelry. At nineteen she had blossomed into full womanhood, and though still uncomfortable with men, she was aware of their attention.

Uri was driving the carriage, its top down to capture whatever breeze they could catch against the muggy heat of the evening. Sergi stood on a small platform outside and behind the plush carriage's seating area. The foursome was riding along a cobbled boulevard as they headed back to their hotel. When they entered a stretch with a park, trees lining both sides of the street, Uri noticed almost immediately that a section of the gas lights that lit the way were absent. He looked up and saw several of the glass globes broken. Tensing, he and called out to Sergi to make sure he was alert. Just as he did a man ran out from behind a bush and grabbed the horse and three others rushed out from an alley. It was highwaymen intent on robbing the vulnerable women. The horse was startled and pulled up stopping the carriage which was the plan. What followed was not part of the plan.

Uri instantly spread his body out to screen Catherine and Mademoiselle Cardinesco from bodily danger for the threat of an attack aimed at Catherine was always the first thought of her bodyguards. Sergi chose to meet the attackers and leaped from the carriage and landed between it and the three approaching thugs. They were startled, but liked their odds at three to one. They were surprised by the heroics of the two presumed carriage handlers, but determined to brush them aside quickly.

They missed their guess as Sergi launched an attack quickly grabbing the closest bandit by an arm that had been flung out to strike him with a club. Catherine heard a snap of a bone caught in the vice of Sergi's strong arms followed immediately by a scream from the man. Sergi instantly slammed his massive closed paw into the second man's jaw, crumpling the startled crook to his knees. A quick kick to the rib cage sent the staggering crook sprawling and gasping onto the cobblestones.

The remaining thug was a very large man, standing a head taller than Sergi. His thick girth was easily fifty pounds — perhaps even a hundred pounds heavier than the fit protector of Catherine. Sergi crouched as the massive attacker lunged at him hoping to crush the opponent with a bear hug. The agile bodyguard's fists struck like two pistons into the giant's groin and then spun out from under the behemoth as he collapsed in agony. Finally he gave a mighty chop with both hands clasped together to the back of the man's head and the groaning ceased as the giant crumpled into an unconscious heap.

Initially stunned in shock which quickly turned to inquisitiveness Catherine watched the scene unfold. In less than five seconds three men lay at Sergi's feet. He wasn't even breathing hard. Only then did she see a glint of metal and hear the click of a pistol's hammer in Sergi's hand as he looked up and down the street for anyone else. As for the man by the horses — he fared much better. Uri never left the carriage. He wouldn't as long as Catherine was in it. In the first moment of the attack he had instinctively shielded his charge and assessed the situation his pistol instantly within his grip. The man in the front was small; in fact even in the evening's darkness Uri recognized the smooth unshaven skin and young voice, likely a teenager learning the trade.

Uri stood and skillfully placed the end of the buggy whip on the teen's behind, then across the boy's shoulders. The boy yelped like a scared puppy. He let go and ran towards his accomplices, but seeing the three collapsed to the ground, and feeling the icy stare of Sergi as his attention turned to the boy, the young accomplice fled back into the darkness. The frightened lad would need to change his soiled and wetted pants before returning to help his fallen partners in crime.

Uri turned his attention to the ladies. Seeing their startled eyes he couldn't help the brief smile that crossed his face, but he cleared his throat and asked politely, "Are you ladies all right? Perhaps that was more entertaining than the art show? Come aboard Sergi!" He called out to his friend as he too subtly gripped the pistol underneath his belt.

"I'm aboard, let's move on," Sergi replied matter-of-factly from the back of the carriage. His gun was still cocked and at the ready, not knowing if more gang members waited in the darkness. Catherine's admiration and respect for her bodyguards had reached a new zenith.

Uri urged the carriage on at a fast clip, leaving the darkened park area behind. Catherine had been startled, but Mademoiselle Cardinesco was literally shivering in fear, her arms held against her body curled into the fetal position on the carriage seat. Her hands were clasped together in a fist covering her eyes and she sobbed from her fright. Catherine stroked and spoke to her in a calming voice. She realized that in the fleeting moment of terror, she could remember every detail — the youthful voice of the boy in the plaid shirt next to the horse. The misshapen angle of the first man's arm — broken by Sergi's blow. The tam flung off the second man's head by the impact of Sergi's upper cut. The bald head of the big man as it smacked against the stones of the street.

In the instant of carnage Catherine was not at all frightened by the events, but had coolly taken in every detail of the melee. It was a skill, a temperament, a quality that would carry the young lady through many such future moments of danger and duress — an ability to remain calm, to observe and think, and to soothe the frightened and unsure around her.

CHAPTER 9

The Mountain Game Is Over

August 28, 1987. Dayton, Ohio

As the story I was feeling so privileged to hear firsthand was unfolding I often found it imperative to remind myself to keep writing as I became more and more engrossed in the princess's life. I quickly jotted a note about the bodyguards' efficient work on the thugs and looked up to Catherine to ask, "It's hard to imagine how radically different your life had become. What was the biggest change you felt as you transitioned from the life of an orphan to that of a royal heiress?"

"Easy choice. I had a family to love and one that loved me." The answer was succinct and without hesitation. "It was hard to understand, to rationalize as a teenager not being able to get to know my mother; it was something that I still have an empty feeling towards today in my twilight. I think of her, and what might have been... every day. Still she left me a great legacy in St Catherine's Crib and I think I did well by that testament of her love for children... and for me.

"My Grandpapa and Granny, they were such special people. They saw to my every need, gave me a great education, and provided me with two of the best role models a person could ever imagine. It was a very mixed up time for me. By the time I learned I was not an orphan, it turned out I really was one...my mother had died and I never had a chance to know her... my father was a rogue who I never wished I had known. Though I was out of my grandparents' lives for so many years they instantly brought me in to their world with unconditional love and gave me a sense for family that I had been robbed of in my childhood. They were the perfect salve for my wounded soul."

The most carefree days of Catherine's life were about to come to an

103

end. A shy rather bookish young lady, Catherine was told by her adoring Granny that another part of her education needed to be fine tuned — socialization. As she approached her twentieth year, every weekend was filled with social events — particularly gatherings that included other young unattached women and men.

"A proper tea lasts one hour; a luncheon two hours; dinner requires three hours; and a fancy dress ball four hours." Granny spent more and more time with Catherine teaching her manners and 'rules of conduct'. Those rules often seemed at conflict with the romance novels that became her 'literary' training: Emily Bronte's, Jane Eyre and Wuthering Heights, Charles Dicken's, Great Expectations, and Gift of the Magi by O. Henry.

As Catherine was soon to be of age Prince George began to have her manage portions of her future estate under his tutelage. The part of his wealth to be given to Catherine was from her mother's share. It also included a large allowance that Catherine was NOT allowed to spend, but rather invest. With this wealth Prince George allowed Catherine a part in the decision making with his guidance.

"The money you spend should never come out of your principal, only out of the earnings of that principal — your assets!" It was his constant reminder. He also emphasized the virtues of hard and diligent work. "The heaviest mill stone grinds slowly, but the grist is the finest." Another of his favorite admonishments related to patience. His favorite parable was, "Some things take time. Sometimes you plant the seed, but someone else will get the harvest and enjoy the bread."

One of Grandpapa's great prides was the new palace he was building in Floresti, north of the capital city. It was modeled after Marie Antoinette's Petit Trianon in Versailles. It was built with white stone, marble, copper roofs, and oak parquet flooring. It was Prince George's golden anniversary gift to his beloved wife and to the extended family. It caressed a mountain, perched among towering pines, with glorious vistas, and a sun that would set within the trough of the valley below.

He also insisted upon a villa to be built for Catherine. He had constructed homes for his other five children and now, the daughter of his sixth should own one as well. It needed to be within the area which would become her farm estate and close to her mother's and now her orphanage. Catherine had already begun an active role in helping Granny administer the orphanage. As she grew older Catherine knew her heart would lead her to a more direct role in **St. Catherine's Crib**. Consequently a site

in Nedelea was found which was close to the new palace that Grandpapa had named Zamora Castle.

Grandfather explained the meaning of the village's name with a laugh. "Nedelea... It means 'woman with an inn at a river crossing'... That is you my dear, though your inn is a rather large orphanage."

Grandfather George was happy Catherine wanted to live in the country, "The villages are important, it is they, not a great city like Bucharest, which makes our country. They provide our food, our crafts, culture, traditions and much of our commerce. When you buy from the villages you help their economy and our country's."

Under Grandfather's guidance Catherine's business education was world class. His knowledge was deep, his experience was broad, and his connections were many. He often teased his star pupil who had been a better student than his own sons, "My dear, you've been trained so well in the history of your country and working of its business... if such a thing were possible... *you* could be the Prime Minister of Romania!" They both would laugh at the very absurdity of such a notion for a woman despite the accuracy of its premise. His foresight exceeded the traditional conventions of his time.

The education of Grandmother's precocious charge peaked on the occasion of Catherine's twentieth birthday. It was the grandest event of the Romanian Royal and society calendar for the year 1913, a formal ball at the Bucharest palace of the Cantacuzenes. There was an endless procession of elegant horse drawn carriages mixed liberally with the new luxury horseless carriages — Mercedes, open and closed topped touring automobiles. A special train of the Orient Express had even been hired to bring guests to Bucharest from England, France, Holland, and Belgium.

The event, of course, had been an excuse for Grandmother and Catherine to go on an excursion to Paris for that special formal gown. Yet the most exquisite moment was saved for the day of the big event. Catherine had just finished having her hair styled and coifed and was summoned by Granny to the 'safe room'. That is what she called a room in a sub-terrain part of the Palace containing safes for members of the extended royal family of Cantacuzene. Throughout the week members of the family had been coming and going and visiting the 'safe room' to get their special adornments for the big night. Many family members Catherine still knew only by the pictures she had memorized with her Aunt Paula in the mountain lodge when she first arrived in Romania.

When Catherine arrived at the jewel sanctuary Grandmother was seated at a table with a box in front of her. She motioned to Catherine to sit beside her and with a smile and a tear pulled out a long string of pearls. "These were your mother's. She wore them often. They were her favorite pieces. I think they will look lovely with the gown we selected for you."

She produced a large green emerald broach set in gold braid with brilliant diamonds accenting the four corners of the square emerald.

Catherine held each piece in her hands and looked back and forth at the two heirlooms, "My mother's?"

"Yes, and now they are yours. I think they will appropriately mark your twentieth year."

Granny took the pearls and draped the long string around Catherine's neck. Catherine, now a woman of age, clutched the little white spheres in her hands, rolling them with her fingers. Looking to her grandmother she fought her own tears though they were flowing freely from the matriarch.

"Oh, Granny!" Catherine's words were choked with the emotions that shivered through her being. Tears finally welled in her eyes, blurring her grandmother's image.

"Granny, I can feel my mother's heart beating next to mine. I've seen these pearls on my mother in many of her pictures."

"They were a gift from your grandfather to *her* on her twentieth birthday," the proud grandmother said as she wiped away her own tears and smiled at Catherine who was clutching the pearls close to her heart. The two embraced, Catherine had never felt more closely linked and intertwined with her own mother and grandmother.

The lavish ball lived up to all Catherine's expectations. Grandfather looked regal in his full dress uniform complete with a sash adorned with ribbons, medallions, and pins. Grandmother looked equally impressive with a jeweled tiara embedded in the looped braids of her long white hair. Catherine of course was the queen of the ball and looked the part. With her pearls and emerald broach set off dazzlingly against the pale green gown she made a most striking figure, for as her grandmother had cooed when they were bought in Paris, "it has a devilishly low cut front."

Though she was a very intellectual and confident young lady, Catherine still found herself generally uncomfortable around men. This she was certain was due to her closed upbringing in the all girls' orphanages and

boarding schools and undoubtedly to her lingering doubts about men as a result of her association with her father. Perhaps, too, her complete adoration of Grandpapa, the living epitome of what all a man should be, left others so woefully inadequate to his measure.

In all her social gatherings of the previous several years Catherine had never come across anyone she considered out of the ordinary. She did find that generally the loud, brazen, and suave types were repulsive — too much like her father. The quiet and reserved young men could not hold her interest, for they were just too boring. There was one fellow that she remembered, however, from an official dinner party given by her special Aunt Paula. Catherine had bonded with Aunt Paula who had been kind and supportive since their first tutoring in the hunting lodge upon her arrival in Romania.

The man who had caught her attention was a tall slender prince from northern Romania. Prince Constantine Caradja was tanned and had a gracefully lean muscular build from his training in the military. He had a thin trimmed mustache and short cropped brown hair, bleached blond at the tips from the outside activity his military exercises demanded. He was an officer in the Cavalry. Catherine had found him to be reserved but energetic on the dance floor and able to engage in conversation on a wide range of topics. While not outgoing, he seemed confident and commanding which likely came from his military calling. It was made clear he should be in attendance at her formal.

Prince Caradja was indeed dashing in his military uniform, and high brown leather spit shined Cavalry boots. Gold officer braids dangled from his white tunic and several medals were displayed across his chest. His dark blue breeches had a gold bond lined with red down each pant leg. When he arrived in his military splendor Catherine put a gloved hand to her mouth to cover her gasp and she turned away immediately hoping nobody would notice she was blushing though she was nearly half way across the ballroom.

Catherine had the time of her life at the event. It was truly her Cinderella Ball, and as the honored subject of the evening Catherine dutifully danced with every man present. Yet her eyes always drifted toward the direction of the dashing horseman, the lanky quietly charming officer. It seemed that more than once she caught his attention directed toward her. When their eyes met she smiled, then quickly focused herself on the dance floor or her partner for the moment. Granny had always instructed her in the fine art of playing 'hard to get.' Catherine feared it

was a lesson she was failing. She did know that her heart fluttered at those flashes of eye contact; and she suddenly realized that despite her keen powers of observation and calm under duress, she couldn't remember anything that she and the young officer had talked about when they were together.

As the evening drew to a close Grandmother escorted Catherine to the foyer of the Palace, where they stood flanked by the two sweeping staircases. "We'll be saying goodnight to our guests in a few minutes. The butler will announce to the guests that their carriage or car has been brought to the entrance. Then they will depart. Remember, be polite to them all, but show no deference... be coy... reserved."

"Oh, Granny, I'm afraid I'm beyond that." Catherine confessed.

"I noticed," was all Granny said as the departing company began to file out.

At long last the tall prince from the north extended a hand to Granny, expressing his pleasure at the invite and complimented her on the evening. Granny smiled, and watched out of the corner of her eye as Catherine held out her gloved hand. She looked down to the floor, not up to Captain Caradja. Her outstretched hand trembled as the Prince cupped it between his tanned and calloused horseman's hands. "Princess Catherine, this has been a memorable evening, one I hope I might have the pleasure of repeating."

There was a pause, Granny looked over quickly and noticed Catherine still was looking down — apparently unable to speak, and she acted quickly, putting an arm around her granddaughter and said, "Of course we will see to that, Captain!" At the same time she gave a tug on Catherine's hair causing the girl's head to rise up to the gaze of the Captain. "Isn't that right, Catherine?" she added.

Catherine looked into the captain's smiling eyes and stammered, "Why, err yes, of course, Grandmother... Captain."

Captain Caradja smartly clicked his heels and nodded a short head bow and quickly turned to leave. Catherine blurted out, "Soon?"

The Prince stopped, turned and smiled, "at your pleasure, your highness." Then he turned and departed into the late evening.

The next day Grandfather George addressed Catherine, still giddy with the success of the evening. "My dear, it's time you take charge of investing your inheritance. You must make your money work for you. Just

saving it in a bank only allows the banker to make it work for the bank. Land is one of the best ways to do it — especially if you've no trade or business to manage. You want your wealth and opportunity to benefit others."

"Grandpapa, I want to benefit my mother's orphanage," Catherine replied.

"I thought you might say that. There is some beautiful farmland near the orphanage I think you should consider. Would you like to ride out tomorrow and look?"

Catherine lit up — almost forgetting for the moment her wonderful ball of the previous night. "Of course, Grandpapa!"

Grandmother attributed Catherine's infatuation with a land purchase over the delicious nuances of a successful grand ball to a faulty passage of traits. The young girl seemed to favor the paternal side of the bloodline. Grandfather just smiled.

The land was wonderful. It was a collection of land holdings of nearly one thousand acres near the hamlet of Nedelea, just a few miles from **St. Catherine's Crib** which was on the outskirts of Ploesti. It was bordered by the Prahova River, the same river that Grandfather's newly completed Zamora Castle overlooked. The river eventually emptied into the Danube.

The quaint village was like so many farming villages of Romania. The farm families clustered together in small, white stucco houses sharing common wells and other community buildings such as meeting halls, medical clinics, and general stores. Since the majority of the land was not owned by the farmers they would not live on the farm grounds themselves. Instead they would congregate in the village, maintaining small personal gardens with pens for livestock, and walk or drive a cart to the fields they tended.

The small homes were blanketed with heavy thatched roofs and usually consisted of just a single room with a kitchen and fireplace on an outside wall. The homes always were pervaded with the smell of freshly burnt wood — typically pine from the nearly mountain forests. Some had lofts for sleeping. Furnishings were few and often a multipurpose chest served as a table or seating bench. The furniture did reflect the people's pride in their few possessions and handcrafts as they displayed ornate carvings and painting, or were adorned with embroidered pillows, hand-woven rugs, or combed sheepskins. They were already or would become family heirlooms to be handed down for generations.

Grandfather had great respect for the workers of his land, always treating them fairly and with dignity. He admired their craftsmanship, envied their endurance, and respected their role in providing the food eaten in the cities. He made a point of buying food directly from his own farmers, and many of their crafts were purchased to be doled out as gifts to the many business and government guests he entertained. Prince George's love of both his country and its people was clearly evident, by his words and his actions.

The two had taken the train from Bucharest to Ploesti and Grandfather had arranged for a car and driver to pick them up and tour the land they were considering. Another royal from Bucharest had died recently and the estate's land was being liquidated. They bounced across the rough roads that had not yet been altered from rutted paths into paved passages. Cars and trucks were still very much a novelty in the rural areas. Prince George loved open air touring cars and was enjoying the ride as much as Catherine. The car rocked and bumped and chugged to the top of a hill and Prince George asked the driver to stop.

"View this wonderful panorama, Catherine. I want to explain this land to you."

As Catherine rose in the car and looked south, she could see a valley spread out before her. There was a river bed off at the bottom. In the distance rising up from the other side of the river, a great plain of wheat fields spread as far as the eye could see. This was the breadbasket of Romania.

"Most of this land, Catherine, is excellent for growing wheat. We'll put it in shares with farmers. They can earn more that way, but I also find they care for the ground better and are more productive because they share directly in the profits of their labor and care. Now look over this way." His outstretched right arm waved towards the north. The plains gave way to the pine covered mountains.

"Our Zamora Castle is three mountains north of here. See how the Prahova River winds around the base of the mountains. I've just purchased the one in front of you. That's my twenty-fifth mountain!" he said almost triumphantly. Then he chuckled. "King Carol will be mad when he finds I've topped him again!"

"What do you mean Grandpapa?" Catherine asked as Prince George relit his large hand carved wooden pipe.

"I was, a long while ago, at a meeting with the King; and had just purchased some land. The king was always interested in my business

affairs and asked me about it. I happened to mention that I had twenty mountains in my holdings. The king smiled, asked a few more polite questions, then left the meeting abruptly. He came back about a half hour later, somewhat subdued. I inquired as to what was bothering him. He looked me in the eye and said that he had asked his business manager to check and found he only had eighteen mountains. He had just told the bursar to go out and "BUY *THREE MOUNTAINS!*"

"I laughed, as did he, but we knew the chase was on... of course, I went out and found another myself. Occasionally we debated as to whether a holding qualified as a mountain. We've been topping each other since. This purchase will put me back on top!"

"You really like King Carol, don't you, Grandpapa?"

Prince George smiled, then took in a deep long drag on his pipe, the embers glowed red as he replied, "Yes, I like and admire the King. Our country had been crisscrossed for centuries by armies; the Greeks, the Romans, the Turks, Russians, Bulgarians — whoever decided to ride over us. We were many small kingdoms and needed to be united. Romania needed a common leader but could not agree on anyone from within — too many jealousies. We also needed recognition from the powers of Western Europe. We found a willing prince in Germany from the Hohenzollern Dynasty. So we now have a constitutional monarchy similar to England, France, and Germany. In 1881 we were recognized as a kingdom and the prince we chose became our King Carol. I have been involved in the government since and have become one of the King's closest advisors and friends."

Upon returning to Bucharest politics and affairs of state awaited Prince George. Central Europe was in turmoil and he feared a horrific war. Early the next morning, a messenger knocked at the door with an urgent communiqué from the King. Prince George retreated to his den to read it in private and ruminate on its contents.

"I will attend a meeting this afternoon," he told his wife upon emerging. Serbia, Greece and Bulgaria are engaging one another to the north. I am afraid Russia will seek to aid Serbia. Germany will then intervene against Russia. Lenin will see this as a moment of opportunity to stir up his Bolsheviks against the Tsar. I'm afraid there will be no end to this mess!"

The weather had turned bitter cold. Snow and freezing rain left a

glistening sheen across the city. Prince George bundled against the cold and wet, but came home soaked from the emergency session of Congress and suffered with a headache and a cold. The next day the cold traveled to deep within his chest, and he developed a fever. Catherine was worried. The palace bustled with activity as nurses and doctors were summoned scurried about. Soon they were joined by the great man's solemn family members and high ranking government officials. Lawyers and business associates of the powerful prince gathered and huddled in the den. The Premier and cabinet gathered in Prince George's chamber on the second day for a continuation of the meeting, but it was hard for Prince George to talk without breaking into severe fits of coughing.

On the third day Catherine paid her beloved Grandpapa a visit. She laid her head upon his chest and prayed for his health. She could hear a strange rattling noise as he labored for breath, Granny explained it was pneumonia. The next day the patriarch died.

Catherine was crushed; it was so abrupt and unexpected. Her world of love and security was turned upside-down. She felt a pain within her being that burned deep in her heart. The only man she had known and trusted in her life had suddenly left her. She felt more alone in her grief than she had ever felt as an orphan.

King Carol made a special request that he be allowed time alone with his friend in the bedchamber, before Prince George was prepared for the funeral. The King sat at Prince George's bedside for several hours, speaking in hushed tones to his now departed confidante and closest friend, perhaps wishing for some last words of advice. Catherine saw the tears running down the king's cheeks as he left the room. She then crept back into the room empty of all but her Grandpapa, and she climbed into the bed as she often had to hear stories from him. He was silent and she curled up next to the stilled body and wept... alone. She thought of the forlorn King, knowing, too, that now the mountain game was over.

The King's wife Queen Elizabeth arrived a short time later and spent an hour with

Granny. It was a gesture of deepest respect. She reminded her mourning friend that the four of them had been friends for forty seven years. It was 1913. The world was about to change dramatically. Catherine was twenty — and her own world was also changing – in a very dramatic way.

CHAPTER 10

The Courtship Was Brief

The devastation and sorrow caused by the death of Prince George weighed heavily upon all who knew him, but was most excruciating on the two women he loved so dearly, his devoted wife and adoring granddaughter. Granny as always had a cure for crisis — she would throw herself into a project and become so occupied and busy, it helped her move on from the tragedy or turmoil. Young Catherine learned to follow suit.

Retreating to the castle in the mountains of Floresti, Grandmother and Catherine split their time between the orphanage's activities and Red Cross work. All diplomacy and discourse failed when a rather inconsequential noble was assassinated. WWI had erupted across Europe. There were so many soldiers not returning from the battlefront that Granny would spend hours writing letters to the families back home waiting for word. She visited the hospitals and recorded the wounded soldiers' words to their families. Her listening and writing letters was a tonic to the injured soldiers and a godsend to the anxious families back home.

It was then with earnest Catherine began to learn the business of the orphanage. The Board of Directors met weekly to oversee the activities of the facility. After each board meeting Catherine would take the train out to Floresti and on to the Zamora Castle. She would review the board's decisions with her grandmother and accompany her to the facility where they would meet with the staff and instruct them as to the decisions. Catherine would then spend much of the day shadowing different staff members to familiarize her with the day to day operations of the orphanage.

Always Catherine found herself thinking back to her days as an orphan and how life at **St. Catherine's Crib** could be improved from those past sad times for her and made into a positive experience for these

113

children. Catherine no longer had any schooling to attend to, Granny was out of the city, and Grandpapa's affairs were being attended to by his lawyers and accountants. The palace became a large lonely place.

Still much of young Catherine's time away from the orphanage was occupied by social gatherings. The young lady was much in demand at parties throughout the city. It seemed that many of these parties were also attended by one tall young officer who was very attentive towards Catherine. His presence always pleased the young princess. She took to calling him by his nickname, Constantine shortened to Costea.

When Catherine would travel back to Zamora Castle to visit with Granny she would tell her about all the social gatherings. It wasn't long before Granny confided to Catherine.

"My dear, it seems as though your social gatherings are having a tendency to focus on just one person."

Catherine blushed, "Oh, *no* Granny! You mean the cavalry officer?"

Her attempt at evasion was silenced by her Grandmother's wry observation, "Yes, the cavalry officer... Officer.... Costea, is it?"

Costea as a nickname was too familiar and personal to be used in a title. Catherine blushed a deep red; her cheeks were on fire. She knew her wise grandmother was on to something.

"You may not even be aware of it, Catherine, but this young man is the focus of much of your thoughts. I can tell by how your eyes sparkle when you speak of him."

"Perhaps I've given away my feelings before I've recognized them myself. Granny, he does seem to find a way to attend many of the events I am at, and I do enjoy his company. He is so handsome too, isn't he?"

Grandma Cantacuzene laughed and tousled Catherine's long curly hair, "You must be cautious about a man in uniform! You must also promise me this as well. Do not on one hand be drawn into emotions to fill the void left by your dear gone grandfather. Your heart is feeling empty. You must also be careful not to hold someone up to your grandfather's level in your mind. Your relationship with grandfather was special. Don't compare others to that standard.

"Now you must also promise me that you *will* allow yourself to find love. You have had a difficult childhood and much of that is because of a man — a man who had done harm not only to yourself but to your mother as well. Just as I have said you must keep your feelings for your Grandfather as special and separate, you must likewise hold your

contempt and anger towards your father separate from your feelings for other men. You have learned at a tender age both extremes of these emotions. You must seek the middle ground."

"Granny, you're right. I have always been shy, reserved, well actually, uncomfortable around men. I'm sure it is because of my thoughts of that awful man who is my father. I can't let him ruin my chances for a good relationship with another man."

"And Officer Costea?" Granny prodded again.

"Yes, Officer Constantine Caradja, he is worth a good look isn't he, Granny?" Catherine said with a broad smile as her cheeks flushed again. Her quick wit followed, "I shall make it a point to insist he wears civilian clothes next time we meet!"

Her grandmother laughed with Catherine. She smiled within as well for Catherine's bodyguard Sergi and Uri had already provided the matriarch with a complete resume of the young officer and his family. Princess Cantacuzene had advised the Caradja family she would approve if things progressed.

Costea loved the military life. He excelled as a horseman, as a swordsman, and in rifle marksmanship. His duties required him to be gone much, but his efforts paid off. He was appointed to be part of the elite King's Guard. His group was charged with the duty of the actual personal protection of the King and his royal family. Of course they had special uniforms that were very showy as they were on hand at all times to protect the King. Many would think with all of the formal marches and parade uniforms, the men might be part of the pomp and circumstances — just a good show. However, their weapons were always loaded and none of the Guardsmen would hesitate for a minute to run their shiny sword through the innards of anyone who might attack the royal family.

When she saw Costea in his first public appearance Catherine beamed with pride. Sadly it was at a military funeral for a respected General of the Romanian Army who had been one of Costea's mentors. The death of the general was marked by all the regality of the highest military order and Costea rode the lead horse of the cortege carrying the general's coffin. He rode rigidly upright with his sword unsheathed and held up against his shoulder at attention. He cut a splendid figure of a cavalryman, barely blinking during the hours-long procession and funeral ceremonies.

The Cantacuzenes as part of the prominent Romanian royalty would

have been expected to attend the ceremony. However, as the late grand-father Prince George was one of the general's close friends, King Carol graciously asked Grandmother and Catherine to ride in a special carriage as part of the procession. It was an honor, foremost, but on a personal note thrilling as well to be part of the event. With her Costea playing such a prominent role and with thousands of Romanians lining the streets to bid farewell to the popular general Catherine beamed with pride. At the still tender age of twenty she truly felt the impact that leaders had upon followers. It also reaffirmed within her a personal sense of her family position, responsibility, and its standing with an entire country. It was one of Grandpapa's lessons the young woman had internalized.

After the ceremony Catherine and Grandmother rode off in the finest Cantacuzene carriage, all polished for the funeral. Catherine put her hand over the folded hands of her grandmother, "Granny...Costea looked wonderful today didn't he?"

"Yes dear, he was elegant and commanding. He certainly held a position of highest honor. I'm sure he has earned his peers' respect."

"Granny?" Catherine paused, biting her lip nervously, uncertain. "He's earned my respect as well."

"I know dear," Grandmother responded in a matter of fact way.

Searching for words Catherine sat quietly for a minute. Her grand-mother knew what Catherine was looking for; the two had become so close — bonded at first by their missing link — mother and daughter Irene. Now, another missing part of their lives, Grandpapa George, had drawn them even closer. Granny knew the subject on Catherine's mind was their eventual separation. She knew her granddaughter was strug-gling with many emotions, with the looming thoughts of their separation from one another.

The awkward silence was broken as Granny spoke first, "The recent funeral brought back memories of Grandpapa, didn't it?" Catherine nodded yes silently as tears formed in the corners of her eyes. Granny continued as her hands unfolded and clasped Catherine's.

"And yet you were looking ahead — to your Prince Costea — as he rode at the lead of the procession. You were, I'm sure, looking ahead in your life as well, to what's in front of you. You're a young woman now, ready to move on to the next stage of your life. The Caradja family, by the way, is a well established name in our country. Your Kretulesco family has ancestry as far back as records have been kept, our side — the Cantacuzenes go back to the fifteenth century. The Caradja family has

been in place in Romania since the sixteenth century. He is a suitable caller for your interests Catherine."

Catherine beamed. Granny, as always, knew what was troubling her and had just given approval to a courtship.

The courtship was brief. Costea's military training required much time away and rumors of an impending conflict added a sense of urgency to life. There were several social events at which Costea and Catherine attended as a couple followed by weeks away for the young officer. In his absence Catherine and Granny sought out events to be attended during Costea's leaves from the military. So far his activities included training and exercises and fortunately no call to action on the fronts. With the passage of several months, the inevitable became the obvious. In a carriage, returning to the Cantacuzene Palace from a festive social event at an art museum in the heart of Bucharest, Costea rather awkwardly asked a question — not exactly *the* question.

"Shall we ask my parents to come to the Palace?"

Not completely sure it was *the* question; Catherine acted to close the deal and excitedly accepted the overture. When the Caradja family arrived a formal announcement of engagement was made. The couple hastily made plans for an early civil service to be attended only by immediate family. Costea was preparing for extensive maneuvers and would leave in late April. Because the marriage was between royalty and because of Costea's rank in the military, the King would have to sanction the union. Grandmother was to see to the details. She used the family friendship with King Carol to open the doors — literally.

Grandmother took Catherine to the Royal palace for a visit with Queen Elizabeth. The elder ladies caught each other up on news and as the topic of Catherine's pending marriage came up Granny explained the need for the King's sanction.

Queen Elizabeth immediately rose and said, "Follow me ladies — love should not be held up for military rules and royal formalities! We shall have the necessary conversation with the King... and later I shall have a talk with my... *husband*... the King"

They walked along the elegant halls adorned with many sculptured busts and paintings. At the end of the hallway were two huge wooden doors, elegantly carved with huge polished brass handles, each in the gloved grasp of formally costumed doormen. They stood at rigid attention as the three women approached. With a quick gesture of flipping her wrist upwards, she signaled her intention to enter the room. The two guards

bowed graciously and simultaneously opened the doors allowing the threesome to pass without a pause.

King Carol looked up surprised from a table scattered with papers and surrounded by advisers. He smiled with his lips but glanced questioningly with his eyes as his wife approached. Again Queen Elizabeth just smiled and glanced in the direction of the advisors and back to the King.

"This will just take a minute," she added.

King Carol understood and asked the gentlemen to excuse themselves to the ante-chamber.

"Elizabeth, to what do I owe the visit of such charming women?"

Pointing with her left hand Queen Elizabeth introduced her well known guests as a formality. "This is Princess Caterina Cantacuzene and her Granddaughter Princess Catherine Kretulesco." The two ladies curtseyed to the King. "Princess Cantacuzene as you remember is a dear friend of mine. Her late husband George was your dearest friend and political confidant. Her granddaughter seeks to wed one of your Elite Guard Corps — Prince Caradja - Captain Caradja. We all would like to see this delightful couple married, and your help is needed."

"Ah, but of course. Captain Caradja, my finest horseman. Well, they're out on maneuvers now."

"Yes, so be sure he's home on the 27th of April. Both Princess Cantacuzene and her late daughter Irene were married on that date, and we would want to keep that date special for Catherine as well. Shall we consider it done?"

King Carol asked Catherine several perfunctory and officious questions, and then cleared his throat. "Well, we will take this all *under advisement.*" He winked at the blushing young Catherine.

"Thank you for bringing it to my attention."

With that he turned to his aide who had jotted several notes and asked for the advisors to be returned. Queen Elizabeth curtseyed to her husband and the two princesses followed suit as they departed the room. The Queen smiled and wished the ladies adieu. The royal formality had been completed. The consent would be forthcoming.

CHAPTER 11

A Fairytale Setting

It was an emotional, hectic, but most exciting time for both the elderly princess and the young princess. First there was the civil ceremony. April 27th, the third consecutive generation to wed on that date... the grandmother Princess Catrina, then the mother Princess Irene, and now the granddaughter Princess Catherine.

Catherine radiated under a *beteala*, the traditional headgear and veil. It consisted of a jeweled headband and glistening threads of gilt silver which fell to her shoulders and then off behind along the elegant train that draped six feet behind the bride princess. Her calf-length dress shimmered. She wore the River of Pearls that had been her mother's.

Prince Constantine Caradja was resplendent in his full dress King's Guard Uniform. He wore a red waist sash through which his cavalry broad sword with shiny gold hilt hugged his left hip. His brown leather riding boots sparkled with a military spit-shine and buffing. Gold braids looped from bright red epaulettes on the tunic and across his broad shoulders.

Costea was involved in intensive maneuvers with the Romanian Army and had only been given 24 hours leave — enough time to get to the ceremony and back to his unit. The political scene in central Europe was tense and volatile. The Bear to the East was always a concern to Romania, and the efforts of the Russian Bolsheviks caused much trepidation in Bucharest. It was much easier to deal with a monarchy even if it were corrupt than to guess what thugs and revolutionaries might do.

Four comrades of the newly commissioned Captain of the King's Guard unit, who were still in the capitol, arrived to act as an honor guard. They wore a uniform similar to Costea, but wore green tunics in contrast to Costea's white. Catherine was accompanied by Mademoiselle

Cardinesco, her tutor, instructor, traveling companion and confidant. Granny, Uri, and Sergi completed her representation at the Kretulesco church — the famous red brick edifice that ironically bore the name of Catherine's despised father for it was a highly revered name in Romania. Funding the monumental building had been provided generations previous by that same lineage. Radu through his Romanian sources had been advised of the event. As if to provide one final insult he sent word that he did not approve of the wedding and would use all legal means to prevent it. Of course her marriage meant the end of Radu's quest for guardianship and any hold on his daughter's inheritance. The threat was of course hollow as Radu was still a wanted man in Romania.

A Romanian Orthodox priest in his black shrouded headpiece and gown with a large gold cross on a thick gold chain performed the ceremony in the candle-lit sanctuary. The small assemblage moved outside the church into the bright spring sunlight that filtered shimmering green hues through the trees and on to the grounds of the picturesque adjacent park. They boarded a procession of carriages for a short caravan to a beautiful plaza where a white canopy had been erected. Beneath it waiters stood ready to serve flutes of champagne and trays of caviar and biscuits. Several toasts were offered to the newlyweds. Then at three p.m., just one hour after the wedding vows, a lorry arrived and the military personnel hopped aboard. The last man on was Costea. After brief farewells to all he embraced his new bride. There would be no honeymoon.

Quietly, Catherine wiped away a solitary tear, not so much in sorrow though she was sad. The wedding most unofficially marked the end of a childhood, yet it was not one full of fond memories. The wedding day typically marked the passage of the bride into a new womanhood, yet Catherine's mother was not present to bestow her private gifts and wisdom and mark the passage. The wedding day also was the day of the consummation of a new couple and that too would be denied the young princess.

The new bride was a warrior's bride; and as her Granny had forewarned, her husband had a duty and orders to obey. He had been granted an emergency leave by order of the King himself — just for the wedding. Now Costea needed to return to his unit with all haste. That was just the way it was to be.

Catherine's Grandmother came toward her 'just married' granddaughter and put an understanding arm around her. "Cheer up! We need

to go to Paris to buy a dress for your formal wedding this summer. We have much to get ready!"

How could one ever tire of the shopping trips to Paris with Granny? The hotels were luxurious, the restaurants were superb, and the boutiques were exquisite. Of course, Granny spoiled Catherine as would any good grandmother. While on the shopping excursion they spent hours discussing plans for the formal wedding. It was to be a grand event being held on July 6th, just after Costea's release from active duty. The beautiful Zamora Castle would be the setting for '*the* social event' of the Romanian calendar that year. One thousand guests were invited. A private train would be chartered to transport guests from Bucharest up to the mountain retreat. Another caravan of lorries would be required to ship all the food, dishes, linens, chairs, tables, tents, and flowers.

The months passed quickly as Catherine divided her time between an ever increasing role in managing Granny's and her business affairs, attending to her larger role at **St Catherine's Crib**, and of course the many details of a royal wedding. Zamora Castle was a fairytale setting. The sparkling white marble structure built into the side of a mountain was complete. It was Prince George's parting gift. He would have been pleased with its final appearance, like a beautiful landscape portrait framed with the giant deep green fir trees surrounding it. The view swept down into a valley with the winding and rapidly flowing Prahova River carrying fresh mountain water to the Danube. The crash of the water against the rocks along the river's course could still be faintly heard from the castle. An expansive terrace stretched across the front of the Castle making a perfect stage to enjoy the beautiful panorama and for hosting a wedding reception.

Across the valley rose several similar mountains which were owned by King Carol. They would always remind Catherine of the mountain game played by King Carol and Grandpapa George. She missed Grandpapa greatly and wished he could have been there that day, though she felt his presence in that special place he so loved.

The wedding day began with the hundreds of guests gathered at the central train station in the capital city to board the 'Zamora Express' at 10 am. There were box lunches served both on the train and at Zamora Castle for the guests who arrived by other means. The meal consisted of cold fowl, caviar, wafers, wedges of white and yellow cheese and chilled

red wine. A small package of white satin paper wrapped in a blue, red, and yellow ribbon — the colors of the Romanian flag — contained morsel of fine Bavarian chocolate.

The church service began at 3 pm in a small church in the valley town of Busteni. The small sanctuary could only hold about 100 in two rows of 10 pews. Hundreds of locals gathered around outside the church wanting to witness in part the royal event that was engulfing their community for the weekend. Costea again chose to wear his Officers of the King's Guard uniform for the wedding. This time a full honor guard of his comrades created an arch of ten swords for the couple to depart from the church. Catherine beamed as the bride — wearing her gown with its white satin brocade covered with a silver net over which a third layer of fine lace from Belgium was attached. Her train flowed from a tiara, draping across the shoulders and cascading six feet behind her gown.

A caravan of carriages wound up the valley from the village to Zamora Castle with local peasant well wishers lining the way to wavy and greet the bride and groom. There were a thousand guests and hundreds of uninvited onlookers had assembled to greet the wedding party at Zamora. There was much food, wine, champagne, music and dancing. Catherine danced with so many guests; she had to remove her shoes from her numb feet. Before the evening was over she heard the same villagers who had gathered outside the church and castle were congregating beyond the garden area asking to see the newlyweds.

Costea was not interested in the common folk and offered his regrets. Catherine, however, perhaps influenced by her humble beginnings in the orphanage, and by the words of her late Grandpapa felt the villagers had gone to great effort to pay their respects, and the events of the weekend extravaganza certainly impacted their village. In her usual persuasive manner Catherine suggested to Costea that the man who expected to lead the villagers' young men into battle as an officer ought to *join* his bride in thanking the locals for their hospitality. After a moment to consider Catherine's request Costea thought of their honeymoon. It might get off to a better start if he was able to actually be with her and not be sitting on the stoop outside the suite wanting to get inside. Catherine had her request granted.

The couple's honeymoon trip was an adventure from the outset. They had received a brand new shiny black Hotchkiss from Granny as

a wedding gift. Cars were a wonderful convenience, a luxury, but were still very undependable with many breakdowns. There was poor access to parts for repairs and few people knew how to make them. Furthermore, the roads had not yet caught up to the age of the motorized car. Many were still rutted dirt and gravel lanes more suitable for the conveyances of wagon and carriage. Most small streams and shallow rivers were without bridges which for centuries were not a problem to a horse and wagon, but far more adventurous for the new motorized carriages.

A trip to Costea's home in Moldovia should have been several hours instead took all day as they constantly had flat tires that needed to be changed and repaired. A small tragedy occurred while crossing a flooded stream ford. Catherine had purchased a beautifully crafted picnic setting complete with folding chairs and tables. She had intended to use it frequently on this special sojourn to the countryside. Hidden under the raging waters of one of the many rivulets they had to ford was a large boulder that the Hotchkiss hit and rode up on tipping the open top car causing several suitcases as well as her special gift to fall out the back of the car. The rapidly flowing waters carried everything downstream and quickly out of sight.

Costea was already very frustrated from the belaboring trip and became enraged. Catherine tried to calm him reminding him they were just items from a store that could be replaced. Costea had no recourse but to hop into the swollen course of the stream and its cold frothing waters and then retreat to a nearby farm to seek assistance. There he paid an amused farmer to pull the Hotchkiss from its perch with a team of work horses. Seeing the humor in the moment, Catherine with deadpan seriousness asked the farmer if he would trade his old horses for the expensive touring car. Costea at last saw the humor in their plight and his scowl was replaced by laughter.

Unfortunately for Catherine, the history of events that shaped the world was going intercede in her life. Just a few days into their honeymoon word was received that The Great War was encroaching Romania. The government put all military units on high alert. Costea was called back to his regiment. The newlyweds did not know what the future would bring. If there was to be fighting — a recall to wartime duty would surely create long periods of separation, and the uncertainty of returning at all, or perhaps a worse fate, returning as less than a whole man.

With the Hotchkiss loaded onto a flatbed car in the freight section Catherine returned to Bucharest by train. She was still determined to

begin building her new life and took to heart her grandmother's example for coping with troubles... find work and throw yourself into it. Catherine would begin building a home on the land she had purchased with her beloved Grandpapa for her new life as a wife and hopefully soon a mother. There was no way of knowing nor suspected what a precursor that bumpy calamitous journey on her honeymoon would be.

CHAPTER 12

Refugees

Life as a military bride became a series of weekend leaves shared with Costea and interspersed with desperately long periods of isolation. Isolation was not a new companion. Catherine happily filled the empty loneliness with the planning and eventually the work of completing a new estate for the family of Constantine and Catherine Caradja. Though just twenty one Catherine was quickly immersed in the management of the affairs of her own inherited estates and **St. Catherine's Crib**. She was quickly becoming a key advisor to the businessmen handling Granny's estate and the distribution of Prince George's will.

Each reunion with Costea was greeted by Catherine with high anticipation, but she was often left feeling disappointed. The Costea she first met was a shy man yet charmingly conversant when spoken to. Costea now was uncommunicative and seemed very remote and preoccupied. The stress of war was having its impact. Granny explained it was sometimes the fate of a war bride, so anxious for her man to be home and perhaps over-estimating the reception. For the man at war being away from the front was a relief on one hand, but feeling extremely guilt ridden at the same time — the soldier was away from his comrades. They could be fighting, dying without him. The horrific events formed among the men common bonds of combat and suffering on the front often blotted out all other emotion.

Romania was once again at the axis of conflict. Though Russia was in the midst of internal conflict — the Red Army Communists against the White Army of the Czarists — it still entered the war as an ally of England and France against Germany and the Austria-Hungary Empires. Romania's frontier region was Moldavia. Its northern borders touched the opposing nations and had always been coveted by the Russians. They

poured across the borders ostensibly to flank the Armies of Field Marshall Bismarck. The Romanians feared the Russians might never leave.

Costea's family was from that region. To escape the conflict they moved at his urging into Catherine's house next to the Palace in Bucharest. Catherine dutifully welcomed them, giving all the bedrooms to them and keeping the old governess quarters as her personal retreat. Unfortunately the in-laws were very overbearing and demanding. Added to that stress was Catherine's condition. She found herself pregnant for the second time having earlier lost a child by miscarriage at a very early stage.

Fortunately, Granny recognized the difficulties the tight quarters were causing and insisted Catherine accompany her to Zamora Castle. The remote surroundings brought rest and the lack of stress enabled Catherine to come to full term. She and Granny returned to Bucharest for the birthing and on July 6, 1915, one year after the marriage, a daughter named for Catherine's mother — the mother she had never known — Irene, was brought into a world at war. Granny set up a nursery on the palace's top floor near the central tower and a gratified Catherine accepted the refuge for herself.

Motherhood... it was such a unique experience, a painful yet joyous act. For Catherine it was also bittersweet. To create, deliver, and then to nurture, physically and emotionally, a new child brought a sense of wonder and fulfillment that Catherine had not before experienced. She felt a closer connection to her own mother and an even deeper sorrow at not being able to share this time, this unique common bond with the woman who birthed her and could only just begin to sense the remorse and anguish her mother must have felt at the loss of her child. And, too, Catherine felt a deeper personal loss for the love and care she had not been allowed to receive.

Costea was allowed only one day to visit his family — Catherine now a new mother and their newborn child Irene. He seemed proud of *his* achievement, though, as with most men, a newborn infant was too delicate and frightening to hold for more than a few minutes at a time. When baby Irene fussed at all, he quickly gave her up. When the infant cried, spit up, or relieved herself, the new father simply left the room entirely. Such things were not his place.

It was always a wonderful occasion when Costea was able to find a few more days in the ensuing months to return home. Catherine's first

year with her tiny daughter passed slowly with Costea gone so much, but it provided an opportunity for reflection about her own mother and motherhood in general. Catherine felt that she too must have inherited that mothering instinct Granny had spoken of regarding her mother Irene. It also did not take Catherine long to learn how fertile she was, for she had that strangely euphoric inner feeling of pregnancy. She knew that another child was already on the way.

Her usual hurried pace slowed as Catherine grew in her pregnancy and learned to become grateful there were wartime shortages of manpower and materials. Such shortages greatly slowed the progress of constructing the new home she was overseeing, With baby Irene approaching her first year's anniversary and another on the way, the young new mother enjoyed the more leisure existence. For once she was not in a hurry to get somewhere. She could not make the new baby come any faster than nature intended so she would just enjoy the peace of the country and mild summer weather.

As the months went on the expectant mother remembered her grandfather's beautiful palace in the mountains. Grandpapa's elaborate Zamora Castle had been completed in nearly the same amount of time as it took to get her home which was more of a farm estate finished. They were different times. The day the new Caradja home was completed, October 19, Catherine went into intense labor. She returned to the Cantacuzene Palace again for the birth. The delivery went smoothly and Catherine joyously welcomed a second daughter into her family. Manina joined her fifteen month old sister Irene.

The demands of motherhood grew, and Catherine was amazed how they were magnified by having two infants to care for simultaneously. She was also happy to have the help of the palace staff, but that help was short-lived. The war was going poorly and Germany was gaining control over much of the country. The day Manina was delivered the city had suffered its first air attacks. The new menace of man's race to destroy himself was launched. It was that wonderful fanciful new invention, the airplane. So exciting and amazing when first introduced to a dubious public, it had transformed an army's ability to inflict destruction far from its own front lines. It also created a new element of destruction and danger amongst civilian populations. People began to flee Bucharest.

The turmoil within Russia from its own revolution had weakened its efforts against Germany on the Western Front. Many of the Romanians accepted the losses with some relief knowing it was Germans, not the

Russians, who were gaining control of the country. Catherine, however, was sensing something different and she preferred to be controlled by neither. Having been like a prisoner for most of her childhood, the thought of being under a foreign ruler gave her flashes of the nun she had once bitten on the ankle! She suspected that she would again end up in trouble if a foreigner tried to tell her what to do. Looking for advice Catherine asked her grandmother for her sense of the plight. Granny knew the rigors of being a refugee and knew she personally could not manage the trials. Besides, she felt a responsibility to **St Catherine's Crib**. She would stay and manage affairs of the estate and the orphanage. But she was empathetic to Catherine's anxiety. The safety of the two babies became tantamount to the young mother.

"You have your infant children to think of and in addition to that I know you cherish your freedom. Realize though that there are hardships in the freedom you choose as a refugee," she warned her determined granddaughter. "I had planned to turn a vehicle over to the Red Cross. My driver wishes to leave now as well. He can drive you to Iasi and then turn the car over."

Granny also provided her granddaughter with cash from the family safe room which would be needed to survive the chaos of war and escape. Catherine was still a young woman with much to learn of life's ways. She had second thoughts when the chauffeur pulled up. Granny was giving up a small Renault. It appeared to be half the size of the massive Hotchkiss touring car Catherine had enjoyed two years ago on her honeymoon. But it had a powerful engine to handle the hardships of the journey burdened under a heavy load and still be very fuel efficient — critical with the war scarcities.

Far more stunning to Catherine and more telling to this young innocent mother was how the small car was arranged. Catherine had packed frugally with several suitcases of her own clothes, a crate of necessities for her two babies, plus she was bringing her nursemaid who also had a suitcase. The car appeared to have no room for them much less any cargo. The escaping driver, it seemed to her, was taking advantage of his ticket out of the city and had piled as much of his belongings into the car first.

The chauffeur was thinking only of himself. Consequently the front seat was occupied by his wife and as much of their personal effects as he could pile between them. The trunk of the car was already flipped up to allow it to absorb pots, pans, assorted boxes and half a dozen rolled up

carpets. These, the driver explained, would be his currency for their new life on the move. He cursed nervously under his breath as he strapped the additional cases between and over the carpets and crammed items into every cranny of the car. Catherine and the maid who was to accompany them sat on suitcases with their legs resting on top of bundles wedged on the floor boards between the seats. Baby Irene was carried by the maid and the ten day old Manina was swaddled against her mother's chest.

The passage was slow, the roads were crowded with every sort of conveyance as people on foot, horseback, carriage, and car moved slowly away from their cherished, but besieged, city of Bucharest. Catherine thought anyone observing their passage would think it a Renault powered gypsy wagon burdened as it was by the mound of people and belongings. They drove twelve hours the first day and progressed just under one hundred miles. Initially the reason for escape was made obvious as German bi-planes swooped out of the skies and roared low overhead. Fortunately for the helpless minions below, the pilots were more intent upon a show of force and a search of military targets. They chose not to strafe or bomb the long slow column of civilians inching out of the city. As the miles of separation mounted the scary roar of the war birds diminished.

By the end of the first day the royal gypsy cart arrived at the home of an elder politician, the man who had succeeded Grandfather Cantacuzene as head of the Conservative Party. He graciously allowed the six strangers overnight accommodations. The next day of arduous travel ended at a small hospital. The progress continued at a greater pace as the congestion eased further away from the city. Ten hours on the road drew them another 120 miles closer to the final destination. The Red Cross helpers from the clinic nearly came to blows over who would be allowed to care for the two babies. After two days on the road with the two little ones who were increasingly fussy in the confinement, dirt and noise of the journey, Catherine gladly accepted the relief. Bathing and soothing the tiny younglings in their whimpers and coos must have been a welcome respite from the groans of agony and death; and the filth and festering wounds of the soldiers the nurses and aides were caring for every day.

It was the middle of the third day when Catherine's little entourage arrived in Iasi, and it was a stunning shock for the refugee princess. The city's population was swelling daily. In peacetime Catherine remembered the idyllic small city on the eastern border with a population of about 70,000. It was now bursting at over 200,000 and more arrived daily. Its many old onion-domed churches were left open as safe harbors for

refugees with no other place to go. Catherine felt relief that Costea's sister had relatives in the ancient city. However, when she found the home whose address she had been given she was in for a surprise. The reception was not what she expected. An older man opened the door just enough to see who was knocking.

"We have no living space here!" shouted the stout white-haired in-law.

"But Costea, Prince Constantine, said we should leave Bucharest — it's under siege! He said we would find refuge, here, in *his* homeland, among *his* relatives."

As she spoke, the maid brought up the screaming infant and apologized. Catherine felt she was in a desperate situation and her children's welfare was at stake. As the old man was waving her off and about the close the door, Catherine placed her foot against it and stood resolutely. She unbuttoned the top of her blouse, exposed a breast, and suckled her eager hungry and crying child to it. The old man watched, both astonished and embarrassed.

"My children and I suffer the trials of the journey. It has hindered my ability to produce milk!" Catherine advanced into the front room and the man retreated. "We must be able to rest — for several days at least! You would not want a two week old baby's death on your conscience! What would Prince Constantine think? What would he do in your place? What might he do to you if you refused us?" Catherine glared menacingly.

The defeated man muttered something and walked away, leaving the door ajar. Catherine would assume he had just invited them to stay. She immediately turned to the maid and said, "Bring Irene, quickly!"

To the driver she ordered. "Bring our belongings in, and you and your wife are now dismissed from our service. You may store your belongings in the car until you find a means to dispose of them."

Catherine would not be taken advantage of in her situation. Even though she had no notion of how to operate the vehicle, she knew it was now everyone for themselves. She was not about to trust the driver with the car for he would as likely hock it for money or lodgings as soon as he could. The car would be given to the Red Cross as Granny intended and not be pawned by their driver. Though once a loyal employee, the man who had been under the hire of the Cantacuzene family for decades could no longer be considered reliable. Not after Catherine had seen how he acted when he picked her up at the palace. Well, she thought, these were desperate times which could cause a person to act ... differently.

The lessons were plain, trust your eyes and your instincts and believe another's actions, not their words or pledges.

The home of the relative was indeed comfortable. The distant in-law had been a teacher at the college. Surveying the home, however, Catherine realized quickly that two other members of the man's family had themselves been forced to flee their homes and come into his small abode. With her arrival, there was a family in each bedroom and her family of four settled into an enclosed back porch. She understood the poor homeowner's initial reluctance to add another family. Catherine was thankful for the mild October nights.

The arrangement lasted three days. A current professor of the university and his wife, also a professor, together with their two children agreed to rent two rooms to Catherine. Their children moved to couches relocated into the home's dining room. A third room had already been rented to a retired judge who had moved out of Bucharest prior to the fighting. He grumbled about the noise and confusion, but conceded to the circumstances when he discovered Catherine grandfather was a Cantacuzene. Prince George, when in service as Romania's Premier, had approved the man's appointment as a judge. Catherine had long ago learned to appreciate the broad sweep of her late grandfather's influence.

Iasi was far removed from the battle front against Germany; however, it was near the border with Russia. As winter closed, food became scarce. It was not just the drain of the war effort or the burden of the refugees that created the shortages. It was the Russian army. They 'liberated' stores of grain, canned goods; even entire dairy herds were butchered for meat. The liberations were often at bayonet point, though occasionally worthless Russian promissory notes were issued to the helpless farmer and merchants. Catherine would soon see firsthand the liberating policies of the Russian Army and it wasn't a pleasant sight.

Her very soul craved action and Catherine could not sit idle amidst the sea of confusion that flowed from wave after wave of refugees. She immediately turned the car over to the Red Cross and signed up to assist with the wounded or refugees as needed. One afternoon as she walked back to the professor's home from her volunteer work, she heard the rumbling noise of a military convoy — which was not uncommon. This one, however, seemed to be accompanied by a raucous noise of shouts and

occasional screams — of fear or joy she was not sure — but Catherine's senses warned her of danger. She turned into the first yard she came to and ran to the rear of the home. There she found a small structure — slightly more than a lean-to yet hardly a carriage house. Still it kept the family transportation. Catherine quickly slid open the entry and ducked inside closing the door so that a slight crack remained to allow her to peer out and witness the procession.

Packed inside the drafty little building were an old buggy and two old horses that snorted nervously in the rear of the small barn-like structure. There was the sweet smell of fermenting hay and horse manure. The military convoy beyond this sanctuary began to pass by and Catherine learned firsthand some of the abhorrent acts of war that did not occur on the front lines.

The lorries of Russian soldiers were filled with grim faced, dirt covered infantry men. The parade included a small herd of dairy cows and horses, recently liberated and soon to be consumed. Then she saw the source of the screams. Several cars — also looking to be recently liberated civilian cars — brought up the rear of the procession. There were soldiers walking alongside the flanks of the cars. On the hoods and trunks of the vehicles more soldiers rested. Some, however, were singing and waving partially consumed bottles of wine. Catherine presumed the resting soldiers were undoubtedly passed out drunk.

Then from the last car she heard a struggling scream, one of desperation. As she watched in horror a young woman's flailing arms appeared from the back seat. She was trying to get out! The woman's hair was tousled and as she rose up Catherine could see that the woman's dress had been torn off as had her under garments. Her face was bloodied. A soldier rose up from the same seat and exposed his hairy buttocks to the world, his pants down to his ankles. His tunic bore patches on the shoulders... he was an officer!

As Catherine caught a gasp from her own lips, she realized she had instinctively put her hand on the door to run out and help the woman. She thought better of doing such a foolhardy thing, for she knew she too would be pulled into the car. The soldier raised his hand high and brought it down with tremendous force against the struggling victim's cheek with a crack. The poor girl fell unconscious back into the seat. The animal in the uniform mounted the stilled woman to the cheers of his comrades.

Adding to her first-hand education, Catherine better understood the bitterness and fear her countrymen felt towards the Russians. The woman

in the back seat would not have been a whore, for there would have been no struggle. This poor young woman, perhaps a young mother herself, could have just as likely been walking down the road much as Catherine had been. She was in the wrong place at the wrong time. It was just as likely the unlucky soul would not even survive the ordeal... but if she did? Catherine found the thought hard to imagine.

Thinking for a moment about the behavior of the Russian officer, Catherine hoped her own country's army did not act in such a manner. She thought of her own Costea, but almost instantly blotted those thoughts from her consciousness. As the noise of the caravan subsided, Catherine quietly slipped outside the crooked little barn and shoved the door until it was completely closed. Leaving lost in her own thoughts, she continued on her lonesome trek to the home where she stayed, and to her two children. Each child received an extra long hug when she arrived.

To Catherine's relief her children were thriving despite the conditions. As the weeks rolled into months everyone in the cramped quarters of the house was both patient and resigned to the circumstances. They had learned to benefit under their present conditions as a group by pooling their resources and sharing rations. One acquired bread, another found potatoes, another would secure fresh produce, and yet another might find some form of meat. When added to the basic diet of cooked, boiled, or mashed dried beans they all had a more balanced and varied diet than most struggling for life in the burgeoning city turned refugee camp.

Somehow Catherine would find the time to spend several hours each morning and afternoon at a Red Cross facility helping either wounded soldiers or deprived refugees. Despite caring for her own infants Catherine seemed to have a reserve of energy that gave her strength to help others as well. The maid she brought with was wonderful at minding the children while Catherine attended to those less fortunate. The young princess often would teach and read to the refugee children utilizing her command of five foreign languages reading each page in a different language to their delight as she reach all the child refugees who had fled from different countries.

Also a popular storyteller, the children would gather around Catherine and for a few hours she would transport them to far away beautiful places with fun things to do and songs to sing. These stories she had brought with from her own childhood as an orphan when she would occupy endless

hours by herself dreaming up imaginary adventures. The children needed to play to occupy their time and to take their minds off their hardships. The organizers at the Red Cross admired the young royal mother's pluck and vigor. They were thankful for her kind heart for the children.

As time went on Catherine gained an even greater respect for the Red Cross and a better appreciation of her own grandmother's admiration for the organization. Yet the fabled rescue group could not secure adequate medical supplies. Most soldiers died behind the front lines as a result of pneumonia and infection due to lack of hygiene, clean bandages, and scarcity of medicine. Not from death by a wound on the battlefield.

There was a new scourge of typhus; a disease Catherine would soon become intimately familiar. It was virtually unknown in Romania, so it likely had come from the Russian troops, who had over the years become immune to the deadly bacteria. The bacteria traveled by way of body lice. In the squalor of the battle fronts and refugee concentrations it was almost impossible to eradicate the deadly pestilence.

As the spring of 1916 warmed the earth, the normal joy of the flower season was overshadowed by two foreboding thoughts. The frigidity of winter reduced the bacteria and body lice and brought a welcome but deceiving respite from the disease. In the warmth of spring they would soon be unleashed. The improvement of weather also meant the full scale resumption of war. Once the soft muddy ground and roads firmed up, the Germans would make their last push through the remaining unconquered region of Romania, the island of land between three rivers with an ancient city named Roman for the earliest conquerors of Romania. The three rivers cascaded off the Carpathian Mountains and crossed the fertile plains sandwiching the countryside against the Ukrainian region of Russia.

In early April Catherine was approached by a Red Cross Director while she was teaching a small group of refugee children a math lesson. "Princess Catherine? We have received an urgent cable from the Village of Grumazesti. Are you familiar with it?"

"Yes, it is in the region of my husband's birth. The Caradja family has its royal bearings in that area. Why do you ask?" Catherine replied while handing her chalk to an eager child who began to work on an addition problem.

"The Mayor has sent a cable. The people are dying in mass numbers from a plague. They are hoping a member of the royal Caradja family could help. They are desperate and call for you."

Having only just married into the Caradja family two years earlier,

Catherine's sense of loyalty and service still led her to believe she had an obligation to act as a member of *his* royal family. Costea was in the battle; other members of the family were obviously not available. She felt a sense of duty. Yet what could a twenty-three year-old mother with two infants do with medicines and resources so scarce?

There was someone who might help. Catherine called a brother of her mother. Uncle Jean Cantacuzene was Chief of Medical Services for Romania's government in exile. He had learned his trade in Paris working with Louis Pasteur and had taught medicine. Catherine was reminded again of what a wonderful family she had been returned to! A moment of anger flashed within her at her father, her kidnapper, for keeping her from so many wonderful people. She let go of the feeling as fast as it appeared for she had work to do.

Uncle Jean advised Catherine the plague was likely a typhus strain and there were no vaccines; there was not much she could do for those who had the illness and only stringent sanitizing would halt the spread of the disease. Catherine expressed some concern for the safety of her young children, but was persuaded by his explanation. Hygiene was the key he told her and the danger to her or her children was no greater in Grumazesti than anywhere else in Romania as long as she maintained the cleanliness. If she decided to go, he would advise her and send what help he could spare. Catherine responded telling her uncle when, not if, she would arrive in the stricken village. He should begin sending all he could. She would call for further advice when she was there and had made an assessment of the disease situation. Catherine understood that often duty was not without risk, and quietly she relished the opportunity.

Chapter 13

The Last Word

Arriving in Grumazesti by bus the next day Catherine stepped off the dusty and dented motored trolley not knowing what to expect. The anxious mayor stood by greeting the young princess with a baby in her arms. He looked past her and over her shoulder. The maid followed with the three year old toddler happily making a game of jumping down each step of the bus exit. The mayor again looked back up at the bus, smiling nervously. No one else exited. *She* was the rescue party, a tiny woman, with two small children, and a middle-aged nursemaid?

Sensing his anxiety Catherine exuded confidence, "This is it, Mayor. The cavalry has arrived!"

The little woman with a big smile was not what the village's belea-guered leader was looking for, and he looked back again to the bus. It was still empty. The mayor's weak smile turned to a frown, and he adjusted his tie while clearing his throat. Catherine realized she was at her Waterloo moment with the man. She knew she must take command immediately or her ability to do any good could be lost. Always treated her own workers with kindness and dignity, and they returned it with loyalty and diligence. At that moment under those conditions it seemed that the military's mode of rank and file with a line of command would be more useful, and Catherine knew who needed to be at the top.

"Mr. Tirgu!" she said with as much authority as she could muster. "Have someone take our belongings to the Caradja estate. Advise the city that Princess Caradja has arrived, and I will require *everyone's* complete and urgent attention... *and cooperation... if they hope to survive!* Now take us to the Caradja estate. *Quickly*, there's no time to lose!"

The beleaguered city father was taken aback for a second. He looked back to the bus — nobody else had magically appeared. He looked

again over to the maid, her eyes glancing over in the direction of the car. Catherine holding Manina was already standing by the car's door looking impatient.

"Let me get the door your highness, um, err, the estate I'm afraid has been empty for several years ..."

"Then you'll get someone to tidy it up! Shall we spend the evening in your home... or is there a proper hotel for us?"

The mayor again took a moment to absorb his directives; he wasn't accustomed to a woman in a place of authority, a woman telling him what to do. He opened the front door of his sedan for Catherine; and as she was getting in, he opened the back door for the maid and little Irene. Turning to close the doors he then cleared his throat nervously and offered, "It would be an honor and pleasure if you'll be my guests until the Caradja estate is ready."

The next day began with a tour of the town. There was no logical source of infestation. Unfortunately there was also no location of glimmering hope. The entire area was ripe for vermin and disease. The local schoolhouse was serving as isolation quarantine for stricken victims waiting to die. A nearby church with a graveyard was serving as a morgue and, ultimately, depository. None of the funeral parlors or hospitals in the region wanted to be exposed to the typhus germs. Catherine was stunned by the many rows of fresh unmarked graves behind the church in the cemetery plot which by necessity had expanded into the school yard. The school building was looked upon by the village as if it were a leper colony. Nobody wanted to be near the place of death.

Without any hesitation Catherine immediately directed the mayor to erect a sign in front of the school yard. The choosing of the name was not an accident. "Mr. Tirgu, this facility shall now become a hospital. We shall call it **Tirgu Hospital** in honor of your fine efforts to save your city!"

The mayor seemed hesitant — this site had been a place of so much suffering and death. He wasn't sure it was an "honor" with which he wanted to be associated. "Perhaps another name would be more fitting... perhaps we should call it..."

Catherine cut him off curtly, "Mr. Tirgu, time is wasting. We need to establish some confidence in the populace. Surely placing your name on this institution will establish credibility and we can begin our work. Do you agree?" It was not a query, simply a polite deferral.

137

"We shall call it Tirgu Hospital, or," she looked at him directly and said very deliberately, "Tirgu *Memorial* Hospital."

The mayor reached for a pen and his clipboard, and wrote a note. "A sign... Next." he said matter-of-factly.

Uncle Jean advised Catherine of the regimen she was to follow and said he had dispatched army medical and carpenter crews to the town. Catherine was amazed to find the crews had arrived that day. But upon reflection she understood. Uncle Jean was — after all —a Cantacuzene, a son of Prince George Cantacuzene. Catherine realized some people are born to be followers and some to be leaders. Uncle Jean was the latter; perhaps she sensed she too would someday be defined as such. Mayor Tirgu already knew.

The task of the carpentry crew was to create decontamination chambers. Trolley cars were added to the mayor's list. Over the next several days a long narrow building was erected on the school grounds with several furnaces confiscated from an abandoned factory building — likely another location erroneously believed by the locals to be associated with the disease. The trolleys were stripped of their wooden tops, the wood was used in the building's construction. The windowless decontamination building had a single sliding door on each end. Trolley tracks and a pulley system completed the building. Clothes and bedding were loaded on the commandeered trolleys that had been converted into flatbed cars and were pulled through by horses harnessed outside to the pulley system. The furnaces raised the temperature to a skin blistering level and the heat eradicated the body lice that carried the disease. Each trolley would be slowly rolled through the building in no less than one hour allowing plenty of time for the vermin to cook thus sanitizing the material.

The medical team collected a crew of brave volunteers who followed the team's supervision in the disinfection of the school building, scrubbing it from end to end, top to bottom. As that process moved forward, forty cots with rubber sheets were placed in each classroom. Crates of medical supplies had also been brought by the medical team. Several classrooms at the front of the school were converted by the crews into a reception area, examination rooms, kitchen, dispensary, staff rooms, and offices.

Within the first week of her arrival Catherine and the medical team on loan from her uncle accepted twenty-two patients stricken with the disease but not yet near death. She hoped that they would survive, at least some of them, and she then would begin to build trust among the locals. During the week one of those original patients recovered and was dismissed from

the hospital. Instead of leaving, the young woman said the other members of her family had already perished from the fever. She had survived and was grateful. She understood she was likely was immune to the disease and asked to stay and help. Tears flowed freely from Catherine as she hugged the woman and accepted her offer. This was a breakthrough in confidence that Catherine hoped for in the town. This brave and giving girl's example was an inspiration to Catherine not to be lost. Perhaps the effort would succeed after all!

"My dear, you are a blessing, but I think there are more people like you in the city. So I want you to go out and find more survivors. Tell them your story. There are so many people flooding the area as refugees, I am afraid there is little work available for people to scratch out an existence. I'm afraid many of the survivors may be shunned by people who are afraid they are carriers of the typhus. Of course you are not. In fact you may all be the angels within your city the rest are praying for. You can care for the sick without fear of catching the disease again. In fact I will pay all of you for your services. Here I will write a letter indicating you can be housed, fed, and receive a measure of payment for your services!"

Another note needed to be written. This one was to the city's branch of the national bank. At her grandmother's advice Catherine brought her mother's string of pearls. "They would make excellent collateral should you need funds," was Granny's advice to her. Catherine would use the pearls to secure money from the bank to pay the workers at the hospital. She could not handle the work load without help.

The plague had indeed infected many. Some did survive. They came to the hospital looking for the work and the money it promised. The schoolhouse had once been like the front door to the cemetery, but within a week it was considered a place that offered hope. Catherine assembled people who could prepare food, feed the patients, tend to matters of hygiene and sanitation. However, the army medical team had to leave. They were needed by the army and could no longer be spared. A doctor was needed.

There was an army hospital in a nearby town. At first there was resistance to Catherine's request for assistance. The army had battle injuries to worry about. Their concern was for the soldiers, not civilians. Catherine quickly reminded the commandant that this same disease had probably killed as many of his men as German bullets. He then reluctantly agreed to allow one doctor for afternoons only, plus Catherine would have

to transport him. All military vehicles were needed for the war effort. He had none to spare.

Initial joy in getting a doctor was tempered by the new set-back. Before the war, under the tutelage of Grandpapa, most problems were thought out, joined in counsel with trusted advisors, and then solved with a well designed plan. The Cantacuzene's had all the resources of manpower, material, and equipment money could buy. Catherine understood planning, but here she had no resources, no money, and little manpower. She was, however, becoming a master of improvising, cajoling, and creating much out of little.

Passing the French Army's headquarters Catherine stopped there ostensibly to practice her language skills and to encourage the lads. They appreciated her efforts but too had no vehicle to spare. They did say their mechanics were very skillful, however, and offered to repair a car if she could find one. They thought there was a car close by, abandoned as junk by the Romanian Army.

Gratefully Catherine thanked the French soldiers and as she left in her one horse buggy, began formulating yet another plan. It was understood that operating vehicles were at a premium for the war effort, especially for the Allied Countries in Romania. The Germans controlled most of the country leaving little opportunity to requisition civilian cars. She would need to 'pull some strings' as her Grandpapa would sometimes say when he needed help from the government.

On the bumpy ride back to the hospital Catherine remembered that the Vice President of **St. Catherine's Crib** was a delightful lady, Madame Jumesque, who was, sadly, married to a horrible man. As it turned out the cranky curmudgeon was the civilian Secretary of the Army. Since the entire Romanian government in exile was working within the remaining quarter of the country not occupied by the Germans, it was not difficult to track down a man of such prominence and reputation. Catherine first communicated with Madame Jumesque who gladly arranged for a meeting. The cabinet would be meeting at the Secretary's temporary residence planning strategy for the pending German onslaught.

Arriving at the country estate home being occupied by Secretary Jumesque Catherine was ushered into the kitchen area in the rear of the huge stucco home. Secretary Jumesque entered, already bristling at the imposition of his wife and having to tend to a matter he did not consider critical to the war effort. "Let's be quick — I have *important* matters to

attend to!" He turned to an aide who accompanied him carrying an armful of folders and maps.

To her surprise Catherine was initially intimidated by the man. Bristling by his manner with her temper flaring she resolved not to be bullied by him and engaged her skills in debate. "I have a matter of grave importance to the *people of Romania...* and isn't that for whom we fight this war?"

The scowling man's thick eyebrows seemed to ruffle and the wrinkles of his forehead furrowed upwards across the top of his bald head. This upstart was challenging him. He slammed the cup of coffee he had been sipping down hard upon the table, spilling some. "Well?" he said eying the brash lady before him.

Catherine knew better than to waste the man's time and got straight to the point. "I have a hospital dedicated to eradicating a typhus epidemic..."

Lord Jumesque interrupted, "Hospitals are *not* my affair!"

"I understand sir, but we need a doctor, and we must have a car to transport him, and there is an inoperable car the army has in a compound, car #005. May I have it sir?"

"Out of the question!" he shouted.

"But sir, if it were operable wouldn't *you* be putting it to use?"

"What are you going to do tie horses up to it?" he sneered.

"If that's what it takes, I will. But at least I would be using it for the benefit of our countrymen! The vehicle would not be sitting and gathering dust as it now does!" Catherine was getting a bit strident herself — in a patriotic way she thought to herself to justify her own flash of discord. "*Please*, call the depot at Neamty, confirm it is useless to the army! It is the Army that has abandoned it!"

Lord Jumesque gave a nod to his aide who nodded back, "I will look into it." He picked up his coffee cup, still dripping from the spill and abruptly left for his meeting.

As he did Catherine got in the final word saying, "The survivors of the epidemic will thank you!" The door slammed behind the two, and Catherine turned to leave.

When she stepped outside Madame Jumesque was tending a small flower tract obviously not outside ear shot of the conversation. She looked up to the determined young lady who seemed a bit crestfallen. "Don't worry, Catherine, his bark is worse than his bite. *I* will check with his aide later."

Two days later a letter arrived from the Office of the Secretary of War.

In it was a one sentence authorization, "I authorize Catherine Caradja to borrow vehicle #005 until further notice. Lord Jumesque"

That same day a strange procession entered the French Army head-quarters. A team of six horses pulled a wagon loaded with miscellaneous auto pieces. Behind the wagon a dusty, damaged, black sedan convertible was also in tow. A wounded Romanian soldier had been assigned to look after the vehicle while it was in Catherine's care. He drove the horse team and wagon. Inside the trailing sedan sat Catherine behind the wheel looking like the Cheshire Cat with a broad grin. The French mechanics applauded and cheered Catherine and the procession as it pulled into their compound.

In three days, working during their free time, the eight mechanics welded, wired, and strapped together the body and tore down and rebuilt the engine. Many parts from their junkyard were hammered, chiseled, and bent to fit into the mutated Italian built car. The metamorphosis was completed when the proud mechanics put a high polish on the transformed #005.

Joyously Catherine arrived with her new Romanian army chauffeur. The French mechanics were very pleased with their handiwork and Catherine was effusive in her gratitude. She was escorted to the passenger side by one of the mechanics who did his best imitation of a court squire. The driver settled in behind the wheel and admired his shiny 'new' touring car. He anxiously examined the controls of the car and nodded to the waiting mechanic who had the crank in the front of the car already in hand. One swift turn of the shafted caused an immediate series of pops evolving into rapidly escalating thumps and finally settling into a soft purr of an idling engine. Catherine applauded happily and the mechanic crew sheered wildly and in unison pointed to the depots gate. The car was eased into gears and the accelerator applied. The car leaped forward with a loud backfire that startled both Catherine and the driver and delighted the audience of mechanics. Catherine headed directly to the Army hospital to pick up the doctor. On their return home she directed the driver to take a bit of a detour — past the farm estate that was the temporary home to the Secretary of War.

It seemed another gift the bold young princess possessed was about to manifest itself as once again. Catherine's timing was perfect. Secretary Jumesque and the cabinet were having a respite from their meetings and were outside in the formal front garden for a stretch and fresh air. A car was seen and pointed out as it approached the estate. Any vehicle on

the road was an unusual occurrence since all were under control of the military. Several speculated that perhaps a general was arriving with news of the war as they gathered to watch.

To be allowed to requisition the military car, to satisfy a bureaucratic detail, Catherine had been appointed a position in the Romanian Army, Nurse Major. The canvas top of her car was pulled down and folded over the trunk of the shining sedan. Catherine stood up rigidly in the car as if on formal parade and offered her first official salute which she held until well past the Army Secretary. She watched as the group of cabinet members and their aides viewed the car as it drove by slowly. She saw Lord Jumesque with a look of disbelief on his face as he mouthed the plate registration number ... "0-0-5!"

This time... Catherine *would* let the arrogant Secretary have the last word.

The work was difficult and time consuming and at first daunting. Would they be successful? Would the scourge come under control and be halted. Would the reluctant people of the area become receptive to the hospital and the pleas for sanitation that Catherine was sending out daily as flyers to post and distribute?

The work schedule was also intimidating. Catherine was putting in eighteen hour days which included three trips each day back to the Caradja estate to nurse her children. Irene was being weaned from mother's milk but Catherine did not want her to give it up all together. There were many nutrients and especially immunities that children were said to receive from nursing and Catherine did not want to chance anything during the difficult and deprived times of the war. Mania, however, still required "a full ration" as Catherine put it to the maid. The toll on Catherine and her energy was staggering, but she had a tremendous constitution and worked on valiantly despite losing a significant amount of weight. There was no other choice.

With the war conditions making things difficult at best and little in the way of government services Catherine was receiving little communication from Costea. It was a constant worry that he was safe and also frustrating for the mother of two young children to not have the emotional gratification of a spouse to share, confide, and rely upon. Yet Catherine remembered Granny's reminder that she was married to an officer and it was war time.

It would be a sacrifice she would need to bear. Sacrifice would become a way of life for the young wife.

As several months quickly passed results of Catherine's efforts at the hospital began to show. With the help of the doctor on weekly loan and the continued regimens of sterilization and disinfection, Catherine and her small army of hospital workers had nearly defeated the epidemic; however, the limited supplies, poor nutrition, and sparse means of sanitation outside a hospital setting meant the scourge would linger. A new threat affected the region. The war was at a stalemate, and the German onslaught did not materialize. Tragically, as winter again approached the renewed specter of starvation loomed amongst the civilian population.

Many farmers were carrying rifles instead of scythes. Much of the farmland was controlled by Germany. Agricultural production was non-existent in many areas, and starvation could become a reality for many. Many of the tillable acreage owned by the Caradja family were leased out to reduce management responsibilities. A sizeable 8,000 acre track of the land was not planted because of the war. The leaseholder wished to get out of the lease since he was not able to make any money from the land. Catherine again collateralized her pearls with the bank to buy back the lease. She was able to negotiate a very good price on the buy-back and the lease holder was happy to have some money in his pocket instead of miles of barren unplanted farmland.

The next part of the plan was beginning to unfold. Eight thousand acres would require a small army to plant and harvest and an army was what she had in mind. Catherine knew from Costea the Romanian Army also was in difficult straits for food, being nearly cut off from most supply routes by the German conquest. The Russians had their own issues, from outside its borders by Germany, and inside them by the Bolsheviks. Catherine approached Costea with a unique idea which went up the chain of command and was signed off by Secretary Jumesque himself. By this time the Secretary of the Army was willing to take a chance on a scheme hatched by the diminutive young Princess, and not as begrudgingly as in the past.

The army created leaves that spring for soldiers in four segments so that just one quarter of them were away from the front at any time. The soldiers could not go home since their homes were in German hands. What they did instead was convene on the Caradja acreage to plant wheat, beans

and produce. Despite the hard labor the change of action and scenery was like a relief leave for the war weary soldiers. Then again in the fall they returned to harvest the crops. The harvest was ground into flour and distributed half to the army and half to the civilians. The army paid Catherine for the lease expense as a repayment. Catherine did not ask for money for the local population for the food.

The greatest benefit for Catherine was the arrangement that allowed Costea to be assigned as the commander of both events giving him a month of time in the spring and later in the fall with his family. The idea was so successful that a month later Catherine convinced Jumesque to allow Costea to lead a brigade of expert riflemen into the mountains to hunt wild game. This harvest too was shared between the army and peasants in the villages. All were extremely grateful to have much needed protein and fat added to their meager diets.

Using guile, wit, good plans, and her personal resources Catherine managed to defeat a dreaded disease and feed an entire region trapped in the throes of war. As her second year of being a refugee was underway, the turmoil internally also broiled and conditions deteriorated. The Russian revolution was punctuated by the assassination of Czar Nicholas and his entire family. The Russian soldiers were tired of the fight with the Germans and were worried about their homes and families and the events of the revolution. Some felt the patriotic urge to return to their homeland and join in the great new experiment. There would be no ruling class — no bourgeois. The people — the proletariat — would all work for the common good. All people were equal. That was the propaganda anyway. Having heard it all before during her lessons with Grandpapa Catherine knew it would be folly.

"Nice thought," Catherine would say. "Sounds like chaos and foolhardiness."

Of course she had a personal bias, being a well established part of the bourgeois. However, she had listened intently to discussions her grandfather engaged in on the subject of Communism. Prince George understood that human nature and mankind's biological make-up made everyone different or unique, not equal or the same. In her own observations from the orphanages of her past to the palaces of her present, Catherine had seen people of different skills and motivation in all classes. Yes, thinkers and doers, leaders and followers, weak and strong. After all, wasn't variety

the spice of life? It would be so boring if everyone were to be the same. Yes, its basic precepts were folly.

Regardless, the Russian Revolution was poorly timed. There was a war to be fought, and now the Russians were putting down their guns and abandoning an entire front. They were creating a scenario in which the Germans might well march across Europe. A worse specter was concern Russia would try to spread revolution across the Continent. Europe would be very venerable after years of war had drained the wealth and will of the people. The communists had been creating mischief throughout Europe for years.

In the near term, Romania was in a precarious position. A stalemate had existed in the conflict for nearly two years. The Allies had maintained its precarious hold on the eastern quarter of the country; however, with the Russian Army disintegrating throughout the eastern front, Germany would have an ability to re-marshal its troops and resources. It was feared that the following summer might mark a heroic last stand to preserve Romania.

Tirgu Hospital had changed functions. As it eradicated the typhus plague, it became more critical as a place to treat the medical needs of refugees as more people fled the hardships of battlegrounds. Under Catherine's leadership **Tirgu Hospital** was no longer shunned. Adjacent buildings to the schoolhouse hospital were converted to convalescent centers to provide care and nutrition for the tidal wave of desperate refugees. While the mayor's name was now synonymous with the heroic fight against the plague, Catherine's own good name became bankable. Her good works and good will were collateralized by the banks in the form of personal loans to pay for the caregivers and supplies needed to keep the hospital operating.

It was in such a setting that what seemed like a rather simple thing had a far larger impact. A tradition in Romania was wine at Easter. There was none available at the hospital. With so few personal belongings or hope for the future, Catherine wanted to give the patients and their families one thing they still had — a common Romanian tradition —wine at Easter dinner. By this time Catherine was well known by all parts of the allied armies in Romania and respected as well. For a young woman only twenty four years old she was confident, determined, and, like it or not, had instincts that usually made her right — this in the face of all manly wisdom

and training. Soon it was the men who not only grudgingly accepted her steely persistence, but also sought her counsel.

What were needed were several kegs of wine. The Generals agreed it would be a real morale boost, and they could spare the wine but not the manpower to transport the red elixir. Catherine was taken aback at first. Driving supplies in a military convoy was one thing, but carrying a keg of wine through five towns that were under the control of roving bands of Russian deserters? That was risky. These rogues did not want to go home and find themselves in a revolution; but on the other hand they did not want to be on the front fighting the Germans. They chose instead to roam as undisciplined hoodlums preying on the countryside to survive. The Allies did not at the moment have the resources to spare from the front to rid the countryside of the bandits. They also lacked the political mandate to conduct military action against Russians, a de facto ally in the war.

Once again Catherine employed her creative side to overcome unusual obstacles. She gathered a lorry and filled it with empty kegs, under the guise to used for kerosene and then had a carpenter remove the lid from the wine kegs and place another 'lid' about a foot below the top. Coating the inside of the shallow portion with wax, her plan was a simple ruse. The kegs were filled with kerosene on the top and the rest would have wine on the bottom three quarters. If the wagon was stopped all that would be found was stinky kerosene, not of high value to the thugs. As it turned out rouge Russian troops stopped the wagon several times. The kegs were inspected and they were allowed to move on. It was perhaps the most joyous Easter many of the hospital patients had during the war years.

Several turns of events marked 1917. America initially was reluctant to engage in the conflict, preferring an isolationist or hands off approach. But the conflict was too large in scope and eventually Germany began sinking American supply ships. On April 4th that year the long awaited call to arms rang out from the United States. Troops began arriving within months.

However, when the Bolshevik Revolution under Lenin gained control of Russia he signed an armistice with Germany. Germany had new vigor to turn its entire military towards the European front of the conflict. It doomed Romania. There was no hope for their army to be reinforced. The month of May marked a treaty for peace between Romania and Germany — a capitulation, a ruinous surrender. Land was ceded, oil and agriculture production were turned over, and support of the German

Army of Occupation was the price Romania paid for defeat. Most of the army dispersed into the mountains rather than lay down their arms to the Germans.

The conditions were too harsh. The Romanian people could not survive without resources. A resistance effort was set up by the government in exile. The armies of Romania remained active — though dispersed into the small mountain units to launch hit and run operations. Costea and his cavalry units fought bravely through the resistance and carried on the battle for another long and arduous year. Romania as it had been over much of its history was a pawn amongst the powers of Europe, a battleground and a larder to be raided. Its people suffered greatly. Catherine suffered her own exile from Costea during that difficult year. As an underground resistance movement his units were forced into the frontiers of the country. There were no government services and they lived off the land and of course there was no mail delivery. She would not have a communication from Costea most of that period.

The entry of American men, firepower, and its overwhelming industrial might which supplied the effort was overwhelming. The following year of 1918 on November 11th Germany was defeated and surrendered. There was great joy and anticipations of reuniting families. Catherine was elated at the thought of returning to Bucharest and reuniting her young family with their war hero, Captain Costea. The frontier region she had escaped to was spared the death and destruction of the War to End All Wars, but the sacrifices and food shortages had been felt by all. Through it all Catherine's efforts had saved an entire region of her country from the ravages of perhaps the war's biggest killer, disease... the scourge of typhus. At just twenty four she was elevated to folk hero status by the local population. She had indeed brought honor to her new family's name.

Catherine though was not so lucky. She began final efforts to turn the hospital over to a local governing board head by of course the popular mayor that was the namesake of the Tirgu Hospital. Beginning to pack for a happy return home her joy was short lived as she found a lone body louse on her arm and killed it and rushed to the dispensary for disinfectant. Ironically, having survived the years of being immersed in war zones and the typhus hospital and constant exposure to vermin and sickness, as the war ended Catherine found red spots welling up on her arm and could not celebrate the end of the war as she hoped. She was infected with typhus.

CHAPTER 14

Return to Normalacy

Suffering from typhus Catherine's immediate destiny was bed for she suffered fever, lethargy, and no strength or endurance. Her only cure was to rest in bed. The doctors advised her that she likely had developed some resistance to the virus from her long term exposure while working in the hospital. Fortunately she had a mild case, and it would also guarantee her immunity to the disease in the future. However, she would be a patient for a month in the **Tirgu Hospital** — ironically the one she established to help others.

The worst part for Catherine was so much time away from her two daughters. They were allowed to visit her each day for a brief time. The threat of them catching the disease was minimal as Catherine had the facility's sanitation standards at the topmost levels. In fact, the success of the hospital had been remarkable. Of the four hundred and fifty patients treated, only forty three perished — a remarkable achievement. Despite the early trepidation of city leaders when a young mother in her early twenties with two babies in hand arrived, Catherine had worked the miracle those who called her hope for but did not expect.

As Catherine started to regain her strength she began to make plans to return to Bucharest. She was anxious to be reunited with Granny, visit the orphanage, and begin the process of creating a new life with her family in peace time. The rebuilding of her nation and the lives of its people was also getting underway. Costea was not expected to be relieved from active service until it was felt the country was more secure, especially in the Eastern reaches along the frontier border. Russian deserters were not anxious to return to their country in its state of revolution. They lived off the land until military units uprooted them and deported them back to Russia. Often they would not surrender. Returning to Russia was either

an instant death sentence or a ticket to a slave labor camp in Siberia. Just as often the Romanian troops did not offer them an option.

Sadly, upon her return Catherine found Granny exhausted and drawn. Her years had caught up to her, and her declining condition was exacerbated by the hardships of the occupation and the rigors of maintaining the orphanage facilities with few of the needed resources. Further stress was added by a crushing need for the orphanage to accept more children left parentless by the war. Granny graciously, but firmly, exhorted Catherine to leave the work at the orphanage to her and make new life with Costea. The young mother and wife must make a priority of her family first and the orphanage would get by without her. A new board for the foundation would be formulated once conditions returned to normal and order was restored. The operations of the orphanage could then be hired out. She would keep her pulse on things until then and make sure Catherine was kept informed.

Word finally came of Costea's discharge. Catherine and the children returned to the new Caradja estate in Nedelea anxious to finally occupy the home that was completed just as hostilities began. The greeting that awaited her from Costea was far less than Catherine had anticipated. The newly dubbed Florence Nightingale, heroine of his family's home region, received no accolades from her war weary officer and prince. Nearly four years of separation at the earliest stages of marriage and child rearing had created stiffness between Costea and his family. The children had naturally become very attached to their mother, and their father was as much a stranger as not. Besides Costea's skills were with the military, not with little children. He seemed very distant, preoccupied, and even uninterested in the children.

He once made the callous remark when Catherine asked him to spend more time with them, "They're just *girls* — I have nothing to teach them!"

It was like a dagger driven into Catherine's heart. She attributed his behavior to winding down from the ravages of war combined with the poor habit he had picked up in the military of drinking sizeable quantities of hard liquor in the late afternoon and on into the evening following supper. Undaunted and with infinite patience she tried to ease her family back together.

Costea was restless. The military remained in a state of readiness and Costea continued to serve as a reservist. As an officer he was called back regularly for a rotation with units on border patrols or for duty as a

field training officer with newly enlisted Cavalry units. Catherine sensed he was called back more frequently than other officers; but he always seemed most anxious before he left and was for a short while more relaxed when he returned home from duty.

Sadly the son, Costea, remained closer with his parents than the father and husband to his wife and daughters. He seemed more connected to the family from which he came and not the family he was creating. His parents permanently moved in to Catherine's home. Worse, Costea ate his meals with his parents while Catherine ate with the children. Costea excuse was that his father was a germ phobic man. The elder Caradja was fearful Catherine's bout with typhus might somehow pass the dreaded pestilence to his elderly parents. Besides, his young daughters were not yet ready to dine with adults. Catherine preferred to accept the typhus excuse over criticisms of the children's manners and training.

Unfortunately Costea's restlessness at home made it difficult for him to succeed in business endeavors. Over the ensuing several years just after the war Catherine financed one calamitous deal after another, all with the same devastating results. Partners often gave up on him after liquor driven quarrels. His lack of attention to business details caused his profits to be frittered away, stolen by employees, or wasted on poor judgments. Ultimately Costea had neither training nor interest in business affairs. He could not settle on anything that would hold his interest. Too plebian and boring he claimed, not the excitement of the military.

In one instance an estate was purchased by Catherine with an heirloom piece of her jewelry, a matched diamond necklace and broach. Catherine was called away to tend to affairs at the orphanage; and upon returning, discovered Costea had sold the land back to the Government. War veterans were being repaid for their service with land grants. Unfortunately, the land was purchased by the Government with bonds which later became worthless.

Later an American Motors dealership, which also sold appliances, was secured for Costea by Catherine. It soon became a worthless money pit as Costea was convinced by slick, fast talking, hard drinking company representatives to buy expensive luxury cars which looked beautiful but languished in showrooms without buyers.

In another failure in his gambit of ventures Costea then became interested in modernization of flour production. He bought — with Catherine's money — one of the finest, most expensive Swiss mills and set up business along the Danube River. The equipment worked wonderfully

and business was good; however, repayment was required to be in Swiss Francs, a not so small detail overlooked by Costea. Business was done with Romanian currency and the exchange rate eliminated any profit. A poor harvest after the first year did not allow the business to survive.

One defunct enterprise, however, did create a pleasant divergence for the family. After the war ended a number of antiquated sub-chaser cruisers was declared military surplus by the US Navy. Turkey secured twelve of the vessels and sold several off. Costea purchased one with the intention of using it in a business venture. Several Danish businessmen were intent on producing a fine quality paper made from the unique papyrus reeds found in the delta of the Danube where it poured out of Romania into the Black Sea. Costea saw great opportunity; however, this business venture was also short lived. The government sought to create a monopoly on the paper making industry and did not allow the new business to become a reality.

Catherine decided to keep the 80 foot boat for the recreational opportunities it provided her family. It was retrofitted into a river cruiser and the family spent many weeks cruising the deep blue Danube in a 500 HP diesel engine warship modified into a houseboat. Catherine christened the boat **Sospiro** a Turkish word for 'sigh'. It was also the name of the Cantacuzene oil company. In Grandfather's gentle self-deprecating sense of humor, his first oil well was not a gusher...so he named the ensuing company 'sigh'.

It was a blessing as well that Costea seemed more relaxed as they cruised the long meandering current of the Danube. Known as *The Highway of Races*, the river was the floating equivalent of the Orient express. It traversed the heart of Europe. The family cruised from Vienna to the Black Sea and followed the coast to Constanta, down to the Bulgarian coastal port of Varna, and finally all the way to Istanbul. It was a grand adventure for the two young daughters. Costea seemed more at peace on the boat and the setting was indeed enchanting.

The always resourceful Catherine used the river adventures as a commencement of her daughters' education as young princesses. It was something she had been deprived of herself. Museums of history, nature, and great works of art were observed in Vienna. Their own family history was revealed as they cruised past holdings of the Cantacuzene estates. The lore of their own country was retold from passages through the countryside as opposed to reading it from text books. There was settlement by Romans; the infiltration of Western Europe; the raids

by Vikings, Cossacks, and Huns; the introduction of gypsies; and the migration of Russians along the coast. It was the story of the land and the farmers, or the river people making a living from barges, fishing, and trading. It was all there in plain sight. Catherine also used a phrase of her Grandfather to describe Romania as, 'an island of Latin influence in a sea of barbarians'.

The flavor of local food on the waterway was tasted in the fowl that blackened the sky and then graced their table as they were bought at markets on the docks. The family also had the pleasure of varieties of fish and mussels bought fresh daily. Other delicacies sampled were the roe of sturgeon netted and milked of their eggs before being returned to the water. Fresh caviar so exceeded the saltier version preserved for transport.

Unfortunately Catherine suffered several more miscarriages, not uncommon in the times, but devastating personally nonetheless. One was particularly difficult, and Catherine continued to hemorrhage. It occurred while on one of the family's river excursions and the danger of infection was great so a doctor from a port town was called. They knew nothing of his qualifications. He asked if there was a 'poker' that could be found in the boathouse or on shore — the kind used for burning decorative designs in leather. Fortunately a leather crafter was found with the needed tool. It had a platinum tip which could hold a very high temperature. That craft tool became a life saving medical tool as the doctor used it to cauterize her uterus at the point of festering.

The process was not only painful to Catherine, but it could also have caused her an inability to bear children. That fear was overcome on April 6, 1920, when a third daughter, a miracle baby named Alexandra, was born aboard the **Sospiro**. The two older girls and Costea were all present for the birth. It was one of the tenderest moments the princess, having just turned twenty-seven, and her family would enjoy together.

As Catherine rested in bed with her new baby she took time to catch up on one of her favorite reading indulgences, **Readers Digest** magazines from America. She was fascinated with America and the little soft covered magazine gave Catherine a cross sectional snapshot of the faraway land of adventure and opportunity, of invention and industry, of liberty and freedom. Within its pages Catherine found a quote from the new American President, Warren G. Harding. "America's present need is not for heroics, but healings; not nostrums, but normalcy; not revolution but restoration; not surgery but serenity."

As she snuggled with the napping infant Alexandra, Catherine sighed and spoke to her child, "That is what I yearn for my dear... healing, restoration, serenity, and normalcy."

"It's time you took over the orphanage."

An exhausted Granny knew she could not continue at the helm. For all the years Catherine had known her dear Grandmother Cantacuzene, she had looked vibrant, strong, and healthy. She now appeared frail, even feeble. Catherine had been thinking about her increasing involvement and role with the orphanage, but Granny's pronouncement still caught her off-guard.

"Granny, you're right. Now is the time. I shall discuss this with Costea, and we can begin the transition," Catherine responded. She wondered quietly how she could handle the demands with two energetic youngsters and her third child still a nursing toddler. She would find a way for she had no choice. It was not so different than when she was called to set up the **Tirgu Hospital** during the war.

"The Board is in agreement," Granny continued. "You have been appointed as the Secretary General and the Treasurer. The staff has been informed. There is much to do, Catherine. The war has destroyed many families, and the demands on the orphanage are the greatest they have ever been. I am just too old now. Your vigor is needed."

With her usual command Catherine began immediately by doubling the workforce to speed the completion of the new addition for her family home at Nedelea. The small estate on a scenic bluff above the Prahova River would be the family's primary residence. It was located downstream on the same river that flowed below Zamora Castle, where Catherine and Costea had wed seven years earlier. The early years of the marriage just after the war, however, were spent mostly in Bucharest to accommodate Costea's attempts at providing for the family. Now the focus of their world must be Ploesti and the orphanage. Catherine thought to herself as she supervised finishing touches, that it seemed her life was constantly being flung to unforeseen fates, yet somehow seemed to come back full circle to familiar places from her life in Romania.

The orphanage's various buildings were bursting at the seams. There were always a number of unfortunate children in need of an orphanage; but that normal intake had been compounded by war deaths, births of

children conceived by occupying troops and by local troops having their way with young girls or fraternizing women. War was brutal in so many ways and so often it was innocents who suffered the most. Those innocents were now arriving in baskets, buckets, and wooden crates left on the doorsteps of **St. Catherine's Crib**. It was now the facility's namesake, Catherine, who would be in charge of those many waifs without parents or identity, so much as she once was herself.

As the need became obvious Catherine took immediate action, pulling the carpenters from her own nearly completed home and assigning them to finish the attic and basement of the original orphanage structure. The improvements were completed in two weeks and the results doubled the capacity from 100 to 200 babies. She then ordered the carpenters to move on to the old typhus quarantine building and convert it as well.

During the war the orphanage also took precautions to counter that scourge. The structure was to become the new infirmary and quarters for sick babies and toddlers. Catherine knew a more permanent building would be needed so she prepared to go before her board and inform the members of the need and projected costs. She had learned to be frugal and efficient in running a hospital facility during war-time, and those skills would be tested by the flood of refugees the war created. To extend the limited budget of the orphanage, she began strict measures to stretch the same amount of supplies to handle the burgeoning numbers of children the orphanage was receiving.

Always observant Catherine's keen eye for detail soon uncovered a cruel scam among the wet nurses serving the orphanage. The most efficient way to feed infants and the healthiest was to bring in nursing mothers and give them a fee to nurse an orphan as well as their own child. Catherine noticed some of the mothers had very fat and contented babies, while crying thin orphan babies suckled anxiously. Upon closer inspection she found the mothers cheating by holding a baby next to their breast but inserting a finger into the infant's mouth thus depriving it of the nourishing milk.

"Oh, what a shame is human nature!" Catherine thought to herself. "Some people will even cheat an innocent child for money!"

Eying a culprit Catherine's temper flared. She approached the cheating wet nurse and began boxing the young lady's ears until the cheater raised her hand from the baby's mouth to protect her ear thus exposing the ruse.

"Out you go!"

The other ladies in the room looked over in shock, several quickly removing hands from under cloths draped over the nursing babies. Catherine turned from her fleeing offender and looked at each of the remaining wet nurses. "From now on you will be assigned specific children and be paid by their weight gain! If you produce good milk you will be rewarded. If you are...'inefficient'... you will be replaced!"

Babies began to gain weight at remarkable rates.

In business dealings Catherine had learned to respect Americans at an early age under the guidance and tutelage of her grandfather. He had profited greatly with the establishment of his oil business under guidance and partnership with the Rockefellers. Catherine had also profited from oil lease contracts with American Standard Oil — the descendant oil monopoly of the Rockefellers. She used her contacts to secure surplus condensed milk and fruit for the orphanage and nursing supplies from the Red Cross.

Thankfully Catherine's personal life improved as well. As Granny taught her — if you are busy, your troubles will find a way to disappear — or at least fade into the background. The additions on the house at Nedelea eventually were completed. Catherine's children accompanied her to the orphanage daily. Catherine multi-tasked providing lessons and play for her children and the orphans, running the expanding orphanage, and overseeing the businesses of her inheritance along with the farms and oil business. Like their mother the children were very bright and good students.

One transition of the family was never successful — that of a husband and father. It was not without a great investment of time, patience, and personal financial resources which Catherine placed in Costea; but there was never any resolution or acceptance of a family or private life. It seemed that he was never completely happy out of uniform. At last it was agreed by the couple that Costea would abandon his business ventures and return to active military duty. It would be better for him to visit occasionally and be happy than to live under the same roof and be continuously miserable.

Despite the contention and turmoil of rebuilding a life after the war, Catherine found a bonus — a small silver lining. She came across an officer parking a huge touring car and went over to inspect the vehicle more closely and was both surprised and amused recognizing several dents in the Hotckiss from her first days as a bride. It was her honeymoon gift car that had been surrendered for the war effort!

The dents were from the ill-fated attempt to cross the river when the car became hung up on rocks. At the beginning of the war when Catherine chose to leave Bucharest with her children, she reluctantly turned the car over to the military. It was the sensible as well as patriotic thing to do. She certainly would not be doing any touring during the conflict and fuel was scarce in any event. Still holding the papers allowing her to reclaim the car, it was well used and some might say amply abused. Serving as an ambulance during the war it was so beaten that it would no longer serve as a luxury car. Catherine had the orphanage handyman make repairs and the vehicle became quite serviceable as transportation, doubling as a bus to transport orphans, or a lorry to transport goods.

<p align="center">*******</p>

At Catherine's insistence her dear Granny did not return to Bucharest, but remained near-by. Having moved from the orphanage to the Castle at Zamora, she seemed to lose her appetite as well as her enthusiasm for life. One evening she caught a cold sitting in the garden. It quickly turned to pneumonia. Catherine received a call to bring oxygen from the medical supplies at **St. Catherine's Crib** arriving to find Granny alert and happy to see her granddaughter. The quickly fading matriarch had soup and chatted with her granddaughter into the evening until she began to slip into brief naps. She asked Catherine to tuck her in for the night and pulled her granddaughter close.

In labored short breaths of broken sentences, Granny uttered, "My dearest Catherine... you have been... a blessing to your Grandfather and me.... You eased the burden... of our pain... from the loss of our daughter, Irene... And I know.... we helped you bridge the gap... of the loss of the mother... you never had... The orphanage... it is what ties the three of us... together."

She smiled weakly and Catherine hugged her grandmother and wept as Grandmother Cantacuzene passed away in her sleep that evening the once lost child at her bedside. Catherine could bear her grief knowing that Granny would be joining their beloved Grandpapa.

Granny was buried in the family crypt in the chapel at Bucharest next to Grandpapa. As she laid her grandmother to her final rest, Catherine realized she was putting way the last direct link to her own mother. Granny was right, the orphanage, **St. Catherine's Crib**, was now the common thread woven among the three generations of women.

As Catherine laid a white rose on her grandfather and grandmother's

sepulcher, she thought, "There is to be no normalcy in this life of mine. I just move from one turn in the road to the next. I can still see that lorry driver, Pierre, 'May there be a road'...Yes, little could I imagine! There must always be a road to move forward on, but must it be so filled with twists and turns and potholes?"

As she turned to leave the church Catherine looked up to the stained glass windows and saw the familiar image of Mary on a donkey with the infant Jesus in her arms. She thought, "So I will carry on... down whatever the road ahead shall bring... wherever that road may lead. Now I will use Granny's example and overcome the grief by throwing myself into work."

The work would fittingly be with the orphanage, keeping true her mother's tribute to a lost daughter. An orphan who was able to returned home to tend to others who had lost their mothers.

Orphans create special problems for their caregivers. Once they reach the toddler stage if not adopted they almost always become permanent wards, living out their childhood and adolescence in institutions. Catherine had seen it in her own childhood and saw it again as the leader of a large institution for orphans. Regardless of the care given, from the orphan's viewpoint, the emptiness, the aloneness, the sense of being forlorn persisted. The result — feeling as though one is on the outside looking in, always hoping for a family and a happy ending — almost always being denied.

It was with solemn understanding Catherine knew what the fate of most of her charges would be. It would not be with a dramatic life changing escape from the orphanage she herself had enjoyed... most orphans do not end up as a princess. Catherine knew she had been very lucky and unique. She also knew she must try to make the lives of those who were not adopted to have hope, even though they were without the benefit of family. They would have a life in which someone genuinely cared for children. Catherine would provide more than a roof, clothing and meals for she would create hope, a future and teach them the ways of the world. That was to be the focus of her leadership of the **St. Catherine's Crib** facilities.

With her own life serving as a catalyst for change, Catherine was determined to create a support system to carry orphans to adulthood. She began to study foster homes. It would be a way to give orphans a chance

for a place outside an institution with a home-like atmosphere. Research uncovered an international organization with a world view of orphans.

The Save the Children Federation was based in Geneva, Switzerland, and had created a foster home plan for older children. Catherine enrolled in classes wanting to learn what others knew about long term custodianship of orphans. The foster program allowed families to take in older children and let them share in a family environment without the commitment of adoption. A key to the program in America was the stipend the government agreed to pay foster parents. Because of the difficult economic times following the war, Catherine would have many families to choose from who genuinely needed the money. The trick would be to find the homes where the child would be accepted and not just viewed as cheap labor or a stipend. She could pick the best applicant families for her orphans.

In a shrewd move Catherine focused on finding homes from communities close to the orphanage. She felt there would be the need for follow up and on-going support of the orphans and the foster families. Catherine took the view that they were all her extended family. Within a year 200 children had been placed with local families near the main facility in Ploesti. The program experienced great success and it created more bed space in the orphanage for the seemingly endless supply of orphaned children.

Even with extensive placements into foster homes the orphanage was still pressed with more children than it had space. New buildings would be needed. There was also an ongoing need to formally educate the children. Catherine used personal funds to build a grade school and high school. The children from the foster homes were transported to and from by buses. **St. Catherine's Crib** began to achieve worldwide notoriety for its successes. A wealthy lady from America had been born in Romania and left an endowment in her will to help Romanian orphans. Catherine was notified of the endowment and immediately began to prepare a petition for **St. Catherine's Crib** to receive the money.

With an eye toward the best care possible Catherine had been building the facilities and the reputation of the orphanage for a decade. Its foster program was being held up as an example throughout Europe. Her orphans were being sought out as desirable workers upon matriculation as young adults for all the excellent schooling and vocational training they received at **St. Catherine's Crib.** Catherine was well prepared to make her case when she was called to London by representatives of the endowment.

It seemed like the blink of an eye, but the years since the war passed rapidly and Catherine's own family had grown up as well. The eldest daughter, Irene had recently passed her college law exams and was about to become a lawyer. She had found a young lad in college who seemed a perfect match. Upon graduation they planned to become husband and wife. The middle daughter Manina was preparing to enter college in the coming fall. Young Alexandra 'Tanda' was a bundle of energy and hormones as she entered her teen years.

Nearly completely removed from his family Costea was fully involved in military life as a Colonel in the Romanian Cavalry and seemed to enjoy his service. He had missed so much of his children growing up. Perhaps he resented not having a son to follow his footsteps — though Catherine doubted he would have changed his ways. Costea still seemed more strongly attached to his old family, his parents and siblings than his own. He rotated leaves between Nedelea and the orphanage, and his parents' estate in Grumayesti. His only passing interest in the orphanage came each summer when Catherine prevailed upon him to conduct cavalry drills on the grounds and followed it with a course in horsemanship for the orphans. The orphans were allowed to ride upon the huge beautiful military horses or in a caisson if they were too young to mount a horse.

In a lovely divergence from her work Catherine took Irene with her to Paris and London when she was called to interview for the endowment. Catherine smiled as Irene danced through the many dress stores trying on clothes she would need as a barrister. Catherine was reminded of the grand adventure of her first shopping trip with Granny shortly after being reunited with her Romanian family. Memories of her dear grandmother flooded her thoughts. Catherine pretended to look for some dresses for herself — an excuse to turn away and hide her tears. The two younger daughters were spending a holiday at the Caradja estate, the home of Costea's parents which had also been the children's home during the war.

When they arrived in London Catherine and Irene went sightseeing for a couple of days prior to the meeting with the Warden family lawyers. Later she answered a battery of questions from the estate's representatives over a day-long interview process. Catherine felt well satisfied by her representation of **St. Catherine's Crib** and its innovative programs. She could only wait to hear if the endowment would come to her.

The trip ended with the long ride on the Orient Express. Catherine

and Irene returned to Grumayesti to gather the two younger daughters. When they arrived, Manina was feverish and very lethargic with a severe sore throat. Catherine left her other two daughters with their paternal grandparents and took her middle child to a doctor who confirmed strep throat. He examined the throat and recommended a specialist in Vienna, Austria. Catherine and Manina went immediately by train. The doctor there confirmed the staff infection was traveling through the child's bloodstream. He recommended a stay in a sanitarium. Unfortunately, after a short rally, Manina weakened. The doctors there suggested they could only make the younger girl comfortable. Manina understood and asked to return to her home in Nedelea.

In a nostalgic mood Catherine and Manina took a lovely boat ride home on the Danube. They shared reminiscences of the early cruises on the family boat **Sospiro** as a young family. Catherine laughed often and was very animated. Poor Manina continued to weaken, but smiled most of the trip home. She enjoyed a final week in the home she loved and passed just 3 days shy of her seventeenth birthday surrounded by her mother, father, and sisters.

The loss was excruciating for the entire family. Costea left for his unit the day after the funeral. At her daughter's request, the burial was in a plot of land within the family flower garden that over looked the river. It was there she had spent so many fun filled hours with her mother and sisters. Catherine wondered how she would cope with her daughter's premature death. Her answer came by special delivery that afternoon. The telegram read: *THE CHASE MANHATTAN BANK, US, IS PLEASED TO ANNOUNCE ST. CATHERINE'S CRIB, ROM. IS THE RECIPIENT OF THE CECILIA NELSON WARDEN ENDOWMENT.*

A new dormitory — **WARDEN HALL** — could now be built. More children would be admitted to the orphanage. A needed addition would be added to the elementary school. Catherine would cope with her grief by being busy.

A view of the Nedelia Estate from the Prohova River

Princess Catherine standing with her family in festival costume. Prince Constantine (Costea), Mania, Tanada, Princess Catherine, Irene

Adopted Polish Countess Kinia-age about 9

Two of twelve orphanage pavillions built in St. Catherine's Crib in Ploesti

CHAPTER 15

The Gathering Storm

Sometimes it seems as if nothing comes easily. The money from the Warden Endowment was to be deposited in the National Bank of Romania. However, even though the money was clearly designated for use by the orphanage, Catherine had reservations. The money was represented by American dollars, the most valuable commodity available. The government was still suffering from the impact of the war. It had blatantly confiscated money within its institutions, 'for the public good'. Fortunately, Catherine was aware of the potential for governmental meddling and interceded, insisting that the money be converted to Bearer Bonds with the endowment remaining in the American institution from which it had transferred which was the Chase National Bank branch in Paris.

The President of the National Bank in Bucharest was furious! He pressed criminal charges against Catherine for interference. Clearly by his actions Catherine's suspicions were well founded. She pressed her friend the Attorney General who had been a strong supporter of the orphanage. Catherine had learned well from her Grandfather that you cultivate relationships in the right places! But this time it seemed to be of no avail.

"Princess Catherine I am so sorry." The Attorney General pleaded, "I can designate proceeds from criminal activities to the benefit of your charity, but I cannot overrule this action."

"I will get that full endowment for the orphanage — even if I go to prison! Surely, we must have recourse!" Catherine countered as she paced in front of the country's top legal officer.

He watched her stomp back and forth as she made her case and knew of her determination. He also knew she would not leave his office without

something for her cause — he had been subjected to her fundraising efforts in the past.

"Might I make a suggestion? You are a persuasive communicator." Catherine paused to listen, "May I make an appointment for you — today — with the publisher of our largest newspaper? He is a friend of mine and is always looking for a good story. I will leave it at an introduction — and you, Princess, can fill in the details!'"

Catherine struck out her hand and with a big smile pumped the man's hand firmly — as Grandpapa had taught her. The persistence she displayed was something she had developed from within... a trait others less kind would refer to as stubbornness. Catherine left the Attorney General's office and headed directly to the newspaper publishers office.

The next morning the phone rang in the office of **St. Catherine's Crib**. It was the Attorney General. "Yes, this is she," Catherine spoke into the phone. "No, I haven't received the morning edition," A broad smile broke across Catherine's face. "Let me repeat that... *National Bank to Confiscate Funds for Orphans...* that's the headline? Then it reads... *Instead of chasing corruption, the National Bank is robbing orphans!* Oh, how simply tantalizing! Yes, and what? There's a cartoon of the bank president as well? The front page headline! It seems your editor acquaintance took my story to heart. Well yes, I guess I did get his attention... Thank you once again! No, that doesn't get you off the hook. I'll see you this fall for our annual fundraiser, but I do sincerely appreciate all that you've done. Good day!"

As Catherine hung up the phone she knew she would be able to move forward with her plans for **St. Catherine's Crib.**

The National Bank was not heard from again. The endowment funds were transferred to Catherine's bank of choice and were quickly leveraged. Learning from her Grandpapa, Catherine knew the value of leverage when secured by real estate, and she also knew that she could make a much better return than the bank offered. She purchased several apartments and commercial properties from the endowment. The cash earnings would provide operational funds for the orphanage in perpetuity. She then collateralized the property and secured funds to build the benefactor's dormitory for female infants, the **Cecilia Warden Hall.**

Capitalizing on the activity of new construction Catherine launched a building drive with the aim of completing her mother's original dream

of six pavilions to house children. To begin the drive Catherine used the inherited sapphires from her mother as collateral for funds to begin construction of the buildings. Catherine had found from past experience it was much easier to raise funds to complete a building then to get one started. She also knew how to borrow ideas. Ego can be dangerous, but it is a wonderful tool for charities. Catherine used the example of the Warden Fund and the building named in the donor's honor to find a name for each of her six pavilions. By 1936 Catherine had been running the orphanage for fifteen years and had completed the twelve building campus her mother had envisioned. Furthermore, she had also increased the families involved in the foster care program to include the twelve surrounding communities. Schools had been built in three locations, and the foster children were bussed daily to school. All this stemmed from the impetus of the Cecilia Warden Endowment and Catherine's efforts to keep it out of the National Bank

Thinking back to her early life as an orphan Catherine remembered how she had been intrigued by what she saw and was guided into learning from a nun in a barn. Perhaps that was a good way to motivate other youngsters into learning — especially if they were not skilled at reading from a textbook. Incorporating field trips to her farms, oil operations, and property holdings in Bucharest became a regular part of the orphans 'real' education... learn by seeing and by doing was the mantra.

The children learned about life, jobs, businesses, governments, and foreign countries through such trips — often led by Catherine herself. She strove to impart the wisdom and ways of life as she had learned from her grandfather, grandmother, her tutor and her own breadth of experience. The orphans had no parents to pass along such knowledge, yet such was a critical part of Catherine's own education. She did not want the orphans to matriculate into society without such exposure. In the universe of orphan care Catherine was breaking new ground and continued to attract the attention of other similar institutions from around the world.

The orphans themselves inspired the concept that brought **St. Catherine's Crib** to its next level — to a level that actually elevated the institution to a pinnacle of study and emulation worldwide. The orphans expressed interest in different occupations or trades. Catherine began to consider the concept of training some of the children from the age of twelve in the different trades in which they had expressed interest. She had the perfect laboratory for such an undertaking. With the vast acreage she owned near the campus there were skilled workers

in livery, mechanics, animal husbandry, agriculture milling, carpentry, maintenance, plumbing, and electrical. In operating the orphanage she had needs in seamstresses, cobbling, child care, infirmary, cooking, secretarial, furniture making, embroidery, silk spinning, locksmiths, vegetable gardening, and administration.

Catherine allowed the children that were of age to intern in a number of various areas for several weeks and then choose one suitable to the child's skills, and of their liking. When they selected a position Catherine provided them with a stipend, part of which was reserved for when the child left at eighteen, so they would have a fund from which they could begin their new life outside the orphanage. The remainder they could spend as a personal allowance under the guidelines of a personal budget that was reviewed by orphanage staff, thereby teaching the children another important life skill of managing their money.

Soon Catherine found when her orphans were old enough to go out on their own they were being sought after as employees as a result of their training. Many orphans returned to Catherine to thank her for giving them skills that helped them secure good jobs and advance rapidly. Catherine began to implement a two track program. One contained more rigorous studies for children who would be college bound. The other placed the children in an occupational training track fully monitored and similar to formal apprenticeships. Many college-bound children could also enter the vocational program to earn the money and to become exposed to occupations in the event they did not succeed at college.

From an operational perspective the vocational program resulted in fiscal and administrative efficiencies that enabled the orphanage to expand without requiring more staff or added expenses. **St. Catherine's Crib** saw a constant parade of orphanage administrators from Europe, the United States and Canada. The self-sufficiency with which Catherine operated the orphanage was envied by most of the observers. Catherine, however, knew it was the only way she could maintain a facility with 3,000 children during the increasingly uncertain times of runaway inflation plaguing post war Europe. The Great Depression in America also weakened the economy of Europe.

After WWI countries adopted an economic nationalism in which they raised tariffs and created trade barriers intent on keeping other countries from selling goods in their country. Retaliation, however, meant a country could not sell its surplus products outside their own country. As trade slowed, so did work. Further complicating the situation was the great

economic engine, the United States. As the largest consuming nation with the strongest currency, America demanded payment in dollars. However, their trade policies made it near impossible to sell foreign goods in America, thereby drying up the sources of dollars. It was a vicious circle. Isolationism was not healthy for the world's economy.

As the economic situation worsened Catherine was so happy she had taken the Warden endowment in bonds instead of dollars, for the pressure to confiscate the dollars would have likely led to the orphanage being deprived of those funds. Now, the self-sufficiency of her operation was unaffected by world matters. Catherine personally remained in good economic stead as oil was a commodity in need throughout Europe and was impacted little by trade policies. Her leases were with American Standard Oil, and Catherine adroitly played turnaround with the American company. Her leases required payment in U.S. dollars. She had no worries financially.

On the political side Catherine had big worries. The harsh economic times caused fascist dictatorships to rise in Spain, Germany, and Italy to the west. At the opposite end of the spectrum, and on her Eastern flanks lay the ominous bear, Russia, now deeply in its Communist Revolution with a cutthroat dictatorship 'for the people' by the butcher Stalin. It was rumored that he had been killing millions of his own countrymen.

As a political philosophy Catherine did not like extremes at either end. She had learned the more fanatical the politico, the less room there was for discussion, compromises, and essential freedom of expression. As tolerance waned all freedoms vanished for the 'cause' — be it left or right. She felt Eastern Europe was kindling tender on a powder keg much as it had been prior to WWI. The dictators built huge armies to intimidate and control their own populations and their neighbors. Soon their zealot fever would breed contempt for others and a sense of superiority. Perhaps as a summer tempest mounts rolling gray storm clouds, a breeze from another direction could dissipate the angry skies and sunshine would return. So it was Catherine's hope and prayer it would be for the nations of the world.

Irene, Catherine's eldest daughter, the lawyer, had also moved forward in her relationship with her beau Titel. Soon Catherine was happily involved in preparing for a royal wedding. Over 500 guests attended and as a special treat for the happy mother, Irene wore Catherine's wedding

gown and her grandmother's River of Pearls necklace. For Catherine, the special day was a natural progression through her own circle of life. The wearing of her dress was special because she had bought it on a trip with her Granny. Catherine chose to pass on the necklace inherited from her mother, and now she passed it on to the next generation. Fittingly it was given to Irene the namesake of the mother Catherine never knew yet loved in her memory. Irene's new husband Titel was from a far northern province of Bessarabia in Moldavia. His family had large land holdings there and was well regarded. The couple's deep affection was obvious from the attention they paid each other. Catherine hoped their hand holding and common laughter would bode better for them than her more formal courtship and long separations from Costea — created by military necessity and by now she knew by his design. Catherine had grown into an uncomfortable acceptance of Costea's dalliances while on 'maneuvers', and of his kept women near the barracks. She had refocused her love toward her children and her mother's **St. Catherine's Crib** which was wholly in her mother's memory, but now in totality, was in Catherine's image.

As events in the world unfolded, Catherine was not able to isolate **St. Catherine's Crib**. In fact it had become a beacon because of its renowned reputation. As Hitler moved into Austria, Czechoslovakia, and Poland, refugees fled and hundreds of orphans were streaming into Romania seeking shelter from the gathering storm all knew was coming. As it turned out there was one special orphan. Catherine received a call from the Polish Embassy in Bucharest. There was a six year old girl — a Polish countess whose parents had been murdered. The young girl had been spared by her mother's quick action in placing the child into a hidden wall compartment with a teddy bear to calm her. The poor girl came out of the hideaway when all the noise and commotion in the house subsided. She was found by a neighbor sitting in a pool of her parents' blood, their lifeless bodies on either side of the weeping confused child. The ambassador reported the details himself to Catherine noting further, that on several occasions, the girl had been tossed into roadside ditches to avoid the murderous hail of machine gun fire as the caravan of refugees was strafed by German Stuka dive bombers. The child was on the verge of collapse. Would Catherine help?

Without a second thought Catherine agreed to house the Polish girl, but upon seeing the poor child's confusion and anguish she went the extra step. Though Catherine could not legally do so, for all practical

purposes the young girl named Kinia was adopted into the Caradja family as Catherine personally took in the orphan. Kinia traveled constantly with Catherine. She was a joy for Tanda and Irene. She loved the country estate in Nedelea and looked forward to her daily adventures with Catherine at **St. Catherine's Crib** or making the rounds of the estates.

Kinia was resilient and in such a loving environment quickly recovered from the shock of her parents' deaths, the terror of the refugee journey, and the strain of arriving in a strange country with a different language and new home. The young girl created a sense of déjà vu for Catherine, their childhood experiences being so parallel and fraught with trauma and turmoil. Soon the young girl was acting as any carefree six years old would. She was cheery and a blessing to the Caradja household still suffering itself from the death of Manina.

For Catherine the orphaned Polish girl was just what the doctor ordered. The last of her own daughters, Tanda was preparing to move out of the family nest and into Bucharest to pursue her furthering education, and Catherine's mothering instincts were reborn with her new charge. Though Catherine was never one to mire herself in pity or depression, having Kinia added a new zest to her life; and it certainly helped to take local political events and uncertainty off her mind.

King Carol II implemented a regime of royal dictatorship and was becoming as ruthless as the dictators on the east and west of Romania. His mother Queen Marie was a cherished woman in Romania and was a bit of a harness on her son. When she died in 1938 **St. Catherine's Crib** lost a vocal supporter, and the King lost his good conscience. King Carol II appointed a Fascist as Prime Minister even though only nine percent of the country had voted for its National Christian Party. Perhaps the royal family's ties to Germany were influencing the king's thinking. He also supported the Iron Guard, a group of thugs and hoodlums not too dissimilar to Hitler's Nazi Brown Shirts.

The Iron Guard turned out to be the King's undoing, however, as they soon worked to unseat him. King Carol II sought to appease them by giving up large tracts of Romania – Bessarabia to Russia and Transylvania to Hungary. The population went into an uproar, and the Iron Guard seized the moment demanding the King's throne or his head! The King fled the country by train and barely escaped a plot of assassination. It was foiled by a station master who refused to alter the train's tracks to lead it to a siding where the assassination was to be carried out. The heroic station master paid for his act of loyalty and bravery with his life.

Amidst this political turmoil, the Army was called up. Costea was already on active duty and was deployed to the eastern frontiers of the country. Irene's husband Titel was called up as well. He was stationed in Moldavia near his homeland of Bessarabia which was no longer a part of Romania. Titel's commander allowed the newlyweds to live off base, and Irene immediately joined him as they settled into a hotel.

Sadly Irene had only been with Titel for two days when tragedy struck. A damaging earthquake shook Moldavia. Titel and Irene rushed from the building to the safety of the streets only to be crushed when the hotel's façade collapsed on them.

By telephone Catherine received the devastating news from Costea. Titel's commandant knew of Costea's relationship with the deceased junior officer and called him directly. Costea left for the ruins that day. Upon confirming their identities he brought the bodies home to Nedelea. They were buried in the garden next to Manina.

The shock and numbing hurt were difficult to bear. Little Kinia understood death from her own brief existence. She was able to provide Catherine a release from the devastating deaths and give the grieving mother hope for life. It was Kinia who the mourning Catherine would use to fill her emotional void. The two became as one when Tanda, the last daughter, left the countryside home for her new life in Bucharest. Catherine would again lose her own sorrow by providing for others, the orphans and Kinia. She knew that just ahead, events of the world would overtake any plans for the future. The future was about to be put on hold.

CHAPTER 16

The Glory Is in the Cause... Not the Fight!

There was little time for mourning. Catherine's heart was heavy with grief, but thankfully, she had much work to do. The orphanage had grown to 1,000 babies, and nearly 2,000 children spread around the twelve villages of the **St. Catherine's Crib** orphanage system. The campus itself housed another 1,000 children that were not placed in the foster program. Kinia as Catherine's personal orphan was joyful company and she kept her close at hand.

As her plan evolved into a reality Catherine's transition of the orphanage to training and vocational facilities was paying big dividends. The turmoil and economic depression in Europe was creating shortages of supplies and donations. Fundraising had become nearly non-existent. Hitler's occupation of Poland, Austria and Czechoslovakia created great demands for **St. Catherine's Crib** to accept orphans from those countries as well. It was a world in the outset of war... and orphans were universally the victims. Catherine knew she needed to find a way to accommodate more children.

Suddenly the war took on a different complexion for Romania. Hitler renounced his alliance with Stalin and began amassing troops in the western regions of the Romanian countryside in preparation of an invasion of the vast steppes of Russia. Romania had long coveted a return of territories lost to Russia at the Treaty of Versailles at the close of WWI. The King declared war against Russia and allied with Germany to retake Bessarabia. Though not declaring war with England or France — those actions placed Romania on the side of the Germans. The Romanian people had no liking of Hitler nor his Nazi regime, yet the retaking of the homeland justified the action. Most Romanians did welcomed Germany as the only power the keep the hated Red hordes of Russia off its lands. Germany was viewed

technically as a protector not ally. However, that was not how the French and English viewed things. Romania was viewed as part of the Axis.

The Germans also had other plans for Romania. The political setting became more sanguine. The goon squads and Iron Guard were eliminated now that the Nazis were in control. Their function of disruption and destabilization were no longer needed now that Germany occupied and controlled the country and its government. Hitler had gained Romania without having to fire a single salvo to conquer it. His desire to gain access to its resources of oil, grain, and men was met.

Soon hundreds of thousands of goose-stepping German soldiers marched through the country as it became a staging area for the assault into Russia. Romanian assets were 'taken' for the war effort. When the Blitzkrieg of Russia began, Romanian troops filled the front ranks. As the war effort continued the Germans 'traded' for war materials. The copper roof at Zamora Castle was traded for tar-paper. The Castle was doomed to ruin.

As the harvests came in Catherine hesitated to take all of her estates' crops to market. It was at the markets where the German Army controlled the trade. Quantities of the produce were directly consumed by the orphanage; the grains went to storage for grinding flour and processing by orphanage mills to be used by the orphanage bakeries. Dairy, poultry, and meat were also consumed.

It did not take Catherine long to figure out the exchange of goods for German marks was definitely a one-sided transaction and ordered that surplus production no longer be sent to market in its entirety. Certainly cash was needed to operate the farms and orphanage, and she did not want to cut off the Nazi trade altogether. That might cause suspicion and lead to Nazi monitoring at the farms. Instead, Catherine quietly siphoned off surpluses and kept them from going to market. A bartering program was instituted with her employees and the peasants in the twelve villages where she had established her foster care facilities. If she was going to give her estates' production away, it would be to her own loyal people — on her terms and not to the Nazi Army.

Soon workers were taking workhorses home to care for instead of leaving them at the farm. However, one of the three bags of feed for the horses was instead filled with flour, produce or meat. A new enterprise was established for vocational training. Smoking, salting, and curing of meats and the creation of sausage processing, replaced selling the farm animals for fresh meat. This allowed for a greater amount of meat to be

distributed to the local populace and to be stored for use at the orphanage facilities since there was little refrigeration available for fresh meat. The encased sausage was much easier to stash away into secret hiding places as well. Cheese production from dairies increased dramatically. The cheese rounds had a much longer shelf life and were also easier to hide away. A new facility was established for canning produce, and grain fields were changed over from wheat to consumable crops of produce. Catherine's subtle defiance and 'cheating' the Nazi at their own game made her a very popular local hero.

Frequently Catherine was driven on rounds of her estates, and Kinia, naturally, was at her guardian's hip, hanging over the side of the open touring car, waving at most of the people they passed. She always took time to point out items of interest, whether on historical facts, geographic formation, or suggestions as to how a farmer might make better use of his land. Catherine's own daughters grew up in a less arduous time and had each other for company on the tours, so they did not seem to have as great an interest in their mother's tutoring. Kinia attention, however, was totally focused, and she seemed to hang on every word Catherine uttered. The rounds on this day included the oil production facilities and the refineries. Standard Oil had been replaced by German technicians under the supervision of the Nazis, who themselves were under supervision of the black coated SS. Catherine came to express her concern over the apparent dramatic decrease in oil production reported to her.

Her driver was once a peasant laborer named Nicholas. He had injured an arm in a fall and was not able to do the heavy lifting required in a farming estate. His familiarity with mechanics was an added bonus in Catherine's mind when she 'promoted' him to chauffeur instead of asking the otherwise vital man to languish as a pensioner. Her car pulled to a stop at the gated entrance of one of her own refinery facilities. She was not allowed to enter. Instead she paced outside the guard house for thirty minutes until an open-top Mercedes pulled up. It was driven by a German soldier; and the back seat contained a suited man in spectacles, a middle aged German Army Colonel, and a rather stony-faced young SS Captain.

"Good morning, Madame." the German officer started, in his most charming, Aryan manner. "I am Colonel Schmiedeskamp."

Catherine deflected the charm immediately — she was mad. She had been purposely kept waiting outside of a facility processing crude under

173

one of her own leases! *"It's Princess Catherine.* And your manners at keeping me waiting belie the courtesy I should expect from your *superior* breeding!"

Catherine's response in clear fluent German dialogue surprised the officers as did her fury. Her sarcasm had matched his charm, and he was offended, yet continued to put on a good front.

"Our apologies... *Princess Catherine.* An unexpected call from Berlin delayed us... Most unfortunate. You had called with regard to production, I believe?"

The questions would be asked though Catherine knew she would get no real answers. She would not stand by idle as her primary source of funds for the orphanages was stolen from her. "It appears from the statements you have submitted that my oil wells are only producing half of what they did a year ago! Yet you seem to be working around the clock with many more workers than Standard Oil used! What happened to German efficiency! It's bad enough I must now trade in marks instead of dollars, now you strangle me further with ridiculous numbers!"

Even the SS officer had a look of shock on his face — he was not used to anyone confronting a German officer or especially an SS officer. His black-suited presence was meant to be one of intimidation and he interrupted. "Pardon me, Princess Catherine. I am Captain Fredriche... of the SS." He paused for effect with a smug grin crossing his face.

Catherine shot back immediately, "Pleased to meet you, *Captain,* but I am speaking with your *superior* officer." Catherine was far from naive about the SS, but she enjoyed rattling the cocky young Aryan snob of smallish stature.

His eyes widened at her brash remark. "Princess Catherine!"... He paused again for effect, then speaking through clenched teeth and a scowl that tried to hide his rage, Captain Fredriche provided a lesson in German etiquette. "An officer of *any* rank in the SS is superior to an officer of the German Army — even a Field Marshal. Now let me tell you..."

He stopped abruptly as Catherine turned her back on him in midsentence and walked back to her car, but did not get in; instead she casually sat down on the running board of her own car. Before sitting, she noticed Nicholas seemed to be sweating profusely beneath his cap and was looking straight in front of the car, his hands turning white from their tight grip of the steering wheel. He indeed had been intimidated by the SS officer. Kinia sat politely in the back seat, though her eyes were focused squarely on her guardian and seemed to be enjoying the act before her.

Catherine winked reassuringly at the young girl just before she turned around to sit down.

She adjusted her dress, demurely crossed her legs, and offered in almost a light hearted fashion, "Oh, excuse me. I was tired of standing... during my long wait. *And* you were saying? Oh yes, I remember. Your *rank?* Let me assure you, in Romania, in *my country...* I outrank you both." At first, as she talked, she glared menacingly at the men before her, and then at her conclusion she provided a very false and brief polite smile to the Germans as her words sank in to their stunned silence.

Col. Schmiedeskamp was indeed a gentleman by birth and training. He quickly assessed this woman was not going to be intimidated by himself, nor, especially, the SS officer with whom she seemed to be playing a daring game which could have a dangerous outcome though he wasn't sure at this point who was at the most risk. He stood from the backseat and quickly interceded before S.S. Captain Fredriche had apoplexy on the spot. In the kindest diction he could muster, he spoke as he stood and left the car to address the princess in a more cordial and personal fashion. He began with a polite bow.

"Princess Catherine, please forgive us. We spend so much of our day dealing with men of the military we forget how to act with a lady, especially one of your stature. Mr. Reinhard here is from our department of geology and oil production... at the University of Hamburg. He has the answers you seek. May he?"

Catherine looked at the meek man who had been sitting between the two officers and motioned him forward with her right hand. "I am all ears," she said, knowing she was about to hear all lies.

Mr. Reinhard cleared his throat as he stepped down from the car; and though he clicked his heels in good subservient German style, he also bowed slightly to the Princess. "We have studied the oil reserves of this area and have determined that this is a finite resource that we do not wish to deplete for strategic purposes. We have actually decreased our pumping. The added activity you note is twofold. First we are upgrading the American equipment to more efficient German technology. Second, much of this activity is for defensive purposes... to protect the... *your* facilities."

Reinhard bowed again, indicating he was through. Catherine held out her hand, and Col. Schmiedeskamp immediately reached for it and helped her up from the running board. She looked contemplative, folding her arms and putting her left hand to her chin. After a moment of reflection Catherine began.

"Gentlemen, you have replaced many of my employees with your military men. Let me make a suggestion... if I may. My people are much better at operating this equipment; they've been doing it for years. Your men are soldiers — let them do what they are trained to do and let ours do the same. Your army is then better off, and my people are employed. I think I will also have a better feel of what your reports are saying is true... if it is my people who are involved in the production process."

Since the German 'accommodation' had been in place Catherine knew that many of her people had been replaced by Germans, and also knew that if rehired they would be under threat of losing their jobs, even their lives, to tell Catherine other than what the Germans wished her to know. In fact she would not even put them in jeopardy by asking any questions. It was understood it was a game of charades she was playing with the Germans, and she knew she would be cheated by them. But, she also felt the Germans would play the game with her and re-employ the local workers giving them valuable jobs and income in difficult times. The Germans would do this to add a façade of legitimacy to their production numbers and to get this determined woman off their backs. It was a win for her workers, a win for the Germans — a win for Catherine, and — if nothing else — she enjoyed watching the face of SS Captain Fredricke as a result of the exchange.

Col. Schmedeskamp huddled with the indignant S.S. officer and Reinhard. Rinehart shrugged and then acknowledged with an affirmative nod. Captain Fredricke's eyes at first widen at the proposal, but then gave a curt nod to conclude the conversation. What she had requested would be done. Her logic could not be denied by the German triumvirate. It was a good deal, for both sides... as her Grandpapa taught her.

Tanda, Catherine's youngest and sole surviving daughter, had been living in Bucharest, enjoying the life of a student and socialite for several years. She had found an acceptable suitor, the son of a prominent business-man who owned a brewery and factory for food processing. Tanda married Demiter Bragadira in a wedding that was as grand as the war times could allow.

Five hundred guests attended, and the occasion was made even more festive by the twelve suckling pigs smuggled into the reception by orphans. Indeed, Catherine had organized various troupes of orphans, one from each of the villages with families that cared for the foster children. They performed at major events, helping raise funds for the orphanage and

teaching the children native folk songs, dances, and traditions. They had grand costumes and accessories. Each troupe found room in their duffle bags of costumes to conceal one of the small roasted pigs. The smuggled pork was the biggest hit of the event — even if it was just enough for a good taste for each guest. Such a delicacy had not been known by most city dwellers since before the years of 'protection' by the Germans.

The wedding marked another occasion of significance for Catherine, though she did not know it was to unfold at the time. Her third daughter was leaving the home officially on that evening. Sadly her other two daughters were already gone in a more permanent fashion. As it turned out the evening of the wedding was also the last evening she would share with Costea.

She often doubted his love, or even his true interest in his daughters. Perhaps, if she had borne him a son? Perhaps his love of the military and comrades was overreaching his abilities to share love at home? Still she had also often and early on doubted his fidelity. For the past several years she could no longer deny his secret assignations.

The rumors had been there from the earliest days of Costea's long absences for the military. Catherine was beloved by the people who knew her to the point that most quietly ignored what they heard or saw. They would never tell their Princess something so hurtful or damaging as a husband's affairs. Yet she had been warned often enough about the dalliances of royalty and officers... and Costea was both. Still Catherine had clung to that innocent notion — perhaps the only such notion she was capable of — that this one man might love, cherish, and honor her. Sadly she had long given up on that notion though she had her pride and hoped too for his discretion.

Because of the special occasion Costea had again been allowed leave from his unit along with six other close officers. The seven officers stood out handsomely in their dress uniforms. A group of women accompanied the officers to the wedding. Catherine was too busy with the evening's activities, greeting guests, and attending to Tanda's wedding day requirements. She had not paid much attention to the little clique of cavalry men and their women. But Catherine was a woman of great instincts, intuition, and was a great observer. As she greeted guests she thought she had greeted seven women with the six officers. She noticed later in the evening the officers all dancing happily and indeed one of the women was standing alone in the shadows. As the evening progressed Costea excused himself for relief and a quiet smoke. The lone woman left as well.

Among the guests Catherine had an old friend attending the wedding. Her former bodyguards, Uri and Sergi, had retired sometime ago from the service of the Cantacuzene family. Uri sadly contracted typhus and died several years earlier. Sergi remained and was still included in Catherine's life in many ways. Kinia called him Uncle Sergi. Catherine called Sergi to her table and whispered a favor into his ear. Sergi looked puzzled, but nodded and readied to leave the room without question. Catherine knew he would not come back to the reception and gave him a hug before he dutifully departed.

Mixing with the guests Catherine noticed Costea did not return for quite an interval. When he did she knew her whispered request to Sergi had been answered. Costea returned with a cut along his eyebrow, and his eye was bruised and swollen shut. He explained he'd slipped outside on the cobbled pavement and fell against the building hitting his head, perhaps too much wine.

Looking across the reception hall Catherine also noticed that the six officers and seven women were no longer at their table. Catherine had seen the seventh lady when she rushed into the hall, alone, and in what seemed a panic. The group of men and women all left suddenly. Catherine smiled and greeted more old friends. Finding a napkin she dipped it into a glass of water and dabbed the cut on Costea's brow. He winced at the excessive pressure Catherine seemed to readily apply.

"My, that's a nasty cut," she noted with feigned sympathy. Costea shrugged and moved on to greet another guest. Catherine knew two things for certain at that point. She had whispered instructions to her loyal former bodyguard Sergi; and although he was past 60 years of age, she knew he could carry out her wishes. If Costea was as bold and crass as to bring a mistress to their daughter's wedding, she wanted to know it and she also wanted Costea to suffer from such a crass act.

Sergi's left hand wore a ring that she had in the past seen in person leave an impression on a man's flesh. That mark was exposed when she wiped the crusted blood from Costea's cut. She also knew Sergi would have completed her instructions with his right hand...a jolting upper cut to Costea's groin. Despite the pain she was sure he felt, Costea was putting on a good show with his swollen eye as he bid thanks and farewell to the evening's guests. But Catherine knew he would not be putting on a good show with his mistress that evening. It was a fitting farewell.

Only months earlier, when the last American from Standard Oil was leaving while the Germans were taking control of the facilities from Romania's security, Catherine asked him, "Why are you allied with the Russians, the Communists?"

"Because, together, we must defeat the madman in Berlin. We have no choice."

"Yes, yes, Hitler is a madman, but don't you see the real threat from communism? Stalin is just as mad and more dangerous in fact," Catherine pleaded.

The oil executive paused and then countered, "Why are you allied with the Nazis?"

Catherine could see the folly of international politics. "You see, we are no more Nazi lovers, than American's are Commie lovers. It all seems so insane!"

"I'm afraid you're right. War is so often about not what is right, but about power, ego, wealth. So many young lives sacrificed for ignoble causes. We have to take care of the Germans first — then we'll keep you safe from the Russians."

Catherine knew back then her argument might seem futile to the seemingly naive Americans, but she had to let them know the true danger of communism and the terrible Russian Bear. Wars are fought for one side's gain and the other's loss. But land, wealth, and power are not nearly as dear to lose as one's freedom. America was the home of democracy and, as her earliest teachings has shown her, its Founding Fathers had indeed captured the noblest causes in their Declaration of Independence. Why could they not see the threat of communism was as great as the threat of Hitler?

Despite the Germans' occupation under the guise of protection, Catherine was allowed to travel on behalf of **St. Catherine's Crib**. The institution was renown throughout the world, even within the upper ranks of the Nazi regime. Her travel was limited and Catherine knew she was followed by SS when she traveled to attend a conference by the Save the Children Foundation in Switzerland. The Nazi's had been conducting censorship and purges of books and film. Catherine had not been able to get her favorite publication for a year, **Reader's Digest**. She had been reading the publication since her early years – even in the orphanages she would find copies of the popular report of all things Americana which fueled a fascination with America. The monthly periodical was a wonderful away to keep up with that astonishing country. She found a recent edition

with an article entitled *The Moon Goes Down*. It was about the Norwegian resistance to the Nazi occupation. There might be some useful information in it for Catherine so she cut it in half, pulled the out the shoulder pads of her winter coat and substituted the book halves in their place. Smuggling was common place and Catherine was adroit at it.

The war's fighting had been removed from much of Western Europe for several years. Germany controlled Europe though Hitler had surprisingly not attempted crossing the English Channel. He had pressed instead far into Russia, and was also fighting the Americans and British in Africa. It seemed to Catherine a faulty strategy by Hilter.

German Luftwaffe Colonel Gerstenberg was in charge of the defenses of the precious oil fields of Romania. The black resource was key to maintaining the 'blitz' in the Krieg, the German military might. Catherine was on tour of her estates and asked Nicholas to stop on a hillside overlooking the cracking plants and refineries on her properties west of Ploesti. She remembered taking a similar pause while on a tour with her Grandfather. Kinia per usual was traveling with her and asked what was wrong?

Pausing for a moment Catherine felt a tear trickling down her cheek and quickly wiped it away. "Kinia, I was reminded of my dear Grandpapa. It was a day much as this and I was at his side, much as you are at mine. But the countryside was more beautiful then. There were no oil facilities and armaments, just farm fields. The haystacks were just that, not hiding places for anti-aircraft guns as they are now. There were farmers in their horse carts and cows in the fields. Today we have tanks in the fields and machine guns on the roof tops. German soldiers outnumber the cattle."

"Will they go away? " Kinia asked. Despite her young age she was very perceptive.

"Yes, I suppose they will — I want them to — but I'm afraid of what might replace them, of what might happen between now and then. It's such an uncertain world, my dear."

Kinia with the clarity of insight that youthful innocence brings asked, "What are you going to do?"

Looking at the young girl at her side Catherine was dumbstruck. At first she thought — oh my child, would that I could do anything! Then she gazed about the panorama before her and knew that indeed she must do something — and quickly! All of those German defenses meant one thing. The Germans expected to be hit, and hard, by the Allies. This was

Hitler's most heavily protected territory because he expected it to get hit the hardest. Her orphanage's fostering villages were entirely within Hitler's primary oil supply. She needed to quickly match the army's defenses with her own — bunkers, bomb shelters and ration storage rooms must be created to protect the orphans and her loyal employees on the estates, in the schools, and at the residential pavilions.

"Come Kinia, we have much work to do! Nicholas, off to the orphanage!"

As the driver pulled up to the pavilion at Filipesti, Catherine noticed four young orphans playing in a ditch. They were throwing dirt clods over the road to the next ditch. Catherine loved to watch children play. She even was tolerant of a certain amount of dirty and torn clothes in their play — thinking back to her own youthful excursions down drainpipes of orphanage buildings and adventures into forbidden woods. "Active play makes active minds," she extolled the orphanage superintendents.

But her pleasure was broken when she approached close enough to hear the boys make sounds like explosions. She ordered her driver to stop, and got out of the car.

"Boys, what is the game you play?"

The boys immediately recognized the commanding woman before them. All four stood up immediately and tried to brush the dirt from their clothes. The tallest of the four spoke. "Princess Catherine, we're German soldiers! We're killing the Russians! It's a glorious day! We're victorious!"

Chagrinned Catherine shook her head slowly in the negative, "I'm afraid soon enough you boys may be faced with doing this for real. Before too long you will be old enough — though still just boys — to be taken into the army. You will be made into men way too soon... with the rest of your lives in the balance. I'm afraid for you lads. And today, I'm afraid you have picked the wrong side."

The boys looked at her with doubt. Then the youngest of the quartet asked, "Surely, you don't want us to be the hated Reds! We could never be the Russians!"

Catherine laughed at the absurdity of his question. "Oh no, no, boys! Of course, not the *Russians*! But you must remember — the glory is in the cause, not in the fight. Neither side today is worthy of your time at play, much less your lives. If you must fight — *fight* for what is right. What is right is to fight for your *freedom*!"

A Plane in the Garden

August 28, 1987. Dayton, Ohio

My head was swimming there was so much to comprehend. My hand ached from the notes I had frantically been writing. The hour was late, after eleven. I hoped none of her 'boys' would show up and toss me out for keeping their 'Princess' up too late. I looked up from my note pad and did not detect any hint of fatigue in what must have been an exhausted woman in her nineties who already traveled over six hundred miles just that morning and attended a gala with literally hundreds of people jockeying for an opportunity to talk to her. I flexed the fingers of my cramped writing hand several times.

There was that magical intuition she was known for exhibited again as she looked at me in a knowing way. "Perhaps you grow tired?" she asked.

*"No! Oh no, no. I'm fine. This is fascinating! I am so enjoying your story. Surely **you** must be tired. It's been a long day."*

With that knowing smile Catherine accepted my premise and nodded. "I have had many days in my life tougher than this. But perhaps you are right. Would you like to hear the rest on my story? Do you have time in the morning?"

At first I was stunned. Did she consider it an option that I wouldn't want to hear the rest? I'm sure the perplexed look I had betrayed me as I began to stammer something. Then I noticed her smile as she had just pulled another of her little 'gotcha moments' and was enjoying the ruse. "Of course you would!" Catherine answered her own conjecture. Can you come back at eight tomorrow morning?" She rose from her chair, not waiting for an answer.

I doubted if anyone had ever walked away this story. I could tell that Princess Catherine enjoyed regaling me with it. My note taking, sincerity, and questions of her were clear evidence of my interest. Besides, she was

honoring a request by one of her 'boys' and such obviously meant a great deal to her. She would not be skimping on any of the details with me.

I pushed away from the table. The stainless steel coasters under the overstuffed maroon chair glided smoothly over the plush gray carpet. "We will finish in the morning," she assured.

I bid her good night as I let myself out of the room. Upon closing the door I looked back and she still stood by the table looking out the window into the night. Surely the infirmity of her advanced years was being felt at the late hour.

It was a restless night. I was tired, but could not find sleep as my thoughts raced. I was on overload from everything I was being told and at the same time in anxious anticipation of what was yet to be discovered about this grand dame in the morning. It seemed I looked at the numbers on the table top alarm clock next to the bed nearly every hour as I tossed and waited on elusive slumber. To add to my fitfulness I began to worry that I would fail to get my requested wake-up call, though surely I would still be awake.

August 29, 1987. Dayton, Ohio
I shot out of bed; my eyes wide open as this loud noise reverberated in my ears. What was it? Then the phone rang again, my wake-up call. I had finally fallen into that deep REM sleep zone and my mind was a blank. I uttered a very sincere thank you into the receiver of the bedside phone and rose from my sleep and the bed.

I enjoyed my quick free breakfast buffet of bagel and crème cheese while surmising the fare at the classier Marriott must surely exceed my Days Inn menu. I arrived early and waited in the lobby not wanting to rush the Princess. The request was be to her room by eight and I was going to honor her schedule, not a minute earlier or later. At the appointed time I knocked gently at her door. Without hesitation the door swung open to a smiling Princess Catherine. She raised her hand in the direction of the table and chairs and she began before I had landed on the cushion.

"Where did we leave off?" The Princess was rested and eager to continue as I frantically flipped through my notepad looking for the last page of my notes.

"I want you to know how much I appreciate your time," I said earnestly.

"Oh, don't thank me. I thank you, and anyone who will listen! You won't know where you are going until you know where you have been. You

must know what it was like, what I have been through. People must know the truth! I hope then they will appreciate what they have here in America, and the sacrifices your men in uniform make to preserve it."

Nodding in agreement I asked, *"World War II was about to start. What was your sense of the coming conflict with your country right in the crosshairs of those two powerful countries? Hitler is one of the most reviled and loathed men in the world."*

"And still we joined with him?" The Princess finished my sentence. *"Well,"* she started with a measured breath. *"Hitler was a dictator without a doubt. He was obsessed with both his and his country's place in the world and history. But he was not yet a madman, not which could be seen in any event. He was by many counts very charming, and, oh my, he was a charismatic and spellbinding speaker — in a German sort of way. Don't forget also that he had just led his country out of a terrible depression and was far in front of the rest of Europe in that matter.*

"Now, Joseph Stalin? He was simply a ruthless man, no charisma — just a demigod, and a murderer. I dare say he killed more people — his own countrymen at that — than Hitler. Russia was just so closed from scrutiny by the rest of the world that we will never truly know this for certain. We, Romanians, did know for certain that we feared Stalin...Russia and its insidious Communism. I make no excuses for Hitler and the Nazis... they were nothing we admired. But the enemy of thy enemy is thy friend. Germany was there to protect us from Russia. I've heard it called the lesser of two evils.

"The Germans made a good show of treating Romania fairly...until the war turned bad for them."

"When did you think the war turned bad?" was my follow up.

The Princess looked at me with a raised eyebrow and leaned forward as if she were about to tell a grave secret. *"Before the war began... When they told the American oil men to leave Romania."*

Sunday, August 1, 1943, started as so many days had in the previous five years of Nazi occupation. There were shortages of food, clothing and other materials for the orphanage, and for every Romanian. The country was inundated with the German military, and there was a tension in the air of the unknown, of a country under foreign occupation, of a pending doom from war. The fighting seemed to be everywhere else — soon it would descend upon Romania.

With her usual vigor Catherine went about her daily routines. She took no days off. The only difference between Sunday and the six other days of the week was that Kinia could spend the entire day with her. They would spend the day touring. Catherine had much to keep track of at the orphanage's facilities in the twelve villages. In addition there were the estate operations, the oil facilities, and the stores and business operations of the orphanage. On touring Sundays Catherine always made a point of sitting down to enjoy three meals — for Kinia's benefit. Sometimes the meals would be at their home, but more often they were at an orphanage facility, or a foster home. Kinia loved the adventures of traveling places with Catherine. There was the added bonus of not knowing what she would be eating or where added to the anticipation and sense of adventure.

On this day the circuit was to be the farms. The journeys of the morning took the two and their driver Nicholas to the estates around Filipesti and Nedelea. They arrived late at the foster home in Filipesti, but enjoyed a meal with a family who had two of their own children and three foster children from **St. Catherine's Crib**. Their table was full despite wartime shortages. Scrumptious fare included a baked chicken and much from the local gardens. Spartan, nothing fancy but filling none the less. Kinia was especially happy to see it ended with freshly picked raspberries, one of her favorite treats.

It was close to 2 p.m. when Catherine and Kinia headed off for their next stop. Suddenly the air was filled with a deafening roar. The noise was so loud the ground shook. Then as suddenly, the sky was filled with huge green planes sporting Stars on their wings, and Catherine knew instantly they were American, not German. The planes were flying just above the treetops, no more than 100 feet above the ground. It was obviously a surprise attack, and the planes were trying to avoid the German radar and AA guns which could not fire at the low flying planes despite the large targets they presented.

With certainty Catherine knew the planes were headed for her oil wells and refineries at Ploesti. Soon the planes would have to pull up steeply to achieve an altitude from which they could drop their deadly bombs. The bombers would steadily climb to yet higher altitudes to form their defensive formations as they retreated to ward off the Messerschmitts that soon swarmed them like angry hornets.

"Quickly!" Catherine ordered her driver "To the pavilion! We must get everyone to the shelters!"

The huge lumbering car kicked up road gravel as Nicholas pressed

the gas pedal to the floor and raced back to the facility. At the pavilion, she found most of the children and staff outside looking with curiosity to the skies. The thundering roar of the planes was being replaced by a distant pop, pop, pop as the Germans began filling the air with Ack, Ack. Small puffs of smoke appeared to the east over Ploesti. The pops were followed by deep rumbling booms as the planes loosed their sticks of bombs on the refinery installations. Then, from twenty miles away, rising columns of black smoke rose slowly to the white clouds thousands of feet above.

The war had arrived. Catherine's life was about to take yet another abrupt turn, and the decade that was to follow would dramatically change her world forever.

Waving her arms frantically in the air to get attention, Catherine screamed out, "Everyone! Into the shelters!"

As they approached the building Catherine with Kinia literally at her heels leaped from the car before it came to a complete stop and ran to the assembled children. Amidst the chaos she was feeling a contradiction of anxiety and relief as she paused with a frightened child from the orphanage grasping at her dress. Looking up at the planes defined the moment. Yes, the attacks were starting and occurrences like this would likely last until whatever fate had in store could run its course — perhaps it would be years. Yet, she was satisfied that the shelters she had constructed throughout her system of orphanages, schools, and training facilities would provide to the children and her workers a degree of safety. She also now felt confident as the repeated drills she had scheduled at the facilities were paying off. The children quickly responded and filed in an orderly fashion into the new shelters.

The impact of what was witnessed was settling upon the children and grownups alike. All appeared frightened or excited; some whimpered and cried or prattled a nervous chatter to anyone and to no one. Catherine walked through the shelter comforting and calming the children. Kinia was a real trooper — she had been through the Nazi bombings and blitzkrieg of her native Poland just several years prior. The children's fear reminded her of her own experience, but the young girl seemed like a chameleon to her mentor. She walked with Catherine talking in a calming, reassuring voice — a peer amongst the other children, a fine example of leadership and reassurance to the frightened children.

Walking through the shelter Catherine found one young boy curled up in a corner his hands covering his eyes — an occasional deep gasp for air between clinched teeth. She patted the lad on his head, and he looked up through tear swollen eyes. Catherine recognized him as the youngest of the four boys she had stopped when she found them playing army. Reality surely did not compare to the playgrounds of fantasy.

"You're safe in here," she reassured him. "You see real war is not so fun nor so simple. Those bombs that are falling are not from the Reds. They are from the Americans. But these bombs that we now must hide from... you must pray that they too will be our liberation." With a final tousle of the boy's hair she said confidently, "Don't worry now; you'll be safe in my care."

There was no air raid siren or all-clear whistle in the Romanian countryside — perhaps not even in Bucharest. Aerial bombardment of this scale was not a form of attack that the country had suffered in the past. The intensity of the attack and of the defense overshadowed any recollections from World War I. The initial attack lasted what seemed an eternity, but was over in less than fifteen minutes.

There was a period of silence and Catherine thought it might be over, but waited out of caution. The rumbles of war had been scary, but distant. The instructors were leading the children in school songs when the rumbles of another wave of the attack began. The singing in the shelter stopped as frightened children held each other. Catherine looked around and all were looking back at her. Without hesitation she grabbed the hands of Kinia who of course was right beside her, and with an exaggerated smile and deep breath began swaying back and forth singing the song the children had just stopped in mid-verse. Kinia seemingly knew what Catherine was going to do and began singing right along with her.

The song was one of those that children clap, and stomp, and do all sorts of gestures, and Catherine and Kinia followed the routine. Soon the children and instructors joined in and the raucous noise was louder than the claps of death and destruction raining down in the neighboring city. Suddenly there was a louder explosion, and Catherine felt the ground vibrate under her feet. Then it went silent. Perhaps it had been a stray bomb or a lost bomber. In any event she hoped the attack was over.

There was a commotion at the door of the shelter and a bright flash of sunlight pierced the room as the door opened and a farmhand, breathless and perspiring called out, "Princess Catherine? One of the big planes!" He gasped for breath. "There's a plane in your garden!"

Sensing urgency Catherine stepped toward to the young man and looked at him with an unspoken question etched on her face.

"It's burning!" he blurted.

Indeed the war had not only come to Romania, it had also arrived in her back yard. Catherine knew she had to go to the scene. Leaving with the farmer, Catherine did not know what mayhem she would see at the crash site. Turning to Kinia with a question, "Kinia, could you stay in the shelter with the other children and keep them playing?"

Knowing the urgency Nicolas drove the solid touring car directly across the fields. Catherine arrived and saw several of the workers from the orphanage extinguishing the fire. All farm orphanage trucks had been equipped to fight fires. Catherine did not want to have the danger of unchecked fires at their institutions or business facilities. She was proud to see her men respond so quickly.

One of the workers was shoveling dirt over a smoldering engine that had rolled away from the charred crumpled metal bird. "Some men jumped from the plane and ran north, to the woods! There are two bodies that we can see. Shall we do anything more?"

A repulsive scene greeted Catherine as she could see the charred remains of one airman strapped in a seat. The other body was slumped over in a glass shell atop the plane. "There's nothing you can do for them. You both were wonderful to get here so quickly and put out the fire."

"Thank you Madame. We'll have the woodshop make some coffins for these poor souls."

Looking at the crashed bomber Catherine surveyed the gruesome scene... twisted metal; charred bodies; black acrid smoke rising into blue skies. Her eyes followed the column upwards. She looked to the west and south, away from the refineries and saw similar plumes rising from the scorched final resting place for other crumpled metal bombers that had been shot down. Catherine took a deep breath and knew much work waited. There would be more bodies. There would be injured survivors. There would be prisoners. There was work to do.

With her mind racing through the profound realities of war, Catherine returned to the shelter and found Kinia, still singing and dancing with the children. Catherine advised the instructors that it was clear to go out, but they now needed to be vigilant at all times. She traveled on to a nearby estate where she had been advised by the farmhands at the plane crash site, a veterinarian was examining some sick sows. Catherine went to see the condition of her stock following the raid. Several hours had passed

since she had been at the crash site when the same breathless farm hand raced to the barn.

"Princess Catherine! One of the dead men... he's moved!"

"What do you mean?" an incredulous Catherine asked.

"I went to the shop to ask that they make us coffins and returned to gather the bodies. The man in the turret has moved his arms and head. I think I heard a groan. We tried to break the glass but our hammers bounced off!"

By the time Catherine returned to the crash site several men were cutting into the metal in an effort to extract the survivor. Nearby small trees had been cut and stripped to make poles to be used as pry bars. Other curious villagers began to gather and watch. Some gathered pieces of the plane — perhaps souvenirs or perhaps something deemed useful back home on the farm in those days of shortages.

After an hour of intense effort a hole had been made in the planes green metal skin large enough to extract the large-framed American who was falling in and out of consciousness. He groaned and winced in pain as they struggled to free him. The smell of fuel was intense. Catherine warned the workers not to do anything that could produce any sparks. Catherine could see several oxygen tanks near the airman's seat and could only imagine the size of fireball if they were ignited.

The airman was slowly regaining consciousness — unfortunately that made him more aware of the pain he suffered. He had a large knot and gash on his forehead. His hands were cut badly and bled freely. Catherine climbed up the crumpled fuselage and poured water into the American's mouth. He muttered some words and Catherine leaned closer and spoke to the man in English, "Are you hurt where we cannot see?"

He looked up to her for the first time replying, "Are you an angel?"

"No, you're very alive, and we will help you. Do you hurt — in the back, the legs, inside?" Catherine implored.

"Water?" he asked, and Catherine complied.

He savored the mouth full of water and struggled to say a sentence, "I think... I'm burned... and... my right foot..."

His eyes floated radically, and he fainted.

"I think his right foot might be stuck!" she relayed to the men around her who could hear the man's words, but did not understand his language. "And be very gentle with him. I think he is severely burned." Catherine held a damp cloth to his head.

The men found a piece of metal structure inside the plane had

collapsed against his foot, probably at impact with the ground. He was pinned down, and it had kept him from escaping the plane with the other crew members. The peasants pried the metal piece with the green tree pole but could not quite extract the foot. They carefully cut the boot away, and the foot slipped from its trap. They eased his body from the plane and lowered him in relays to the ground.

The man groaned as he was handed down to where Catherine had blankets prepared. He was sure to fall into shock which could be the end of him. They took off his flight jacket. Catherine quickly turned her head away as she nearly fainted. The odor of gas fumes was released along with that of burned flesh. There were large blisters on his chest and she was thankful he had remained unconscious as he was removed from the plane. She knew from treating the soldiers in WWI that burns were the most painful of injuries. Doubting the man would survive, she still felt it her duty to give him hope.

A cheer went up as the man was at last gently lowered to the ground. The enthusiasm was not for the sake of the airman. Rather it was for the efforts of their beloved Princess Catherine and their men — neighbors and farm peasants — who accomplished the heroic task. Many, however, harbored less than kind thoughts about these monsters that had rained terror on their people and land. Some had pitchforks and scythes and claimed to be 'hunting down' those flyers that had fled.

"We must get him to Dr. Maria. He will go into shock, and the burns are very infectious."

As Catherine spoke a Nazi lorry with the large black and white cross on the side panel arrived. A junior officer, young, cocky, and with a lock of blonde hair poking out from under his cap emerged along with four soldiers in grey uniforms carrying carbines.

Catherine looked directly into the eyes of each of the four peasants picking the airman up, speaking quietly, but with no doubt, "Put him in *my* car."

"STOP! HALT! SCHNELL!" the officer shouted.

Catherine stood between her people, the fallen American airman, and the Germans. She smiled, always ready to use her charm first. "I am Princess Catherine," she said in her perfect German, "I am sending him to a hospital. He will be under my supervision and turned over to proper authorities when he is well."

"Nein! He is an American prisoner of the Third Reich!"

This was obviously as close to military action this very young officer

had been, and his adrenaline was overflowing. He wanted to return to the barracks with a prize.

"This man is so badly injured... he will likely die before the day is out. Then you'll have to spend your time dealing with his corpse, burying the body."

Determined yet dubious Catherine hoped to convince the excited young officer. Perhaps the charm would work... or maybe a preponderance of logic? She smiled and reached out gently resting her hand against the lieutenant's forearm on his grey sleeve. He quickly pulled his arm away. Catherine ignored his reticence and spoke to his reason.

"We are only trying to help the Fatherland. Think of the resources you will divert from the front to care for these prisoners. Wouldn't your men's time be better spent fighting for The Third Reich — not babysitting a defeated enemy?"

The officer would not be deterred. He moved toward the car and the injured airman as the four farmers struggled to be gentle, yet get to the car and out of the German's way as fast as they could. Catherine sidled over as she talked to keep between the German and American. The officer was furious and ordered his troopers to take their prisoner. He tried to shove the diminutive Catherine away. It was a bad move.

Calling on her past training Catherine had been protected for six years by two of the finest bodyguards in Europe. They had also given their young charge numerous lessons in self defense, and, perhaps some moves on the more aggressive side. As the officer pushed at her she feigned stumbling and fell into the officer; and as she did a deft right hand found its target... a pair of royal German jewels which she yanked and twisted. Nobody saw anything other than the big commotion, but the German troopers were frozen in their tracks as the officer yelped like a dog with its tail stepped on, and then crumpled into a fetal position gasping for breath, unable to speak.

Gathering herself Catherine quickly stood up and uttered in her most wicked voice at the confused troop of soldiers, "He should be shot for attacking a woman, a Romanian Princess!... shame!... the swine!" Then she added sardonically with her favorite German phrase, "Dummer kopf!" She continued with several more German slang epithets that froze the confused German soldiers while she boarded her car with the airman nearly inside. One of the troopers ran over and grabbed the American's foot before the door closed. Catherine looked to Nicholas whose eyes

were the size of saucers and ordered, with no hesitation in her voice, "DRIVE!"

Grabbing the airman's shoulders she held on in a frantic tug of war with the German soldier. The car took off ripping the American's feet away from the trooper's grasp. By this time the Romanians who had gathered to look at the plane, nearly 100 had decided en-mass to protect their Princess. They surrounded the fallen officer still writhing in pain on the ground. The four troopers would not move further without orders; and though they had rifles against a few farmer tools, they thought better of creating an uprising among the locals. The American airman was going to the hospital.

The grapevine of information and rumors was working and Catherine soon began to hear of other Americans who had been shot from the skies during their daring low level raid. Some, she was afraid, had been killed by angry farmers such as she had found herself that afternoon. Some peasants had lost family members and property from errant bombs or a crash landing. Perhaps, unknowingly, these innocent simple folk had also suffered losses from the rounds shot by the Germans towards the low flying attackers.

A number of Americans were being detained at local jails or locked in barns and basements as orders for their disposition or possibly rewards awaited. Catherine had much to do now, and it had nothing to do with running her orphanage or businesses. First she would attend to the dead airmen, then to those who survived. She must work fast if the plan she was formulating stood a chance.

As soon as she could Catherine returned to Filipesti. The wives of the farmers who had extracted the body felt it was their duty to complete the task their husbands began. They would provide clean clothes and prepare the body for burial. Catherine expressed her gratitude and went to the hospital to check on the burned airman.

Dr. Maria was not optimistic medically. "Much of his skin came off as we removed his clothes, and he surely has lung damage from the flames and fumes. We have covered him with petroleum jelly and wrapped most of his body. I gave him a shot of morphine. He mostly sleeps. His dog tag is here." She handed it to Catherine. It read 'Richard Britt' with some numbers and letters.

"He must have this. He will wear it when he is not bandaged, or we will give it to the Red Cross if he does not survive."

Dr. Maria looked at the tag. "I will put it on him over his bandages. His body is in serious condition, but I think his spirit is well."

Catherine was grateful for the encouragement. She continued on her rounds to find the local clergy. When she did, he adamantly refused to preside over a funeral ceremony.

"This American was killing my people! You can bury him at the crossroads with the other strangers and trespassers! I will not officiate."

A frustrated Catherine pleaded but could not budge the priest. She continued on her journey to Bucharest. There she called on the Bishop – another friend of her late grandfather. The Bishop was more than happy to provide a letter of direction for the too patriotic priest who had forgotten his religious vows.

From there Catherine went to a meeting she had called of the Foundation Committee for **St. Catherine's Crib**. Her reason was to report on how the preparations — the air raid shelters, the fire equipment, and the drills — had paid off and there had been no damage or injury to her charges. Her other agenda was to gain the committee's support in her plan — a plan that could have far reaching consequences. Her impassioned plea to the committee received unanimous endorsement.

Young and vivacious Queen Helen was the honorary head of **St. Çatherine's Crib**. Her husband King Michael was brought into the throne as a teenager when King Carol II fled the country. The energetic queen eagerly assumed her role as a benefactor and assumed her place on many organizations. Catherine admired the spirit the youthful royal pair brought to the throne. Queen Helen had been a strong supporter and believer in Catherine's leadership of the burgeoning orphanage system. It did not take Catherine long to convince the Queen of her plan's merit which resulted in an arranged meeting with the King — that day. Queen Helen made sure his schedule found fifteen minutes for Catherine.

Nicholas slowed as the car approached the Palace coach house entrance. An officer of the Romanian army held up his hand palm out and Nicholas stopped. Catherine was ushered inside. The main entrance was for show and royal occasions. Those with business were admitted in this more informal, yet very private manner which kept royal business much more discreet. The palace was alive with activity and people. More

193

than one hundred served the Royal Family as cooks, maids, gardeners, coachmen, and other functions. There was always a detachment of twenty-five members of the Royal Guard for ceremony and to literally guard the family. There were perhaps another hundred government advisors, foreign diplomats and their staffs. Not more than a handful would actually see the King or Queen on any given day.

The royals work and living chambers were isolated and access was limited, especially so in these times of war. Within the palace there was an office for the German Army — for appearances. However, it was manned only by Army bureaucrats. It was an agreed arrangement — they stayed out of Romanian affairs, and the Romanian government did not interfere with German military actions in Romania... until that day.

A uniformed member of the Romanian Army ushered Catherine to a prominent receiving hall, and then into a side office. From there she passed into a study. There were tall racks of leather bound volumes, maps and globes, and a fine marble desk with a high back chair behind it and three cushioned chairs in front. Catherine chose to stand while she waited. She went to a globe and spun it until the United States was in front of her. There she slowly walked her fingers across it reading the names of the forty some states that made up the country. Her fingers stopped at Texas where the burned airman came from, and then up to Kentucky, home of the deceased flyer. They were so far from home she thought.

The side door opened and young King Michael appeared. Just in his twenties, he had been appointed to the throne to help restore order in place of the deposed King Carol II . The new king's safety had been a guarantee by Hitler, which also guaranteed the young king's cooperation, if not always his acceptance. King Michael came to the throne with the best interest of his country at heart; however, he had very little in the way of options. His country was in a vise, and he understood Germany was the only option at the time with Russia being an unacceptable alternative. He admired Princess Catherine, though he may not have found time for her had Queen Helen not insisted. It seemed this little lady from the orphanage always asked for and received something from him and was also not shy about giving him advice. He found that more often than not she was correct in her assessments. She had always been subtle with her advice which he appreciated since she was, well, a woman.

"Catherine, so nice to see you! I understand you had some anxious moments yesterday," the King said as he by-passed royal protocol in exchange for a hug in greeting. With no one else in the room the informality

was refreshing to the King still too young to be caught up in the formal trappings of office.

"King Michael. The bombs of the Americans were no more irritating than the manners of the Germans!"

The King chuckled. He had already heard of her run-in with the young officer. "Catherine, I do believe that the young officer so eager for *action* will be getting plenty of it in his new assignment in Stalingrad!" Then he laughed, "Though I hear it will be another day in the infirmary before he is able to sit for the long ride east."

Catherine blushed, "I believe I grabbed something to break my fall," They shared a good laugh.

"Your Majesty, forgive me if I speak out of my domain, but we now have a situation that requires an immediate response from the Romanian government. Yesterday we found ourselves under attack. Yet, I think you'll agree, although our land was attacked by Americans — they will eventually be our best chance as a savior. We turned a corner yesterday. Things will get worse before they get better. I believe we witnessed the opening round in the end of Germany's power. What will we do if we don't have another protector against the Russians?"

"Princess Catherine." His more formal approach stung Catherine, perhaps she was stepping beyond her boundaries, and perhaps she had misread King Michael.

The King continued, "We do have a conundrum. But my hands are very tied. If you haven't noticed, we are 'occupied' by about 1 million Nazi storm troopers!" The king's smile was gone. He paced around the desk and stopped, "Queen Helen said you had a proposition for me. Please... give me something I can really do for my countrymen."

It was a difficult time and Catherine felt sympathy for her king and his frustration at being in a position without options. "The Americans are not our enemies, but they are the friends of our enemies, the Russians. Yet they represent more than anything the best hope for our freedom when this is all over. Surely, they will eventually see the true intentions of the Reds. King Michael, I dare say we must survive and to survive we must cling to hope... not hopelessness!"

Pausing for effect Catherine brought home her point. "These Americans who have *attacked us*, and have crashed into *our country...* should they not be *our prisoners?*"

After stating her position Catherine stopped and looked into the young man's eyes. King Michael searched for a moment through the complexity

of her question. He put his hands on the broad desk and leaned forward, narrowing his eyes as he thought. Catherine had learned to appreciate the young man's bright mind. She remained silent. He thought aloud, "If they are our prisoners — we'll have to house and care for them — it will tie up some of our military." He began to pace again.

"More and more raids will mean more and more prisoners." Catherine added.

The king shot a glance at her as she went on, "they will come, and keep coming, and come some more until they destroy the German Army."

King Michael paused, his arm folded as he listened.

"I have been reading about America, studying its people and history since I was old enough to read. It is a mighty country, but its people are mightier still. They have a greater respect for freedom than any other people on this earth. And here is my point. If we take the American flyers as our prisoners — they will stay here and not be shipped to a stalag in Germany. If we treat them with respect, perhaps they will return the favor. Perhaps when the Germans tumble, the Americans will be at our door steps; and we can negotiate surrender to them — *not* the Russians! It gives us something to cling to... *some hope!*"

King Michael walked over to the globe and looked at the large shape of Russia and its border with Romania. Then he moved the globe westward, across Europe, across the Atlantic, and stopped, placing a finger on Chicago.

"It's a long way from here, isn't it? What you suggest is a longer shot still, but it's better than no shot at all. My many advisors have yet to give me *any* shot." He paused to consider Catherine's suggestions through a bit more. "You know sometimes you can over-think things too much. Sometimes you have to go on instinct and educated guesses. I would need a near-unanimous backing of the government to suggest this to the Germans."

Without hesitation Catherine interrupted, "I think you'll have that support, and if you do, I think you don't *ask*... you *tell* the Germans what you are doing."

Satisfied with the meeting Catherine drove back to the Nedelea estate that same day. She was exhausted. Kinia greeted her and asked a hundred questions. As tired as she was Catherine sat in a lounge chair

and answered question after question, much as she and Grandpapa had done so many years ago. Certainly he must have been just as tired back then. She never knew it at the time. There was no Granny now to call them both off to bed either. The two just talked until they both fell asleep in the chair.

The next morning Catherine was awakened by sunlight streaming through the east windows of the great room where they slept. Kinia just entering her teens was deep in sleep oblivious to the sunlight or the clatter of the Caradja household moving into action. Catherine called to her driver to be ready to go to the hospital at 8 a.m. sharp. After that she would sweep the locations where prisoners were being held to check on their condition.

At the hospital Dr. Maria said the American had slept well and that there had been a guard assigned to watch the prisoner. Catherine thought that was strange since the injured man was totally wrapped in gauze and would likely not be able to get out of bed for weeks. The novelty of American prisoners was Catherine's guess as to the reason for all the attention.

She walked into Lt. Britt's room and asked how he was doing. The guard eyed her suspiciously as she looked at the airman who watched every move the guard made. She was dubious and asked Britt how he had been treated. He responded with a shrug and a wince, forgetting how tender he was. Catherine looked at the guard who was still watching them closely.

Turning back to Britt she explained, "He does not understand English," and to prove her point she said loudly, "Your guard's mother is a dog, and she raised a son of a bitch!" Britt laughed, and winced again, winking now at the guard — who then turned away.

"I was burning with fever last night and didn't get much sleep. So he didn't keep me awake."

Catherine sensed there was more, "Yes, yes..."

"Well, he choked me, took his bayonet from his rifle, and slit it across the gauze on my throat and then put his gun to my head and pulled the trigger. I guess I felt so bad I wouldn't have cared if it fired. They must not trust him with bullets."

Upon hearing this Catherine was enraged. She turned to the unsuspecting guard and slapped him hard across the face. The shocked man raised his arm up to protect himself from another blow. Then she kicked him hard in the shin, and he dropped his rifle to grab his throbbing leg.

Catherine grabbed the rifle and struck him in the backside with the rifle's butt as she began to offer suggestions about the man's heritage — this time in his language. The guard must have thought she would use the bayonet next and quickly hobbled down the hall and out of the building.

When she returned to the bed Catherine turned to Britt who had a shocked look on his face. Catherine smiled remarking casually, "Actually, I have been shown how to use this by, shall we say, experts," as she set the gun against the wall. "How was your daytime guard?"

Britt grinned and offered, "He was fine. You can leave him alone!"

"Good, then he will have double duty. The other guard, well, he's abandoned his post, lost his weapon, and interfered with the business of a Princess of Romania. I think that shall earn him time in the brig and a transfer to the Russian front!"

Leaving the wounded airman Catherine traveled on to the village and found at the church the coffin with the deceased airman, a cross of flowers which had been prepared at the orphanage, and a grave dug in the church cemetery. She went into the church office and found the priest.

"Read this!" she said curtly as she handed the Bishop's letter to the man of the cloth.

The priest was about to protest when Catherine stopped him short. She held her hand up and he stopped. "Read your letter carefully. It applies to all future burials as well. These boys are far from their home; having died on foreign soil. We are doing for them what we would hope other mothers *and clergy* might do for our sons who may be dying far from home."

The issue was settled. Catherine was not going to give the priest the option of a protest. She turned her back to him and strode off to her car.

The day still had more work to be done, and Catherine drove on to the town hall of Filipesti where five prisoners were being held, locked in the basement. They told her they had been treated respectfully, though one bore the marks of the pointed end of a pitch fork from his capture. Their jackets bore the names of a people made up of various heritages; an Italian, a Swede, an Irishman, a Portuguese, and Britt she knew was of German descent.

Thinking to herself, they are from two of the countries they are fighting against and one from a longstanding neutral country. Americans... such a cross-section — like a mutt dog. But like a mutt they could exhibit the best of all the breeds of their makeup, and a mutt's pleasing

temperament as well. It is the cultural mix that is the strength of America, their rugged individualism, and their acceptance of different people. It is their promise of freedom that unites them. They bring, not just bombs. They bring the hope of freedom. Bless these boys. They are worthy of our protection and help.

At long last Catherine traveled back to the orphanage school at Filipesti and was told she had been called by Queen Helen and was asked if she would return the call? Catherine immediately phoned and waited. After getting transferred through many desks and gate keepers, she finally talked to the Queen.

"Catherine? King Michael will be making a trip to visit *Romania's* prisoners from America! He will be making arrangements for a POW camp to be devised from some facility in your area."

Catherine was beaming with pride. The king had acted both promptly and dramatically. "Did he have good support?"

The Queen laughed. "Your meeting with the Foundation board was quite successful. The wives of the cabinet members on your board were very supportive and convincing. Could it be your suggestion that they lock their bedroom doors until their husbands' agreed have been an influence?"

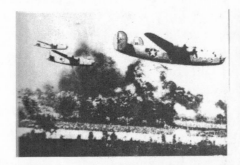 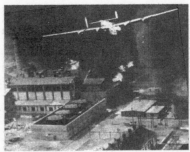

The famous low level bombing raid over the Ploesti oil fields, August 1, 1943
All photos courtesy of U.S. Air Force

Crashed B-24 of Richard Britt and Frank Keyes. Note the section of the bomber cut away to remove Britt.

Britt's crashed bomber

The crew for Britt's doomed plane. Britt, back row, third from left; Keyes, back row, second from right

Prisoners from the low level raid were held at a converted hotel in the village of Timisul (near Brasov)

Prisoners in the recreation room of the "Gilded Prison" of Timisul, so named because of the lavish details of the converted hotel.

CHAPTER 18

Aiding and Abetting the Enemy

The destroyed bomber lying in a crumpled heap in Catherine's garden quickly became much more than a curiosity. Souvenir hunters carried away insignias and identifiable items. Scavengers stripped pieces they thought would be useful as a metal door or gate, a roof, wires to run electricity, a myriad of things to the resourceful peasants. Catherine thought on a broader scale and also with her orphanage at the forefront of her mind. Long coveting the aluminum cookware such as she had seen in her American magazines Catherine directed her metal-working foundry men to strip the aluminum to see if it could be melted and cast it into pots and pans. The experiment worked and soon people across the countryside were stripping the aluminum from the approximately 60 planes that had been shot down on the daring but deadly low level raid. Catherine offered to pay by the pound for the scrap. The lure of cash money during the scarcities of war and what it could buy far outweighed the comparative utility of irregular scraps of metal for use around the house and barn. The orphanage soon had a new industry creating previously unavailable cookware to sell in the orphanage shops.

Continuing visits to the hospitals and what served as make-shift medical clinics that contained wounded airmen, Catherine added stops at the new prison camp established in the mountains north of Ploesti. A resort hotel was commandeered by the Romanian government to convert into a POW camp. Bars were placed on windows, and a barbed wire fence was erected around the perimeter of the building to house the fifty or so prisoners that had been collected. Within several weeks stragglers from the shot down bombers who hid in the woods and those wounded grew the number to just over one hundred. Catherine's schedule became all the more cramped with the extra stop at the remote camp in Timisul added to

her rounds, but she felt an obligation to serve as a liaison with the men. After all she had been instrumental in their being held by her government. She inquired as to what the prisoners needed and determined that she would try to fill their wishes.

There were no other large scale attacks during the year. The Germans boasted it was due to the superior defenses they had in place. The Americans had been scared off! Catherine knew the prisoners were unhappy that more attacks were not forthcoming. It meant their stay as POWs would be extended. However, the attentions paid to them by the Romanian Princess caused their hardships to be more tolerable. They exercised regularly with the assortment of balls she provided. Volleyball was the most enjoyed sport. Inside they played cards with a passion and had many other board games such as chess and checkers to keep themselves occupied.

To assist at the Containment Center as the Romanian Army had named its prisons Catherine organized the older orphans in the villages to create sewing kits for the POWs which allowed the prisoners to maintain their clothing. The Red Cross was continually receiving calls from Catherine to fulfill their obligations to the prisoners. Winter clothing arrived in the fall to supplement the summer clothes the men wore when they unexpectedly arrived so suddenly in August.

After several months of convalescence the burned flyer, Britt, was ready to join his fellow POWs. Though he was treated more like a VIP at the hospital and three nutritious meals a day was part of his recovery program, the young officer said he wanted to join his fellow prisoners. Catherine agreed to help transport the man she considered her 'special boy' to the prison camp in the mountains. She knew he should have more time for physical recuperation, but from her service in WWI and her husband's issues outside the military life she understood his mental need for the companionship of his fellow servicemen. The move should be simple enough — so she thought.

"We cannot spare an ambulance from our soldiers for a captured enemy!" was the desperate cry of the transportation director for the local military barracks.

"Then I can take him in my car," Catherine replied.

"No! He is a prisoner. He cannot be transported unless it is in a military vehicle!" was the response.

"Aren't we being a little rigid here?" Catherine was quickly becoming impatient with military regulation, protocol, and bureaucracy. Whatever one choose to call it she was losing interest in the game.

"I must adhere to military regulations!"

Finally, after reasonable negotiation appeared to be of no use with the officer Catherine used her clout.

"Look, you find a military vehicle to transport this soldier, or I'll report you to the International Red Cross!"

Catherine was not known for idle threats and pulled out a personal letter from the International Director of the Red Cross regarding her orphanage. "Do you want to see what they think of your rules?"

She finally had the bureaucrat's attention, "I'll see what I can do."

The next morning he called. "I have found a solution. If you take a guard along with you, I have the authority to declare your car a military vehicle for the trip. You may then transport the prisoner."

"Thank you," was all Catherine said. It was amazing what a bureaucrat could do when faced with trouble. She had accomplished her goal and could get Britt to the camp with his fellow servicemen. On the way they passed piles of debris still remaining from the American raid. Catherine noted it was a refinery that had been completely destroyed. Britt was excited until Catherine tempered the flyer's enthusiasm.

"You did hit your targets and reduced oil production... I own those facilities..." Catherine said flatly. Britt's smile faded, and he looked away from the destruction. Then she added, "You also caused a cost to our people. When your raid began, the jailer fled from a women's prison. A bomb hit the building, and they could not get out. They all perished in the flames."

"Princess Catherine, I am sorry, but I cannot apologize. This is war!" Britt told her frankly.

Knowing he was correct Catherine quickly assured him she understood. "Our country has suffered at the hands of conquerors for centuries. I wanted you to know that our country, our people, are not just targets, but human flesh and blood and they suffer because of this madness. You Americans will end this insanity of Hitler and the sooner the better! When you do, remember our sacrifices as a people, not as the pawns of that madman. He is not our friend or ally. He conquered Romania as well — just in a more subtle fashion. Let your people know — when you are liberated – *we* wish to be liberated as well!"

Months passed in the resort turned prison camp. The Timisul Hotel rose five stories and was built into the side of the wooded mountainside.

More trees were cleared away to create a larger exercise yard for the one hundred and four 'guests' it eventually housed. The larger open area also created a greater space of unobstructed viewing for the prison guards and a greater exposure to thwart any escape attempts.

In captivity the hours seemed like days. The men had known boredom at the air bases between missions. There was a great deal of anxiety before flying a mission and a tremendous adrenaline rush when a mission was deployed. Such extremes made the hours of waiting seem interminable. When missions were scrubbed for weather or tactical reasons, the empty hours that followed dragged even more. The young warriors now captured faced the long hours with no divergences, no missions, no heroic acts, no moments of tragedy, no brushes with death. Just moments, upon moments, upon moments of nothingness all within the same walls, eating the same food, seeing the same faces, awaiting the same future.

Anticipating future raids was the most difficult thing for the airmen. Where were their fellow warriors? Future raids meant the war was being executed; the battle was being brought to the enemy. With their total confidence in the Allies' ability to win the war, the airmen knew as the prosecution of the war continued it would result in their liberation. That there were no raids just raised doubts.

Despite the heavy burdens of maintaining the orphanages, estates, and business facilities, Catherine remained true to her personal pledge to help the Americans as much as she could. She was drawn to these young captives, 20-30 years her juniors — most the ages of her own children. In fact she soon came to call these war calloused young men her 'boys'.

With a lifelong fascination and admiration for all things American Catherine had enjoyed a wonderful relationship with the American oil giant, Standard Oil. Besides she couldn't help but look into the fresh faces of the American officers and be reminded of happier times with her own young officer. On her regular visits she asked what she could provide, how she could help. English language books, magazines, board games, balls of any size — those were requests to be met. Some such as liquor, women, and keys to the front door — were all taken in the vein they were requested and responded to with humor, a wink and, "would that I could", or "I'll check with the authorities!"

They always had Catherine's attention though on requests that were doable — but difficult, or that walked the narrow path of infringing upon military regulation or jurisdiction. She loved the challenge! Catherine of course did not view the prisoners as the enemy. But she also could not

allow herself to be arrested or denied access to the Americans for doing something foolish or deemed to be questionable.

Always asking how she could help her 'boys', she found they expressed a strong desire for music and theatrics. Sheet music for singing was not enough. They wanted instruments. A piano! Clarinets — any kind of wind instrument. They wanted to put on a Christmas pageant, a play, music, magic acts. This was a good thing — Catherine saw the challenge and admired their good morale. She promised to deliver.

Wood, electrical cables and lights for the stage and risers for the audience were easy. Wood was not scarce — not in the beautiful Caspian Mountains. There was much wiring and lighting salvaged from their downed planes. Costumes were also in demand. The commandant of the camp was very cooperative but did insist that the costumes be women's clothing. He did not want the prisoners using them as disguises in an escape attempt.

Undaunted Catherine pushed the envelope on contraband. Her 'boys' convinced her that their morale would be aided greatly if they could follow the progress of the war. All newspapers and magazines were censored, cut up and blacked out. Not even letters from home that came through the Red Cross were immune from the cruel snip of the censors' scissors. A radio, however, could not be censored. This was an understandable request but one with which she could not be connected as the consequences would be great.

The Sunday following the request for the radio Catherine produced a slain goat for the men to butcher and make a stew for the camp. One of the airmen had been a veterinarian before the war. He was given the task of butchering the carcass. As the goat was tossed from her car trunk to a table in the yard used by the kitchen staff for butchering, Catherine noted, "I've brought the entire beast — everything but the goat's baaa."

That grabbed the attention of the men around her. They all laughed at her poor imitation of the goat's bleat. Then she cautioned, "These critters roam all about and will eat anything. Careful what you might find."

After Catherine left the camp the vet began to skin the goat. He quickly noticed the animal had recently received some sort of surgery. The belly had been very professionally sewn. The vet had not even noticed the incision until the hide was being cut for skinning. His medical inquisitiveness immediately drew his attention to the area of the incision. He quickly sliced across the stitches revealing the organs inside. The vet instantly saw the stitches in the stomach of the goat and grabbed the organ. It had

more than grass in it. His fingers deftly penetrated the sliced stomach and extracted a small piece of something wrapped tightly in grass. He did not recognize the object but quickly slipped it under his belt to avoid the notice of the guards that at best were casually watching him.

After completing the butchering, the vet washed his hands and gave the table over to the men assigned to cook. He returned to the building with the secreted part he had extracted from the goat. A group huddled to examine the object. A flight engineer laughed out loud saying, "You have the speaker for a radio!"

Each Sunday a new goat was delivered by Catherine. By the end of September a radio was operating providing the prisoners with entertainment and news. Listening was done secretly. Small groups rationed limited time slots to avoid notice by the guards. A map of the European Theater of War was drawn by the navigators. The radio reports were used to plot the progress of the war.

On one inspection, the map was discovered by the guards. The prison commandant was brought in, and he spent a long time examining the lines marking the fronts. As he left, he complemented the prisoners on their map — 'an art work in progress' as he referred to the drawing and said he wanted to see its evolution weekly. The commandant knew the prisoners must have a source for the news and suspected that it would be more accurate than the Germans were willing to let on about the war's execution. If the activity did not cause a change in the number of prisoners, he was willing to let some things slide in exchange for news he too wanted.

As Thanksgiving approached Catherine was pleased to see an outdoor stage with canopy erected as were the risers for an audience and was anxious to see the rehearsals. Often heard were the men playing the instruments. Knowing the instruments had been scrounged up and they were banged and dented; and realizing the men had been away from their playing days — likely high school bands at that, but, she was dubious as to the quality that might be expected out of the performance. As long and often as they practiced, they did not seem to get better and frankly they were horrible. They were trying, however, and it kept them busy and in good spirits.

Her 'boys' seemed to be in very good humor for weeks when it all came to a sudden crashing end. On the first Sunday of December Catherine arrived as usual at the prison gate, a new goat, more books, and an extra box of poker cards — they must have played cards around the clock as replacement decks were always on her list. The driver Nicholas

was asked to toot the horn. Nobody came. He tooted several more times. Finally, the commandant came out with his arms flaying about in the air as he gesticulated wildly to punctuate his acerbic diatribe. Catherine was horrified. What could be wrong?

"It's entirely your fault! You knew what they were up to! Get out and don't come back!" His veins were bulging from his neck and forehead. "You are aiding and abetting the enemy! I shall have you arrested! In the mean time you are forbidden to ever enter this camp!"

Intuitively Catherine knew the raving was serious; but she really had no idea what he was ranting about. She told Nicholas to put the goat and other supplies at the gate and they drove off. Catherine determined she best ask among the many foster parents of her orphanage to find out what happened. Someone would know a guard or supplier of provisions for the prison camp. Soon she would have her answers.

To her shock she discovered she was indeed complicit in an indirect way. The prisoners' gambit of a play was partly true. They did use wood for a stage, but also for the shoring of a tunnel they were digging. The wires and lighting lit both the stage and the tunnel. The rehearsals were bad on purpose — they obviously needed much practice, but the noise of their playing covered any noise their excavating made. When the stage and risers were disassembled, large mounds of dirt remained — the slag piles from the tunnel dumped a handful and pocketful at a time.

The escape effort was discovered before anyone was able to get outside the fences that enclosed the compound. The escape means and route was discovered by one of the Russian prisoners kept in the camp for labor. He turned the location over in exchange for freedom from his duties. The rest of his time in prison was now set, though the prisoner was transferred out of Timisul to spare him of the retribution he was sure to get from the angry Americans who had put so much time into the tunnel.

Duped! Catherine knew that she had been played by her 'boys'. Though she sympathized with their situation, she firmly believed their best interests were to stay where they were and wait for liberation, just as she was doing. She quickly penned a letter to the camp commandant with apologies, but admitted no complicity, reminding the commandant that he too seemed delighted with the idea of a play and approved her providing the materials... a fact, she reminded him, she would not hesitate to bring up at any hearing.

The next Sunday was the early delivery of the Christmas package the Red Cross was a big event and highly anticipated by the POWs in

the mountain prison. Leading the parade through the gates of the camp, was none other than Princess Catherine. There she stood in the back of her touring car, dressed in red as Mrs. Santa Claus with Santa himself represented by one of the stout men from her farms. The commandant took one look and threw up his hands in defeat. He certainly could not keep out Santa Claus. But he envisioned Princess Catherine to be even a harder foe to stop. He slipped out of the office by a back door to save face and drove off claiming some logistical quest in the nearby rail town of Brasov.

As Santa called out the roll and distributed the boxes with mail, candy, cigarettes, and other necessities, Catherine called the POW commander, Col. Nedeiros, for a good old fashion scolding. "You are just naughty boys! I have cautioned you against trying to escape! You have it good here! If you escape, you might be tracked down and shot, or you might be hunted by the Nazis and sent off to a German Stalag!"

The Colonel looked contrite but was not repentant. "Princess, it is our duty to try to escape. We must occupy our enemy's resources, cause disruption, even create security concerns; all in the name of returning to our side to resume the fight or distracting the enemy from putting forth its best attack against our forces. We are a casualty of war, but we must carry on the fight as best we can."

With her familiarity of military orders and customs Catherine of course understood, though she took it perhaps a little personal that her 'boys' would be trying to leave when she worked so hard for their benefit. "Well just the same — *I* cannot be seen as playing a role in any escape attempt."

The Colonel understood the jeopardy they had placed her in and was sorry, but responded, "You'll just have to be more careful, Princess Catherine. We must use all of the resources at our disposal. By the way, those women's dresses you gave us — our tailor loves the material; he made me a wonderful shirt and slacks. In fact most of the men have nice outfits," he added with a charming smile.

Smiling back and understanding what he was saying Catherine asked coyly, "Are you planning an Easter Program?"

"If the commandant will allow it — and we can get some linen from you — say, for angel costumes."

Appreciating the humor Catherine pointed a stern finger at the American Colonel in mock anger, and then put it down. As she turned to walk away she said, "I'll see what I can do."

I Will Be the Best – Not the Worst

"The tide has turned! There will be more raids! We must be prepared. We cannot turn these prisoners over to the Nazis. They may be our ticket to freedom — these Americans. They are our saviors — though they destroy our country today — they are our future, and our only hope against the Reds."

"Princess Catherine, you rant!" The Mayor of Bucharest retorted. "The Reds will soon be destroyed! Hitler still controls much of Russia. The Reich's armies will regroup and destroy those ill equip and poorly led Russians. When Moscow and Stalingrad fall it is over for the Communists."

There were a few murmurs of consent, acquiescence to the still perceived might of the German Army. "The Americans aren't interested in anything that happens east of Germany. Once they've saved the French's asses, they'll pursue a hasty end to the war, and if Hitler hasn't gone mad — he'll take it!"

Another silver-haired man in a distinguished grey suit with an equally distinguished handlebar mustache asked, "Why do you defend these enemies of the Reich? The Americans rain bombs on our country. Why coddle them?"

Catherine shook her head, "Because *we* are not the barbarians! And because we must be the wiser — since we are not the mighty. And I am not so certain of the outcome in Russia. I hear a very different story from the American POWs than what the Germans are telling us! We must increase our odds and build bridges with the Allies. Besides those to the east of us *are* the barbarians. The Reds are just waiting for their time. They are very patient. Hitler may have the upper hand now, but wait... you can mark my words. As for your comment about the sanity of the

mustached man in Berlin, the fact that you mention the possibility ought to be caution enough for you!"

There was a smattering of "here, here", and some scattered applause. There were some scoffs as well. Many of those in government accepted German domination; many benefited from the association. It was far from a general consensus in the room.

"Perhaps it is you who is being deluded by propaganda. What would you expect those cocky Yanks to say? You've gotten too close to them! Who do you think can stand up to the might of the German war machine?" one influential Cabinet member questioned. "No one has yet!"

"If Hitler's stall is a collapse, then the horde from the east will roll and *we* shall be crushed as well!" Catherine replied caustically.

There was only one woman in the closed chambers of City Hall. It was a convenient meeting place. Parliamentary activity existed only on a sporadic basis and only under the guise of democracy as the government rubber stamped edicts from the Nazi advisory board. It was dangerous to speak out against the Nazis, for one never knew who might be a spy and report back to the Gestapo. Many people had 'gone missing' since 1939, but this small group had been friends and associates in government and business for decades and were too valuable to Hitler who wanted a stable Romania... now that he was in control of it. He would rely on the country for food, oil, and manufactured goods for his own armies to help sustain the war efforts. Most in this cloistered group had known Prince George Cantacuzene, and that had always been Catherine's ticket into their elite club.

Most, however, still did not appreciate her presence — only tolerating a woman in deference to the memory of her grandfather. Most too, though they would not state so publicly, would have preferred to negotiate with Hitler, Stalin, or the devil than with this tenacious woman. They also knew her wealth and influence likely exceeded that of all the collected men in the room. Yet it was a man's world. Catherine understood that fact as well. She knew she could not accomplish her goals without the acceptance of these ruling elite.

It had been nearly five months since the daring low level raid of Ploesti. People had been complacent or had begun to believe German propaganda that the German defenses had frightened off further attacks, the Americans and British would tire of the fight, and eventually seek peace. Catherine knew better. She talked to the American POW's weekly, and she believed not just in what they said. She believed in them and in

their country. They were not fighting an enemy who had attacked them, or even threatened them economically. They were fighting for a way of life and to free Europe of the despot who was Hitler. She did not believe they came to Europe to negotiate with Hitler and hoped that America would soon realize that Stalin was no better. They would not let her down. It was still her fervent hope. She would not let them down.

The debate continued into the late evening. Catherine's argument carried in the final assessment – since it seemed by many present to be rather hypothetical at that point. She won the argument solely upon the simple logic of... what if? The fear of Russia far outweighed the relatively small cost of holding out a small gesture or offering of conciliation towards the Americans. The Romanian government would continue to absorb the responsibility and costs of holding the small number of American prisoners. It was still a small number. If more came they would cross that bridge then.

On the ride home, Catherine drove past the refineries and cracking stations. What had been deemed destroyed by the low level raid had long ago been returned to nearly full production. The Germans were amazing technicians. She saw more concrete abutments around facilities and within each operation. The masses of concrete would limit damage even with a direct hit by absorbing and deflecting the impact. Armaments had been escalated not just around the facilities, but across outlying locations in an effort to avoid the surprise of the low level raid and to create more hurdles en route to the target areas. The German strategy was to reduce the number of bombers attacking and to disrupt the effectiveness of those who might get through. Catherine looked to the heavens and uttered a prayer for the crews yet to come into the face of these staggering defenses. Soon she knew they would come.

Winter passed to spring. More decks of cards were worn out at Timisul. Catherine kept an eye to the sky. She began to feel she was more anxious to see bombers than her 'boys'. Kinia was being given a lesson in gardening. It was the fourth day of April and early vegetables — spinach, peas, lettuce, and radishes — were lined out in the turned soil of the small private garden Catherine enjoyed on her estate. Catherine smiled as she looked at Kinia working the garden. Ah, the spinach! It was already coming grandly. Kinia was about the same age as Catherine when

she instigated the 'Spinach Revolt'. Never learning to like spinach, she accepted its value for her children — in moderation of course.

There were gardeners to do the mundane yard chores, but Catherine always enjoyed working in the flower and vegetable gardens — dating back to her days in the English orphanage where a nun had spent time teaching an eager youngster about nature. Catherine's thoughts now often wandered back those years past, such a long time ago. She straightened up to see Kinia covering the bean seeds with the thick rich humus. There was a small dark puff of a cloud in the sky, then suddenly another cloud, then another. Her heart pounded. Soon the sky was spotted with hundreds of deadly puff balls. She saw the contrails, the white gases left behind by bombers at high altitudes. Today was the day!

"Kinia, quickly, let's get into the house!"

"What is it Catherine?" the beautiful dark haired teen asked.

Catherine pulled Kinia close to her in a hug and as she looked to the sky told her, "It's the beginning of the end of this war. Our lives will change yet again after today. But come along, let's get ready to be off and check on the orphanages."

There was no thundering roar of bombers skimming the roof tops this time. These planes could not be heard, or seen, they flew so high. The Ack Ack guns threw up a veritable wall of flak for the planes to fly through. German Messerschmitts swarmed the formations like a hive of angry hornets. Below zero cold and fatigue from the long flights and high altitudes numbed the airmen inside the bombers. Still the violence of the German barrage of Ack Ack, and the swarms of the Me-109 fighter interceptors pumped adrenaline into every pore, follicle, and nerve ending of their beings. The extremes of fatigue and full on action had such a horrific impact on the airmen's psyche, was now being called battle fatigue.

Soon those on the ground would suffer from bombing raids daily and again nightly. Between the raids the people on the ground would try to go about their jobs and schooling. It was another recipe for battle fatigue, this among the citizens instead of serviceman. Catherine had witnessed the effects during WWI and knew it was difficult. She hoped her 3000 plus orphans would be able to hang together and weather the side effects of the conflict. She was confident her facilities would not suffer a direct bombing; however, accidents, miscalculations from 30,000 feet above,

damage from German shells falling to the ground, and crashes of stricken planes all posed danger on the ground and to her precious orphans.

As Catherine arrived at the facility in Nedelea, Kinia pointed to the sky, "Look, there are puffs all around!"

Scanning the sky Catherine looked to the four points of the compass. The outer rings of defense had let loose on the attacking planes and were likely following the bomber formations both coming and leaving their targets. Soon the repetitive pops of the nearby Ack Ack guns defending the oil facilities began firing. Then the rumbling cascade of explosions erupted from the refineries. Tons of bombs from hundreds of planes meant horrendous damage from the many deafening explosions.

As a precaution Catherine had seen to it that sirens were installed in all of her orphanages and business facilities. All her orphans and workers were in shelters. Catherine asked Nicholas to take her to a high hill. From her vantage point she looked towards her oil fields. The Flak over them was the most intense. The sky was virtually grey with smoke. From the ground rose black columns of smoke indicating several bombs had hit their mark. The Germans also poured smoke into the sky from below with smudge pots to create a cover and make it harder for the bomber to site their targets.

Looking across the fields below, Catherine's gaze caught a site that brought initially a sad image and yet a sympathetic smile came to her lips. The vision mixed pride with sorrow. In field after field the farmhands continued toiling at the ground, preparing it for planting. Occasionally they would look skyward — as if a thunderstorm approached — not bombs from a distant attacking power. Then they returned to their work; simple, unaffected, hardworking people. It was why she loved her country's peasants.

Catherine looked to the south, in the direction of Bucharest. In the distance she saw several columns of smoke rising from the horizon. The city had become a target as well — likely the rail yards. The Allies had expanded the targets. They were not making a statement as before with the surprise low level attack. This was the beginning of a campaign of destruction of the German war machine and all that supplied it. There would be more civilian deaths and injuries. It would be even tougher to keep peace with her countrymen against the newly downed pilots.

With worried eyes Catherine looked to the west and saw more black columns from another oil installation. Perhaps the marshalling yards of Brasov and she thought of her 'boys' in the camp at nearby Timisul. This

attack seemed to have more scope and detail, more strategic planning. The Americans were hitting multiple targets in different locations. They were spreading out the German defenses and expanding the impact of war on her country. They had definitely upped the ante.

As the war rained bombs upon her countryside Catherine saw something different in the sky. A large ball of fire exploded high over the Ploesti target, then another. The German gunners were finding the range and some of the bomb and fuel laden planes incinerated upon a direct hit. Looking to the north a stream of flame and black smoke arc across the sky and the shape of broad wings from a falling bomber could be seen. It was not going to explode in mid-air. This one would wait until its impact with the earth. As she watched, the fatally wounded Liberator B-24 began to make a wide spin like a cork screw, and then the wings ripped off from the force of the dive. She saw several other huge bombers losing altitude. One of the doomed planes had smoke pouring from an engine — its curling black cloud searing a rip in the soft blue of the sky following the plane as it approached the unforgiving earth.

There was a cacophony of noise in the sky, a symphony of death as the American B - 24s groaned, the Messerschmitts screamed and the guns of both cackled menacingly at one another. As the planes descended she saw several small fighters swooping back and forth across the plodding bombers. There were tracers from the machine guns blasting carnage from both the bombers and the fighters. The bomber with the smoking engine erupted into roaring red flames. It rolled over and nosedived to the earth, disappearing over a hill, a dark column rising slowly after its crumpling impact echoed across the fields.

The horrible realities of war were sickening, and Catherine's attention returned to the other bomber as white parachutes opened behind the plane. She counted 1, 2, 3... more opened, then a sixth and seventh... like little dandelion seeds blowing in the wind. What she saw next she could not believe. The German fighters stopped swooping by the plane and instead took passes at the parachutes. Two parachutes collapsed and dropped from the sky, hit by the strafing Messerschmitts. She turned away; the moisture in her eyes did not douse the fire of rage beneath them. Her fists pounded the back of Nicholas' driver's seat. "Take me to Bucharest — at once!"

Nicholas looked up to her. "Your highness, perhaps we should check the orphanage first. I believe there will be some difficulty in getting into the city now while the attack is underway."

"You're right. Of course... good thinking. Let's go to Filipesti."

As the car slowly gained traction, Catherine looked back up to the bomber as it dropped steadily. It was low enough that she could see a man on a wing — perhaps the last man out, the pilot who kept the plane aloft long enough to allow his crew out. Now it was his turn. He jumped from the plane. A chute began to unfurl. There was not enough air. The chute did not open in time.

The aftermath of the raid was frenetic activity everywhere as German and Romanian army vehicles raced throughout the region attending to damages, supplying new munitions, and deploying troops. Catherine had a trip to Bucharest to make, but it would have to wait. On her way to the orphanage school in Filipesti she saw a crowd gathered around the town hall. In the center of the crowd was a farmer's cart. Sitting in the back was an American airman. His youthful smooth skinned face was etched with intense pain, and the young man was awash with sweat flowing from every pore his adrenaline working overtime to keep him functional under the duress. His leg was bound. Two branches were strapped to his left leg and held together by the man's nylon parachute which had been ripped into strands and tied into knots around the leg. It was obviously badly broken, a compound fracture. Visible was the blood stained tear in the man's trousers where the bone had extruded. He must have set the shattered bones himself. Catherine could not even imagine the excruciating agony he suffered.

Pushing her way into the crowd Catherine found the periphery of the cart surrounded by stern looking peasant farmers bearing pitchforks with knives protruding from their belts. One man had an old rusty hunting rifle. Catherine thought the man's life was likely in more danger if he fired his weapon than who he was shooting at — man or beast. The airman did not appear to be afraid; pain and shock were his enemies.

Quickly assessing the situation Catherine began giving assertive directions to which even the burliest of the peasants would have responded. "Get this man some water! Move away — give him some air! My guess, you haven't had a meal? Get me a bowl of soup and bread! Has the doctor been called? Gentlemen, do you think this boy is going to get up and run someplace? Take your pitchforks back to your cattle — they're not needed here!"

The American's leather flight jacket was still on, despite the sweltering

heat. Devlin was written on a patch across his chest. "Help Lieutenant Devlin with his coat, let's put a wet towel on him, clean him up a bit, but keep a blanket over him, we don't want him to fall into shock."

"How are you feeling, Mr. Devlin?" Catherine had discovered long ago that nothing sounded better to people in strange and traumatic situations than their own name. It gave them a sense of bearing and importance in a universe of the unfamiliar.

The airman let a brief smile show, "I've been better," he sighed.

"We'll take care of you the best we can — you're not making it easy on us you know."

The American laughed, "That's the idea ma'am."

Catherine smiled and patted her new 'boy' on the forearm. "What is your first name?"

"Joe, hey it's good to hear English. How do you come by it?"

"I once spent several years in England," Catherine responded. "Where do you come from, Joe?" A blanket and piece of black bread had already appeared and Joe examined the heavy hard piece of bread for a second, and then began to devour it.

"Pittsburg," he said with a mouthful. "Pennsylvania."

A pitcher of water was set on the cart. Devlin looked at it, but could not bear the pain to reach for the container. Catherine saw the agony etched in his face and handed it over to the injured airman. He took a long drink.

Devlin wiped his mouth with the back of his soiled hand. "So what's going to happen next — I'm guessing — I hope — I'm past the lynching phase."

The lad's calm in the midst of chaos appealed to Catherine. She liked the matter of fact manner found in most of the Americans. They generally had a good sense of humor as well. She jibed back at Devlin, "I can't make any promises about the lynching... but first we'll feed you a little, get you cleaned up, and try to get your leg looked after. Tonight you will likely be inside this hall. I'm afraid we'll be looking for a place to keep you, and — it appears — a good number of your comrades."

It was nearly a week before Catherine found her way to Bucharest. The renewed bombing raids continued daily, though there was a pause on the fifth day, likely because of heavy clouds from a storm front. It was a pleasant respite from the attacks. Catherine found it difficult to leave

her orphanage facilities while the attacks were occurring. She traveled between facilities with Kinia at her side. They spent each night in a different village sleeping in cots, often in an office of one of her pavilions. One night before she drifted off to sleep, Kinia started talking about the grand four-post bed she had back in Poland. It was an escape to a faraway place and time for the young girl who had been through so much in her short life. Those thoughts surely gave the young girl comfort, definitely a happier place and time. Catherine herself had done the same thing many times as a youngster in the boarding schools, though her worlds had been entirely imaginary.

"What kind of bed did you grow up in, Catherine?"

Catherine looked up to the ceiling in reflection. She had put her own childhood out of her mind being so busy with day to day existence, knowing Kinia would require an answer. Catherine had grown up sleeping on the hard cots of her own orphaned past. Her actual childhood memories were not so pleasant. Using her imagination as she had done so often at Kinia's age Catherine created a very different bed.

"My dearest child, I had the grandest canopy bed my mind could imagine. It would have had lace around the edges, and animals from around the world would be embroidered on the covers. I would have stuffed animals in place of pillows. My sheets would have been of the finest oriental silk, and I would have worn a soft warm fuzzy flannel gown with angels sown on it."

She looked in the direction of Kinia and heard deep rhythmic breathing.

Oh, to be able to sleep like a young teenager, she thought. Catherine looked back up to the ceiling... her mind filled with thoughts of the next day, her orphans, and her 'boys'.

The steady rains continued into the morning. Catherine drove to Bucharest. She would pick Devlin up on the way and drive him to a new prison being readied in the city for the new wave of prisoners. Old garrisons from the eighteenth century were temporarily being used as prisons for the downed flyers until fencing and guard facilities could be completed at a large girls' school that had been declared the next Containment Camp. The government agreed to continue the practice of claiming the fallen airmen as Romanian prisoners. The Germans did not object — all of their resources were directed towards the Russians on the

ground, the Americans and British in the air, and the restoration of the oil, rail, and other facilities damaged by the raids.

Though never mentioning the fact Catherine was not sure Devlin's leg could be saved. It had swollen terribly so immediately she ordered baths of Epsom salts and the swelling had subsided, though she knew the pain had not. It would be a jolting painful ride; but as with Britt in the low level raid, Catherine knew this American would heal best in the company of his fellow airmen. She had also insisted that full medical assistance be provided to the prisoners. Five other prisoners had since been rounded up by the locals and brought to the town hall. So had a leather jacket with a large red eagle painted on the back. Devlin recognized it as his captain's and tried to ask the villagers about his pilot.

"Where was the man that belonged to the jacket?"

The best he could make out from the crude lingo and sign language they communicated with was the jacket was all that remained intact from a body crashing into the hard earth. Devlin surmised that the chute did not open, he had been shot while descending, or his captain had been beaten to death by the peasants and dragged away.

Work never ended and Catherine planned to take a shipment of aluminum pots into Bucharest to the orphanage retail shop. She added a truck from the orphanage and reduced her car's load to make room for the six prisoners and two Romanian Army soldiers who would be guards. Devlin was packed into the back seat of her touring car with blankets to cushion his ride as much as could be. Catherine still kept the letter she had been given certifying her car as a military vehicle when she transported Britt to the hospital. The dates in the letter were conveniently smudged away with water stains. Catherine was always quick to assure any questioning soldier at check points that the letter was good for the duration of hostilities. Besides she was saving the bureaucrats much hassle and time.

The 90 mile trip took five hours. The roads were in poor shape with the spring thaws and rains. There was some commerce taking place, but the roads were clogged with the heroic efforts to repair bomb damage. German military personnel always had the right of way. Devlin watched from his backseat as lorry after lorry drove passed filled with what appeared to be boys who should be in school and grey haired men too old to be in battle. That gave rise to Devlin's spirits — Hitler's human resources were becoming depleted. When they finally arrived at the makeshift prison and Devlin reported his news to the other airmen who gathered to

greet and assist, he was met with cheers. Catherine left Devlin and his fellow POWs at the old garrison feeling he would be well looked after.

Despite the heavy bombing Catherine was pleased to see little damage in the city. The Americans were assigned the riskier daytime missions to increase the accuracy of their attacks. The results were at once devastating and yet humane as the focus was military targets and not areas heavily populated. The city was nonetheless a city under siege. Anti-aircraft guns now prickled the horizon like an upset porcupine. The once dazzling shops and sidewalk cafes and well lit boulevards that at another time garnered Bucharest the title of Paris of Eastern Europe were no more. Gone were the sidewalk vendors. Instead, the drab gray and green uniforms of German and Romanian soldiers were everywhere.

Urgency was evident as Catherine left the orphanage shop after a quick check-in while the aluminum pots were being unloaded. She had other business in need of her attention. Nicholas wove through the tangle of streets and alleys. Many side treks were required due to primary streets being closed while military convoys rumbled to eastern battle positions. Eventually they arrived at her destination, the Popsetti aerodrome, Romania's Air Force Headquarters. The overcast weather had spared the country of Allied bombing raids that day, and the Axis fighter squadrons would be grounded as well. Catherine's cousin Bezu Cantacuzene was the leader of the 9th Romanian Pursuit Group the elite air force fighters that had wrecked havoc on the Soviet Air Force and since been returned to Romania to offer protection against the building Allied air attacks.

Without a second thought Catherine knew where to find the person she sought and it was in the officers' quarters, likely in the canteen. The room was packed full, raucously noisy, and smoky. Not the place a woman would be expected. The soldier standing at post by the gate did not know what to make of the short woman marching towards the door of the canteen full of drunken pilots. He looked around for someone to tell him what to do but was on his own. He stepped in front of the doorway. "Your papers, Madame!" he ordered as sternly as his sixteen years could muster.

With patience at a minimum Catherine looked at the too young soldier almost disdainfully. She planned on intimidation — not charm — for this encounter. She thrust in front of the lad the same letter she used to declare her vehicle military — the boy likely could not read.

"I am," and then in a very deliberate and slow intimidating cadence so

there would be no question, *"Princess* Catherine Cantacuzene Kretulesco Caradja. I am here on official business — as you can see," waving the paper under the chin of the nervous and sweating private.

Next she placed her own nose in place of the letter and glared at the guard. "If I am not inside those doors in ten seconds, you'll be standing guard over the latrines on the Russian front!"

The soldier's mind was not engaged in any real thought connections. He simply processed 'official papers', 'Princess', 'Cantacuzene'. Yes, Cantacuzene was the name of Romania's flying hero, the officer inside, the country's first and most decorated ace pilot. He clicked his heels and saluted, and slid to the left, allowing Catherine to walk through the door. The smell of the room was repugnant, spilt liquor, cigarette smoke, overused toilets and the odor of bodies far removed from the luxury of a bath. It was everything she expected — except the amount of German ale, and liberated Russian Vodka present. Catherine had a brief amusing thought — perhaps, if they flew drunk and weaved like they do when driving — yes, perhaps, that was a good thing.

She recognized in the center of the room the flamboyantly attired man with the pencil thin mustache and ascot and called out, "Bezu!"

The hall went silent at the sound of a woman's voice and a stern one at that. Col. Bezu Cantacuzene, Romania's finest ace pilot with three American bombers already to his credit – two from the more venerable low level raid and one in this the first week of high level attacks. The hero displayed a new medal on his chest and was indeed being given celebrity treatment. He glanced in the direction of the door, towards the voice — one he immediately recognized.

"Catherine! Come give me a *hug!* I'm so *happy* to see you, cousin! Get her vodka! Here — *compliments of Comrade Stalin himself!"*

Given the circumstances Catherine, of course, recognized that Bezu was feeling no pain. She would use her charm on this side of the door.

"Bezu, Bezu! I'm indeed proud of you. I am sure Uncle Michael is a proud Papa now, too. How are he and your mother, Aunt Marie?" Catherine pressed her tumbler against Bezu's with a clink and set it down on the table without taking a drink.

"They are fine, though I think they will be leaving this mess in Bucharest soon for their mountain villa. I hear we are keeping you busy up by Ploesti. You're once again being called Romania's Florence Nightingale! You should have a medal too!"

Embarrassed Catherine waved him off with both hands, still smiling.

"I only do what is right, what I can. Just as you — you follow orders and do the best you can do." She admired his medal holding it up from his shirt for a moment in her hand and added, "And your best seems to exceed standards, I see."

Bezu admired his medal again. "I am a hero today! And I survived. That's what really matters. Who knows what tomorrow brings? Even in victory, many must die. We pilots have a saying... you don't know what living really is until you've been kissed by the breath of death."

Approaching her cousin, Catherine gave Bezu a big hug and kissed him on both cheeks. "Bezu, you are so courageous!"

"Ah, my dear, remember courage is not the absence of fear, but overcoming it!"

"You represent your country so gallantly. But Bezu..." Catherine's smile faded and in a very serious tone added, "I want to *stay* proud of you."

"What do you mean?" The other pilots had lowered their various drinking glasses and hushed to listen with Bezu.

With a calculated calm Catherine spoke in a quieter tone – she knew she was speaking to all that listened, not just Bezu, "I know that war is horrible, and you are asked to do things only acceptable in time of war — you must kill or be killed. But I have witnessed things in the skies over our country that go beyond what is acceptable. I have seen our planes strafe men already defeated. They have jumped from their planes. They float helplessly through the sky in parachutes and are fired upon by our planes. I could not be proud of you, of my fellow countrymen, if I knew you were doing such an atrocity."

Bezu looked shocked, his eyes widened, but he did not berate nor contradict Catherine. He had seen similar acts in the course of battle.

"I am sorry you have had to witness such acts. It goes beyond the execution of orders, the rules of war. I cannot explain or justify what you have seen with your own eyes. It may be the act of madmen, battle-weary pilots who have suddenly found themselves on the defense, not offense. The German pilots are proud men who are now frustrated. They once ruled the skies and now must fly with little rest, in poorly maintained planes, with limited munitions, at a seemingly endless procession of enemy planes. I cannot speak for them. But I assure you, Catherine, if I am ordered to shoot down American or British bombers I will shoot down one, then the next one, then the next one." This brought cheers from his compatriots.

222

Then they grew silent as he continued, "But you have me on my word and honor in front of my men. Man can show us the worst of the human spirit and reveal also the best. For me the choice is easy... I am here to represent the *BEST* of my country, not the worst! And I mean that to the last drop of my blood."

Bezu looked from his cousin's eyes and then into the eyes of all his fellow Romanian pilots before continuing, "...*And* by the last drop of *their* blood. I pledge to you... we shall hunt down our foes' planes, but we will *NOT* hunt down our brethren of the sky, even as our enemy, as they fall helplessly back to the earth."

Raising his glass upwards Bezu offered a toast, "I salute our fallen foes! They are heroes in their own country just as we are here!" The other pilots held up their glasses and in unison called out, "Salute!"

Catherine picked up her glass and smiled warmly at her cousin. This time she would drink the shot, and she added, "Salute."

1980 front and side street view of former containment
camp #13, Bucharest, Romania

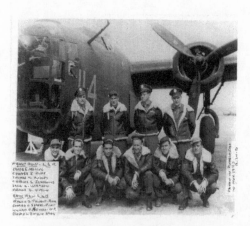

Joseph Devlin's flight crew from the B-24 shot down over
Ploesti in April of 1944. Devlin 2nd row, far right

The map and description of containment cen-
ter #13 as provided by Joseph Devlin

The Angel of Ploesti

All of her wealth and power could not provide Catherine with her most precious commodity. More precious time was slipping away yet again. In addition to her other responsibilities there was now a prison camp in Bucharest for the fallen airmen of the 15th Air Force who led the new onslaught of high level bombing raids. There would also be further shortages for the orphanages because of the bombings. There were new targets, not just the oil refineries of Ploesti. The huge Bucharest railroad marshalling yards, factories, military installations — the war was being brought to Romania by the Allies in its full fury from the air. Desperately needed supplies would be destroyed or delayed. There would be much more death and destruction to the citizens of Romania. It was inevitable, and though painful to watch and bear, Catherine understood it would be the only way to defeat the Nazis.

As the Americans began falling from the sky, a large women's boarding school in the center of Bucharest was confiscated and converted into a prison. The Romanians continued to call them Containment Centers; perhaps more inoffensive terminology to the captives who they hoped would be won over. Catherine's earlier beseeching of her government prevailed and the new wave of POW's again remained in the custody of Romania. Catherine made a visit to the new camp for a personal inspection. She retained her letter from King Michael making her a special envoy of Romania to the American captives which more importantly gained her personal access to their camps.

Everything in Romania was becoming more difficult. The number of air raids, their intensity, and their destruction caused transportation, communication, and supplies to be lost or disrupted. Phone lines went down, power was lost, and roads were cratered and littered by the

bombs and their devastating explosions. German and Romanian Army convoys raced in all directions — some to complete repair work after the bombings, and some to reinforce positions at various locations. Supplies of food, medicines, dry goods, and building materials were diverted to military use or were destroyed in the freight yards by the bombing, and that which was distributed was delayed as they were held up waiting for the military convoys to pass or detoured around bombed sites.

Trips to the prisons by Catherine were curtailed greatly, and what she could provide was meager. She was fortunate to have her vast country estates providing meats, grains, and materials which she used for the orphanages and siphoned off some for the two containment centers. Across the country it was a subsistence existence mixed with bartering of the meager surpluses for other necessities. Yet Catherine remained dedicated to providing for the American POW's. These soldiers would still be the best — perhaps the only — hope her country would have of protection from the dreaded Russian hordes, once the Nazis were removed. The Red Army's progress in the east was now evident and the German army was in retreat. Catherine's dire predictions to her country's ruling elite now appeared prophetic. It would only be a matter of time.

Nicholas honked at the gate. The large Plymouth touring vehicle with its driver and short female passenger barely visible in the rear seat was a common sight throughout the city. Catherine was loved and respected by her countrymen for her selfless devotion to both her orphans and to the working peasantry. Known equally by the gentry and elite of the country for her convincing arm twisting on behalf of her orphanages she was known too for her humor, her persistence, and her razor sharp tongue lashing at those who would not cooperate, or worse, get in her way. She indeed was a force with whom to reckon.

The guards at the entrance of the prison opened the gate and waved her inside the barbed-wire yard of the compound. She recognized one of the Romanian guards as a former orphan and waved to him. He smiled and nodded back. Catherine noticed the newly erected guard towers rising fifteen feet at the corners of the yard, the covered nests resting just three feet above the razor sharp concertina wire coiled around the top of the ten foot fence. Iron bars had been bolted into place outside the rows of windows on the three story stone structure. At least the men would have some daylight, she hoped.

The prison's commandant strode out of the building. He was a short man with a tall ego. He wore a crisp dress uniform adorned with various

medals. Catherine laughed inwardly, thinking surely, if this fellow had merited such an array of decorations he would have been of greater service commanding troops on a front somewhere.

The commandant strutted very deliberately down the six steps to the white crushed lime of the yard. His knee high brown leather boots shone in the sunlight of the clear morning — no doubt recently spit-shined by the Russian prisoners kept at most military facilities as the equivalent of slave labor. He carried a short riding whip evidently favoring the charade of a cavalry officer. He strode toward Catherine's car as she waited in the back seat thinking his exaggerated walk resembled a goose-step march displayed by the parading German soldiers.

Suddenly, he lashed out with his whip striking the hood of Catherine's car, "Who are you!" he screamed. "What are you doing in my camp?"

At first startled by the phony angry outburst, Catherine chose to show no emotion. She just stared intently at the little man with the big Napoleon complex. Her stare made the colonel nervous. Striding over to the door nervously clicking the whip against the leather boots, he knew who the lady was — he was putting on a show — and he knew unfortunately, she understood the same — on both counts.

With impunity Catherine let him stand there next to the car and wither for a moment under her stare. Then she motioned for her driver Nicholas to listen to her whispered instructions. Catherine could play the game of self importance if that's what his game was.

Nicholas had long ago learned to play along with his charge as she carried on her business. He nodded obediently and straightened in his seat, looking out the front and not turning to address the colonel. "The *Princess*, Catherine Cantacuzene Caradja, has her papers from... *King* Michael... she would like to meet with you — briefly — *unless* you are too busy. Then she will leave... for our next appointment... with the *King*."

The colonel considered the driver's words. Was this a bluff, a show on her part? Under an icy stare a small smile moved across the lips of the woman in the back seat. He was not willing to risk his cushy job in a bet with this shrewd royal.

"Yes, yes I see," he stuttered. "I am very busy. But if you insist, I have just a few minutes... in my office."

Deliberately he turned and walked back up the steps and into the building. Catherine noticed his ears and neck had blushed to a fire red glow of anger and embarrassment. The commandant's rude behavior would not be forgotten. Catherine, though, knew when to play her cards.

Her object was to inspect the prison and descent treatment for the POWs, not to win any head games with such an insignificant person. Nicholas opened her door, and she stepped down and followed the colonel to his office.

Once inside the sparse cubical, Catherine noticed the Romanian flag in a small stand on his desk and the standard army issue portrait of the young King Michael in his full-dress white uniform hanging on the wall behind the commandant's chair. She opened with a little dig,

"You know, the King looks very elegant in his *brown* riding uniform sitting atop his *black* Morgan... don't you agree... commandant?"

Her obvious familiarity with the royalty exceeded his limited experience. He had seen the King only once, at his commissioning — along with 1,000 other newly commissioned officers — several years earlier. He was so far back in the ranks, he could not even remember seeing the King's horse to know what color or breed it was.

"Colonel Prezanu?"

"Yes, of course," Colonel Prezanu agreed and quickly asked, "What can I do for you?" The little man knew that the diminutive woman sitting across from him had just pulled her own form of rank and trumped him.

"Colonel Prezanu, I have been asked by our King to check on our American POW's. We must treat them humanely. We must think of our future, after the war."

The colonel looked at Catherine with shock. "That is preposterous! What you say is treasonous!"

Catherine quickly countered, "No! I speak of pragmatism, of survival. I speak for our country, Romania, not for Germany."

Catherine produced her letter from the King. "As you can see, this is my mission... in writing. The reason for my mission I have just stated. I understand you have staked your position through your alliance with our German occupiers Just remember the country to which you have given your oath." For emphasis Catherine pushed the Romanian flag on the desk forward. "I'll be keeping my eye on you." She stood up to leave, but stopped long enough to add another thinly veiled threat, "If you become confused in this matter, perhaps I can arrange for you to get a chance to earn a few more medals", she pointed to his chest, "on the rapidly approaching Russian Front."

Through tightly clenched jaws, the colonel wisely kept his mouth shut. Catherine left knowing this would be a much more difficult place than

the hotel in the mountains was for the earlier fallen POWs of the low level raid. She would do whatever it took to help the new 'boys' now arriving in ever increasing numbers.

The classrooms of the boarding school were converted into barracks for the downed airmen. They became more crowded as the raids continued and the number of planes shot down increased and with them the number of POWs continued to mount. The havoc and destruction the Allies wrought made the conditions in the POW camp worse daily. The conditions for the Romanian guards worsened at home as well. Loaves of bread intended for the POWs were diverted to the guard's bags and then home to their families. This went on until supplies of flour dwindled and sawdust was added to make enough loaves for the growing prison population. Supplies were running low and the number of prisoners continued to grow and fill the new containment center.

Despite her best efforts Catherine was undergoing similar shortages at the orphanages. She implored the peasants of the villages to spare home baked bread and home grown vegetables for her trips to the POW camps. She still was able to spare a goat from her farms to add meat to the meager diet of the prisoners. A feeling of helplessness crept over Catherine as she watched the prisoners continue to decline in weight and overall health. There were no scales to verify it, but most were losing weight at a rate of ten or more pounds for each month of captivity. Their clothing began to become quite baggy as once stout young soldiers lapsed into shrunken bent prisoners.

It was not a stretch to believe the prisoners knew exactly how the war was progressing. Catherine suspected the POWs' knowledge of the war was refined as new prisoners were added with each raid. They would update the others concerning what they knew about the battles and direction of the war. The greatest help Catherine could provide the prisoners would be hope. The best way she could accomplish that was as she had at the mountain prison — with a radio. Catherine completed that task the same way she had smuggled a radio into the mountain... within the innards of a goat!

The prisoners in the camp worked at creating routines and discipline within their own numbers as strangers in a common cause and predicament collected within the former school. Rank and longevity as a prisoner determined the pecking order among the Americans. The Romanian

prison facility was much different than the typical German Stalag. The Stalags built by the Germans were organized into separate single story barracks. The prison in Bucharest was a single massive structure three stories high. Instead of being located in an isolated area, it was in the middle of the city and surrounded by city streets and a ring of buildings. Inside the primary building each of the classrooms of the former school for girls were converted into the equivalent of barracks and lined with bunks for the prisoners. The upper two floors housed the prisoner quarters. The first floor contained POW officers' headquarters, mess hall, recreation room, infirmary, Romanian Army offices, kitchens, and supply rooms.

The old school was built in a U-shape with a courtyard in the center. Service buildings completed the enclosure. The encircled courtyard served as an exercise yard for the prisoners. However, the sheer number of prisoners milling about made any sports impractical. Four machine gun nests overlooked the small green patch. A fence was erected around the entire facility completely segregating it from the city. Escape over the twelve foot tall barbed fence appeared futile. Appearances, however, did not suppress the need to try. It was a prisoner's duty to try to escape to ascertain any information that could be useful if a way was found to relay such, and then to finally create havoc and disruption in the enemy's war effort.

Devlin was settled into his role as a prisoner. His world within the camp was limited. His broken leg made him a permanent resident of the first floor infirmary. As a navigator he was an officer; as one of the first prisoners, his seniority assured him a permanent spot on the Command Committee. The POW camps were organized into various committees: the escape committee, food committee, medical committee, and others as needed. The command committee was the ruling body — authorizing all escape plans and attempts; approving activities for prisoners such as plays and card tournaments; and served as the liaison between the prisoners and the Romanian Command.

Although Devlin was still suffering great pain from his broken leg, the danger of infection seemed to have passed. His leg would be saved. Crutches provided by the Romanian Army aided him getting around. His bunk in the school building was within the infirmary since he could not manage the stairs. This isolated him from a majority of the prisoners. Because Devlin could not negotiate the stairs nor exercise, he was

frustrated because he could not be considered a factor or a participant in any escape plans.

As a member of the Command Committee, Devlin was an obvious choice for chairman of the Medical Committee. He was known among the committee members as a quiet leader. His counsel was sought and heeded, even if he personally did not seek a leadership role. The Command Committee also served a role similar to a board of directors overseeing all activities and arbitrating all disagreements.

In the few months he had been captive Devlin observed wryly the role of the Medical Committee had evolved. Initially it was concerned with injuries — burns and broken bones. In the beginning men spent time in the infirmary for wounds from within their bomber or their fall from the sky. As the injuries healed, men mustered out of the infirmary. Still newly downed flyers were always adding new injuries to the ward. However, as the months went on, illness became the primary focus as malnutrition, dysentery, lice, and the germs they carried invaded the weakened bodies of the prisoners.

The radio secretly provided by Princess Catherine was not only a great source of information for the imprisoned soldier but served as a form of great entertainment as well. It became a divergence against the boredom of the prison's endless hours of waiting. There was waiting for meals; waiting for roll call; waiting for mail and Red Cross deliveries which were few and far between; and waiting for visits from the Princess who they sometimes referred to as the 'Blue Cross Lady' because she usually wore a blue nurse's uniform of the kind used by her orphanages.

Few prisoners of CC#13 as this prison within the city was known got to meet their bold lady guardian. Her visits were less frequent, and the number of prisoners was much larger than the intimate group on the mountain 'retreat' at Timisul. Also, the commandants were very different in their views of Princess Catherine. Major Saulescu of Timisul was unconcerned and welcomed her visits. Colonel Prezanu at CC#13 resented her interference and more so her ability to threaten his very existence.

Despite the initial unfriendly reception at CC13, Catherine found a way to get a goat delivered almost every week. Unfortunately with nearly a thousand POW's compared to just one hundred at the resort, the Bucharest camp had to stretch its offerings much further. Occasionally Catherine managed two goats. She was constantly seeking contributions from the

peasants. A single turnip, rutabaga, or an onion from each cottage garden would fill her car trunk and add substance to the prisoner's diet.

There was one activity that the prisoners seem to take great joy in, but turned Catherine's stomach. She had an abhorrence and personal revulsion to the 'eye-ball stew' game, yet Catherine's sense of humor found acceptance and admiration of the GI's ability to make the best of a horrible situation. To maximize the protein, a cauldron of boiling water was prepared for each goat. Into it everything but the hide and hooves were tossed — bones, tail, and even the skull. The soldiers would put up their Red Cross cigarettes, candy rations, or other items in a kitty. Whoever had the *good* fortune of having an eyeball ladled into their bowl would win the prize immediately *after* they swallowed the eyeball. It helped pass the time.

The ration of bread became more regular when the sawdust became a prime ingredient. With its new ingredient the Romanian guards no longer stole the bread to take home to their families. The bread was dark and heavy bearing little resemblance to the white bread the Americans were used to back home. With the addition of sawdust the loaves became coarse and took longer to chew and swallow. This became a source of forced humor as well. Countless jokes about 'bark' bread, turning into beavers, and of course, the 'logs' they formed later were all bantered about the barracks.

Card games went on endlessly, literally. Points were translated into money to make the games more interesting. Some bets, of course, went uncollected, but more than a few soldiers bought a car or paid for an engagement ring when they returned home after the war with their card game earnings. Some simply bought a huge hangover with their winnings when they returned stateside. Still the games were played over and over and over. Catherine's greatest challenge was finding card decks to supply the prisoners. Cards were a priority for Catherine at CC#13 because of the larger number of seriously injured airmen. Many could not get outside for exercise or other recreation so card games were even more important to those so confined. Catherine's repeated trips to both prisons earned her the affectionate nickname, "The Angel of Ploesti".

News on the radio confirmed what the incoming prisoners were relating as they entered CC#13. The war was rapidly escalating across the continent as the Allies pushed the Germans into an ever shrinking

circle and everyone sensed that the fighting was now aiming to an end that could be felt was within sight. As the spring invasion turned to the summer of '44, the American and British Armies were advancing across France towards Berlin. The Russians were rolling across their own ground and pushing westward. Germany was collapsing on all sides. Allied bombing raids intensified. Missions were being flown over Berlin and other prime German targets. As the Germans retreated and pulled Luftwaffe's assets to help protect the Fatherland, the number of planes shot down over Romania declined.

In the middle of August a plane was shot down that contained a bright, high ranking commander, Lt. Colonel James A. Gunn. His arrival created a change in the Command Committee as he became the highest ranking officer in the camp. He was shocked when he was introduced to the other members of the committee. The officers who had been captives for more than four months looked drawn and pale, their clothes hanging loosely from shrunken frames. Gunn held his hand out to shake the hand of one such officer holding a crutch.

Looking at the name stitched on the shirt, Gunn greeted the officer warmly, "Good afternoon, Lt. Devlin. Pleasure to meet you... despite the circumstances!"

Though he appeared tired Devlin smiled and replied, "Joseph... Joe Devlin, sir... Pittsburg and navigator." Devlin continued by answering the standard opening questions and happily accepted the Chesterfield cigarette Gunn offered each man from the pack he had carried in his jacket when he was shot down. An American smoke was greatly superior to those issued by the Romanians.

"You look haggard. You feel OK?" Gunn questioned.

"Been better, sir. Had to punch some new holes in my belt — can't seem to adjust to our Russian cooks."

"How's the leg?" Gunn inquired looking at the bowed left limb.

"I know why I didn't go to med school, sir," Devlin managed with his crooked smile. "I don't really need this crutch, though," he said looking disdainfully at his wooden prop. "I keep it for balance and to beat the bed bugs away. The Medical Committee hasn't been able to get me any into a physical therapist yet," Devlin added with a wry smile. "I just need to move around more... like on the other side of that fence out there," he said with a grin as he pointed outside with his crutch.

"Hang in there, young man. I think we'll be going home soon," Gunn replied. He did not know how prophetic his statement would become.

The continuous bombing raids were increasing the hardships across the country as well, heightening the sense of the inevitable, the fall of Germany. The airmen viewed the news with excitement in anticipation of their freedom. For Catherine it was not anticipation, but rather anxiety. She knew her country needed guardianship from Russia. If the Germans were pushed out, Romania needed America to step in to keep the Russians out. It would be her country's only hope for freedom.

There were rumors that the Allies were making deals regarding who would oversee the peace-time transition. The execution of the war showed the rumors to appear true. The American and British Armies were pointed directly at Berlin. The advancing Red Horde from the east was pushing the German Army across Eastern Europe and back to the Fatherland. In the process they were taking control of entire countries. Most of the Slavic states were occupied by the advancing Red Army which found a way to leave hundreds of thousands of its forces behind, ostensibly to establish and protect supply lines. Only the very foolish did not suspect other sinister ulterior motives. Catherine searched for the answer to her fears. There must be a way to make Romania safe from the Communist threat.

CHAPTER 21

Surrender to His Prisoners

The situation had become extremely grave. Continuous Allied bombing of the Ploesti oil fields crippled Hitler's war machine. The invasion of Europe by Allied armies was advancing from its foothold in Normandy and was pushing across France toward the German Fatherland. The collapse of the German Armies in Russia after the defeat at Stalingrad was complete and the Red Army was racing across its own soil after the fleeing Nazis. If Hitler's Nazi dream was once a bright shooting star arching across the continent... it was now a collapsing black hole and its once vaunted war machine being sucked in at an accelerating pace into the vacuum of a Berlin bunker.

Prayers by Catherine for the end of the war were being replaced by anxiety and worry about what might replace it. The fear of a conquering Russia was looking more and more like a pending reality. Before the war, Romania had capitulated to the Nazis, not as co-conspirators, but rather as a means of escaping the menacing bear, Stalin's Russia, to the east. Now the once proud German Army beat a disorganized retreat across Romania in shameless tatters. It seemed as if events were overtaking any opportunity for finding a diplomatic solution that might spare Romania a Russian occupation.

The ever resourceful Catherine would not allow a Russian conquest to take place without making some attempt to spare her country such a fate. It appeared that Russia would enter Romanian territory within days. She called her cousin, Bezu, her insider at the military's high command. "We will meet tonight at 7 pm at the Palace. We must do our best to convince King Michael of an immediate course of action. I believe it is our only hope! Yes, yes... you agree then. Fine, see to it that as much

of the Romanian Army high command is present. This may be our only chance."

At 7:00 pm the Romanian Commandant at the prison received a most unusual call. He was to appear at the Palace at 8 pm sharp...and he was to bring the American POW commander. The city was under blackout conditions as the British bombers were making their night attack of the rail and manufacturing centers of the city. The American bombers had completed their daylight run three hours earlier. The redundant raids were not only devastating upon its targets, but also it was wreaking havoc on the nerves of the populace. Commandant Prezanu was no exception, not having been exposed to battlefront conditions. His political connections secured him his prison commandant assignment. He did not want to leave the security of the prison; being certain the Allies would know its location and would not bomb it. To leave its walls, he would be exposing himself to the rain of bombs to which everyone else was subjected.

Colonel Gunn was surprised by the Romanian Sgt. and pair of privates who barged into the POW command cell block and escorted him to the commandant's office.

"Col. Gunn, you must accompany me outside the prison... we must leave immediately!"

"This is highly unusual. I protest!" Colonel Gunn countered.

The commandant was agitated and quite nervous himself, and did not relish a motor trip across a city, under bombardment. "Colonel Gunn!" he started stridently. Then pausing to collect his emotions, he reiterated in a very slow and controlled fashion, "Colonel Gunn, your presence is requested by none other than King Michael... at the Palace...within the hour. You are being asked to attend as a guest... you are not being ordered. It is your choice. I do not know why... I do know, however, it is customary to sip fine cognac as a guest of the King," he concluded with a little flair and tip of an imaginary glass to his lips. He hoped this might induce the American to go.

At first Colonel Gunn was stunned. He still was not sure of the authenticity or motive for such a trip — was it true? These were harrowing times with many desperate people trying to preserve and protect themselves and their belongings, or perhaps it was a more sinister venue. The Germans had become renowned for their plundering. Was the Commandant involved in some elaborate scheme with the Germans?

Perhaps a kidnapping? Was the Commandant acting on his own behalf? Was this a ruse or, if not, what was it? Col. Gunn knew instinctively he needed backup.

Gunn needed time — he had to stall and give himself time to think about this unusual proposal... and to consult his command team.

"I must meet with my staff first."

To Gunn's surprise, Commandant Prezanu agreed, almost flippantly, waving the colonel off with one admonition. "My car will be waiting outside the front gate. You have 10 minutes. We should not make King Michael wait."

Hastily Colonel Gunn was escorted by the two guards and sergeant back to the first floor command room of the converted school house. The centrally located room had served as the POW headquarters since the prison was first opened in the spring. The command staff awaited the Colonel's return from such an unusually late meeting initiated by the prison Commandant. There was plenty of speculation, but none in the room was willing to put a bet down on the purpose. None would have guessed what Gunn told them.

"Gentlemen, I have been asked to go with the Commandant, immediately, to a meeting at the palace with King Michael."

Cheeseman offered an immediate and resounding assessment, "I smell a rat!" His outburst received several concurring nods and grumbles. "I've heard of some of our POWs being shot as escapees under similar circumstances."

"Colonel," Tillman stood up to be heard, "It's highly unusual for POWs to leave their confinement — in the company of the Commandant, that is." His afterthought garnered some laughs for his reference to escapes. It eased the tension.

"These are unusual times," Gunn observed dryly.

"Sir, what is your take?" asked Buckmaster.

"I really don't know what to think, but the Commandant doesn't know me well enough to have anything 'in' for me personally. I've only been down a week. I also don't think he'd let me come back and tell you what I was doing if he was up to something. It appears the choice is mine. I am not being forced to go. It's an invitation. Besides, there would be too many questions if I disappeared. From what I've heard from you, Commandant Prezanu is a coward — can you really seeing him pulling something?"

"I don't know about you, Colonel, but a coward may be scared enough to do anything to save his skin."

Gunn sought to wrap up the meeting saying, "Gentlemen, I don't have much time. I think I should go! I'm one man, and perhaps we may gain something for the twelve hundred men here."

"Colonel," Devlin stood up slowly, a slight grimace belaying the pain he still suffered in his self-set broken left leg. "Sir, I agree with you — I don't think we have anything to lose, but if you're going to have an audience with the King... if you're going to be taken outside the camp... I don't think you should go alone. I think you should be granted an aide-de-camp... your man in waiting... someone watching your back."

Gunn eyed Devlin. The navigator did not speak often, but when he did it was well reasoned. He also knew that Devlin had not been able to participate in escape activities due to his injury and felt as if he was not contributing. Gunn thought it would be a good opportunity for him to help; besides, he liked the man's level headed reasoning.

"Are you volunteering?"

Devlin grinned back, "You said he'd drive us, right? I can't walk there."

"Straighten your cap, Devlin; we're going to an audience with King Michael!"

When Gunn and Devlin arrived at the prison gates, they found a battered and muddy Mercedes touring car with the top down, the engine running, and Commandant Prezanu standing impatiently by the open rear door. He looked surprised when he saw Devlin.

Anticipating questions Gunn spoke first, "Commandant, you were expecting us?"

"Colonel Gunn, you are a smart man. Indeed, I expected *you*. However, there was only *one* invitation," the commander replied eyeing Devlin with disdain.

"Sir, if you'll excuse my audacity... as an officer, in command of the Allied contingent within Romania, I felt an audience with your King entitled me to an aide. Mr. Devlin, here, will take any notes and otherwise assist."

Initially Commandant Prezanu had a bewildered look. Colonel Gunn had not asked permission for a second; he demanded it. Quickly gathering his wits, however, the Commandant smiled. He would let others at the Palace debate this matter with Gunn. He would do what he had been asked and deliver the American commander by eight.

"As you wish," he replied, tipping his cap to Devlin and pointing to the awaiting back seat. "Let's not keep the King waiting."

The ride to the palace was bumpy at best, traversing streets strewn with debris and occasional bomb craters, but the air raid that evening appeared to be over. They passed the railroad marshaling yards and witnessed a surreal scene. Tankers and box cars thrown about like toys ripped opened and crushed into nearly unrecognizable masses of steel. Long sections of rail were strewn about twisted like pretzels. The bombing was devastating and the Germans and Romanians at this stage were not able to keep up with any repairs.

At the Palace an officer greeted the car and opened the rear door. The commandant emerged first and strode to the entrance, dusting off his uniform as he walked. Colonel Gunn emerged and waited for Devlin who moved stiffly and made no attempt to hide his limp. Despite blackout restrictions, the Palace windows were well covered and the rooms inside brightly lit. It was particularly bright for Devlin who sheltered his eyes. For months room lighting in the prison camp consisted of a lone low wattage bulb hanging in the center of the prison school classroom that was his home. Oftentimes that light was out due to a disruption caused by a bombing raid.

They were ushered into what appeared to be a formal ballroom, elegant beyond anything two commoners would have ever witnessed. Ornate crown moldings were gilded in a golden frame around a ceiling that appeared to be about 20 feet high. Murals splashed across the walls of the room depicting what most certainly were historical events of the Romanian past. Heavy maroon velvet curtains with large gold braids hung over what must have been huge windows that would have opened to grand balconies in happier days. Both of the POWs' eyes were drawn to something that had been missing it seemed since their military days had begun. Before them lay a huge spray of bright pink gladiolas splashed with red and white roses. Large lacey ferns accented the huge centerpiece on a broad table.

Then a grin crossed Devlin's face. What he first thought were blue flowers in the bouquet moved out from behind the arrangement. The flowered hat swiveled revealing a familiar face as Princess Catherine moved from behind the table in the center of the room.

"Gentlemen, I'm glad you were able to... break away!" she said with

her wry smile, happy at her little pun. Devlin guffawed out loud, used to both the Princess' humor and irreverence. Colonel Gunn was a little stunned, as he had not met the little dynamo yet, having only been shot down the previous week. Devlin moved toward the Princess and clasped her outstretched arms in greeting.

"I somehow figured you'd be behind whatever it is we're here for. Oh, Col. Gunn, This here's our Angel, Princess Catherine. I don't know if you have been brought up to speed on her in your briefings since you dropped in last week. Pretty much, as best as I can tell, nothing happens here in Romania without her knowing about it, causing it, or doing it. What is going on your Highness?"

The Princess was offering a hand in greeting to Colonel Gunn. "I've not had the pleasure — if that's the right word — before Colonel. This is a most unusual venue for prisoners, but I must tell you... we exist in most unusual times. In a minute our young King Michael will meet with you, and he has a request. It's not my place to intervene, but King Michael allowed me a few minutes to explain our position.

"You must realize we were never allied with the Nazis, but we had no way to resist them. We found ourselves faced with the lesser of two evils, between Germany or Russia. Now I know you are allies with Russia and may find this hard to believe, but indeed the Germans are not to be as feared as much as the Reds. Nazism is nearly dead. The Bear of Russia, communism, however, is just awakening. If you want to free Europe... you cannot let Russia gain control of any country beyond its own boundaries. If you must, join with them, partner with them, but do not trust them or give them control."

A huge double door behind the Princess opened a crack and closed again with a light click. "That is my signal, I must leave now. Please heed my appeal if you can. We will do everything in our power to help you. Now I must bid adieu. This is not my place to be. You see this is a man's world."

With that Princess Catherine allowed herself a hesitant smile and with her customary quick firm handshake turned to leave. As was her style she moved directly without looking back to the door through which Gunn and Devlin had entered. With the door closed behind her the two soldiers who watched her departure with stunned silence, kept their eyes to the door – as if the answers they were searching their minds for might appear from behind the closed gate. The doors at the opposite end of the room opened, and they turned to face them.

The High Command of the Romanian Army entered in military dress. Then King Michael followed dressed in full military regalia, holding a golden helmet with white feathered plume, white gloved hands, and wearing a broad leather strap across his chest and waist to support a sword and scabbard. The King's military advisors formed a line between the POWs and their young imperial leader and stood at attention.

It was an intimidating scene for the two prisoners. Colonel Gunn and Lieutenant Devlin faced the assemblage and returned the clicked-heel and rigid attention military standard for acknowledgement of authority. They saluted the Romanians who returned their salute. There was a brief uncomfortable pause until a man entered the room with a silver tray containing a stack of shot glasses and a large green bottle of cognac. The king took a glass as the butler poured a shot. Then very formally the butler with his bottle in his right hand and the tray in his left through the procession of officers until all had a filled shot glass in hand. He turned to Gunn and Devlin, offering them each a glass of the fine brandy, at which time King Michael raised offered a toast. He raised his glass before speaking and addressed Devlin and Gunn.

The king was of average height and weight, but carried himself erectly and proudly. He spoke his English with a British accent; speaking the language as an Englishman would, the result of his preparatory and college years at Eton and Cambridge in England where he received his formal schooling.

"Gentlemen, *to you*, our American guests," the King then looked at his officers and back to the two Americans, tipping his glass to each man, "and to our noble profession."

Everyone raised their glasses and downed the clear spirits. It had been nearly a year since Devlin had enjoyed the smooth warmth of liquor down his gullet. The power of the fine cognac made him shudder slightly. Before they had all brought their glasses down the butler stood with the bottle at the ready pouring a second round.

Hesitant, Gunn wasn't sure of royal etiquette, but thought it appropriate to offer a toast from the American perspective. "If I may, your Highness, Gentlemen... Your Highness... you referred to us as your guests, I thought we were prisoners... So to our, shall I say, reluctant hosts," and then with a glance toward Devlin with his crooked leg and shrunken frame that had once carried sixty more pounds he added, "To survival."

His Romanian counterparts hesitated awkwardly until King Michael

raised his jigger high and uttered a hearty, "Here, here!" to which his followers answered in kind.

Politely Colonel Gunn had held his glass up when he offered his toast but refrained from downing it until the Romanians raised their glasses.

King Michael then waved off the butler who was prepared to pour another round, "Colonel Gunn, your toast is very appropriate. You hit upon exactly why we invited you hear tonight... Our mutual survival. I believe that what oftentimes makes a great soldier is a strong desire for survival. A hero knows fear, and chooses to face it. If he survives, well then he likely has earned the title... hero.

"The same can be said for a country. Today I fear for my country. Our puppet government set up by the Nazis was dismissed by me with the support of our armed forces just hours ago. The German Army is disintegrating on our frontiers, under the onslaught of the Red Army. I have ordered the Germans to be out of the country in 48 hours; for they no longer have our cooperation."

The king stopped for a moment, searching the eyes of Colonel Gunn, for what he was not sure, perhaps measuring the man's mettle. What he saw was a stony poker face, but he already had a sense of the American's gumption from his toast. It was appreciated. "Let me get to the point as time is short. Perhaps just days are left — before the course of Europe's future is settled, much less that of our country. Yet it is indeed *my country* that I have the deepest concerns for and seek... your help."

What was happening? Colonel Gunn's mind was racing. They've capitulated? Thrown out the Germans? What does this mean? He looked over at Devlin who had not downed his second shot of cognac, choosing instead to sip and savor its harsh invasion of his innards. Devlin noticed the glance and winked back at Gunn, adding a knowing nod as if to say, 'go for it boss'.

Gunn looked back at King Michael and was flabbergasted. The man was unbuckling his saber!

"Colonel Gunn," the king resumed formally. "I am here to offer my sword, to surrender my country to your forces, here and now. I wish to place our armed forces under your command. We ask that you place Romania under American rule."

The king of a country was about to surrender to his prisoners. Colonel Gunn was staggered and silent for a moment, collecting his thoughts knowing, however, that he had no authority to do what he was being asked. He understood desperation, he had witnessed the chaos, and he

realized the futility of the situation. His concerns, however, were foremost for his men.

"Colonel Gunn, I implore you — accept my sword. I fear an occupation by Russia, nay, a conquest. This will be not unlike our being overrun by Attila the Hun. We are at our Rubicon. We wish not to fall into its turbulent waters, and find our country at the abyss of great darkness — the cave of the Bear to the East." King Michael again offered his sword sheathed within its scabbard, symbolic of submission, surrender, and peace.

The king was nearly pleading. "Our armies are now at the eastern front fighting the Russians, not as the German army's rear guard, but as our only hope to buy us time. We are now being shot at by Nazi soldiers and German SS troops here in Bucharest. From the air Stukas and Messerschmitts are raking our lines as the Russian tanks pummel us. The Germans are destroying our infrastructure to slow the Red Army and are burning our meager stores of supplies that they cannot carry away to keep the Russians from them. What the Germans do not get, the Reds certainly will. The British are bombing us by night and the Americans by day. Our country is being ravaged. Please... take my sword."

"Your Highness," Colonel Gunn began, not knowing where to take this, but knowing he needed time. Instinctively he was sensing an opportunity knocking. "Your Highness, I appreciate your predicament. But surely you must recognize your problem is, at its roots, political. I am just a soldier, and an airman at that. I do not have the knowledge nor any training to take command of ground forces, and I do not have the authority to accept your offer. But what I am sure of is I have a prison barracks with over a thousand men under my command who are obviously in peril. I must protect them. Let me speak with my command group. I think we both can agree we must work together. If you can help us at this most dangerous time, we will do our utmost to help you in yours."

King Michael reluctantly withdrew the outreached sword, hooking it back to his waist. "Colonel, you have our complete cooperation, perhaps there is a way." He nodded to the butler who set his tray down and bowed to the King then turned toward the POWs. The audience was over.

Putting their glasses down Gunn and Devlin were led out of the elegant room by the butler. The two officers flew bombers. They were not knowledgeable in military tactics, and they were not field commanders. Most certainly they were not administrators of governments. Then there were the political questions. Gunn could not put his men in the middle

243

of a situation whereby he would be commanding forces that may be in a shooting war against an Allied force, Russia and take the side of a former belligerent, Romania and be the side of the former enemy. It was a formula for an entirely new conflict and he could not have any part of such an occurrence. His primary consideration had to be for the men under his command.

Gunn knew that the Germans still controlled the country's communications and transportation, despite King Michael's sense that they were expelling the Nazis. They knew too that the Red Army would march forward ruthlessly and that their orders would come from Stalin — not the Joint Allied Command. The two Americans knew their fate had been more secure an hour earlier as prisoners, yet would become less secure as the hours advanced. The word in the trenches and the prison barracks was no one could trust the Russians, despite what was assumed of the Allies back in Washington and London.

As the doors were opened, they passed into the adjoining receiving room and found Princess Catherine pacing nervously. They approached her and Gunn began to speak, but was cut off by her upheld hand.

"No, no don't repeat — I stood by the door and heard everything." She glanced up with her sly grin. "Such a meeting was not my place to be — I just happen to be in the next room, however, with my big ears."

"The situation is tenuous at best — for us all, Princess. Our men are in no condition to fight yet that may be what we are facing. We have no weapons or provisions and we are facing uncertainty from both sides — the Germans and the Russians. What can we do?" Gunn asked.

Assessing the moment Devlin looked at the two, and then focused on the furrowed brow of the diminutive lady and remarked, "Colonel, I am glad you are a realist and understand the situation. I'm not sure what it is yet, but something is going to happen if this little woman has anything to do with it."

Hearing the comment from Devlin Catherine looked up from her momentary pause and responded, "Colonel Gunn. You need more authority to do anything for us — for Romania, correct?" Not waiting for his reply she continued her logic. "Your men are also at high risk... We need answers quickly... It's really quite simple. We need to get someone from here back to your high command in Italy quickly, and I know how we can do it!"

CHAPTER 22

I Bring You an American

The task was daunting, and once again Catherine would be put to the test. She knew how to get things done, and to her thinking this would be just another challenge. Summoning the awaiting palace butler she told him to bring her cousin Bezu Cantacuzene from the adjoining room. The best way to describe the daring ace pilot would be in a word — swashbuckling.

Casually, Bezu came out of the ballroom holding out one of the opened bottles of cognac left behind from the toasts with the King. A slender man, short by American standards, with a pencil thin mustache just above his lips, he had a quick smile and ready laugh, and his jet black eyes had the intensity of a man who successfully pursued a war in the extra dimension of aerial combat.

"Gentlemen, I think you forgot this," holding the partially finished bottle of cognac. Then with an impish grin, he produced a second unopened bottle of the King's finest. "With the compliments of King Michael — I'm sure!"

"Bezu!" scolded Catherine.

"Oh my dear Catherine, we are so much alike!" he howled and gave her a big hug.

Catherine pushed him away feigning disgust and straightened her dress.

"Bezu, can we — *you* — get an American out of our country and into Allied territory? Quickly?"

Bezu was Romania's highest decorated ace was credited with 167 victories which were tallied based upon enemy propellers shot down. A fighter would have one or two propellers and bombers would have two or four propeller engines. Sixty Allied planes came down after passing through his sights. He was responsible for putting many Americans in

245

their graves or in a Romanian prison camp. Now he was being summoned by Catherine to save his former targets and at great risk to his own life. No matter, he was a patriot, a flyer for the Romanian Army and would do what his country required.

This was a moment of deadly consequences. Bezu paused from his high-jinks and thought for an instant. His smile faded and he grew serious. The pilot placed the bottle on the table and paced. Bezu turned to Catherine with his right arm at his waist holding a bent left arm, his chin resting in the left hand. He knew he would say yes. The pause was not for dramatic effect... he was pondering the task.

"My fighter is a Messerschmitt, so — perhaps — the German's won't shoot at it. Of course when I get to the Allied territory, what will keep the American's from shooting me down?" Bezu stroked his thin mustache, looking to the ceiling as he spoke.

Colonel Gunn was getting the picture and offered, "We would need to get to Bari, Italy. I will be your passenger. I can let you know where our gun emplacements are."

Bezu was warming to his task, "Ah yes, it will be a flight you won't soon forget!"

"I hope I will be able to remember it!" Gunn countered.

"Good one, Colonel, but not to worry — I will get you there. We can paint an American Flag on the plane — surely your Yanks won't shoot us down! We'll have to go unarmed though. The only way I can get you into our one seat plane is to stuff you into tourist class — no, actually it's baggage — the plane's belly where I would otherwise have my munitions and radio. You have to draw me maps, and we won't be able to communicate. Nor will I be able to communicate with the ground or another plane... friend or foe."

"Bezu, the Germans control the airports," Princess Catherine noted.

"No, not Popesti Aerodrome, I think — I hope — it is still under control of the Romanian Army. My plane and crew are there."

The Princess made several suggestions, "We should get more of the army over there to make sure it *stays* in our hands? And trust no one, Bezu! I fear many of the workers at the airport could be Nazi sympathizers or just desperate people willing to sell information. There also could be just as many Reds infiltrating and hiring spies. And have your plane guarded around the clock only by your most loyal men."

"My dear Catherine, your worries are well founded. I already trust

no one. Only my personal flight crew is allowed near my plane. They are the reason I still stand here before you. They have taken very good care of me during this little six year skirmish. We will be gone before the clock goes around again. The army has already been ordered to set up defensive positions around Popesti. I took care of that before I left the Command group next door with my complimentary bottles. You see my dear, they were given to me... I did not steal from the King!" Bezu gave a hearty laugh and tipped his bottles of cognac as he prepared to leave. "I must go at once and make preparations."

Turning from the Princess to the American, Bezu directed his passenger, "Colonel Gunn, return to your quarters and advise your command group... have them prepare your men for German attack *and* to be ready to escape... at a moment's notice! *Do not* let the Germans take your men! You would be hostages, or a shield from attack and believe me, the Russians would *not* care about accidentally hitting the American prisoners. They would kill all of you if it meant killing some Germans too. I will advise Commandant Prezenu that I will send a company of our army to add to the prison guards who will be ordered to defend the Americans against the Germans... and the Russians, until I hear otherwise. When the Russians reach Bucharest this will become a very confused and deadly ground.

"Get some sleep Colonel. I will send someone for you when we are ready. Also, remember to please prepare accurate maps and try to locate your radar and gunnery installations. We will have to be clever and try to avoid contact from *all* sides en route. Unfortunately, you will not be able to see where we are and we will not be able to hear one another during the flight. In fact you should plug your ears, you'll be so close to the engine noise down there."

Preparing to leave Bezu saluted the Americans, bowed to Catherine and departed in a hurry — as soon as he polished off his glass of cognac. There was momentary silence and a lot to consider. Princess Catherine broke the silence as she reached out and clasped Colonel Gunn's hands, "Godspeed, Colonel, you are in the hands of a very brave and skilled pilot. He will get you there. Good evening — and the best to you lieutenant." Catherine shook Devlin's hand and quickly left the room.

Upon returning to the prison entrance, Gunn and Devlin immediately noticed the gate opened and unattended. Word was out about the

247

Steven E. Aavang

Romanian capitulation, and many guards just put their weapons down and went home. As far as they were concerned the war was over, and they had no plans to face the charging Red Army with a rifle in hand. Several American POWs were armed with the abandoned weapons and stood guard at the prison gate.

Inside, the American airmen were gathering up their few belongings, but they had no idea what might be in store. Their options were few and seemed bleak: would they stay; be taken by the Germans to a stalag; strike out as a group or individuals and head for Allied lines; would they be shipped off to a Russian 'holding camp' or a labor detail in Siberia — never to be heard from again; and what about those too weak or injured to travel? All the men in the area gathered around Gunn as he strode into their midst on the first floor common area. The room was the general purpose area for the prison and fully half the 1200 POWs had assembled looking for information, guidance, and for leadership.

"Gentlemen," Colonel Gunn addressed the group. "I am going to attempt to get to Bari and seek the assistance of our forces. The top ace here is going to give me the flight of a lifetime! The Romanian government and Army are now on or side. When I get to Bari I don't know what, if anything, they can do for us, but they will know firsthand our situation and that will be a start. It can become very dangerous outside these walls, but in my absence you won't have any reliable information about what our forces can do. Therefore, be at the ready... I have received many warnings about the Russian Army — even though they are our allies. There are politics at work here that none of us are prepared to comprehend. I don't think the German's will have the time or resources to mess with us. However, if their retreat goes badly they may want to use us as poker chips or human shields from Russian forces or as hostages against our own forces.

The Romanians — I believe — are going to cooperate with us, but be careful. *DO NOT TRUST ANYONE*! This country is in total turmoil and disarray. From the Romanian Command level, they are with us — wholeheartedly. At the street level — well, it's survival. For the Romanian people saving a home, a farm, a job, a loved one will rule over all other considerations."

"Our captors have been telling some of you for over a year that *your* war was over when you arrived here. Well — it was — then. Now — it's on again." Gunn paused, and looked slowly around the room before speaking.

248

"I can make no promises. I hope I can bring General Patton back with me." There were more than a few cheers at that notion.

"But I promise I will be back as fast as possible — in this man's army," Gunn's comment drew a few sneers and some laughter broke the tension. "My recommendation is to stay together for a week — you may not get any word... if I don't make it. Consider our prison to now be our fort, our sanctuary. Ask the Romanians for supplies, ammunition and weapons. Organize some recon patrols to get firsthand knowledge of what is going on out there. Be ready to move out in a hurry. Worst case scenario — remember your mission as POWs. Escape and evade and cause disruption and havoc among the enemy. It may come down to every man for himself. I trust the Russians will act in accord with the Geneva Conventions and treat you as the Allies you are if they get here first. Our wounded will need to be left behind in the event I am not successful. Perhaps there could be several volunteers to stay behind and look after them... until they too can be liberated."

Knowing this was a defining moment, Gunn looked out at the surrounding faces. He hoped he was exuding calm and confidence. In the eyes before him, he saw doubts, questions, and anxiety, the same feelings he was having himself. He hoped his feelings did not show to his men as they were showing theirs to him. This would be a time that would test their training and their courage.

An anxious Catherine drove to the aerodrome at Popesti in the middle of the night arriving there at 3 a.m. passed through by the Romanian Army guards solely upon visual recognition. She found Bezu in the belly of his slender fighter plane throwing things out to make room for Colonel Gunn. Catherine gasped at the painting on the fuselage. A crude American flag was being painted on each side — on the right side it was painted backwards in error! Regardless, what it was could not be mistaken; in any event it was too late to change it.

Confidently Bezu explained his logic in a whisper, "We will leave at early dawn and rely on our silhouette against the darkened early morning dawn to protect us from Germans who should recognize the silhouette of a friendly plane, but perhaps not be able to see our art work. We could still be in trouble without a radio – should they try to contact us. In the daylight we will be over water, and I feel we will have no German

opposition. It is then I hope the flags painted on the plane will keep us safe. Well... I actually hope we see no one — that will be safest."

"I have told everyone I will fly tomorrow afternoon as a deception, but I also told them I need to do a test run with the Colonel this morning to check out performance with the weight change and plane modifications. Frankly, I do not trust half of my countrymen here, and I fear betrayal or sabotage. We will just leave then as soon as we are in the air."

Trying not to look worried Catherine expressed confidence. "If anyone can do this... it is you, Bezu. Please, come back with Roosevelt or Churchill!"

Cousin Bezu smiled, "Catherine — I've always loved your humor. I would personally kidnap them if I had the chance. But I'm afraid our country's fate is sealed. We do what we must... what we can... and then we see what will happen."

Indeed Bezu trusted no one, so his last request to his fearless cousin was to go to the prison herself and bring the Colonel personally. Catherine arrived at the prison by 4 a.m. in her well recognized touring car along with her driver Nicholas. As always she tried to plan for every contingency. She told Gunn to don a tattered tweed jacket and an old soiled cap she had brought along. As he looked at the jacket Catherine wrapped his head and hands in gauze that had been liberally rubbed over a freshly butchered goat's blood. The goat was then left at the prison for her boys, one last goat... a parting gift.

"What is this for?" Gunn protested initially as he held up the jacket with his free hand, "If I'm caught I'll be considered by the Germans a spy!"

Catherine responded without pausing from wrapping his hands, "Understand Colonel Gunn, you are new to these parts. You'll have to trust me on this one. You're just as likely to be shot if you're recognized as an American pilot! You will be one of my farm hands, recently injured from a stray bomb dropped by those despicable Americans. I'm taking you to a hospital where a surgeon will try to save your hands. Your face was burned badly so they can't remove the gauze and you are unable to speak. That should work for any roadblock whether it is German, Romanian or Russian."

"Russian!" Gunn was totally surprised.

"Yes, they have advance patrols now entering the city. Many of the

explosions you hear in the distance are from the Russian advance. The Red Army has learned the famed German blitzkrieg and now puts it to shame as they seek to extract revenge on the Nazis and I'm afraid gobble up as much land as they can before the war stops. The bombs nearby you hear, however, are from the Germans, not your bombers. The Germans have begun bombing raids throughout Bucharest. It is to both extract revenge against Romania for capitulating, and also to destroy any resources that may aid the Russian advance. Advise your men to stay in a protected area. The prison itself may be a target of their dive bombers.

"The Germans have several areas they are trying to keep secure as they retreat, but my credentials should get us through those. The Romanian army has of course left the German command, and most of our soldiers in the city are being deployed around Popesti to secure the airport – *not* for your departure Colonel, but for your *return*."

Her gaze moved from the hands to the eyes of Gunn. He nodded in acceptance of her challenge saying, "Ok, then. Let's get going."

Tapping his shoulder Catherine told Nicholas to avoid the main high-ways which were cluttered with the retreating German Army. Unfortunately the side streets were not much better. Many German officers had been in the country for several years. They had taken up apartments and often mistresses as well during their stay. Many, too, had taken storage space to store their plunder. Now the roads were clogged with carts and trucks trying to navigate the narrow streets overburdened with their pillage. In the haste to load and escape many items were falling off and strewing the streets making some areas nearly impassable. Catherine saw Gunn's eyes shift nervously to and fro as their car would come to a halt while a truck passed filled with German soldiers or as a nervous Nazi SS officer was barking orders or stopping traffic to secure his stolen booty.

At one point the car came to a stop in the blinding lights of the troop carrier blocking the right of way. German soldiers surrounded the car. They banged on windows motioning the driver out. Gunn shrunk in the shadows of the back seat not wanting to give the Germans a good look. His right hand gripped the pistol he took from an obliging Romanian guard and was wrapped beneath the gauze of his hand.

Catherine quickly told her driver to stay put and got out of the car herself! The purple hew of the early morning sky was just breaking the evening's blackness. Catherine knew Bezu wanted to fly into the sunrise, so she had to hurry. The Germans looked startled when confronted by the woman, and Catherine quickly took charge. She brushed away the rifle

of the nearest German and stood in front of the sergeant who seemed in command. The sergeant looked chagrinned as she poked him with her index finger on his chest as she began a tirade in his native tongue.

Slouched silently in the car Gunn did not understand the conversation Catherine was having with the soldier using her fluent mastery of German, though he was sure he heard "dummer kopf" in her tirade. She was animated as usual using her hands and arms to illustrate her points. Gunn saw her pointing to the air and to her hands, then to the car. He picked up his queue and raised his bloody bandages to the window to show the sergeant.

An indignant Catherine then shoved one of the other soldiers away from between her and the door, and got in, slamming the door as if in a rage. She told Nicholas to move ahead. He put the Plymouth in gear and the soldiers backed away as the car maneuvered around the truck. Nicholas slowly turned the vehicle and rode two tires up onto the sidewalk as they lurched around the German truck and forward once again. The surprised detail of German soldiers simply moved out of her way.

Settling back into her seat Catherine looked at Gunn and gave him a quick smile, "They thought they'd prefer to ride my car than walk back to Germany. I advised them that this vehicle belonged to the people of Romania, and that I had a hero in my back seat who needed emergency care. I told them to shoot me or get out of my way because they were not getting the car, and I was in a hurry."

A relieved Gunn chuckled at this plucky woman. "What else did you tell them? Did you tell them who you were?"

"No, I save that for when I really need it. It's more of a challenge to talk my way through these little occasions. I enjoy the mental exercise."

The drive to the airfield took over an hour though it only covered just over 15 miles. At the entrance Romanian soldiers were present in full force and machine gun nests flanked both sides of the gates. Gunn noticed rifle barrels protruding from second and third story windows of the buildings nearby. It appeared the airport had indeed been secured. Princess Catherine was recognized by the guards and was waved on through. Bezu was standing in front of his hanger awaiting their arrival, looking impatient.

"Are you ready Colonel? The Flying Circus departs in minutes, before the sun crests the horizon."

"You better believe I'm ready. I've got a map here," Gunn said as

he reached into his flight vest and handed it to Bezu after he ripped off the bandages.

"Careful, Colonel Gunn," Bezu moved Gunn away from the ME-109's fuselage. "The paint is still wet."

A questioning Gunn looked down, seeing the inverted American flag. He also noticed a number of dents, scratches, and patches on the fuselage that were reminders of many near misses the pilot had barely escaped on his many missions. "Oh well, so much for the little details. This map should get us around the American radar installations and into the air base in Bari. I do not want us to get spotted and attacked by my own planes. What about the German radar?"

"Colonel, those positions have been destroyed or abandoned by the Germans for several days now. We'll have to watch out for any random Luftwaffe flying support for the retreating army, but I would be more worried about your side — bombers and fighters patrolling for targets of opportunity. I will fly low over the land to try to avoid contact with any plane from either side." Bezu added as he studied the map.

"Remember now we have no ammunition or radio — to make room for you. I will not be able to talk with you en route, nor with any planes or ground installations. When we get to Italy I will continue to fly very low. If we are spotted, well, are you feeling lucky today? Perhaps the Americans will see the flag and not shoot at us."

"Or maybe they'll be laughing too hard to get off a round!" Gunn answered with a laugh of his own while looking at the crude art work.

"Are you ready to go Colonel?"

With honest admiration Gunn nodded confidently, "I'm in your hands, sir." Gunn clicked his heels and saluted the Romanian Ace of Aces.

Looking casually about the hanger Bezu folded the map and stuck it inside his leather flight jacket. He gave Gunn a quick nod and turned to the men surrounding the plane, barking orders to them as he adjusted his flight scarf.

From behind, Gunn heard Princess Catherine speak, "You'll be off in 5 minutes for your 'test run'. Until you return, my brave 'boy', adieu."

Spinning quickly towards the princess who he knew first as the 'Angel', but now, with some luck, perhaps as the 'Liberator' of the POWs was the American Colonel who hoped to cheat death that morning. Catherine held out a hand, her eyes red and moistened. Gunn took her hand in his and received a very firm shake. "I'll be back, *we'll be back*. Don't worry."

253

"May there be a road, Colonel Gunn," she said turning quickly to depart from the hanger.

Gunn looked back to the plane and saw Bezu motioning him towards the open panel in the belly of the plane below the cockpit. It was time.

The fuel tanks were topped, and Bezu had the plane pushed out of the hanger for its test flight as the dawn's red sky was pushing out the purple shroud of evening's end and marking a new day's beginning. Gunn crawled into his nest and was curled up in a near fetal position. The radio compartment hatch was screwed tightly by Bezu himself to be sure it was done right. He certainly did not want his cargo to fall out of the plane. There was not enough room to give Gunn a parachute. Putting the screwdriver in his jacket pocket the skilled pilot confidently walked up the wing and lowered himself into the cockpit. The plane engine roared to life with a blast of black exhaust from the tired and well used engine, and Bezu slid the glass hood of his faithful plane over himself as it taxied to the runway. He throttled the Bf-109g to take off and raced down the runway lifting gracefully at its end and banked directly into the orange orb of sunrise breaking the horizon.

There were many questioning looks by the men in the hanger after 5, then 10, and 15 minutes past on the 'test' flight. When it was becoming evident the plane was not returning Bezu's surprised flight crew and the Romanian Army personnel who had gathered left to return to their other assignments. Several unknown men dressed as airplane mechanics had wandered casually into the hanger area to observe the activity. They slipped quietly away — perhaps they had been there just to satisfy their curiosity or perhaps to observe and pass information on to others.

Having flown so many missions in his plane Bezu felt sluggishness in its controls as the normally agile '109 struggled under the weight of topped off fuel tanks and the large American in the belly of the fuselage. Pointing the nose of the battle worn Messerschmitt just south of due west and throttling the plane fully searching for top speed he quickly left Bucharest, crossed the Danube, clipped the northwest tip of Bulgaria and raced across Yugoslavia, hoping his prediction of abandoned radar and German airstrip's was accurate.

The sky was a clear, calm, blue, and strangely empty. Bezu flew much lower than considered safe from an aviation standpoint skimming the treetops; but if there were any random fighters about, those planes would likely be at safer higher altitudes. In his overweight plane Bezu would have no hope of out-running or out-maneuvering another fighter.

Once he crossed the coastal plains and saw the flatness of the Adriatic Sea Bezu leveled off at one hundred feet. He no longer worried about German interceptors; it was the American fighters he feared. The early dawn twilight masked the painted American flags, but now in the distance the silhouette of the Romanian fighter could be easily distinguished. Officially it was a Bf-109g the original version of the famed German war bird built before the war officially began in 1939. The Bavarian Air Factory was then taken over by the Messerschmitt company and was tagged with the familiar Me-109. The plane had been continually modified to keep up with the Allied planes it would face in the violent skies over Europe. The shape and engine sound were the common identifiers, however, and their only hope was to not be seen — at least until he was over Italy's coast and in the bright daylight which would expose the Stars and Stripes.

The American Air Base in Bari was just off Italy's east coast on the lower part of the boot. The heavily guarded primary airbase supporting the Allied invasion of Europe was a hub of air activity with squadrons of escort fighters coming and going at all times, and on that day hundreds of heavy bombers would take off for destinations throughout central and eastern Europe. Gunnery Sergeant Leon Torrens was not sure at first what he saw from his advance defense position. He had never seen a real Messerschmitt, though he looked at so many images in training he instinctively knew that was the kind of plane came into the view of his binoculars.

"Captain of the watch! Sergeant Torrens at outpost 27. I have a bogey, ME-109 coming in low and slow. Sir, it has an American flag painted on the fuselage!"

Captain Emmett Blazier immediately hit the scramble button and dispatched a squad of P-38's already aloft to that sector of the defense grid.

"Sergeant Torrens — just one bogey?"

"Yes sir. And he is *flaps-down* and is a waggin' his wings — nice and friendly like sir!"

Blazier paused for a moment thinking out the remote possibilities. He made his decision and issued a call to all the gunnery positions, "Gunners! Do not shoot it down. I repeat... *DO NOT SHOOT IT DOWN!* Let's bring that puppy down under full escort. It's likely a deserter, but let's put every gun in the air and ground on it! Be ready!" Several itching

index fingers twitched nervously between the trigger and safety as they kept the slow bogey in the crosshairs.

Next Blazier alerted High Command giving the order, "Major Shaw, alert all the brass! We have a solo enemy fighter approaching the base. It's giving us all non-hostile signs and displaying our colors. We have every available AA gun trained on it. We have an escort of P-38's coming in to shadow it."

Before they took off, Colonel Gunn told Bezu what to do to try to keep from being shot out of the sky when they reached friendly territory. Gunn was happy the 550 mile flight was quick and uneventful so far. He was squeezed into the lower fuselage behind the cockpit just below the pilot's feet. There was no light in the compartment. It was cramped and very disorienting since he could not see anything and was lying prone. This caused him to roll and dip with the plane blindly following the movement as opposed to leaning into the plane's moves as the pilot does. He had never felt nausea in a plane before. On this trip the sensation never left him.

Upon approach Bezu was flying in so slowly, he was afraid he might stall and crash. He began waving his hand as well as dipping the plane wings over each gun emplacement. The daring Ace flew close enough to see the gunners eyes squinting through sites aimed at him. He genuflected as he passed each one when the gunner did not open fire. Overhead four American fighters arrived and flew in tight formation on all quarters of their quarry. As Bezu approached the runway he saw it lined on both sides with jeeps mounted with machine guns. The plane dropped softly to the pavement. With Colonel Gunn in mind Bezu managed one of the smoothest landings he had ever executed.

The plane rolled to a stop with an escort of armed jeeps racing up to surround the enemy fighter. The formation of P-38s flew over the top of the craft. Bezu opened the sliding glass hatch and clamored out smiling and waving at the heavily armed greeting party.

"Greetings from Romania!" Bezu stood confidently on the wing with a beaming smiling, his goggles pulled above his eyes, and his arms folded across his chest as his white scarf billowed out flowing in the breeze.

The MPs and other soldiers closed the circle around the foreign and enemy pilot. Bezu jumped from the wing and quickly unscrewed and raised the radio access panel. As he reached in he heard many weapons click into the ready. He paused for a moment, looked back at the soldiers and smiled. Then with the flare of a showman he pulled on a pair of

shoes for all to see. The legs of Colonel Gunn were pulled, and finally he extracted the dizzy and staggering American.

"I bring you... *an American!* Colonel Gunn!" Bezu applauded to himself gleefully.

Awkwardly Colonel Gunn wobbled, his cold and cramped muscles fighting gravity. Bezu supported the Colonel and used his scarf to wipe vomit from the American's left cheek. Two MPs flanked the officer, recognized the uniform and rank, and grabbed Gunn by the arms. They supported him as he urged them, "Take us to the Base Commander immediately!"

He glanced back at Bezu who with a dozen pistols and rifles pointed at his head was being frisked and readied for the brig. The two MPs attending to Bezu saw the Colonel's look and quit their search snapping to attention. "See that he gets a *good* meal... *and* some cognac! Take him to your officer's canteen! He's one hell of a pilot and one of the bravest men I know. He's here as my guest shall I say. I will join him later."

The predicament of the American POW camp in Bucharest was obvious to the Air Command once they were briefed by Gunn. The British were immediately advised to suspend bombing in the areas of the prison and Popesti aerodrome. An escape plan was needed immediately. Neither the retreating Germans nor the advancing Russians would be trusted to act within the general accords of war. Over 1400 airmen's lives were at stake.

Within hours a plan for the largest prison breakout in military annals was hatched. An O.S.S. officer who had staged a number of Allied breakouts in Europe would be flown in that day from Brussels. He would return with Colonel Bezu the next morning to go to the prison and organize the POWs. The Air Command immediately gutted both a B-17 and B-24 and began running landing and takeoff tests on them. They were loaded with 4,000 pounds of sand bags — or roughly two hundred pounds of airman, times twenty men per plane. There would be a short runway in Romania to deal with and hopefully it would not be damaged. It also had to be determined which plane could best handle its unusual cargo. On this unique mission they would be empty leaving and loaded with men on their return.

Though many of the POWs had been on B-24s for their missions, it was determined that the B-17 was best suited for the take off conditions

and maximizing the number of men they could haul. They would have to fly in without any armament to make room for the precious human cargo. An armada of fighters, however, would provide heavy escort. Other bombing missions on German targets would be pursued to create diversions and to provide payback to the Germans who had unleashed their revenge attacks on the city... a promise Gunn had made to the Romanian High Command. There would be a lot of fingers crossed the following day when the bombers left on this mission of life — not their usual death and destruction.

The next morning Colonel Bezu took off solo in a new toy. He had been awarded his own P-38 by the Americans to fly back to Romania. He considered it an even trade-in for his old German fighter. It seemed no matter what side he was on they eagerly wanted him to fly one of their planes. Behind him in two more P-38s was a specialized crew of men who were trained to conduct POW breakouts. Colonel Kraiger had arrived from Belgium and had been thoroughly briefed by both Gunn and the Romanian ace. He would head the breakout and three other military personnel who had accompanied him the previous day lifted up in tandem. The three metal raptors aimed east for the return to Bucharest air field they hoped was still under Romanian control. Each American was versed on the orders, redundancy in the event anyone was shot down. There would likely be no opportunity for a do-over. The fighter planes made the return trip in less than two hours, much faster than the lumbering bombers would take.

As a student of flying Bezu was having the time of his life in the high performance fighter — compared with his dated Messerschmitt. He spent most of the return trip testing the controls to demonstrate to himself the plane's maneuverability and speed. The American fighter planes were far superior to even the more advanced German planes. The other pilots on the return flight laughed at the Romanian hero as he learned literally by the seat of his pants to fly his shiny new toy. The other pilots performed maneuvers which Bezu attempted to copy to their amusement and his excitement. It was an exhilarating reward for his heroic efforts.

There were no encounters with Germans on the return to Romania. Bezu figured they were all covering the retreating German army. There were no assets more valuable to protect than their own troops. Unknown to the Romanian flyer, the Americans had decided to have him land first in case there was a trap or the airfield had been overrun by Germans or Russians and in case the fields had been sabotaged. It was a cheap ruse,

yet if Bezu had known their concerns he would have volunteered to go in first anyway. It was after all, *his* aerodrome.

As a genuine Romanian war hero Bezu was use to being in the spotlight. He knew his newest prize of the war; an American fighter plane would elevate his reputation in Romania to even greater heights. As the nation's top ace flying a single seat iconic German fighter he had shot many Americans and Russians out of the air. The two seat twin hulled American fighter, a Lightning, he flew back to Romania was much bigger and faster than his Bf-109g, much more heavily armed, and lacked only in its finer maneuverability capabilities. During his return ride with the opportunity he had to take the controls for the flight, Bezu was very envious of the American fighters. His longevity as a fighter pilot later in the war, he had become convinced, was due to his ability to avoid the American fighter escorts. After flying in one and seeing its capabilities firsthand he knew his assumption was correct. As the American fighter squadron approached the airfield, Bezu radioed down to the Popesti control tower and advised, "The *Americans* are arriving!"

The Popesti airfield was still secure though pock marked from Allied bombings earlier in the campaign. But, the runway was intact. It had not been cut up or sabotaged since he left, and Bezu landed without incident. After emerging triumphantly from the American fighter plane he was carried off on the shoulders of his cheering countryman accompanied by popping champagne bottles into the hanger, a hero yet again.

The other planes followed behind Bezu. The Americans who landed after Bezu immediately began to reconnoiter the airfield, its defenses, and how they would be able to carry out the daring rescue of fourteen hundred American POWs. In command Colonel Kraiger quickly assessed the situation. He had been instrumental in several POW liberations in Eastern Europe, but never one of this magnitude. Timing and execution were going to make or break this operation.

In quick order and Col. Kraiger gave instructions to the others of his reconnaissance crew. The Colonel was greeted by Princess Catherine who had paced for hours awaiting their return. Colonel Kraiger gave his orders relative to the airfield and hopped into her touring car. The Colonel had been advised by Bezu who he would need to work with in Romania if the escape was to be pulled off and it was not anyone from the military. The two sped off to the prison to organize the operation.

The field was small, actually barely long enough for the B-17s to land. There was little room for maneuvering the planes. With hundreds of the POWs and Romanian troops that would deployed on the grass edges of the landing strip, the best option appeared to be to land the planes by squadron, four in a group and one at a time, load twenty airmen on each retrofitted B-17, and take off immediately. Once they were in the air the next group would land. It would greatly reduce the exposure on the ground and the amount of time the fighters would have to fly escort and cover the rescue planes. The protection by the fighter escorts was tantamount since the bombers were stripped of all weapons and only three crew essential members — the pilot, co-pilot, and navigator — were used to make more room for the prisoners being rescued.

Before Bezu was able to finish his bottle of champagne, he was asked to re-board his American fighter and return to Bari, Italy yet again. The advance group quickly established radio communication with Air Command Headquarters. The American commanders and Colonel Gunn wanted Bezu to brief them further on all German ground defenses and air fields. In light of the Luftwaffe's recent attacks against Bucharest and the POW camps a previously unthought-of of crisis existed that added further urgency to the rescue attempt. They wanted not only to guarantee the safety of their bombers and POWs; they also needed to occupy the remaining German air force so there would be no raids on the Popseti aerodrome. Any attack could destroy the field making it impossible to land the huge bombers. Attacks from the air by German fighters could be devastating once the rescue mission began. There was always the fear that there were spies or informants who would tip off the Germans.

Colonel Gunn had also convinced the American commanders to extract the revenge the Romanians requested of him against Luftwaffe Commander General Gerstenberg. Hitler's orders to bomb Romanian civilian targets while the Germans retreated as punishment for Romania switching sides seemed an atrocity though it would soon pale with discoveries within the Nazi concentration camps. The attack of German bombers and strafing by the fighters went on unopposed for three days until the American response. This German attack was met with a good measure of America's might following the third day resulting in the destruction of the Luftwaffe's remaining air assets. The Germans could do little against Romania after 24 hours of Allied bombing raids aimed solely at their once vaunted air force.

While traveling with the colonel to CC#13 Catherine provided an

update. "Things have worsened dramatically. Our Romanian soldiers took some small arms fire from advancing Russian patrols that have been probing the city. The main divisions of their advance are just several days away!" she explained as they entered the outer limits of Bucharest. "Some of the POWs have been exploring the city — in the event you did not make it here. They had a plan to disperse into the mountains — each for themselves, until things settled... the Russians in, the Germans out, and the Romanians under any rock or other hiding place they could find.

"At 1400 men their numbers were too great and resources too minimal to logistically support themselves in a large group. Hiding, it was decided, would be easier in small groups; and many would have been left behind too sick or injured to survive the rigors of being out in the elements."

Colonel Kraiger looked out the car's window at the horizon, seeing it was peppered with plumes of smoke from recent Red Army mortar and cannon fire or from smoldering fires of past explosions by the Germans and the Allies. It was a hell on earth such as he had never witnessed, and he was glad he would get these men out so they would not have to suffer through anymore of it.

"Princess Catherine, when you have dropped us off, you'll need to leave the city. It will not be safe for you to stay. Go back to your orphanage and be with your children. Your boys will be gone tomorrow."

Those words landed heavily and with finality upon Catherine. She knew that was what they all had been so feverishly working towards the past several days. Yet being herself so busy, the thought of the Americans being gone had not settled into her consciousness. The world was so in turmoil, so uncertain. These brave wonderful liberators who she enjoyed so much would soon leave her country – and be replaced by ruthless Russians... She put that thought out of her mind and began to focus on what she needed to do for her orphans. And despite the dangers she knew she existed Catherine was not quite ready to leave. Her 'boys' in the 'Gilded Cage' needed to be rescued and their fate was not known.

A Dangerous Place to Be

After Colonel Gunn departed with the Romanian ace the POWs of CC13 were in a state of high anxiety. The ensuing 72 hours at the prison camps had seen confusion, chaos, destruction and death from the German revenge air bombings. There was also the unknown factor... did Colonel Gunn make it through? How long should they wait for word before heading out away from the city. Furthermore, did the prisoners, their comrades in the Timisul camp even know a rescue attempt was in the works? There was no direct communication with them. In Bucharest the men wondered what the arrangements would be or if there even was a breakout in their future? Some made plans to head out on their own. Others were making plans to buddy-up with a prison mate or in small groups such as surviving bomber crewmates. There was a growing sentiment of thought that it was best to have security with numbers as a large single regiment. Still others feared the logistics of supplying such a large force was beyond the means of a POW detachment unless the Romanian army was able to assist.

Questions existed about what they would find on the outside. How would the civilian population of Romanians treat them? Many had faced pitch forks and axes upon their first arrival. After all the Americans had bombed them heavily for over a year, killing people, ruining homes, destroying places of work, and countless special and historic sites. How would they be received beyond the protective embrace of their Angel, Princess Catherine? Of course there were lingering doubts about the Reds. Would the Russians be friendly? They were America's ally, yet so many foreboding stories had been told.

There was a new urgency to leaving the prison barracks. Gunn departed without knowing that the day he flew to Italy, Bucharest came under bombardment from a new more deadly source, the vengeful

Luftwaffe. All day German bombers and fighters dropped their payloads against both Romanian civilian positions and military posts, including the prison barracks, in complete disregard of the Geneva Accords. Hitler was enraged at the capitulation and wanted to extract revenge against the population. The madman's days in his bunker were limited, but he saw nothing other than the psychotic mural he painted within his deranged mind. He could not understand or accept reality. Everyone was either lying to him or being disloyal. The dictator was an island surrounded by an ocean of his own insecurity and hate that was engulfing him.

Several American prisoners lost their lives in the raids. The infirmary was also hit forcing an evacuation of the wounded and the loss of equipment and the meager stores of medicine and pain killers. Several of the more severely wounded would not last long without proper care and medication. A way would need to be found to transport those men to a Romanian hospital — if one could be found — if it would accept them.

Lt. Colonel Tillman was left in command when Gunn departed. All the weapons and munitions left behind were commandeered and distributed to the fittest of the ranks — typically those who had escaped injury and had been imprisoned less than a couple of months. Tillman organized several patrols to reconnoiter the city, find a hospital, get a sense of the German and Russian positions and activities, and perhaps scrounge up some food. The prison's stores had been fleeced bare by the guards on their way out.

A final warning was given before the bands of men left. "Don't get split up! Watch your backs. Avoid encounters of any kind. You've been imprisoned once already — do not test your luck again — remember Colonel Gunn's warning, next time you won't be a prisoner — you'll be a human shield, war trophy, a hostage, or even a target of spite. In the environment out there, I would not count on the Geneva Accords! We've already witnessed what the Germans think of them. And don't count on the Russians either; you don't want to become slave labor."

Augustine, Bennett, and Glover were crewmates who already knew each other well from training and missions. They were from the Midwest, all athletes in high school and avid hunters. They did not know much about Bucharest, but they were strong, agile, crack shots, and knew their directions — they would not get lost. More importantly they had only been

shot down several weeks earlier. The three still retained their endurance, strength, and were relatively healthy.

They cautiously walked outside the prison under the dim light of a fading dusk. The cover of darkness limited what they might be able to find, but it more importantly limited the chance they themselves might be found. Although they were airman and as such had not been trained in scouting, these three were perhaps the best equipped to handle the chore based upon their earlier years of stealth needed while hunting in the woods back home only this time their position would be reversed.

The three slipped down alleys, clinging to buildings and doorways as they traversed streets, always keeping their bearings if a fast retreat was needed. They had been out for several hours and still no locals were to be found having either fled the city's bombings or hiding deep within their sanctuaries. The city was in a blackout due to the bombardments, though the Allied raids had mercifully stopped the past two days. The clear sky would have meant good bombing, on this night, however, it provided just enough light for the men to see the silvery outlines of things in the night. As they came up to a tributary, a creek within a broad willowed ditch that flowed to the nearby Danube, there was the sound of trucks approaching. The three dropped and rolled into the thickets of the creek bank. Three German trucks pulled up at a small public square, not more than 150 yards from the three Americans.

"What do you see Glover?" whispered Bennett. Glover put up a hand to Augustine and Bennett to signal quiet.

The three trucks, each with four German soldiers; were not on a patrol, they were collecting war booty for their commandant. They pulled a rattling case out of the lead truck. Glover heard the pop of a cork and some laughter from the Germans as cups were filled. Surely a bottle or two wouldn't be missed by their commander. Several minutes dragged by with occasional whispers in German — accompanied by the noise of the glass bottle touching tin as cups were refilled. Not far away Bennett thought he heard several muffled metallic clicks. Then nothing, just idle, meaningless German chatter from the trucks filled with stolen Romanian goods.

Suddenly there was a flash and a sharp crack, followed by a multiple of blinding flashes and an eruption of rat-a-tats echoing across the little plaza, like multiple snare drums being pounded by drumsticks. Germans screamed out, several slumping, others were knocked violently from their seats. One could be heard calling out, but the words were distorted by

a gurgling noise as blood frothed into his mouth from his lungs. Shots came back from the truck, the panicked Germans firing into the eerie nightscape in all directions. Several rounds whizzed over the hidden Americans who had plastered their bodies as deep into the muck as they could. Five of the twelve Germans scrambled into the truck farthest from the Americans and their unknown attackers and sped away — leaving the other two trucks and several of their comrades writhing in agony, calling out in frantic, pained pleas.

Glover, Bennett, and Augustine incredulously watched as at least a dozen Russians appeared from three nearby points around the square. They had triangulated the Germans in a perfect ambush. One group of the Reds was lying in the same creek bank as the Americans perhaps only 100 yards away. The three Americans surely had miraculously just been spared their own lives.

The Russians swooped to their quarry and their prize. Several climbed on board the trucks to inspect their captured treasure while a couple of the Red soldiers gathered up the unfinished bottles of spirits and hurriedly drank the contents down. Four Russians inspected the Germans — several were on the ground, three not moving. Four more Germans left behind with wounds were sitting up as best they could placing hands in the air or behind their heads in surrender.

There were no directions, nor orders. It seemed as if no one was in command. One of the Russians looked at their German prisoners contemptuously. He spit on one and then kicked another in the ribs. The German curled up in agony. One of the Russians popped out of the back of the truck with a bottle of liquor in each hand. There was great joy among the entire band of marauders. He sat down on the tailgate of the lorry and said something while pointing at their captives and popped a bottles cork. One of the Germans must have understood Russian and began to scream, "Nein, Nein!"

The Russian standing alongside looked at him and smiled, "Da, da!" he said calmly as he raised his Zukof and shot the German between the eyes. The Americans witnessing the carnage could see the orange flash of the gun shot in the shadowy darkness, but fortunately were spared seeing the splatter of brains follow the bullet out of the back of the German's head. The other Russians followed suit, executing the remaining living Germans, almost casually, and then joined their comrades who were already drinking from the newly opened bottles of plum brandy. To the victors — the spoils.

Glover, Bennett, and Augustine crawled away from the bloody booze party scene through the weeds and thickets of the soggy creek bottom. They had no desire to meet and greet their allies from the west, especially if their counter parts were drunk. The Americans crawled through the muck for five minutes before risking a return to the streets of the city under siege. They huddled together in an alley off the darkened street covered with mud from head to toe.

Glover looked at his companions. "Do you realize we were a couple of steps away from walking into the middle of that mess?"

"Yes, and from the looks of it, those Ruskies wouldn't have cared much if we *did* get in the way," Bennett replied to acknowledging nods from the other two.

Augustine spoke, "Fellas, we've got the answer to a couple of our orders, there are Germans *and* Russians out here, and it is... a *very*, very dangerous place to be. Now let's try to find some grub for the boys and get the heck out of here!"

Earlier she had watched the silhouette of the Messerschmitt disappear into the red blaze of the rising sun Catherine chose not to wait around. She knew the plane would not be returning from its 'test' flight, and she had one other place to go. Nicholas was tapped on the shoulder and the well-used touring car exited the gates of the Popesti Aerodrome and headed for the mountains of Timisul. The prisoners there needed to be aware of what was happening and had to somehow be transported to the airfield if they were to escape or otherwise joined with the other POWs within the Bucharest in whatever the alternative escape plan would be.

Word of the capitulation spread rapidly. The guards at the 'Gilded Cage' in the mountains began hugging their former captives and announced, "Bune Comrade!"

As the reality of freedom began to sink in, the reality of how to actually carry it out became a burden to the POWs. All the men had knapsacks with extra clothing and other odds and ends to be used in an escape. Their packs and clothing had been assembled and made courtesy of the Princess's donations provided to the prisoners for their earlier theatrical production.

What was happening with the Americans in Bucharest they wondered? The Princess had indicated there were over a thousand men imprisoned in the city. What would the Germans do as they retreated?

Would the Americans be a target of slaughter, angry retaliation? Would the American lives be barter for passage back to Germany, to be a shield or slave labor? What about the Russians? Would their fates be any better in the hands of the Reds?

The men of Timisul had become great companions with the Russian prisoners who had been their cooks for the past year and a half. But those friendships were a thin veil for the onslaught of the massive Red Army that was bearing down with all guns blazing and to hell with anything that got in their way. The Americans in the mountains had not been so isolated as to be immune from the rumors by the guards of the atrocities the Russians were inflicting and the warnings from their Princess did nothing to dissuade the rumors.

There was a warning called in from the Romanian military that the Germans were sending tanks to destroy the camp and its occupants. The men grabbed their packs and scrambled up the mountain side and remained in hiding until a prearranged signal appeared — a sheet hung from the top floor turret — calling them back to the courtyard. It had all been an ugly panic driven rumor. When they arrived they saw a familiar sight giving them encouragement. In the middle of the courtyard was the familiar Plymouth and standing up in the back seat greeting them, the Princess.

"Gather around 'boys'! This is what we know. We have flown one of you out; hopefully he will be in Bari, Italy by now. He vowed to find a way to get you out!"

A collective cheer rose from the hundred plus airmen.

"You will need to get to an airfield that the Romanian Army controls. I have made some stops and calls along the way and I think we have transportation arranged. However, it is too dangerous at this moment for you to come to Bucharest. The Germans are not very happy about being asked to leave. They have been bombing and strafing the city... mostly civilian targets... but also the prison of your comrades."

There was an angry reaction and a number of unsavory epithets hurled out at the Germans. Catherine responded to the oaths. "To that I add some of my own insults... and I can do it in their language!" Catherine laughed with the airmen and then continued, "For your safety you must leave here for it too may be a target. You will disburse into the nearby village of Piertrosita in small groups, two or three to a home. The locals will come by to get you. When it is safe to proceed to Bucharest we will send for you."

The next day there was a low rumbling as if a storm were rolling in... it wasn't the weather, however. The Romanian hosts explained it was the approaching Russians pursuing the fleeing Germans. The men had left their camp for their new hideout and were enjoying the hospitality of the local village. A number of men had even walked to a local café and used their Red Cross money to buy a breakfast of bacon and eggs, a rare treat only available in the countryside. Britt was sitting on the front porch of the house he was staying at when he saw a cloud of dust from the lane that was the highway to the plains of Ploesti below the mountains. As Britt watched, a convoy of twenty troop carrying German lorries rolled past. Britt acted casually as if he owned the place as the trucks rolled past. The Germans soldiers on board looked exhausted, dirty and tired of the fight. They had only their own survival urging them on and would fight if they had to but they certainly were not out looking for one, and of that Britt was grateful.

Several days passed and the men were getting anxious to get on with whatever it was they were going to be doing, but the respite was also welcomed. It was like being back home on a summer's weekend, very relaxed and above all, free — outside the walls of confinement at long last. That all changed on the morning of the fourth day. The Mayor of the village had just received word from the Princess that an American airlift was arriving that afternoon and though the route was not secure the airmen needed to make the journey immediately! A crude caravan of buses and trucks were assembled in the market place center.

The men boarded the five vehicles as if they were going on a picnic outing or a school field trip. They were celebratory and relaxed belying what they had endured for months. They hoped this was the beginning leg of their trip back to freedom. Britt boarded the last truck and as he closed the tailgate the caravan rolled out towards Bucharest.

The trip, however, was not to be a joy ride nor was not without mishap. The rough mountain road was not wide enough for two trucks to pass simultaneously so as trucks approached the American POW convoy pulled over to the edge of the road in a heavily wooded area. A German convoy was approaching headed away from Bucharest. The Americans sat silently as the trucks roared past. They could hear the Germans speaking among themselves. Occasionally, the opposing soldiers would look out at the old buses and trucks they passed. More than once the eyes of enemies met each other in silent stares. The convoy continued on without incident and everyone breathed a sigh of relief. The Americans

did bring about twenty old rifles left behind by their Romanian guards, but the only hope if there was a confrontation would have been to run into the wooded hills and pray the Germans were in too big a hurry fleeing the Russians to pursue them.

The caravan started rolling again and wound its way down the mountain. The first village on the plains was Tirgoviste. The caravan came to a stop at a fountain in a town center. The lead truck had a flat tire that needed to be changed. Men hopped off to relieve themselves behind buildings.

Another rumble and gnashing of gears was heard. It was smaller convoy of Germans. Again the trucks passed without incident until the last truck. It was unlikely the Nazis had any inkling that Americans were in the other vehicles. Perhaps it was thought that the men working on the flat tire were part of the Romanian Army that had just turned on the Germans making their bleak situation more desperate. Perhaps it was battle fatigue. Whatever the cause as the final truck drove past the fountain a German soldier stood and uttered an oath and sprayed the fountain plaza with a long burst from his machine gun.

Everyone hit the deck. The convoy continued out of the village. The men stood and dusted themselves... all but two. They were not even out of their vehicle. Sitting waiting patiently they both had been hit, one in the chest and the other in the head. Both were dead instantly and did not even have the chance to know what hit them. They were in Britt's truck and he looked at the men who had been sitting next to him in anguish. Their deaths seemed such a waste, but that was war.

Captain Taylor gathered his men and said a prayer over their fallen comrades. He took their tags and ordered the men be laid at the base of the fountain. He would have to let the locals see to a proper funeral for the two. The Captain had to get his men to the airport immediately. The remainder of the ride was soberly quiet. They had come so far together. They had all witnessed and suffered the trauma of death before. They thought that they had left that behind when they parachuted from their planes and were captured. Being imprisoned was not a joy, but it had become safe and secure. The war was nearing an end, but for two it had not come soon enough.

Glover, Bennett and Augustine finally succeeded in the second half of their mission. They found an abandoned German garrison with many

269

provisions left behind due to the hasty retreat. They found cases of rations and racks of bread. A German troop carrier with two blown tires had also been left behind. It could not be used to carry the retreating troops, but it filled the needs of the Americans just fine. They loaded it up and rode it back to the prison camp on the rims, sparks flying out from the wheels against cobblestones casting an eerie light show in the encroaching light of pre-dawn as they finally returned to Containment Camp 13.

They were met joyously by the anxious prisoners left to wait. The hungry liberated prisoners devoured the food. Unfortunately, many of the POWs who had been detained the longest ended up vomiting much of it. Their stomachs had contracted too much from months of deprivation. After the meager feast the hours dragged. The afternoon found those who were not on lookout or in defensive positions napping. There was yet to be any word from Colonel Gunn. Soon, perhaps, they would all be on their own.

A call from a lookout caused a wave of tension to ripple across the courtyard and a flurry of activity as men raced about. A small convoy of military trucks was heading towards the prison barracks. There was no immediate way of knowing if it was German, Romanian, or Russian troops. The prisoners with guns took up positions near the gates, and more guns protruded from windows facing the entrance.

The lorries were from the Romanian Army. A white flag was held out of the passenger's window and the Blue, Yellow, and Red Romanian flag rippled from a pole held out on the driver's side. As tumultuous as things were in the city, this convoy wanted no confusion as to who they were.

The convoy stopped a respectable 100 feet from the entrance gate. Eight men jumped out of the rear of the first lorry. As many as 30 rifles clicked to the ready position, trained on the men approaching the prison. Men holding the truce and Romanian flags left the truck and joined the group marching forward.

"Sir, I don't see any weapons!" called out one of the men at the gate.

"Colonel, I think I see American uniforms!" another called out to the prison camp commander who paced at the entrance to the building.

Tillman had yet to get word from Gunn's mission, and he was growing apprehensive. What did this band of Romanians want? He had gathered about 1100 men under his command. There were a large number of them too weak from long confinement and others injured when their planes were shot from the sky. Soon he would have some hard decisions

to make. Would he stay put and trust the invading Russians? Should the entire group move out of the city and if so where would they go? How could they defend themselves against a fully armed, albeit retreating German Army? Surely they would be taken as prisoners if they had a confrontation. Perhaps they would just be viewed as a nuisance and dealt with in a different more immediate and final fashion.

He could also let the healthy men find their own way and fend for themselves and, maybe, somehow find their way to an allied unit. Perhaps they could just find a place to hide out and blend in until the war ended. He would also have to keep a detachment of volunteers at the prison to aid the weak and injured and see what could be worked out with either the Romanian government or advancing Russians. He did not like any of those options. Perhaps those he was watching walk towards him might be a different option, the one he had been hoping.

"Let them in, bring them to my quarters."

As the group entered the prison gates it became obvious the soldiers in US Army garb were indeed Americans. They were mobbed immediately by the anxious prisoners. Lucky Strike cigarettes were passed around to men eager for an American smoke — American tobacco. The prisoners began to feel just a little closer to home, to freedom.

The procession moved across the courtyard and towards the building that had been their prison. As they made their way inside the cold stone building, one man emerged at the front of the pack. The figure in front was an imposing man standing at 6' 3" with broad shoulders and a commanding presence. His voice was deep; his eyes had a steely grey tint and a piercing stare that could bore a hole through a person. His jet black hair had flecks of silver at the temples providing a hint of wisdom and authority. There was no mistaking who was in command, but why he had come to Bucharest?

He entered Tillman's quarters and after a quick salute held out his right hand providing a firm handshake. In his left hand was a folder with papers giving him his orders. "I'm Colonel Kraiger of the OSS. My job is to get your men out of this hell and back into Allied territory. We have 24 hours to be ready."

271

CHAPTER 24

Your American Orphans Are Going Home

The wait on the windswept tarmac seemed endless. Chaos enveloped the entire scene. Trucks arrived at the aerodrome carrying the POWs from the schoolhouse prison in Bucharest. Catherine thought the downed airmen were most noticeably differentiated by their physical conditions. Those who had been imprisoned the longest looked the worst. Those who had been held more than three months were showing dramatic weight loss. Clothes fitting loosely, shoulders appearing more squared as the collar bone — not muscle — formed the top framework from which their uniform hung. Necks seemed long, again an optical illusion as the shrunken neck made a pointy Adam's apple protrude from a slender stem that supported a head with sunken drawn cheeks and hollow eyes. Their walking seemed stiff and many shuffled their feet to get around as the muscle tone and natural coordination had suffered from inactivity as well as the malnutrition. Catherine regretted she could not have done more for them.

Nonetheless they were battle ready in their minds and when their roles were abruptly switched from prisoners to soldiers the men's spirits would supplant their physical infirmities. They might not hold up long, but there would be fight offered if needed. She knew these were formerly very fit young men — the enlisted were generally younger and in their teens and twenties. Many of the officers were in their twenties though a number looked to Catherine to be in their thirties. However, the war and their stay in Romania had aged her 'boys'.

As Nicholas drove slowly along the airstrip Catherine observed the men looked pale and it was not just from a lack of sunlight. Those in worse conditions with infections, dysentery, or perhaps just a cold virus had an ashen paleness, not unlike the faces of the typhus ridden soldiers

she treated in the Tirgu Hospital of Grumazesti in Moldovia nearly thirty years earlier in WWI.

The airmen who had been downed recently appeared to be fitter, healthier, unless they had been injured in their plane or in their fall from the sky. Those lads bore the banner of white gauze, some still smudged with dark patches of blood leaking from recent unhealed wounds. Many walked with casts and crutches or canes — some stubbornly dragged a limb unaided. Others walked with the help of a comrade. They all were being assembled in the untended grass way alongside the main runway, all but the hundred from the 'Gilded Cage' in the mountains. Catherine prayed they would arrive in time — that they had not been ambushed or captured by the Germans or the Russians along the way.

Col. Kraiger stood in an open-topped car secured for him by the Romanian Army. He looked at rosters of soldiers being brought up to him by the able-bodied POWs. The groups of twenty were divided roughly equally between the healthy and the sick and injured. He wanted those less mobile to have a healthy buddy to help them board the plane for the trip home. The loading of the planes was going to have to be accomplished quickly. No one knew what the Germans might attempt or for that matter the Russians.

The bombing of the infirmary just the night before had been lesson enough to Col. Kraiger who currently had only remnant units of the Romanian Army — such as it was — to surround the airbase and provide cover keeping both the retreating German Army and the advancing Russian Army at bay. They had no anti-aircraft weaponry to fight off any Messerschmitts or Stukas. The German dive bombers daily bombing missions since the King's denouncement of Romania's cooperation with the Axis had wreaked havoc and death throughout the city. The targets were sometimes aimed at advancing columns of Russians, but more recently were aimed as retaliatory strikes against Romanian Army positions, the palace, civilian gathering places, upon assets they did not want to be used against their retreat and, yesterday, at the prison camp. As it was, the pulsating boom of cannon fire from the advancing Russian army left echoing reverberations careening through the air. Columns of smoke on the surrounding horizons put sinister exclamations on the explosions.

The day's events would not be settled in Catherine's mind until the transports arrived from Timisul — until her 'boys' from the mountain resort arrived. Those 104 POWs had been under Catherine's care the longest — nearly eighteen months. They were the men for whom she had

fought so fiercely with the Germans and her own countrymen to spare, to treat with deference, and to have held as Romanian prisoners. She knew most of that group by name. With some she had spent considerable time making sure they healed from many devastating wounds. The first airman — the one who had fallen from the sky into her garden — the dead one who moved, and with whom she had had a tug of war with German officers — Richard Britt would be among those prisoners. He had miraculously survived his wounds.

By eleven that morning all the prisoners of CC #13 had arrived and been divided into their lots of twenty. The airlift bombers were expected by 1 p.m. Col. Kraiger was in direct radio contact with American Air Command in Italy. The lead detachment of escort fighters was expected by noon to clear the air of all German Luftwaffe. There could be no messy situation at the aerodrome. Not a single bomb crater in the runway.

He could not allow Catherine to be in the area any longer. He gave word to his Lieutenant to escort her outside the fence with a warning that she should be returning to the orphanage in Ploesti; the Russians were advancing on the city. And, oh yes, he needed to thank her for her efforts.

"Where are the boys from the hotel on the mountain?" Catherine asked as she accepted her orders to evacuate. The response was shrugged shoulders. There was no word from the group, just that they had been told to come to the aerodrome.

There was no telling what might happen over the airfield. Would the Germans have received word of the rescue attempt, make a last ditch effort of revenge and attack the airfield? Strafing or bombing runs would be devastating on the men in the open fields. If the runways were cratered by bombs the mission would be scrubbed. The large B-17s needed the full length of the short main runway to take off with their precious cargo of liberated airmen on board. She worried too about the Russian Army. As Catherine's Grandpapa would often say, "One's reputation often precedes one's actual self."

The Russians were known well by the Germans and those of Eastern Europe who had lived in the Bear's shadow for centuries. The Americans and Brits entered their association with Stalin and his henchmen with open arms and trusting attitudes, but reports of the atrocities of the Red Army combined with reports and examples of truth bending and manipulation of agreements caused concern and reticence. Would they attack the airport under the guise of disabling the facility from the Nazis

and from the Romanians who had only several days ago been firing upon them from beside the German Army? Perhaps they had sinister designs on the American prisoners. It was a certainty that they had sources within Bucharest providing intelligence about the assembling American POW contingent at the airfield.

The old touring Plymouth roared its engines and lumbered down the runway. It was to be Catherine's farewell review of the troops. She stood in the back seat and waved her hankie in a fond but sad sendoff to the prisoners. Those that were able stood and either waved back or saluted her. Those not able to stand raised canes and crutches high into the air or saluted to the sky as they lay on their backs looking skyward. As she passed she could hear a cheer rise up from the tarmac. The familiar cheer, "Hip, hip hooray!" for the 'Angel of Ploesti', rippled down the runway. She smiled and waved back. They would not see her tears.

Most knew or sensed that this small of stature but large of heart and determined woman had either directly or indirectly saved their lives. She was now bound down a runway in a cloud of dust and uncertainty, just as her American 'boys' hoped their own uncertainty would soon disappear. In hours they hoped they would be lifting off from their princess' beloved country in streams of contrails as they winged to safety... paths likely to never be crossed again.

As the big car left, the aerodrome entrance gate was being pushed closed by the Romanian soldiers guarding the sand-bagged position. The Plymouth turned to head north, toward the distant orphanage compounds of the Ploesti region when Catherine noticed the gate swinging back open.

She called out, "*Stop* the car, Nicholas! *Stop!*" A column of dusty trucks and buses barreled up from the intersecting street. Catherine turned and climbed up the back seat of her car to watch. The leading trucks were Romanian troop carriers and they were followed by two old school buses. The vehicles were confiscated by the Romanian Army to transport the POWs of Timisul, her 'boys' from the 'Gilded Cage'!

"They made it!" Catherine sighed a deep breath of relief and she waved a greeting and goodbye to the lumbering convoy.

Some of the passengers, her 'boys', saw her and waved back. Several vehicles tooted horns. They roared past hell-bent for the aerodrome. The last bus rolled past. There, in the back seat sat Dick Britt, at first not aware of what the men in front were hollering about. It had been a rough bouncy ride after the incident at the fountain, with several tense moments

as retreating German Army columns roared past going in the opposite direction. The POW convoy under orders from Captain Taylor was racing at full acceleration to the airstrip without stopping for anything. He did not want to risk any more of his men and he did not want them to miss their flights. A few random rifle shots had been unloosed at the caravan without hitting anyone as it entered the city, but the Germans were more intent on fleeing the advancing Russians than engaging what appeared to be a column of Romanian soldiers or civilians — no flags with national colors were displayed.

Hearing several men utter 'Princess'! Britt turned his head and looked out of the window as the bus rumbled toward the gated aerodrome compound. His attention was drawn to the waving white object. There was the Princess, the courageous woman, one like no other he ever had or would ever again know. His eyes looked briefly into the distant glistening eyes of his 'Princess' — *his* very special 'Angel'. He raised his hand to wave, it seemed so inadequate. His lips moved as he said, "Adieu," — her favorite way to leave — 'farewell, not goodbye... have a good journey, till we meet again... and finally he uttered, "May there be a road", as he had heard Catherine so often say.

Sadly, hesitantly, Catherine waved again, this time perhaps a more poignant, real farewell... as the trucks and buses disappeared and the gates swung closed. She called out to no one and to everyone... to her 'boys' going home — "Adieu!" As the dust of the last bus settled out of sight and her hand dropped to her side she whispered almost as in a prayer, "until we meet again... May there be a road!"

Col. Kraiger looked at his watch as the three men from his personal detachment moved without needing his orders to meet the newly arrived caravan and the last of his charges; all told he was in command of 1274 downed airman. There were an estimated 1400 accounted for by the Red Cross. The Colonel could only assume the variance of numbers came from several sources. Their records may have been inaccurate. Some of the freed men of their own volition had headed for the hills before the 'Breakout Commander' arrived and never received word of the rescue. They were on their own, as they had chosen. Others were scattered about the city and countryside in hospitals with severe injuries. They would be left to the mercies of the advancing Russian Army.

As the men from this last group of mountain POWs filed off the

vehicles inside the compound, rosters where handed to Kraiger's two uniformed American MPs greeting them. They were sorted and assigned slots in the formation of soldiers already in the grass along the landing strip. They were marching to their designated areas when a scream echoed across the tarmac.

"Hit the deck! Dive bombers!"

The distant hum of high pitched airplane engines turned into the screaming yowl of a ton of high horse powered death machine. The men just arriving had not heard the noise in the sky as the engines still idled from the caravan of troop carriers. As they idled away the time unaware, the small specs appeared in the western sky. Squadrons of fighter planes were approaching rapidly. Upon hearing the warning shout the men hit the ground and lay flat, trying to become worms and wiggle deep into the earth.

An officer standing with Col. Kraiger peered through his binoculars and sang out, "P-47s!"

The Jugs, or more officially Thunderbolts, were single seat, heavy but very fast fighters with a single nose mounted engine. Cheers went out as the men stood up and waved. Soon the sky was dotted with what seemed like hundreds of the squatty workhorses of the air corps fighters. The planes were not pretty, nor were the damage they could inflict. They were there to seek and destroy any German Me fighters that dared to be in the sky and challenge their arsenal of wing cannons. Squadron after squadron approached the air field and veered off in every direction — first dipping and wagging their wings in greeting to the men cheering them from below and then veering off looking for trouble if anyone dared. For fifteen minutes the planes circled, dove, and buzzed the aerodrome and fanned out to search for foes beyond the city. Their soon to be rescued comrades on the ground were being given quite an air show.

The high pitched drones of the P-47s faded and were replaced by a second wave of protectors, P-38s. The Lockheed Lightning was the first dual engine wing mount fighter to be introduced into the conflict. It was a marvelous deviation from conventional design with dual fuselages and tails and a pilot hull in the middle. They, too, swept past the air field then climbed to escort positions. Their job was to provide direct cover to the bombers that were soon to arrive.

Then came the sweetest music to the grounded army of airmen; the low rumble of the first B-17 bomber approaching the field flaps down. The already pounding in the hearts of the grounded bomber crews

accelerated. Col. Kraiger was barking orders and waving his arms in various motions, the meaning known only to his specialized team of breakout soldiers. As directed the first group of prisoners stood up and moved to the edge of the tarmac.

Approaching at near stalling speed the first air leviathan slowed quickly once it hit the runway. The plane loomed huge, its wheels kicking dust, gravel, and rubber on the rough surface when it touched Romanian terra-firma. The broken concrete strip was just long enough to handle the dark drab green bomber. The challenge remained — would the plane be able to take off with a full load? *Screaming Eagle* was painted on the first plane's forward fuselage, and it became visible to the liberated prisoners as it taxied to the end of the runway and turned 180 degrees to face the way it had just entered. The three other bombers of that first squad landed in quick succession once the first had shown it could be done. The *Screaming Eagle* had been the designated guinea pig, much as Bezu had been when the rescue team first arrived. Its success or failure would be the ultimate signal to the rest of the approaching rescue bombers. It taxied to a position parallel to the groups of waiting and cheering prisoners all engines still at full throttle. Word immediately went out to Air Command and the rest of the bombers, the mission was on!

The side doors opened and two soldiers waved to the first group of twenty. They hurried to the plane fighting against the dust and wind draft created by the whirling propellers. They climbed aboard using the belly ladder. The men of the group not able to use the ladder were thrown a harness and with a hoist from the top and a lift from the bottom all were efficiently elevated and assisted into the plane.

As they were brought on board they were saluted and greeted as welcomed warriors and "former POWs." They were issued a blanket and were positioned two by two, laying prone across the bomb bay door area that had been retrofitted with wooden decks for the men to lie across. All four planes of the first squadron landed quickly loaded their precious cargo without a hitch.

The former captives entering the crafts all instantly noticed there were no machine guns mounted on the planes, and no machine gunners. The navigator and engineer were the two men that helped them aboard; the pilot stayed at the controls. The engines were kept at a high pitch of revolutions with brakes applied and groaning against the thrust of the blades. As the last man was positioned and the door secured a thumb went up from the engineer to the pilot and the navigator strapped himself

into his nose position. The ground crew for Col. Kaiger received the thumbs up relay from the pilot and in return gave the pilot his all clear sign.

The first plane's engines revved to an even higher pitch and the brakes were released. The heavy machine lurched and skipped forward under the strain of rapid acceleration. It was scheduled to take less than twenty minutes for a squadron of four of the planes to land, turn, load, and take off. This first squad was on schedule. The first takeoff was still considered part of the experiment; could it get airborne on the short runway with a full load?

The men on the ground also noticed the plane was stripped of all armament. There were no machine guns protruding from the plane. They came to the realization that bomber crews were flying — unarmed — 550 miles into enemy territory to rescue their fallen comrades. The excess weight of the armament, munitions, and crew would have limited the space and payload of prisoners. Time was the critical factor in the breakout so the command decision had been made to fly the rescue planes naked. It reduced the number of plane missions needed to get the men out and so shortened the window of exposure and risk.

The first bomber throttled fully and skipped across the broken surface of the tarmac. The POWs still waiting to be liberated stood up anxiously to watch knowing their hopes of escape were now in the hands of a fellow pilot straining at the controls of the big war bird. Some cheered wildly, pushing their arms up against the invisible air perhaps hoping to give the plane a boost. Several put their heads down or their hands together utter a prayer. Others turned away choosing not to look and as many others just gazed silently at the delicate balance of tons of metal and men trying to ride the nothingness of thin air.

The **Screaming Eagle** lived up to its name as it bounced twice then slowly elevated off the runway with just several yards of pavement to spare. It groaned against gravity and quickly banked as the wheels beneath began to close into the plane. It headed west... to freedom. Behind it nearly 1200 gasps of relief and cheers of enthusiasm. They were going home! As the loaded bomber cleared the aerodrome the next B-17 behind it was already barreling down on the runway. When the third and fourth planes rose slowly into the sky another group of four bombers could be seen on the horizon heading in, and Colonel Kraiger — the land maestro of what was to be a well orchestrated choreograph of man and

machine — made his motion for the next four groups of twenty liberated prisoners to stand at the ready.

After the first four landings and take-offs had successfully been completed and it was determined the "experiment" they practiced in Bari could be executed in the field successfully, the next group of bombers in the flying armada landed. This second squadron of bombers had men getting off the planes before the liberated POWs could board. The first of one hundred sixty uniformed members of the Armistice Commission deplaned and deployed quickly. The contingent was made up of American, British, and French military advisers whose task was to work with the occupying Russian forces to establish an orderly transition to self rule following the nearly six years of control by the Nazi war machine. This perhaps would be the chance for salvation Catherine had wished for from the control by Russia that was feared. Likely their presence had not been requested by Stalin.

Roughly an equal number of personnel were dropped off as more squads of bombers repeated the dramatic fly-in. These disembarking personnel had a decidedly different purpose. There were about one hundred men and twenty women, in peasant and working garb. This group was immediately loaded into trucks and left the aerodrome. Speculation among the airmen waiting to leave was they were members of the OSS, spies sent in to disperse across the countryside to gather intelligence.

Twenty by twenty the rescued airmen were airlifted to the Allied Air Command in Bari, Italy. The effort stretched over five hours. From the distant horizon one squadron of retrofitted B-17s bore down on the airstrip as another peeled off to the left and headed west to friendly territory. The ***Windy City, Rip Van Winkle, American Queen, Nothing Exposed***, each with a unique insignia often punctuated by a depiction near its nose of a gorgeous and endowed girl of a soldier's dreams, landed, loaded, and took off.

By three in the afternoon squadrons of the sleek Mustang, the P-51 fighter swooped over the airfield in relief of the Lightings which had provided cover for the previous two hours. While this amazing display of air superiority played out above, the men below bided their time in a relaxed and joyous way trading pins and patches with the Romanian soldiers who had risked their lives to secure the base from both German and Russian incursions to make the rescue possible. These same soldiers were fighting to save this collection of their former prisoners. The Romanian Army days earlier was fighting with the Nazis; then against them; and had even been

surrendered to the1200 American POW's. Now they were participated in their airlift rescue; and within hours would be entrusting their lives and their country's future on just 160 American, British, and French advisors against one million of the Red Army. They had one million reasons to have doubts, but the 160 advisors gave them a glimmer of hope.

This heroic effort, the airlift breakout of 1200 POWs repeated itself seventy two times that afternoon in squadrons of four. Seventy-two missions of liberation, seventy-two acts of self-less courage as planes stripped of all defensive weapons flew into hostile territory with the sole purpose of plucking their comrades out of the bowels of purgatory and lift them away to a safe haven. It was a journey filled of unknowns, of trial, and with luck, no errors. It was one of the Air Corps finest moments... bravery, action, and compassion, a mission of life and not death and it was pulled off without a single loss.

Devlin was already in flight by the time the Mustangs took positions above the Popesti airfield. The flight back was a mixed and confusing time for the airmen. Several of the men in Joe's group of twenty had to be coaxed and shoved into the plane. The last time they were in a bomber, Lord knows what terror they had witnessed. One of them had poured a living man's intestines back into his ripped open body cavity and rocked the dying man for comfort as the stricken airman quickly met his maker. Another had seen a buddy engulfed in fuel and ignite like a torch. The man next to Joe witnessed others dive from a plane without enough altitude for their chutes to open. Climbing back into the steel superstructure, smelling the fuel, the exhaust, hearing the roar of the engines — any of these things may have triggered the nightmares that ravaged their inner beings that day. For many those ravages and those mental images would continue for a lifetime.

Most of the men, however, were happy to be getting one step closer to returning home. Others lay quietly on the planks in stunned silence, some curled into a fetal position — sobbing — whether for joy or fear would be their personal secret. Many of the prisoners had enough missions that when added to the bonus credit for being a POW, could muster out. Others would be given furloughs, 'time to fatten up' and then would be called back into the action. It was what they had signed up for, it was their duty.

When Joe climbed out of his plane after the highly anticipated touch-

down in Bari, Italy, he was surprised to find several large bonfires along the runway, surprised until a medic approached his group and told the men to strip off everything. The clothes were carted to a bonfire and added to the burn. Next the naked men were moved to a holding pen and another group of men in rubber suits with gas masks sprayed every liberated POW top to bottom with DDT to kill the lice and bed bugs. Immediately they were hurried to another station where a GI trim was administered to their matted hair and beards were shaved. The sheared hair was quickly swept up and added to the bonfires. They were next hustled to rows of portable showers for the first cleansing in months. Most stood under the spray of frigid water for as long as they could luxuriating in their wash despite the cold. New uniforms were issued and the last stop was a hanger set with tables and a mess. Turkey, mashed potatoes, and green beans in unlimited quantities were served. Unfortunately, the shrunken stomachs of most caused the food to come back up. But they all enjoyed the first attempt in a long time to satisfy their hunger with real food.

Grabbing the bars beside the fuselage hatch Britt boarded one of the last flights. The airmen of the low-level raid were the first in Romania and it turned out the last to leave. Britt settled in for his flight and found his thoughts meandering. There would be the camaraderie and jostling and joking of men being rescued after many months of captivity, followed by moments of retrospection. The war was not yet over, not as his German captures had once claimed, so what would his next assignment be? Would he fly again, could he... physically... mentally?

The door to the bomber shut with a loud clang of metal on metal. The engines revved and pushed against the brakes as pilot and copilot danced their tango to get the air ship sailing fast on the short runway. The plane lurched forward when the copilot released his hold on the brakes. Inside the men quieted as the metal vessel fought gravity and physics. It bounced several times before the bomber rose free of the earth.

As the plane grudgingly left the ground Britt's thoughts stayed in Romania for a moment. "Princess Catherine, return to your Romanian orphans now. Your American orphans are going home."

The road north of Bucharest was not as cratered or littered with debris, unlike the city that suffered under bombing first from British and

American aerial forces, then the Nazis, and finally, Russian land forces. Catherine made good progress that afternoon as she and Nicholas drove towards Ploesti. It had been a busy and challenging couple of days, and emotionally draining. There was a beautiful overlook from a hillside that panned across the plains southward to Bucharest, once thought of as the Paris of Eastern Europe, now just another war torn outpost of hungry, tired, and frightened mankind — the nameless victims of man's greatest failure of civilization — war.

The huge car strained to climb through the rolling terrain. At Catherine's order Nicholas came to a stop at the top of the hillock. She left the car and climbed to a rocky outcropping. Fighter planes of the American aerial cover for the rescue mission roamed the skies above her. There was no resistance from the German Luftwaffe. What was left of it had retreated to Germany after the raids of revenge against Romania to escape the ravages of the American offensive against it.

Catherine stood on a rock for a few moments her arms folded across her herself as if cradling something, perhaps her fleeting hopes, thinking for a fleeting moment about nothing, it seemed. Soon her thoughts took in a panorama, and she thought for a moment of happier times when her Grandpapa first brought her to this place. The distant silhouette of another American bomber rose from the ground and arched slowly in the sky across the horizon as it headed west with its precious cargo of former POWs, now liberated airmen. Catherine followed its path upward into the blue sky. Her 'boys' were now free. She moved higher up the rock to get a better view. As the first plane became a speck, she looked back along its path and saw another rescue plane reaching upward. Behind it yet another of the large craft was elevating above the low skyline of Bucharest.

The wind blew across her face from west to east tousling her hair and ruffling her long skirt. Catherine's gaze moved into the wind, westward. Was it the breeze that chilled her to a shiver? She rubbed her goose bumped arms. Plumes of smoke drifted eastward towards the city. She saw orange flashes arching briefly skyward and new plumes of smoke appeared downwind. It was the advancing tanks of the Red Army. Within days Bucharest would be in their control.

The cracks of the cannon and the thump of their impact see-sawed — out of rhythm with the visual view, distorted by the distance that the sound traveled — yet it was indeed a surreal image. From behind her a squadron of American P-38s raced up flying at tree top height. The four

fighters roared over the top of her, one after the other. Startled, Catherine ducked at first then turned to watch them zip past barely fifty feet above her head. They began to elevate and raced towards their charges on a mission to escort her 'boys' back to Italy, back to safety, back to freedom. Reminded perhaps of her personal mission, Catherine knew she hadn't the luxury of idle time. She turned and approached her faithful and brave driver. Catherine was certain he was not aware of what he was in for when he signed on — then again neither was she, but his loyalty never wavered. He had been with her for the entirety of the war as heroic as any soldier.

"Nicholas!" she hollered. "Let's get on the road! We've work to! Let's be off to the orphanages!"

It was not long before Catherine had her first direct encounter with the Russian Army. As Nicholas drove toward her estate at Nedelea, the distant booms of cannon fire she originally heard at Popesti Aerodrome continued to ring out and the sound grew louder. They were driving directly into the path of the advancing Reds. The lone car on the road rounded a bend and Nicholas hit the brakes.

"Madame, there is a Russian artillery company in the field ahead."

A vehicle raced toward the touring car. As the car pulled next to Catherine's a salvo of 10 cannons roared. They were aimed in the direction of Nedelea. The Russian officer stood up in his open sedan and barked commands in Russian. To his surprise Catherine stood in the back seat to face him and replied in Russian. "My home is in the direction you are firing! That is where we are headed!"

"Not today! My apologies in advance if we hit your home," replied the Russian with a cocky smile.

"What is your target? I have orphanages in that area!" Catherine protested.

"There was a column of Germans we have been chasing for a week. They are moving west. We simply are encouraging them to hurry up!"

The officer took a drink of clear liquid from a bottle. Catherine guessed it to be Russian issue 'potato' water. He wiped his mouth with his sleeve. "You can't go there today... maybe tomorrow."

A disgusted Catherine turned to her chauffer. "Turn around, Nicholas. Let's go back to the Burchi monastery we just passed and spend the night there."

The two spent the evening sharing the stone floors of the edifice with a dozen other people caught in the path of the military hide-and-seek game. By morning both Catherine and Nicholas were stiff from their respite on the cold stone floor of the church and anxious to return to Nedelea. A hazy morning had the lingering odor of explosives and burned diesel fuel from tanks and armored personnel carriers that had been filing past. The shelling had thankfully ceased during the night. Their route showed the results of the artillery. Several vehicles and homes were destroyed.

The road turned a bend into a wooded area. Nicolas slowed seeing trees had been laid across the road. He stepped out to see if there was room to get around the logs. Suddenly several Russian soldiers appeared. They pointed their rifles at Nicholas. Catherine grabbed her revolver from under the seat and hid it up her sleeve. She quickly jumped from the car and in Russian scolded the soldiers.

"If you cannot tell... we are not the German Army! Go do your job — so I can do mine!"

An officer walked out of the woods. He brandished a captured coveted black German Luger and said, "You can get around these trees only if you follow my directions."

Poking the gun against Catherine's chest he directed the driver to get into the car. The three sat in the front seat and the officer instructed Nicholas to drive to a small village off the main road. There another officer stood, looking to be of higher rank. He demanded Catherine's touring car. Catherine knew she would be losing her faithful car that day, but she needed transportation desperately for her orphanage. She explained her plight. The Russian considered her situation, and he agreed to a trade. Nicholas knew what was happening without knowledge of the language and deftly slipped his pistol from under the seat to beneath his belt covering it with his shirt. Catherine cast an anxious eye to the vehicle the officer offered in trade. Nicholas examined the beaten car. If it had been a horse trade it would have been described by a farmer as "ridden hard, and put up wet".

Nicholas was not sure the vehicle would run, but the Russian officer ordered a group of his men to give it a running push start. The vehicle sputtered and began chugging forward. It continued to run; carrying Catherine and Nicholas back to Nedelea. Catherine told Nicholas not to turn off the engine when she got out, but rather to drive on to the orphanage workshop. The beat up vehicle might not start again. The mechanically inclined boys on the estate could work together with the

farmers who were familiar with engines. Catherine was confident Nicholas would be able to keep it running.

Kinia rushed up to greet Catherine and looked questioningly at the strange vehicle. Suddenly the stresses and lack of sleep from the past several days all seemed to rush into Catherine's tired body at once. She was near collapse, but Kinia gave her strength. Catherine just shook her head sadly as she exchanged a big hug with her adored adopted Polish girl who was quickly reaching adulthood. Pulling back from the hug she looked at Kinia, brushing away a lock of brown hair from her brow. Catherine remembered the day back in WWI when she watched a parade of Russian soldiers with a young girl struggling in the back seat with a Russian officer. She feared for her Kinia.

Catherine looked at her charge and simply said, "Kinia, the Russians have arrived."

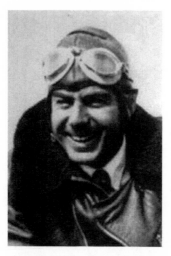

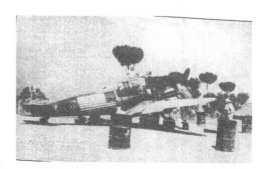

Col. Cantacuzene's Bf-109G2 with inverted U.S. flag painted on fuselage; used to fly American Colonel Gunn to Bari, Italy
Photos courtesy of U.S. Army

Prince Bezu Cantacuzene, Colonel in Romanian Air Force; top ace in Romania history with 60 planes to his credit

Col. Gunn and Col. Bezu celebrating successful escape in Italy

Decontamination of pilots and burning of clothing after breakout rescue flight from Bucharest to Bari, Italy

CHAPTER 25

Europe Got the Marshall Plan, We Got Raped

August 29, 1987, Dayton, Ohio

I could see the fury mount even though the memories were of so long ago. The Princess' thoughts traveled back forty years to the horrible aftermath of the war. Her face flushed, and she leaned forward in her chair. Then she pounded a fist on the table saying, "Everything was a mess!"

"Of course the war tore apart factories, homes, lives, and families. But such things can be dealt with when there is some order and a degree of confidence in one's government. Homes and factories can be rebuilt; limbs and families can mend, with love and care; the dead can be buried and mourned. No, it is not the physical belongings nor human frailties. It is the condition of the heart and mind. As I've said, a person needs hope. They need to feel secure; they need to have faith in their government and those in control; most importantly an individual and a society need freedom. Not unbridled freedom — that is anarchy. But there must be choice, an ability to express oneself, an opportunity to improve one's condition or be satisfied."

"The commies did not want that. They seek total control. They have all the answers... just ask them! Only they know what is best — and best is for them, not those they govern... no... that is not the right word. They do not govern; they dictate and use their pawns. Ah, their creed is such a sham... 'all power to the people'... such a lie!

"The Allies brought in an Armistice Commission of one hundred sixty American, British, and French bureaucrats, and some spies. The Russians brought in one million armed, hungry, thirsty soldiers filled with egos as the conquering warriors; emboldened with victory; and drunk with power and vodka. The mindset of the Russians was to rebuild their country on the backs of the Slavic nations. America focused on rebuilding Western Europe. Russia was left to its own devices to handle Eastern Europe.

"The Russian troops were unleashed, rampaging across the countryside as bands of thugs and looters. They stole our goods, molested our women, and defaced our culture. The evenings were punctuated by fear and the screams of victims. I am sorry to say Europe got the Marshall Plan, and we got raped! First they took our property... then they took our freedom."

The Princess pounded the table again. She looked at me then relaxed and smiled, settling back into her chair remarking, "You see my feelings still run deep."

<p style="text-align:center">*******</p>

No place and no one was safe from marauding Russian soldiers. A knock on the door at night might be an invitation for a house being ransacked or a gang rape. Many people were robbed and beaten on the streets in broad daylight, even stripped of their clothing, being left with literally nothing; having also been stripped of their humility. Catherine's work at the orphanages required significant travel around the villages that encompassed her orphanages, estates, and business holdings. Her notoriety had kept her safe initially. Nevertheless, her driver Nicholas carried a revolver under his seat as did Catherine.

The home at Nedelea was Catherine's retreat, a safe haven after a busy day. Her favorite relaxation was sitting with Kinia. A young, bright teen Kinia no longer was interested in stories or being read to at night. She enjoyed sitting with Catherine at the kitchen table, sharing a pot of tea and perhaps a biscuit or bowl of fruit and just talking. On one such occasion as they settled into the high-backed wooden chairs, warming their hands around the steeping cups of tea, there was a loud knock, almost a banging at the back door. All the doors of the house were always locked and the windows shuttered.

"Go to the bedroom, Kinia. Get into the safe locker," Catherine said, directing Kinia to slip into the hidden closet within her wardrobe. Catherine turned her attention towards the back entrance as a second; more urgent pounding against the stout oak door was heard.

"Who's there?" Catherine asked. She heard mumbles that she could not make out, but she was overwhelmed by the smell of body odor and cheap liquor. "Go away!" she said firmly and repeated it again in Russian.

The angry and drunk Russian soldier wanted in and uttered several phrases of which Catherine was not sure, but picked up enough words to gather he was speaking of animals and her ancestry. He rattled the

doorknob and shoved against it with his shoulder. The heavy oak door stood firm. Catherine again yelled at the would-be intruder to go away.

The enraged intruder took the butt of his revolver and smashed the glass of the small window at the top of the door. Glass shattered, showering Catherine with the shards. An arm reached through the high opening groping below for the door knob or a latch. Catherine grabbed a wooden meat tenderizing mallet hanging from the hook over the preparation table and thought how appropriate. Catherine's active life created a sturdy and stout frame. She took aim and holding it with two hands directed the mallet onto the roving arm striking the knuckles. She would take great joy in tenderizing this piece of meat.

The Russian shrieked with pain and reflexively yanked his arm away up through the jagged opening. This further compounding his pain as his jacket and skin tore against the jagged glass that remained in the frame. Blood spurted as the man's forearm was sliced in several places. He screamed with pain and rage. Putting his face up to the opening, though it was too high for the Russian to look down at Catherine crouched beneath it. He cursed his invisible foe.

Catherine screamed back at the soldier in Russian, "Leave!" then pulled back a right hand, stood quickly and punched with all her might, hitting him squarely in the nose. She pulled back a bloodied fist certain she had broken the nose of the would-be intruder. The belligerent man's left hand came back through the window holding the revolver. Catherine dove under the table as several shots were fired wildly, penetrating the walls and ceiling. Just as quickly the hand pulled back away from the door and the bloodied man retreated.

Catherine hurried to the bedroom and called Kinia, "Come out now, dear."

Catherin held a revolver she kept in the bedroom.

"What were the gunshots?" Kinia screamed before she was even out of the closet. She saw the blood on Catherine's hand and saw more splattered on her face and dress. "Oh, my! Are you hurt?"

"No, Kinia, this is not my blood. I'm fine. A bit worked up, but not as bad as our visitor!"

Kinia smiled in a knowing way, "Did Sergi and Uri help?"

"Yes, dear, I think they guided my hands again today."

Romania never had the luxury of postwar aid. America did not airlift

necessities. In fact, just the opposite occurred as truckloads, barges, and long chains of trains pulled out of Romanian depots and ports sending finished goods and raw materials across the steppes of the Ukraine and over the Black Sea to Russian outlets. Already suffering from wartime shortages, the people of Romania found their deprivation deepen at the hands of the Russian bent only upon rebuilding their own country.

The new post-war government was infiltrated by Communists. It wasn't difficult to find converts to the Communist way. If one wanted a job, wanted an apartment, even hoped to stay together as a family — then cooperation with the ruthless Reds was a way of life, like it or not. Corruption was rampant throughout all levels of life because the communists infiltrated business and schools as well as the government. All newspapers were written in Moscow to assure control over the information. Party members ran the radios. The Iron Guard of the Fascist was replaced by the Red Guard thugs. Their functions were the same... create disruption and fear. They mercilessly punished those who did not follow the party line.

Governments, established to satisfy the terms the Allies agreed to prior to the war's end, were never intended to give local rule. It was after all a time of great travail and stern measures were needed to deal with the circumstances and the destructions of war. Local efforts of governance were constantly suspended. Leaders were arrested, defamed, or more likely just disappeared. When reconvened, new replacement members were always Communists — in action if not in spirit. It was survival and for many, espousing a political philosophy was a weak second choice... well below a regular meal and roof over one's head.

Gradually freedoms, jobs, and property were confiscated, always in the name of protecting the government or protecting the workers — the proletariat — the new ruling class. Catherine had many discussions with Grandpapa about governments and governing as his confidant in her teens. She understood resentment of workers against arbitrary bosses, of the capricious and elitist ruling class. However, most workers were not educated or trained to lead, did not understand the complexity and nuances of large enterprises whether they be a business or a unit of government, a country.

It was not long before party action committees took over schools, libraries, and private gathering places such as churches and museums. Theaters, auditoriums, and cinemas also came under control. Catherine's family residence, the Cantacuzene Palace in Bucharest was confiscated for the good of the state. Catherine did not mourn for the loss, not because

she wasn't sad to see all the family possessions taken from the edifice. She had seen too much of war and occupation and understood the palace was a victim of war, much as the deterioration of Zamora Castle had been under the Nazi occupation. In Catherine's eyes the country was suffering both an occupation by Russia and a war of attrition. Bombs were not being dropped on buildings. Instead salvos against society ripped into shreds the fabric of a former way of life. The devastation exceeded what any bomb destroyed. Just as soldiers suffered from battle fatigue, Romania's citizens succumbed to the constant stress and fear of the communist overlords.

There was one blow Catherine had not steeled herself to endure. All refugees were ordered to leave the country. Kinia had no family left in Poland. When the war was over she had been given the option to return to Poland, but having spent ten of her sixteen years in the loving care of Catherine, Kinia, did not even consider the offer. Her home was Nedalea, Romania her country, and her family was Catherine.

Unfortunately, what Kinia or Catherine felt meant nothing to the bureaucrats. Kinia's fate was sealed. Her departure would not be voluntary, she was being deported. Using money from the sale of land holdings gave Catherine the cash she needed to 'secure' Kinia comfortable and safe passage to Italy. It assured Kinia residency with her grandmother who had survived the German occupation of Poland and fled to Italy as the Communist took over in Poland.

The money was not needed for train fare. It was used to bribe multiple layers of bureaucrats — those installed by the Reds to 'serve' the people. Initial payments were made to the correct people and arrangements were made for passage out of the country. When Catherine confirmed Kinia's safe arrival at her Grandmother's she would pay a bonus.

Both Catherine and Kinia understood the certainty of their pending split — a rendering brought upon solely by the new Communist State. Catherine was about to gain an insight into what her own mother suffered when Catherine was stolen from her by the kidnapping. Her mother, however, did have an opening, a ray of hope that she might be reunited with her daughter. Her untimely death prevented that reunion when Catherine eventually found her way home. A future reuniting of Catherine and Kinia seemed remote at best. Kinia's life was in front of her. She was young, healthy, bright, and had a wonderful upbringing under Catherine's tutelage. In addition to a wonderful formal education, she learned to be a fighter, a survivor, and to be resourceful. Though only sixteen Kinia

was prepared to make a life on her own though it was not a choice she voluntarily made.

What was in Catherine's future was more doubtful. Soon she was stripped of her wealth. Her oil facilities were the first to be declared the property of the state. The farm estates, business holdings and apartments would likely soon also be confiscated for redistribution to the workers. She still clung to her home in Nedelea and the orphanage system. Catherine presumed the state did not yet want the burdens of caring for the thousands of orphans, despite the State's claims of knowing all and being all.

Even with the State's reticence to claim **St. Catherine's Crib,** Catherine knew the day would soon come. She also had been a witness to the many executions, arrests, disappearances — the elimination of entire parts of the Romanian culture and society. The entrepreneurs, the intelligentsia, the political leadership, teachers, the keepers of art, culture, and history were gone. Catherine was a realist and knew she too would be a target when she was no longer needed to support and run the orphanage. She did not fear such a Damocles' sword hanging over her head for she did not rue her own demise, if it was inevitable she had the conviction that it was God's will. But she doggedly resisted the destruction and cultural reinvention of her Romania. Catherine would not sit and let that happen — it would be a cause for which she could struggle and fight for as long as she had a will and could breathe the air of life.

The day of the departure regrettably arrived too soon. It was a Sunday and because of the price Catherine had paid, Kinia's departure would not be at the hands of cloaked thugs arriving at three in the morning. A bureaucrat would oblige Catherine's wishes — and accept her bribe to be the young lady's escort out of communist East Europe and into neutral Vienna, Austria, via the Orient Express. There Kinia would change trains and arrive in Rome the next day to begin her new life. It would not be a gloomy day. She would be free outside of a Communist country. Catherine would have given Kinia the ultimate gift.

It was not a good night for Kinia. She came into the kitchen with swollen red eyes. She cried herself to sleep the night before; and for the entire time, she at last completed the procrastinated chore of packing her bags that morning. She steeled herself for breakfast — her last meal with Catherine.

The kettle on the stove was whistling loudly as Catherine busied

herself with food preparation. "Good morning!" she sang out with a forced cheerfulness.

Her ebullient cheery morning greeting disguised inner anguish. Catherine insisted the morning would be a joyous occasion, for Kinia was about to begin her greatest adventure of all! It would be far more exciting than those they had made up at bedtime or had played on so many of their outings on the rounds of estates and orphanage facilities. This would be for real. Kinia was after all on the threshold of her new life. There was a promise by Catherine to visit after Kinia became settled with her Grandmother. It was an empty promise for Catherine knew her own existence was so tenuous and uncertain. It was perhaps more certain that she would not be doing any traveling for pleasure in the near term. Life itself was still a nebulous thing in Catherine's future as she felt the ever tightening noose of the communist state around what was left of her world.

There was also an unspoken acceptance of the untruth by Kinia. Being raised by Catherine taught her to be insightful, worldly and aware of the world they lived in and she knew her Catherine likely would not survive in the new world that was being created in Romania. But Kinia dried her tears and maintained the thin veil of acceptance of the charade... which she did for Catherine's sake. She had learned much from Catherine.

"Oh yummy, my favorite breakfast! Poached eggs on biscuits and marmalade on muffins! Catherine, can we go on just one more ride-about?"

The pleading almost did Catherine in, yet she maintained her composure and her promises to herself... no tears, just smiles. "Kinia, the ride-about we took yesterday. You will be traveling all day today and tomorrow. Today's journey will be one of the most important trips of your life. Yesterday was a journey into the past. Always remember my child that a memory is made in an instant, but it lasts a lifetime. We have made many memories together. It always seems darkest before the dawn. Today, my dear Kinia, you will be on the voyage into a bright new day and new future. Besides, your escort is on her way. You've just enough time to eat this fine meal and have a sip of tea with me."

The two shared the meal and time with little to say, just small talk about the weather and idle chatter about Catherine's recollections of her sojourns into Vienna and Rome with her teacher Mademoiselle Cardinesco. There was the honk of a horn outside. Catherine and Kinia

each collected two bound suitcases that would carry all of Kinia's belongings and memories. They embraced at the car. Catherine gave a quick stern gaze at the woman who was to be paid a handsome sum to deliver Kinia safely. The woman understood the stare. She would be paid well for accomplishing her task... she also sensed that somehow she would pay dearly as well if she did not.

It was a tearful goodbye for Kinia — forced to leave Catherine's tender and loving guardianship still in her formative years. For Catherine's part she smiled to the end. It was yet another heart wrenching loss of another daughter. Kinia had been accepted and raised by Catherine as such. She was ripped from Catherine's protective embrace at the same age that Catherine's youngest daughter had been when she died, thus making the absence of both all the more hollow in Catherine's heart. Still, it was the same age as Catherine was when she escaped her life as an orphan and her father... the same sixteen that she began her new life and so it would be with Kinia. So it was a reason to be hopeful — encouraged.

As the car pulled away from Nedelea and down the graveled road Kinia leaned out the window as she had so often in the past and waved back to Catherine until the car was out of sight. At that moment Catherine turned away and allowed but a single tear to trickle down her right cheek. She knew this was just one more in a series of tragedies she must leave behind. It was time to move forward, to begin to search for the triumphs that surely must lie ahead in her future. There must indeed be something in her future and she needed to search for it beginning at that moment.

The financing of the vast orphanage system became Catherine's sole responsibility. She could no longer call on her wealthy friends and associates for donations. There were none. All businesses were controlled by the state which had no sense of largesse or giving. Wealth was no longer a mark of success; rather it was a bull's eye on the back of an enemy of the people — in other words — a target for confiscation and redistribution, and perhaps the lining of an unscrupulous bureaucrat's pocket. Government support of **St. Catherine's Crib** vanished. Catherine could see the future of private ownership quickly disappearing. There was a gut-wrenching decision that needed to be made.

"Good morning, Mr. Antachescu," Catherine chirped happily to one of her long time banking associates.

Mr. Antachescu had risen to the level of Minister of Mortgages for

the Budapest National Bank, the largest lending institution in the country and it was still controlled by interests in England. He had always been a generous contributor to the orphanages — perhaps influenced in part by the vast amount of business he had done with Grandpapa Cantacuzene and Catherine as well. Mr. Antachescu was very careful and had not yet been replaced by a loyal party member.

"Princess Catherine. A pleasure! I hope you weren't kept waiting too long."

"Oh no, I enjoyed a wonderful cup of coffee. Such a rare indulgence! You still have Margarite as your secretary I see. She is wonderful *and* resourceful as ever to find such a commodity as coffee."

"Princess," Antachescu lowered his voice. "I have a private wager with her as to which one of us will become expendable first."

Catherine shook her head in disgust. "These are troubling times, and I am afraid things will get worse. Perhaps you can be of assistance before your wager is collected?"

"I would love to be of assistance in any way that I can." Hedging his ability to produce, he added, "We both know that soon I will not have much ability to accomplish anything at all."

"Good, I'm glad we are of the same mind," Catherine replied as she paused to stare intently into the eyes of the once prominent banker. She wanted him to know she was there for serious business.

"I want all of my holdings mortgaged... to the maximum amount."

The silver-haired executive stroked his bushy mustache as he contemplated her request. He furrowed his brow, then sighed, and looked up from his desk top. Catherine's icy gaze was still focused on him. He stood up and looked out the expansive windows from his sixth floor office. He clasped his hands behind his back. He continued to stare through the window as he began to speak once again to Catherine.

"Princess Catherine," he paused and began again. "Princess Catherine, as I understand it, your oil wells are still under government control."

"Yes, worthless," was her blunt response.

"Yes, worthless," he repeated. "But your grain mills have been repaired, correct?"

"Yes, at full capacity."

"And your apartments and buildings in Bucharest and the Ploesti regions?"

"All repaired and occupied. I have a complete inventory right here;

of course I have omitted the properties that the state has already confiscated." She added pulling a file from her large purse.

"Always prepared. Thank you." Antachescu turned from the window and reached for the file. "I see you have all of the estates listed here as well," he remarked raising an eyebrow as he looked up from the files.

"Yes, except you will see I have asked for forty acre parcels to be carved out of each estate to be given to each manager."

"Each manager? I see, yes — very generous."

"They have earned it, no telling how long they will be able to enjoy it, but if things ever get turned around perhaps a record that they once owned something will count for something." Catherine leaned forward in the leather armchair, "I will use this money to operate the orphanage. I will want the funds in gold coins and wish it to be deposited with the Swiss Bank branch of Vienna, Austria, please."

The banker was used to her presumptive closes. "Princess, this will eventually catch up to me."

"Mr. Antachescu, you give too much credit to the bungling bureaucrats that examine you. You will be reassigned by then anyway. I would expect you to receive 1% as a service fee. I would also expect you to take a long vacation, perhaps England, with your wife right after we close the transaction."

"I believe you are right about that, and I will personally see to this business."

"You must expedite this. We've no time to waste!"

The banker looked at the folder and then up to the ceiling as he contemplated figures. The Princess had just made him a wealthy man with the 1% fee on her remaining estate. It too would be deposited into a Swiss account — out of the country. He looked back to Catherine with a slight grin turning under the mustache at this bold lady's panache. "I will have to set this up as multiple transactions so the amount is not so overwhelming and attract suspicions. You, of course will have to pledge all of your assets as collateral against the mortgages."

Knowing she had his cooperation Catherine's stern expression relaxed and she too allowed a smile to crease her lips. "Yes, of course. Property 'A' will back property 'B'; property 'B' will back 'C', etc; and I, *of course*, will *personally* guarantee each mortgage, though nobody but you will know that I would be worthless." Catherine smiled gleefully at her long time banker and friend. "And when the Communists decide to take it all over, they can have all the mortgages, too!" She held out her hand to

Antachescu, her accomplice in this little ruse with the 'State', knowing too she would never see him again.

"Princess, this is probably the best loan I have ever made!" he said as he exchanged a hearty handshake.

Satisfied, Catherine left the bank knowing that she had secured enough money to operate the orphanages for a couple of years. There she still housed several thousand children — a small city in itself. The facilities were very self-sufficient for food, clothing, and materials from her estates. However, the schooling, medications, utilities, payroll all required hard money. As she walked towards her car, she recognized one of her former orphans walking along the sidewalk towards her. Catherine recalled he had been a good woodworker, though he had not been the sharpest tool himself. He was wearing a new suit, not the coveralls of a tradesman.

"Princess! You will be so proud of me!"

"It's George, isn't it?" she asked. He smiled and nodded in acknowledgement. "What is it, George?"

"I have just been chosen to be a *judge!*"

Catherine was stunned. She inquired casually, "Civil or criminal?"

George had no idea what she was asking and just shrugged. "Does it matter? I will wear a suit and a black robe, and there will always be someone there to help me so I will not even have to go to school!"

"That's wonderful, George. School never was your strong suit... but you look marvelous in that nice brown suit and I'm sure the robe will look good on you as well. Best wishes."

Meeting orphans on the street was a fairly common occurrence for Catherine, and one that she relished. It was always to pleasure find them and to know how they were doing. At that moment she was just happy George had been chosen by the Communists for the legal profession and not banking. She hoped Mr. Antachescu's job would be safe until her mortgages were completed.

Changes were being made to all facets of society. Churches were closed for repairs or turned into museums honoring workers or heroes of the Communist Party. Permits and fees were required for every activity: weddings, funerals, birthday parties, graduations, everything imaginable it seemed. Graves had yearly taxes imposed. Publication of obituaries was taxed. To get any position of worth one needed to be a declared

member of the Communist Party regardless of any other qualifications or training. This included teachers, administrators, museum directors, librarians, and judges.

People began to disappear. A brilliant man who had served as an interpreter for the Armistice Commission was sentenced to 23 years of hard labor in Siberia for helping the Americans after the war. The doctor who saved the airman, Richard Britt, during the war was jailed for two years for that crime against the State. One of the most accomplished of Catherine's orphans had risen to Minister of Agriculture during the war years, but was made the scapegoat for failure to meet unrealistic production goals using ineffective collective farming. He was arrested one day and taken from his office never to be seen again. Catherine herself was spared to this point, presumably because of her standing as a vestige of past stability within the society and because of her strong popularity with the masses, but she knew those factors would diminish as the Communists stranglehold over society strengthened.

All levels of personnel in educating, governing, or administrating under the free government before 1945 were removed, fired, jailed, or simply disappeared and replaced by loyal Party members without regard for their competency. While many people were going hungry, hunting Romania's plentiful wild game was prohibited. All forms of guns and weaponry were confiscated so that the population would have no weapons that might be used in a revolt.

Fences were built along the frontiers. Not to keep invaders out, but rather to keep the citizens within from fleeing. Towers were erected along the tall fences and the machine guns all pointed in to shoot anyone trying to get out of the country. Bounties were given to guards for their marksmanship. The more ruthless were accused of shooting innocent people in their homes and then dragging their bodies to the no-man's-land, so they could collect their bounties.

Having been spared interference for several years, Catherine still had her orphanage to operate. When her properties had indeed all been confiscated by the government, she had already closed her mortgages with Mr. Antachescu. He had long ago departed on his well deserved 'vacation' and Catherine was able to pay for the food previously grown on her estates for the orphanages.

The date was March 1, 1949, and Catherine was traveling from her

home at Nedelea to Bucharest to conduct business for the orphanage. She was standing at the train station — her car had been confiscated so she could not get to the city by car. Fortunately there were still vehicles needed to operate the farms and other businesses contained within the orphanage itself and Catherine was able to get a ride to the station. The cold and gloomy day was punctuated by a steady drizzle of rain. By chance her former chauffeur was then driving a truck for the state controlled dairy. He had a load of milk cans, en-route to the city when he noticed Catherine.

"I can give you a ride, Princess? Much better than that smelly train," Nicholas yelled from the cab of his truck.

"I would be delighted!" Catherine yelled back as she ran over to greet her former driver of twenty years. "This weather is miserable. I'll not miss standing here in this rain."

As they drove the two hours into the city catching up on news and enjoying each other's company once shared for so many years, unbeknownst to them the orphanage was being swooped upon by several lorries loaded with army personnel. The teachers and administrators were gathered and pulled away from the woeful screams and tears of confused and frightened children. The orphanages were being taken over by authorities. Communist officials would begin operating the facility and Catherine was being sought. Her home was broken into and ransacked. The train was boarded when it arrived in Bucharest and searched. Catherine's picture was distributed on flyers as a 'person of interest.'

It was a day of abomination; perhaps the darkest day in the modern history of Romania as Romanians did despicable things to their fellow countrymen. Twenty thousand people around the country were rounded up. The lucky ones were jailed, others shot while trying to escape or slaughtered en masse. Some were placed in barbed wire pens and left in the cold rain of March without shelter, food, or water — left to perish. Stalin it seemed had brought another of his tools of submission from Russia to Romania, the pogrom.

Nicholas dropped Catherine off near her destination and she headed off down the street completely unaware that as of that morning she was a wanted person. A former orphan saw Catherine as she walked a busy street and the young woman caught her by surprise. "Madame Catherine! You must seek hiding! I was on the train from Ploesti, and it was boarded by the army. This is what was given to the passengers. You are being sought!" She handed the poster to Catherine who studied it quietly for a

moment collecting her thoughts. "You may stay at my apartment for the night." the young lady offered to break the silence.

Considering the paper Catherine was puzzled momentarily and looked again at the flyer. Not a very flattering picture she thought searching for the humor of the moment as she saw her likeness on the equivalent of a wanted poster. Using levity in moments of crisis was always a help. Yet this was the day she rued, and knew would come. Once again her life was about to change very dramatically. Catherine was certain that by this time the orphanage and anything else that was considered hers except the clothes on her back had been taken... for redistribution of course. If caught she was equally certain her very life would be taken.

It was a courageous offer from her former charge and Catherine was grateful. "Yes, my dear, perhaps I should... just for the day. I don't want to put you into any jeopardy. Thank you."

By several chance coincidences Catherine had been again spared.

The next morning Catherine sent a message to her attorney to see if he knew anything. She dared not go personally to his office for she was sure it would be watched. The former orphan she was staying with delivered the message personally and returned with a reply.

Reading the note Catherine nodded to herself in acquiescence to the facts she suspected. "Mrs. Caradja, **St. Catherine's Crib** and all of your property have been taken over. I have 'official' paper work here. I also have a request from Mr. Caradja's attorney. It seems that once the last of your assets were confiscated, Mr. Caradja no longer wishes to be associated with you. He is filing for divorce."

Costea had lived his own private life since Tanda's wedding. Catherine knew that he had been unfaithful long before that ceremony. He continued to serve the Army and had sworn allegiance to the new government. He would be well taken care of and likely had participated in the actions of the previous day on behalf of the regime. Despite all of that there still was a small pain deep within, there once was a time.

The greatest loss of the day, however, was the last vestige of what she had considered her life's work — her orphanages. She knew they would be doomed to mismanagement and ultimate failure under the Communists. Catherine understood for some reason unknown to her, known only to her maker, she had been spared her life that day, and there must be a reason.

301

Having been stripped of her last remaining cause, her reason for staying in Romania, Catherine was convinced it was for a divined reason, something the Communist would never understand. For decades the orphanage system had been her reason for living. Yet, though that was now taken, she was not about to give in to the Communists. They had destroyed her country, destroyed her family, destroyed her home and great wealth... and now her life's work... But, they would *NOT* destroy her spirit... and they would *NOT* destroy her hope for her fellow countrymen and for Romania itself! She would find that reason, a new life's work and mission. That thing, whatever it was, would give her life meaning and a will to carry on. Until she found it she would hide, she would survive, and she would prevail.

CHAPTER 26

A Princess No More

"Is my time limited? Is my life truly at risk?"

The chilling thought kept creeping into Catherine's reality. The Communist regime stripped her everything. Because she was a wanted person of interest she had no food ration, no apartment ration, no clothing ration, if she were discovered or anyone who helped her were discovered there surely would be an unspeakable consequence.

Costea was now only a distant memory and few were fond. Her sole surviving daughter Tanda had long since escaped from Romania with the help of her CIA connections and was living in Paris. Thoughts of dearly beloved Kinia were a constant but painful shadow at Catherine's side. Poor dear Kinia. Catherine could only hope the orphaned girl snatched from her embrace had learned well the lessons to be a survivor from the time in her guardianship. Kinia's cheerful voice would never again be heard by Catherine. Was there anything else that could be stripped from her?

Just to survive, Catherine, now stripped of all her once vast material resources, needed to call on all her personal resourcefulness. There was still something that Catherine held so close her very soul it would have to be ripped from her insides. There was still her freedom and with that she had hope. If there was one thing her years of travails had emblazoned on her soul it was that if you could cling to even a single thread of hope you had a chance. Knowing the best chance of having a reason to survive was to never lose hope. In the past Catherine had always found hope for others. It got them through and now it would need to work for her. She would survive, she would prevail, she would find a way.

Catherine's original plan for the American prisoners to rescue her country had fallen short. But she had not given up on her 'boys'. She settled upon an extreme plan for her own survival, to escape from the

303

communist regime that wanted her to wither away if they could not find her otherwise. There was no connection to the underground, but through her daughter Tanda's activities during the war she knew one existed. Now as a person with an identity that could be her undoing she was going to have to negotiate the treacherous world of the clandestine. No longer be able to use her own passport and simply leave the country, Catherine would have to sneak out and anyone that helped her would also be at risk. Not knowing how she would accomplish her escape, she did know that the communist had such a stranglehold on the country she would not be able to get out just by happenstance. A clandestine plan would be needed and she would require the assistance of others, of strangers. She was a survivor and that is just what she would do until a plan... a way to escape presented itself. It was for the time being something that seemed very remote, but it was based upon her hope, her faith in her 'boys', and their country America. It was the best hope for her freedom! It was the best hope for her country. Of course that was it, she would escape to America.

That burning desire to help others remained Catherine's primary focus. Her love of her country gave her a larger purpose. She had helped people survive typhus epidemics; orphans find homes, jobs, and purpose; and American prisoners to survive captivity and escape it. Now she had a new target... perhaps she could help her entire country — perhaps even the other captive countries of Eastern Europe? To do anything, though, she would have to escape.

If Catherine could get to America, with the help of her 'boys' and the strength of the American ideal of freedom, perhaps there would be a way to stand up to the world domination sought by the Communists. If she could get to America she could tell them of the hardships endured by the nations strapped by Communist overlords and the dangers their own country could face if it did not recognize the dangers of communism. If her Romanian countrymen felt there might be hope coming from America, they too could get through this ordeal. Catherine knew she now had no choice. Her very existence depended on getting out. She would have to leave her homeland, once an invisible unknown land she had sought for so long as an orphan, then a country whose customs and lore she had learned to love, the home of her family and ancestors, and the burial grounds for her daughters, but she was now at a point of no return — *Catherine needed to escape from her beloved Romania.*

After the departure of Kinia and before the purge Catherine had requested a visa to leave the country to visit her daughter, but she was

declined for being too intelligent, too well known. Her anticipated criticisms of the State would be detrimental to the progress of the *new* Romania. She thanked the bureaucrat for his compliment and received an icy stare in response. Catherine explained to the bureaucrat that she would not characterize any future remarks she might make outside the country as *criticism, just the truth.* The conversation was left it at that, though her outspoken response was duly recorded and forwarded. Perhaps that day had marked Catherine, had finally put her on the list of undesirables, of those in need of elimination. She would never know those intricacies, but did know that getting out of the country had become nearly impossible, but getting out was her only hope for survival.

Knowing little of the world of spies, underground movements, or clandestine activities, Catherine still understood she could not leave the country without putting herself and possibly others at risk. She was a marked woman and furthermore was in such an unusual untenable position. The communist regime would not allow her to have food or housing rations, and they had taken all of her belongings. They knew she was a popular figure in Romania so they hesitated having her blood on their hands. Yet it would never let her leave the country — not unless she was cold and in a pine box. They knew she was vocal and charismatic and as such could cause great harm to the regime.

Catherine had to somehow get word to her daughter Tanda whose life in Bucharest before leaving the country was in the underground world — the domain of spies, intrigue and skullduggery. Tanda divorced her Romanian husband and was living with the pilot for a man known as 'Wild Bill' Donovan who was the head of the Armistice Commission — the cover for the Office of Secret Services — America's spy network.

The American, English, and French Embassies still existed in Romania though they were under 24 hour police surveillance. Catherine began secretly visiting the U.S. Information Service under the guise of once again being a nanny and keeping honed up on her English language skills should they ever be useful to 'the state' for translation purposes. Catherine had become adept at playing the 'game' with the bureaucrats, the needed to be invisible, indeed as if she really were dead. There was no need to worry about a disguise. She already owned only the clothes given to her by sympathetic friends and former orphans. Her new look was like any other of the countless homeless from the war. Still her face was once so familiar to so many though now she had lost so much weight as to make her barely recognizable Often she wore a scarf tied loosely

over her hair so that it fell across much of her face and added reading glasses when she ventured out. To add a final touch she let an orphan, who worked as a beautician, dye her hair blond. A floppy hat would complete the ensemble. She could not be recognized by anyone who did not intimately know her.

As a regular patron of the American library at the USIS, Catherine was very friendly and attentive to the other patrons. Often asking one for their time to practice her skills in the language she never revealed her identity and she was very, very subtle in her conversations knowing the building was likely a harbor for spies — from both the good and bad sides. She altered her schedule and noted who was there at certain times. She found several of the people were too willing as cooperators. When they seemed to be leading her on with their questioning Catherine intuitively pasted a 'do not dance' card on their foreheads — she quickly stayed clear of those types. Others she probed gently. Several women offered friendship outside the building in very open and casual settings. Everyone was understandably cautious and unsure.

After several friendly conversations with one young lady, Catherine asked if she could meet with her for a walk down an open promenade near the library. The professionally appearing woman had been very open and willingly accepted Catherine's conversations in the library. Catherine knew it would be impossible to be overheard or to be followed without it being noticed on the promenade. The lady, Sonja Opsal, had papers that indicated she worked for an international shipping and export company based in neutral Sweden. Catherine would eventually have to take a leap of faith that this person was sincere and not just a very clever Red spy.

"My assignment here is nearly complete. I will return to Sweden at the end of the week," her new acquaintance offered in casual conversation as they walked. The safest way to have a conversation was walking. That way you could not be overheard by someone lurking just out of sight. If you were being followed it would be too obvious and the conversation could be stopped.

Catherine was caught off guard by the comment about leaving. It was so hard to connect with people and now one of those connections said she was leaving. She thought she was losing a hard won friend. "That's a shame; I'd hoped to continue our conversations."

Sonja then offered, "My next country will be France. We have subsidiaries in Paris and Nice."

Catherine's pulse quickened. "Where will you go?" She fought to hide her excitement — Paris — Tanda.

"Both cities I suspect. I proof read foreign documents and orders going to different countries. The travel is both exciting and boring."

"I do miss my daughter," Catherine pined.

"Do you have a daughter in France?" Sonja asked.

"Why, yes. I guess I hadn't mentioned her before – too personal you know – when you're just talking to a stranger."

Sonja laughed, "A stranger may be the safest person to talk to here. It seems very lonely people live here."

"It wasn't always this way."

"And your daughter?"

As she continued Catherine was acting coy, though her heart was pounding. "Oh yes, Tanda. I'm afraid I don't even know her address. She escaped from Romania in '48 to join an American pilot — a member of the Armistice team — with whom she was living. He moved to Paris to pursue a career in his musical interests when the Armistice Commission was disbanded. I have since lost my own home, I have no address – so we haven't communicated. I would love to get word to her."

"Perhaps I might find her? Can I give her a message?"

"Yes, tell her I need to visit her. Ask her to write me in care of your office here in Romania – since we haven't an address for each other. Besides I have not been getting my mail for several years. It is all intercepted and now I am a vagabond, a *persona non grata*. I will stop by on occasion at your office here if that's all right... to check for mail from her.

"Oh, one more favor. Could the letter be included with correspondence you would be mailing here, to your office? I would not want it to be intercepted — do you know what I mean? And though I don't know much about these things, I think the message needs to be disguised in some fashion — to protect all of us if it is read by others."

Sonja was a smart businesswoman who knew her way around, and who knew what was regular — and irregular. She knew from this new friend's appearance there was something amiss as the woman sounded so educated. "Oh, don't worry. It will be read. This is where I catch the bus. But Catherine, I understand what you are saying. I'll try to do as you ask — if I can find your daughter. You must be patient." She held out her hand. Catherine grasped it firmly with both of hers.

As an undesirable — *persona non grata* — Catherine was not able to get work or to have an apartment since all was doled out by the state and everything required identification. The government had not succeeded in killing her outright. However, a single woman in her late 50's, homeless, and without the ability to acquire food, shelter, or clothing and of a patrician and pampered royal background, certainly such a person would not last long. Death, they presumed, was inevitable, even if they could not find her or administer the sentence.

An elderly sister of Catherine's former mother-in-law had always been friendly and at this stage for Catherine it was any port in a storm. Nicolle Vanessau was in poor health and needed some assistance so a couch in her living room was offered at no charge. It was warm and safe. Catherine found a way to have meals without taking any of the meager sustenance from her hostess by walking the streets, and on her walks would come across a former employee or one of her past orphans. They would talk with her and learn of her needs and offer food, mainly scraps as everyone seemed a little hungry.

One former orphan upon seeing Catherine's state asked incredulously, "You are starving?"

Apparently her condition was becoming obvious. After learning of the plight of their former caregiver the previous orphans and employees through word of mouth would carry a piece of bread, cheese, or dried fruit, a scrap — as it were — from their tables. Catherine did not consider it begging. No, it was the return of a past favor, or kind gesture repaid. It was also survival.

The young lady who had stopped Catherine, a beautiful black haired woman named LynnAnn Petryniec, was concerned when she saw Catherine and asked, "Are you a princess no more?"

Grabbing the young woman's hands and pulling her close Catherine implored, "Look at my eyes, look into my soul. Feel my heart beat within. I may no longer be considered a princess by those in control of our country, but to *my* country and to *my* countrymen, I *am* your princess and will be so until the day this heart no longer beats."

As she walked... and walked... and walked... she learned the ways of the street. It was something she had not needed in her previous life as royalty. Now it was her new court, her new kingdom. She learned of others planning to escape the country and offered lessons in languages

that would help them if they were successful in their escape. As payment she would accept a meal, a ration card, occasionally a small amount of cash that she too began to hoard for her own escape in whatever form it would take.

Every week she stopped at the Export House of Kjellstrom's looking for a letter. The waiting was frustrating and disheartening. Did Sonja find her daughter? Would she even look for her? Was she just being polite? Was she a spy for the Reds? Could she find her? Perhaps Tanda had moved from Paris — it had been four years since she escaped and since they last communicated. Heaven forbid... could something have happened to her? The Communists would not have been happy with Tanda escaping their grasp. Despite these doubts each week Catherine stopped at the office and inquired making it a part of her routine, stopping while going to or coming from the U.S. Information Service library.

The hope she invested in each visit gave Catherine courage to suffer and endure her hardships as the days ticked by. She remembered Sonja's admonition, 'Be patient'. At the library she continued her game of casual conversation in an effort to create other possible connections. She could not place all her chances in just one possible contact. It was a certainty several of the regulars at the library were informants. Most were so scared of the communist regime that their brief conversations — if they would engage with her — were stilted, cautious, and at best polite.

On her sixth visit to the export office her prayers were answered!

"Mrs. Bardin. Good Morning! I think I have something that should please you! We have word of the package you are expecting."

The receptionist had fallen into a comfortable friendship with Catherine even though she knew her by the alias Catherine chose to use. It was perfect with a twist of irony. It was the name her evil father had given her when he wanted no one to discover her. Though still not used to being called upon without title, since the orphanages had been taken she had no position in life, no connection to her country. Royalty of course was not recognized in the Communist country and anyone using a title or even addressing someone as such would be in jeopardy for that would be disloyal to the State in which all were equal. There was always the danger that it would draw attention to her as well. It was sadly a foreign existence in what seemed now to be a foreign country.

Life was taking another one of those detours and this one would be grand. Catherine accepted the condition and thought it would be best if she just blended in as well as she could. She certainly looked more a

peasant than royalty. So much so, Catherine felt her credibility or sanity would be questioned if she tried to pass herself off as a princess. Yet defiantly she scoffed to herself, "a princess no more... One day, I'll show them."

Her eyes lit up and she edge up to the counter to see what the lady had. She produced a shipping order. Catherine was puzzled and it showed. The receptionist laughed. "It caught us by surprise at first when we tried to process the order. Sonja is very resourceful. You see most of our correspondence is monitored. We are in business in many parts of the world — we could be bringing things in or out of the country that did not meet the 'state's plan'. The form in here is filled out and typed — though I suspect you recognize the signature."

Looking at the bottom line of the document was a signature – Sjonia *Tanda* Opsal. Catherine looked up from the letter to see the receptionist smile, and the emotion she showed was matched by the glistening eyes of the receptionist.

"Here take this too — I couldn't finish my lunch today."

Catherine accepted the bag with thanks and hurried off to read the shipping order.

"Come back and visit, won't you Mrs. Bardin?"

Catherine was already nearly out the door. "Oh yes, of course!"

She crossed the street to a small park and looked for the nearest bench to sit and decipher the typed sheet.

> *An order of 15 cases of diamond grinding discs. Various sizes. Canceled, from a Belgium manufacture, with an office at 1514 Rue Des E'cole, Paris, France. The reason for cancellation... insufficient specifications – please replace your order... We highly recommend a representative of your company should meet with us to assure accuracy. Your business is greatly valued... please advise.*
> *Sonya Tanda Opsal!*

Catherine could not decipher any other message within the order. But at least Tanda knew her mother was alive and needed to get out of the country, and Catherine now had her daughter's address. What she needed to know were Tanda's plans, her means, and would there be any options or alternative plans; a backup. Could she somehow get out of the country?

Sitting on the bench, Catherine's mind was swimming with thoughts and questions. Her stomach growled, a reminder she had not eaten since lunch the previous day. In the brown bag she found a hunk of brown goat

cheese, a heel of black bread, and sheer delight — quarter of a donut. Catherine's unconscious thoughts connected with her days as an orphan, breaking up the rock candy to make it last. Taking a pinch of the donut she savored its sweetness. There were enough pinches to make the donut last several days.

The impossible now seemed doable, and the grass seemed greener, the sky bluer. Catherine sat on the bench, slowly savoring her lunch. Despite her ravenousness, she knew the meal would last longer and be more satisfying if she ate little bites. After nearly an hour she looked at the remaining donut piece. Yes, one more pinch — for dessert. It was a great day — she deserved the treat. A smile grew on her face as she peered into the bag at the morsel of sugar, butter and flour. She even had a happy thought for the communists...they were helping her regain her girlish figure, looking at the baggy blouse and she had not been this weight since she was a twenty-one year old in Paris getting fitted for her wedding gown.

After finishing her lunch Catherine made her way along her wide circuit of travel, from Kjellstrom's offices to the U.S. Library. When she arrived she was stunned. The doors were boarded up with a notice posted "**CLOSED – UNAUTHORIZED ACTIVITIES AGAINST THE STATE**". Several other people stood at the door.

"It was horrible!" one bystander exclaimed to the other. "We are so lucky. Everyone in the library when the police arrived was handcuffed and put in the police lorry — they all are in jail! It could have been us if we had been here an hour ago!"

There was no sense standing around and being noticed. Catherine was sure the building was being watched from one of several of the cars parked across the street. Once again by luck, by fate, she had been spared. The contact from her daughter and the lingering meal past to her by a kind receptionist had delayed her visit to the library by that same window of time... just over an hour. The noose around her country's throat tightened, but Catherine had slipped the knot of the henchman one more time. How long would her luck hold... would she be able to get out in time?

The walking at times seemed endless and directionless. In fact it was, and it was hard for someone whose entire life had been so full of activity to

wander without direction. Catherine decided to visit her aunt. She slipped quietly and unannounced into the home after darkness.

Her mother's sister Alexandria was well into her 70's. She had managed to keep her large home in the center of the city near the Houses of Government. She had leased most of the house to the Spanish Ambassador and a French diplomat. It was the only place Catherine felt she could safely store the last remnant of her once vast wealth, a three piece setting of emeralds. Somehow she had been able to keep this one last vestige of her great wealth. She assumed it would be needed to pay for her escape... an escape she now hoped would surely be forthcoming in the very near future.

Also stored with the jewels were the last of her English language books. With the library closed, she wanted to read something to keep her skills in the language she hoped would be her future. Four volumes with a wry but grim purpose were selected: the classic **A Tale of Two Cities** by Charles Dickens for her personal travails; the most recently banned book George Orwell's **1984** for reality — Big Brother *is* watching you; a touch of home with Bram Stoker's **Dracula**, an evil phantom beast sucking the blood from Romanians — so like the Russians; and lastly Mark Twain's **Huckleberry Finn** — a boy's adventures down a mighty river, just a fantasy... and pure Americana.

Aunt Alexandra was managing on her ration coupons and her rent money. Catherine was invited to stay for dinner. It was a wonderful meal of boiled turnips, baked beans and a luxurious duck. Catherine unfortunately had difficulty sleeping that night. She usually had a bite at lunch of whatever she could find and a cup of soup at night. Her shrinking stomach rolled and struggled with her two meals that day and a fullness she seldom enjoyed. Her mind too was racing with the possibilities of an escape.

The next day Catherine came across one of her former orphans and another stroke of luck. The woman worked in a canteen for a factory and could get enough food for herself snitching bites as she prepared meals — or cleaning up after others if any food remained on the plate. She gave her lunch card to Catherine. For the time remaining she would be able to have a satisfying lunch in the cafeteria.

There was so much good fortune. Was it a sign that things were finally turning in her favor? No. It was in the lunchroom that Catherine overheard the shift supervisors discussing recent gossip. People in the U.S. Information Library had all gone to prison. Employees got sentences

running into years. Those just using the facility got months — though some suspected of spying were sent to Russia likely to never be heard from again. They claimed the facility was a denizen of espionage run by the Americans. Then Catherine overheard the stunning rumor, the Spanish Embassy had just been closed. The claim was it was selling illegal passports and visas. The building had been confiscated. Could it be Aunt Alexandria's house?

Seldom did Catherine leave food at the table. This news was so horrific she had to find out the truth and left immediately. She made a beeline for the exit. Unfortunately, when she arrived at her aunt's home she found the rumor was true. Again a door barricaded and a sign posted — **CLOSED**. The building was being watched over by two heavily armed members of the military. Outside were lorries being loaded it appeared with everything from inside: furniture, clothing, cooking utensils, and, surely, a small leather jewelry box containing three precious green stones.

Anguish filled Catherine who felt truly despondent and defeated. Just when things were looking up... so much for a tide of good luck. She felt alone, helpless, and discouraged. There was still no word directly from Tanda. Innocent people were being arrested for the flimsiest of reasons — Aunt Alexandria's very existence could not be determined by Catherine, perhaps she too was shipped to Siberia. And Catherine's only source of wealth that might be used for an escape — now gone. Some Communist bureaucrat was going to have a happy day when he found a box of jewelry for 'reassignment'.

Then Catherine felt anger, but would not be defeated. Her fate was not to be sent away ... to never be heard from again! Far from feeling defeat Catherine's will had stiffened.

NO! She would be heard! She would expose these evil people! First she would escape their hold and then get the word out; she would *shout* a warning to the free world about the horrors! Catherine felt she could not wait for Tanda to find a way, but would continue to look for one herself and to search out the local underground. It would be dangerous, she might be caught. But she would be trying and that gave her hope. To stand by and wait was no longer an option.

CHAPTER 27

Trust Implicitly

There was nothing in her meager existence so pressing, and yet so daunting as the need for escape. A quick learner always, Catherine had found hope from her experience with Sonya. There were people interested in helping that had the means and the will to assist. She needed to proceed as she had done before; make many contacts, speak carefully, look for signals, words, winks, nods that would allow one to cautiously advance. The urgency to get away was reinforced by the recent arrests.

Catherine's biggest advantage was also her biggest albatross. She was a well known figure among the populace, yet a sought after fugitive. Not that she was recognizable anymore. She wore clothes she was given as her own did not fit anymore. Her once robust presence was a shrunken figure, seventy-five pounds lighter from little food and lots of walking. There were none of her former trappings of wealth and power. But her formidable personality was untouched. If one had known Princess Catherine, they knew this woman was no imposter. And if she escaped they would know, too, what side of the fence she was on; there would be neither doubt nor betrayal. The authorities also seemed aware of the powers of this shrinking woman whom they hoped would ultimately vanish — but yet they would not allow to leave. It was a cruel dichotomy. Often Catherine thought she was being followed though no attempt had been made to haul her away... not yet.

Trying to escape became an ordeal in and of itself. She was like a pariah to those she needed to help her on her mission to escape. If her identity became known association with Catherine by itself would be enough to create danger or bring unwanted attention to people in the business of escaping from or disrupting the communist state. Despite such risks Catherine finally made a contact that could be helpful. Her skills

at translation were useful. A publishing house appreciated her language skills and did not care if she had proper credentials to be hired. They would just take her work and find a way to compensate her in a way no snooping official would be able to track. She accepted the terms and they gave her an assignment. Her pay would be given food or clothes in trade for her work. It was terms Catherine could accept.

It turned out that the company did a few other unconventional things. Unknown to Catherine the manager of the firm was aware of who the new translator was and had admired her for many years as the head of the orphanage. He was sympathetic to her plight and had the means to help. Knowing she could not reveal her true identity from the beginning yet sure, she wanted out of the country the manager took a chance. There were many people who did not agree with the government and who were willing to take risks to protect someone of their ilk or to help someone who was in trouble with the despised government. This particular manager was connected to the underground. Catherine was given a translation assignment at the end of the day and was told to take it home and work on it there. Sitting down she saw that the first sentence to be translated began with the phrase '*Burn after reading*'. This was no ordinary translation assignment. The letter was a set of instructions for Catherine to follow if she so chose.

The publishing house had representatives writing manuals... the representatives had a draftsman who created technical drawings for the manuals... the draftsman was also skilled at forging documents — especially travel papers. Catherine was given a carefully laid route to deliver papers to this man. Any conversations she might have with him after she delivered the papers would be her personal business. Catherine knew not to ask any questions and just accept the fact this was an operation of the underground or just people willing to use connections to help her. Her instructions were to take several train and bus routes to the forger's shop. She must wait at each stop to see if anyone was taking the same surreptitious route for this man could not be discovered.

On her first attempt at a rendezvous, Catherine noticed the same man hidden behind a newspaper at the final three stops. Casually she went into a dress shop and the man followed. He appeared to be in his thirties, had a neatly cropped mustache, and dressed in a pullover wool sweater. Inquiring about a piece of material, she explained she hadn't the money to make the purchase. Catherine knew few men would wander casually into a dress shop so this man was obviously tailing her.

315

Returning to the bus stop she took a long disappointing ride back to the apartment where she was still fortunate enough to have a couch on which to sleep. The same man followed her to her door. Her heart pounded; she had not tried to lose the man and chose instead to lead him in a different direction refusing to expose the forger. As she put her key into the lock, the man approached and said something she could not hear. She ignored him and fumbled even more with the key, her nervous fingers shaking. The man's footsteps were on the stairs, and he approached her. Catherine stopped — she would face this person and would not go without a struggle. Visions of Uri and Sergi flashed in her memory and they would be proud! She spun around to meet her attacker.

"Caradja!" The shadowy man said abruptly. "You have passed."

Hearing her name stunned Catherine. She was prepared to fight not talk. "Passed what?" she said cautiously, her hands clenched into fists and ready to strike.

"The trip was a test. I followed you to see if you would notice or if you would give away our operative. The route you were given was not true. Here is the route you must take tomorrow — same time." He handed her a scrap of scrunched up paper. Catherine opened it seeing three bus routes following a brief train route.

"Can you remember this?" he asked.

"Yes, of course." Catherine said as she read the numbers several more times.

"Good, give me the paper." He crumpled the paper and stuck into his mouth and chewed. "When you get to the last stop there will be a woman cleaning windows and tending to plants in front of her flower shop across the street from our man. You must go to the shop and buy a flower. If she gives you a red flower, there is danger, move on — return home; if you get a white flower — you may proceed across the street." The man left without a further word.

The following day Catherine boarded the train for a short ride and getting off per the instructions. Catching the first bus as she had memorized she then waited for the second bus on each new route — always on the lookout for someone following — always wondering her fate if she were caught. When she finally arrived at the last stop the bus pulled away, the acrid diesel fumes of its exhaust filling her nostrils.

Recognizing the location as her final stop, Catherine quickly sought her bearings. Across the intersection was the florist shop. There was nobody to be seen, not as had been arranged. Catherine was very dubious.

She sat at the bench by the bus-stop and began to read the newspaper she carried. Actually she read nothing — it was all communist propaganda. Perhaps she was a bit early, best to wait for a while. Her nerves were a jumble. Catherine could feel herself perspiring though it was not warm outside.

Another bus rolled to a squeaky stop in front of her. The driver peered out at Catherine who waved him off with a smile and received another face full of exhaust fumes. The next bus came along fifteen minutes later. Catherine stood up and moved away from the spew of this bus. It was now thirty minutes past her scheduled rendezvous. She decided to walk to the florist shop, go into the shop, and perhaps find the lady.

The fragrance of the flowers was sweet as Catherine reached the flower tables outside the shop. She stopped and casually admired the bouquets, trying to appear an interested shopper hoping to draw a shopkeeper out, and then decided to enter the store. As she turned past the flower bin into the doorway she saw the sign on the door.

CLOSED

Looking down Catherine saw a handful of red carnations lay strewn upon the welcome mat. It was an alarming signal! She looked up and across the street. As she did she saw a man emerge from the building where she was told the forger would be found. The man was wearing a long leather coat and slouchy fedora — the 'uniform' of the secret police! Catherine turned away from the man and began to walk away.

A black sedan raced up the street and stopped as the back door of the car opened. Two more police emerged from the building with a man in cuffs between them struggling against their tugging. They dragged the doomed artisan into the car and it roared off. Catherine quietly returned to the bench at the bus stop and boarded the next bus. By some quirky brush stroke on the canvas of fate, she had been spared... once again.

The long ailing in-law Nicolle passed in her sleep the following week while Catherine was still staying there. The three room apartment was quickly claimed by a new family of five who began moving in and actually working around Nicolle's corpse which was later carried into the undertaker's van when it finally arrived late that afternoon. Before the body was removed Catherine folded the old woman's arms over her chest and said a prayer. The new 'State' of course did not condone religion, and

Catherine felt Nicolle would have appreciated a good word to her maker to help carry her soul to a definitely better place.

Working around the people moving in Catherine put all her belongings in her lone leather suitcase and a cardboard box. They did not ask any questions... she did not offer any conversation. What was happening was not an uncommon occurrence since housing was so scarce after the war. She helped herself to the remaining ration coupons on Nicolle's bureau before representatives of the 'State' arrived to redistribute the deceased woman's belongings. Catherine quickly moved her suitcase and box across the street less they too be claimed for redistribution.

Again doubts crept back into Catherine's thinking. Now she had no place to store her meager belongings, no roof over her head. She had not heard from her daughter since the first shipping order. Her own attempt at the spy game had nearly been a disaster. Catherine continued to write letters to Tanda weekly. Had her letters ever reached her daughter, was the address good, were any responses being intercepted? Such negative thoughts could not deter her; rather they must steel her determination to simply, somehow, get out of the country.

A despondent Catherine sat on her suitcase contemplating her next move. There was a man waving at her to come over. It was Mr. Kresteanu, the manager of the cartage company located below Nicolle's apartment. Catherine carried her box and suitcase across the street to the waiting man.

"Here let me help you. I'm sorry for your loss — your friend — *and* your apartment." Mr. Kresteanu had always been friendly. On several occasions he would share food with her. Catherine always responded with a kind word to the burdened man who seemed to constantly battle the inefficiencies of the new 'State'; no parts to fix broken trucks; hurry up directives to pick up a shipment only to find it would not be ready for a week, 'protected' employees — Communists — that often did not show up or would return from lunch drunk. Whenever Catherine saw Mr. Kresteanu she would share the latest joke she had heard in her wanderings about the new Communist regime and get the beleaguered man to laugh.

"Madame Caradja, I know who you are," he began cautiously.

Catherine was surprised by this — she had never mentioned to him her real name, everyone it seemed had become used to or at least accepting of anonymity. Nicolle had been asked to do the same with

Catherine. They continued in the ruse of using Jeanne Bardin for her name instead.

Mr. Kresteanu continued, "My father was one of the many you saved at the hospital in Grumazesti in the Great War. He, and I by his example, kept track of your activities since then. I recognized you from pictures in the papers. We always gave something to your orphanage when you conducted your fundraisings. Of course we were a successful enterprise then. Even in your present situation, I admire you, and your kindness to me — a stranger. And please, be assured, I have never mentioned your name save to my wife.

"I have room for a cot in the closet I store records. It used to be a basement entrance that was closed off. I am the only one who goes in there. It is accessible from the rear stair landing. I would consider it an honor to repay some of the kindness you showed my father and me. If you find it acceptable, please take it."

Catherine understood the man's offer; nobody working for his company must know she was there. She appreciated the courageousness of his offer for it was made at great personal risk. "Mr. Kresteanu, I could not impose, or put you in any jeopardy."

Hoping she had not just given him an out from his offer, or she would be sleeping with the rats under the staircase landing... she really had no other place to go.

"No, I insist — may I call you *Princess* Catherine? It would be an honor."

Hearing 'princess' was music to her ears. She smiled and nodded affirmatively.

"Princess Catherine, if you would, please allow me to be of service to our country, err, our *old* country. Let me help you. Stay here. I would consider it but small repayment *and* my duty to that *old* country. I insist — until, of course, you can make better arrangements." He smiled knowingly at her.

"Yes, Mr. Kresteanu, Your offer would indeed be helpful."

It was after hours and there were no other employees present so Mr. Kresteanu picked up her box and suitcase and showed Catherine his vacant space. "Now if I need to come back here to find a file, we'll have to stand this cot up on end."

The cramped space had an amber tint. There was dim light from the single low wattage bulb on a pull chain hanging from a wire attached to the ceiling. Catherine paused then took a slow deep breath. The old bed

must have been his father's WWI army cot. Still she was happy to have shelter and thanked Mr. Kresteanu profusely. As he left she shuddered. Her box rested atop the black four drawer file cabinet. Her suitcase stood on end at the foot of the cot. Despite her short stature her head touched the closed door as she lay down. Catherine's mind returned to thoughts of her self-imposed entrapment at the orphanage when she hid under the stage. Claustrophobia was not something she had grown out of as an adult. It was difficult to breathe, and felt as though the walls were crushing in on top of her. The air felt thin — stuffy. For a moment, Catherine began to panic; could she last in such tight quarters? She knew of course, that her fears were all in her mind, but the mind was powerful. There was a need now to be in control of her thoughts for this was to be her new home.

To quell the fears Catherine occupied her mind with other musings. She would leave the room by dawn and stay away during the day while people were at work. In nice weather the stair landing would be her living room — a place to sit until she was ready for sleep. Then she could crawl into her sleeping compartment and pretend — like when she was an orphan — it was like a sleeping car on a train — like the Orient Express and imagine it was carrying her away, far away, to freedom again.

In the meantime Catherine faced reality. There would be no bathroom or way to bathe, no place to have a proper meal, no refrigeration, no way to heat things up. The only escape would to be out wandering in the city all day. All the walking certainly made her fit, but if the weather was bad... well, then unfortunately she would just get wet. It was clear that she would need to find a cap to wear at night to keep her warm as the space was not heated. To cope with her claustrophobia she would have to cheat just a little and sleep with the door ajar — the cool air and noise from outside, she convinced herself, would be soothing and the little crack would be just enough to calm any fears of suffocating entrapment should they creep over her.

The next morning Catherine went to the Export House of Kjellstrom's. She found the same friendly receptionist and casually said, "I need to ship something, please."

This was how Catherine sent her letters to Tanda. The lady at the counter played right along with the deception. There were other people in the office and no one could be entirely trusted. "You'll need to complete this form, please," she said in her best bureaucratic and uninterested fashion.

Catherine examined the document and began to fill it with a message

for Tanda. "And how is Ms. Opsal? I would like her to personally handle this shipment."

"Oh, Ms. Opsal is working out of our Belgium office now... but she often travels to Paris. I see that is where you want your shipment to go."

"Yes, I do want this expedited, but I appreciate her expertise in the matter, so, yes get it to her please," Catherine confirmed.

She admired her creativity as she described what she wanted shipped.

Irregular shaped; more than 100 pounds but less than 200, extremely fragile; Antique; requires carting of 5' x 3' x 2'...

The secret message was a source of humor to Catherine. She was indeed to the point of crating herself and going by freight to Paris, though she suspected there was a Communist bureaucrat someplace who inspected every crate leaving the country. Somehow, Tanda must receive a message demonstrating desperation, and making this location her point of contact. Desperation was what Catherine hoped Tanda would understand from the message anyway.

The next week a confirmation letter at long last arrived. The letter was written by Sonja and indicated there would be some delay involved in her availability, but she was working on the problems on her end. There was a curious closing.

P.S. Be sure to disinfect your hands with ammonia, there is an epidemic of sorts — it's the reason for the delays — we don't want anyone catching it back there.

What a strange request, ammonia is a cleaning solution, but not a disinfectant? Catherine was happy to have a response, yet puzzled by the P.S. She walked back to the cartage company. It was nearing dark and the office was closed. Finding Mr. Kresteanu sitting on the back stoop she hoped he was not in any trouble.

"Good evening, Princess Catherine. We were shipping a load of sausage and a box was damaged. I declared it as lost on the road. I shared it with my staff — my 'workers' on the staff that is. Here, you can also keep some and slice a piece off when you are hungry. This will stay preserved without any need for refrigeration. I have a knife, and here is part of a loaf of bread."

What a great day! Catherine was delighted! First she received a response from Sonja, and now, food. She had not eaten all day. What could be better?

"You are too kind. Surely your own family could use it," she offered.

Kresteanu had already cut a slice of bread and sausage for her. She ate ravenously and was no longer embarrassed by how it might have appeared.

"We are sufficiently taken care of... and please... sharing good fortune is one of the few gifts I can give these days. We occasionally *arrange* for such damages."

"Do you have any ammonia among your cleaning supplies?" Catherine asked.

"Sure, here, eat this while I get it."

He was back shortly; the two slices were already consumed.

"Let me cut you another slice — is there something in your room that needs cleaning?" he looked around with curiosity while he cut more sausage and bread.

Opening the bottle Catherine crinkled her nose at the smell. Then she poured some in her hand and sprinkled it over a piece of paper. Kresteanu's curiosity grew as he watched Catherine. At first she studied the letter and looked puzzled. Then her eyes opened widely. She took the ammonia and sprinkled more directly on to the letter.

"I can't believe it! This is wonderful!" Catherine looked up to Mr. Kresteanu with a huge smile and gave him a hug.

"It's a message — like a magical message in a bottle! Ha! A bottle of ammonia at that! Mr. Kresteanu, please be sure to keep this wonderful liquid in supply."

"Of course I can, just keep this bottle in here," he said still confused, still holding the sausage and bread. "But what are you talking about."

"Read this! Invisible ink!"

'*Your shipment must be cleared. Look for instructions to follow — same form. Tanda.*'

"That's my daughter; I think Tanda has found a way for me to escape!"

The next week Catherine returned to Kjellstrom's. There was another transmittal from Sonja. She impatiently wandered through shops, parks, and neighborhoods until darkness approached as she could not know what was hidden in the dispatch without pour her magic potion over it. Once darkness fell she rushed back to her closet home and sprinkled ammonia over the letter. Instantly a message appeared.

"*You will be contacted by people you must trust implicitly. They are part*

of an underground movement. Remember their lives are at risk — and so is yours — be careful. Tanda"

The days turned to weeks — then a month went by. Catherine waited patiently at first. Eventually an attempt at a contact was made. It was a rendezvous in an open street market. A man, who appeared to be the contact, looked nervous and restless. Finally, he threw his newspaper in the garbage and walked off. That was the signal to scratch the connection. Catherine received four more arrangements for contacts that were all waved off. Was she under surveillance? She never noticed anyone following her. Catherine was growing increasingly anxious and frustrated, yet hopeful. Someone was trying — she had yet to speak a word to anyone, but there was at least a glimmer of hope.

Finally, a sixth attempt. Four bus routes, a long walk across a promenade, and a visit to a Doctor's office. "Bardin?" Her name was at last called after sitting two hours in the waiting room. She held up her hand.

"This way!" was the curt response by the nurse.

Inside the examining room more commands, "Sit. You have a stomach problem?"

There was no plan for this conversation; Catherine was playing it all by ear.

"Yes — it doesn't get enough food," she said as curtly as the nurse who talked to her.

The nurse looked up and eyed the woman sitting on the exam table. She did not see the humor. In fact she was rather stout — well fed. Catherine noticed the fact and guessed this nurse was a good follower of the Party, a Communist.

"I think I have an ulcer, or worse — blood in my stool."

The nurse eyed Catherine suspiciously – "did you bring a sample?"

"Sorry, I have to come when I am told I have an appointment. With my current diet I only manage to pass once a week." Catherine now appeared apologetic.

The nurse softened, just a bit. "You'll have to produce one before we can complete our exam."

Nodding, Catherine acknowledged, "I understand."

She wondered, was there a message here some place? Was this impolite nurse her contact? She would just have to play along and see.

The nurse got up, "The doctor will see you next." She left the room

with a quick slam of the door. Catherine heard the woman's voice outside the room as she called out for her next patient, "Postlovic! This way!"

The door opened a crack. There was a polite knock and a short, balding doctor with spectacles half way down his nose. "Bardin?" the meek voice asked in near a whisper.

"Are you sure you have the right room?" she answered. She had of course entered her pseudo name Jeanne Bardin on the paperwork. She hoped this was a positive sign.

The doctor smiled briefly and nodded once.

He entered and looked out into the hallway before he closed the door slightly. Dr. Adamtibovitch was stitched on his white frock. He sat on a stool so that Catherine was between him and the door. "Ulcer, Ulcer — lots of those these days. Open your blouse. I'm going to ask you to change your diet... and I hope you will enjoy the change." Catherine smiled, the Doctor smiled back and continued, "I have a bottle of medication for you," he pulled out a bottle with a white thick milky substance.

His voice lowered to an urgent whisper, "There is a pill in the bottle that will kill you almost instantly. If you are stopped you must take it. I'm sorry. If you don't take it our operative will shoot you in the brain — then himself. Your choice... Are you prepared to go on?" Catherine nodded yes.

"There are instructions written on the back of your prescription which is taped to the bottle. Do exactly as instructed — always be ready at a moment's notice. We know where your room is; where you stay... a man will come for you when it is time."

The door opened suddenly and the overweight nurse filled its space. Catherine was startled and clutched her open blouse in a reflex motion. The nurse stared at Catherine. The doctor wiped his stethoscope, though he had not used it.

"We can only medicate, nurse. See that we have a stool sample from her and let me know the results." The busy doctor stood abruptly.

The nurse made notes on Catherine's chart and passed another clipboard to the doctor who left for his next patient — one every five minutes was his quota. He left with a sign of resignation. "Not enough time with the patients," he muttered as he exited without a second look back to Catherine.

Quietly buttoning her blouse Catherine noticed the nurse watching her.

"Bring the stool in when it occurs."

Catherine looked up innocently — "Shall I put it to your attention?"

The nurse glared. "No! Just put your name on it — clearly — so we don't mix it up with another — I'd hate to mistake your prognosis and have an unnecessary surgery done!"

The comment was almost like a menacing threat. Catherine knew she had to comply with the sample, however, to keep up the cover until she could escape.

Returning to her room Catherine was ready to explode with anticipation of what had been written on the bottle. Hopefully, it would tell her when her escape would be launched. The excitement was tempered when she poured the white substance of the bottle out under the stairway. A capsule fell out, the poison capsule. The peril of her situation was in the palm of her hand. But Catherine's sense of humor pervaded the gloomy morbid thoughts.

"Well, I hope you rats down there lap that medicine up... less competition for my bread." She laughed at the cartoon image in her head of a dozen rats lying around the puddle of the white liquid — four legs up, tongues out, eyes closed; then peeled the prescription taped to the bottle. It was a request for some items and instructions on how to gather them. Catherine did not know if the items were for her escape or to be used in helping another. No matter, she would complete the requests and find the items. She assumed more details of her escape would follow.

The next morning she went to an address in a poor part of the city. As Catherine approached the house she realized she likely looked more like someone who belonged in that part of town. When she knocked at the door and an elderly woman in her eighties pulled an envelope from under her sweater. Ironically Catherine was given a large sum of cash separated into several bundles bound by colored rubber bands. There was another address, a stop located across town and housed in a haberdashery, and tailor shop.

At the first stop she 'paid' a bundle of cash in a red rubber band to the hat maker for a hat. She noticed the inside brim had extra stitches and felt a thickening of the brim. Surely a message she thought. Then she went on to the tailor where she received four handkerchiefs. The tailor told her where the next stop would be. Walking several blocks to a pharmacy she 'bought' some solution with the cash in the green rubber band. The

pharmacist gave her a bag with a prescription which was then carried...
the pills, solution, and hankies to a portrait studio.

The man ushered her into a dark room putting the hankies and pills
into a pan and poured a solution over it. Then they continued to the studio,
a little behind the counter with a backless chair and curtains hung from
the ceiling to form a backdrop for the portraits. He took several pictures of
Catherine and as he did he gave her instructions. "Look this way, SMILE!
Good, now turn a little", and another flash. The photographer walked
over to the pan and smiled to himself. The handkerchief had magically
turned into an elaborate map.

"Ok, turn and sit this way — wait, can I comb your hair
differently?"

He came over and brushed her hair back and gathered it into a
ponytail. As he did he whispered, "Bring me the travel papers of a person
from Moldovia; a member of the communist party; someone with military
credentials; and lastly a person of unhealthy social origin — Royalty. The
remaining cash in your envelope is yours. It should help you in these
matters. I will have travel papers for you by this time next week, bring
the documents at that time." He stepped back. "Smile!" and the camera
flashed again.

Catherine understood her role, she was to be used to help others — she
was part of the network of the underground now. Enjoying the challenge
of the assignment she also felt at last she was at last being useful again to
her countrymen. The person of royalty was easily completed with her own
papers. Kresteanu provided his father's papers for the military man. By
a stroke of luck, her departed in-law, Nicolle Vanessacue, who had been
granted the apartment Catherine, formerly stayed at because she agreed
to sign on as a card carrying communist. Catherine thought of her relative
for a moment and forgave her. It was after all an act of survival — not of
commitment to the ideology. The card was in the little leather purse that
Nicolle used for her ration cards. Nicolle, as a former Caradja, also was
born in Moldovia — two of the needed items in one stroke.

Having completed her mission in just one day and with no need to
'buy' any documents, Catherine was in possession of more cash than she
had held in several years. She would not spend the money. Instead she
folded it and slipped it into the meager clip of currency she had been
saving for her escape and tucked it back into her brassiere.

At the appointed time Catherine picked up her travel papers — with them a lovely picture. Her hair was pulled back and she wore a hint of a smiled. Admiring the picture she thought with all of the weight she no longer carried and the youthful hairstyle — she looked years younger. The crisp evening's air of late September and the beauty of the changing leaves lifted Catherine's spirits as she was about to embark on yet another new road in the adventure of her life. She was ready.

CHAPTER 28

Blue Danube Redux

The waiting seemed interminable. Summer had lapsed into fall. Fall was creeping toward winter. It was getting dark early. The weather was turning noticeably colder. What could have been an ideal time to attempt an escape was eroding into whether an attempt would even be advisable — especially for a woman already over fifty years of age. Catherine found the waiting far more difficult than any action she had ever undertaken. In the past she always had things to do to occupy her time, to keep her mind busy and removed from life's troubles — be it her own children, the orphanages, the business of her oil holdings, farm estates, or business enterprises. Now she had nothing to trouble her... nothing except to save her very own life itself! The communists' regime had taken everything they could and wished mightily for the last — but that she held to fiercely. They had gotten everything but her spirit... her essence, and with that she would survive.

Struggling with the intangibles — the vicissitudes of life under the Reds cast doubts and cracked even Catherine's personal sense of indomitableness. Was she too old to survive the rigors of a dangerous escape attempt? Had she been too weakened by the long months of poor nutrition — no — virtual starvation? Had the commies' control of the country — of all Eastern Europe — pulled down the Iron Curtain as Sir Winston Churchill had called it and left those captured nations in the darkness of its totalitarianism without hope for freedom?

The anxiety of waiting was increasing and Catherine could only bide her time with nothing to do. As the air chilled she would take long walks wrapped in yet another coat given to her by a former orphan. The walks were times Catherine would reflect on her life's past adventures, often

wondering what new adventures awaited on her journey to freedom, for that was still the hope that carried her.

It was a Saturday in November and a glorious day. The temperature was in the middle fifties; the sun sparkled in a cloudless blue sky, casting sharp shadows from the leafless trees. Those fallen leaves crunched beneath the worn treads of her shoes. The aroma of firewood wafted through the air. The walk this day was long and meandering — going nowhere — and unlike most of her life — she was not in a hurry. Catherine rounded the corner across the street from her closet quarters.

Looking through the wrought iron fencing that lined the sidewalk across the street Catherine saw a small man huddled on the stoop of the back porch — the entrance to her tiny hovel. She had seen many a friend and neighbor hauled away from their home by the Communists. Yet the man was not like the burly secret police who swooped down upon the unsuspecting. He wore a blue wool sweater and a black wool stocking cap against the cold of the late autumn day. His face was weather-beaten and unshaven. This man did not fit the description of the secret police — tall, clean shaven, with leather overcoats and fedoras.

A quick decision must be made. Catherine had to meet this stranger or do an about face and walk away from her safe-house and her island of sanctuary in a sea of unknowns. If it were the police and she turned away now she knew she could never return for they would keep returning until they had her in custody. On the other hand if it was the police and she was taken in she also would never return, though for quite a different reason. She clutched the tiny capsule Dr. Adamtibovitch had given her months ago which she had since always carried.

If this stranger were someone in need of help she would feel guilty about walking away from him. Perhaps, though this was not her first thought, maybe it was someone who had finally arrived to whisk her away to freedom. Her instincts pushed her forward into the alley and towards the man.

"Princess Catherine." It was not a question — the man knew who Catherine was — and he addressed her as 'Princess'. He was not a communist. Catherine relaxed, and then almost instantly tensed rigidly. Who sent him? What did he want?

"Yes," she answered, and followed up, "and you?"

"I am Nicky, I have *waited* here for hours!" the short swarthy man said almost indignantly.

Was he from the underground? "Well *I* have *waited* for months!"

"Your wait is over, we leave now — gather your things." Nicky looked up and down the alley nervously.

Noticing the glances Catherine added with certainty, "I have not been followed," Then she said confidently, "I never take the same route, I always go at different times, and I am very careful."

Quickly Catherine entered her tiny living quarters of the past many months. Her heart was racing wildly; the day she had long awaited had finally arrived. Her mind too flounder a bit at the consequences she may face. It might be the final trip, the last adventure of her life for she knew the dangers were real. Still the risk actually was on the up side as she understood the certainty of what would happen to her if she did not escape.

She kept a small satchel packed with two pairs of wool socks, a wool underskirt, and quilted overskirt. Hanging from the door were two knitted sweaters and a heavy winter jacket. The blouse and shoes she was wearing would suffice for her exodus. She placed a note on the cot indicating she was off to visit a sick relative for several weeks — perhaps it would hold off a search for her if her absence were noticed. Mr. Kresteanu would also understand the note's meaning.

Nicky tried to follow her into the room and was surprised to find he could not close the door with the two of them standing inside the tight quarters. He waited in the doorway and watched. He was pleased to see that she was ready to leave in an instant.

"Princess Catherine... I have a question."

Catherine cinched her satchel strap and looked up at the strange man from the underground that she sensed she would be entrusting her life too.

"If we are caught, I have a pistol... shall I shoot you first?"

"Of course!" Catherine answered emphatically, without batting an eye.

Nicky looked at her closely. Dubious perhaps of her physical condition, but now, without a doubt of the courage and spirit of the woman for whom he was to risk his life.

He nodded affirmatively and said bluntly, "Then I will take you."

He held the door open and Catherine left the room — with just her small satchel — and without a backward glance.

The sun settled quickly in the late afternoon sky. A red glow put

an amber cast on the surroundings as the innocuous man and woman hurried to the train stop. They boarded the train to Giurgu, a port town along a wide expanse of the Danube. Nicky explained as they walked to the station he would expect her to do certain things that a woman of her bearing may find difficult to accept. He would only tell her that he would accompany her to a neutral site, and then she would continue on to France where Catherine would find freedom. The estimated days the escape could take was put at about twenty days.

There were no delusions. Catherine knew the trip would be rigorous and demanding. She understood it would be dangerous and respected the short but thickly built man alongside her knowing he was prepared to die to get her out of the country. Also accepted was the knowledge he would expect her to be prepared to face death in her quest for freedom. Catherine was confident she had the will to do whatever it would take to be free of the communist regime.

Allowing herself a moment of reflection Catherine mourned having to once again leave her country under duress, but she had come to accept the sad fact the nation now within the boundaries of Romania no longer represented the land and people of the country she loved. That country would have to remain locked within her mind and heart. Catherine would be consciously entering a situation that would put her life in danger. On this journey she would have no Sergi or Uri to protect her, yet she willingly put herself under death's dark shroud for her chance at regaining her freedom.

"When the train stops, I will get off by the front door. You leave by the back. We must be extremely careful. The stations are closely watched. You will not be missed for a while, but it would be suspicious for us to leave together — we do not look like a matched pair — we would attract their suspicion. We must both walk toward town as do the other passengers who get off the train. You know the drill, walk several blocks and be sure you are not followed. Then you must meander back and cross the tracks several blocks from the station. Find the darkest place you can. Just beyond the rail yard there is a drop off to the river. It's dangerously steep. Stay on the path you find and follow it east towards the shipyard. You'll see the glow of lights from the docks.

"I will meet you along the path and lead you from there. I won't tell you where I'm taking you. We can't afford the risk of exposing our cover if you are detained."

"Captured, you mean," Catherine intoned. "I won't talk... and I have

331

my pill!" Nicky looked at her seriously and nodded assured. "I believe you."

Casually Catherine disembarked from the train. She looked across the platform in time to see Nicky disappear around the other side of the train station. Nobody seemed to be following him. Acting very nonchalant, she looked at a piece of paper she found on the train as if it were directions to some destination. Catherine glanced around casually, as if she was not in a hurry, waiting for the crowd to thin. It would help her pick out anyone else who might be lingering — someone waiting to follow her.

Quickly scanning across the platform area Catherine went inside the train depot and used the ladies' room. When she emerged she noticed a man in a black leather overcoat and stylish grey hat sitting at a bench reading a newspaper. She looked away immediately. Catherine walked outside and observed the man stand up and walk towards the same door she had just used. Quickly she moved away from the station and down the main boulevard. When she reached the street lamp she stood to examine her sheet of imaginary directions looking around as if getting her bearings. The man in the grey tweed hat was walking slowly in her direction.

Today was to be a beginning — not an ending. She gathered her courage yet Catherine's heart was pounding with the surge of an adrenaline rush. Fighting the urge to run, instead she turned at the intersecting street and headed away from the direction Nicky had taken. Walking briskly as was her habit she looked briefly behind and saw the man stop under the same street light and open his newspaper to read under the street light. She walked on to the next corner placing a little more distance between the man and herself, then stopped and looked at her piece of paper and stole a quick glance back up the street. Headlights of a car shone down the street at her. Catherine thought back to the day a car swooped to the door of an engraver as three men dragged him away.

The man folded his paper together and got in the car. The engine of the car revved and shifted into gear. The car launched forward. Catherine would not go quietly. She spun to her right and headed back toward the train tracks and the river away from the car. Her pace was quick, not quite a run... at least not yet. The car reached the intersection. It drove on without a pause.

Relieved, Catherine stopped and leaned within the arch of a doorway

as she collected herself. Despite the brisk temperature of the November evening, she was panting for breath and sweating profusely. As she collected herself Catherine looked nervously up and down the street. She still feared the car was just driving around the block. Was she to get this close to her escape only to be cruelly dragged into a sedan never to be seen again? Likely it was just a man getting picked up at the train station she reasoned. When one is traveling with a poison pill it seems as if everyone is following, every car held a goon squad, and every corner or alley place of capture. Catherine turned away from where the car had been and headed toward the river. She would never look back.

Across the tracks, Catherine found the path Nicky mentioned and the steep embankment that dropped to the Danube River. As she looked down a gasp of breath escaped her lips. It was almost a vertical five story drop to the river below, interrupted by outcroppings of boulders — some the size of a car. A few rocky shelves existed forming rocky platforms providing a place for weeds and shrubs to grow and an aerie from which sea gulls could launch.

Though she was not afraid of heights Catherine thought perhaps it was best the evening sky was cloudy making it very dark and might have been more frightened if she could have seen how dangerous the embankment appeared in daylight as opposed to the near blackness of night. She advanced very slowly along the narrow rocky path. Looking up from the path she could see the glow in front of her from the dock lights. Though she only looked up briefly towards the light but found she was nearly blinded and paused in the darkness for a minute until her eyes adjusted. Below she could hear the water of the Danube lapping up against the rocks at the bottom of the steep slope. It reminded her she never learned to swim.

Proceeding on faith alone Catherine did not know where she was going, how far she would walk, or what awaited when she arrived at the undisclosed destination. Nicky had advised her for his safety she would be working on a need-to-know basis. Should she be captured she would have nothing to divulge under interrogation, well... torture, if her pill were found before she could swallow it. The method of escape and the personnel involved would be safe from disclosure by her.

As she crept along Catherine smiled thinking the commies would be upset if they realized their starvation of her had shed her of many pounds and made her much nimbler and fit. It would be an aid in her bid for freedom. Continuing along the path Catherine was not aware of the gulley

that cut the trail. It was the result of the rainy season downpours that had washed away the little topsoil along that portion of the narrow pathway.

Her feet slipped on the loose gravel at its edge, falling to her knees. Frantically she scrambled to regain her footing and felt her ankle give way as she collapsed and then slid down the gorge on her left hip. The impact was painful, the descent along the gravel raked against her skin, tearing at her dress and her flesh. She shuddered in pain, but was afraid to scream out, not wanting to attract attention, not knowing who would hear, and assuming the worse — the police for she would have no business on the treacherous path at nighttime, no good alibi if asked.

With no other reason than luck she slid into a lonely scrubby tree, perhaps too knocked over by the recent gully washer, but still clinging to the slope with about half its roots. Catherine clung to her lifeline. As the dust settled and the noise of the falling gravel subsided as splashes into the murky river swirling below she assessed her situation. Having slid down only about ten of the fifty foot drop-off, she was still wheezing and sucking in the cold air for its precious oxygen that seemed to have fled her lungs with the fright, impact, and exertion of the fall along with her struggles. As Catherine slowly caught her breath she also became aware of the pain from the fall. Her left side burned and she could feel blood oozing from the skin of the hip and thigh shredded by the tumble. Her ankle throbbed. She hoped it was only a sprain and not a break — which surely would bring to question her ability to continue her escape.

The small shrub would hold her for the time being, but for how long? How long would Nicky wait? Would he look for her or just leave when she did not appear? She had to get back up the embankment. If she didn't she would surely be found — or worse — Nicky would leave without her. He could not risk his underground operation.

Catherine still clutched her carrying pouch — her meager belongings. She put the strap over her neck to free both hands. Then slowly and painfully she inched herself up the narrow trunk of the fragile bush and closer to the path. As she tugged herself up she could feel the plant she grasped give a little as the roots were pulled against the loose soil. Catherine froze — she couldn't lose her lifeline.

She heard a whisper, "Princess... Princess Catherine!" She recognized Nicky's voice, and relief swept through her body. The pain disappeared for the moment.

"Nicky!" she whispered urgently.

"Stay put. I heard the fall — you are just one hundred short meters from our rendezvous."

Nicky was familiar with the gulley and skipped over the wedge of missing trail. In daylight it was merely a step-over. At night it was a canyon.

"Don't move. The little shrub you cling to is barely attached."

Holding on desperately she could hear the gravel kick away as the nimble short fellow lowered himself to the base of the solitary plant. Catherine knew the man was already at this early stage of the escape risking his life and limb to get her back up from the drop-off. She prayed his added weight on the slender trunk would not send them both down the embankment.

"I can't quite reach you! Is your travel bag from before or after the Russian take-over?" Nicky asked.

Catherine thought it was a strange question in light of her circumstances. "It was given to me — made by one of my orphans who had been taught leather crafting. Why?" she asked.

"It has a long strap. Take it, carefully, off your neck and flip it to me, but don't let go of your hold on the shrub or the purse!" he whispered urgently.

Catherine did as she was told. Nicky grabbed the pouch, dug his heels into the root structure of the scrub tree and pulled. "Use your feet now, let go of the shrub and scramble up me as I pull — *come on now!*" he encouraged as she struggled.

Fortunately Catherine's new fitness in her legs from miles and miles of walking were paying dividends. She put her faith in the little man, letting go of the shrub and grabbing the strap with both hands. Her feet sought traction and churned at the rocks beneath that rattled as they fell away to the bottom some splashing into the river. She felt herself rise slowly as Nicky tugged — each thrust with her left foot pierced her body with pain, but she did not cry out for she would not let Nicky know of the injury. This accident would not be a reason to be denied her freedom!

There is a primordial desire to survive which gave Catherine strength as she struggled against the slope to reach for Nicky's outstretched hand. She felt his rough skin and he locked his fingers around her wrist like a steel snare trap with strength that belied his size. He pulled her up to his level, and they stopped, both gasping for breath.

"We have no time to spare; we need to get to our destination under the cover of darkness!" Nicky pressed upon Catherine. "Quickly, crawl

up my body and get your feet up on my shoulders. I will lift you up the rest of the way — it's only a few more feet!"

There was no dignity left for Catherine, not anymore. Catherine thought momentarily of the awkwardness of her immodest position as she climbed across the splayed body of Nicky using his thighs, then his belt, and finally his broad shoulders as hand or foot holds. No time for royal modesty she thought as she struggled, digging fingers into the gravel. She felt a shove against her feet and the pain shivered in her body. At last she reached the flat of the pathway with her hands. Nicky kept pushing her upwards. The pain on her left leg was excruciating!

Rolling on to her bloodied left side she gave a kick upwards with her right foot up to the path. Her heel hit the level dirt path and she dug it in for a hold as she rolled herself up from the gorge and over to the safety of the path. She lay on her back, gasping for the brisk clear evening air to cool her burning lungs.

The leather bag flopped next to Catherine. Then the sweating head of Nicky appeared, and he deftly hoisted himself up to the path.

"Are you ok?" he asked.

"I'm fine, let's get on with this! You lead!"

Her ankle ached and Catherine did not want Nicky behind her where he could see her limping. Before she began walking she had to satisfy her curiosity and asked, "Why did you want to know about my baggage?"

Nicky laughed, "Had it been made by the Reds in a factory, I'm sure the straps would have snapped off. Since it was hand-made I took the risk that it would hold up. It was our only hope I think. So, I just wondered if you would be coming up... or going down."

The path started to wander down an incline. They were approaching the edge of the Danube River. When they reached the river's shoreline a small rowboat was tied under an overhanging willow, out of sight. A lady sat in the stern, under the branches.

Nicky grabbed Catherine's arm as he pushed her towards the boat. "Get in the stern. I'll take the middle."

The river looked broad and flat, but Catherine knew the current was very strong. She always regretted never learning to swim, but that was just another part of her stolen childhood. As she settled onto the bench seat in the back of the rowboat, Nicky got into position while asking the accompanying woman to push off. As the boat bobbed in the water he began pulling at the two oars.

"Catherine — this is my wife, Anna. Together we operate the oil barge

you can see on the other side, across the river. It's now fully loaded. We have eight vessels connected. There is a cabin in the front — it's ours. The cabin in the rear belongs to my shipmate and his wife, but they are *not* a part of the operation. They are out for an evening in town before we ship off tomorrow. They have a guard dog."

At that moment Anna chimed in, "Here!" she tossed something to Catherine that plopped at her feet. She picked up a piece of raw meat, bigger than any she had held in over two years. Anna continued, "The dog may bark at you — you're a stranger — give him the meat, and it will keep him quiet."

Rowing across the expanse of the Danube, Nicky filled in his new passenger, "We have hiding places in the cabin of the lead barge. They are not comfortable, in fact just the opposite. There is a cubby-hole beneath Anna's closet in the hold. There is a last resort storage compartment under a bench seat. We will give you a pill to swallow if you are found — oh yes — I remember, you brought your own. So we have extra." Nicky chortled at the absurdity of having extras of the deadly poison... as if they would need more.

"We would all be taking the same medicine. It will be a better fate than what would await — I assure you.

"There is also a special hiding place when we know the boat is to be searched. My shipmate and his wife can never see or hear you. They, unfortunately, would surely turn us all in for a modest reward if they discovered you. If you do exactly as I say we will have you in Vienna in three weeks. Once you get through Austria you will be in France — and free."

With water gurgling under the oars Catherine listened to Nicky as the rowboat approached the barge. She began to hear the water lap up against its steel sides as they neared. Nicky lifted the oars as the boat slid next to the hulking vessel. "How's your ankle?" he asked.

Thinking he hadn't noticed, Catherine looked at him in surprise. Nicky added, "I saw it was quite swollen when I hoisted you up to the path. You are a tough woman, and brave. If it were broken — I could have carried you... I suppose."

Without hesitation Catherine shot back. "If it were cut off... I would have grabbed you like a vise, and you would have *dragged* me here!"

"No matter, you won't be needing it much on this trip, you will spend most of you time lying on your back." Nicky responded.

There was a rope ladder hanging from the side of the barge and

Catherine had to be first off as Nicky steady the rowboat and Anna tied it off the bow. When she pulled herself up to the edge she heard a low menacing growl.

"Quick... the meat!" Anna urged in a whisper. Catherine flung the meat towards the rear cabin and soon heard the chomping noise of the dog. She lifted her legs over the edge and Anna was right behind her. Nicky secured the stern of the rowboat to a platform on the rear of the blunt shaped vessel. Anna offered a hand which Catherine was about to stubbornly refuse, but her first step was too difficult. The swollen ankle was stiffening and her adrenaline was wearing off. Catherine too was exhausted. Anna's arm was a welcome crutch as she limped along the narrow catwalk that connected the eight segments of the barge.

Once inside the forward cabin, Anna produced soup for all three that she had prepared before she crossed the river for the rendezvous. There were more chunks of meat in it than Catherine had eaten in the past several months, combined. After the soup, Catherine was given a piece of hard black bread with a generous mound of white glistening ooze. She hesitated.

Anna looked at Catherine. "You must eat it. It's lard." Catherine put the bread to her lips, paused, and then took a bite of the substance. She gagged, but would not spit it out, then chewed voraciously, mixing the bread with the pasty substance, and gagged again when she tried to swallow, but finally got it down.

Knowing the rigors ahead of them, Nicky looked at her with a frown. Catherine noticed and quickly held out the piece of bread and said, "Put some salt, pepper, any spice you have on it!"

Anna applied a generous dose of salt, and sprinkled curry over it. Catherine politely thanked her and methodically ate the bread without as much as an eye blink as she stared at Nicky. Whatever it took she reminded herself.

When she was done, Nicky explained, "The Eskimos and Laplanders live on lard and fish. The oils and fat allow them to survive the frozen Arctic. You will not have our direct heat in your hiding place — and sometimes none at all. There is only room for you and this sheepskin in your hiding places." He handed her the animal hide — somewhat oily from the cargo of the barge, and smelling much like it was still attached to its original owner.

It was time to crawl into her new quarters, the cubbyhole under the hold. The sheepskin was not large enough to cover Catherine entirely. She

used her bag as a pillow. When the hatch was sealed and the coverlets thrown over the opening, the compartment became pitch black. Before an hour was up, Catherine was struggling against the cold, but was exhausted and shivered herself to sleep.

Several slivers of light filtered into the dark hold through the edges of the closed hatch by morning's sunrise. There was also another smell she could distinguish, this one better than the putrid diesel fuel exhaust of the tow-barges or the pungency of the sheepskin. Catherine had flash backs to the farms of her estates. At last it dawned on her — the smell was reminiscent of fresh cut crops. More light suddenly shone down on her as the hatch was moved aside by Anna. Catherine's eyes watered as they adjusted from the dark to daylight.

"What is that sweet smell?" Catherine asked as she wiggled up and out of the small opening into the cabin.

"It's these bags of wheat. Baksheesh... the clean white Romanian wheat. Nicky often uses it as 'gifts' to soothe a nosy border guard," Anna explained.

What an ironic twist. The wheat Grandpapa had developed seven decades earlier was now part of Catherine's ticket to freedom. Now the sweet smell also gave comfort to her as she clung to the memories of long ago days with her wonderful Grandpapa.

"Please come up. Vladi and his wife have not returned yet," Anna said.

It was a struggle, Catherine was cramped from cold, the tight quarters, her left leg had stiffened considerably and her left ankle was too painful to move. Anna examined Catherine in the morning light shining into the cabin. Catherine soaked in the warmth of the cabin. The injured ankle was twice its normal size and an ugly purple color. She could see the dress was shredded on much of the left side and was matted with blood. Anna poured Catherine some tea and motioned with her hand for Nicky to leave.

"Let's take these clothes off and get you cleaned up and bandaged while we have time in this light. You won't have this luxury for most of the trip — once Vladi and Christina are aboard."

Still shivering in the new welcomed warmth of the cabin Catherine looked alarmed for minute, "I'll need all my clothes."

Anna looked sympathetically at her passenger. "It's cold down there isn't it? I'll clean them and dry them in the sun on the deck with my

339

laundry. They'll be ready in several hours. I'll pass them down to you. In the meantime wrap my blanket around you."

Reality began slowly creeping in as Catherine looked back at the cubbyhole. She realized it was to be her new home for much of the journey, and by Nicky's description it would be her nicest accommodation. She thought of the time she escaped into Romania. This journey certainly would not be like her ride on the Orient Express.

Exhaustion had been her ally the past night. How would she cope with the cold, with the dark, and with her claustrophobia in the days and weeks to follow? Catherine looked out the cabin window, sipped on the hot tea, and tried to ignore the pain as Anna carefully dabbed the wounds.

Pieces of sand and grit were mixed with the clotted blood and in some places imbedded in her flesh. Catherine's mind wandered to other parts of her life's past adventures. She didn't feel the pain as her mind wandered to other places and times. The warmth of the water and soft cotton rag was therapeutic. What would her new life be like? How would she fend for herself? How would she find her way to America? Working through those thoughts would occupy much of her time in the coming days and nights of solitude and cold... a seemingly unending cold.

While her thoughts continued to drift back to years gone by, Catherine remembered happy days aboard the **Sospiro**, her family's converted cruise boat, as it plied its way up and down the Danube. She now knew her means of escape would be on this ancient waterway of Europe, the same waters her family had once traveled for leisure. This would be a very different cruise she thought. Looking out of the cabin and across the blue rippling waters of her highway to freedom there was no doubt in her mind. This barge and this river would be her slow winding path to her new life. This would indeed be a memorable cruise — the Blue Danube Redux.

CHAPTER 29

An Iron Sarcophagus

There was a strange rhythmic knock on the door. Catherine froze.

Anna laughed, "Don't go hide. Here, wrap the towel around yourself. Come in Nicky. Our knock is two quick raps, three times."

"Anything else I should know?" Catherine's shoulders drooped as she relaxed from the fright.

Nicky nodded his head. "I must show you your hiding place in the light of day, before Vladi and Christina return. Put Anna's overcoat and scarf on and grab the broom. Should they arrive from a distance they will think Anna and I are doing chores."

Once up on the deck in the morning's bright daylight, Catherine gathered in more details of the oil barge. It gave her a feel for the vessel and not a good one. The tow barge was not pretty. There were cabins at each end for crew, and to house the engines that propelled the oil carrier. The cabins had not been painted in a long time, although it could be seen that at one time they had been proudly maintained. The siding was a blistered and flaking white paint, the trim around the doors and windows was a faded green, the fascia and baseboards were red. It was the colors of the company that once owned the barges. Now the property of the state the pride of ownership no longer existed. The cargo barges themselves were rust buckets with oxidized surfaces intermixed with battleship grey and smeared with the residue of their black oil cargo.

Nicky gestured with an outstretched arm pointing to the opposite end. "We have no true stern or bow. Either end of the vessel is the same. As captain, I take the lead as I trust my navigation skills. It's hell if you run aground. We have the eight segments attached. Our freight — oil — is very heavy. Our engines strain under a full load — which we have now.

341

Other tow barges with lighter loads or bigger engines might be twice as long. The crews use bikes to go back and forth.

"Vladi and I and our wives are a team. We work together and go back and forth. Our wives have chores as well. In the evenings and at lunch we often eat together — sometimes we will play cards at night. As you can see everything is wide open and in plain sight which is why you must stay concealed."

"Then why are we out here?" Catherine interrupted. "Where could I possibly hide?"

"Sweep around the deck here, and I'll show you." Nicky said as he leaned over the tanks with a large wrench about the length of his arm.

With several deft cranks, four bolts were removed on the rusty cover plate to the ballast holding tank. "Each of the cabin quarters is separated from the oil by two buffer tanks — here and here." Nicky pointed to the parallel tanks running across the width of the deck.

"They are about four feet wide. They hold the ballast water to keep the barges on an even keel as the loads are taken off. They also keep the fumes away — sort of — and are a safety spacing between the crew and our dangerous freight. We are given wide berth by other vessels and our slimy, smelly, decks reduce our number of inspections. Some find the smell noxious."

Nodding in agreement Catherine added with sarcasm, "I've of late been finding comfort from the aroma of my sheepskin."

Deftly Nicky removed the section he had unbolted. It was a two foot square section with a hand hold bar. As Nicky set it down the solid iron cover clanged heavily on the barge deck. "This is how we go inside to service... for cleaning and repairs. They're empty now — come fit yourself inside."

A dubious Catherine looked at Nicky and the hole — then back to Nicky. It was an iron tomb! Nicky saw her reluctance and slipped himself ahead of her into the pitch black hole that was to conceal Catherine.

"Come, I'll help you."

Catherine had barely survived the cubby hole the night before. Her claustrophobia paralyzed her.

Trying to be encouraging as he looked back and saw her hesitation, Nicky said with confidence, "Nobody has ever been discovered here." He could have added nobody had ever tried before also.

Closing her eyes Catherine's mouth felt like cotton, but she steeled herself. If this was the path to freedom — like the rocky path the night

before — she would do whatever it would take. Sitting on the edge of the tank opening Catherine's thoughts flashed to the first orphanage. She would climb out the windows, walk a narrow ledge to a downspout and slide down to the freedom of the woods. Well, this would just have to be another similar adventure. Lowering herself, she grimaced while trying to ignore the pain and tenderness of her ankle.

Using the huge wrench as a pointer Nicky motioned across the upper portion of the tank. "There is a platform welded to the side of the tank. I have an old sofa back resting on it to keep you off the metal. Try it... this will be your safe haven."

Painfully Catherine lifted her injured left foot up and balanced on her good right foot. Then she stretched her torso out like a ballerina doing a pirouette — an old ballerina. She rolled up onto the platform and lay still for a minute. The sofa back was very lumpy and smelled of mildew, but it was likely a great alternative to the cold, hard, metal platform. The curved top of the tank was only inches above her face.

Once she was settled Nicky explained the worse part. "Catherine... this tank will be filled with water. When inspectors come aboard they tap these tanks with metal rods. If they sound full, the inspectors continue on their way. If they echo and are empty — they will open the tank to inspect it for contraband. When you get in, we'll fill it with water up to the platform. After the inspection is over — we empty the tank and you return to the cubbyhole — at night of course so Vladi and Christina won't see you. There will be no problems."

"You sound so sure!" His reassurance meant nothing to Catherine. She was fighting to overcome her desire to scream and jump out of the tank as he spoke... and the hatch hadn't even been closed! Sweat was already beading on her forehead from nervousness. She could not think of a worse nightmare than inside a tank, bolted tight, no light, and water lapping at her sides. The old hymns, the ones she memorized hiding under the stage, helped her then, and they would have to help her now. She started to hum some of the verses, and thought she would be just fine.

Hearing her Nicky cautioned her, "You will have to remain silent."

For the first time Catherine took pause and a calm came over her. Considering all the circumstances and nuances already of her passage onto the barge — she looked over at the short, but determined accomplice to her flight out of Romania and simply smiled at him. She knew his courage would sustain her and calm her fears. She would sing in just her

343

imagination if that was the rule, and she would do whatever he said. Her goal was to be free. There was more work to do in her life. This was only the beginning of her life's next journey.

"I find the accommodations quite... adequate, umm, there is no upgrade?"

Nicky smiled back and tried to assure her. "It will only be at the crossings you'll have to be in here. There will be inspections at each border; before and after as we cross Romania to Yugoslavia, to Hungary, then Czechoslovakia, and lastly into Austria."

Delays, delays, delays... it was the way of the new communist regimes. So inefficient, so corrupt, so broken. Sadly, Russia's only export to its Eastern Europe puppets. The barge sat for three days while Nicky was awaiting confirmation and orders to leave. Once underway the going was slow, the fully loaded barge laboring to go upstream against the current. During the delay Catherine used her time to rest and let her injuries heal. There was little else she could do.

Her cubbyhole in the cabin hold had two small portals, tiny round windows about the size of dinner plates. They let in light and she could attempt to see outside during the day, but the polluted water of the Danube left the glass an oily smudge. Anna even lowered herself over the bow, suspended by a lifeline and wiped the glass as clean as she could. Her effort improved the amount of light coming in but did little to improve Catherine's ability to see outside.

It was only at night when Catherine was allowed out of the hold and into the cabin area and then only after Vladi and Christina's cabin lights were turned off. Then she would absorb as much heat as she could, eat some soup and her 'caviar on the barge', her Eskimo sandwich, a heaping dose of seasoned lard on black bread. Catherine let her imagination run to the fanciful as she had done all her life as she pictured herself as an Eskimo princess eating the most exquisite lard in the land — likely from a great polar bear or walrus slain in her honor. Her dreams had kept her entertained in her youth in the orphanages. It would serve her well now. This time she was a captive by her own design and for a noble purpose, not as then, when she was a pawn of a deranged father seeking only to satisfy greed and revenge.

Too soon it seemed the dreaded order from Nicky came. "Time to hide!"

The swelling in Catherine's ankle was subsiding, but was still very tender and bruised. Her left side had stiffened from the fall down the ravine as the raw areas of her skin had scabbed over. They were beginning to itch now as they healed.

Nicky removed the bolts and the lid to her iron cave and motioned for her to hurry over and get into the tank. Catherine carried just her sheepskin cover with her as she approached cautiously with only the starlight illuminating her way in the dark of night. She did not hesitate to climb in, but her fears began as the lid was placed over the hatch. She listened while she stood in the damp oily sludge in the bottom of the empty tank as each bolt was tightened. The blackness was complete.

Catherine sensed disorientation as she had no visual points of reference in the void of sight. She lifted her leg and rolled up onto the iron platform that was to be her home for the next 24 hours. It was the first time she tried the maneuver in the dark and she bumped her head against the iron top of the container with a halting jolt. As she settled onto the platform Catherine head ached and she raised her hand to rub the sore area, but it too impacted against the metal. Her tight new quarters would require some getting used to. Slowly lifting her palm up to her nose she touched the metal surface and found it only inches, barely the palm of her hand, from her head. It didn't matter if her eyes were closed or open — the blackness was total and enveloping. She lay flat on her back, fiercely gripping the smelly sheepskin — her only companion.

Then the water came. Lying flat on the lumpy cushions Catherine heard at first a burst of air, then water splashing and gurgling about the bottom of the tank. As the level rose, the splashing noise subsided. The level of water rose above the inlets. The splashing was replaced by sloshing while the pond of water below her continued to rise. It pressed against the sides of the tank when the barge pitched and yawed as it pushed through the water outside. She felt a cold breeze as the frigid air inside the tank was squeezed by the encroaching water.

Catherine shivered as the air inside the tank was further cooled by the icy water of the river. The panic began. Her mind started to race with fear. What if the water didn't stop — a malfunction or the level was misjudged by Nicky? What if the barge pitched and she fell into the water or if she fell asleep and rolled off the platform? She would drown! What if there was not enough oxygen left in the tank when it filled with water, would she suffocate? What if Nicky and Anna were arrested and taken off the barge and she was left behind? Would this indeed be her final repose?

345

There was no escape. Catherine began to gasp for breath as panic began to overwhelm common sense and her mind spun out of control with fear. She perspired despite the damp cold of the metal coffin and wanted to scream to get out! She knew it was not possible... orders from Nicky... but could she hold in the scream that pursed her shivering lips?

The water stopped rising. Catherine could feel it lap against the base of the platform she laid upon. There had to be a way to settle her thoughts... all those wild questions with horrid images raced across her mind's eye. She had to rely on her mind to save her now for she could not allow imagined or real fears to overtake her common sense and fight the panic, she had no choice. This is what she needed to do to escape. Nicky would not let her out. If he did the mission would be aborted and she knew she would never get a chance to get away again. If she screamed out when the inspection was taking place she would be discovered, taken out and likely killed... or worse for she would also then have the deaths of the other four on the barge for they would all be complicit.

A hymn suddenly popped into Catherine's head. She rolled the verses across her closed eyes, and the panic subsided slightly. Her breathing and heart rate calmed. Her senses began to respond to her endless black environment. She lay in the stony quiet of the floating coffin.

Hours went by agonizingly slow and there was no way of knowing just how many turns of the clock had elapsed. There was nothing to be seen, but she began to hear noises never before noticed. The engine didn't just chug, it pinged, clanked, moaned, squealed, and pounded as a thousand moving parts did a synchronized dance of energy, power, and motion. The barge itself was alive with noise as water pushed against its sides, as metal buckled slightly to the pressure and current of the river, then pushed back out against it. Rivets and bolts shifted. Water lapped at the sides, and was pushed aside as the barge grabbed more water while it pressed forward. Footsteps and voices seemed distant, muffled by the water and metal, but she could hear them. The sounds gave her something to focus on and any noise outside helped her, there alone inside her watery tomb — inside her iron sarcophagus.

With desperate determination Catherine focused her mind. She had talked to people about the solitary confinement many soldiers had been forced to live through as prisoners. They all indicated the dangers of the mind breaking were the most difficult. Many had gone crazy — even killed themselves — seeking to escape their mind's own prison. Those who survived all maintained they had focused their thoughts. They

recreated their past, they constructed a future, they did not think about the present. They counted; they recited things, they did whatever they could to avoid dwelling on their situation of confinement.

Catherine had lived a very full life with many different periods, many adventures, many sorrows and rewards, and she would try to recall those moments of her past to recreate each year of her life sequentially starting at the beginning of her memories. She would start with a little girl, probably only remembered from a few photographs taken before being kidnapped. It had been quite a life to that point, even if it did not go on much longer.

When she tired of that exercise, Catherine tried to remember the hymns and verses she at one time committed to her vast memory. Fighting against sleep for fear of falling into the water filled tank, the monotony would cast its spell on her and sleep finally would overtake her only to be jarred awake by a an echoing noise, a groan of the barges metal skin, or a motion shift of the barge. Catherine thought of her future and the very special goals in mind which she had formed several years prior. She was determined to not give up and die in the clutches of communist despots and their terror. The thoughts of a new life and somehow getting to America would sustain her.

Her goals for the new life were simple. Be free of the communists and warn the free world of the dangers of communism. Then she wanted to get to America and find all her 'boys' to thank them for their sacrifices in the cause of freedom. She had not found an opportunity to do such in those horrid final days of their escape and airlift out of Romania. It would be her reason for going to America! It would be what she focused much of her consciousness on to maintain her sanity and survive her escape.

Thunk, thunk, thunk!

That surely was the inspectors tapping the tank. Catherine heard muffled voices. Was that laughter she could hear? Nicky was cajoling the inspectors. That meant it must be daytime. Was it eight AM or four PM? There was no way of knowing what the time was. Her body was numb with cold, but she could feel the hunger so it had to have been at least a day that she had been confined. Catherine was used to hunger. Her body was telling her something else as well.

Nicky kept a metal pail — a white owl — in her cubbyhole under the hold of the barge. It served as her latrine during the daytime. However, inside the tank such was not an option. Catherine had been fighting the urge of nature's call for hours but could wait no longer. Ah, the indignities

she thought as she finally gave in and relieved herself. But, whatever it takes! It was her new mantra.

Time dragged on, it seemed as endless as the darkness. When would Nicky come to get her out? Before she left Bucharest Catherine had prepared a list of contacts in Europe and America. Some of the contacts were just names, others had addresses, several had phone numbers. Then there was also a list of her 'boys'. She knew some better than others, some she did not know at all beyond the name on a roll call of prisoners. In her cubbyhole Catherine had found enough light coming through the portals to read the list and memorize it. To occupy her time in the darkness she spent hours reciting the names.

With nothing else to do she used her time in hiding to replay all the lists in her mind over and over again. Catherine's ability to remember faces and facts had always amazed her acquaintances. It had served her well in the business world. It allowed her to recall many of her own orphans in the streets of Bucharest as she wandered about after the Communist takeover. Many a meal or piece of clothing had been provided by a former charge — impressed that their one time benefactor recognized them and knew their name. Catherine hoped some of those names and faces would remember her. She had nothing now, except the memory of the people who were attached to those names and faces.

The hours dragged on, for how long Catherine had no idea. She was becoming cramped from not being able to move in the tight and very cold quarters. The narrow space was not as much of a deterrent to her movement as was her fear of falling off the platform and into the water lapping just beneath her. Catherine turned to another distraction to take her mind off the claustrophobic waves that would constantly arise and suddenly sweep over her. While waiting to begin her escape Catherine spent hours in the U.S. Information Office library practicing her English skills by reading. One of her accomplishments was to read an entire 22-volume edition of the Encyclopedia Britannia. Locked in the tank was an opportunity to go back to Volume 1 to try to remember as many subjects in the 'A's as she could. She moved on to the 'B's, eventually completing the 'Z's. Then she would start over again as the hours — seemingly endless hours —dragged past.

<div align="center">*******</div>

The change was imperceptible at first. Catherine began to notice the water noises that surrounded her seeming to echo, to sound more distant.

She reached over the edge of her platform trying to find the water level and found the water subsiding. It was more than a hand's length lower. The tank was draining!

It was a slow process, but eventually she heard air gurgling in the water as it sunk below the upper drain holes. She heard the wrench against bolts, as Nicky quickly removed the bolts and hatch. The rush of clean fresh air was intoxicating. The light of a thousand stars filled the dark emptiness of the tank. It hurt her eyes and she recoiled, not knowing there could be so much light in the dead of night.

"Are you ok?" Nicky inquired as he poked his head inside the hatch.

"Yes, yes... it was wonderful! When can we do this again?" Catherine feigned shear joy.

"Careful when you get up. Your balance will be distorted."

Catherine responded with a good natured chuckle, "My balance, my vision, my bowels... everything of importance is now... distorted!"

"You survived, Princess."

"Yes, I did, again... and that's a good thing." Catherine quickly added, "I'd like to un-distort my stomach, if you know what I mean."

"Anna has chicken pot pie ready for you!"

Nicky explained the plan for the next several days. The inspection had gone without a hitch. However, he had been directed to unload part of his cargo at an unscheduled port ahead. The port, unfortunately, was undergoing some repairs and several other barges were lined up to unload as well. It would undoubtedly take several days for the repairs to the dock to be completed, and all the barges in the queue would be unloaded in order. It would cause a delay of up to a week.

"A tribute to the efficiencies of state run facilities," Catherine scoffed.

"It's the way of the river these days," Nicky responded. "The good news for you is that Vladi and I will take turns again going ashore while we wait. You will have several days to stretch and move about the cabin. Perhaps in the evening when they are gone you can take several laps around the catwalk — get the kinks out."

Such seemingly small gestures had become great favors for Catherine. It had been about a week since she left the streets of Bucharest. She wondered if her absence had been discovered. Perhaps the manager of the trucking firm had led authorities to the backroom, and they found her note explaining an emergency visit to a sick acquaintance in the

country — an undisclosed location of course. Maybe that would put them off her trail for another week. Maybe she was already on the fugitive list. Catherine was impatient because of the delay, but thankful for the respite from the cramped cubbyhole that was her new home. Quite a contrast to the grand cavernous spaces of the Cantacuzene Palace in Bucharest she once roamed.

It was hard when the time came to leave the cozy cabin for the unheated berth below it. After her stay in the ballast tank, however, Catherine had a new appreciation for the hold's dryness, its dim shafts of light, the two tiny portals with their fuzzy views, the room to sprawl out and change positions, and the luxury of the use of the white owl, her potty bowl. Cramped though it was — the cubbyhole under the bow suddenly seemed so spacious. It far exceeded the water tank platform. Catherine was reminded of how everyone's problems were relative.

The delay dragged on for five days not the couple of days hoped for initially. As the barge finally unloaded and pressed on it moved further away from the Black Sea and its temperate climes. It became decidedly colder. Catherine had taken to wearing all her clothes in layers as a protection against the frigid air. The daily dose of Eskimo sandwich seemed to be working though for Catherine had not caught a cold.

The next inspection while entering Hungary was not unlike Catherine's first experience in the black hole — long, cold, uncomfortable, and unceasingly dark. Catherine did make an adjustment that helped. She took with her a small loaf of hard bread, clutched it, and held it beneath the top layer of her clothes the entire time not wanting it to fall into the water when she dozed. Then whenever she felt hungry, as she had done with her rock candy as an orphan, and even just days before on the streets of Bucharest she would pinch the tiniest piece of bread and let it dissolve slowly in her mouth and imagine consuming an entire meal. It occupied both her mind and her stomach. When Nicky opened the hatch nearly twenty-four hours after she entered the tank Catherine still clung to half a loaf and had truly not felt hunger.

Never looking forward to the order for concealment, Catherine resigned herself to the moments of panic the black hiding place always induced. The fear never left her. She fought the claustrophobia with sheer willpower and her mental exercises. While the experience never improved, it seemed more controlled. Familiarity of the circumstances was a help, but the anxiety, the doubts did not leave. Catherine always took another loaf of bread and the pinching technique helped her hunger.

She also no longer suffered from a reluctance to exercise bodily functions for as uncomfortable as it was to take care of such necessary business — it beat the alternative of constant internal discomfort.

Each new time in her repose lying upon the iron platform, Catherine heard more sounds from the inside of the tank and took it as a personal challenge to discover more. She was becoming adept at interpreting noise. With her heightening sense of hearing Catherine became adept in telling when the inspectors were boarding and leaving the vessel. Different vibrations through the steel hull translated into other things of meaning. Her body clock was becoming adapted to the passage of time — she could sense if it was morning, afternoon, or nighttime by her internal clock and from the noises on the barge she was learning to translate. This process too absorbed more minutes during what had once seemed to be a timeless confinement. The concentration on all such things overcame what had been hours of fear and doubts.

It had been a long lapse of hours since the inspection had been completed. She waited impatiently for the water in the ballast tank to drain. More hours ticked by and still the water sloshed just beneath her. The frightening thoughts crept back. Had something gone wrong during the inspection? Were Nicky and Anna discovered, turned in by Vladi? What else could have gone wrong? Finally, she heard the bolts loosened and the lid came off even though the water had barely lowered below the platform that was her bed.

"Catherine? The pump is not working. Do you want to stay until I can fix it in the morning? We'd still have to keep you inside till nightfall tomorrow."

"Teach me to swim!" was her instant response. "Please, no more time in here than necessary!" she said with desperate urgency. There were clouds of vapor coming from their mouths made visible by the cold as they talked.

"I thought that would be your answer. I've put on my swim trunks. I will go into the tank, and you can get on my back. I can carry you to the opening."

"What if I fall?" Catherine asked.

"Don't!" was Nicky's instant retort.

The water was cold, so cold the movement of the barge was likely what kept the water within the tank from freezing. In the dim light Catherine could see frost from her breath that had formed above her head on the top of the tank. She was stiff and numb with cold, and her ankle and hip

were yet to fully recover from the fall. Nicky gingerly lowered himself into the frigid water which came up to his chest and waded his way slowly and cautiously over to the platform. In the brief time it took for him to go the short distance his teeth were chattering and his lips were turning blue.

Nicky's back was slippery. Catherine could not wrap her legs around his waist and she clung to his neck. As she rolled off the platform she was like a dead weight pulling him backward. He lost his balance and slipped to his knees, submerging them both in the brackish water. Caught by the surprise submergence Catherine began to panic underwater, but Nicky grabbed her arms firmly not wanting her to flail and struggle to get out. He knew a panicked swimmer most often caused the drowning of a rescuer. His firm grip helped Catherine remember he was there to help her and also kept her from strangling him. Instead of struggling she relaxed and went limp putting all confidence in Nicky to get her out. Nicky used her calm to regain his balance.

The cold water was quickly numbing them both. Slowly, purposefully, Nicky squared his shoulders and gathered his legs under himself and pushed up. Catherine had gone in with her mouth and nostrils open and took in water. She coughed and choked on the awful tasting river water, trying not to aspirate it into her lungs where surely the filthy waters would harbor bacteria and create pneumonia. Nicky kept both of his stout arms up to his shoulders where he still firmly grasped Catherine's forearms. He slogged forward to the opening. There they were met by Anna.

"Shush, quiet. A light is on in Vladi's cabin, perhaps they heard you slip, you must wait!"

To help while they waited Catherine grabbed the hatch opening and tried to give Nicky balance and remove some of her weight from him. She still coughed and gasped for air reflexively yet struggled to cover her mouth with her arms to subdue the noise she made. Her body shuddered convulsively from the cold. The aching cold was having a numbing effect on her hands and feet. Nicky stood like a statue. The minutes ticked by like hours as they waited for Anna's signal. Soon they were both shivering uncontrollably in the water with the night air swirling around their wet skin which was exposed out of the water. Hyperthermia would soon become an issue. Anna knew she could not pull them out yet but time was running out. Soon their lives would be in jeopardy.

In hushed words Anna whispered back into the tank, "The light has been out several minutes now."

Nicky made his decision. Vladi was a heavy sleeper. If he had been

the one who got up he was likely asleep again. If not — well, Nicky would take his chances. They had to get out.

"Can you lift yourself up, Catherine?"

"I am too numb... and too old."

"Anna, put the life ring around Catherine and be ready to heave ho. Catherine, remember the trail, when you climbed while I pushed. Get the life ring under your armpits, Anna will hold on and keep you from falling back. I am going to duck down and grab your feet and push you up... like we did in the gorge. Got it?"

"I've got it!" Catherine was already fumbling with shivering and uncooperative arms adjusting the life preserver. "Anna's ready and so am I."

Taking a big gulp of air Nicky submerged and pushed with a mighty thrust of his legs. Catherine went completely out of the hatch and landed on Anna and they sprawled on the deck. Nicky scrambled though the opening and didn't stop to secure the hatch. That could be done after he had warmed and put on dry clothes.

With no modesty they stripped of their wet clothes and toweled off inside the small cabin. The three huddled together near the coal heater draped under blankets. Catherine did not go back into the cubbyhole that evening. They ate steaming stew, hard bread, more wonderful lard on rye and drank piping hot tea. Catherine soon fell asleep exhausted from the cold ordeal. Anna hung the soaked clothes over the heater to dry while Nicky ventured out of the cabin and bolted the hatch shut.

The lard on rye — with a pinch if salt — continued to work its magic. None of the three suffered a cold. But the trip lingered on as several more schedule changes were ordered. Catherine lost track of time and grew restless and bored. She asked Anna to find something for her to read. There was the found the manual for the old diesel engine. Already Catherine knew every sound it made so she might as well read about it.

An old edition of **Life** magazine was also discovered amid the engine manuals. It celebrated the end of WWII — Catherine never was able to celebrate the end of the war. The magazine was a great divergence and very enjoyable. The last thing uncovered by Anna was a calendar — dated 1908. It must have fallen behind a cupboard and became wedged there those many years past.

Catherine looked at the calendar cover. She flipped through its pages,

and then looked up at Anna. "You know, this is a funny coincidence. This is the year I escaped from Paris and returned to Romania. How many people do you know have to escape first into and then out of their homeland?"

On the cover was a poem about a journey. Catherine found it fitting and copied it down on a small piece of paper and put it in her bag.

By the Rules

August 29, 1987. Dayton Ohio

I leaned back in the chair for a moment and glanced up from my notes to consider the old woman's face. I had a far greater appreciation of what a survivor she had been. Asking Princess Catherine if she remembered the poem... I suspected she did. She smiled at me and opened her purse producing a picture holder stuffed with keepsakes, pictures of some of her 'boys', and their families. From it she pulled out a scrap of faded paper and handed it to me. This remarkable lady had kept it with her all those many years. On it was a handwritten poem that I began to read to myself. Her eyes wandered back out the window, and she began to recite it out loud:

The Journey's Prayer
The journey of life goes many a way,
A path must be found day by day.
So Lord guide my way to seek what's true,
To find true peace and The Golden Rule.
It's not the destination, it's how one walks the trail,
With you at my side, we cannot fail.
Together we'll see what's around the bend,
Lo the journey we take will never end.

The barge was tied up at one of the frequent stops it was making. Catherine was not sure if this was the usual way of river travel, or if Nicky was perhaps running more errands as part of his underground duties. Time was no longer relevant. Catherine simply knew that when the barge moved, it went upstream and that meant she was closer to the west,

and closer to freedom. Nicky had risked his own life for her on several occasions and pulled her out of several tough spots. It would be simple enough to trust him and do what he said for she had gained deep respect of both Anna and Nicky and had developed a growing fondness of them both. They were plain folk, hardworking, and of course very courageous. It was so admirable what they risked for the freedom of others.

After a final walk around the decks of the barge, Nicky went ashore. Vladi and Christina had left already. Anna stayed on board. It was the rule that someone always stayed behind for security. As twilight quickly darkened from a frosty purple to the freezing crisp blackness of a December evening, Anna opened the cover of the cubbyhole and beckoned to Catherine. Catherine crawled out, once again thankful for the seventy-five pounds she had lost in the last two years. It was unlikely she could have negotiated all the tight spots she found herself in had it not been for her 'Commie Diet' and so many long walks. Anna was fiddling with the short-wave radio. Sitting on the table waiting for her was a steaming bowl of soup, a cup of piping hot quince tea, and of course her Eskimo sandwich of salted lard on black bread.

"Come sit with me on the steps," Anna said as some Christmas music could be heard faintly beneath the crackling of the radio. Catherine was sipping the tea, happy for the warmth it sent down her innards. "Nicky said we could enjoy some music this evening — as long as it was not so loud as to and aroused the indignation of the Communists. They officially frown on Christmas celebrations, but of course you know that sad fact."

Catherine put her tea down and had a puzzled look on her face. "Sad is an understatement!" Then it struck Catherine, "It's Christmas Eve isn't it?"

She was totally unaware of the day or date. They were well past the original estimate of three weeks for the journey. One day was just like the next.

"Yes. Vladi and Christina are ashore for the evening and tomorrow. I'm hoping Nicky will surprise us with some cooked goose and wine! You know, despite the party line, most folks still celebrate Christmas behind the Iron Curtain... just very quietly. Nicky said there would be a broadcast from London we might pick up on the radio this evening."

Together they sat on the steps watching glistening stars twinkling in the sky with the faint strains of Christmas songs floating out from the cabin behind them. The songs warmed their souls as the coal stove inside the cabin warmed their backs. They both sat quietly lost in their

memories of a Christmas past as the carols and hymns played across the cold blue waters of the Danube.

It wasn't long before Nicky returned with a sack. "Could I interest you ladies in some slices of roast goose, cranberries, and a sugar-coated pound cake... plus some wonderful Chianti wine?"

Such a treat yet Catherine's emotions were mixed. Warmth and joy to be with Anna and Nicky, savoring the music, food and wine while on her way to freedom... sorrow at not having her own family in her own home to celebrate with. Of course there had been for years the tradition of watching the orphans of **St. Catherine's Crib** celebrating the Holy Holiday with a program of plays and songs that ended with a fine feast and a gift for each child, provided by Catherine. A melancholy crept over her.

Trying to relax for the moment was difficult. Catherine was anxious to finish the voyage and begin her new life, yet at the same time always on the lookout — fearing capture that would end the dream and surely her life. She hoped she would be able to relax once the escape was completed. Her dream and prayer for this holiest season was to help rid the world's captive countries of dictators and Godless Communism. Still she acknowledged and feared the zeal of the Communists for world domination. As she tipped her cup in a toast to the holiday with her two friends, Catherine promised herself to live her remaining days without fear, full of hope, and with a zeal for freedom exceeding any zealot of communism who hoped for its domination and control.

Another week passed. New Year's Eve came and Nicky announced they were nearing Budapest. BUDAPEST! Catherine mentally reviewed her geography lessons and recalled her family cruises on the Danube. Budapest, Hungary, still two more inspections and a third of the way yet to go! The trip already exceeded Nicky's estimated time by double! Her patience was wearing thin, her nerves were frayed, and her body was constantly on the verge of shivers. The energy she consumed to fight the cold sapped her of the vitality she was used to. The monotony of her routine and cramped quarters without any mental stimulation left her listless. Empty... as empty as the hold within which she hid. That sense of emptiness pervaded as she was becoming a shell of whom she really was, her true being. Doubts... the menace of doubts always nagged at her.

Once again Catherine summoned all her resilience and looked for the

silver lining. Her loved math and numbers helped pass the time as she ran some mental projections. If the trip had taken already twice as long as originally planned, it certainly could not go much slower. So if they maintained their current rate, Vienna would be at most twenty — worst case — thirty days away. That could be done! At nearly sixty years old, she quickly calculated that to be 720 months — well then one more month would be just a blink of an eye in her life's story.

The duration and stress of the trip was wearing on Nicky as well. He had given Catherine a candle to use in her cubbyhole so she could play solitaire. It was a sign he was letting his guard down. Not that anyone would see the candle light flickering through the two small portals in the hull. The likelihood of the candle starting a fire was miniscule — though it was an open flame in a combustible environment. Nicky had found his passenger far exceed his initial reservations. He had exploded when first told he was to escort an elderly ex-royal out of the country and a woman to boot! No way would he risk everything on such a person! Such a person of privilege would never survive the trip, she would expose him to capture, she would not be cooperative, she certainly could not endure the hardships!

He accepted the assignment only under the strongest objections and a promise on his part to terminate her instantly if anything went wrong. Yet she was enduring pain and suffering many men half her age would have succumbed to a long time ago. Catherine far exceeded the assurances he had been given of this person of great courage and tenacity. He now understood she was indeed worthy, not just of the escape, but his adulation as well. He also felt he could trust her. Yet relaxing his own procedures was dangerous — was not by the book, and that's how Nicky always ran his boat and his underground operations... by the book.

In another act of kindness outside the rules Catherine was also allowed more time in the warmth of the cabin. It was a particularly cold winter; besides it was a treat for Anna to have the company of Catherine. As a princess she once led a fascinating life unlike anything a commoner would ever experience. She had many stories she was always eager to share with Anna.

One afternoon Nicky was in the stern section of the barge. Vladi had been having trouble with his diesel and the two sailors were below the deck cursing the old equipment. Christina was doing laundry, and even

if she noticed the approaching boat it would not have caused her any alarm. If it was an inspector — it was just one of many. Anna on the other hand would have normally been posted and on alert with Nicky away and occupied. She would have been on the lookout and Catherine would have been stowed below the deck. Instead Anna was hearing about the typhus hospital Catherine set up in WWI.

The speed boat pulled even with the barge and tossed a grappling hook up to the deck. It snagged against the outer catwalk. The boat was secured and three uniformed men boarded the barge — two with machine guns, the third with a clipboard. Christina went out to hang her laundry in hopes the sun and breeze would dry them before they froze stiff. Seeing the men on deck Christina called down to Vladi, "Three uniforms at mid-ship! Looks like an inspection."

Nicky heard the words and froze, absorbed momentarily in imagining what an unscheduled boarding and inspection might portend. He jumped up and told Vladi to keep working on the engine. He grabbed a rag to wipe the oily grime from his hands and waved the soldiers to the rear, hoping his calling out and waving attracted the attention of Anna or Catherine in the forward cabin as well as the inspectors. It did not.

"Hey, we're down here! Engine trouble! Can I help you?" Nicky hollered out loudly, hoping that too would catch the attention of the two women at the opposite end of the barge.

"Inspection, sir. Let us see your manifest please!" The officer with the clipboard made his request in a polite, but stern fashion.

"Of course, of course, yes — this way." Nicky continued in his loud voice. "Excuse me while I wipe my hands. Don't want grease and oil all over the papers." Nicky scrubbed furiously with the rag as if in deference to the clean uniformed inspection team. He was trying to buy time.

Copies of the manifest were kept in both crew cabins. He reached in to the stern cabin for the clip board that hung from a nail. Nicky watched — acting as nonchalant as he could while the officer and one of the soldiers moved in his direction. The other soldier was being given some direction by the officer and moved off towards the forward cabin. Nicky began to consider other options. He kept his revolver in his own cabin. He knew Vladi had one also, but he didn't know where it was hidden. Pirating and thievery were not uncommon occurrences on the river routes these days, and many crews hid weapons to protect themselves.

Looking all business-like Nicky walked over with the folder to meet the two men coming his way. He looked over the side at the military speed

boat quickly trying to assess the situation and formulate a plan of action. Just one mate on board was keeping the boat trolling in pace with the barge. Most inspections were done at a port. This was unscheduled and appeared more of a military operation than a bureaucratic affair. Had Vladi become suspicious and turned him in, he likely would become the new Captain of the barge. Were they on to Catherine's escape? What was Anna doing? Had they heard his shouting and gotten Catherine hidden away?

Fortunately, the door of the forward cabin was locked and the curtains drawn. The armed soldier rapped on the door three times with the butt of his weapon.

A surprised Anna looked at the door in disbelief. Catherine knew it was not the three double knocks of Nicky. She instantly moved without any encouragement from Anna silently into the closet's hidden compartment. Anna followed her and stood by the closet, trying to spread the clothes to conceal the false back panel in the closet.

There were three quick raps — this time a command, "Open up, immediately, inspection!"

Quickly unbuttoning her blouse Anna called out, "Just a minute, I'm giving myself a bath, let me get dressed!"

"Open up, now!" was the terse command.

Without a second thought Anna took her blouse off and poured the pitcher of water from the night stand over her head and let it drip down over her shoulders as she unhooked her bra. She reached for the knob, took a deep breath, and opened the door. She confronted the stunned soldier with her left hand covering her breasts.

She shouted with indignation, "I said... I'm bathing and need to get dressed! Do you mind?!" She paused to let the soldier get a good look, and then slammed the door closed.

The soldier was flustered, embarrassed, confused. He couldn't remember what he was doing. He turned and walked away to join his comrades in the rear. Nicky snatched several glances forward while the officer reviewed the manifest. He had heard the door slam close. The other soldier made a pass through Vladi's cabin, looking through the closet, lifting bench cushions, as if he was looking for something.

The officer looked at the soldier as he approached. "Are you so out of shape a walk across a barge does you in?"

Nicky could see the man sweating despite the frigid air.

The soldier replied meekly, "I suppose so, sir."

What's up forward?" the officer asked.

"One woman, young. The cabin, well, it's clear, sir."

"OK, let's check the tanks — one, three, five should be empty, is that correct?" the officer directed his question to Nicky who nodded affirmatively.

"Let's open them up and take a look."

Anna watched from the window. As the tank inspections began she opened the closet. "Quickly, Catherine, into your cubbyhole!"

The sacks of wheat and rug over the hatch were pushed aside and Catherine wiggled down into her den. Anna put the canvas rug and wheat bags back over the closed hatch, then rearranged the closet and slipped a turtleneck over her head. She wrapped a towel over her wet hair turban style, and sat at the table with a cup of tea, facing the door.

As the group of three soldiers and Nicky worked their way to tank number one, the offending soldier returned to the cabin and knocked on the door lightly.

Anna responded with an agitated, "Come in!"

The young soldier opened the door half way. "My apologies, Madame."

Not responding, Anna simply stared daggers at the head of the offender, who meekly, closed the door with a slight click.

The inspection was over. Nicky was too relieved to be angry when he returned to his cabin. He simply said, "We've come too far to mess up... it's by the book from here out."

The 'book' as it turned out by the wayside again two days later. Anna it turned out was several months pregnant and suffered a miscarriage. Nicky felt Anna should see a doctor and explained his position to Catherine. They would get off at the next port and take a train to Vienna to see a doctor. Catherine had experienced a similar loss several times and agreed with their decision. Still, she had just several small concerns. Vienna was her destination. There was still the Austrian entry inspection. The hiding place in the water tank would be out of the question with no one onboard to close the tank and let the water in and out.

"I'm sorry for this emergency," Nicky assured Catherine. The Austrian border check will not be intense. It is a neutral country not yet under the yoke of the Communist. You will be safe underneath in your

cubbyhole. I will meet the barge in Vienna and complete this mission. You will be free."

Nicky sounded very confident, but Catherine's doubts surfaced again. Austria it was true was not under the control of the Communists, and still maintained a status as a neutral. Russia though maintained a presence in the country under the Yalta agreement, but it did not yet, have the domination it exercised in the other countries they had passed through. The inspection there was merely a formality so it was said, but still a point of grave danger to Catherine way of thinking.

The only choice was for Catherine to stay by herself in the cabin and in the cubbyhole. There could be no heat in the cabin for it would be noticed by Vladi and Christina. They may even enter the cabin and check things out while Anna and Nicky were gone. Under the circumstances Nicky agreed to let Catherine use the cabin in the day only if she maintained the highest alert. She would still have to sleep in the cubbyhole, and of course hide there for the inspection. Nicky moved the wheat sacks so Catherine could get in and out of the hatch by herself. He showed her how to flip the rug with her fingers as she closed the hatch so the opening wouldn't be noticed. He moved the table and chair slightly to conceal the opening even further.

"It's a risk. We have come so far, don't do anything foolish, and don't get surprised. Be alert! You know what's at stake!" Then as if for emphasis Nicky handed her a cloth bag, in it was his revolver and a cyanide pill.

"If it comes to this, put the pill in your mouth. Don't bite on it until you've had the satisfaction of emptying the pistol into your captors — if something unforeseen happens. Please... Catherine, don't let them take you!"

CHAPTER 31

To Be a Beacon

Alone again, it seemed to be déjà vu, first her old and then her new lot in life. Catherine scraped the frost from the window pane of the unheated cabin. The barge was moored downstream of the Bratislava docks just east of the Austrian-Hungary border. The long eight tow vessel had to lay up along the shore until its unloading was scheduled by the dock master. It was too cumbersome for other ships to maneuver around the long barges. When at last the barge was ordered to the dock Catherine knew she would soon be on the last leg of her voyage up the fabled Danube River.

The next day the barge pulled away from the dock and began its slow passage to the final stop in Vienna. Catherine stayed inside her lair feeling much as if she indeed was a wild animal hibernating through a harsh winter. The stove had not been on since Nick and Anna went ashore, and the January cold was penetrating every pore and bone of her body. Catherine noticed the two portal windows were caked in a thick layer of frost — the moisture of her breathing in the confined space collecting on the cold glass. Vladi and Christina made several visits to the cabin in the absence of Nicky and Anna. On one occasion they stayed for several hours and lit the stove for their own comfort. Though meager the heat that transferred below was welcome. Catherine resigned herself to the tiny frigid sanctuary below the bow, just her and the sheepskin companion.

The words of Nicky consoled Catherine. He said he would be back to finish aiding in her escape. If she learned anything in her time with Nicky, it was she could bank on his word. But nagging doubts persisted in the dulling frozen throb that was her brain's function. What if the shipmates from the rear cabin came forward and brought their dog? Would it smell

her and give away her hiding spot? What if they just wanted to satisfy their own curiosity and rummage through Nicky and Anna's belongings? What if the border inspection was more thorough than Nicky thought? What if there was a freak accident, another boat ramming the barge?

Perhaps it was anxiety caused by, finally at long last, being so close to freedom and that mixed with the fatigue of the demanding journey. The cold was having other serious side-effects. Catherine was having difficulty with her cognitive processes and putting things together. She was still miles inside territories controlled by the Communists, still at risk of capture, and still trapped within the frozen cubical of her current existence. The only option was to wait. Nicky would come... a new mantra repeated over and over.

It had been a full day of waiting. Catherine thought she heard the dog bark and other voices. Did Vladi and Christina leave with their dog — or had someone else joined them on board? Was it communist soldiers with a vicious police dog that would sniff her out? She peered cautiously out the cabin's frosted rear window in the direction of the barking. Thankfully it was nothing, just a stray dog roaming the edge of the river. Catherine relaxed for the moment. Then she crawled back into the hull forgetting to roll the covering rug back over the hatch.

All Catherine could do was to continue to wait. Nicky would come. Her energy and even an ability to do simple muscle functions were ebbing in the cold damp hull. Her senses were becoming as numb as her extremities. No longer aware of the deep hunger of her fast, there was also no awareness that fuel was not being added to her body's engine. She fell into a dangerous deep slumber. The Austrian inspection came and went. Catherine was not even aware of it. Frost had attached her hair to the metal skin of the vessel. She drifted into the deep sleep of the frozen. Hypothermia was beginning to descend, and with it a slow quiet death. The barge docked in Vienna its final destination and Vladi prepared to unload the last shipment of oil.

It had been quiet for hours. There was no light coming through the portals. Catherine's stomach ached for nourishment. The sensation at last dragged her from her unconsciousness. As she struggled to sit up her head ached as if someone was pulling her hair out. Then she realized it was matted and stuck, frozen against the hull. With all the energy she had remaining after some tugging with both hands she freed herself

leaving a number of strands of hair still attached to the wall. Catherine struggled to summon her thoughts and her remaining strength. She was not ready for the Grim Reaper. It was Nicky for whom she was waiting. She had a plan for a future and the hollow guts of a barge were not part of that plan. She had to survive.

Guessing it was late evening, Catherine yearned for something to eat, clean clothes, and warmth. In the ever dimming recesses of her mind was a sense she had been cold for months, though now she was absolutely frigid and shivering. There was a recollection of an expression — cold to the core — that was her state. Her teeth clicked together uncontrollably. The effort to free her hair was too exhausting, she had no physical strength, just will. Lying back down to consider her plight she realized the urge to sleep was overcoming her and she rose again on her elbows. She knew she did not want to fall back to sleep. There must be a way to stay awake. It was so cold. Catherine had fought typhus, fought the Germans, and fought the Reds, but she could no longer fight nature itself. Reluctantly she gave in and finally curled into the fetal position, wrapped under her faithful companion, the smelly sheepskin, and held it as tightly about her as she could.

Dozing off into brief uncontrolled fitful sleeps as she fought to stay awake, Catherine knew she might never wake from this last sleep. Her body was nearly sapped of its limited energy reserves to fight the cold. She yearned for one of the hated lard sandwiches. Her once heightened senses, fine-tuned by days and days of being virtually sightless, had been stripped by the numbing refrigeration of the unheated steel space surrounded by the thirty degree water of the Danube. It was at once frightening to be aware she was lapsing into hyperthermia, but it was useless to struggle as she couldn't resist it any longer.

The creaking of the door was not heard. The vibrations were not felt of the cabin door close quietly, nor the footsteps stepping lightly across the wooden floor of the cabin. She did not sense the pressure change as the hatch to her hibernation den was removed nor feel the touch of the hand.

Suddenly Catherine's eyes ached. Even with her eyes closed in her fitful state the light flooding the black hold seared her sensitive pupils. It was too cold to be in Hell, was she at the entrance to Heaven? People always spoke of the blinding light near death. She struggled to bring

a hand up to her eyebrows to shade her eyes as she struggled against the light, confused and unaware of what was happening. She always envisioned meeting her maker in a clean dress from Paris, but that was another life.

She was like a person in a heavy drunken stupor. The light became more intense, and she felt herself being tugged by the arms. Catherine struggled to free herself, a reflexive reaction to be free, but her muscles would not respond, stiffened by both the cold and lack of movement inside her space.

"Let go! Leave me be!" she protested in a mumbling barely comprehensible way through her numbed lips to whom she did not know, still trying to conceal her eyes from the bright light.

"Come along, now," was the tense reply.

Still resisting Catherine felt the added cold and draft as she was dragged from her hiding place into the unheated cabin. Clutching her precious sheepskin within her feeble grasp against the strong hands pulling her out, she blindly searched for the bag with the revolver and pill. She could not be taken, she must fight! Struggling to get back into the hull and find her bag, she remembered her promise to Nicky to empty the gun first, then bite the pill. It was no use. She hadn't the strength the resist.

Then she felt the sharp bracing impact of an open hand against her face and heard the slap. Her eyes tried to focus. Her mind jogged slowly to consciousness as she opened her eyes and looked up at her attacker.

"Princess, Princess Catherine! Forgive me, but we must get off the barge!" Nicky implored.

At last Catherine's clouded mind now understood that Nicky *had* returned for her.

"Ni... Ni... Nicky." It was all she could utter as she looked at into his eyes.

With a final hoist Nicky pulled Catherine the rest of the way out of her frost encased metal cave. She looked back at the opening, thankful it was her last stay in the hideaway. It and the iron tank had been her home for fifty-six days.

Nicky quickly wrapped a blanket about Catherine and was rubbing her arms furiously to get the circulation of blood flowing. She tried to speak through chattering teeth, "I t-t-told you I would not-t-t be t-t-taken

from here without a f-f-fight! K-K-Kicking and fighting the whole w-w-way!" Catherine beamed through her clicking jaws at Nicky. Though her voice was a staccato, her humor was returning with the rest of her senses.

He smiled back at her, "Yes, you did tell me that. Oh, sorry about that slap."

Catherine was warming quickly though her words still sounded garbled as she struggled to get them out with jaws and tongue not yet ready to cooperate. "Actually... I q-q-quite enjoyed it... I d-do believe it's the only p-part of my body I can feel right now!"

With warm hands Nicky was rubbing Catherine's legs and shoulders to get her blood circulating again. "I want you to rotate your arms, stretch and bend your legs, walk around the cabin for a few minutes. In the past days we've had a bit of a heat wave and the temperature has risen above freezing."

Once again Catherine had been saved by a quirk of fate. Had the temperatures fallen below freezing she likely would have perished.

"I'm not sure we'll try this experiment again in the winter. You've still a little bit of a journey ahead of you. Here, I brought you a treat."

On the table was a slab of black bread with a mound of seasoned lard. Catherine thought momentarily about how she once suffered revulsion at the concoction they joking called the Eskimo sandwich, but she hadn't even the slightest hint of the sniffles on her journey. She snatched at the food like a hungry jackal and began devouring it. Nicky had been right again and besides it had been over thirty-six hours since she had eaten last.

Though she had been drawn to the edge of death's precipice from hyperthermia, Catherine was quickly regaining her wits. As she chewed on the bread she also chewed on what Nicky had just said, 'experiment'. "Do you mean you've never used this escape method before?"

Stammering a bit Nicky admitted, "You were such a special cargo we wanted to be sure you were not discovered, you would have faced such torture... we wanted to be sure you got out..."

"Alive!" Catherine cut in quickly. "That would be the operative word here... at least from my perspective!" She took another bite of the sandwich and as she chewed she added, brushing aside the sarcasm, "So we've made it this far. What *is* the rest of my trip?" Catherine asked between bites as she paced around the cabin to regain her circulation and the warmth the movement provided.

"We will leave the barge soon as the blackness turns to early morning

purple. By waiting till the morning traffic picks up after dawn and we can blend in as workers walking to our jobs. We'll ride several buses and street cars to our destination. You know the routine, check for followers, no direct paths.

"What if we are followed?" Catherine interrupted.

"We'll walk several blocks to see if we can shake them — if not we will take a bus to Central Station — it's very busy, and we have placed several allies there with kiosks and vendor stations that we'll be able to duck into. If need be they'll close up and walk away with you inside one of the push carts. We'll regroup at night and try again."

"I thought I was done with tight dark places!" Catherine protested.

As she spoke Nicky handed Catherine the bag from the cubbyhole with the pistol and pill. It was an unspoken reminder of what to do if all else failed.

Just as quickly Nicky replied, "*All* of Eastern Europe is like a black hole — you won't really see light until we have you free!"

Nicky had given Catherine a large hanky that she put over her matted hair and an unsoiled coat to cover her oil smudged clothes. She rubbed her face with a damp cloth, but there was little else she could do before it was time to go. It was still very dark when the two left the oil barge and walked over the narrow gangplank to the dock. It felt good to be on land again, and even better to be moving about though the stiffness persisted and her body ached every step of the way. Her balance was still very shaky. The exertion of her walking was generating warmth and stimulation to her muscles.

They took several buses in a meandering route, and then boarded a streetcar. The Russian zone of Vienna was plastered with red hammer and sickle posters. Red stars were attached to the streetlights glowing brightly in the yellow haze of dawn. They were like a reminder to every-one that big-brother was watching them everywhere. As they boarded the streetcar, Catherine saw three Russian soldiers sitting in the front of the bus. They stared menacingly at her. A young man with a leather case stood and offered Catherine a seat which she gladly accepted as she was worn out by her first walk in nearly three months. She and Nicky had walked several miles between the dock, bus routes, and streetcar. The inactivity on the barge had atrophied her leg muscles, and they ached. She also felt blisters forming on both feet.

The person seated next to her also stood up and moved toward the center of the streetcar. The trolley was crowded in the morning rush to work, yet no one took advantage of the empty seat. A young lady boarded the streetcar at the first stop and sat momentarily next to Catherine who smiled with a friendly good morning nod. The stylish girl — likely a salesclerk at a big department store — returned the smile, but had a strange look on her face. She stood up immediately and moved to a leather strap in the aisle several rows down. As she moved, Catherine caught a scent of the fragrant perfume that was perhaps a bit too heavy on the young woman. Catherine smiled thinking back to her courting days and perfume and stylish dresses of youth. Looking down to her dress, her smile vanished. The dress was badly wrinkled and soiled from crawling in and out of the hold of the barge. Her hands were chafed and her finger nails lined with dirt and grease from her weeks on the oil barge.

Then a horrible reality gripped her. She had not been able to make a proper change of clothing or bathed in nearly two months! When one is immersed in something it's easy to lose sense of it. The smell of the diesel exhaust on the barge was overwhelming at first, but after a week Catherine was not even aware of it. Now she sat in a crowded streetcar with a bubble of emptiness gradually expanding around her. Her odor she realized must have been horrendous. She hoped the smell of the oil and diesel fuel of the barge masked the lingering smell of her own body odor and the sheepskin!

Moving to the side door of the street car Nicky indicated it was time to get off. Catherine stood. She would leave the car from the front exit. Now self-conscious about her smell, Catherine understood why when nobody else stood to leave.

As the streetcar pulled away Nicky turned to his right and walked across the intersection towards a coffee shop. Catherine hurried up to his side.

"You didn't say anything!" she scolded.

Nicky looked quizzically in her direction.

"I swear, I must smell like the pachyderm house at the zoo! No, make that like the rotting remains of a Mastodon that's stuck in the tar pit!" Catherine was flushed with indignation. She had after all spent most of her life as a princess in the lap of luxury and boundless wealth. Today she looked and smelled like a homeless street urchin... no, far worse.

Chagrined Nicky looked at her as he opened the door to the shop, its strong aroma of coffee wafting in the air. "Forgive me. I've become

accustomed to it, I guess, but it has certain advantages in keeping anyone from wanting to detain us!"

"You noticed!" With feigned indignation Catherine punched Nicky harder than playfully in the arm.

Nicky winced as he nodded to an empty booth isolated in the far corner of the small parlor Then he smiled. "I'll get us some — *aromatic* — coffee."

Nicky brought a large mug of dark rich smelling java topped with a large dollop of whipped cream. He also bought pastry topped with powdered sugar. The treats were far from the quality of the fine Vienna pastries and cappuccinos she enjoyed as a royal, but on this day they had never tasted better. Nicky made a phone call as Catherine savored her tiny nibbles and sips.

The safe-house for Catherine was in a congested neighborhood market area. It was easy to get lost in the crowded humanity, something that made Nicky comfortable. He gave his familiar six rap knock of the side door off an alley and it opened immediately. An elderly Austrian woman named Lorraine — about Catherine's age — greeted them, and in the same motion pointed Catherine to a side room with a black and white patterned ceramic floor and lime green wainscot walls. In the middle of the room was a galvanized metal tub with steam rising from the water. No invitation was needed and Catherine exchanged no further pleasantries as she shut the door to the bathing room already ripping off her old clothing.

She soaked and soaked, and when the water cooled Catherine added more from a pot heating on a small coal stove next to the tub. The lady of the house knocked quietly and entered. Catherine sat soaking in a mound of bubbles.

"Are you all right in there? It's been a long time." Lorraine queried.

"If you could refill the pot, I'll soak a bit longer." Catherine replied. "I've warmed my outside layer; now I'm heating my bones."

"I have new clothes for you. Here... I'll put them on the bureau. If you don't mind I will just burn these others. Nicky called before you arrived and suggested you might enjoy a bath."

After luxuriating in the warm water Catherine finally emerged from

the bathing parlor. She was feeling much more human as she was greeted
again by the Austrian woman.

"There is a bowl of cream of wheat at the table, and an orange."

Having not eaten a piece of fresh fruit in weeks Catherine took the
precious citrus in her hands and began peeling it as she spoke. "Thank
you, so much Lorraine! I must thank Nicky for his thoughtful call to
you."

"I'm sorry. Nicky has left. He had to tend to matters with his barge.
He will return to Romania as soon as his wife is able to travel."

The underground had no place for sentimentality. Catherine was
disappointed she could not say goodbye to Nicky. She knew she likely
would never see the brave man again. But her life was not about to settle
down. A tall Frenchman entered the kitchen.

"Bonjour, Madame. I have your travel papers. We will need to have
a picture taken now — err, as soon as you've done eating."

"Wonderful, but first I must get my hair done."

The Frenchmen looked up in shock, "Impossible! It is dangerous to
move around!"

"If it's dangerous to move around, then going to the photographer is
dangerous as well. I saw a beauty parlor on the same block as this house.
I'll take the risk. I've just spent two *months* in the hold of an oil barge.
Two *hours*... you can spare."

The underground operative could tell when he wasn't going to win an
argument, but he was not going to let it go.

"You can tell *me* on this one count. I shall tell *you* on the rest!
Comprendez vous?"

"Oui, oui. Merci." Catherine said waving the indignant man off as
she savored the orange.

Of course Catherine understood. These people — all strangers —
were at great risk to help get her out. She had learned from Nicky to just
trust them. She would be free soon and until then she would follow their
orders... after she had her hair done.

More waiting. It was not part of Catherine's make-up. She was a doer.
After her hair was properly cleaned and set in a fashion of Catherine's
choosing her picture was taken. Then it was time to stay in the house
and wait. The underground operative returned on the fourth day with
the travel documents.

"You leave tonight at eleven by train. You will travel as though you are alone. It will complete your journey through the Russian zone. You will be shadowed by one of our Austrian members. He cannot intervene if you are stopped. If something happens, he will report the fact to us if it occurs, and we will see what we can do. Nicky gave you a pill...just in case. I have another."

Knowing what he was going to suggest Catherine saved him the uncomfortable request. "Yes, of course, I don't need another one. I know what to do."

The train was very crowded. Most people settled in and quickly nodded off. Catherine closed her eyes to look like the others. She knew not to draw attention to herself, though she couldn't sleep. Her mind again was fraught with doubts and raced with questions. What if her papers were not in order? Who would be looking at them? What was that surprise inspection on the barge all about? Were the Russians looking for her? If so, should she be disguised? What would she say to her daughter after all these years? Catherine was used to being in charge. Now she was at mercy of others and did not like so many unanswered questions.

The train rocked and swayed through the night. Catherine watched the sun break over the mountainous terrain. The countryside turned from an eerie twilight to a rosy cast, and then an orange glow as a new day dawned. The train suddenly screeched to a shuddering stop. Catherine noticed a gravel lane next to the tracks. She saw a convoy of Russian troop carriers parked alongside a large number of soldiers with automatic weapons. The doors at the front of the passenger car opened and three Red Army privates entered followed by a man with a leather overcoat and grey fedora, holding a handful of papers. He was definitely not from the local police.

Though the country was technically a neutral one, the Russians still exerted a large degree of control in their 'zone' as the terms of the Armistice dictated. Catherine grew nervous, her heart thumping so loud she hoped it couldn't be heard by others. She could only hope that within the grasp of the man there was not a paper with her picture on it. Then she thought that perhaps if there was a picture it would be a picture from years ago. There had not been a picture taken of herself since she was forced to go underground to avoid arrest. Since that time she had lost so much weight that she was sure she would be unrecognizable in her

current condition. Still there was uncertainty and she felt in her coat pocket for the cyanide pill and wrapped her fingers around it.

Two soldiers took the lead, asking for documents from each passenger. The third soldier stood back watching. The civilian bureaucrat with the papers looked at each passenger, occasionally shuffling through his papers. Two rows in front of Catherine the civilian official said something to the third soldier who reached out and grabbed a passenger by the collar and yanked him out of his seat. The man began to protest, but was slapped across the face soundly and shoved down the aisle without his baggage. Catherine looked nervously to the Austrian who accompanied her. He sat a row behind her on the other side of the aisle and looked down immediately. Catherine looked back to the approaching soldiers. A uniformed man left with the unfortunate chosen man being pushed down the aisle. Catherine could only hope she would not be grabbed next.

One of the soldier's weapons clanked against the metal frame of Catherine's seat. She looked over to see the barrel pointed at her just inches from her nose. Looking up the weapon's housing she saw the automatic was not being aimed at her, but was shouldered by a strap, the soldier's hands examining travel documents of another passenger. A sigh of relief crossed her pursed lips.

In German, French, and English he ordered, "Papers!" Catherine held hers up to the soldier who was now close enough to be smelled. He reeked of garlic or other pungent cooking spice, which only barely softened the man's body odor. Catherine tried to look bored, hoping her nerves would not betray her as she again put her trust and her life in the hands of an unknown operative of the underground. The soldier counted her stamps and flipped the papers back at her, then moved to the next seat. Catherine released her grip on the capsule, and it fell to the bottom of her coat pocket. She leaned over to gather her papers with both hands, relieved.

Lurching forward and belching smoke to gain momentum the train moved ahead slowly once the Russians left. It stopped again in a few minutes and was boarded once more! This time several young American soldiers came on board. They were laughing, making jokes with the passengers. They reminded Catherine of her 'boys' from the prison camps. Proudly she held out her false papers not caring if they discovered the fraud. Weeping with joy Catherine hugged a surprised stranger next to

her. She had made it! At last she was outside the Russian zone. The train would stop at Innsbruck and continue on to Basel on the French-Swiss border. There Catherine could reclaim her own identity and reunite with her daughter Tanda.

As the locomotive chugged through the valleys between the rugged Alps, Catherine noticed a man who walked up and down the aisle several times, looking; it seemed, very carefully at her. Catherine by this time was used to this cat and mouse game of spies and underground cloaked agents. There was a sense this man was checking her out. The Austrian who had accompanied Catherine from Vienna left the train at Innsbruck. She was on her own — or was she?

The man wore glasses and brightly colored wool tam. On his third pass down the aisle he stopped at Catherine's seat. "Bonjour? Hello?"

A casual Catherine looked at the man with skepticism. There were no further instructions from her underground contacts. She was left to her own devices. "Hello," was her simple, nonchalant response.

"Madame... Princess Caradja. You are now on the other side. I have your proper credentials."

Catherine's journey from the sinister dark abyss of communism into the light of freedom was over. She was about to begin on her new journey, a mission that would last her many remaining years.

Climbing the stairs to the apartment, Catherine was pensive. At long last she would be reunited with her daughter. Would this mean she was at last free? She knocked and there was no answer, then a second time. What would she do if there was no Tanda? She banged on the door loudly a third time. At last it opened. There stood her daughter.

Catherine's reunion with Tanda was emotional as they exchanged deep embraces and wept together. It was their first meeting since Tanda left Romania with her second husband to go to Paris in 1948, four years earlier. Tanda became involved with members of the OSS when the Armistice Commission came in to Romania as the war closed. The Americans needed a network of spies within the country to help them keep tabs on the Russians during the occupation. Tanda of course was well connected within Romanian society; however, all the intrigue cost the marriage. It was during this time that she met her new husband.

The broken marriage probably was a blessing down the road for both Tanda and Catherine. Had Tanda stayed married to the owner of

the brewery, she would have of course lost everything as did Catherine. Instead she left with the help of an American member of the OSS for Paris. Those connections were instrumental years later in Tanda's ability to work with the French underground who were ultimately able to get Catherine out from behind the Iron Curtain. Catherine did not yet fully know the world of spying played out by her daughter, but this dangerous game of intrigue necessary to escape Romania ironically would eventually put her stay in America in jeopardy.

Sharing the experience of her escape with her daughter and the two members of the underground was a catharsis; Catherine was finally beginning to relax. The coffee she held was warm against her hands and felt good even though she was comfortable for her mind still lingered in the frozen confines of the oil barge. As they talked, Catherine remembered an envelope of papers she had carried all those miles that she somehow was able to keep in her pouch.

"I'm sorry; let me give you this before I forget."

Tanda looked surprised and reached for the envelope. The Frenchmen snatched it first from a startled Catherine.

Tanda demanded, "What is that!"

"The documents I collected in Bucharest," Catherine answered. "I'm sorry I wasn't able to get all the papers. I missed one of the eight sets of papers requested."

Turning to the Frenchman, Tanda glared, and then screamed, "How dare you! You had my mother do your dirty work for you!"

Tanda was red with rage, veins on her temples pulsed as she stood. Catherine feared her daughter was about to assault the man. She noticed some of her own genes showing in her daughter, but she felt she should intervene.

"It was all right Tanda. It's over now. Besides, it added some excitement and purpose to my boring existence in Bucharest. Anyhow, they risked much to get me here."

Catherine sensed the discussion wasn't over and decided to diplomatically exit. "Excuse me, please. I didn't get any sleep on that train and I need some rest."

The next morning, Tanda apologized. "Mother, I'm the spy of the family — not you. But you did have access to things they needed. You know, at your age they weren't sure they wanted to risk exposure of their operations, nor their method of extraction. They needed to test your willingness to do what it takes — they were willing to risk *you* before

they would risk themselves on you... I did, however, know you would be asked to carry a pill."

Catherine remembered the tiny capsule that she still kept in the pocket of her dress, "I guess I don't need it anymore."

Fidgeting uncomfortably Tanda looked at her mother for a moment and said solemnly, "You may want to hold on to it. The Communists will be furious you were able to slip from their sticky web. They'll fear what you say about their reign of terror and dehumanization of entire societies. They may try to kidnap you and take you back or to try to make you give up your method of escape and those who helped you."

With a knowing look Catherine studied her daughter's face for a minute. This business they were in was indeed sinister and diabolical. "I understand, my dear. Rest assured that I have been kidnapped once before and don't intend to let that happen again! But you must understand that your mother is not going to go find a cave and hide. I've had enough of the darkness. I seek the light of day... and freedom! I intend to be a beacon... to bring brightness to the world. Still, I will keep the pill, as a favor to you."

Resuming her walking Catherine wanted to recapture the fitness she gained before the escape. Always a person of action she was getting antsy and wanted to begin her life's new mission. At an age when most people were ready to retire, Catherine was ready to begin. There was a needed to get to America, to press that mighty country into seeking freedom for her Romania and the other countries held captive by the communists. She had to find her 'boys', those brave airmen shot down in her country, to thank them for their sacrifices. Those goals would take time and she still had no idea how she would get to America.

Catherine received another shock to her previous notions of life. She had once roamed the continent at will, visiting its finest shops, mingling with the elite of government, the captains of industry. Her new official papers were now blotted with a huge red stamp... **REFUGEE**. It was further evidence that she was indeed a Princess without a country.

No longer could she possess a passport since that was a document issued by a country and Catherine no longer had a country. Her travel anywhere would need to be approved and sanctioned by her host country — France, or by the country she would be entering. With many contacts developed before the war she would use her network of acquaintances to

travel around Europe, but she did not yet know what she would need to travel to America.

Always with an insatiable desire to aid the helpless, especially children, Catherine asked Tanda about going back to Switzerland where she could meet with the Save the Children Foundation. They were familiar with her and her work at **St. Catherine's Crib**. Tanda said traveling back to Switzerland would be difficult. It was a neutral, and Catherine's high profile as an escapee would become a diplomatic issue. Being a neutral meant not taking either side. The Swiss would not wish to risk offending the Communists without some extra pressure.

"Then get me to Munich, Germany!"

Tanda asked, "Who do you know there?"

"Sam Woods, the American Consul General. If he is there he will help."

Woods had been a part of the Armistice Commission that had been dropped into Romania on the day of the prisoners' breakout. She got to know him before the Russians gained their stranglehold of the country. He was transferred to Germany upon its surrender. Catherine met with him several times seeking aid for her orphanages when there was no help from the Communist regime, and he had been very sympathetic. He was able to provide Catherine with assistance in basic sanitary and food assistance before he left.

It took a month to get the travel papers to Germany and find Mr. Woods. He graciously received Catherine and personally took her to the Swiss Embassy where he used his influence to get a permit for Catherine's travel. He also began to inquire about a visa to allow her entry into the United States.

Unfortunately it was in Switzerland where Catherine began to learn about the new world order. Every move, every action was measured by a new set of rules. It no longer mattered if there was a need or someone was offering to help. What was important was whose side you were on and how any activity influenced an outcome favorable to a political reality. The world had become a charade of umbrella organizations, ulterior motives, and political sensitivity.

Relief efforts were conducted by larger organizations such as the Red Cross, but the floundering new bureaucracy the United Nations had to recognize the effort, organization, and origin of need. If anything was

to happen in Eastern Europe then it also needed to pass muster with the Communist Party in Russia. Slowly, but with certainty, all of Eastern Europe was being cut off from the western world. An Iron Curtain indeed was descending to divide the continent separating the freed nations from the captives.

Wanting to be useful Catherine asked to help children in the resettlement of the Gaza Strip, but the area was too politically sensitive. She wanted to help the many Romanian children, orphaned by the war, now living in refugee camps scattered throughout Europe. But Romania was not recognized by the UN; and if any effort were to be organized, it would have to be sanctioned by Russia. Catherine was appalled! The Reds would send their own delegation to assist the Romanian children, and she knew they would come only to indoctrinate and infiltrate. Catherine would surely be a target for kidnapping or elimination if she became involved in those operations.

Returning to Paris, Catherine was disheartened and felt she had failed to find a way to help children she knew were in desperate need. The experience, however, gave her even more resolve to expose the Communists and their totalitarian puppet regimes. She needed to find a vehicle to begin to get her word out. She needed to tell people what the communist regimes were like. She needed to find a way to speak for freedom for those captured countries and their imprisoned souls. And she still needed to find a way to America, and to her 'boys'.

CHAPTER 32

Penniless Is Rich Enough

While her departure was a clandestine secret, Catherine's arrival in France was an event of great fanfare. It seemed the free people of Europe were anxious to hear all about how a little old princess pulled one over on the big bad Commies. There was a natural interest and curiosity about life under Communist rule. Life behind the Iron Curtain was a much closed and well guarded secret and the rumors ran rampant. There was an equal amount of anxiety for millions of the fortunate on the west side yearned for information about loved ones on the east side of the divide... family, friends, and business associates trapped in the suffocating throat hold of Communism.

Word of the daring escape by the Romanian princess quickly spread across the Continent. The attention by the media was on the edge of frenzied. Though little mention of the escape was made in the American media it was a different story in Western Europe where the coverage was likened to America's coverage of the Charles Lindberg baby abduction two decades earlier. As Catherine settled at Tanda's apartment in Paris she found a stack of telegrams and letters arriving daily. She flipped through the sheaf of papers and found many to be from radio, TV, newspaper and magazine reporters requesting interviews. Several offered a substantial amount of money for 'exclusive' rights to her story... "The Princess Who Escaped Her Homeland." and "The Lone Woman Against the Commies." Catherine had a dilemma, no money and no source of income, yet she would not find a way to America without some hard currency. It was tempting yet she refused all the offers.

The reporters were mostly interested in the details of her deliverance and that was off limits. She would not betray those who helped her. Nor would she divulge her method of escape or the names of accomplices. The

379

Communists were vicious and determined. They would be embarrassed at her liberation and would be ruthless with anyone involved in her stunning clandestine departure — even innocent children and relatives of the accomplices would not be spared. Nicky could be in the midst of bringing another of her countrymen to freedom. There was no price she would put on denying another's bid for freedom.

The Associated Press was the most persistent, with reporters actually sitting at her doorstep to try to gain access, to be the first to know. Catherine thought the behavior was a bit rude at first. Having spent her adult life as a Princess, she was used to the attention whether it was newspapers or loyal countrymen. However, those overtures were more adoring or of a respectful nature, or just curiosity. This was so much more frenetic, like a contest to find something out. Catherine understood and appreciated the public's interest in her daring escape. It helped to draw attention not just to her plight, but to so many who were suffering under the imposed communist regimes across Eastern Europe who had little hope for an escape. She tolerated prying and questions, and freely offered to talk about the conditions and atrocities, but stood steadfast against revealing any details of her daring escape.

As she established a new routine in Paris, Catherine spent the weeks following her deliverance as she had the years before her sudden departure taking brisk walks — only now she wasn't an anonymous street person for all the time she with reporters following her seeking an interview. She stood fast and would continue to talk to them about her hardships and those of her countrymen living under the dominion of the Reds, but nothing about her escape.

After a month of sitting at her door step and getting the same polite brush-off, one persistent reporter had a smile on his face. "If I could have a moment of your time this morning, Princess Caradja? I have something for you to consider."

Cautiously Catherine eyed the young man with a reporter's notebook. She had seen him almost daily for such a long time. She knew his name was Ronald Schmitt; that he was married and had two young children, 3 year old boy, and a one year old girl. His wife Ruthie was a freelance writer who worked at home as she gained assignments. Catherine liked the reporter, who despite his persistent perch at her door had always treated her with respect.

"What do you have on your mind?" she asked as she watered some potted flowers on her steps.

"Of course, our offer of $2,000 for an interview, a brief article stands."

"Yes, I am sure it does — and you know my answer," Catherine replied without looking up from pruning the plants.

"Have you ever thought about writing a book? An article appears in a newspaper for a day, a magazine might have a shelf life of a month or two. But a book! A book is sturdy and gets passed around. It goes on coffee tables, on shelves, to school and universities, in libraries."

Ronald stood up from the stoop. "We would like to offer you a book deal, we will pay you a $50,000 advance and a generous royalty that can bring you returns for years. We will take you on a book tour — We will take you to *America!*"

The money caught her attention, it was a huge amount! But the book tour... to America... that grabbed her interest like no other offer she had heard.

"And what would you want in your book?" she queried cautiously.

"We would want to know all about the oppression you suffered in Romania — under the Communists. Of course."

"And of how I got here?"

The reporter cleared his throat and went on, "*All* of the details, the escape too, of course." He began to plead as he saw her brow furrow. "That's what people want to hear! It is the excitement, the adventure, the danger, the sacrifice. It is what *sells*! We need those details... to offer you so much money! Think of how many people you will reach. Think of the comforts the money will bring you. The traveling you could do. You will be rich. You won't have to live like you are now... penniless!"

"Of course," was Catherine's short reply as she plucked a flower to enjoy inside. She looked up from the red blossom and focused on the reporter and thought of the florist who had given so much to help Catherine get out, likely her life. "Ronald, penniless is rich enough for me. You see, I have my freedom today. That makes me rich — rich in a way you may have the good fortune of never knowing. You have never lost your freedom; otherwise you might understand."

Pointing her finger at the reporter Catherine continued, "I only wish I could better help you fortunate people living in freedom to understand that you must be vigilant — to protect it or you will lose it! Now, I contend in this divided world, you must go the next step and give the greatest gift you can give to those in the captured countries of Europe; those oppressed by dictatorships of Asia, Africa, and South America; and all

others not free in this world... the gift of freedom. Don't just give them the gift of aid, wheat, and clothing. Of course, they are hungry and poorly clothed; but if you give the gift of freedom, those people will be unleashed! Break the bonds holding back the human spirit, and we shall all reap the benefits."

"But Princess..." the frustrated reporter began.

"Ronald, I will not accept money knowing that it could cost another soul his freedom or his life," Catherine replied. She turned and took her plucked red flower inside.

Since the war's end in '45 Catherine had been sending letters to America. Wanting to keep in touch with people from America in the hope that someday they might be able to help her, she wrote to the oil men of Standard oil, their wives, to the many visitors that had toured her orphanage system, to government dignitaries she met at formal occasions, and to other business acquaintances and friends of her family. Her correspondence was always one-sided. During her seven years in the Communist Romanian she never received a response. It was not just because of inefficiency in the postal system under the communist regime or from a lack of interest by those she wrote. It was plain and simple the efforts of the communist regime to withhold any mail sent to her.

Catherine had not been deterred, though, for if her mail was somehow getting through she hoped she might be able to contact those people when she escaped from the hell of the new Romania. Her hopes proved correct for as reports of her escape began to appear in the news media and she established a mailing address at her Paris apartment, mail began to arrive from former business acquaintances, people familiar with her work at the orphanages; as well as other Romanian escapees and freedom fighters.

There was so much mail that to answer all of it, Catherine sometimes would skip buying groceries to pay for postage and stationary. Hunger was not a new thing for her and the warm thoughts and well wishes helped to recede into the deepest part of her memories of those frigid days of her escape within the bow of the barge. The letters from America were the most encouraging as Catherine pondered how to get across the ocean. News of her escape had not been carried by the American media so most over there were not even aware she had survived communist occupation. The country had fallen back into a new sort of isolationism though really it

was more of a new focus as it turned its attention to starting new jobs, new families and putting behind the horrors of war. Catherine still awaited the first correspondence from any of her 'boys'

There was one publisher who took an interest in her refusal to tell the story of her escape. When Schmitt and the AP finally gave up, Catherine thought the pursuit was done. That is when a bespectacled, balding man, with bold red suspenders holding up worn trousers on his rounding girth, approached her sitting at a sidewalk café sipping a small cup of espresso.

"Madame, my card. We would like to hear more about the conditions in your Romania."

Examining the business card, Catherine read, 'Kenneth Fiske, **Voice of America** , Paris, France — Washington, D.C., USA.'

"We have an offer for you to consider. We would like you to write a series of articles for our publication."

Responding with excitement Catherine said, "This is exactly what I hope to be, a *voice* of America! Can you get me to America?"

"Well, no." he said bluntly. "But exposure in our publication would certainly not hurt your efforts. We will pay you twenty-five dollars per article. I am sorry we can't do any better, but we are a not-for-profit."

"Yes, yes, I personally now understand what that is," Catherine quipped. Then she put a hand up to stop Fiske who appeared to be ready to leave. "Young man that is enough money for me to pay my rent here. You see, I am an independent woman wishing to be a burden to no one. What would you want me to write about?"

Fiske took his glasses off and cleaned them with a handkerchief as he spoke, "Simply tell us all about the conditions in Romania since the end of the war."

"And what about my escape?" Catherine asked. Do I need to write about that?

He turned to leave, "No. We are offering hope, not adventure. Please just consider our offer...

Catherine put her hand up again to get his attention and replied, "I don't need to *consider* your offer. I'll do it!"

The assignment was eagerly accepted by Catherine and she began her new journalistic career with earnest. The writing exercise was good

discipline for her. One of her primary goals for her new life was to expose for the world to see, the horror as well as the folly of Communist rule. By writing her thoughts in a series of articles, Catherine was able to organize those thoughts and enumerate many points. Over a period of several months she wrote forty stories in all, and Fiske was correct in predicting excellent exposure for Catherine. A French patriotic organization invited her to tour France speaking at chapters of the organization around the country. She visited two or three towns each week for the next two years while telling the story of horror and oppression under the rule of Russia. The money was saved as best she could for her trip to America; however, Catherine was still having difficulties with authorities getting a visa for the trip.

One chance visit gave Catherine closure to an early phase of her life just as she was opening a chapter in the later stage. While in the south of France on the speaking tour, she came across a chateau owned by a royal named Radu Kretulesco — the same name of her father. She made inquiries and found the owner had been a famous romancer. It sounded a familiar note. Upon further inquiry Catherine was taken to a cemetery and found the man's grave dated 1942. The caretaker of the hotel said the estate was sold at the man's death to pay back taxes and expenses. Of course he owed much and hadn't made any effort to pay his obligations. Yes, this sounded just like the man she pictured.

There was still no real proof that this was indeed her father. Catherine had seen too many coincidences, too many contrived truths during the occupations of both the Nazis and the communists to be satisfied. She went to the local city hall looking for something to confirm the man's identity. By chance she found a box of belongings that did not sell at the estate auction. Catherine asked if she could go through the box.

The elderly caretaker could not resist the opportunity to solve the mystery of the charming lady from Romania. He pried open the lid of the crate and stood back. Catherine removed the contents — items of no value to most. There was a picture of a dashing young mustached man with a cute little girl riding his back — both smiling. Could this have been the man who kidnapped and ransomed his daughter?

She found an old worn red book and carefully removed it. This she knew she had seen before. Catherine opened the cover and found it to be the Kretulesco family history, the genealogy book the evil man threw at her forty-five years earlier when he confronted her in a fit of rage and tossed it on a bed at the boarding school. The old man was grateful for the

few francs the very grateful lady pulled from her purse. The expression in her eyes and the way she clutched the tattered red book against her assured him he had helped her find something of worth.

Richard Britt was operating a movie theater in the small Texas town called Comfort. The community's existence with a population of under a thousand was barely noticeable in the huge state. Just a short hour by car to San Antonio, Comfort seemed closer to Hell with its barren plains and sun blistering heat scorching the dusty earth. The theater, however, was air-conditioned making it a popular stop for the locals looking for relief from the heat. It often did not matter what was playing on the screen for patrons to purchase a ticket. There was enough business to provide a satisfying existence for the war veteran and former P.O.W.

The residents wouldn't know those past facts of Britt's life except perhaps if they noticed the V.F.W. cap he wore on Veterans Day and Memorial Day. He was private about his war time experiences, though occasionally he agreed to give a talk to school groups. When the war ended he was anxious to move on with his life, happy to get on with the routine of daily life in the quiet of southern Texas... something he had yearned for and looked forward to during those long months in prison at Timisul, the 'Gilded Cage'.

Waging war, putting his life on the line for his country, nearly losing his life, the rigors of captivity, all made coffee at *Jack and Nancy's Café* with the local clutch of downtown Comfort businessmen a ritual of simple yet deep satisfaction. Everybody knew each other there, and Jack was a Marine veteran who had spent his military time jumping between islands in the Pacific. Nancy, his college sweetheart had waited patiently four years teaching art until his return.

Britt was reflective as he waited at the counter of the simple café for his coffee to cool. Jack was the cook who always seemed to find time to pop out of kitchen to chat with his customers except at breakfast rush. Nancy took pride in knowing most everything about most everybody. It was her art work that adorned the walls and graced the menu. Britt enjoyed their food and mostly their conversation.

The list of chores for Britt that day: taking the previous night's cash to the bank in the morning; unloading an order of popcorn seeds; and putting up movie posters. They were simple everyday things. For Britt however, it put meaning on what he had done for his countrymen. It gave

him the ability — the freedom to make of life what he saw fit, use his own ideas and plans, taking his own chances. It was a simple life and it was the way he liked it.

It wasn't that Britt forgot about his wartime experiences. In fact he thought of his friends, made and lost during the war; of the places he had seen, and things he had done as a young American flier. He also remembered the searing pains of his wounds; the screams and groans that were the last utterances of fellow servicemen as they gave their final measure of devotion; the hardships of his captivity; and the deadly destruction of the bombs he helped to rain upon so many innocents below.

Everyday the thoughts flew in and out of his consciousness — by day as now over a cup of java, and by night in and out of his dreams. Britt kept those thoughts close, locked inside not even to be shared with his wife Dorothy. He was not bothered or tortured by his memories as so many others were. He would stay too busy getting on with his life to let the thoughts linger. He considered himself one of the lucky ones.

There was one person Britt always wanted to remember and keep in his thoughts, one he could not forget. It was a person with whom he felt there was still unfinished business. In the frantic days of the escape and rescue he had not had a chance to thank her one more time... nor to say goodbye. The short lady who was a giant among men, his 'Princess' was always on his mind. She had saved him and many others by her care, her drive, and sheer personal will. Britt wondered how she fared in the communist ruled Romania if indeed she had survived. He felt certain that if anyone could it would be her.

Often he shuddered at the morbid thoughts that crept into his mind when he heard of the atrocities that were reported in the news about events behind the Iron Curtain. He hoped that some of it was exaggerated propaganda as the Red Scare ran its course through the media and in the halls of American government. Prominent Congressmen like Wisconsin Senator McCarthy and California Representative Nixon were always chasing people in the United States rumored to be Communists and having them deported out of the country. In Eastern Europe, by contrast, if one wasn't a communist then the dreaded Siberia was the gulag of ice and fear deep within the new Soviet Union that was depository of those determined to be undesirable.

Letters that had been sent by Britt to Bucharest and Nedelea to his 'Princess' were never answered — never returned. Doubts invaded Britt's hopes for his 'Angel of Ploesti.' He could not envision her taking

the communists quietly. He hoped that her attitude wouldn't get her into trouble, but he also knew she would not cave in to their ways. If only there was a way he could find to reach her so he would know whether she was safe — to learn of her fate.

Nearly every month Britt would travel to San Antonio for business. He never failed to stop at the huge municipal library and browse the **London Times** to see if any word of Catherine appeared. He nearly fell out of his seat when he saw *Princess Survives Communism*. As he read on he learned of Catherine's escape and residency in Paris.

"She made it!" he thought with pride.

The problem then became how to reach her. Right there in the library Britt opened his briefcase and pulled out some stationery and wrote a letter. He asked the reference desk for the address to the U.S. Embassy in Paris, hoping if they knew Catherine's whereabouts they would forward his letter.

A month had passed when a large yellow envelope arrived at Britt's home. Dorothy saw it was from the U.S. Embassy, Paris. She immediately called Britt at the theater. He was getting the showplace ready for the new big hit **East of Eden** starring heartthrob James Dean. He was hoping for a full house, but upon getting the call he left the theater in the hands of his sole usher, popcorn maker, and ticket taker to race home. The envelope lay on the kitchen table; Dorothy had placed his letter opener next to it along with the other mail. Forgoing the opener he tore at the flap. Inside he found his unopened letter to Catherine and a letter on Embassy stationary. The letter read succinctly... *'It is not the policy of the Embassy to locate internationals or refugees, nor to deliver mail to or from private citizens. Thank you.'* The bottom of the letter had a rubber-stamped signature.

Dorothy was preparing supper and looked over from the sink where she was peeling potatoes. She could tell from her husband's expression it was not what he was hoping for and she offered, "Sorry, Dick. Did they give you any leads?"

He looked over dejectedly and just shook his head. Another dead end. "No. At least we know she's alive! We'll figure something out."

The next day the Britt home received another letter from France. Again Dorothy called the theater and Britt raced home. Dorothy stood by as he picked up the light blue airmail stationery. Britt examined it first. It did not appear to be official, and he did not recognize the name on the return address.

"Barbara Hallam?" he said with a puzzled look. "Don't know anyone by that name, sounds English or American."

Quickly Britt opened the folded envelope that doubled as stationary.

Dear Mr. Britt, I work at the embassy and processed your letter today. To be honest I was disappointed we did not do more to assist you, but as you know things are rather delicate politically these days...especially when it comes to refugees from Eastern Europe (a.k.a. Communist). I'm afraid your friend has some baggage as far as the Embassy here is concerned, but I'm just a clerk so I'm not privy to all the information. Your Princess Caradja does live here in Paris and I see her mentioned in articles from time to time. It seems that she does a lot of traveling and speaking these days and is writing articles for the Voice of America. I have enclosed the name of the reporter from that office who wrote an article about Princess Catherine, Mr. Kenneth Fiske. I've included his address. Perhaps he could pass on your letter. I admire the work that Princess Catherine is doing. I suspect the "big-wigs" are wrong on this one. She's a courageous lady.
Sincerely, Barbara Hallam, P.S. Please do not mention to anyone that I helped you in this way.

With a gleam in his eyes Britt looked up from reading the letter. "That lady... that special lady! The Princess has a way of captivating people. What a coincidence one of her fans worked in the embassy!"

Dorothy was beaming with her hands clasped and held against her lips. Britt smiled back like the weight of the world had been removed from his shoulders. He grabbed Dorothy in a big joyous bear hug and swung her around the kitchen. When he put her down Britt looked at his wife with a strange look on his face.

"Speaking of coincidences... the movie we're showing tonight... **East of Eden**. You know during my recovery after I fell into her gardens, we often talked about America. Me... I was homesick and scared. But,

her? I think she had a yearning. She wanted to know as much as I could tell her about this country, and I don't think it was curiosity... or just keeping good company with a downed airman. I think she had a desire to come to America. She loved what America stands for and the freedom our government allows and spoke of those things often while I lay there recuperating. I think that is where she's at now. She's East of Eden! I think she wants to come to her Eden... to America."

Life in France was satisfying, but Catherine was not gaining in her goal of reaching America. She was busy writing articles and engaging in speaking tours. From the payment she received she was able to put enough money away to eventually purchase a tourist berth passage to America. Procuring a travel visa to allow her to sail to America, however, was a very slow process lacking in progress. An earthquake struck Algeria in 1954. Catherine listened to and read reports in the French media. The African colony was still under the control of France. Catherine could not suppress the thoughts of losing her oldest daughter to an earthquake. If there only was a way to help in some fashion.

A week went by after the quake and aftershocks subsided. A ring at the door of the apartment brought Catherine to the entry. A telegram was handed to her. It was from an old acquaintance, Mrs. Doughty-Wylie from England. She was a wealthy woman with many philanthropic interests, children in need being a priority. A world traveler, she had visited Catherine's orphanage operations nearly two decades earlier before the war, and the women communicated with each other often before Catherine was lost in the Communist takeover.

Naturally Catherine too had lost contact after the Communist began to lose her mail, but Doughty-Wylie had seen Catherine's name in several news reports since her arrival in France. The heiress knew who would assure her of a successful mission of aid and she sought out Catherine to head a relief effort in the earthquake area aimed at children. She could think of no better steward of her donation than the princess whose work in Romania she had so admired. Catherine was excited to be able to help the stricken children and accepted the assignment — on one condition — her salary be donated to the cause.

The task took several months. When the mission was done Mrs. Doughty-Wylie invited Catherine to a society fundraising gala in London as a guest of honor for her generous work. While attending the event,

Catherine met an old friend from America, Mrs. Walters, the wife of a director of Standard Oil. Her husband had been a company representative in Romania and part of a longtime association going back to the turn of the twentieth century and her Grandpapa's association with John D. Rockefeller. Catherine expressed her desire to get to America and the resistance she was getting from the State Department.

Mrs. Walters used her own great influence to arrange a meeting with the American Consul General who was attending the gala. He was not receptive.

"Why won't you see the Princess?" she demanded. The direct question did not get a direct response and when pressed, the man became defensive.

"Why does an old woman want to go to America? Does she even speak English?" queried the agitated Consul.

"You should talk to her and find out yourself," Walters replied. "She has her reasons for going to America, and I think she'll surprise you."

The Consul would not divulge a reason for not meeting with Catherine, but it was obvious the woman was a political liability as far as the U.S. State Department was concerned. As an accommodation to the influential Mrs. Walters, however, he agreed to set an unofficial meeting with the Vice-Consul a Mr. Wayne Gastonia. Mrs. Walters called the new contact to be sure he had an 'open mind', and to make sure there wasn't a way she might be able help him with in other areas, gently reminding him of her influence and past support.

Characteristically a charming Catherine took advantage of the arranged meeting two weeks following the gala. She did not fail to impress, and she was granted a visitor visa to America at long last. Wayne Gastonia had been authorized to grant the visa by his boss. The favor had been granted on the condition the Counsel General's name would not appear on any documents. The perfect political solution.

After several more months of waiting, a permit arrived. It was a 6 month visa with a six month renewal. The princess without a country began to make plans to leave the continent, finally, four years after her escape from Romania. She booked passage aboard the Dutch ship, **New Amsterdam**. At long last she was bound for America!

There were lots of things to do, arrangements to be made, and people to see before Catherine left. One such visit was to the offices of the **Voice**

of America. Her dear friend and writing colleague Kenneth Fiske was aware of Catherine's preparations to leave and was happy to see her since he had some unfinished business with her.

"Catherine, we here at VOA are sad that you are leaving us, but happy that you are at long last able to fulfill a dream of getting to America. Please stay in touch, and I personally wish you the very best. You have a wonderful message and a dynamic way of getting your point across... keep it up if you can find a way to do so in America. You know they don't read us over there. America has not heard your message yet."

"I hope to, Ken, I hope to. I hope I can have an impact in some way to be a voice over there as you have let me be through your publication over here. I don't know what the future holds for me in America, but if ever there was a place to put your faith in — a place to provide hope for the rest of the world, I think it's America."

"Do you have any arrangements when you get there? Where will you stay?"

"My boat lands in New York... sometime in mid-December if things go according to schedule. From there I will have to trust my instincts and my fellow man. I have a little prayer I began this journey with and it has sustained me. I let the Lord guide my way to seek what is true. He will guide my way." Catherine smiled at Ken and added, "I'll be just fine."

The two friends embraced and Catherine put her gloves on as she prepared to leave. Ken reached behind and picked up an envelope from his desk. "Oh, by the way, a letter arrived at our bureau for you... just yesterday. It's from America."

Looking puzzled Catherine accepted the letter. It was postmarked — Comfort, Texas — the stationery was from the Comfort Movie Theater.

CHAPTER 33

I'm Here As a Guest Not a Beggar

August 29, 1987. Dayton, Ohio
The Princess relished her task. I already understood the telling of her life's
story to me was not a chore but a joy. I sensed it was even more, to her it was
a cherished responsibility and not just reminiscence. I truly believe in her
later years she came to an understanding about her life, so full of tragedy,
hardship, and sacrifice, it was all for a purpose larger than she. I think
having such a view helped her prevail now in her later years... the endless
schedule, the travel, the pace she kept. I still had so much to hear.

"When you were about to board the ocean liner and come to America,
what were your emotions?" I asked.

"Oh, it was a grand day full of emotions. Perhaps I felt a bit like your
famous astronaut John Glenn as he sat on the launch pad. He trained an
entire lifetime for the mission, that unique moment, off on a journey that no
other had been on before, and nobody knew for sure what he would find...
if he would even survive. Would everything work in application as it did on
paper or in practice?

"I was happy to at last be on my way, yet sad for I would be leaving
— perhaps forever — my homeland, my country, my culture. The com-
munists had actually physically taken it all away years earlier though it
still remained her in my heart, but once you board the vessel there is greater
finality. I was filled with anticipation, having read so much about America's
history, having my sense for what it stood for... and I was also racked with
anxiety. I did not know if I would be accepted, I had no means of support,
with no place to stay. I was thrilled at the hope that I would be reunited with
my 'boys', though unsure they would even remember me."

She looked across the table with a devilish grin and twinkle in her
eyes. "I didn't know if I would like American cooking!" she added with a

hearty laugh as she patted her tummy. Then she paused and grew quickly
serious. She was a woman who was once so wealthy and powerful with
many people working on her endeavors. For the past four decades she had
been a vagabond, constantly traveling and without any money or known
source of income.

"It worked out," she said in a matter of fact way.

She leaned back in the chair and paused momentarily. "I think most
of all when the boat at last landed in America, I was hopeful... very
hopeful."

<div align="center">*******</div>

It was little wonder Catherine hoped the long rough traverse across
the depths of the vast waters of the Atlantic was going to lead to calmer
waters in her life ahead. Passage over the Atlantic Ocean during a stormy
December was never a treat for sailors. To those unaccustomed to the
pitch and yaw of an ocean liner, it became a threat of great intestinal
challenge. Catherine booked a cabin in steerage because it was affordable
and because it placed the cabin lower in the ship. Smoother sailing
resulted, and she needed some calm.

En route, a call came to the ship's radio phone on the bridge. It was
a request to speak with 'Princess' Catherine Caradja. She was brought to
the Captain's quarters to take the call.

"Yes, this is she." she replied to the query of the captain. He smiled
and handed her the phone.

"**NBC**? Yes of course I've heard of it. American television."

"I certainly will." she said speaking into the phone.

She handed the equipment back to a smiling captain.

"I've been asked to do an interview on the **Today Show**!"

The captain was pleased to discover he had a celebrity on board,
but at the same time embarrassed. "I was not aware of your presence on
board... your Highness. Your visa and boarding information made no
note of royalty."

"Neither I nor my country is recognized by the international com-
munity. I am just Catherine Caradja, a refugee to the bureaucrats. But I
thank you for your deference."

"We would be most pleased if you accept an upgrade to our state
room and its full privileges. I also ask the pleasure of your company at
my dining table for the remainder of the voyage."

A gracious Catherine accepted the offers. Her room was lavished with

bouquets of flowers. A box of fine chocolates were set on a bedside table along with an ice bucket equipped with vintage French wine. She was not sure if the treats and upgrade of menu would be of much value to her in the rough seas though she decided she would take a chance with the sweets. Catherine settled into the large cushy bed that evening thinking how fortunate she was to be able to gain national exposure on her first days in the U.S. What a great way to start her efforts to find her 'boys'.

"Give me your tired, your poor, your huddled masses yearning to breathe free..." Catherine's lips moved in recital to the poem. It was one of the first things that caught her attention as she began to read about America in her youth years ago during her stay in the English orphanage. At that time the picture of the iconic statue holding the torch of enlightenment beckoning the immigrants into her arms was just an image, a dream. Seeing it in person caused a stirring within her that exceeded all Catherine's expectations.

Standing on the bridge deck adjacent to the state rooms Catherine took in the sight with others. There were a few on the deck with her, but not many. The women were wrapped in exquisite furs against the frigid damp breeze bracing the early morning air. Perhaps the affluent passengers in their plush accommodations had crossed the ocean before and had seen the French gift to America's Independence. Catherine looked down to the deck below at the crowd that was gathered.

Most of the steerage passengers were crowded to the bow to get their first look of their destination. Most did not know who made the statue, that it was a gift, or even that it was sheathed in copper. Likely they didn't know Lazarus' famous verses, as most still clutched their English lexicons to learn their new language. Yet there was a collective gasp, and then a cheer, and a mix of dancing, tears, and some fell to their knees in prayer.

The green iconic statue meant so much to so many. It symbolized many things to many walks of life. To most it was a beginning, a new beginning... and a chance, a chance to apply their skills or just their labor... and thing, some mysterious often dreamed of thing and perhaps never before realized. They sensed its wondrous intoxication as they pulled into the harbor of their destination and their destiny for wherever it was they were bound it was someplace in American. Whatever it was to those on the deck that morning, it certainly represented something

they hoped would become the centerpiece of a life in their new chosen country. A chill coursed through Catherine, down to her toes, and it was not the cold that she felt.

Readying herself on the deck Catherine headed for the descent down the gangway to American soil. In the past she had traveled across most of Europe and into Africa and excitement filled her, but never had she felt the sensation that welled inside her on this arrival into New York City and America. There was certainly a degree of high anxiety about her future. What would she do to get by? Where would she stay? She entered the country virtually broke and without support. How would she get around? Would anyone even care if she was there? Catherine would soon find out.

The doubts were not just about her situation either. They were about America itself. Was this really the land of the free — the home of the brave — or was that another fabricated myth bloated to unfathomable proportions by the ever hopeful oppressed of the world? Was it an unattainable — unimaginable dream? Catherine's experience with so many Americans in business and war gave her courage that it was truly a reality.

All she possessed was a temporary visa, her vision of a mission to be accomplished... and two rather heavy and bulky brown leather suitcases, somewhat tattered by her travels. As the crowd on the deck surged toward the departure ramp, Catherine stepped back. She was a rather short woman, sixty-two years of age and did not wish to begin her stay in the States with a broken bone or some such malady under the stampede of others racing to the gangway, the immigrants anxious to start new lives in this — the land of opportunity.

The ship's horns were belching loudly and many bells were ringing. Orders were being shouted out by the crew as preparations for docking were rising to a crescendo. Heavy ropes were strung out and raised to create channels through which the passengers would need to file into the Port of New York Authority, segregated by ticket, passport and visa, wealthy or poor, American or visitor, immigrant or as in Catherine's case, a refugee with just a temporary pass.

By this time, ten years after the war, she was getting used to her status as... *'None of the above'*. Oh yes... she was now poor... but her situation and status were unique. She was not an immigrant. She was

without citizenship or recognition from her place of origination, Romania. And she was not seeking to become a citizen of any other country. She had no family here to take her in, she simply existed and little else but a refugee — a person without a country.

Glancing down to her hand Catherine saw the six month visa, a temporary permit to visit and then leave. She was about to embark on a journey, not sure of her status, bound for an unfamiliar country, led by a dream. Catherine thought of a similar circumstance five decades earlier when she discovered she was no longer an orphan. One day she was in a boarding school, without parents, and being called by a name that was never her own. The next day she was off on an adventure racing through unfamiliar streets in Paris to find who she really was. Well, she had made it through those times. She would get along now with the same pluck and determination — and do just fine.

"Ma'am! Excuse me, ma'am?"

Looking up from her respite of thought Catherine saw a young American soldier. He was an officer; by the wings upon his lapels, he was in the Air Force. She smiled immediately at this twenty-something man, a spit shined and crew cut officer.

"Can I help you with your bags?" he offered, as he presumptively began to pick up her suitcases along with his duffle bag which he flipped over his shoulder.

Looking briefly into the cherubic officer's blue eyes and nodding once, Catherine replied, "Why thank you, young man," thinking to herself as she spoke, "this could be a good sign, me getting help from an American airman. How fitting."

On the wharf in the passenger terminal waited, unbeknownst to Catherine, two of her 'boys'. Both were from New York City. Scott Brunswick wasn't much older than the officer now helping Catherine. The tall strongly built Midwestern boy passed on a chance to play college basketball at Indiana University to sign up when the war broke out in '41. His height almost disqualified him for the air corps. His math skills got him through as a navigator in a B-24 bomber. Shot down on only his third mission late in the war, his plane was one of the last to go down over the Ploesti oil fields. The pilot of his plane was Colonel Gunn. He was just over eighteen when he was airlifted out of Bucharest in the famous military rescue of POWs.

With him was Larry Jones who had been a seasoned co-pilot, a career soldier with just five missions to go before earning his rotation

out of action. Then his plane was shot out of the sky in that first daring daylight low level raid over Ploesti. He had spent a year and a half in the original prison, the 'the Gilded Resort' up in the hills. He had remained good friends with Britt who called from Texas and asked him to meet their 'Angel of Ploesti'.

Both men were civilians now. Brunswick after several restless years finding himself was going to school on the GI Bill at NYC College. He was studying to become a history teacher. He felt he had some personal experiences that might help make his lessons more intriguing. Jones had retired from the military just months ago, having reached his twenty years of service. His closely cropped salt and pepper beard showed his age more than his youthful and elfish smile and twinkling eyes. He was anticipating reaping the rewards of his service by collecting a military pension and by making big bucks as a pilot for Pan Am flying out of La Guardia to Europe.

Her two greeters had flexible schedules that allowed them to comply with Britt's request for a greeting committee and 'chaperones' for Princess Catherine while she was in New York. They both stood craning to see their tiny charge. After anxiously watching a steady stream of people leave the boat, Jones thought he saw the image he had seen so often at the POW camp and later in his memories.

"Brunswick, I think I see her, yes, it's the Princess! I'll be... she's with an American Flyboy! Well I'll be... if that don't beat all!"

The two men jostled their way through the crowds and positioned themselves behind the threshold the Princess would pass as she filed through Port Authority Customs. After Catherine passed through the gate she shuffled through the papers in her purse she had shown the Customs officer. She looked up to an unexpected surprise as she instantly recognized one of her 'boys'. Scott shook hands with the Air Force officer and took the suitcases. The young military man hurried off in the direction of a young woman waving happily to get his attention. He was lucky to be home for the holidays.

"Larry!" Catherine was ecstatic at seeing the first of her 'boys'. She held out her arms to embrace a man who was stunned she recognized him eleven years later.

"How did you remember me?" Larry asked.

"A mother would always know her children. Those of you up in the resort at Timisul, you were like my own." She responded.

"This is Scott Brunswick. He fell into Bucharest just before it all ended... He's one of us too. You just never got to meet him."

"Pleased to meet you, Scott. You missed some exciting times — didn't he, Larry. Oh, could you post these for me?" Catherine asked handing him a large bundle of envelopes. "I've written almost everyone in America whose address I could remember. I suppose many letters will come back... ***address unknown***."

Catherine then thought of a slight problem. "Gosh... come back? Where would they come back to?"

"How about you use my return address and you keep in touch with me. I'll be staying in one place for quite some time," Larry advised.

"Oh, that would be wonderful! I couldn't bring my address book with me when I escaped Romania. I had to memorize several hundred names and addresses. Back then, I had a lot of alone time to repeat them. I sometimes still see my address book pages in my sleep!"

Scott had been quiet, thinking through the conversation of the other two. He cleared his throat nervously, "Princess, just where you will be staying?"

"Well, I booked a night at the YWCA in Manhattan. I have a distant cousin who lives here in New York City. Then Dick Britt has invited me to visit him in Houston."

Brunswick looked quizzically down to the tiny silver-haired woman with two suitcases, still thinking. "How long will you be in the U.S.?"

"Scott, I have much to do here. My visa is good for six months and several renewals, I hope, and I will of course see if it can be extended."

Brunswick was still grappling with Catherine's travel plans. "Didn't you lose everything to the communists?"

"Why of course! Like I said, I couldn't even bring my address book." she said with a smile as they negotiated the crowded wharf. "Speaking of travel plans, where are we headed?" It was like the old days again, always off in a hurry with so many things to do. Catherine relished the thought of once again being busy.

Jones replied, "**NBC** has arranged for a limo. We'll take you on a little sightseeing tour, and then there's a wonderful dinner waiting for us at the Lexington Hotel. Oh, you won't need that night at the 'Y'."

Brunswick was still troubled. "Princess Catherine, you've no source of money, no job, no home... how will you survive?"

"My dear, I am here as a guest, not as a beggar. I will stay until I

have thanked all my 'boys'; until I can no longer speak of the dangers of communism, of the rewards of freedom, and the price and sacrifice freedom requires; until I can return to my country — when it is free. Don't worry about me. The Lord has led me through much graver difficulties than what I face today. I've been in worse situations many times in my life. This is a big, friendly, generous country and people. It's the land of plenty! I will be taken care of, I am confident."

Brunswick was still puzzled and amazed at the pluck and courage of his new acquaintance, or perhaps her naiveté. Jones could see the troubled look on Brunswick's face and smiled knowingly. He was familiar with their guest having watched her manage things quite well while he was imprisoned for a year. He was not worried.

They arrived at the street and found a uniformed man with a sign that said **NBC** with the familiar peacock symbol beneath it. He stood next to a large black limo. Catherine sized it up and looked at her boys with a grin. "My Hotchkiss — a wedding gift — was bigger. But this will do just fine." She climbed inside the door being held open by the chauffeur dressed in a snappy grey suit and cap.

Brunswick and Jones placed her bags in the trunk. "Larry, this does not sound like a good plan to me. I think she's read too many romantic novels," Brunswick commented still dwelling on the supposed plight of his new charge.

Jones laid the suitcase he carried down and closed the trunk lid, his hand still grasping the chrome lever. "Scott, you never had an opportunity to watch this woman work her magic. She's a bantam sized fighter with the punch of a heavyweight! I was in Timisil for months watching her making the Nazis hop — she can get things done. She may just be on stage with the Radio City Rockettes by tomorrow evening — if she's a mind to. Why do you think Britt asked *two* of us to chaperone her? I think we just do as she bids and keep out of her way. She's read a lot, but not just books. She's read the hearts and souls — of her countrymen — and her American 'boys'. She knows what she's doing."

Two of those 'boys' had been reunited with Catherine and joined her in the rear of the Lincoln Continental. It was the first of many such reunions. The chauffeur looked to the back seat through the mirror on the windshield and queried. "Where to, folks?"

Jones and Brunswick looked to the Princess, who looked up and said, "Take me to the Greyhound bus station — I need to get a ticket to Houston! That's my next stop."

With time to spare in the afternoon and the company of two of her 'boys' Catherine did allow herself the luxury of a tour around Manhattan. They saw Times Square, Wall Street, the famous sports venue called Madison Square Garden, and the glitter of Broadway — so many places she had heard and read about for so many years. They were impressive, yet Catherine pressed her 'boys' for information, taking copious notes in a small lined pad she pulled from her purse. What cities and states are in what time zones? Is bus or rail cheaper to travel by? What are the proper expressions in America to greet someone by, to offer gratitude, to express urgency, to negotiate a price? How much could you buy for a dollar?

The limousine pulled up to a courtyard area with a long row of flags, and the chauffeur announced the United Nations. Catherine asked him, "Stop, let me out for a look, please."

The driver pulled over to a curb painted red, no other cars parked there. A large policeman walked directly to the driver as he held the door open. "Can't you see the damn red curb, buddy?"

The driver looked at the paunchy officer with fuzzy ear muffs and rosy cheeks. "Officer. Indeed I can. I would like you to meet,"... and with great flare announced, "Princess..."

With a few sweeping strokes of her arms Catherine was straightening her coat after stepping out of the car. Always a quick study she completed the driver's sentence in her most Romanian accent, "Catherine Cantacuzene Caradja."

She looked at the officer for a moment, and then curled her brow as the look became a stare, and then a glanced at his badge. "Officer Timothy Conway?"

The policeman took a step back, took off his cap, and made an awkward, stiff bow. "Err, uh, pleased to meet you... your highness."

Catherine smiled demurely as her two 'boys' stood to either side. She held up both arms for them to take and they walked along the sidewalk.

Larry leaned over to her and whispered, "Diplomatic immunity?"

"Is that what you call it? I'll remember that. In Romania, I got through many road blocks with a glaring stare followed by a sweet smile. I always called it, 'bluffing'."

They walked the length of the flags, Catherine pausing at some trying to recognize as many as she could. "There are a great number of flags missing. Do you suppose those countries are missing? I did not see the Romanian flag, yet I know the people, the land exists. Somehow, its

government which is supposed to reflect, represent, the will of the people — that has gone missing. The Communists are very good at destroying a nation's will. They are great at making all sorts of things... and people disappear! Even an entire country I see.

"These countries are not missing — they are captured! You see Scott, Larry; this is part of my mission here. We must find those missing — captive — countries. We must give them hope and allow them to regain their will. Then they will be able to stand up to their captors and throw off those shackles. Let their flag fly with the rest and let it truly represent its people. Nobody deserves to be a puppet on a string.

"That is what we must do... we who are free must face those who seek to control and dictate. America is the shining light – like the torch of the great statue I passed this morning. We must let everyone witness the glory of that glowing flame. That is why I have come here, boys."

<p style="text-align:center">*******</p>

Dick Britt had received a call at work just after Thanksgiving. The lady at the other end said she was calling from New York City — she worked for **NBC** and the **Today Show**. "Are you the airman the princess rescued from the wreckage of the plane in her garden?"

"Yes, I am."

"David Garroway would like you to come to New York for a couple of days...all at our expense of course. Princess Catherine is arriving on December 4th and has agreed to appear on the morning show **TODAY** on the fifth. We would like you to appear on the show on the fourth and tell our viewers some of your stories, your imprisonment and escape, and how the Princess fit into those situations. We think it will capture more audience for the following day — and we would like you to surprise her on the show the next day."

Brimming with excitement Britt knew his princess was at long last arriving and scheduled to visit in early December. What in the world — a small town boy from Texas on national TV!

"Sure I'd love to come and be on your show. It would be great to put one over on my 'princess'. But I need to ask you a favor."

With a little pleading Britt was able to convince the producer to allow his wife, Dorothy, to accompany him to New York. A week later they arrived at Sam Houston Airport. Britt hadn't flown on an airplane since he had mustered out of the service. It was his wife's first airplane ride and she was very nervous, but several of Britt's stories from his days

in the Army Air Corps made her realize what a hayride she was on by comparison. She actually enjoyed the experience.

New York City was everything the couple imagined. The treatment from **NBC** was first class and like a vacation they could have never afforded. The morning of December 4th found Britt early at the studio for the **TODAY SHOW.** It was 5 a.m. The producers of the program brought Britt and his wife some coffee and sweet rolls. Garroway came out early and introduced himself.

Despite Britt's initial nervousness, Garroway was an excellent interviewer and put Britt at ease. Calls were coming to the show before it was over from other ex-POW comrades and military acquaintances that had seen the interview. After the morning's show the Britts were treated to a tour of the city and an exquisite meal at the Warwick Hotel just blocks from the **NBC** studios at Rockefeller Plaza. The evening was capped with the Radio City Music Hall Christmas Show and the famed line of legs of the Rockettes. Still Dick was more excited about the following day.

The bedside phone rang at 4:30 am at Catherine's request. The program was scheduled for 6:30 that morning. A producer from the show told Catherine that hair styling and make-up could be done at the studio, but she needed to be there by 5:30. The limo was waiting when she emerged from the Lexington Hotel. The same driver greeted her with a broad smile as he ushered her into the backseat.

"Good night's sleep, your highness?"

Having grown accustomed to a paucity of such deference in recent years Catherine was learning that royalty was uncommon in the States, and she would attract extra attention because of it. She always enjoyed the title, perhaps as a result of her early years as an orphan when she had nothing — not even, as it turned out, a real name. Ironically she was almost in that same predicament again, a very old orphan of sorts, a princess without a country.

At the studio, Mr. Garroway introduced himself while she was in make-up. He was very pleasant and briefly told her the line of questions he would follow. He had done his homework and told her he understood she would not speak of any details regarding her escape other than acknowledge it occurred, and that it was not a pleasant trip. The smooth television personality wanted to know why she had come to America. Catherine assured him that was exactly what she wanted to talk about.

Interviews were not a new thing to Catherine. Big spotlights, heavy make-up, and huge cameras of a television studio were. She was not at all nervous when the staff held up fingers for a countdown; everything in the studio went from hustle and bustle to quiet. A man held up cue cards for Garroway to read.

With the preliminary introductions and a word from a sponsor completed, the prominent TV newsman leaned towards Catherine and welcomed her to the show. Catherine was not aware that Britt was brought into the studio and hidden in a closet, awaiting his queue to appear from Garroway.

Garroway led immediately to the prearranged signal. "I understand you will be leaving New York shortly to go to Houston to meet with the officer who crashed in your garden, Richard Britt. Will you recognize him?"

"Of course" she replied flatly, with not a hint of doubt.

At her response there was movement and commotion from the side of the set. To Catherine's surprise the tall Texas veteran walked in behind the host. She clasped her hands and beamed with pleasure and sentiment as she stood and they embraced in an emotional hug.

After a moment to settle Dick into a third chair, the interview continued. Because of the program the previous day with Britt, viewers had alerted other ex-POWs from Romania to watch the program. It had been ten years since these Americans had been locked inside the barbed cages of confinement, and since they had last seen or heard of 'their princess'. Seeing her on the TV screen was a wonderful moment. Garroway invited them to call into the studio and allowed Catherine to field several screened calls on the air. Her mission in America was off to an auspicious start with many contacts made and yet more numbers to call back.

The program closed with Garroway asking Catherine, "Princess Catherine, tell us your reason for coming to America."

"David, just as I have done here before your audience, I have met one of my 'boys,' one of your finest and bravest young men who risked their lives when in their prime to rid the world of fanatical tyrants. Several thousand Americans did not return from that mission and died over Romania, my homeland.

"I have come here to personally thank those 1400 American airmen who crashed but survived, then lived through imprisonment, some, like Dick here, for over a year. I want to thank them for their courage and through them their fallen comrades who did not return. Second, I want

to tell as many Americans as I can, you have a tremendous country and people, organized by the cherished documents of those remarkable Founding Fathers that have put forth a system of governing that captures those basic human rights of freedom... the pursuit of happiness. America is the *hope*, the salvation of those rights that have been taken from so many.

"Your blessings must be shared with the rest of the world — only America is strong enough, brave enough to stand up to the bullies of the world who want to control and rob countries of their wealth and its citizens of their freedoms. Americans, protect your freedom, and please, help other captive nations — the other Romania's of the world to regain their freedom."

With a signaling finger for a wrap up from the director of the program Dave Garroway looked at the camera, "America, the gauntlet has been thrown down by this grand dame from a faraway land... the princess from the Transylvanian Alps, a country now behind the Iron Curtain. And that's... Today, December 5, 1955."

CHAPTER 34

Finding a Voice

What a grand introduction to a wonderful new country. The **Today** program served as a great take-off point for both of her missions. Catherine received through the network many calls from both ex-POWs and organizations wanting her to speak at various meetings and programs. She also found a little bit of celebrity went a long way as people stopped her and Britt on the streets of New York to say they were recognized from the TV program. One of Britt's friends called to say he worked for **Look Magazine,** and the company suite in the Lexington Hotel was Catherine's while she was in New York.

Being thrilled with her interview and the fine reception, Catherine enjoyed the relaxation of a daylong sightseeing tour with the Britts. She was even more excited when the clerk at the hotel desk produced an envelope for Catherine with an airline ticket to Houston on the same flight as the Britts, courtesy of **NBC**.

Upon arriving in Houston, newspapers and TV stations were waiting. The next day following the newscasts and late edition papers, calls began to inundate the Britt home. More 'boys' and more groups began seeking out Catherine and they were exuberant when she was found. It was an auspicious beginning.

A call came in from Bryan Air Force Base in Texas. Colonel Gunn was in command of the base and had seen the TV programs. He invited Catherine to visit the base and speak to his officers. Gunn offered to help in her quest to meet and personally thank her 'boys'. He knew it would be a daunting task the men being so scattered after the war.

"I have contacted the Pentagon. They will compile a list for me of the 1400 airmen held captive in Romania. There is a big problem, however.

Unless the men are still in the service, the military would only have the address from which they enlisted."

In her usual optimistic way Catherine replied, "Wonderful! A list of their place of origin is a good place to start. Perhaps some will have remained in the area. If not there may be friends or relatives who know their whereabouts. Colonel Gunn, as you know, I love a challenge!"

A national travel schedule was in place before Catherine departed from the Britts. An organization from California arranged talks throughout the state. Local Legion halls and VFWs greeted her with open arms and filled her days between booked engagements. In West Covina, a distant suburb west of Los Angeles, Pierre Giser the commander of the local VFW asked, "What is your speaking fee?"

"I don't ask for a fee. You may pass a hat or do a free will donation at the door. I do not want any group to choose *not* to hear me because they do not have the funds. Besides, a small group from a church in a less affluent area would not be expected to pay as much as the private men's club in a large city. I give the same effort no matter what the ability to pay."

Receiving a small meal or being given an overnight stay at a club member's home was often all Catherine received for a program. At times a bus fare or perhaps a ride to her next stop was offered. There were occasions when she spoke to a group in a small remote location in which the passed hat contained more cash than she would have dreamed of asking. She was finding that Americans were very generous.

A meal, an overnight stay, a ride... and sometimes a purse full of cash. Catherine seldom knew what she would receive but was always thankful. And she was always grateful for an audience for she had a compelling story to tell and an urgency to tell it. She always adjusted her speech for the audience yet the message did not vary. America is a wonderful place with great blessings, one of the greatest being the legacy of its Founding Fathers. The democracy they established was something to cherish and to spread throughout the world. America must be vigilant to its own freedoms and must carry its banner to those not as fortunate, and it must stand up to those who would take freedom from others. She wanted the captive nations, especially her Romania to be free again. She wanted to be able to return to her homeland and be a citizen... not a princess... just free. And somehow after each program she managed to have enough to pay for bus fare and a meal or two and then she was on her way to the next destination.

Several months into her tour Catherine gave Britt an update by phone, "I am in Sacramento now. I have several more stops in California and will be done here in February... Yes, Missouri in March. I will go to the Woman's League offices in St. Louis and then travel to Canada from April 12 to May 12... Yes, my visa will be honored there as well. Yes, that should be delightful. I'll be sure to visit Niagara Falls. My tour of the Great Lakes begins in Buffalo for Memorial Day... I have been managing just fine... Oh, yes I'm doing fine. My audiences have been very receptive and generous. My best to Dorothy and the children."

ASSOCIATION JUNIOR LEAGUES WALDORF
ASTORIA NEW YORK, DECEMBER 14, 1955
11:00 AM DAY LETTER

MRS. THEODORE S. CHAPMAN
GENERAL FEDERATION OF WOMEN'S CLUBS
1734 N. STREET, N.W.
WASHINGTON D.C.

HAVE REQUEST FROM A JUNIOR LEAGUE FOR INFORMATION CONCERNING CATHERINE CARADJA. PRINCESS STATES SHE IS SPEAKING TO MANY OF YOUR CLUBS. IF THIS INDICATES YOU HAVE CLEARED HER OFFICIALLY WILL YOU PLEASE SO INDICATE BY WIRE COLLECT. IF ADVISABLE PHONE COLLECT (ELDORADO 5-4380) AS SOON AS POSSIBLE. THANKS MARGARET G. TWYMAN, ADMINISTRATOR, ASSOCIATION OF JUNIOR LEAGUES

Steven E. Aavang

December 15, 1955

Mrs. F.C. Corley, Education Chairman
Junior League of Saint Louis
7010 Washington
Saint Louis 5, Missouri

Dear Mrs. Corley:
In answer to your letter of December 5th I wish to give you what I consider to be satisfactory "clearance" for Princess Catherine Caradja.

It is not always easy to ferret out this kind of information, but I contacted the national headquarters of the General Federation of Women's Clubs requesting information from them in light of the fact that she had been scheduled to speak to some of their clubs. This morning Miss Grace Nickless stated that they investigated her through customary channels and found she was not considered a "security risk." in any way. Also, she does not seem to regard her speaking engagements as a fund-raising method. Apparently she is a delightful speaker and has a fascinating story to tell. Her experience with the communist forces precludes sympathy in that direction apparently.

Good wishes to you... all seems to be well. If she is "outstanding" let us know, and perhaps we can suggest her as speaker to other Leagues who might write to us for ideas.
Have a happy holiday.

Cordially yours,

Mrs. Margaret G. Twyman

Friday, April 13, 1956

Dear Mrs. Twyman (Marg):

Know you are aware that Saks 5th Avenue has purchased Lockhart's in which the League Headquarters is located. The Junior League of St. Louis Inc. has politely been invited to vacate by next December. In order to eliminate all summer month expenses, the tentative plan is to move out in June, store the files if necessary, while shopping for office space or a house to rent or buy.

Our President, Mrs. Spink, and the Executive Committee would appreciate information and names of other Leagues who own or rent office space or houses for their headquarters. Doubly appreciate your time on this matter in view of your pre-conference rush.

Thank you for your official check on Princess Catherine Caradja of Rumania. Her dedicated and sincere delivery on February 20th to the League and Tearoom members was most impressive. Believe other Leagues would find her on-the-spot knowledge about Rumania and Europe before, during, and after both world wars most informative. Her itinerary and biography are enclosed. It may be too late to line her up this spring but she hopes to return in the fall if she has set engagements to fill. A note from you or other Leagues would be well received and an encouragement to her. Her honorarium is optional. One hundred to one hundred and fifty dollars has been asked for her by her American friends. However she was most pleased with our fifty dollar honorarium. Since she is not trying to raise money except to make expenses, she frequently speaks without a fee due to her desire to inform the Free Nations to be alert and wary of Communist infiltration.

As Corresponding Secretary elect, I am looking forward with

anticipation to being a delegate at the Quebec Conference (a far cry from being in charge of Ushers and Information during Kansas City's 1942 conference——dating one's self?)

Hope to catch a glimpse of you at Frontenac!

Most sincerely,

Barbara Barton Corley (Mrs. Francis C. Corley)
Education Chairman

Could stand a few typing lessons before taking up my duties next fall.

April 19, 1956

Mrs. Francis C. Corley
Education Chairman
Junior League of Saint Louis
4932 Maryland Avenue
Saint Louis 8, Missouri

Dear Barbara,

....thanks a million for sending further information about the success of Princess Caradja's program for your League. She should be wonderful, and I will send this information to Margaret Winger, Consultant on Education, who is in a position to suggest her as a speaker to other Leagues who are interested in having such a program.

Will you please either write directly to Miss Kildegaard prior to Friday, April 27th, or send your instruction regarding the information we can send on to headquarters to Miss Daisy Shea, Secretary, Reasearch

410

Department. AJLA. Then, the information will be on its way shortly thereafter.

I will look forward to seeing you at Conference...I can hardly believe it is so close!

Most cordially,

Mrs. Margaret G. Twyman
Administrator

The success of the tour in its first several months gave Catherine no indication of a subtle undercurrent. Many of her programs in small town America were treated as special events, often word of mouth... "Come to the Presbyterian Church tonight at 7 p.m. — Hear Princess Caradja — Fire and Brimstone — You don't want to miss it; The Horrors of Communism — The Blessings of Freedom."

However, in the halls of the larger organizations there seemed to be more caution. In some cases a polite, "already have a program", or outright rejection. Catherine never took a decline in a personal way. Perhaps she should have. Perhaps she would have, had she seen the correspondence sent from the federal agency. Perhaps she would have confronted the janitor at the hotel in St. Louis if she knew he went to her room after her checkout and perused her waste baskets, pulling out envelopes and crumpled correspondence. One piece of paper seemed of more interest... It was in her handwriting and contained dates, locations, names. It was marked up; new dates squeezed in ahead of later dates as stops were added. It was a busy itinerary, one that she must have rewritten as a fresh copy to take with on her journey.

Princess Catherine Caradja

27 Mar - 5 Apr.	Cincinnati	% Mr. & Mrs. George Kees Sr.
		Poplar Ridge Road
		Alexandria, Ky
6 Apr-11Apr	Enroute - Washington to New York	
11-13 Apr	Buffalo	
14 Apr-13 May	Canada	%Association of Canadian Clubs
		248 Albert St. , Ottawa, Canada
14 May	Cincinnati	%Kees
? May	Indianapolis	
21 May	Muncie	%Mrs. Fred Petty
		3 Brian Road
		Muncie, Indiana
22 May	Chicago	%Mrs. Miller
		2121 N. Milwaukee
		Chicago, Illinois
2 - June	Wisconsin Milwaukee	
6 June	Michigan	%Gerald Totten
		24 Canton St.
		Grand Rapids, Mich
12 June	Ohio	
	(Akron-Cleveland)	%Clell B. Riffle
		717 Hudson
		Akron, Ohio
22 June	Pennsylvanis	
	(Pittsburgh - Philadelphia)	
29 June	Hartford Connecticut	%Mr. Spencer
		US Dept. of Labor
		Veterans Employment
		Service
		92 Farmington, Ave.
		Hartford, Conn.
July	Boston-Houston-Denver	

The note along with other pieces of paper was folded and placed in the pocket of the janitor's coveralls. He did not wear a fedora and leather overcoat and boldly crash into a room as counterparts in Eastern Europe might have done, but his purpose was as sinister. A discarded paper left behind in a waste basket may have bought its author a one way ticket out of the country. The janitor left without doing any other cleaning.

The suitcases were collected by the bellhop and taken to the Greyhound bus waiting to depart St. Louis and take Catherine to Cincinnati. The trip was three hundred forty miles on US Route 50 across the southern hill country of Illinois and Indiana. With meal breaks and stops to add and drop off passengers, Catherine would be riding for twelve hours. She was fascinated with the life outside her window as the American countryside unfolded mile after mile. Often scenic, at times, it seemed like row after row of just corn. The homes, the villages, the towns along the way intrigued her. The people were industrious, busy. They were always going someplace, doing something. In general they seemed happy. Many waved at the bus — the big Greyhound, its blue and white panels and the sleek running dog painted on the sides. They were waving at strangers — people passing through, never to be seen again, never to be known. Yet, they earned a friendly acknowledgement and greeting back from Catherine. It seemed to be part of the fabric of life in the country, the material that made up the quilt that was America.

From the terminal in Cincinnati Catherine found a taxi driver willing to take her to a small town about 20 miles away in northern Kentucky. The driver apologized that she would have to pay extra for his empty drive back to the city. Catherine said that was expected and understood.

"So... you have a funny accent there, lady," the driver noted with a southern drawl as he put her lone leather case in his trunk.

Catherine, always ready with a reply, countered, "I noticed the same about you!"

The cabbie slipped into the front seat, adjusted the mirror, and pulled the lever on his meter. He looked back at his passenger with a wide grin — several teeth missing from his broad smile. "I got mine up in the hills of Kentucky; where'd you get yours, Ma'am?"

She liked his country politeness and answered, "England. Though my forty years in Romania have clipped my Queen's English a bit, I'm afraid."

"Romania — I know where that's at, ma'am. Never been there, though. Knowd some that have — well, at least that's been **over** it — actually knowd some that did stay there a bit. They didn't like it though, ma'am."

A look settled across Catherine's face of puzzlement. She was putting things together. "When were your friends there — perhaps I might have known them?"

"Doubt it ma'am. It was a time back... '43 and '44, during the war."

A smile creased her face, "You might be surprised. Were you by chance in the Air Force?"

By the time the cab arrived in Alexandria, Catherine had a new friend. Toby Behrens had indeed been in the Air Corps, stationed in Bari, Italy, working as part of the ground crew loading bombs and making repairs on the planes flying throughout Eastern Europe and Germany. They pulled up to the VFW post. Catherine arranged to meet a family there. "That meter's made a few turns," she said.

"Princess, ma'am. Don't you worry none about that there fare. It's on me — I insist. I heard so much about you when the boys — your 'boys' got back from that there rescue. You've more than paid your fare. In fact, when you are ready to come back to Cinnci, call this number. I'll pick you up."

"You're so kind, Toby," she responded picking up her suitcase.

"Shucks ma'am. Could I shake the hand of a Princess?"

Smiling Catherine looked up at the vet and put the case down. "No... but you can have a big hug," as she opened both arms.

Inside the dimly lit painted cinder block building Catherine stood for a minute as her eyes adjusted. There was an open hall with a small stage. An American flag rested in a stand to the right side of the stage and the Kentucky state flag stood on the opposite side. The walls were adorned with photographs, black and white portraits of men in uniform. Several had black cloth draped around them. There was a bar at the other end of the hall and a small lounge with tables and chairs. Catherine had already been in dozens of similar halls during her three months in the country.

That afternoon in a small Kentucky hill town a very private family was coming to the VFW, not for drink or companionship or to hear a rousing speech. This was to be a private meeting. They had come for closure. They had come for their son.

414

A man about Catherine's age, wearing his Sunday best suit and tie stood and walked towards Catherine who instantly held out a hand in greeting.

"Mr. Kees?"

"Yes, Ma'am. George, please. You must be Princess Catherine?" She nodded and looked over at the other members of the family. "This is my daughter Bessie." As Catherine approached the table, the rest rose. "Frank's brothers Grant and Jack," he continued as they held out hands. George went on, "George Junior." He was about to introduce Frances, his wife, but the plump woman of sixty, pulled up a hankie to her red swollen eyes and broke down sobbing.

Many times Catherine had given comfort to others. She turned to the woman and wrapped her arms around the grieving woman. "Your son did not die in vain. He died a hero... that I heard directly from several of his crewmates."

The shaken mother looked at Catherine through teary eyes. "I know this happened thirteen years ago. It's still hard," she said through sobs. "I just can't believe you would come all this way to see us? Why? You never even had a chance to meet our son."

Standing back and looking at the entire family, Catherine began, "No, I actually did not meet him, though I feel I know him from what others have said. I heard many complimentary things about him from his surviving crew members." She paused, "But I buried your son.

"The peasant women, after their husbands pulled out his body and the remains of another badly burned man, they saw to his preparations. There was the third man, who was thought to be dead, but he fooled them and they took him to the infirmary at my orphanage. Your son was cleaned as was his uniform. The boy we pulled out who lived explained that the 'P' on Frank's dog tags indicated Protestant. Several other deceased airmen were brought to my estate later that evening. We brought in the local priest who officiated at a Protestant funeral over the grave, and he was laid to rest with his comrades. The same ladies who prepared him for burial brought flowers. My woodshop prepared caskets and crosses to mark each grave. Their names were carved into the crosses. We sang some hymns."

The family was taken by the efforts of Catherine and by the special journey to their remote insignificant spot on the vast continent. They asked if she had time to stay — could they offer her some old-fashion Kentucky hospitality — would she be their guest?

415

"Princess, our home is a simple farmhouse; but could we make it your castle for a few days?" George asked.

"George, it has been ages since I've slept in a castle!" she guffawed. "Let me tell you about some of the hotels I've stayed in recently!" She held her fingers to her nose.

Bessie, who hadn't said much before, asked, "Would you tell me about some real castles?"

"Oh, Bessie, I can tell you about some wonderful places! I've missed telling stories to my own children."

It was a cleansing and as it turned out a joyful meeting, not a reunion, more like a memorial, but perhaps even more beneficial. Catherine found a remarkable family, one she would visit often in her travels back and forth across the country. Their common bond was a young man thousands of miles from home, who many years earlier in the service of his country gave the full measure.

Soon Catherine found her visa needed renewing. She could not believe six months had passed. Summer would be for touring the northern half of the country and in winter she would fly like the birds for the south. Catherine refined her speeches to her audiences: to churches she explained how churches had become museums for propaganda — Communism was godless; to labor groups she explained the myth of a workers' society — the laborer who was told to but could not run the business; to civic groups she extolled the virtues of local leadership and democracy and the harsh realities of the Communist Party running everything.

As word of her visa renewal was received via a call from Dick Britt, who was also serving as one of several mail posts for her, Catherine was preparing to deliver a speech to a full house in a lecture hall of the Political Science Department at Harvard University in Boston. A sense of relief and calm came as she knew that she would have at least another year to seek out her 'boys' and to send out her message. It was so exciting to have been given an opportunity to speak at the revered institution. Catherine gazed into the eyes of many in the audience, young idealistic college students and tweed-cloaked professors with bushy grey eyebrows. It was easy to understand why she was not aware that within the lecture hall stood two men in suits with guns strapped beneath them. They carried identification and badges from the F.B.I.

416

Catherine drew a deep satisfying breath. By this time and at this venue she knew she was finding her voice in America. Her message was no different in Cambridge, Massachusetts than it was in tiny farm village of Hebron, Illinois. She held the audience's rapped attention for an hour. In closing Catherine warned, "There are dangers of complacency. The efforts that you as individuals, and collectively as the world's beacon of hope — your great nation must protect, preserve, and for the sake of my Romania, provide freedom. It is the duty of those blessed with freedom to find ways to spread that basic human desire. It is no less a necessity to human existence than food, water, and shelter."

"The only real way I can be of service to the people in my country is to tell those in the free world, to tell you, about the conditions existing behind the Iron Curtain, and to encourage others to protect and defend *their* precious freedom! Thank you."

CHAPTER 35

An Act of Congress

"Look, I've got nothing on her! We've been trailing her for nearly two years now. She moves too much, every day, just about! We don't have a case!"

Special Agent Scott Bigelow looked at his file jacket as he spoke. It was a frustrating reminder he had been assigned to monitor the activities of: **Catherine C. Caradja, Romania (royal); Status: Temp visitor's visa (Expires Dec. 26, 1957); Refugee/stateless.** The very fact that a call by Agent Bigelow to organizations had been enough to make them cancel programs by Catherine — no reason given — gave credence to the power of the FBI and the insidiousness of the 'red scare'. Well aware of his influence, he still had a job to do despite his share of doubts about his assignment. Agent Bigelow could not convince the Bureau to drop Caradja from the list. A dirty list.

At the other end of the phone was an emphatic Operations Chief, Fred Roberts. "If we get rid of her now, we won't have to worry later whether she is or isn't! The lady lived in a Communist country for eight years. Look, she couldn't have survived unless she was one of them. She claims she 'escaped' from the country, but refuses to tell anyone how she got out! It's a cover... and she's a plant by the Reds! Congressman Die of Texas, *THE* chairman of the House Committee of Un-American Activities has a file on this Princess! I'm sure Senator McCarthy has seen this same file. Do I need to remind you where that increase in funding has come from? These boys want some fish to fry! She's a spy at worst! A troublemaker at least. She's obviously must be a Communist sympathizer. We need to get rid of her!"

"But I've heard her speeches. If she's a sympathizer, she has a funny way of expressing it. I'd hate to be someone she *didn't* like!"

"Listen, Bigelow, these people — these Communist infiltrators are

418

shrewd. They want us to put our guard down, then they will pounce. Do you know how many calls I am getting from Congressman Dies' office looking for someone to hang? I am going to get them one!"

Bigelow made one more appeal, "There are other fish to fry, Chief. There are others who really are acting for the Reds. Turn me loose on someone else."

"Don't be naïve, Bigelow. Besides we're looking for star power here. This woman is a Princess! She still claims her Romanian citizenship. That should tell you something! These congressmen want us to get someone who will catch the public's attention. You tell me — who's the public going to notice, some union hall organizer in Pittsburg... or a Romanian Princess!"

Bigelow gave up, "OK chief! OK!"

"The only way you can stay in the country after your visa expires is either become an American citizen or see if you can get a status of permanent visitor; those are the choices," Britt explained to Catherine.

"I will not take American citizenship. I love this country, but I am a Romanian. I maintain hope — here," Catherine put a fist to her chest, "that someday, by some miracle, my country will be free. No, I will not give up hope for my country. That is the point of my talks. If America stays strong, and at least provides hope to the captive nations, someday they may be able to find freedom."

"That's my point too, Catherine. That's why you need to stay! But we have to work within the rules. We have until December 26th. To stay you need to be given that permanent status. Catherine, it will take an Act of Congress."

"Then that's what we'll do," Catherine said in a matter of fact way as if it were nothing. "I am going to Washington D.C. Dick, you must contact your Congressman! Call the 'boys' too. Tell them we need an Act of Congress!" Catherine exclaimed as her fist punched the kitchen table for emphasis, and the conversation was over. She left for her bedroom to pack.

Britt sat at the kitchen table stirring his coffee. He looked over to his wife, Dorothy, who was bringing him a slice of apple pie for an evening snack. She set it down on the new Formica table. She looked at her brooding husband still twirling his spoon in the full cup. She knew he was worried about this turn of events.

"Dick, you best stop worrying and start making calls to the 'boys' and to our Congressmen. She isn't leaving... not without a fight."

Time ticked by quickly. Britt and Gunn called everyone in Catherine's address book urging them to seek sympathetic Congressmen. Some legislators would not even return the calls. Others would only acknowledge the calls without committing to a position. Some noted suspiciously they had seen the name on some 'lists' circulated around Capitol Hill. There was a haunting legacy of the Red Scare of which J. Edgar Hoover was not letting go. Congress recessed for the Christmas holidays. Gunn and Britt traveled together for a personal pitch in Austin. The lanky powerful Senator from Texas, Lyndon Baines Johnson, agreed to meet with the men in the State Office Building.

"It's a pleasure, gentlemen, we are grateful for your service to our country."

The familiar slow drawl came from the deep nasally voice as Johnson held out his huge hand. The Senator was one of the most powerful men in Washington.

"Thank you, Senator Johnson," Gunn replied. "Your time is valuable, so I will get right to the point. There is a good chance that we and 1400 other vets would not be here if it had not been for Princess Catherine. Now we've heard she has been blackballed — listed as a threat. A Communist! That's preposterous!"

Senator Johnson held up a hand, "Gentleman, I've seen the lists. An esteemed colleague from my own state is on the House Committee. But I think our country is ready to move beyond the McCarthyism nonsense. Now, I've read your letters. This lady, your 'Princess', she seems to be quite a gal," he added as a young male aide walked into the office and whispered a message to 'LBJ' as he was known to Texans. At six feet four inches tall Johnson bent down to listen, "Tell them I'll be right with them."

He signed a few papers held out by the aide before his attention returned to the two veterans. "I will prepare a rider and attach it to a bill when we get back after the Christmas break. From what you have told me in those many letters is *that* lady needs to be heard... now if you'll excuse me?"

As Johnson and his aid left the office Britt looked over to Gunn. Both men had big smiles on their faces. Britt spoke first, "That was quick. I

didn't even have to show my scars! Why was that so easy when all our letters and calls seem to get us nowhere... or is he just blowing us off?"

Shaking his head Gunn was folding the unused sheaf of letters in support of the princess and put them in his jacket. "Ours is not to wonder why. He did acknowledge the letters. Perhaps showing our faces emphasizes our sincerity and effort. We just have to hope he remembers to tell that aide to draft the legislation. We don't have time for a second chance! Call Catherine and let her know."

The Immigration Office of the State Department was familiar with the determination of a lady who had visited their office daily for the past two weeks. It was the day after Christmas and Catherine had news for her new friends at the I.O. office.

"I've received a late Christmas present! A bill is in Congress with my name on it!"

The ladies at the reception counter were by then familiar with Catherine's problem. They all applauded her news.

Hearing the commotion, the Chief of Immigration, Philip Piliod, came out of his office. He did not normally get involved in individual cases. That he was a veteran and had a brother who served in the air corps may have helped influence his involvement. His brother was stationed at Bari, Italy, when the rescued pilots were flown in, so the story of the 'Princess' had been passed through the family as war stories were exchanged after the soldiers returned home. She was a person revered in his very house.

"Mrs. Caradja," he said with a constrained smile, "please come into my office."

As Catherine entered through the doorway and held out her hand in greeting, she sensed a reticence in his demeanor.

"What is it?" she asked directly as he motioned her to a couch.

"You are an intuitive woman," Piliod observed as he sat on the couch next to her. "A bill as you know has been introduced. It has broad terminology which I think we can deal with, however, there are some other issues that concern me."

Pulling out a small spiral note pad and pencil she always carried in her purse, Catherine looked up to Piliod, waiting for him to continue. "Well, you need to justify your need for staying — the reasons why you need more time to complete the original purpose for your visit. You need to provide a medical certificate showing good health and show there are

no felony charges against you. You cannot have any unpaid taxes. Finally, you must provide evidence of $2,000 cash. Can you provide this... in a week?"

As she wrote the list Catherine found answers to all but one. Her mission in America had only begun. There were around 1400 POWs liberated from Romania that she intended to thank personally. She had found 108 in her travels to date. All of the walking and food shortages she experienced in eight years behind the Iron Curtain eliminated her weight and blood pressure issues. Those were the only medical concerns of which she was aware. There were no problems with the law, and she had kept scrupulous records of donations and fees she received on her speaking tours. Even though much of her remuneration was in the form of cash, every event and the amount received was dutifully recorded. Britt was at that very moment preparing to file a tax return with the IRS for her at the end of the year.

Two thousand dollars in cash... now that was a problem. She brought little money with her from Europe and most of her income from speaking was consumed in bus fare, hotel rooms, and meals. To have that much money sitting in a bank account was a problem. It equated to about half a year's salary for an average American family. She remembered once selling a single pair of her earrings for that amount to pay for one of her husband Costea's business mistakes forty years prior.

"Thank you, Mr. Piliod."

"Can I begin processing your papers?"

Deep in her own thoughts, Catherine had to pause for a moment to focus on the words of Piliod. Using her best poker face she did not provide any hint of the concern she felt. "Oh, sorry... Yes, please do and I will see to the requirements which are no problem. See you in one week?"

After thanking Mr. Piliod Catherine left the office and the huge building walking briskly down 23rd Street, south towards the vast park that stretched from the Potomac River to the dome of the Capitol Building. It was a magnificent park filled with the iconic statues and monuments of a young but great country. Though much grander in size and scope it reminded her so much of the parks in which she used to wander throughout Bucharest.

There was an empty bench at the foot of the Lincoln Memorial. Despite the cold temperatures of late December there were many people wandering in and out of the majestic edifice. Catherine sat there and could see the massive stone statue, the bearded President looking out across

the Reflecting Pond. Her own eyes turned from the memorial and across the greens to the pillar on the hill. The impressive obelisk that was the Washington Monument stood alone against the grey clouds in the sky.

Lincoln and Washington — Catherine felt a kinship to both men of whom she had read often in her orphan and boarding school days. Both had often stood alone and against great odds. Both were resolute and persistent. Both had been willing to retreat for a day to prolong the fight and eventually overcome. Perhaps that is what she would need to do — retreat. There were only ten days until she would be deported. She would not ask any of her 'boys' for the money; it was doubtful any could spare it.

A telegram was sent to a friend in London. Catherine would need to find a place to stay across the pond when she was sent back. She called to Britt explaining her plight and plan. It made no sense to return to Houston for ten days and then travel back to New York as a deportee. She left him the name of the hotel where she would be staying.

Four days later Catherine treated herself to a glass of wine with her dinner. She retreated to her hotel room and would spend a quiet New Year's Eve reading, <u>*A Long Day's Journey Into the Night*</u> by Eugene O'Neil, a best seller with an intriguing title, as if she'd been there herself.

A knock came at the door, "Mrs. Caradja?"

"Yes."

"Ma'am, this is your bellhop. We took a call in the lobby for you. It's Mr. Britt."

"I'll be right down," Catherine replied wondering at the call. Certainly not a casual call, it would either be good news or bad. Her hotel did not have phones in all the rooms. She had found a reasonably priced room in an older hotel that rented rooms by the week for far less than the standard nightly rates of the hotels in the capitol city. The stairs from the 7th floor would be faster than the old small caged elevator of the aging hotel. Besides, Catherine still had problems with small enclosures.

The desk clerk took Catherine to the house phone, in a small booth. She left the door open. "Hello, Dick?"

"Catherine, I have received a cable from Lloyds Bank of London."

"Yes, I kept a small account open there."

"The cable says you received a deposit yesterday."

"Dick, how could that be?"

"Says here you had a deposit of $2,000 made by a Mrs. Doughty-Wylie."

Catherine sat in the tiny booth speechless for a moment. She was incredulous.

"Dick ... say that again."

As she listened, Catherine closed her eyes trying to comprehend her good fortune.

"Dick, that's wonderful news! Oh Dick, I am thrilled! I guess you and the other 'boys' will be seeing me around for a while longer!"

Once again an unsolicited endorsement of support had come. Mrs. Doughty-Wylie was contacted by the friend Catherine had cabled in England about her possible premature return via deportation because of the lack of the needed money. The benefactor knew Catherine would never ask for the money, and she knew too how important the dynamic lady's mission in America was. Mrs. Daughty-Wiley viewed the deposit not just a token of payback for the Algeria earthquake and Romanian refugee work Catherine had done, but also as a shrewd investment in the future.

Catherine's thoughts went back to the two great Americans represented in the park. They were men of faith who inspired others to follow their lead, who rebounded from disaster, and ultimately achieved their goals. Now with this reprieve, Catherine's dedication to her missions would be unwavering. Hope swelled within her. Perhaps she, too, could move forward and achieve her goals.

January 2nd found Catherine back at the State Department, back in the office of Mr. Piliod. "I have a copy of my tax return, a doctor's exam and certificate, and here is a wire confirming the transfer of $2,000 to an account I have set up here at a branch of the Chase Bank here in Washington."

Piliod's smile broadened as he laughed in relief and joy, "I will expedite the paperwork personally, Mrs. Caradja!"

On January 5th, Catherine returned to the State Department Building where she received her green card in the office of Mr. Piliod. In addition to the card she found a letter signed by the Chief of Immigration — for her files if she ever needed it — granting her permanent visitor status with his warmest regards. In the break room at the back of the office area there was a cake, a round of applause, and good wishes from the entire staff of that same Chief of Immigration.

CHAPTER 36

Hope Dies Last

Touring the vast land of America was one of Catherine's great adventures and joys. Free from ever having to worry about renewing a visa she was also free to roam at will. Though she had not been aware at the time of the scrutiny she had been given she later took great pride in being the one who got away from J. Edgar Hoover. There would be no encumbrances on her travels and searches for her 'boys'.

Her reading of **Reader's Digest** early in her life gave glimpses into the character and sights of the country. It could not, however, prepare her for the expanses of space, the diversity of its geography, the openness of its way of life that can only be understood by firsthand experience. The pictures and words of the articles did not do justice to that which Catherine observed from the seat of her bus or the park bench of some village's downtown square.

Crisscrossing the country on the road, however, was a daunting task. It was so many hours on a bus and in terminals waiting for the connecting route to take her to her next destination. There were thankfully a few home-cooked meals to go along with countless potlucks and the ever popular 'rubber chicken' as she so often heard the favorite main dish called. When she was lucky, she was able to stay overnight at the home of a member of the organization where she was a guest speaker, and a dinner, breakfast, or sometimes both were offered.

She did eat many meals at the meetings. Kiwanis breakfast clubs would be scrambled eggs. Rotary Noon Club would be perhaps a roast beef and mashed potato affair — though just as often it was a sandwich and chips. Churches provided pot lucks which delighted Catherine as she could taste homemade local favorite dishes. She made no apologies for return trips to be sure to get a sample of *all* the dishes. Everywhere there

was chicken... baked, fried, roasted, ala something, cream of something. And the dessert offerings... in her estimation they were the mainstay of evening programs.

There were times when the physical rigors of the endless journey were tiring. Catherine had endured so much throughout her life; she felt it prepared her for her the mission she was undertaking. Her rewards were simple and abundant. She was finding her 'boys' at a rate of one or two a month, occasionally more. Each time she found one, he had a lead or an address of another. Colonel Gunn had been especially helpful. As an officer of rank and a hero of the war, he had considerable 'pull' at the Pentagon. By dogged persistence he eventually secured a list for Catherine with the names of all 1400 American POWs from the Romanian camps. Unfortunately, with only the address from which these men had enlisted, Catherine had much detective work to do to find were they might be found.

Her favorite times were the opportunities she had to spend a week, sometimes more, at the home of one of her 'boys' or with other friends she made on her travels. A living room or sunroom to sit and read, a front porch to relax with a book, a kitchen where she could prepare a meal, or grab a snack — so easily taken for granted by others, yet such things were luxuries for her.

When Catherine received an invitation for an extended stay at some-one's home she relished the time in one place. She could put the suitcase aside and pretend she was at home, even if was not hers. Whether it is a small town or busy city, she would read the local paper, and watch the local TV news as she tried to learn as much as she could about life in America. During time between talks, Catherine would walk slowly around the neighborhoods. If possible she enjoyed a walk to the town center. Her time was spent browsing the store fronts and wandering the aisles of the Woolworths and True Value Hardware stores. There were so many things available to the Americans.

To accommodate a life on the road, Catherine established a seasonal wardrobe which she kept in two suitcases, one blue and the other brown. Her choice of suitcase depended upon the season. The blue one contained winter clothes and the brown one summer clothes. The suitcase not in use was left at the Britt home. Laundry was always an issue. Staying in a home was her best opportunity for doing her laundry. Otherwise she often was compelled to use the sink or tub in a motel and a bar of soap. The small highway 'mom and pop' motels often let her do a load in their

big machines that normally did towels and sheets. This generally was not an option in the big city hotels.

A small amount of money dedicated for emergencies was always kept in a pocket of Catherine's purse so when a stain, a tear, or just being thread-bare and worn out afflicted a garment, it could be replaced at the time as needed. Blue was her clothing color of choice. Her shoes, accessories, and blouses were all selected to match with blue garments, which simplified packing. Catherine felt the color blue was dignified, and she had grown accustomed to it — blue was the color of the nursing uniforms of her orphanage system. In her many years of work with the **St. Catherine's Crib** orphanages, she chose to wear the uniform so that she would be viewed as being more connected with the staff members and children — not as a distant wealthy benefactor.

Correspondence was always difficult for Catherine, moving nearly every day of the year and not having a permanent address. She carried an address book with phone numbers. The well-worn journal of her contacts had business cards and photographs and assorted notes stapled, clipped, and taped to various pages. As Catherine established a travel itinerary she set up a network of friends who were willing to receive her mail and phone calls. Every couple of days she would check in to see if she had received a call or letter. Then Catherine would have the mail forwarded to a post office or the home of one of her benefactors that was still on her route and pick it up when she arrived.

Since her addresses and phone numbers were constantly changing, letters would often arrive at an address she had used months before. The letters were then usually forwarded, hopefully to an address she had yet to reach where she was finally able to read it. It was trial and error and eventually Catherine decided on a single address to have all mail and phone calls directed. The widow of one of her 'boys', Gracie Naylor became a close friend and she agreed to take the mail and calls for Catherine. The two kept in close contact with Catherine calling in for messages and advising Gracie where the mail should be sent. It was cumbersome and slow means of communication, but sufficient under the circumstances. Catherine simply made do without complaint.

Money was another real problem for Catherine causing great issues. Her problems were quite simple... if she received a check from an organization she would have to cash it the next morning at the bank from which it was drawn. Being a stranger with a foreign name, neither having citizenship, nor having a permanent address caused problems for banks

and delays for Catherine. Occasionally this would mean missing a bus departure. There were times when an officer of the club could give her cash if she signed the check over. Sometimes a generous and inspired free-will donor wanted to give more money than was available in cash. A check would appear in a hat, plate, or bucket that was passed around the room causing the same problem with the banks when Catherine attempted to cash the check.

There were bank accounts Catherine maintained in Houston and Boston; however, she would often not be in those areas more than once or twice a year. To make deposits or withdrawals she typically utilized the services of Western Union. Money would have to be wired to a hotel down the road so it would be waiting when she arrived. There were more than several times Catherine spent a day or two without money.

Life as a gypsy is what Catherine called it, not unlike those gypsies she remembered from her own country — traveling with just the clothes she carried, living with just the money in her purse. At times the generosity of her audiences was overwhelming. That was the good news; however, carrying a purse loaded with cash and change was both a burden and a risk. She had various hiding places in her suitcase and purse. Even her shoes and undergarments served as reserves for surplus cash.

Money was always a guessing game for Catherine; she never knew what she might take in from donations at a program. There were always dry spells... the days between stops... and as Catherine would say... "No talkie, no money!" Sometimes she would be at a program in a church or a school where the parishioners and students simply had no money to give her. There were many engagements where the standard honorarium was $10 or $20; and Catherine might spend $4 on breakfast and lunch, $3 on taxi fare, $9 for a room, and $15 for a bus ticket to get to the event. Yet she never wavered in her confidence in the generosity of Americans and always found a way to exist.

More than once she traveled by truck as a hitchhiking guest of a different kind than to which most truckers were accustomed. Hitchhiking was great fun for Catherine. When she missed a connecting bus to her next town or when she lacked money to buy passage, she would simply ask in her direct way if the surprised driver would give her a ride. On those sometimes meandering routes, Catherine would even pitch in to assist the driver at a stop to load or unload — by holding doors, helping with the paper work, or just providing conversation. Invariably Catherine

would tell the driver of her very first ride in a vehicle when she hitched a ride in France to get away from the boarding school.

She always enjoyed the conversations she would have with the everyday Joe. Many turned out to be former GI Joes as well, and they would often exchange war stories if the soldier was willing to talk about them. There were many who wouldn't believe "...in a thousand years..." that she was a princess. Sometimes she would speak in all of the five languages she commanded to try to convince doubters. If it didn't convince them, she always seemed to entertain with her many fascinating adventures. Often times she would end up with another speaking engagement in the trucker's hometown.

Life on the road wasn't all dusty, bumpy highways and byways, dimly lit meeting halls, and well used cheap roadside motels mixed with naps in a bus terminal. After ten years and tens of thousands of miles, Catherine received a unique invitation. One of the nation's leading patriotic organizations, the Order of Lafayette, in New York City awarded her their annual 'Freedom Award'.

The organization took its name from the famous French patriot who served much of the Revolutionary War as the right-hand man to General George Washington. It was established to honor those of service to France in a number of military applications, members of the French Legionnaires, and descendants of the same. As their guest, Catherine was flown to New York City to attend the prestigious event. She was met at the airport by a familiar friend, Larry Jones, the same 'boy' who had greeted her off the boat eleven years earlier when she first arrived in America.

"Hello, Princess!" Jones said happily as he hugged Catherine.

"Hi, Larry! How are your wife and children?" Catherine greeted.

"Everyone's fine, thanks," he answered. "The two boys are in high school now." Jones picked up Catherine's suitcase as they moved within the throng filing through the terminal towards the exits.

"Do you know where the Plaza Hotel is, Larry? My room is there. So is the banquet," Catherine noted.

"*Princess*, it's a five star hotel — top shelf! This is a *very* special event. It's covered by the national media and there will be hundreds in attendance. There's an article in the **New York Times** this morning. You're on the dais with Senator Barry Goldwater, General Omar Bradley, writer William F. Buckley, and union leader Tom Gleason!"

"Well, of course, I am very honored, Larry. I hope it brings greater attention to the sacrifices you 'boys' made. I think it's an opportunity to

remind such an influential audience that they have a responsibility to defend freedom today, just like you did in the skies over Europe twenty years ago!"

They found Jones's car in the vast parking lot of La Guardia Airport. He held the door open for Catherine as she climbed into the passenger side front seat of the shiny new Chrysler. Jones' pay from Pan Am afforded him a very comfortable living. He noticed Catherine's coat in need of cleaning, perhaps a few stitches at least... no, really outright replacement. "Princess, I want you to come with me to Macy's."

Looking in the mirror, Catherine was pleased. She wore no make-up, no eye shadow though she did have an apple red lipstick she applied. By the generosity of Larry Jones she felt dressed for the event. At Macy's he bought her a beautiful new dress, blue of course. It had a fanciful ribbon of a multi-colored chain that encircled the neckline. An exquisite little hat of brightly colored feathers was also purchased. Larry said it looked like a little crown for his "Princess". He also wanted to buy her a necklace, but Catherine refused. She had no room to cart jewelry around on her travels. He bought her a new calf-length winter coat, but told her he had another surprise for the evening's event.

After a wonderful buffet in the Macy's Restaurant, Jones drove to his apartment. There he turned her over to his charming wife Judi. Judi took Catherine to her walk-in closet and pulled out a beautiful fur jacket to wear to the event. She then picked out a dazzling gold chain with a heart locket embedded with several diamonds. Catherine was very excited. It had been twenty years since she had furs and diamonds to wear. It was so wonderful to feel truly ready for her gala event.

Jones' guess about the event was right. The evening was crowded and had a frenzied atmosphere of a high society celebrity outing. The hotel literally rolled out a red carpet from the curb, through the lobby, and to the huge double doors leading to the grand ballroom. As a guest of the hotel Catherine did not have the opportunity to make a grand entry from a limousine as did so many of the well known attendees. She walked off the elevator by herself and entered the vast hall unescorted and unrecognized.

As a royal in pre-war Europe, Catherine once enjoyed similar trappings of great wealth and attended many similar events. The Grand Ballroom reminded her of the great halls within palaces across Europe

that once was her playground. High ceilings, paneled and edged with ornate layers of crown and carved moldings, were shimmering from the massive array of lights sparkling from huge crystal chandeliers. The parquet flooring was barely visible under a sea of white linen covering over a hundred tables. Sprays of flowers accented the end of each table and gold gilded plates were flanked symmetrically by highly polished silverware. Catherine walked casually amongst the tables, stopping occasionally to read the names etched in gold calligraphy. There were senators, congressmen, generals, and admirals names by the place settings. She recognized the name Rockefeller; descendants of the same J. D. Rockefeller who helped her grandpapa establish and build the oil business of Romania. Mayor Robert F. Wagner, Jr. of New York City shared the same table.

"Ma'am?"

Catherine looked up to see a nice young lady wearing a badge that read "**Courtney Tibble** - *Event Hostess*". "Good evening, dear. Looks like you'll have a busy evening tonight."

"Oh, yes, very busy... can I help you?"

Catherine thought the young lady had a beautiful smile, just perfect for her job as a greeter. "No, no, I'm just soaking it in; it's so lovely in here."

"Thank you ma'am, but... it's not time to be seated yet. Could I show you the lobby?"

Catherine wondered why she seemed to be the only person not wearing a white apron over a green dress, "I'm so sorry... I don't want to get in the way."

"Not a problem, just follow me." the hostess opened a file she carried and asked, "If you give me your name I can tell you where you'll be seated."

"Caradja."

The young girl flipped through her papers. "I don't see your name," she said hesitantly but politely. Catherine looked at the hostess furrowing her brow and cocking her head to one side. "Let me look again," Hostess Tibble said with a dubious smile. "No, I'm sorry; you're not on my list."

By this time they had reached the doors to the lobby. "Can you follow me to the catering office, perhaps there is a mix-up"

Catherine suspected the hostess was really heading her towards the security office — another party crasher. They went past a marquee just beyond the lobby and she glanced at it quickly, "Oh, Ms. Courtney, *here's* my name!"

The hostess stopped abruptly and turned. The marquee read, Loyal Order of La Fayette — Freedom Awards Honorees. At the bottom of the list was Princess Catherine C. Caradja, Romania. As the woman blushed Catherine smiled sympathetically, "I guess I'm not as recognizable as the other distinguished gentlemen on the list."

Ms. Tibble was turning a crimson red, "I am so sorry, of course, you are at the head table. This is so embarrassing. We have a VIP lounge for you to wait in, I'll take you there... your highness."

Once inside the dignitaries retreat Catherine quickly introduced herself. The posh suite was quite crowded; it seemed the other luminaries came with entourages. Senator Goldwater was looking tanned and relaxed. William Buckley was very formal and struck Catherine as rather patrician and stuffy. General Omar Bradley went out of his way to greet Catherine. He was in uniform and wore many medals and ribbons. He said he had been 'briefed' about her from other military personnel... "A nice memo from the Air Force," he added. Tom Gleason, the union boss was, true to his reputation, running late and still had not shown up when the announcement was made to head for the ballroom.

As the honored guests and officials of the Order of La Fayette entered the hall and climbed the platform of the raised head table, the ruckus of conversation and clatter of serving dishes and clinking of glassware halted and a spontaneous applause broke out. General Bradley, the war hero, waved back, occasionally returning a snappy salute from other military brass in attendance. Senator Goldwater was still in campaign form from his failed Presidential campaign two years earlier. He had many loyal fans in the audience and was glad to recognize so many. Buckley, too, had his following and as a New Yorker was acquainted with many of those assembled. He put his hands together in front of his chest as if he were praying and nodded in modest acknowledgement. Gleason arrived just in time to climb the platform with the others. To him it was another union rally, and the audience all was his. Raising his arms in the air like he had just won a prize fight he waved back towards the applause. Catherine was the last on the program and also the last chair at the long table. She smiled and nodded politely to no one in particular, and no one in particular seemed to notice her.

Retired Colonel Hamilton Fish was one of the organization's founders and served perpetually as President of the Order. The evening was both the organization's formal annual meeting and its showcase. The banquet at a pricey $25.00 a plate was also the Order's major fundraiser. Colonel

Fish made a number of recognitions and introductions of members in the audience who stood to take a bow. He reminded the audience of past prestigious recipients which included President Eisenhower, John Wayne, Admiral Rickover, General McArthur, Bishop Sheen, Chiang Kai-Shek, Norman Vincent Peale, and Clare Boothe Luce. Catherine was happy to hear at least one woman's name mentioned.

The event was obviously one for those wishing to be seen. The clergy at the head table was asked to give a blessing which was something more akin to a speech as the priest appeared to lobby for attendance in his hall of worship the following morning. Then the noise returned as the multiple courses were brought out by the army of servers and the chatter of lively conversation echoed over the tables across the vast banquet hall.

The invitation to the event had been sent out under Colonel Fish's signature and noted that here would be a letter of nomination read for each recipient followed by a brief acceptance speech. Catherine did not use notes for her talks to organizations, preferring to gauge her audience and respond to their interests, questions, ages, and so on. This night would be no different. She was happy to see she followed Senator Goldwater — as she remembered his appearances on TV, he had a rather boring monotone delivery. He would not be a hard act to follow.

<center>*******</center>

Colonel Fish returned to the podium as the applause died down for Senator Goldwater. Catherine was certainly glad he was brief, because he sure was not — as anticipated — titillating. She may have to wake this group up a bit. Colonel Fish cleared his throat and nodded in appreciation one more time to Senator Goldwater.

"Ladies and Gentlemen, as you know our awards recognize distinguished leadership in combating Communism. Our final award recipient perhaps knows Communism better than anyone here tonight. She is a princess who once had everything and then it was taken from her by the Communist regime in Romania. They attempted to even take her life, but she outwitted them for months until she could escape the horror they inflicted upon her homeland.

"She is before us tonight an expatriate though not by choice. She speaks before schools, churches, and clubs traveling back and forth across our great land extolling the virtues of America — and condemning the folly of Communism. Princess Catherine came to America because she knew of America's ideals. She asks that we Americans wake up to the

<center>433</center>

threat before us, the menace of the captive nations, and to value anew our heritage. She travels our highways snow-swept by winter, dusty and blistering by summer, asking for no fee... only if someone will listen. I ask tonight that you *listen* to Princess Catherine Caradja."

Raising up from her chair and politely stopping at Goldwater's place to shake his hand and congratulate him on his award and speech Catherine shuffled slowly towards the podium. There was a polite applause. The audience had heard prior to her, celebrities, well-known politicians, and a war hero. The short little grey-haired lady about to speak to them was not even from their country and most had never heard of her. The applause quickly died; most were getting restless and ready to go home, happy this was the last of the program. A stepstool was placed behind the podium which would have otherwise hidden the little woman. The microphone was bent to its lowest position to reach down to her.

Catherine took a deliberate drink from the glass of water placed under the podium. She looked out across the sea of faces and paused. The audience seemed to lean closer to hear. She waited briefly for the sea of faces to be ready. Then she began.

"FREEDOM!" It rang out in a loud voice belying her tiny stature. As heads in the surprised audience snapped back she rang out again, "FREEDOM!", and again with even more vigor a third, "FREEDOM!" thumping the podium with an open hand that clapped loudly into the microphone,

Panning slowly across the tables her eyes searched. Everyone in the hall by then was at full attention. Every person in the audience was sure the speaker's commanding and expectant look was directed at their eyes personally.

"Perhaps I know that word... better than *you*... who *live* in the land of the free. For I have had it taken away! I come to you tonight wearing borrowed jewelry, borrowed furs... I do not say that to shame myself ... or you. I congratulate you! I once had many vaults to hold all my jewels and furs... today I have nothing. A cruel system has taken it all from me. That's not all they took. They took my freedom. *That*... is my warning to you!

"Don't be comfortable, complacent, ignorant. Be constantly cautious, always on guard, ever mindful. America is at the Rubicon. There *is* no turning back. The torch of freedom is in your hands and must be carried into a slowly darkening world. *YOU* must be that soldier of freedom. *YOU* must always be that sanctuary for the oppressed; the captive people

denied their freedom. *YOU* must stand tall, and be that indomitable spirit that is America... *that*, my friends, is *freedom*!

"Value your heritage! Make those founding fathers proud of you.

"Your nation is but a child in the world of nations. I must warn you. Do not fool yourselves. Your nation's place in history will not stand on the billions of dollars given by you to foreign lands, no matter your altruistic motives. It will not come from your amazing technological advances; or medical breakthroughs; your enviable contributions to sports and the arts.

"It will stand among other nations upon what dedicated patriots fought for over 200 years ago... and what your brave lads have fought for generation after generation." Catherine turned and gave an appreciative nod to General Bradley who proudly saluted back to her. "They fought to right injustices and oppression; to preserve the dignity of the individual; to bring the principles of those founding documents alive — not just for *you*, here, but for the *world*! ... *That* is freedom!"

With a well-honed skill from so many speeches Catherine lowered her voice to just above a whisper, slowed her cadence, and continued as the audience now leaned forward to capture her every word. "Why? Because these are the truths, they are universal and touch all mankind — as long as mankind has a heart to touch... *And* because of what dictators and despots do. They try to take away one's heart... They numb one's senses and sensibilities... They want people to *give up!*

With her voice now rising like a boiling cauldron Catherine jabbed a finger into the air "People don't *want* to give up! They *won't* if they have hope! That's what *you* must provide. *You* must be the light of hope — the burning intense heat within all of us to make our own way, to learn from our own mistakes, to control our own destinies! That *is freedom!*"

Catherine paused for a drink of water.

"*I* am a refugee! *America* must never become a refugee! If you did, it would mean there are no free countries left. Where could you go? Where would *anyone* go?"

Leaning forward into the microphone, Catherine sounded cold and menacing, "I have watched from within their midst, inside a communist regime as they listen to you... to America... telling the captive nations to be patient... They say *you are afraid*. They watch your kindness... and say *you are weak*! They see your God-fearing ways ...and say *it is a crutch*! Then they *spit* upon God — for the *State, a dictator...* is the supreme ruler,

and there can be no other! Shame on them... and shame on *YOU... if you allow them!*"

Once again her voice rose as she shook her head and wagged her finger at the audience, "No one is so blind, as he who... will... not... see!"

"*WAKE UP!* OPEN YOUR EYES! LOOK! SEE! Do not be blind!"

Catherine looked across the audience again, with a pause, and then leaped upon them with a challenge, "*What* allows someone to stand by and watch while another human being... another nation... is being hurt, robbed, defiled? America! Don't *stand by...* you have to *stand up! That* is freedom!"

"You cannot let your freedom... nor that of others... be frittered away. What will you have left to pass on? Your vast personal belongings would be worthless. Look at what happened to me! Until there is common justice everywhere, the *world is not safe!*"

Again lowering her voice Catherine challenged those in the ballroom, "You do not have to be the world's police; you must be the world's conscience and its champion. You don't need to be every nation's friend; you must have their respect. You don't have to make the world in your image; rather you must make sure nations can be true to their own cultures, beliefs, and religions! *That* is freedom!"

As her speech proceeded, Catherine noticed the doors to the serving area had quietly opened and the servers, many among them recent immigrants, were crowding along the back walls of the great hall to listen. Her eyes moved to the wall and she looked at them. She spoke to that audience, many of them recent immigrants, as well as to those in furs and tuxedos before her.

Her voiced quieted again as she continued, "Now, being here in this great country gives *me* hope. I now have your freedoms... But I *don't* have a country. My countrymen are not free, so I am not complete... Not yet.

"I feel that the only way I can be of service to our captive, to our lost countries... to my Romania... is to tell the Free World about the worth of freedom. It does have value... but it also has a cost. This is why I speak... to explain the conditions in the captive nations, and encourage the still Free World to protect and defend that precious freedom."

Pausing again only to return in a thundering crescendo Catherine extolled, "I get angry when people talk about wanting peace... but *peace* only? You need peace *and* freedom... *Peace... without freedom is... not... worth... having!*

"You do not know what it is like to live with liberty *lost... I do*! So I tell you... I implore... You must know how precious your freedom is; how special your country is; and that *you* represent the best hope for the captive nations and their people throughout the world.

"There is a common thread that connects all mankind. It is *HOPE*! The earliest man watched the sun go down and it got cold and dark. He *hoped* the sun would come up again. When we get lost we *hope* we can find our way. People go to sleep at night hungry and *hope* they will find nourishment in the next day. There are many that look out unto a world were they are without choice, a voice, or so many of the things you take for granted, and they *hope* that will change."

"If one does not have freedom, there must be *hope*! If you doubt that, ask your boys who were POWs — captives then — like so many nations now. They survived because they dreamt daily of returning to America. This was *NOT* because of your beautiful shores, plains, and mountains, but their ability to choose which of those to enjoy. *NOT* to your wonderful universities, but to the choice of which to attend. *NOT* to your fertile fields, but to the right to plant what they feel is best. They dreamed of returning to the opportunity to engage their own skills and work. They dreamed of returning to *FREEDOM...* to the pursuit of life, liberty, justice... and happiness."

With a measured cadence and challenging stare to every corner of the great hall Catherine pointed her wagging finger into the hearts of the audience, rising up on her tiptoes as she delivered each ringing sentence.

"*You...* were your '*boys*'... your soldiers... your heroes *hope...*

"*You...* were *my hope...*

"*You...* today... *are* the *world's hope.*

"Please, *always remember...*

"*HOPE DIES LAST*! ... And *YOU... AMERICA...* are that *HOPE! And that my friends... is freedom!*"

With that final flourish Catherine pounded her fist on the podium. The sound system picked up the loud thump against the wood and it rang across the hall. Catherine turned away and stepped down from the stool. As she did she heard a thunderous roar of approval in front of her and looked back up. The audience was on its feet clapping. Cheers were ringing out from the tables.

Looking out over the hall Catherine paused and considered for a moment the standing and cheering throng. As she did the crowd noticed

her stop to acknowledge the ovation, and they raised the salute to an even higher level... a crescendo of adulation.

Perhaps, she hoped, they had been awakened. Pleased, she smiled and nodded back at them politely. Then Catherine returned without fanfare to her chair. As she settled into her seat she smiled and thought to herself, "I think they know me now."

CHAPTER 37

Like a Summer's Breeze

It became a ritual, simple but purposeful. At each stop whether it was a one night stay in a roadside inn, a big city hotel, or an extended stay at the home of friends, Catherine always opened her suitcase and emptied the contents entirely. All the clothes would be shaken out and hung in a closet or folded and placed in a dresser. The suitcase would then be stowed under a bed, behind a chair or in a closet out of sight. It gave her a sense of being settled. Each move for her was a fresh start — like packing for a new, exciting journey. It was no longer a series of stops in an unending road trip. Instead Catherine would appreciate the stop, her new surroundings, and the people with whom she would be spending her time. And it helped her keep her sanity.

As her stay in the country extended beyond years and into decades, she continued to make more friends and her opportunities for stopovers of several days or even the luxury of a week's respite increased. Her growing network was also like having an advance team making her visits more efficient. There were fewer taxi rides as her acquaintances would pick her up. There were fewer bus rides now that her 'boys' or their wives would drive her to the next stop. An extra benefit of course was the fewer meals in restaurants and fewer nights in motels, replaced by those blessed nights in a home. She had not had a home since 1949 and the day of the Romanian pogrom. Since coming to America she had lived on the road and out of a suitcase every day for over twelve years.

After creating a list of all the names she had already entered in her address book, Catherine made copies and enclosed it with a letter to each 'boy' asking him to add to the list. By 1968 the list had grown to over three hundred names. It was progress, but ever so slow for the dynamo that was Catherine. There were still 1100 more yet to be found. The next

year was the 25th anniversary of the airlift rescue. During the war the 'boys' arrived in Romania on different days — a day each would like to have forgotten. The day of their rescue, August 31, 1944, however, was a golden day in all their lives. This was the day of their escape and return to freedom. Catherine suggested to the 'boys' she had found that they try to meet and have a reunion.

Some skepticism abounded at first as many of the ex-POWs were in the midst of raising families and developing careers. Four men — Robert Cheeseman of Joliet, Illinois; Harry Harris of Weatherford, Texas; Robert Strieioski of New Jersey; and Julian Curry from Jackson, Mississippi — all arranged for regional gatherings. The informal gatherings were so popular that it was decided that an annual reunion to be held in different regions of the country would be a better choice.

The men began in earnest to search out more of their comrades in arms. Colonel Gunn was again able to be a big help in the process as he was able to secure from the Pentagon the addresses of men who received medals and citations after the war. This created a whole new set of leads and more discoveries. By the 1970's a roster of eight hundred men, over half of those shot down over Romania, were checked off Catherine's list of 'boys' to thank.

As Catherine began moving through her eighth decade of life, some of the vestiges of her long journey crept upon her. She had high blood pressure as a result of too many fried chicken and mashed potato meals on the speaking circuit. Bombings during two world wars and the noise of too many bus engines also took their toll on her hearing. Catherine, in her usual humorous fashion, would declare these infirmities were her medals, signs of success that she was still on top of the world... not underneath it.

Then an unexpected and unusual request came to Catherine. It was 1975, and she was speaking before a group of women from an organization called the Women's Christian Association of Kansas City, Missouri. The program was held at a lovely facility in a campus-like setting of eighteen beautifully landscaped acres. The building was a stately brick structure three stories tall. The inside was wonderfully appointed with large lobbies and sitting areas with plush well-groomed furniture, thick carpets, plants, vases, beautiful paintings, and soft lighting. It was much like a fine hotel in its appointments, but its feel was more like a cozy living room in its atmosphere.

There was a rich history to the Armour Home for Pensioners as it

was called. The organization was created in 1870 by a group of twenty prominent ladies from Kansas City who felt a need to help the local orphans and widows of the Civil War. In 1895 in honor of the Women's Christian Association's 25th anniversary, the wealthy Mrs. Simeon Brooks Armour, of the Armour Meat Packing Company; gave a gift of $25,000 to build a home for the elderly.

Catherine was a guest at the facility, staying in a third floor suite. The room was not used by the elderly residents because there was no elevator to the third floor. Federal regulations of course would not allow the space to be used by a resident. At breakfast in the dining hall the morning after her program Catherine was approached by Stephanie Cook, the Director of Armour Home.

"Catherine, your program was exceptional. You are such a great motivator. Our board members later discussed you at great length."

"I am flattered. I think you provide a wonderful service here, and I am greatly taken by your facility," Catherine replied as she nodded a greeting to several residents who were arriving for their morning meal. "The food, by the way, is delicious!"

"Catherine, our board would like you to consider an offer. The room you stayed in last night is of limited use to us. We seldom have overnight guests. We know you have been on the road giving these wonderful programs for over twenty years. Surely it would be nice to have a place you could call home. We feel our mission, and indeed our hearts, would be served more fully if you would consider this *your* home."

The stunned look on Catherine's face must have been very noticeable and Mrs. Cook followed up immediately, "You don't have to answer us right away. We know you have a very busy schedule ahead."

"Please, please forgive me. You have caught me by surprise. That does not happen very often! I'm 82 now... I have been on the road virtually every day for twenty years! It's like my worn suitcases are my home. It is what I have come to accept. I've never given a thought to having a *home*."

Mrs. Cook reminded Catherine, "It's just an attic space we've converted into a suite, a large room with an alcove by the window dormer, a place for a desk, perhaps."

"Well, it's *twice* the size of the nicest hotels I stay in, but, I am such a vagabond. I can't..."

"Catherine! We want you to be our *guest*. There would be no cost for the suite and because you travel so much we will only charge you

for the meals you eat while here. The room is better half used than left empty."

Caught totally off guard, Catherine's mind raced... such generosity! "Can you make me a list of chores I can do to repay you... cooking, dishes, gardening?"

Mrs. Cook laughed, "Of course! And if you wish, snow shoveling, too! Catherine, you are a gift. You're precious! We want to help... if it is something that works for you. Perhaps having a place you can really call home, a place you can come to and rest, will extend the time you can continue to make your speeches."

Taken by the unexpected generosity Catherine's napkin was up to her face, dabbing tears from her eyes. A closet to place her clothes, a familiar bed, walls to hang mementos, a desk to organize her letters and scrapbooks, a mailing address, a local bank account, a receptionist to take phone calls when she was traveling, laundry facilities, and no need for cooking — the chef was provided! With Kansas City so centrally located Catherine's travel could be shortened and better coordinated. Though she would never admit it to anyone, the years of daily travel was taking its toll.

"Mrs. Cook, I have always been able to make quick decisions. This I will not need to think about. The answer is, yes. Yes, yes, yes!"

The same offer for living quarters in Eugene, Oregon, or Tampa, Florida, may have been declined by Catherine because of her travels to all corners of the country. She had no plans to settle down. She was after all in America on two missions, both of which were not complete. There had been tremendous recent progress finding her 'boys'. Catherine was always finding new towns to visit where she would contact local radio, TV, and newspapers to put out the names of 'boys' yet to be uncovered. With the efforts of Colonel Gunn, she had the hometowns from which they enlisted and from which military follow up had been sent after the service. Yet many still slipped through the cracks. Catherine had several hundred of her 'boys' yet to find, meet, and thank for their efforts and sacrifices above and upon the soil of Romania.

Without question Catherine's second mission was having an impact. Her crusade to expose communism and challenge Americans to appreciate and protect their freedom was always well received. She did this by reaching out and speaking to as many groups as she could. In

her mind this task was unending, though she knew her time was ebbing. As Catherine finished her tour schedule in 1975, she was approaching 83 years of age. Even she began to admit there were limits to what her octogenarian body could handle. Having a home base centrally located at the Armour was quite a stroke of good fortune, and it would indeed extend the years she could travel. She begrudgingly realized she now needed more time to rest.

Kansas City, Missouri could not be located any more in the middle of the country, both north/south and east/west. It was a sizeable metropolitan area with access to rail, bus, and major air routes. Being in the middle of the country made much more manageable legs for future journeys both time and expense wise. As much as she rued the thought — long bus rides were becoming taxing on her old bones. Although she preferred to keep herself on the ground, a couple of hours by jet were ever more attractive than a couple of days by bus. Of course, the costs were greater for the faster and smoother jet option. Still, her arrangement for free residency at the Armour reduced her need for renting a motel every night. If she was careful in her planning, she could afford the new means of jet travel across the vast reaches of America.

<p align="center">*******</p>

The phone in her new apartment rang. Catherine looked at the black device ringing out at her. "Yes," she grinned, "my very own phone!"

"Hello, this is Catherine. Why Dick. Yes, you *are* my first caller. Isn't it exciting! How is Dorothy... and the children? Great! What's playing at the theater?

'**Jaws**', the shark movie, very scary you say. No, I've spent my time in a boat. Not my cup of tea. Give me the beautiful blue eyes of that Paul Newman. I'll watch him instead!

"Dick, it is wonderful. I have already hung that picture of you and me taken after the **Today Show**. It is so nice to have a place, Dick... yes, and Dick, the food is wonderful, too! So here is my plan. I will travel half the year, in the spring and then late summer, early fall. Of course, I can make exceptions for special occasions or needs. I think March, April, May, and maybe part of June would work. Then in August, September, October... yes, of course. I will fly to a destination, maybe take some bus routes to nearby engagements and then fly back. I have already been planning my trips this spring... Oh, yes, you can believe me... if I find a

'boy', I will change my plans in a heartbeat... Did you say Pennsylvania? August? Why?"

<center>*******</center>

The plane ride was perfect. No delays in Philadelphia International Airport. Waiting to greet Catherine at the terminal was Bill Fili. Bill was, of course, one of her 'boys'. He was one of the last to leave Romania. He stayed with the POWs in the infirmary when the Germans began their final bombing attacks just before the rescue. He remained with those who were bed-bound and flew out with them. Fili was a dapper dresser and wore a tailored suit with a colorful paisley tie. His thick wavy hair was a very distinguished salt and pepper with white edges along the temples. His bushy eyebrows were also tinged with white. On the wide lapels of his gray suit was an American flag pin.

Excited to see him again Catherine waved happily upon finding him waiting for her. "Bill, hello, my dear! My, you just never change. Same slim self." Holding the index finger of her left hand up, she admonished Bill, "Now, don't even try... I know I have gained weight since I have found a home. It's a good diet, but they've a wonderful dessert cart that I cannot refuse. Doctor says my blood pressure is way up, too! I just sit too much. After all those years, running to catch buses, carrying my luggage all over creation... the movement was good for me."

Bill stood by patiently. Catherine was never at a loss for words. And as he took her bag he knew the talking would increase and become more animated. Catherine seemed to be better able to express herself if her hands and arms moved about as part of the conversation.

"Have you ever been to Valley Forge?" he asked.

"No, but I had read about it when I was ten years old at the orphanage. I have always been fascinated by the Revolutionary War, George Washington, Ben Franklin, Thomas Jefferson, The Founding Fathers of this country... it was such a unique blend of minds and backgrounds. All of those people together at one place at one time and whose work was so enduring. I am convinced it was divine intervention."

Smiling as they left the parking area and merged into I-95 westbound for the one hour drive to the Valley Forge National Park Bill added, "Yes, Catherine, once in a while there's a remarkable person — or people who, you are convinced, that but for fate... a plan beyond what a simple mind can comprehend; was placed on earth to make things happen — things that you would have never dreamed possible."

An animated Catherine started to go on about the Founding Fathers; "You know they..." She stopped mid-sentence and looked across the seat at Bill, still with a big grin and eyeing her out of the corner of his eye as he drove through the traffic. She realized he was talking about her and put a gentle hand to his shoulder and patted it. "Bill, that is very kind of you."

"Princess, there are a great many of our 'boys', this one included, who thank their lucky stars and their maker each night that you were in a certain place at a certain time. And I think that in some school assembly in Nebraska, some women's club in Virginia, some Rotary in California... there are people young and old who are hearing your message and heeding your words."

"Yes, when I think of it, helping the 'boys' of Timisul, and the twelve hundred of CC #13 in Bucharest, it was not an easy task. Now I sometimes think of what I do today... it is like trying to save *millions* of prisoners all over the world. It is so daunting. Yet, I *warm* to the task."

"Catherine, you have found, what, nearly one thousand of your 'boys' now?" She nodded to affirm as Fili continued. "You have yet to meet the last one. You will continue to find them in the obscure reaches of this country. I am sure you will continue to have positive effects on their lives. Meeting you will cause them to have an effect upon someone else in their life. Your work goes on, and it is a *good* work you do."

<p style="text-align:center">*******</p>

The afternoon sun shone brightly over the wooded ridges and open fields of the hallowed grounds of Valley Forge. The 80 degree temperature was comfortable, and made all the more pleasant by the breeze of air drawn up the Delaware Bay from the cool Atlantic waters a scant 60 miles to the east. Catherine was the invited guest speaker at the commemoration of a new plaque to be unveiled at the headquarters of the Freedom's Foundation located adjacent to the national park. Called the Peace Monument, the large bronze tablet showed clasped hands in a greeting of friendship and peace. The ceremony was held in front of the symbol of the organization, a statue of General Washington, kneeling, eyes closed, and hands folded in prayer. Prayer seemed to be the iconic General's only ally during the long months of the extraordinarily harsh winter of 1777-78.

Dignitaries were seated in a row behind a podium. The plaque rested on an elevated easel to allow easy viewing for the crowd of supporters

and contributors seated on the lawn just outside the Washington Chapel. As she was introduced Catherine stood slowly from the wooden folding chair. She smiled to the applauding audience as she approached the speaker's podium.

The master of ceremonies greeted her and adjusted the microphone after his introductory remarks. Her years of public speaking taught Catherine some lessons about addressing a crowd. Always walk slowly — you don't want to trip on a cord or seam in a carpet or tarp just laid out for the event. Besides the audience was always watching... to see if the old lady trips and falls! The slow gait also served another purpose. The tension of watching her approach raised anticipation and then relief when she made it eased the anxiety so her audience was more relaxed. Additionally, it gained the attention, the focus of the audience which she wanted before she would begin her talk.

"It is indeed an honor for me to have come all the way from Romania... no, not today... though it feels like it after the ride from the airport... with these old bones."

Catherine waited as the laughter subsided. "I came to this country over twenty years ago. Not because I wanted to leave my country... No, I dearly love that special place, my homeland, my Romania. You see we have a warm caressing breeze off the Black Sea — as you enjoy here today off the Chesapeake; the verdant fertile plains — our bread basket; the unending flow of the great Danube River; the craggy and mysterious Transylvanian Mountains... it is indeed a beautiful country so much like yours. It is also the home of my ancestors... and the burial grounds of my family and my two beloved daughters, my grandparents, my mother.

"However, I was *dead* to my government then and still today... and they were hoping... *really* dead." There was more laughter and Catherine paused just long enough to let it ripple across the audience and then cut it off..."But... But I lived... for I hoped to live free... That was not possible in a communist regime or a dictatorship. So I escaped! Still... I love my country and want it to be free too... as it once was! I yearn to go back.

"So I came to America... and believe me it was not easy. The Reds almost got their wish! I came to America because you are the best chance for that wish of mine... for my Romania to be free again. You are the symbol around the world of FREEDOM! You give the HOPE to those that are denied and oppressed! You have the power to preserve and protect that which is most dear to us all.

"Yet I find your people sometimes need to be reminded of your own

heritage, your own good fortune. Your great strength can be your greatest weakness, your own worst enemy. You have become complacent; you don't have to worry about your freedom, it is your birthright. Well, if history has taught us any lessons it is that *freedom...* is not *free!*"

Catherine's cadence and volume increased. "It demands vigilance, morality, sacrifice, and courage! It is a responsibility... not a privilege!"

Pausing for effect Catherine looked across the lawn at the rows of faces — always making eye contact as much as she could. She continued, thumping the podium for emphasis after each pause as her tempo picked up. "I am here today to be that reminder... that example... that conscience that says to you 'be careful... be mindful... be prepared'... I am here to tell you what it is like to be without your freedom... for I have been there! When you *don't* realize there is danger... that my friends, is when you are *in* danger!

"I have been told that I am no longer a *spring chicken...* I am only 84... when does that happen in this country... that you become an *old hen?*" Catherine had to laugh at her own joke with the audience.

"I am often asked... when will I stop? When will I retire? *Ha!*

"When I see that you are *concerned...* that is when I will take up knitting!"

Catherine held up her hands over the podium and pretended to knit in the air to the delight and applause of the audience.

Feeling the warm gentle wind against her cheeks she asked, "Do you feel that lovely breeze?" She pulled her hanky from her sleeve and held it up letting it flutter for everyone to see. "Freedom is like a soft gentle summer's breeze. It is not constant. You cannot assume it will sustain. You cannot will its existence. Yet isn't it a comfort as it breathes life into a still and stifling existence? You cannot see it, yet it sows the seeds that become next year's flowers and the next generation's trees. Will you... America... be that breeze upon the face of this earth... caress a stifling world... spread the seeds of freedom? Occasionally, those breezes brew up storm clouds and the lightning and thunder may be loud and scary for a while, but they pass, and the rain's moisture left behind helps quench the earth's thirst and gives rise to new life.

"I want to let you know how precious your freedom is, how special your country is, and how caring your people are. I have spent the last twenty years in that warm embrace of your people. I want to thank you for being that shining light that glows from red embers burning deep within, and ask that you keep it kindled so that it's never extinguished.

"Freedom's Foundation... I applaud your mission. You are doing your part. Your collective voices are carried in that summer's breeze of freedom to gently caress the cheeks of all the peoples of the world. May those voices gain in strength so that breeze becomes a hurricane that sweeps all totalitarian governments into the Abyss!

"It is with great pride that I dedicate this plaque, the Peace Monument to the people of this great nation, the United States of America."

Catherine stepped back from the podium and returned to her chair. She turned before sitting to acknowledge the applause with a simple smile and nod of her head, before sitting down.

The Master of Ceremonies returned to the podium still clapping appreciatively and looking over to Catherine. "Ladies and Gentlemen, we do have one more award to present this afternoon."

Looking out over the crowd Catherine found the smiling face of Fili. She was not aware that she was about to again be a part of the program, but she sensed a knowing gleam in her 'boy's' eyes. Was there something he had not mentioned to her about the day? She turned to listen to the host.

The prestigious organization's chairman stood back and was handed a velvet lined box from a staff member. He approached the podium and opened the box as he set it on the oak stand. "We want to conclude this afternoon with a special presentation. Each year the Freedom's Foundation bestows our most prestigious award — the General George Washington Freedom Medal." He held the medal out for the audience to see and described it. "On the face of the medal is the same depiction of the General we see behind us, a kneeling Washington in prayer. Our organization was founded in 1949 and at that time General and later President Eisenhower served as our chairman. He held that post until his death in 1969. For those twenty years he presented this award and it is now my distinct and privileged honor to do so. So it is in the shadows of two of our greatest generals and Presidents that I bestow this award.

Today, the honor is a bit more *unique...* Today I will be presenting this award to one of the most deserving recipients that I have had the pleasure to know. This honoree has crusaded for the American way of life centered upon the principles of freedom established by Washington and preserved by Eisenhower. What is *unique* is this person is *not* even an American. So for the first time in our history our award for:

'OUTSTANDING ACHIEVEMENT IN BRINGING ABOUT A
BETTER UNDERSTANDING OF THE AMERICAN WAY OF LIFE'

is conferred upon someone from a foreign country — Princess Catherine Caradja of Romania. God bless you and thank you."

A surprised and delighted Catherine stood slowly as the Chairman approached. She clasped her heart and beamed with pride. With care and dignity the red, white, and blue ribbon holding the medal was placed around her neck and Catherine was again asked to return to the podium.

"Ladies and Gentlemen, I accept this award with humility, honor, and the deepest respect. Your great General Washington has stood for two centuries as a symbol of determination, persistence, and valor. It is with great pride that his image — one which I first held up in my mind's eye over 70 years ago, a child in an orphanage yearning for freedom, as I read of his struggles here at Valley Forge and it gave me strength — now, it rests here next to my heart."

Catherine placed both hands over the medal and her heart. "I feel a kinship to that other great general as well. Every night after the invasion of Normandy I prayed for your General Eisenhower that he would succeed with his armies of your sons and fathers who fought so bravely to free the world of a scourge... to set us free.

"My heart is warmed by this award and by your appreciation of my work in your country. That I and those two Americans be mentioned in the same sentence swells my entire being with a pride I cannot adequately express. This feeling will be cherished in my thoughts until my last breath is drawn. Thank you."

Princess Catherine's joyful reunion with her "boy" Richard Britt at the NBC Studios of David Garroway's Today Show, December 1955

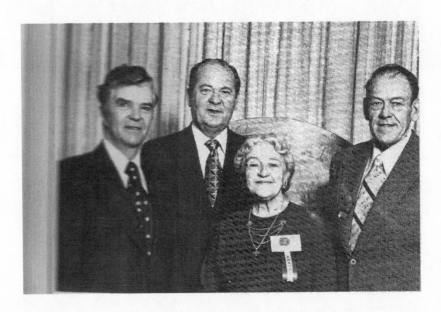

Princess Catherine with Fili and Britt as she receives the Freedom Foundation Award in Valley Forge, PA in 1977

Underground photograph of Princess Catherine, age 50 used in fake identifications

Princess Catherine while on her 30 year speaking tour

The entrance of the Armour Home as it currently stands (2010). The third floor dormer windows are the location of Princess Catherine's apartment that she was so grateful to have been provided by the organization. Note the cornice piece at the top of the structure which reads 'Margaret Klock Armour Memorial' in honor of the benefactor. Photo courtesy of Carol Davis.

Princess Catherine in borrowed furs and jewels entering the Waldorf Astoria

A Letter, A Call, A Visit

Friday evening approached on a warm sticky Midwestern summer's day in 1979. It was just a quiet evening in the town of Macomb, Illinois. The main attraction of the area was a mid-sized and vibrant state university; still the west-central Illinois community was considered more a farm town than a focal point of intellectualism within the Corn Belt. George Victor Young was sitting on his front porch enjoying a glass of iced tea his wife Edith had just brought him. Vic liked to relax after a busy day at work in the Piggly Wiggly grocery store.

The daily paper, a regional edition of the *Peoria Journal Star,* arrived. Vic took the pitch from a neighborhood boy who was a darn good paperboy, always hitting the steps — or Vic, never the flowers in front of the porch. He sat back on the porch swing and it creaked under his weight. He rolled the rubber band off the paper and unfolding it, saw his name on the lower half of the front page in bold print. His heart raced as only it can when the totally unexpected happens — especially when it is plastered across the front page of the local paper. He called to his wife who was preparing supper in the kitchen.

"Edith, come here, bring your glasses — you've *got* to read this!"

Wiping her hands off on her apron Edith entered the porch and looked at the paper. The headline read, '*George V. Young Target of Search by War Princess.*'

Yet again Catherine had reached out and found another reporter who in turn relayed both the princess's story and the name of a 'boy' who had grown up locally; in this case it was in Peoria. George Victor Young was another of the young lads who went off to Europe to serve his country as soon as he graduated from Peoria Central High School in 1943.

Vic immediately left the swing and raced to the phone on the wall

in the kitchen, and called the number in the paper that he still gripped tightly in his hand. It was the front desk of the Marquette Hotel in downtown Peoria. His 'princess' was staying as a guest while she gave several speeches to different organizations in the city. To his relief he was informed Catherine was still checked in still in Peoria, just over an hour away!

The front desk put the call through to her room and he heard the elderly voice of a lady with a mixed English and Eastern European accent, a voice he recognized after all the years. He couldn't believe his ears not even hearing what she said at first. Once his mind comprehended it was really his 'Angel' he was talking to after all these years it was like a switch was flipped. They talked for half an hour. Edith listened in and heard several remembrances she had never heard before from her husband of thirty-two years. Then she saw something she had never seen before as she dabbed tears from his face with her apron while he talked on the phone.

Catherine's last program was Friday, and she could adjust her schedule to visit with him. Young offered to drive to Peoria and bring her back to Macomb and host her as his guest. He said he certainly thought he could get her to speak before several groups in town. Catherine was delighted to accept his offer.

The reunited 'princess' and her 'boy' spent the next day touring Macomb, the campus of Western Illinois University, and then walked around the two quaint squares of the idyllically small town. One housed the old ornate county courthouse and the other a park. They talked about her unending tour of the country and of Vic's life in the thirty four years following the war. He was stunned to hear how really terrible her years behind the Iron Curtain had been.

Sunday was the following day, and Vic asked Catherine to come to his church, the Macomb Baptist Church. He had already asked, and the Rev. Blake agreed to let her speak to the congregation. As the Reverend put it, this rare guest's mission was that of a Christian Soldier, and she deserved to be heard. He would gladly give her the pulpit.

The church was a prominent red brick edifice near the older center of town. Word of the guest spread rapidly around the community. There was an added buzz in the pews as the congregation plus an added number of the curious non-members filled the rows of wooden benches to overflowing. Ushers hurried to add folding chairs in the aisles. Rev Blake dabbed his mostly bald head with his white handkerchief as he

Steven E. Aavang

delayed the beginning of the service for ten minutes while late arrivals settled down. Among the small talk were comments like...'There was a Princess in town. Vic had a Princess as his guest! Did you know Vic was in the War? Young was a POW?'

Once the service began Reverend Blake conducted his usual opening liturgy until the time for the sermon. Then he paused and with his broad warm smile and slight hint of a southern drawl he began, "One of our parishioners has a part of his life that I never knew of until just the other day," he started. "I believe you will be fascinated as I was to learn a bit more of our neighbor, Vic Young. He has recently been reunited with a lady who he says, saved his life in a faraway place many years ago. Most of you have heard by now that I have relinquished my pulpit this morning to a princess from Romania who has been a guest of our country for about twenty-five years now. But I think she has a message worthy of your attention. So, Princess Catherine, if you will be so kind to come to the pulpit, my congregation is now yours."

Rising from her place with Vic and Edith in the front pew, Catherine walked up to the altar, and climbed the three steps up to the beautifully hand-carved and polished wooden pulpit. She paused and smiled graciously to the assembly of parishioners.

"Thank you so much, Reverend Blake, for allowing me to say a few words. And Vic, thank you for bringing me to your lovely town and letting me be your guest for a few days. Please excuse my use of your language... I'm still practicing it... not English... it's 'American' that gives me trouble." There was a sprinkling of laughs as she continued, "sometimes I am perhaps too blunt in my translation, but most find most understand my meanings.

"I see your faces today, and you are like so many faces I see in every part of this great nation of yours. You are a God-believing and God-fearing people, and you need occasionally to be reminded of what a privilege it is, how precious being able to hold your beliefs is, how truly lucky you are. That is what I do; I become your conscience if you will."

It was easy for Catherine to speak from the pulpit of a church, she had done it often. She talked about her 'boys', and of the heroism displayed by Vic Young who, just beyond his teens, was shot down from the sky, floated 20,000 feet through the air surrounded by flak explosions and tracer bullets, then survived months of imprisonment. She spoke about her travels across the North American continent in search of the other American heroes of Romania. She told the assembly it took her nearly

454

twenty-five years to find Vic, and she hoped she would see him often now that he would be included in the association of ex-POWs of Romania. She said more were still not found and asked as she always did for help in finding her 'boys'.

As she spoke Catherine looked out over the pews, the congregation in rapt attention. "The communists are not just atheist; they are anti-God. America is a *Christian* country. You are followers of Christ. You cannot deal with, accept, or feel impelled to consort with those who spit on God. To do so is not being benevolent. It is beyond tolerant. It is moral idiocy! You are viewed by *them* as having a weakness by which you are to be taken advantage. Do not let your churches become museums to be used to indoctrinate your children against all religions. That is what they have done in my country, Romania.

"We have all just witnessed on our TV the power religions have on nations. Pope John Paul II has just returned from his visit to his homeland of Poland. Poland, like Romania, suffers under the yoke of Godless Communism. Ah, the folly of Communism. They try as they might to convince a nation of devote Catholics that there is no God! *Ha*! Yet you saw millions of Poles gather to hear the Pope speak. The government may be Godless, but the people certainly are not! Just what was his message? What did they yearn to hear? He said... 'You must be strong... You must be strong with the strength of your faith... When you are strong with the spirit of God, we are also strong with faith in man... there is, therefore, no need to fear!'

"So *you, you too* have no need to *fear*! Freedom as you enjoy in America must be brought to the *world*! Freedom of speech, freedom of religion, and the right to worship. Do not all of your brothers and sisters throughout the world deserve no less? In his Catholic Poland, in my Orthodox Romania, in the countries of many of your forbearers in so many parts of the world that today suffer under a Godless totalitarian state!"

Catherine paused and returned to a softer tone as a grandmother who tells children a story. "Follow this thread of thought for a moment... There is a biblical verse that goes something like this... 'If you have *faith* — even as tiny as a mustard seed — all things are possible.' Now... with faith there is hope... with hope there is a will... with the will comes courage... and a courageous people will be compelled to supreme effort...with that effort will someday be great accomplishment... and with accomplishment

comes inner satisfaction... and at long last... peace. So please... keep the *faith*."

Concluding her sermon from the rural small town pulpit Catherine's voice rose up again and sang out a ringing chorus like a good Baptist minister would have done, "*Freedom*... of worship! *Freedom*... to praise the Lord! *Freedom*... to live the way you believe! *Celebrate* this... for you have it!

"We lost our freedom in my country. They have tried to take our religion... but my people, I believe... I know... they have faith. *You* must give them hope! They will have the will, they will be courageous, there will be great accomplishment, and there will be in the end great satisfaction and a lasting peace! Beliefs become reality!" Catherine paused to wipe her brow with a handkerchief and a chorus of Amen's rang out from the pews.

"What lies behind, what lies in front... is nothing when it compares with what lies within."

Catherine leaned forward over the pulpit raising her hand waving it with the hanky open over her head as she looked across the sanctuary and spoke to each and every person gathered. "Do not wave the white flag, do not surrender! If you don't wake up, it could happen to you! In fact... do more than wake up... Get up! Stand up! Stand tall! Stand up in your pews and sing the lord's praises; stand up in your halls and city parks and sing praises upon your 'boys' in the services; stand up and sing the joys of being a God-fearing nation! Yes, stand up and carry the torch that brings God and freedom to the whole world!

Relaxing her posture back from the podium to an upright stance Catherine clasped her hands together in a prayerful repose. "I stand today in your pulpit, before you, and before God. I tell you war is *not* glorious. I do not speak lightly of the horrible act that is war. Rather I speak of the heroic acts of your neighbors, your countrymen who once put their lives — in their prime — on the line for your freedoms. Don't let them down. You must stay vigilant; and you must be prepared to sacrifice! Don't give up! The world needs you... today as much as it once did with men like George Victor Young. You do not need to be in the military or on a battlefront. Just be brave in your faith. *Be* a Christian soldier, just as your hymn says. *Stand up and march, you Christian soldiers*! I thank you. And may God bless you all... and your country."

Rev. Blake immediately stood up from his altar-chair behind Catherine. He looked up towards the ceiling and said, "*Lord*, she does

inspire!" Then looking out to the congregation he added, "I want you all to give our guest your warmest applause," which he began and was joined vigorously by the entire congregation.

As Catherine was seated and the applause receded Rev. Blake then added tongue in cheek, "Now I hope you won't expect me to top that sermon next week!" to a chorus of laughter. "Let's pass our plates again and give to our Princess, give what you can, give with your hearts so this amazing woman can continue her fine work. While we're doing that... I think you know what's coming... Choir, can you lead us in hymn number 347... **Onward Christian Soldiers**."

As he sang with the congregation, Vic knew his stature in the community had been elevated to a rare level. His personal act of discretion about his participation in the war was out now in his adopted town. His efforts during the war years were to be recognized with genuine reverence and adulation by the community. When word of the sermon spread, Vic was asked to bring his 'princess', Catherine, to speak at four more organizations in Macomb that week. At the week's end Catherine returned to her original itinerary, returned to her travels crossing America, one town at a time.

<p style="text-align:center">*******</p>

It was the summer of 1980. A man with an almost imperceptible limp had just taken a seat and was pondering what the next couple of hours would bring. He would be meeting someone special for lunch that day.

As he sat awaiting his guest the memories came rushing back. It was thirty-six years earlier. The distinguished white-haired president of an electronics distribution company and mayor of the suburban village of Roselle, Illinois was no longer thinking of supplies, customers, municipal codes, or pot holes. He was thirty thousand feet in the air, clouds passing above and below — sometimes enveloping the view from his perch in the navigators chair in the all-glass nose of the B-24 Liberator bomber.

The plane rocked, followed immediately by a black puff of an exploding round of an anti-aircraft canon. The first blast was always a surprise; soon they would surround the formation of bombers. One had to mentally turn off the noise and jostling of the plane the Ack Ack caused. There was a job to do — focus on your job. He was a navigator responsible for getting not just his plane, but an entire formation over the target. Then the call, 'Bombs away... now let's get the heck out of here!'

The plane rocked violently, his equipment lights fluttered and went

blank. Smoke filled the compartment. 'Bail out!!' He was no longer surrounded by the tension, fatigue, and fear of a bombing raid. He floated through those clouds, other parachutes around him, Messerschmitts swooping all around. The trees below were rushing towards him. He was surrounded by the unknown.

"Mr. Devlin... Mr. Devlin? Your guest has arrived."

The green he was seeing was no longer the pine trees rushing toward him from below as he neared impact with the earth looming beneath. Whoever said parachuting was like 'floating in air' had never landed wearing one. The rich verdant color was from the walls and carpet of the dining area. The wood was no longer tree limbs, but highly polished tables and chairs. The setting was the posh Green Room Restaurant of the Chicago Hyatt, just east of the Magnificent Mile as Michigan Avenue was known in downtown Chicago.

Joe Devlin stood up to greet his visitor. The hotel room and meals for his guest would go on his expense account, but he wouldn't be closing a business deal that day. He was going to close an empty place in what was the essence of the man once called Lieutenant Joe Devlin. So busy raising a family, building a business, and guiding his community he had never been aware that for twenty-five years someone was looking for him... and he was just one of fourteen hundred others like him.

He saw the tightly curled grey hair just visible above a large bouquet of flowers gracing a table by the entrance. Devlin smiled, how reminiscent it was of the last time he saw Princess Catherine. It was in the palace the day he nearly closed a deal for an entire country — when the Romanian King tried to surrender... to his prisoners. She poked her head around the plant and spotted Devlin, recognizing him as if it was yesterday.

"Joe!" She held out her hand in greeting. "You've filled out handsomely! That's a lovely gray suit."

"Princess Catherine, you're a sight for sore eyes!"

"Is that a good thing?" Catherine teased. "I haven't heard that saying yet."

"Yes, it certainly is good. I am so happy we could meet. I never knew you were in America. Please, sit down."

To others in the dining room who might have noticed the two, it would appear to be an elderly mother and her 'mature' son having a nice lunch... not a war hero and Romanian Princess. There was no gaudy jewelry, just

a tasteful lapel pin, leather wristwatch, and clip-on white plastic earrings. The dress was simple dark blue cotton with a pattern of white flowers.

Devlin was amazed that this woman who had once been so powerful and wealthy was living on only the fees donated to her as a speaker, residing in an attic apartment of a complex for the unfortunate elderly. He was excited to hear of Catherine's missions in the United States. On the spot he arranged for her to speak before his Chamber of Commerce and a municipal association. Devlin promised to look for more venues for her to speak. He was humbled that she would crisscross the continent for decades looking for the American servicemen who had bombed her country and then had fallen into its abyss as a prisoner.

"How was it you called me, Joe?" Catherine asked.

"I got a letter from my sister and a copy of an article in the **Pittsburg Post Gazette**. You were there looking for three of us who had enlisted from the Pittsburg area. I grew up there. My sister still lives there. She sent it to me with your contact information."

"A letter, a call, a visit. I've done this hundreds of times."

"How many of us have you found?"

"Nearly a thousand, Joe. I have already added your name to our association of POWs. How's your leg?"

"You remembered? Aches on occasion, but I play handball several times a week, and golf when I have to. It keeps my weight down. Oh, yeah, you noticed that didn't you. I have put on some weight since you last saw me. So I'm fine. And you?"

"Joe, I'm eighty-seven now. What can I say? My hearing is weak, my eyesight is poor, I have high blood pressure. I have the stiffness of old bones. And I can't turn away a homemade dessert. But I cannot complain. I still get around. Not every day, but I still travel over one hundred days a year. I have many 'boys' like you that I have not yet found so I'll keep searching. And my country is not yet free, though your President is on the right course. I like that man, the actor — Reagan. The 'Evil Empire' as he calls it is right on target! He will stand up to the bully — they will back down. You mark my words."

<div align="center">*******</div>

"My dear, I am very pigheaded. What I want, I get!"

The young reporter was furiously writing as Catherine spoke in rapid fire. There was a convention of the Association of Former Prisoners of War from Romania. Catherine, as always, was in attendance and sitting

in the lobby of the William Penn Inn greeting her 'boys' as they arrived at the hotel in a suburb near the Philadelphia Airport.

The reporter looked up from her writing for a moment as her interview subject had just bounced out of her chair and rushed over to an older gentleman wearing a green polo jersey under a white cardigan sweater buttoned up the front. What was left of his thinning hair was very white. His face was very tanned — obviously a man who enjoyed a life of leisure and retirement. The hotel clerk registered Lynn Belcher and his wife Paula. Catherine retrieved a packet with name badges and itinerary from a hospitality desk.

The couple left and Catherine returned to the young lady. "It's Cheryl, isn't it?" Receiving an acknowledging nod she continued. "So I told the Prison Commandant that I would be coming back the next week. Period!"

The reporter was writing a feature for the Sunday magazine on the roving Princess. Catherine bragged to the reporter that she had found in thirty years of searching over 1,000 of her 'boys' of the nearly 1,400 names she was able to gather from the Pentagon. Her conversation was animated and full of hand gestures and sound effects. Another veteran caught her by surprise and tapped her on the shoulder in the middle of her showing the reporter how her cousin the Romanian ace pilot pulled Col. Gunn out of the belly of a plane.

"Wayne Irvin! I'm an old woman! Don't startle me like that!" Then the smile spread and she stood to give a hug. "Where's your wife?"

"She's doing the paperwork at the front desk. I heard your voice and had to come over to say hello." the tall Carolinian said with a drawl and a big smile. Hey, do you know if a guy can get a good hot bowl of eyeball stew in this place?"

Everyone shared a good laugh at that old memory. Catherine poked the slightly protruding belly of Wayne and added, "Do I recall you were the overall eyeball stew champion?"

"Sure was," he responded with genuine pride, and added, "and pinochle too!"

"Excuse me, please, Cheryl" Catherine begged of the reporter, who was getting quite used to the interruptions. The reporter couldn't get annoyed at the woman — each 'boy' she saw was like greeting a son — home for the holidays.

Catherine quickly returned to the lounge chair and picked up where she had left. She was pounding her fist as she spoke of the Russian

occupation. She recalled their cruelty, and then laughed at the stupidity the Communists demonstrated. She held her nose to demonstrate how she ate her first Eskimo sandwich of lard on rye. The reporter grimaced.

"I became half and half."

The reporter looked at Catherine quizzically which was the desired effect the elfish looking spry old princess was after, and she laughed at the success of her ruse. "Yes, half of me escaped, and half stayed in Romania. I lost eighty-four pounds in total by the time I arrived in Paris. When I escaped I only brought ninety-five pounds with me — and little else! It gives me comfort though to think some of me is still in my homeland," she added with a twinkle. "But it looks like most of it has caught back up with me!" she regaled.

"What a gal she is!" It was Don Fus who along with his copilot of forty years past, Mike Hellyer, were standing nearby quietly listening to her story. They were an inseparable pair in the military and that bond stayed intact. Catherine immediately popped out of the chair to greet two more of her 'boys'. The conversation with the enthralled reporter continued. Catherine looked at the paintings hanging on the walls of the hotel. They followed the theme of the hotel's namesake, depicting William Penn and colonial times. "I was always so fascinated by your founding fathers and how your nation formed. So many brilliant — and brave — men in one place at one time. It was not an accident... it was divine providence. It was the destiny of America to create the documents and a government that embodies what all men want", she smiled at the young female reporter and patted her knee, "and women, Cheryl. Excuse me, I am old-fashioned. I still speak of all people in the masculine. No slight to feminists, please."

The reporter nodded in acceptance and looking over her notes and questions on a different pad asked. "Princess Catherine, you're... ninety-two?"

"Three," was the immediate correction.

"Ninety-three. Do you get to these gatherings often — at your age?"

The grand dame put a hand up immediately, halting the reporter in mid sentence. "I get to them *all*. I may be old, but I'm not infirm. I fly in planes now... mostly. I used to take buses and trains everywhere. I like being on the ground, seeing the faces of people as I drive by, enjoying the beauty of this wonderful country. But my old bones and posterior appreciate the softer, quicker ride of the jet. I have reduced my travel

now as well. I only go out six months of the year — not all twelve months. I did that for over twenty years.

"I did not come to America to make a home — to just stay in one place. I cannot take that message out to the people of America sitting in my rocking chair, can I? I came to America on a mission to find my 'boys' and to challenge its people to stand up and stay free! To stand up and carry the torch of liberty. Don't leave Lady Liberty alone in the harbor to greet those coming in — instead take her to foreign shores — free the captive nations. The Communists once claimed you were weak. As I see it now it is they who are struggling against the burden of those wanting to be free and it's you, America, who is keeping the pressure on them. They will collapse... just keep the pressure on them!"

Catherine rummaged into her purse and pulled out a battered, worn spiral note pad. She flipped to a familiar page, dog-eared for quick reference. "Here is my schedule for this year — so far. If I find another boy, I add another city!"

Catherine passed the pad as another of her 'boys' walked in, "Manson! Manson North... you silver haired old fox! You look great!"

The reporter took the pad and began writing notes from the itinerary as Catherine had penciled them in the pad: *Comfort, Texas; Jacksonville, Florida; Georgia - Atlanta; Kansas - Topeka; Wichita; Pennsylvania - Pittsburg; Missouri - St. Louis, Joplin; Jackson; Mississippi, Gulfport ; Louisville, Kentucky; Nashville, Tennessee; Springfield, Illinois...*

CHAPTER 39

On the Right Course

She always trusted her instincts and Catherine's admiration for the tough talking President Reagan grew. She did not know if he could really produce the amazing technological advancements that he so often bragged about in his 'Star Wars' program, but she knew the Russians believed him. Why else would they protest it so strongly? Catherine was also suspicious of the new Soviet leader Gorbachev. He was not like his predecessors Khruschev and Breshnev. They were classic bullies, megalomaniacs, dogmatic dictators. One knew exactly what their intentions were. This Gorbachev was different. He was educated and very intelligent. He was hailed as a reformer, but to Catherine it was all talk. The proof is in the pudding... an old but accurate saying. She still could not return to her homeland.

After living in America for thirty years, Catherine had witnessed an evolution in its society; the fabric of such is one that sometimes can best see from the perspective of a distance. She had seen more of the country than perhaps any of its Presidents, and without the screening and filters of politics, staff, secret service, and trapping of office, or the suffocation of the media. She could speak her mind, listen to others speak theirs; she traveled anonymously on public transportation; she stayed in the homes of private citizens or in cheap hotels; she made her own schedule. If anyone had the pulse of the country it was she, of all people, a refugee from Romania.

As a visitor and with her unique perspective Catherine had during her stay in America witnessed the county's leadership at the hands of seven Presidents. Eisenhower was the first and she watched under the great general's steady hand the post-war boom as the nation turned away from the war and was bent on prosperity. Returning from war its soldiers were

463

anxious to resume life in a society they fought to preserve and a new world order they helped create. She saw this most vividly in her own 'boys'.

Then there were the turbulent times of the Kennedy and Johnson years. It was a time when internal issues of race and conflict in Vietnam absorbed all of the energy and resources of the nation. During that period Russia's control over its satellite countries — Eastern Europe and her beloved Romania — was solidified and the dark red cloak of communism covered over the neglected captive countries. The new Soviet Union was at the apex of its power and cast a yearning eye on every corner of the earth. World domination and the spread of the ideology of communism was the focus. The populace within their empire could only be focused on survival — physically and culturally.

Nixon and Ford were able to take a new look at the world order. The strength of Russia and its Soviet Union was growing, spawning further adventurism and instability throughout the world. Détente, appeasement, peaceful co-existence were disconcerting words to Catherine's way of thinking. It seemed to only be an excuse to delay the inevitable. The Watergate fiasco only deepened the country's lack of interest in the affairs of the world. There did not seem to be in America a resolve to do the right thing, it was more like a time to hide and lick wounds. A post-Vietnam hangover abroad and a desegregation whiplash within its borders crippled any attempt to push back the probes of the Soviet Union. America showed only a reticence to act, a hesitant effort to fend off the Communists. Catherine feared, as one with her age and experience might, that America was creeping into an isolationism not unlike what followed WWI, something that led to the rise of Hitler and a depression. Despots always were ready to fill the vacuum left by weakened democracies.

Carter was the ultimate expression of a man, a President, who was well meaning, but perhaps too naive to lead a nation amidst crisis. He appeared weak, and Catherine never felt the shining beacon of freedom burn so low, just a flicker. She feared freedom's light around the world was being extinguished. She sensed as she traveled from town to city, and mountain to seashore, that the greatest nation on earth was hanging on by a thread, the last thread in the fabric of its proud history. The quilt of America was becoming a patchwork of everyone for themselves and it was not sewn together in a unified way. People didn't wave at the Greyhound bus as they once did. President Carter did find the right word for it. 'A malaise', he called it as he sat by a fire wearing a sweater and told Americans to turn down their thermostats, rather than scold them

and challenge them to fix their energy problems. This was once a country of fixers, proud and independent, not one resigned to turning down its thermostat.

The last was President Reagan who seemed to Catherine so much like the heroes he once portrayed in his movies. Yet by her reading of the man's actions he was the real thing. He stood tall and proud and Americans responded to him. He was called the 'Great Communicator' and his people listened to him. Catherine spent so much time talking with the American people: clergy and parishioners; company president and taxi driver; war heroes and college war protesters; train porters and hotel clerks. They didn't all agree with the man and his policies, but they felt better, they felt more strongly about their country — and its place in the world. There was confidence and a renewed sense of America and its ideal that spread across not just the country. Catherine felt the downtrodden of the world who were always seeking hope had found their warrior. As Reagan himself said, 'Washington was once again the shining beacon on the hill for the world to look to' and Catherine agreed with the assessment. Perhaps, she hoped, his light would shine on the captive countries and her Romania.

There had been meetings — summits with Gorbachev. Catherine was still unsure how to feel about that man with the funny mark on his bald forehead. She agreed that talking, especially leaders, face to face were far superior to not talking. It was certainly superior to just saber rattling, for the rattles often became thrusts. An American and Soviet summit could be a step in the right direction. Catherine also felt that the willingness of the Russians to talk seemed to indicate there was perhaps a chink in the armor, a need to retreat from former positions.

Always well read, Catherine had become accustomed to also watching the evening TV news to keep her up-to-date on events all over the world. It was a luxury she had learned to enjoy when she started living at the Armour Home and had a regular schedule. She worried that the discussions on TV were too brief, and if there was manipulation by the media. She would remember how she had used newspapers to get her way back in Romania, but fearfully to how the Russians had used all of the media for propaganda and subtle brainwashing. Catherine of course used the media herself in America so many times her personal charm induced a reporter to write a story to her find her 'boys'. Catherine read several magazines every week. **Readers Digest** was still her favorite, but **Time Magazine** was her favorite source for more in-depth news. Several

of her 'boys' sent her the Sunday editions of their papers. The **Austin Statesman**, **New York Times**, **Chicago Tribune**, **LA Times**; and of course the **Kansas City Star** gave her a cross-section of opinions and points of view across the country.

The recent summit in Iceland was described by almost all sources as a disaster, yet in Catherine's opinion it was a great success. She understood that no breakthroughs on issues had occurred. What she did notice was the expressions on the two leaders' faces as they walked out of their final meeting. President Reagan was downright mad. His body language and expression, spoke to her more than his words which were curt, even as they were diplomatic. Gorbachev looked shaken, perhaps fearful, at least unsure. He spoke boldly, while his eyes darted about nervously. He looked as if he wanted to be somewhere else, perhaps under a rock. Catherine was a big fan of this forthright President of the United States. Yes, he was on the right course.

<p style="text-align:center">*******</p>

It was a blustery snow blown day as Catherine sat in her attic apartment, her retreat, her royal suite as she thought of it for it was truly a blessing for her. She could hardly imagine at her age negotiating the blizzard in a bus stop or being stranded at an airport. She was so grateful to be able to stay in one place and schedule her travels for times when the weather was more cooperative and conducive to her old bones.

Often Catherine used such times at the Armour Home for reminiscing to herself and to reflect. She found a folder she had placed a keepsake box of hope. In it was a speech by a former President. Though the words were spoken twenty years earlier, the words of President Kennedy were firmly etched in Catherine's memory. She remembered one of the most definitive moments of the free world, a young President standing up to the Soviet Union for the first time since the end of WWII. She remembered watching the handsome young President boldly pronounce, "Ich bin ein Berliner!"

As she retrieved the folder Catherine remembered the moment. On June 26, 1963, the young and charismatic President arrived in Berlin, a divided city in a divided country, in a divided continent. This unique place was the most dramatic demonstration of the divergence and world view of the two super-powers, the US and Soviet Union. Catherine did not like to listen to this President's press conferences or interviews thinking his halting speaking style and Boston accent hard for her to follow. His

speeches, however, were marvelous. Her hope then was he would be able to say something in Berlin that might give hope to her countrymen. He did not disappoint.

She reread her copy of the speech. She had kept it these many years and pulled it out of the storage box to read from time to time to renew her own fervor and buoy her own wishes of freedom for her Romania. It had given her hope over and over again. She had prayed often that it had given hope to her countrymen as well and that they remembered it. She knew they would not have the luxury of a copy of the speech as she had and she prayed that some still remembered his words. She took time to read it again.

There are many people in the world who don't understand what is the great issue between the Free World and the Communist World. Let them come to Berlin. There are some who say that communism is the wave of the future. Let them come to Berlin. And there are some who say in Europe and elsewhere, we can work with Communists. Let them come to Berlin. And there are few who say that it is true that communism is an evil system, but it permits economic progress. Let them come to Berlin.

Freedom has many difficulties, and democracy is not perfect, but we have never had to put up a wall to keep our people in or to prevent them from leaving us. What is true of this city is true of Germany real, lasting peace in Europe can never be assured as long as one German out of four is denied the elementary right of free men, and that is to make a free choice. You live in a defended island of freedom, but your life is part of the main, lift your eyes beyond the dangers of today, to the hopes of tomorrow, beyond the freedom merely of this city of Berlin, or your country of Germany, to the advance of freedom everywhere, beyond the wall to the day of peace with justice, beyond yourselves and ourselves to all mankind.

Freedom is indivisible, and when one man is enslaved, all are not free. When all are free, then we can look forward to that day when this city will be joined as one and this country and this great continent of Europe in a peaceful and hopeful globe. When that day finally comes, as it will, the people of West Berlin can take sober satisfaction in the fact that they were in the front lines for almost two decades.

All free men, wherever they may live, are citizens of Berlin, and therefore, as a free man, I take pride in the words. "Ich bin ein Berliner!"

Looking back at the few phrases she had highlighted twenty four years earlier when she first read the speech, Catherine mouthed the words silently a second time...

"The elementary right of free man and that is to make a free choice..."

"Freedom is indivisible, and when one man is enslaved, all are not free..."

"When that day finally comes, as it will..."

It will... Yes, his words were of hope, and she still had hope. Thinking back on those times she remembered feeling it was too bad Kennedy was slain... for when he died, so did some of that hope.

Then there arrived a generation later a new persona of hope, not a political being, not a man of ambition, but a man of God, Pope John Paul II. He was so different than the other Popes she had known; he was such a man of the masses. He had come from Poland, and so his homeland too was under the yoke of Godless Communism and he did not make a secret of his disdain for a system that espoused such a doctrine. He had already made a triumphant return to his homeland and embarrassingly debunked the Communist party with huge papal masses attended by hundreds of thousands and listened by most of the nation. As Catherine had been declaring for decades across America, a government may be Godless, but the populace certainly held close to its bosom the creed of beliefs.

Within the same box as Catherine put away the Kennedy speech she pulled a tattered copy of **Time Magazine** that covered the Pope's visit to the United States. He had stood in Battery Park on Manhattan Island with The Statue of Liberty as his backdrop, and it was not by coincidence. There he delivered words of hope for those captive nations.

```
...On this spot I wish to pay homage
to this noble trait of America and
its people. Its desire to be free,
its determination to preserve free-
dom, its willingness to share this
freedom, to remain a moving force,
for your nation, for all nations in
this world today...
```

<div align="center">*******</div>

It was a new day, June 12th, 1987 twenty-five years later. Berlin was still divided and walled. Eastern Europe was still captive and suffering under the communist regime. Despite the cruel reality of the world, Catherine waited with optimism for the day Europe might be reunited and her Romania freed. She was patient though she knew her own time was becoming limited... she was ninety-four. Still there was a chance for a diplomatic breakthrough. In her long life she had learned there was hope, always hope.

A reflective Catherine looked about her wonderful suite at the Armour Home of which she was always so grateful to have. So many memories hung from the walls, or were stuffed in boxes filled with letters from her boys, along with thirty odd years of new friendships. So much had been accomplished, but so much was yet to do. At ninety-four, Catherine did not have the stamina she once possessed at... eighty-seven... she chuckled to herself at the absurdity of the thought. She still walked the three flights of stairs to the dining room for each meal. She could go on for a bit longer. Just hurry it up a bit, Mr. Reagan, she to herself.

Adjusting the television she listened to anchor Peter Jennings of **ABC News** update the events of President Reagan's tour of Europe marking the anniversary of the Marshall Plan, the great plan of which her Romania missed out. There was much media buzz about the President and what he might say or do. He seemed to almost take some pleasure at surprising his closest aides at big events. The camera's view switched from Jennings to the podium, though Jennings was still speaking. As Reagan was introduced, Jennings wrapped up his commentary in hushed voice, noting that Reagan wrote most of his major speeches. The anchor concluded by adding the President's staff was uncomfortable since they had not seen the final draft of this speech, and this was a delicate time of negotiation with the Soviets.

Reagan began:

We come to Berlin, we American presidents, because it's our duty to speak in this place of freedom. I must confess, we're drawn here by other things as well: by the feeling of history..., by the beauty..., most of all, by your courage and determination... I come here today because wherever I go, whatever I do, Ich hab noch einen koffer in Berlin. I still have a suitcase in Berlin (the crowd cheers).

Our gathering today is being broadcast in Europe and North America. I understand that it's heard as well in the East (Reagan looks in that direction to more cheers). To those listening in Eastern Europe, a special word: Although I cannot be with you, I address my remarks to you just as surely as to those standing here before me. For I join you, as I join your fellow countrymen in the west, in this firm, this unalterable belief: Es gibt nur ein Berlin. There is only one Berlin (an enthusiastic crowd roars).

Listening to every word as if she huddled with those in the captive nations next to a radio hidden and turned low so eavesdropping ears would not hear to what they were tuned. She knew those in all Eastern Europe understood his meaning. She knew Reagan used Berlin as a metaphor for all the communist nations. He was speaking to a worldwide audience his reach far beyond the throng before him. As she watched and listened to the speech she leaned forward and edged closer to the TV concentrating on every word as did so many in those countries behind the Iron Curtain.

Behind me stands a wall that encircles the free sectors of this city, part of a vast system of barriers that divide the entire country of Europe... a gash of barbed wire, concrete, dog runs and guard towers... to impose upon men and women the will of a totalitarian state... yet it is here in Berlin where the wall emerges so clearly... this brutal division of a country upon the mind of the world. Standing before the Brandenburg Gate... every man is a German, separated from his fellow man. Every man is a Berliner forced to look upon a scar...

Today I say: As long as this gate is closed, as long as this scar of a wall is permitted to stand, it is not the German question alone that remains open... the question of freedom for all mankind. Yet

I don't come here to lament. For I find in Berlin a message of hope, even in the shadow of this wall, a message of triumph...

This is the Fortieth Anniversary of The Marshall Plan... The Marshall Plan is helping to strengthen the free world. A strong, free world in the West, that dream became real... leaders understood the practical importance of liberty — that just as the truth can flourish only when the journalist is given the freedom of speech, so prosperity can come about only when the farmer and businessman enjoy economic freedom... From devastation, from utter ruin, you Berliners have, in freedom, rebuilt a city that once again ranks as one of the greatest on earth. The Soviets may have had other plans. But my friends, there were a few things the Soviets didn't count on — Berliner heart, Berliner humor, yes, and a Berliner Schnauze (Reagan's frenzied German onlookers laugh, applaud, and hoot their response!).

Clasping her hands in a praying fashion in front of her Catherine's thoughts were of her countrymen as she whispered — "My Romanians... have heart, have humor, have hope."

In the 1950's Krushchev predicted: "We will bury you." But in the West today, we see a free world that has achieved a level of prosperity and well being unprecedented in all human history. In the Communist world, we see failure, technological backwardness, declining standards of health; even want of the most basic kind — too little food. Even today the Soviet Union still cannot feed itself. After these four decades, then, there stands before the entire world one great and inescapable conclusion: Freedom leads to prosperity. Freedom replaces the ancient hatreds among the nations with comity and peace. Freedom is the victor.

"Stand up to those Russians!" Catherine thought as she rocked in her chair in excitement and pounded fist into palm. She harbored a long held resentment she would not forget. Lost in the moment she extolled the man speaking to her through the television "Give it to 'em, President Reagan!"

We believe that freedom and security go together, that the advance of human liberty can only strengthen the cause of world

peace. There is one sign that Soviets can make that would be unmistakable, that would advance dramatically the cause of freedom and peace...

General Secretary Gorbachev, if you seek peace, if you seek prosperity for the Soviet Union and Eastern Europe, if you seek liberalization: Come here to this Gate! Mr. Gorbachev, open this Gate. Mr. Gorbachev, **tear down this wall**! (At first the reaction was slow as the throngs absorbed the audacious words just uttered, then the ground swelled with enthusiastic approval. Reagan looked defiant as he continued.)

I noticed words crudely spray painted upon this wall... "This wall will fall. Beliefs become reality."

Yes, across Europe, this wall will fall, for it cannot withstand faith, it cannot withstand truth. The wall cannot withstand Freedom.

As the speech continued Catherine had stood from her chair and was pacing the floor in front of the television. She clapped joyously along with the Berliners. "America *is* going deliver on our prayers," Catherine thought. No man gave hope like this man.

When Reagan finished, Catherine raised her clenched hands to her mouth and blew a kiss to the televised President. As Reagan stepped back and received his accolades from the assembled Germans in Berlin she raised her opened palms and looked overhead and sang out to nobody, to everybody, "Mr. Gorbachev, *Tear-Down-This-Wall!*"

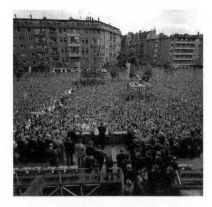

President John F. Kennedy viewing the Berlin
Wall separating East and West Berlin

President John F. Kennedy speaking before the en-
thusiastic throngs at the Brandenburg Gate telling
the German people "Ich bien ein Berliner"

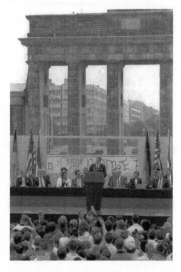

President Ronald Reagan with Chancellor Kohl viewing the
Berlin Wall with barbed wire and guard towers

President Ronald Reagan in his speech be-
fore the Brandenburg Gate where he uttered
the challenge "Mr. Gorbachov, tear down
this wall"

My 'Boy' – Adieu

August 29, 1987. Dayton, Ohio

The hours had quickly been filled with nearly a hundred years of tragedy and triumph, of the best and worst of humanity, of hoping and yearning for something better for others. The clock on the wall of the suite showed the approaching noon hour. My right hand ached from the copious notes I was furiously jotting down on my pad. Princess Catherine, I knew had to leave for afternoon commitments. She'd more 'boys' to see, and then the drive to her next destination on the Kentucky side of Cincinnati and her old friends the Kees family. Later in the week, she would travel to Cleveland where there was a new Romanian museum, and she was donating many of her letters and mementos from her years in the States. Catherine it seemed was putting her affairs in order.

I too needed to head out, back north to Illinois. My weekend sojourn was also at an end, but I sensed for me there would be another new journey yet to be taken... one that would involve in some way this Princess. Joe Devlin was certainly right when he first told me about this woman, how she wheedled her way into your heart and soul.

"It's been just two months since President Reagan gave the speech in Germany," I noted. "Challenging the Soviet Union to 'tear down that wall'... Some of his critics feel he may harm our relations with the Soviets with such inflammatory talk."

I got that stare from Catherine... was I looking for trouble or just asking a very naive question? Hadn't I been listening to her? Catherine straightened in her chair and out came that finger pointing at my nose. "I know what you think... you think like me. He was telling the truth, President Reagan. Sometimes the truth hurts, but it needed to be said...so there are no mis-

understandings. I think Mr. Gorbachev understands President Reagan very clearly."

"So Princess Catherine, how many of your 'boys' have you been able to visit with now?" I asked. "What do you still have left to do?"

Princess Catherine did look exhausted as she settled back into the chair, but she smiled sweetly as she paused and reflected. "I feel that I have seen all my 'boys', my dear. All that were alive and able to be seen," was her poignant answer.

She looked out of the window to the blue sky and nothingness beyond the Dayton, Ohio, hotel room. She saw it filled with roaring B-24's, the acrid splash of Ack Ack smoke, and swaying floating white puffs of parachutes — where I saw only birds flying, blue sky and scattered clouds.

"And so, you see, young man, I have been here now nearly thirty-two years." Princess Catherine turned away from the window and looked back at me. "That's nearly as many years as you've been on this earth — a full third of my life. As you could see yesterday — I'm still at the top of many dance cards! The belle of the ball!" she added laughing. There was a sly little smile forming on her wrinkled face. Her lips parted on the right side of her mouth enough to show the worn and yellowed teeth of an old woman.

"I know your Moose Clubs... and Elks, Lions, Kiwanis, and Rotaries. I know your VFWs, Legion Halls, the Auxiliaries. I've visited your schools, churches, community halls, and capital domes. I have been to every state in this great country, witnessed your nation's blessings and appreciate most of all your freedom."

I could see the fire still glowing brightly under the faded eyes, could still hear the conviction of her heart roll out within a voice so old, yet forever strong.

Catherine twirled a ring on her finger with her thumb. "I was once very wealthy, perhaps the richest woman in my country, perhaps even beyond! I owned ships, oil wells, great jewels and thousands of acres of the most productive land in Romania. That is all gone." She looked back up at me to make a point. "Though not forgotten.

"Yet, today I still am one of the richest humans on this earth. For I have my missions, I have the company of friends, the comfort and security of America's freedom. As I look into your eyes — and the eyes of others — I sense I have the esteem or at least the veneration and acknowledgment which tells me in all these many years, I have made an impact, stirred a thought or two. And that's important for an old lady.

"But what I appreciate most in my life is the knowledge of the sacrifice

and the price that so many in this world have paid for freedom. Your question... What do I still have left to do? I want to see this freedom come to my country... and for all people. You understand?"

She raised that crooked index finger and waved it at me again for emphasis, "I still want to return home... to Romania. If that is a dream unfulfilled... I still have my 'boys'! I may or may not find any more... I will always look for those I have not found. But I have had the luxury, the benefit, the extreme pleasure of a fifty-year love affair with 1400 of America's bravest men in uniform. Who could ask for more?"

The princess could not resist enjoying her own humor with another skewed smile and a wink at me. I think, too, the little tear rolling down her left cheek was not just from tired old eyes.

Princess Catherine rose slowly but steadily from her sofa and extended her right hand to me. I knew it was time to go. As I watched her stooped frame and arthritic movements I was struck by the thought of such frailty of the body yet invincibility of the human spirit.

She eyed me one more time, looking for a place deep within. "To be a success in this world you must love something more than yourself. So, as surely as I breathe, I am rich in so many ways. Now I hope you too can understand why... and how truly... I am in love with freedom."

With her firm grasp of my hand, she shook and swept her free left arm towards the door. "My 'boy', adieu." Then with a soft smile she added, "May there be a road.

"I must rest now... for I have not completed my journey... just yet."

<div align="center">

The End

</div>

Had I just undergone a life-altering experience? At the time I was sure of that much, but I was certainly overwhelmed by the life of the person I had just met. I initially met Princess Catherine at the urging of one of her 'boys', Joe Devlin. He said if I wanted to meet a *real* hero of the war it must be the Princess. He certainly opened a fascinating door for me, and I hope for the readers of this work. I was inescapably drawn into the fascinating spell of this fiery 'little old lady', as she often referred to herself, and to her quest. I was quickly captured by her magical charisma, her directness, the roughness of her edges, and strength of her convictions and character.

I stayed in touch with Princess Catherine over the few years she had remaining. She still had work to do and it seems, as her life quickly waned and slowed, events in the world swirled faster and faster. I could imagine her standing in front of her TV, her fist shaking the air as she repeated President Reagan's famous call to *"Tear down this wall"*, then I watched in near disbelief myself as it really at last fell under the sledge hammer blows of civilians, not armies.

She must have glowed inside as the news of the crumbling of the USSR and communist Eastern Europe was broadcast throughout the world. Her cherished homeland of Romania had been especially subject to a cruel dictatorship. The collapse there was completed by the overthrow and killing of the despised Nicolae Ceausescu. She finally knew her country was at long last free. She could go home at long last.

In 1990, Richard Britt made what he called a sentimental trip back to Romania to visit the site of his crash and the POW camps. While there he found that Catherine's orphanage still survived after forty-six years of communist rule and neglect. It was still in operation with seven hundred and eighty babies; however, it was in appalling condition and down 3,000 children from its peak under Catherine's stewardship.

My 'Princess' suffered from several T.I.A. events — slight strokes, and was failing rapidly at the age of 98. She was nearly blind, and her hearing was almost gone. Catherine inquired through her daughter Tanda

who still lived in France, if Romania would allow her to return. When the affirmative answer was received, she quietly announced that she had to make 'one more trip'. Princess Catherine Caradja announced she would be returning home. Her 'boys' greeted the news with mixed feelings, concerned both about her ability to make the trip and perhaps, selfishly, not wishing to lose her.

When asked why she wanted to return, Catherine was as expected simple and direct, "Because I am a Romanian."

She also thought of her family, "I want to go see the place my children are buried. I want to go to their graves."

One of her 'boys' recalled Catherine telling him, "My dear, when these old bones are finished, I hope they are buried in Romania to fertilize those beautiful plains."

Yet she was conflicted. "My 'boys' are here in America... but I need to go. I have a duty. It is my country. I am torn in two." She even wondered if the new government would allow her to... make speeches on democracy when she returned.

Nonetheless she had made up her mind and that was it, so the 'boys' raised money to pay for her flight on board the supersonic jet, the Concorde. They held a going-away party for her in San Antonio, Texas on May 18, 1991. At that event Catherine gave the clarion call once again. It was a familiar refrain, one she used at every reunion with her 'boys'. It was not a militant call to arms, rather a plea for peace by a woman who had seen so much death and destruction from wars and their aftermath. Her admonition was of freedom's preciousness and fragility. Her challenge the same... if you have freedom you must be prepared to sacrifice to protect and preserve it. Finally, it is a responsibility to seek and secure freedom for those who do not have it. In part this was her final address to her 'boys'.

Dear Ex-POWs and friends:
I came to America thirty five years ago to speak to you of the worth of freedom and to find the 'boys' who fell in Romania in WWII. I did not run away, but came to alert you to the dangers of losing your freedom in this great land...
The world is not safe yet...
I have loved every minute of my stay here, taking in all the fifty states and enjoying your great hospitality. With your help I have found nearly all

the 'boys'. It hurts to know I will not return, but age has finally caught up with me.

My message now is "Keep your Hopes High, but keep your powder dry!"

I Love you ALL. And perhaps you can visit me back there. May the Lord keep you in His kind care.

Good-bye and Godspeed!

Then just two weeks after the farewell party and days prior to her departure Catherine was again struck with another more severe TIA episode and her doctor declared she was too ill to travel. The trip was canceled and the money raised by her 'boys' for the trip was diverted to pay for her medical expenses. Catherine was placed in a nursing home where she seemed comfortable but very confused and disoriented.

It seemed her long held dream of returning to her homeland, her beloved Romania would not be fulfilled. Still, can one ever really count Catherine out? Showing the will power and determination that she demonstrated her entire life, she made what her doctors described as a 'miraculous recovery'. By the middle of June she stood within the San Antonio Airport with all of her belongings and memories packed tightly into three suitcases.

She returned to her homeland and was greeted with open arms by the new government and by her people. She was granted 20 acres of land and a small pension. Her once mighty family had owned a thousand times that much at one time, yet Catherine was equally proud to once again be able to lay claim to just a small piece of beautiful black earth in the place called Romania. She was treated by the populace as a celebrity and yes... as royalty... she was a princess in her own country again. Catherine was up to the task and even made several appearances and conducted several interviews. And, yes, she *was* able to make speeches about freedom and democracy in her cherished country, both she and Romania free at last.

Fittingly Catherine was granted permission to live in a small apartment previously used by caretakers at the orphanage bearing her name, founded by her mother, and built by herself to world prominence. The institution too had weathered a frightening period. She had returned to the cradle of **St. Catherine's Crib.**

The son of her former driver offered to look after her needs. There were nurses and doctors still working at the facility from the time

479

Catherine was in charge of the facility. They saw to her medical care with the kindness and attention due a dear mother. The following year, just after her 100th birthday, Catherine passed quietly in her sleep. She was buried in the family church in the crypt next to her mother and beloved Grandpapa and Granny, her journey finally complete.

I felt honored yet unworthy when Princess Catherine addressed me as her 'dear boy'. I felt I had become a part of a very limited and unique fraternity. Perhaps she with her great intuition knew something then that I did not, and I hope I have measured up. I certainly could not stand up to the heroics of those brave men in service to their country to whom she had been an angel. Still she had a wonderful intuition. I am certain it was *she* who was the little bird on my shoulder whispering to me to work, work, and work some more on this project as I so yearned to do all those years. I am sure now as I complete the work... she was right yet again. Her love of *FREEDOM* was, and... I know... still is contagious. As she said, with it one has *HOPE*. With *HOPE* one can and will continue the struggle for *FREEDOM*. In this world there are so many that still need hope and freedom and perhaps some may draw that encouragement, a glimmer of hope, and a measure of inspiration from Catherine Cantacuzene Caradja so necessary to continue their fight.

It is my wish this work will continue as a legacy to an amazing individual, my 'Princess', and make me worthy of the special moniker given to me by Catherine in her final letter making me one of special people, her 'dear boy'.

And to you, I say, "May there be a road."

Steven E. Aavang

Author's final communication from Princess Catherine before she returned to Romania. Note salutation in which the author is referred to as one of her "boys"

Last letter from Princess Catherine to Author

Oceanside, Cal.
Jan, 6th

Dear boy,

My mail so forwarded so I got your letter here. Am with my sister in law. Widow of my step brother, also an escapee! It may be my last trip, as I tire more & more easily. I go back to Dick Britt then home to K City end of the month. He has published a book The Princess and the POWs. You can get it. Mine is written, but I must try to correct it. If I get it published, I will send you one for sure!
 Tell them All the Best.
 Yours most sincerely,

 Princess Caradja

Typed copy of same letter for legibility purposes

St. Catherine's Crib administrative building; small office converted to apartment for Princess Catherine's return in 1992 after the collapse of the Communist Regime

The Kretelusco Church in Bucharest, Romania; the final resting place for Prince George, Princess Caterina, Princess Irene, and Princess Catherine. Her journey finally completed in 1993

YOU CAN PLANT A
THOUSAND FORESTS
WITH A SINGLE ACORN

Ralph Waldo Emerson

DO NOT GO WHERE THE
PATH MAY LEAD, GO INSTEAD
WHERE THERE IS NO PATH
AND LEAVE A TRAIL

Ralph Waldo Emerson

PROTEA PRESS

PUBLISHERS

BOX 254 STELLENBOSCH
7600 SOUTH AFRICA
PHONE (02231) 3182, 2645
TEL. ADD.: "PROTESS"

15. 4. 78

To:

Mr. Robert L. Iacopi

With compliments from

David F. van der Spuy

Reference:
Una van der Spuy's letter of
15th April 1978

DIRECTOR D. F. VAN DER SPUY

GARDENING
WITH
GROUND COVERS

UNA VAN DER SPUY

GARDENING

WITH

GROUND COVERS

GROUND COVERS OF THE WORLD
FOR GARDENS
IN THE SOUTHERN HEMISPHERE
AND OTHER TEMPERATE REGIONS

PROTEA PRESS . STELLENBOSCH . 1975

This Hypericum of prostrate growth makes a
delightful show in summer. (*H. reptans*)

Other books by the same author:
Gardening in Southern Africa
Ornamental Shrubs and Trees
Garden Planning & Construction
Wild Flowers of South Africa for the Garden
South African Shrubs and Trees for the Garden
Gardening with Shrubs.

PROTEA PRESS
Box 127
Stellenbosch
South Africa

ISBN O 909065 01 2.

Set in 11 on 12 pt Baskerville
Lithographic reproduction by Hirt & Carter (Pty) Ltd,
Cape Town
Designed and printed by Creda Press, Cape Town
Binding by Edward D. Seabrook (Pty) Ltd, Cape Town

Contents

I

Part I
Introduction

Ornament the water garden with different ground covers —
to bring colour from season to season.

Introduction

An alternative title to this book could be *Labour-saving plants and where to grow them*, for I believe very firmly that in this day and age we all have to think carefully about reducing the amount of labour required in the garden.

A garden is for pleasure. It should present a pretty picture when one looks out from the house and it should create a pleasing frame to the house. It should provide space for the occupants to relax and be at one with nature, and, it should be all this without involving the owners in difficulties with regard to maintenance.

We all probably suffer from a lack of time. We haven't the time to deal with annuals and perennials which need particular care, such as daily watering during hot dry weather, staking, constant cultivation to keep down weeds, and replacing, when their period of bloom is over. We cannot get labour to help or we can no longer afford it. So, if the garden is to be a pleasure it should not drain our pockets nor restrict the time we would like to spend on other forms of relaxation.

This book is for those who wish to have pleasant home surroundings with a minimum of effort, and it should be of particular value to the owners of small plots who have no space for a wide range of shrubs. We all want interest and colour in the garden during different seasons of the year, and this can be achieved by planting ground covers. The book is for all age groups – for the young and not-so-young, who are creating new gardens or remodelling existing ones, but who have other recreations; and it is for the older generation who may be finding that the growing of annuals is becoming too back-breaking a task for them.

Economy in the garden is something that concerns most of us. For the last decade we have been facing steeply escalating costs of all commodities, and the biggest increase has been in the cost of labour. Wages, having more than doubled, those of us with large established gardens may have to remodel them in such a way that we can manage with half the man-hours required hitherto, for the expense of maintenance has become a very real problem, and its solution a matter of urgent necessity.

The pages which follow are intended to help the owner of the small plot to maintain the garden without the help of outside labour and with a minimum amount of his own time, and to indicate to owners of large gardens how to plant in order to reduce the wage bill.

The book is based on the outcome of thirty years in close touch with the soil and in creating and changing, when necessary, our own two-hectare garden to reduce the labour required to keep it trim. We have enough free time to enjoy it in a relaxed way and it delights our visitors, who are astonished that it can be maintained with the little help we have.

One point on which I may be taken to task by some gardeners and nurserymen is the fact that some of the ground covers mentioned in this book are not at present obtainable in the country. The reason why ground covers do not feature in a

8

number of nursery catalogues is because for a long time the public has shown little interest in them. Recently, however, gardeners have begun to think in terms of growing them to reduce labour, and, once the demand is established our nurserymen will be quick to start propagating a wide range of these plants.

The planting of ground covers can solve many problems and enhance the beauty of the home surroundings whilst at the same time reducing maintenance. It is not suggested that ground covers should take the place of lawns. In private gardens and public parks no other ground cover is as pleasing, as restful, as practical and as decorative as a well-kept lawn, and the home lawn of ordinary proportions requires little effort to keep it in good order.

There are, however, areas where it is impractical to grow a lawn – e.g. on a steep bank where it is difficult to operate a lawn mower. Such a bank could, it is true, be turned into a rock garden, but beautiful rock gardens are not easy to make and they are difficult to maintain. Ground cover plants are the answer to the problem of covering steep banks – whether they be in the small town garden, in a large garden or park, or along main roads and railway embankments.

The value of ground covers. The attributes of ground covers may be briefly summarised as follows:—

1. They are effective for covering the bare soil between newly planted shrubs, roses and trees.
2. They act as a living mulch, keep the soil cool and damp, and thereby promote the growth of the plants in their vicinity, and reduce the amount of watering necessary.
3. They are a great help in preventing erosion, whether it be caused by water or wind, and are therefore the best plants to grow on a slope.
4. The shade-loving ones are invaluable for ornamenting the ground under trees where grass does not grow well.
5. Once established they help to suppress the growth of weeds.
6. They require little maintenance and, if started off in good soil, most of them demand a minimum of care, beyond occasional trimming, and watering when necessary.
7. They introduce variety which is needed in gardening as much as it is in architecture. They form a contrast to a lawn in form and in height, in foliage texture and in colour.

What is a ground cover? The plants described in the pages which follow vary in many ways, but most of them have one thing in common – they tend to grow horizontally rather than vertically. Some of them hug the ground and form a dense carpet; others grow in clumps or tufts; some send out trailing stems and some are bushy in habit of growth. All of them will spread to cover the bare ground, and most of them are evergreen.

A prerequisite of a good ground cover is a profusion of leaves of good quality. Flowers appear on most plants for such a short time that they are of secondary importance.

Amongst the plants included are a few which are deciduous and a few which die down and show no top-growth for part of the year. If these are interplanted with trailing ground covers, the absence of their top-growth will pass unnoticed for the short period when they are dormant.

Because of their different habits of growth ground covers are propagated in different ways. A few will grow readily from seed, but most of them are grown from root sections, layers or cuttings. Many of the trailing types send down roots as they spread across the ground and these can easily be multiplied by cutting off a piece of the stem with the roots attached. Those of bushy habit are generally propagated from cuttings. Evergreen plants with soft growth can be increased by cuttings made in spring or early summer, whilst those which are deciduous are best propagated from cuttings of mature or hard wood made in late summer or early autumn. When plants of tufty growth become too crowded lift the clump and cut down through the foliage and roots with a sharp spade or a knife and replant sections, discarding those which would overcrowd the bed.

Ground covers are perennials, planted to keep the garden attractive without involving the trouble of replanting from season to season and year to year. No annuals should therefore have been included in this book, but three have been described for specific reasons. They are easy to grow; they have incomparably beautiful flowers, and they carpet the ground more quickly than the permanent ground covers. They are, therefore, of great value for seasonal effect in the new garden. Two annuals of great merit for short-time effect are the Bokbay vygie, also known as iceplant or Livingstone daisy, which is dazzling in late winter and early spring; and portulaca which produces its profusion of little rose-like

Drosanthemum speciosum produces a gay display in spring. The leaves are verdant throughout the year.

A group of different ground covers will beautify the entrance to the garden.

Plant ground covers to
enhance the garden.
They take up little
space and are easy to
maintain.

Gazanias with silver
leaves make a delightful
edging to a bed of
brightly coloured
flowers.

Ground covers with a
restricted root-growth
are best ones to plant
in a rock garden.

flowers in summer. Grow them to cover the ground whilst the permanent ground covers are settling down.

How to choose ground covers: When selecting plants for ground cover it is essential to take into account the climate, soil and aspect, because ground covers, like all plants, will not grow well if subjected to uncongenial conditions. The shade-lovers will look miserable in bright sunlight whilst those which need sunshine will perform poorly in the shade, and those which like acid soil will not grow in gardens where the soil is alkaline.

Consider also the habit of growth of the plant in relation to the size of the plot. The ground covers chosen should be in proportion to the size of the garden. Rampant plants such as Algerian ivy and carpobrotus, both of which have large leaves, are excellent for covering large banks in a country garden, or for planting along the roadside or in a large park, but they are totally unsuited to the small town garden. Plants with small leaves and those which do not spread very rapidly are the right ones for small gardens.

Before acquiring any ground covers plan just where they are to grow and envisage the picture they will eventually create. It is far more important to decide what type of plant should occupy a given position than to procure plants and then go round the garden looking for somewhere to plant them. This latter method will result in an unsatisfying and spotty effect, whereas proper planning before planting is likely to produce an harmonious and aesthetic picture.

All gardeners want to cover the bare ground as quickly as possible but it would be unwise to choose only those ground covers which are rapid growers, as these may eventually prove tiresome to control. The ones which spread quickly are those with runners which root along the ground, or with roots which increase rapidly beneath the ground. The plants which grow in tufts or clumps take much longer to make a dense cover. Generally it is advisable to interplant slow-growing ones with those which spread rapidly, but be prepared to cut back those which romp along enveloping the small plants in their path. If quick-spreading plants of different kinds are planted near each other, trim them back when necessary to keep them within bounds, as a mass of tangled trailing plants which have grown into each other is not a pleasing sight.

The area allocated to each different ground cover should depend on the size of the garden and the nature of growth of the plant. Those of trailing or spreading habit will naturally need more space than those of tufty growth. In the small garden avoid having too many kinds of ground covers, as small plantings of a number of different ones will produce a patchy effect and make the garden look cluttered and even smaller than it is. Group the non-spreading ground covers in colonies so that each species has an area of not less than half a square metre, or, if planted to form a border, let each type of plant take up a strip measuring a metre in length and half a metre in width, or somewhat more.

An entire border can be composed of ground covers, choosing the shrubby types for the background, those of tufty growth interplanted with trailers for the middle part and prostrate ones for the front. When making a selection remember to evaluate the foliage, and interplant some of those with silver or grey leaves with plants with leaves of different shades of green. The maintenance of a border of this kind calls for little effort. Remove dead heads, shear off the top-growth should it become straggly or shaggy, and snip off the ends or fork up the roots of the plants which are determined to travel too far afield. There will be practically no weeding, as well-grown ground covers tend to suppress the weeds.

Where large areas have to be covered, grow as ground covers some of the climbing plants such as ivy, honeysuckles and bougainvilleas, and prostrate-growing conifers. Climbing plants will also solve the problem of covering, disguising and beautifying unsightly areas of concrete and man-hole covers. Where climbers are grown as ground covers cut them back when necessary so that they do not clamber over and smother other ground covers or shrubs nearby.

Time to plant: Ground covers can be transferred from the nursery to the garden at any time of the year, but it is obviously easier to get them established with a minimum of effort if they are moved during the rainy season. However, this is not always practical and transplanting them during the dry months of the year usually calls only for some shading for the first couple of weeks after they are moved, thorough soaking immediately after planting and regular watering thereafter until the roots are established. Deciduous plants are usually planted out during winter when they are bare of leaves, but even these do not suffer

when moved at other seasons, provided they are shaded and watered adequately until they are settled in. An indication as to when to plant any which are seasonal is given in the remarks which follow the descriptions of the plants.

Preparing the soil: A few ground covers will grow in hard, dry, inhospitable soil, but most of them want something better. Some can be found, in nature, in porous sand, whilst others require rich soil. In between is a range of plants which do fairly well in mediocre soil and which may spread fairly well even when neglected. All of these different types will, however, do better if planted in soil to which humus, in the form of compost, old manure rotted down with litter, or leaf-mould, has been dug in.

Ground covers are planted to beautify the garden not for a season, but for as long as you wish to have them, and spending time and money on the thorough preparation of the soil before planting will ensure healthy, luxurious growth and reduce time and money required for later maintenance.

The roots of the plants go down into the soil in search of nourishment so it is advisable to see that the humus is incorporated in the ground where the roots will settle – that is 10 to 30 cm below the surface. Prepare the entire area rather than dig holes for individual plants. This will encourage the roots to spread rapidly and produce more verdant foliage.

In the pages which follow, the cultural instructions sometimes state "Plant in well-drained soil". This indicates that the plant is unlikely to thrive in a heavy impermeable clay which becomes water-logged. Do not, however, misinterpret this reference to well-drained soil and expect plants to grow in impoverished sand without water. There are a few which ask for little else and they will come up smiling under such harsh conditions, but most plants which prefer well-drained soil require a good nutritious one which allows water to percolate through and which is well-aerated. Generally well-drained soils have a loose or gravelly consistency.

If the area to be planted is a large and steep slope it may be necessary to take precautions to prevent erosion until the plants have spread across it. First, where it is practical to do so, reduce the angle of the slope, as a gentle slope looks better than a steep one. If this cannot be done, make small ridges along the slope and set the plants in rows just above the ridges, staggering the plants so that those in one line are not immediately below those in the line above. Should this not prove efficient enough to arrest erosion put a thin layer of straw over the plants and cover the whole area with a light plastic net for a couple of months during the season of heavy rains.

Ground covers which grow well create their own humus in time and so continue to flourish, but, if the plants appear to be suffering from malnutrition, sprinkle a little general garden fertiliser on the soil between the plants and water it in. Poor growth and the yellowing of the leaves of plants is usually an indication that the soil lacks some element they need and calls for a pep-up in the form of fertiliser. Those plants which like acid soil should, however, never be given a general garden fertiliser, as their leaves tend to turn yellow because the soil is not acid enough for them and the application of a general garden fertiliser would make things worse.

Where the soil is even slightly alkaline it is inadvisable to plant ground covers which like acid soil. There are many good ground covers for soil which is not acid.

In some parts of the country the soil is strongly alkaline and this makes it difficult to grow a wide variety of plants, as most of them prefer a soil which is neutral or slightly acid. Filling beds with leaf-mould and compost will make it possible to grow a range of plants, but in time the alkaline water is likely to build up adverse conditions. Inexpensive soil-testing kits are available and in regions of alkaline soil it is wise to have one of these. Should a test reveal that the soil is becoming too alkaline apply a light application (as lightly as one would apply salt to food) of aluminium sulphate and/or sulphur. Both may be used. Aluminium sulphate acts more quickly than sulphur but the sulphur is longer-lasting in its effect. Always water the ground thoroughly after applying them to produce a more speedy reaction. A list of plants which will grow in alkaline soil is given on page 27.

Propagation: Most gardeners buy rooted plants from nurseries and for this reason details as to how to propagate ground covers have not been included under the particulars given with regard to their culture. They can be raised from seed sown in spring, but, being perennials this method may take a year or two to produce flowering plants. Furthermore hybrids generally do not come true

13

Low-growing plants are the ideal ones for a floral clock or for pattern bedding.

Dorotheanthus (Bokbay vygie or Iceplant) looks charming tucked into the crevices between stones.

Plants with coloured leaves are useful for brightening the garden throughout the year.

Alternanthera is a splendid plant for carpet bedding or to grow as a ground cover.

Lampranthus, better known as Vygies or Iceplants, make a sparkling show in dry sandy ground.

The grey leaves of Cerastium (*C. tomentosum*) look effective against a red brick wall.

Plant gazanias as a ground cover and to highlight the rock garden.

Grow Portulaca or other prostrate plants to soften the severe outline of paving slabs.

Pelargoniums make a glorious show trained up a wall or fence or spilling over a bank.

from seed and these must be propagated from cuttings or root sections taken from the mother plant. For example, gazanias of great beauty will result from the sowing of a packet of seed, but the double forms and those with special markings or colours can be duplicated only from cuttings which are usually made in spring. Plants grown from cuttings or root sections flower more quickly than those raised from seed, and this is therefore the best way for the gardener to propagate them. Generally it is advisable to make the cuttings in spring and to shade them until new growth indicates that they have formed roots. Some plants root within a couple of weeks whilst others are by nature slow. The rate of rooting will also depend upon the temperature, and no rules can therefore be given as to the length of time it takes to root cuttings. A large number of ground covers form roots of their own accord as the plant grows and spreads its stems across the ground. These are the ones to watch and cut back when they spread too far and wide.

Frost: The severe frosts which occur in a few parts of the country cause damage to many plants but fortunately there are a number of ground covers which are hardy to frosts, and some of them in fact do best in regions which have cold winters, provided that they are not allowed to become too dry at this time of the year. Many of the ground covers which appear to be affected by frost and lose their leaves as a result, may send out new shoots as soon as the weather warms up in spring. Very often, too, a frost-tender plant will survive if it is given some protection during its first two or three years. Ground covers can be protected from frost by a mulch of straw put over them for the winter months, or by a plastic sheet. This should be thrown over them in the evening and removed in the morning before the sun becomes hot.

The position a plant occupies in the garden may also minimise the effect of frost. For example, plants shaded from the early morning sun are less likely to suffer frost-damage than those exposed to the rising sun. Strong sunshine after a night of low temperatures results in greatly increased damage to plants subjected to it, whereas light shade from a neighbouring tree, tall shrub or a wall, will afford protection, resulting in less damage. The tables on pages 23 and 24 list the names of plants which are hardy to frost.

Water: Although water is the very life-blood of plants it is difficult to be precise as to how much water to give and how often, as this depends on the character of the plant, the type of soil in which it is growing, and the general weather conditions. Nature has provided us with ground covers which grow in desert and semi-desert areas and such plants flourish in gardens where the soil drains readily and where the rainfall is low. Other ground covers will make no headway unless planted in soil which absorbs and retains water and unless watered regularly throughout the year. In the tables on page 26 there is a list of plants which will grow under dry conditions, and an indication is given in the body of the text as to what kind of climatic conditions suit different plants.

As a general rule it is advisable to ensure that ground covers are watered well during the first year of their life, after which many of them will have developed a root-system which enables them to survive fairly long periods with little water.

Ground covers under trees may require to be watered more liberally than those planted elsewhere in the garden, because many shade-loving plants like damp conditions and because the roots of trees absorb a good deal of the water given. Plants growing on a slope also dry out more quickly than those on level ground and they too will therefore have to be watered more frequently.

Slugs and snails: Ground covers appear to be free from pests and diseases, but the very nature of their growth encourages slugs and snails to breed. Both slugs and snails require moist conditions and they feed at night when the weather is cool – during and after rains. In the day they shelter in cool surroundings under the ground covers or any plants with leaves close to the earth. During periods of hot dry weather they remain inactive for months. Various proprietary brands of bait effective against these pests are procurable, but gardeners who like experimenting can try using meta (obtainable from chemists) to kill them. Crush a tablet, add it to 2 cups of mealie meal or bran, and sprinkle this under the leaves of the ground covers. As meta is somewhat toxic keep it out of reach of small children and animals. If the snail population is not large and the garden a small one, it is not a difficult task to keep them in check by making a tour of the garden in the late evening or early morning and picking them off the leaves of the plants. If you feel squeamish about trampling the little wretches underfoot, throw them into a bucket containing a mixture of

16

sulphate of ammonia and water (a small handful to a litre of water).

Names: Most gardeners tend to be put off by the botanical names of plants which are often ponderous, and difficult to spell and pronounce. The common names are more homely but it is not practical to use only the common names in a book of this kind, either because some plants have no common name or because in some cases different plants are known by the same common name, thus leading to confusion. For example the plants referred to as "vygies" or "iceplants" belong to several different genera and are to be found described under the following botanical names: carpobrotus, cephalophyllum, dorotheanthus, drosanthemum and lampranthus. For the sake of clarity it is therefore essential to use botanical names, but the common names, where they exist, are given, and there is an index of common names at the back of the book for ease of reference.

All plants have two botanical names – the first one, spelt with an initial capital letter is the genus name and is equivalent to a surname, whilst the second botanical name which follows it is the species name and can be likened to the first or Christian name of a person. If one wants a particular type of vygie, or any other plant, one should know both its genus and its species name, to be sure of procuring the right plant.

In addition to the genus and species names, in some cases a third name – that of cultivar – is mentioned. The word cultivar has replaced the term variety originally used in horticulture to indicate a hybrid. The cultivar name is written with an initial capital letter between single inverted commas and always appears after the species name. In the case of pelargoniums, for example, a few species which occur in nature are still planted in gardens, but most of the pelargoniums grown for garden show are hybrids and they have been given cultivar names to distinguish them from one another. Very often the cultivar name describes a characteristic of the plant. For example, *Berberis stenophylla* is a large shrub, whereas *B. stenophylla* 'Nana' is a small form suitable for use as a ground cover – the word *nana* meaning dwarf.

Acknowledgements: In writing a book of this kind one has to rely to some extent on the experience gained by other gardeners and horticulturists, for the simple reason that one cannot grow all the plants oneself under different climatic conditions. I am grateful to many people in different countries who made suggestions and gave me the benefit of their experience in growing some of the plants under their local conditions.

To Dr. John Rourke, Director of the Compton Herbarium, Kirstenbosch, South Africa, I owe a great debt of gratitude for he was always ready to ascertain the correct botanical names of plants and to share his great fund of knowledge with me.

I am indebted to Rosaline Redwood of New Zealand, for the photographs of gazanias on pages 30 and 70 and to Mr. T. Wannenburg for the picture of pattern bedding on page 14.

Finally, a word of appreciation is due to my husband who cheerfully put up with a somewhat neglected household whilst I was busy taking photographs and writing.

Una van der Spuy
Old Nectar,
Stellenbosch
October 1975.

Part II
Plant Selection Guide

II

Plant Selection Guide

The lists which follow have been compiled to assist gardeners to choose the right ground covers to suit their climatic conditions and to introduce variety in form and colour from season to season.

GROUND COVERS

QUICK-GROWING GROUND COVERS

All gardeners want to cover the ground about their homes with the least possible delay, and the question most often asked of a nurseryman is "how quickly will the plant grow?" There are ground covers which are by nature rapid spreaders whilst others are slow-growers. In the small garden it is advisable to plant some of the latter with those which spread quickly, as the quick-growers can prove a nuisance in a small area by being too invasive.

Although speed of growth is an innate characteristic of a plant, the rate of growth depends to some extent also on soil, aspect and the degree of attention given the plant. If a quick-growing plant fails to live up to its reputation see whether it has the kind of conditions it needs.

Acaena species
Achillea tomentosa
Akebia quinata
Alternanthera bettzickiana
Anthemis cupaniana
Aptenia cordifolia
Arctotis species and cultivars
Asperula odorata
Barleria obtusa
Carpobrotus species
Cephalophyllum species
Cerastium tomentosum
Chlorophytum comosum 'Variegatum'
Cistus species
Coleus neochilus
Conicosia pugioniformis
Convolvulus mauritanicus
Cornus canadensis
Coronilla varia
Cotula squalida
Crassula multicava
Delosperma species
Dianthus species
Dichondra repens
Didelta carnosa
Dorotheanthus bellidiformis
Drosanthemum species
Duchesnea indica
Erigeron species
Felicia amelloides
Gazania species and cultivars
Geranium species

Helianthemum nummularium
Helxine soleirolii
Heterocentron roseus
Hypericum species
Iberis sempervirens
Kalanchoe blossfeldiana
Lamium species
Lampranthus species
Lantana montevidensis
Limnanthes douglasii
Lonicera species
Lysimachia species
Malephora crocea
Osteospermum species
Oxalis semiloba
Pachysandra terminalis
Pelargonium species and cultivars
Plectranthus species
Polygonum capitatum
Portulaca grandiflora
Rhoicissus tomentosa
Rosmarinus lavandulaceus
Sutera cordata
Tradescantia fluminensis
Trifolium repens 'Purpurascens'
Ursinia sericea
Verbena species
Vinca major
Viola species
Waldsteinia ternata
Wedelia trilobata
Zebrina pendula

EVERGREEN GROUND COVERS

Most of the ground covers described are evergreen and therefore of practical value in keeping the ground verdant throughout the year and in suppressing the growth of weeds. Plants with ornamental foliage are marked with an *

Achillea tomentosa
*Acorus gramineus 'Variegatus'
Aethionema species
*Ajuga reptans
*Anthemis species
*Aptenia cordifolia
Arctotis species and cultivars
Arenaria species
Armeria species
*Asparagus densiflorus
Asteranthera ovata
Aubrieta deltoidea
*Aurinia saxatilis
Barleria obtusa
*Bergenia cordifolia
Berberis stenophylla 'Nana'
Calluna vulgaris
*Carissa grandiflora cultivars
Carpobrotus species
Ceanothus species
*Cenia sericea
Cephalophyllum species
*Cerastium tomentosum
*Cheiridopsis species
*Chlorophytum comosum 'Variegatum'
*Cineraria species
Cistus species
Coleus neochilus
*Convolvulus species
*Coprosma species and cultivars
Cotoneaster (some species)
Cotula squalida
*Crassula multicava
*Daphne cneorum
Delosperma species
Dianthus species and cultivars
Dichondra repens
*Didelta carnosa
Drosanthemum species
Dryas octopetala
*Dymondia margaretae
*Echeveria species
Erica species
Erigeron species

*Euonymus species and cultivars
Euphorbia species
*Euryops acraeus
Felicia species
*Festuca ovina 'Glauca'
*Ficinia truncata
*Ficus pumila
*Gaultheria procumbens
*Gazania species and cultivars
Hardenbergia comptoniana
*Hebe species and cultivars
*Hedera species and cultivars
Helianthemum nummularium
*Helichrysum species
*Helleborus species
*Helxine soleirolii
Hermannia verticillata
*Heterocentron roseus
*Holcus species
*Hymenocyclus purpureocrocus
*Hypericum calycinum
*Juniperus species and cultivars
*Kalanchoe blossfeldiana
Kennedia coccinea
*Kleinia acaulis
*Lamium species
Lampranthus species
Lantana montevidensis
Leptospermum humifusum
Leucogones leontopodium
Leucospermum prostratum
*Liriope species
*Lonicera species
Lotus berthelotii
Lysimachia nummularia
Malephora crocea
*Nepeta species
Osteospermum species
*Ophiopogon species
*Oxalis semiloba
*Pachysandra terminalis
*Pelargonium species and cultivars
*Pennisetum setaceum
*Phalaris arundinacea 'Picta'

*Phyla nodiflora
Plectranthus species
*Polygonum capitatum
Potentilla (some species)
*Raoulia lutescens
*Rhoicissus tomentosa
*Rosmarinus lavandulaceus
Sagina species
Santolina chamaecyparissus
*Saxifraga species
*Sedum species
*Stachys olympica
*Stoebe plumosa
*Sutera cordata

*Tanacetum densum
*Taxus baccata 'Repandens'
Teucrium chamaedrys
*Tradescantia fluminensis
*Trifolium repens 'Purpurascens'
*Ursinia species
Verbena species
*Vinca species
*Viola species
*Waldsteinia ternata
*Wedelia trilobata
*Zebrina pendula
*Zoysia tenuifolia

GROUND COVERS HARDY TO SEVERE FROST

The ground covers listed below will stand severe frost. It should be remembered, however, that most evergreen plants need to be watered regularly during dry months of the year, and that in regions where winters are dry and frosty the damage they appear to suffer could be due to dryness rather than to frost.

Acaena species
Achillea tomentosa
Acorus gramineus 'Variegatus'
Aethionema species
Ajuga reptans
Akebia quinata
Anthemis species
Arabis albida
Arenaria species
Armeria species
Asperula odorata
Asteranthera ovata
Aubrieta deltoidea
Aurinia saxatilis
Berberis species
Bergenia cordifolia
Brunnera macrophylla
Calluna vulgaris
Campanula species
Ceanothus species
Cerastium tomentosum
Ceratostigma plumbaginoides
Cistus species
Convolvulus cneorum
Cornus canadensis
Cotoneaster species

Cotula squalida
Cytisus species
Daphne species
Dianthus species
Dryas octopetala
Duchesnea indica
Erica species
Erigeron species
Erinus alpinus
Euonymus species and cultivars
Euphorbia gatbergensis
Euryops acraeus
Festuca ovina 'Glauca'
Ficus pumila
Gaultheria procumbens
Genista species
Geranium cultivars
Gypsophila repens
Hebe species and cultivars
Hedera species and cultivars
Helianthemum nummularium
Helleborus species
Holcus species
Hypericum species
Iberis sempervirens
Juniperus species and cultivars

Lamium species
Leptospermum humifusum
Leucogones leontopodium
Limnanthes douglasii
Liriope species
Lithospermum diffusum
Lonicera japonica
Lysimachia nummularia
Mentha requienii
Muehlenbeckia complexa
Nepeta species
Omphalodes cappadocica
Ophiopogon japonicus
Origanum vulgare 'Aureum'
Pachysandra terminalis
Pennisetum setaceum
Phalaris arundinacea 'Picta'
Phlox subulata

Polygonum species
Potentilla species
Rosa species and cultivars
Rosmarinus lavandulaceus
Sagina species
Santolina chamaecyparissus
Saponaria ocymoides
Saxifraga species
Sedum species
Silene schafta
Stachys olympica
Tanacetum densum
Taxus cultivar
Thymus species
Tiarella cordifolia
Viola (two species)
Waldsteinia ternata
Zoysia tenuifolia

GROUND COVERS WHICH STAND MODERATE FROST

All of the plants named in the previous list are suitable for gardens which experience moderate frost – that is drops in temperature to $-3°$ C. Should any of the plants listed below show signs of being affected by frost, cover them with a plastic sheet on nights when sharp frosts are anticipated.

Alternanthera bettzickiana
Aptenia cordifolia
Arctotheca populifolia
Arctotis species
Asparagus densiflorus
Barleria obtusa
Bulbine caulescens
Carissa grandiflora cultivars
Carpobrotus species
Cenia sericea
Cephalophyllum species
Cheiridopsis species
Chironia baccifera
Cineraria species
Coleus neochilus
Conicosia pugioniformis
Convolvulus species
Coprosma species
Coronilla varia
Crassula species
Dampiera diversifolia

Delosperma species
Didelta carnosa
Dichondra repens
Dorotheanthus species
Drosanthemum species
Dymondia margaretae
Echeveria species
Felicia species
Ficinia truncata
Gazania species and cultivars
Geranium incanum
Gibbaeum pubescens
Hardenbergia comptoniana
Helichrysum species
Helxine soleirolii
Hermannia verticillata
Heterocentron roseus
Hymenocyclus purpureocrocus
Kalanchoe blossfeldiana
Kennedia coccinea
Kleinia acaulis

Lampranthus species
Lantana montevidensis
Leucospermum prostratum
Lotus berthelotii
Malephora crocea
Myoporum parvifolium
Osteospermum species
Oxalis species
Pelargonium species and cultivars
Phyla nodiflora
Plectranthus species
Raoulia lutescens

Rhoicissus tomentosa
Stoebe plumosa
Sutera cordata
Teucrium chamaedrys
Thunbergia alata
Tradescantia fluminensis
Trifolium repens 'Purpurascens'
Ursinia sericea
Verbena species
Wedelia trilobata
Zebrina pendula

GROUND COVERS FOR TROPICAL AND SUBTROPICAL GARDENS

Warmth and humidity encourage the speedy growth of many plants and often the problem in the sub-tropical garden is not that of encouraging plants to grow but rather the necessity for cutting them back regularly so that they do not over-run the entire garden. In regions with a high rainfall, plants included in this list which like dry conditions should be planted in well-drained soil.

Akebia quinata
Alternanthera bettzickiana
Anthemis cupaniana
Antigonon leptopus
Aptenia cordifolia
Arctotis species
Asparagus densiflorus
Barleria obtusa
Bougainvillea cultivars
Bulbine caulescens
Carissa grandiflora cultivars
Carpobrotus species
Cenia sericea
Cephalophyllum species
Chlorophytum comosum 'Variegatum'
Coleus neochilus
Convolvulus mauritanicus
Coprosma species
Crassula species
Delosperma species
Didelta carnosa
Dichondra repens
Dorotheanthus bellidiformis
Dymondia margaretae
Erigeron species
Felicia species
Ficinia truncata

Gazania species and cultivars
Geranium incanum
Helichrysum species
Helxine soleirolii
Heterocentron roseus
Kalanchoe blossfeldiana
Lampranthus species
Lantana montevidensis
Lippia repens
Nepeta species
Nierembergia repens
Osteospermum species
Oxalis semiloba
Pelargonium species
Phalaris arundinacea 'Picta'
Phyla nodiflora
Plectranthus species
Polygonum capitatum
Portulaca grandiflora
Rhoicissus tomentosa
Sutera cordata
Thunbergia alata
Tradescantia fluminensis
Trifolium repens 'Purpurascens'
Verbena species
Wedelia trilobata
Zebrina pendula

GROUND COVERS FOR DRY GARDENS

Those who live in regions where the rainfall is low and where there is a shortage of water need not feel that it is impossible to keep the ground covered with plants, for some plants are by nature adapted to grow in dry areas, whilst others listed here will stand fairly long periods with little water.

Plants marked with an * are more tolerant of dry conditions than the others.

*Achillea tomentosa
Aptenia cordifolia
*Arctotis species
Armeria species
Berberis species
Bougainvillea cultivars
*Bulbine caulescens
*Carpobrotus species
*Cephalophyllum species
Ceratostigma plumbaginoides
*Cheiridopsis species
Cistus species
*Conicosia pugioniformis
Coronilla varia
Cotoneaster species
*Crassula species
Cytisus species
*Dampiera diversifolia
*Delopserma species
*Didelta carnosa
*Dorotheanthus bellidiformis
*Drosanthemum species
Dymondia margaretae
Echeveria species
Erigeron species
*Euphorbia species
Ficinia truncata
Ficus pumila
*Gazania species and cultivars

Genista species
*Gibbaeum pubescens
Hardenbergia comptoniana
Helianthemum nummularium
Helichrysum species
*Hymenocyclus purpureocrocus
*Kalanchoe blossfeldiana
Kennedia coccinea
*Kleinia acaulis
*Lampranthus species
Lantana montevidensis
*Malephora crocea
Muehlenbeckia complexa
Myoporum parvifolium
Nepeta mussinii
Osteospermum species
Oxalis semiloba
Pelargonium species
Pennisetum setaceum
Polygonum capitatum
Portulaca grandiflora
*Rosmarinus lavandulaceus
Santolina chamaecyparissus
Sedum species
Stoebe plumosa
Thymus species
Verbena species
Waldsteinia ternata
Wedelia trilobata

GROUND COVERS FOR ALKALINE SOIL

Most garden plants grow best in soil which is slightly acid or neutral, but there are some which grow in soil which is limy or alkaline, provided that the lime content is not extremely high. This acid/alkaline quality of soils is measured in terms of what is known as pH values. Those with a pH of 7 are termed neutral; those below are acid, whilst those with a pH of above 7 are alkaline. Soil-testing kits are procurable at a modest price and gardeners who live in regions where the soil is known to be extreme either way should test the soil

in their gardens. Should it be definitely acid with a pH of below 6 it is advisable to grow plants which like acid conditions, whereas if the pH is above 7,5 plants which prefer alkaline soil should be tried.

The plants listed below will grow in alkaline soil and they will also grow in neutral or slightly acid soil. Where the pH value rises to 8, take action to change the character of the soil. (See page 13).

Plants which are more likely to tolerate alkaline soil are marked with an *

Acaena species
Achillea species
Alternanthera bettzickiana
Aptenia cordifolia
Arabis species and cultivars
Arctotis species and cultivars
Armeria species
Aubrieta deltoidea
Aurinia saxatilis
Berberis (some cultivars)
Bergenia cordifolia
*Bougainvillea
*Bulbine caulescens
Campanula species
*Carpobrotus species
*Ceanothus species and cultivars
Cenia sericea
Cephalophyllum species
*Cerastium tomentosum
Ceratostigma plumbaginoides
Cheiridopsis species
*Cineraria geifolia
*Cistus species and cultivars
Conicosia pugioniformis
Convolvulus species
Coprosma species and cultivars
*Coronilla varia
*Cotoneaster species and cultivars
Cotula squalida
Crassula species
*Cytisus species
Delosperma species
*Dianthus species and cultivars
*Didelta carnosa
Dorotheanthus bellidiformis
Drosanthemum species
Duchesnea indica
*Dymondia margaretae
Erigeron species
*Euonymus species and cultivars
*Euphorbia species
Festuca ovina 'Glauca'
*Ficinia truncata
Ficus pumila

Gazania species and cultivars
*Genista species
Geranium species
*Gibbaeum pubescens
Gypsophila repens
Hebe species and cultivars
Hedera species and cultivars
Helianthemum nummularium
Helichrysum species
Hymenocyclus purpureocrocus
*Hypericum species and cultivars
*Juniperus species and cultivars
Kalanchoe blossfeldiana
Kleinia acaulis
Lamium species
Lampranthus species
Lantana montevidensis
Lonicera species
*Malephora crocea
*Muehlenbeckia species
*Myoporum parvifolium
Nepeta species
Osteospermum species
Pelargonium species and cultivars
Phlox subulata
Phyla nodiflora
Polygonum species
Portulaca grandiflora
*Potentilla (some species)
*Rosmarinus lavandulaceus
*Santolina chamaecyparissus
Sedum species
Stachys olympica
*Taxus species and cultivars
*Sutera cordata
*Tetragonia decumbens
*Teucrium species
*Thymus (some species)
Trifolium repens 'Purpurascens'
Verbena species and cultivars
Waldsteinia ternata
Wedelia trilobata
Zebrina cultivars

GROUND COVERS FOR COASTAL GARDENS

The countries for which this book is written – Africa, Australia, New Zealand, California and some of the southern states of the U.S.A. – have long extended coastlines, and some of the biggest towns are situated on their coasts. For this reason considerable research has been done to ascertain what plants are likely to grow in gardens along the coast under the different climatic conditions which obtain from one region to another. The climate varies from cool to extremely hot and it varies also in humidity, which has a tremendous effect upon plant growth. The list which follows includes ground covers which grow under these different climatic conditions.

The factors affecting plant growth at the coast are somewhat different to those encountered inland. Generally it is the wind which causes most damage. Near the shore the wind is laden with salt, as a result of which plants suffer not only from the force of the wind but also from the salt which it deposits on the leaves and stems. Gardens a short distance from the beach are not affected to the same degree, as the salt in the air is much less, and those a few hundred metres from high water mark are unlikely to suffer at all from salt on the foliage.

There is not much that can be done to reduce salt damage of this kind except to water the plants well in order to wash the salt off the leaves and to leach it out of the soil. Fortunately there are some plants which are salt-tolerant and can therefore be grown near the beach. These are marked with an * below.

For plants to thrive, whether at the coast or inland, they must have their roots in good soil. Many plants in seaside gardens look pathetic not because of the force of the wind or salt in the atmosphere but because the soil is lacking in fertility or is too alkaline. The application of artificial fertilisers is not the answer to this problem because beach sand lacks humus, and, unless plenty of it is dug in before planting, and generous dressings given each year thereafter, growth is likely to be disappointing.

Compost, peat and stable litter make a tremendous difference to the growth and health of plants. Soil to which humus has been added is more fertile, more retentive of moisture and less likely to heat up quickly than poor sandy soil without humus. Furthermore there will be a lower proportion of injurious salts in it. For these reasons coastal gardeners should make a point of improving the soil properly before any planting is undertaken.

Should wind blow the sand over newly planted ground covers near the shore, erect a low barrier of wire-mesh threaded with brushwood to protect them until they are established. Generally also, in gardens on the sea front it is a good idea to have a barrier of shrubs to shelter the smaller plants which might otherwise become covered with sand.

*Achillea tomentosa
Alternanthera bettzickiana
Anthemis cupaniana
*Aptenia cordifolia
*Arctotheca populifolia
*Arctotis species
Arenaria balearica
*Armeria species
*Asparagus densiflorus
Barleria obtusa
*Bulbine caulescens
Calluna vulgaris
*Carissa grandiflora cultivars
*Carpobrotus species
Ceanothus species
Cenia sericea
Cephalophyllum species

Cerastium tomentosum
Cheiridopsis species
*Cineraria species
*Cistus species
Coleus neochilus
*Conicosia pugioniformis
*Convolvulus species
*Coprosma species
Cotoneaster species
*Crassula species
Cytisus species
Delosperma species
*Didelta carnosa
Dichondra repens
*Dorotheanthus bellidiformis
*Drosanthemum species
Duchesnea indica

28

*Echeveria species
Erigeron species
Felicia species
Ficinia truncata
*Gazania species and cultivars
Genista species
Geranium incanum
Hebe species
Hedera species and cultivars
Helianthemum nummularium
*Helichrysum species
Heterocentron roseus
*Hymenocyclus purpureocrocus
Hypericum species
*Juniperus conferta
Kalanchoe blossfeldiana
*Kleinia acaulis
Lampranthus species
*Lantana montevidensis
Leucospermum prostratum
*Muehlenbeckia complexa
*Myoporum parvifolium
Nepeta mussinii
*Osteospermum species
Oxalis species

*Pelargonium species and cultivars
Phyla nodiflora
Plectranthus species
Polygonum capitatum
*Portulaca grandiflora
*Rosmarinus lavandulaceus
Santolina chamaecyparissus
Saponaria ocymoides
Sedum species
*Stachys olympica
Stoebe plumosa
Sutera cordata
Taxus baccata 'Repandens'
Tetragonia decumbens
Thymus species
Tradescantia fluminensis
Trifolium repens 'Purpurascens'
Ursinia species
Verbena species
Vinca species
Viola odorata
*Wedelia trilobata
Zebrina pendula
Zoysia tenuifolia

GROUND COVERS FOR SHADY PLACES

The quality of shade varies. In the southern hemisphere the south side of a building has open shade all day, whilst in the northern hemisphere it is the north side which is shaded. An east-facing wall has morning sun and afternoon shade. The shade cast by trees differs in degree, too. There is a great deal more shade beneath a large tree with leaves densely arranged than under a small one with feathery foliage. When selecting ground covers for shady places consideration should be given to these factors.

Shade-loving plants which prefer shade to sun are marked with an *. The other ground covers listed will grow in partial shade – that is in filtered shade or in a position where they have sun in the morning and shade in the afternoon.

Aethionema species
*Ajuga reptans
Arabis albida
Armeria species
*Asparagus densiflorus
*Asperula odorata
*Asteranthera ovata
Aubrieta deltoidea
Aurinia saxatilis
Barleria obtusa
*Brunnera macrophylla

Bulbine caulescens
Campanula species
Cineraria geifolia
Coleus neochilus
Convolvulus species
*Cornus canadensis
*Crassula multicava
Daphne species
Dichondra repens
Dryas octopetala
Duchesnea indica

Echeveria species
Erica species
*Erinus alpinus
Euonymus species and cultivars
Euryops acraeus
Gaultheria procumbens
Geranium species
Hebe species
*Hedera species and cultivars
*Helleborus species
*Helxine soleirolii
Heterocentron roseus
*Hypericum calycinum
Iberis sempervirens
Juniperus species
*Lamium species
Leucogones leontopodium
Limnanthes douglasii
*Liriope species
Lithospermum diffusum
Lonicera japonica
Lysimachia nummularia
Nepeta hederacea
*Omphalodes cappadocica
Ophiopogon japonicus

Oxalis semiloba
*Pachysandra terminalis
Phalaris arundinacea 'Picta'
Phlox subulata
Phyla nodiflora
*Plectranthus species
Polygonum species
Raoulia lutescens
Rhoicissus tomentosa
Sagina species
Saponaria ocymoides
Saxifraga species
Sedum species
Silene schafta
Stachys olympica
*Sutera cordata
*Tiarella cordifolia
*Tradescantia fluminensis
Trifolium repens 'Purpurascens'
Veronica species
*Viola species
Waldsteinia ternata
Wedelia trilobata
*Zebrina pendula
Zoysia tenuifolia

GROUND COVERS WITH COLOURFUL LEAVES

Foliage of different shades of green contributes a good deal to the beauty of the garden, and leaves which are variegated or of shades of grey, silver or purple, play a very important part. Leaves marked with white or cream and those of grey tones make a splendid contrast to dark green leaves and it is a good idea to plant such ground covers in front of climbers, shrubs or trees (such as conifers) with dark foliage, or else to interplant them with other ground covers having dark green leaves.

Ground covers with colourful leaves are also of great value in creating interesting designs in pattern bedding and in adding a colourful note to the garden generally.

Acaena species
Achillea species
Acorus gramineus 'Variegatus'
Ajuga reptans cultivars
Alternanthera bettzickiana
Anthemis cupaniana
Arabis albida
Arctotheca populifolia
Arctotis cultivars
Artemisia schmidtiana cultivars
Aubrieta deltoidea
Aurinia saxatilis

Bergenia cordifolia 'Purpurea'
Berberis thunbergii cultivars
Cerastium tomentosum
Cheiridopsis species
Chlorophytum comosum 'Variegatum'
Coprosma species and cultivars
Didelta carnosa
Dymondia margaretae
Euonymus fortunei 'Variegatus'
Euryops acraeus
Festuca ovina glauca
Ficinia truncata

31

This Gazania with silvery leaves and handsome double flowers was hybridised in Australia.

Ficus pumila cultivar
Gazania species and cultivars
Gibbaeum pubescens
Hebe pinguifolia 'Pagei'
Hedera canariensis 'Variegata'
Hedera helix (some cultivars)
Helichrysum species
Holcus cultivars
Juniperus (some cultivars)
Kleinia acaulis
Lamium species and cultivars
Leucogones leontopodium
Liriope muscari 'Variegata'
Nepeta hederacea 'Variegata'
Ophiopogon japonicus 'Variegatus'
Origanum vulgare 'Aureum'

Pachysandra terminalis 'Variegata'
Pelargonium (some species)
Phalaris arundinacea 'Picta'
Polygonum capitatum
Raoulia lutescens
Santolina chamaecyparissus
Stachys olympica
Stoebe plumosa
Tanacetum densum
Thymus (some cultivars)
Tradescantia fluminensis 'Variegata'
Trifolium repens 'Purpurascens'
Ursinia sericea
Vinca major 'Variegata'
Zebrina pendula 'Quadricolor'

COLOUR THROUGH THE SEASONS

Although most ground covers are worth planting for their foliage there are some which highlight the garden with colourful flowers. The tables which follow indicate the seasons when these ground covers bloom.

The month of the year when a plant flowers varies according to climatic conditions. In regions where winters are mild many ground covers which are spring-flowering will come into flower from mid- to late winter. Because of the differences in climatic conditions in different parts of the country it is desirable to indicate here when seasons begin and end.

Spring	September to November
Summer		December to February
Autumn		March to May
Winter	June to August

An indication is also given in these tables as to the habit of growth of the different ground covers. Some of them make a carpet of leaves; some are trailing; some form tufts, clumps or cushions of leaves; some make a mound or hummock of growth and some are bushy.

SPRING

NAME OF PLANT	Growth	Yellow	Orange	Red	Pink	Blue	Mauve	Purple	White
Aethionema species (AETHIONEMA)	Mound				●				
Ajuga reptans (BUGLE FLOWER)	Carpeting						●	●	

NAME OF PLANT	Growth	Yellow	Orange	Red	Pink	Blue	Mauve	Purple	White
Anthemis cupaniana (ANTHEMIS)	Bushy								●
Arabis albida (ROCK CRESS)	Prostrate								●
Arctotis cultivars (TRAILING ARCTOTIS)	Trailing	●	●	●	●		●	●	●
Arenaria species (SANDWORT)	Carpeting								●
Armeria species (THRIFT, SEA PINK)	Tufty				●				●
Asperula odorata (SWEET WOODRUFF)	Mound								●
Asteranthera ovata (ASTERANTHERA)	Climber			●					
Aubrieta deltoidea (AUBRIETA)	Mound				●		●	●	
Aurinia saxatilis (YELLOW ALYSSUM)	Mound	●							
Berberis cultivars (BERBERIS)	Bushy	●							
Bergenia cordifolia (BERGENIA)	Clump				●				
Bougainvillea cultivars (BOUGAINVILLEA)	Climber	●		●	●		●	●	●
Bulbine caulescens (BULBINE)	Cushion	●							
Calluna vulgaris and cultivars (SCOTCH HEATHER, LING)	Bushy				●		●	●	●
Campanula species (BELLFLOWER)	Cushion					●	●	●	●

SPRING

NAME OF PLANT	Growth	Yellow	Orange	Red	Pink	Blue	Mauve	Purple	White
Carpobrotus species (Hottentot fig, Sour fig)	Trailing	●					●	●	
Ceanothus species (Ceanothus, Wild lilac)	Mound					●	●		
Cenia sericea (Cenia)	Mound	●							
Cephalophyllum species (Mesem, Iceplant, Vygie)	Varies	●	●	●	●		●	●	
Cerastium tomentosum (Snow-in-summer)	Carpeting								●
Cheiridopsis species (Cheiridopsis)	Cushion	●							
Cistus cultivars (Sunrose, Rockrose)	Bushy			●	●				●
Coleus neochilus (Coleus)	Mound						●		
Conicosia pugioniformis (Conicosia)	Tufty	●							
Convolvulus species (Ground and Bush morning glory)	Mound						●		●
Cornus canadensis (Ground cornus)	Carpeting							●	●
Coronilla varia (Crown vetch)	Bushy				●				
Cotoneaster species (Cotoneaster)	Varies								●
Cytisus species (Broom)	Varies	●							
Dampiera diversifolia (Dampiera)	Trailing					●			

34

NAME OF PLANT	Growth	Yellow	Orange	Red	Pink	Blue	Mauve	Purple	White
Daphne cneorum (Garland daphne)	Mound				●				
Delosperma species (Mesem, Vygie, Iceplant)	Varies				●		●	●	●
Dianthus cultivars (Pinks)	Tufty			●	●		●	●	●
Didelta carnosa (Didelta)	Hummock	●							
Dorotheanthus bellidiformis (Bokbay vygie, Livingstone daisy)	Carpeting	●	●		●		●	●	●
Drosanthemum species (Mesem, Vygie, Iceplant)	Varies	●	●	●	●		●	●	●
Dryas octopetala (Dryas)	Carpeting								●
Duchesnea indica (Wild strawberry)	Trailing	●		●					
Echeveria species (Hen and Chickens)	Clumps	●		●	●				
Erigeron species (Erigeron)	Varies						●		●
Erinus alpinus (Erinus)	Mound				●				
Euryops acraeus (Mountain daisy)	Bushy	●							
Felicia species (Felicia, Wild aster)	Mound					●	●		
Gazania species and cultivars (Gazania)	Prostrate	●	●						
Genista species (Broom, Gorse)	Varies	●							

NAME OF PLANT	Growth	Yellow	Orange	Red	Pink	Blue	Mauve	Purple	White
Geranium species and cultivars (GERANIUM, CRANESBILL)	Varies				●		●	●	●
Gypsophila repens (GYPSOPHILA)	Trailing				●				●
Hardenbergia comptoniana (AUSTRALIAN PEA VINE)	Climber						●		
Helianthemum nummularium (SUNROSE)	Bushy	●	●		●				●
Helichrysum (some species) (EVERLASTING)	Varies	●							●
Helleborus species (CHRISTMAS OR LENTEN ROSE)	Clump				●	Green			●
Heterocentron roseus (HEERIA)	Carpeting				●				
Iberis sempervirens (EVERGREEN CANDYTUFT)	Hummock								●
Kennedia coccinea (CORAL VINE)	Climber			●					
Lamium species (LAMIUM)	Trailing	●			●		●		
Lampranthus species (MESEM, VYGIE, ICEPLANT)	Varies	●	●	●	●		●	●	●
Lantana montevidensis (CREEPING LANTANA)	Carpet or mound						●		
Leptospermum humifusum (LEPTOSPERMUM)	Carpeting				●				
Leucogones leontopodium (NEW ZEALAND EDELWEISS)	Mound								●
Leucospermum prostratum (CREEPING PINCUSHION)	Trailing				●				

NAME OF PLANT	Growth	Yellow	Orange	Red	Pink	Blue	Mauve	Purple	White
Limnanthes douglasii (Limnanthes)	Mound	●							●
Lithospermum diffusum (Lithospermum)	Mound					●			
Lonicera japonica cultivars (Japanese honeysuckle)	Climber	●							●
Lotus berthelotii (Trailing lotus)	Trailing			●					
Lysimachia nummularia (Creeping jenny)	Carpeting	●							
Omphalodes cappadocica (Omphalodes)	Bushy					●			
Osteospermum species (Trailing daisy)	Trailing						●		●
Oxalis semiloba (Pink sorrel)	Clump				●				
Pelargonium species and cultivars (Geranium, Pelargonium)	Varies			●	●		●	●	●
Phlox subulata (Rock phlox)	Carpeting				●		●	●	●
Phyla nodiflora (Lippia)	Carpeting				●				●
Polygonum species (Polygonum)	Varies				●				
Potentilla species (Cinquefoil)	Varies	●			●				●
Raoulia lutescens (Raoulia)	Mound	●							
Rosa wichuraiana (Rambler rose)	Climber	●		●	●				●

SPRING

NAME OF PLANT	Growth	Yellow	Orange	Red	Pink	Blue	Mauve	Purple	White
Rosmarinus lavandulaceus (DWARF ROSEMARY)	Carpeting						●		
Saxifraga species (SAXIFRAGE, LONDON PRIDE)	Varies	●			●				●
Sedum species (SEDUM, STONECROP)	Varies	●	●		●				●
Tanacetum densum (TANACETUM)	Bushy	●							
Thunbergia alata (BLACK-EYED SUSAN)	Climber	●	●						●
Tiarella cordifolia (FOAM FLOWER)	Clump								●
Ursinia sericea (LACELEAF URSINIA)	Bushy	●							
Verbena species (VERBENA)	Trailing			●	●		●	●	●
Veronica species (VERONICA)	Varies						●	●	●
Viola odorata (VIOLET)	Clumps				●		●	●	●
Waldsteinia ternata (WALDSTEINIA)	Prostrate	●							
Wedelia trilobata (WEDELIA)	Carpeting	●							

SUMMER

NAME OF PLANT	Growth	Yellow	Orange	Red	Pink	Blue	Mauve	Purple	White
Achillea tomentosa (Woolly yarrow)	Cushion	●							
Antigonon leptopus (Coral creeper)	Trailer				●				
Aptenia cordifolia (Aptenia)	Carpeting				●				
Barleria obtusa (Barleria)	Bushy						●		
Bougainvillea cultivars (Bougainvillea)	Climber	●		●	●		●	●	●
Carissa grandiflora cultivars (Dwarf amatungulu)	Bushy								●
Cenia sericea (Cenia)	Mound	●							
Ceratostigma plumbaginoides (Dwarf plumbago)	Bushy					●			
Chironia baccifera (Christmas berry)	Mound			●	●				
Convolvulus mauritanicus (Ground morning glory)	Mound						●		
Cotoneaster species (Cotoneaster)	Varies								●
Dampiera diversifolia (Dampiera)	Trailing					●			
Dianthus species and cultivars (Pinks)	Tufty			●	●		●	●	●
Hebe species and cultivars (Hebe)	Mound				●		●	●	●
Helianthemum nummularium (Sunrose)	Bushy	●	●		●				●

NAME OF PLANT	Growth	Yellow	Orange	Red	Pink	Blue	Mauve	Purple	White
Helichrysum argyrophyllum (GOLDEN GUINEA EVERLASTING)	Carpeting	●							
Heterocentron roseus (HEERIA)	Carpeting				●				
Hypericum species (HYPERICUM)	Carpeting	●							
Lotus berthelotii (TRAILING LOTUS)	Trailing			●					
Mentha requienii (JEWEL MINT)	Carpeting						●		
Nepeta species (CATMINT)	Varies						●		
Pennisetum setaceum (FOUNTAIN GRASS)	Clump				●				
Plectranthus species (SPURFLOWER)	Mound						●		●
Polygonum capitatum (POLYGONUM)	Trailing				●				
Portulaca grandiflora (PORTULACA)	Carpeting	●	●	●	●				●
Potentilla species (CINQUEFOIL)	Varies	●			●				●
Raoulia lutescens (RAOULIA)	Mound	●							
Santolina chamaecyparissus (LAVENDER COTTON)	Bushy	●							
Saponaria ocymoides (ROCK SOAPWORT)	Prostrate				●				
Silene schafta (MOSS CAMPION)	Tufty				●				

SUMMER

NAME OF PLANT	Growth	Yellow	Orange	Red	Pink	Blue	Mauve	Purple	White
Stachys olympica (LAMB'S EAR)	Carpeting						●		
Sutera cordata (GROUND COVER SUTERA)	Carpeting								●
Teucrium chamaedrys (GERMANDER)	Bushy				●				●
Veronica species and cultivars (VERONICA)	Varies						●	●	●
Wedelia trilobata (WEDELIA)	Carpeting	●							

AUTUMN

NAME OF PLANT	Growth	Yellow	Orange	Red	Pink	Blue	Mauve	Purple	White
Barleria obtusa (BARLERIA)	Bushy						●		
Bougainvillea cultivars (BOUGAINVILLEA)	Climber	●		●	●		●	●	●
Ceratostigma plumbaginoides (DWARF PLUMBAGO)	Bushy					●			
Chironia baccifera (CHRISTMAS BERRY)	Mound			●					
Cotoneaster species (COTONEASTER)	Varies			●					
Polygonum capitatum (POLYGONUM)	Trailing				●				

AUTUMN

NAME OF PLANT	Growth	Yellow	Orange	Red	Pink	Blue	Mauve	Purple	White
Portulaca grandiflora (PORTULACA)	Carpeting	●	●	●	●				●
Sedum (some species) (STONECROP, SEDUM)	Varies	●	●		●				●
Silene schafta (MOSS CAMPION)	Tufty				●				
Sutera cordata (GROUND COVER SUTERA)	Carpeting								●

WINTER

NAME OF PLANT	Growth	Yellow	Orange	Red	Pink	Blue	Mauve	Purple	White
Arctotis cultivars (ARCTOTIS)	Trailing	●	●	●	●		●	●	●
Aurinia saxatilis (YELLOW ALYSSUM)	Mound	●							
Bergenia cordifolia (BERGENIA)	Clump				●				
Carpobrotus species (HOTTENTOT FIG, SOUR FIG)	Trailing	●					●	●	
Crassula multicava (FAIRY CRASSULA)	Mound				●				●
Dianthus species and cultivars (PINKS)	Tufty			●	●		●	●	●
Erica (some species) (HEATHER)	Mound				●			●	●

NAME OF PLANT	Growth	Yellow	Orange	Red	Pink	Blue	Mauve	Purple	White
Gazania species and cultivars (GAZANIA)	Varies	●	●						
Helleborus species (CHRISTMAS OR LENTEN ROSE)	Clump				●	Green			●
Kalanchoe blossfeldiana (RED POSY)	Mound			●					
Iberis sempervirens (EVERGREEN CANDYTUFT)	Hummock								●
Lantana montevidensis (CREEPING LANTANA)	Carpet or mound						●		
Osteospermum species (TRAILING DAISY)	Trailing						●		●
Verbena species (VERBENA)	Trailing			●	●		●	●	●
Viola species (VIOLET)	Varies				●		●	●	●

III

Part III
Descriptions and Culture

Low-growing forms of Arctotis look charming as an edging
or ground cover (*A. auriculata*).

Descriptions and Culture

ACAENA ACENA

DESCRIPTION: A genus of about a hundred species of hardy perennials some of which are of ornamental value for most months of the year. The top growth dies down during the winter months and reappears early in spring. The species described are native to New Zealand. They have dainty much-indented leaves which either spread flat over the soil or combine to form mounds or hummocks of growth. The foliage is often prettily coloured as well as being attractive in form. The flowers are insignificant but they are followed by globular burrs in summer which are not unattractive. As the stems elongate the plants tend to form new roots and spread out. The height of a well-grown plant is 20–30 cm and its spread will be 45 cm or more. The following are the names of some of the most attractive species: *A. adscendens* (bronze leaves); *A. affinis* (blue-grey leaves); *A. anserinifolia* (grey leaves); *A. buchananii* (jade-green leaves); *A microphylla* (bronze leaves); and *A. novae-zelandiae* (green leaves).

CULTURE: Acena can be grown from seed but quicker results will be had by purchasing rooted plants from a nursery. Set them 45–60 cm apart in good soil and water well until growth is established. They stand severe frost and when well rooted will also endure fairly long periods with little water.

ACHILLEA TOMENTOSA WOOLLY YARROW

DESCRIPTION: A care-free plant which is only too ready to grow. Its fernlike, olive-green and somewhat hairy leaves make a mat on the ground, and in the summer it bears flat clusters of little golden flowers which show up beautifully against the colour of the leaves. Shear the flowers off as they fade to keep the plant looking neat and tidy. Plant it anywhere in the garden as a cover to the ground or grow it in clumps in a rock garden or in rows as an edging. *A. ageratifolia* is another decorative species similar in growth but with grey leaves and clusters of showy white daisies 2–3 cm across.

CULTURE: Yarrow grows in alkaline or acid soil and in full sun or partial shade. It stands frost and fairly long periods with little water. Although it is not fussy about soil conditions the leaves look prettier on plants grown in reasonably good soil. Space plants 20 cm apart.

ACORUS GRAMINEUS 'Variegatus'

DESCRIPTION: This is a grass-like plant which has slender tapering leaves rising to 20 cm. They grow in dense tufts and are of a pretty apple-green striped with ivory. Planted in clumps it is effective at the side of a pool or forming part of a pattern-bedding scheme. The flowers are insignificant.

CULTURE: Stands severe frost but wants an abundance of water to keep the leaves looking verdant. Will grow happily in a boggy spot. Plant 20 cm apart in well-prepared soil to encourage its spread.

AETHIONEMA AETHIONEMA

DESCRIPTION: The genus includes some decorative evergreen perennials and small shrubs which can

46

make an impressive sight when closely planted to form a cover to the ground or when grown separately as specimen plants in the rock garden or towards the front of a shrub border, or on a bank or wall. Most of them are native to the Mediterranean littoral.

CULTURE: They stand severe frost but not long periods of drought. Plant them in good, well-drained soil in full sun or in filtered shade. They flower in late winter and early spring and should be watered well at this time of the year. To keep plants neat shear off the fading flowers.

A. cordifolium 'Warley Rose'
Makes a delightful show in spring when it bears its massed heads of rose-pink to cyclamen flowers which look somewhat like those of candytuft. They show up well against the greyish-green of the leaves. It grows to 30 cm in height and spreads across 60 cm.

A. grandiflorum
Is native to the Lebanon and Turkey. It grows to only 15 cm in height and spreads across 45 cm. The stems are soft and covered with grey-green leaves. The flowers of palest pink arranged in domed heads about 4 cm wide make a charming sight in spring.

A. pulchellum
Is similar in many ways to the above but is more compact in habit of growth and has smaller leaves. The flowers are of a rich rose-pink colour.

AJUGA REPTANS BUGLE FLOWER
DESCRIPTION: Is grown for its neat carpet of lustrous leaves which hug the ground closely. They are smooth, rounded and dark green in colour. In spring, when it produces its dainty little spikes of blue-mauve flowers it is even more delightful than during other seasons of the year. Cultivars with more colourful foliage are: 'Atropurpurea', which has leaves suffused with deep purple; 'Metalica' with leaves having a metallic sheen, and 'Variegata', which has leaves marked with cream and greyish-green. Ajuga is a good plant for the rock or pebble garden, for crevices between paving stones, and as a ground cover under trees.

CULTURE: Spreads fairly rapidly if planted in soil rich in humus. Plant the root sections at any time of the year, spacing them 20 cm apart. This little plant does best in shade or partial shade. Although

it will survive fairly long periods with little water the leaves do not look attractive unless the plant is watered regularly. Thrives in regions with cold winters provided it does not become too dry.

AKEBIA QUINATA AKEBIA
DESCRIPTION: This vigorous climber, native to Japan and China, is very willing to grow and is a useful ground cover for the large garden or park and for roadside planting. The leaves are oblong-oval, notched at the tips and carried in fives. Their size is variable, depending on soil and situation, but they are usually 4–8 cm long and of a deep green hue. The flowers which appear in spring are not showy. They are followed by ovoid fruits 5–10 cm in length which are edible but not very tasty.

CULTURE: Akebia stands frost but does not do well if allowed to remain dry for long periods. It is evergreen except in very cold regions. Cut back established plants every two or three years to encourage fresh new basal growth and to restrain the spread of the stems. A single plant will soon cover a square metre of soil.

ALTERNANTHERA BETTZICKIANA
ALTERNANTHERA
DESCRIPTION: A quick-growing plant which reaches a height of 20–30 cm. Its flowers are insignificant but the leaves are prettily tinged with pink, rose and yellow. It makes a pleasing ground cover and is also ornamental as a miniature hedge, forming a border to a bed of flowers or roses. To encourage good basal growth and keep the plants neat, trim them back from time to time. When grown as a hedge cut regularly, to keep it compact. How often it needs to be cut will naturally depend on the rate of growth, which is faster during the warm months of the year than during autumn and winter.

CULTURE: Plant roots 20 cm apart for a ground cover and about 10 cm apart to form a low hedge. It grows in full sun and in poor soil but the foliage is more luxuriant on plants growing in good soil. Tolerates mild frost but severe frost will kill the roots.

ANTHEMIS ANTHEMIS, CHAMOMILE
DESCRIPTION: The genus includes two rewarding ground covers which are widely different in

Aethionema, when clothed with a myriad flowers, is a glorious sight. It likes cold.

Grow Anthemis (*A. cupaniana*) to cover a rocky bank or as a border to shrubs or roses.

Hybrid Arctotis are used in many countries of the world to highlight the garden in spring.

manner of growth and are therefore described below.

CULTURE: Plant them in full sunshine or partial shade, in soil enriched with compost. Both species will grow fairly well even in poor soil but much better results will be had if the soil is improved. Once established they survive severe frost and they will also tolerate fairly long periods with little water.

A. cupaniana ANTHEMIS
A shrubby plant with attractive mounds of silvery foliage. It spreads across 60 cm and reaches a height of 30 cm. This species, which is native to Italy, makes a pretty sight spilling over a bank, interplanted with colourful flowers at the front of a border, in a rock garden, or edging a rose garden. Dainty white daisy-like flowers appear in spring, and on and off during other seasons, too.

A. nobilis CHAMOMILE
(*Chamaemelum nobile*)
A prostrate plant which is sometimes used as a substitute for grass, but it tends to die off if walked on a great deal. It forms a spreading, ground-hugging mat of small, bright green, finely-cut aromatic leaves, and it roots itself readily as it grows. In summer small white daisy flowers appear in masses. If the top-growth becomes untidy or spongy mow or shear it off. It is said that this was the plant used for the bowling green on which Drake was playing when the Armada was sighted! Set plants 10–20 cm apart.

ANTIGONON LEPTOPUS CORAL CREEPER,
 QUEEN'S WREATH, HONOLULU CREEPER
DESCRIPTION: A delightful plant which is generally grown as a climber. Planted at the top of a bank or retaining wall it will spill down over the slope making a decorative picture as a ground cover. The leaves are arrow- or heart-shaped, soft in texture and of a pleasant shade of mid-green. In summer when it bears its charming shrimp-pink flowers it is a joy to behold.

CULTURE: Coral creeper is quick in warm areas but slow to establish itself in cool regions. It wants an abundance of sun and tolerates fairly long periods with little water but not severe frosts. In gardens where frost does not cut it back it is advisable to trim the tip-growth in late winter or early spring to prevent the plant from ranging too far and wide. Set plants 2 m apart.

APTENIA CORDIFOLIA APTENIA

DESCRIPTION: A quick-growing, semi-succulent, which runs along the ground making a delightful carpet with its sparkling dark green leaves and glistening stems. It is a good plant for a dry bank as it grows quickly with little attention. Small scintillating flowers of bright cyclamen appear for a short time in spring and summer. The plant is grown for its foliage rather than for the flowers.

CULTURE: It grows well in sandy, windswept seaside gardens and inland where frosts are not severe. Plant it in well-drained soil and in full sun, setting the plants about 30 cm apart for quick cover. Should plants show signs of deteriorating it is easy to root cuttings to replace old plants.

ARABIS ALBIDA ROCK CRESS

DESCRIPTION: This is a charming ground cover which makes a delightful display in spring when it bears a profusion of white, pink, or lilac flowers. It is a compact plant with small greyish-green rosettes of leaves forming a neat carpet over the ground. Arabis is pretty in the rock garden, when planted between bulbs, or on a bank or wall. The cultivar 'Flore Pleno' has double flowers and 'Variegata' has leaves edged with creamy white.

CULTURE: Propagate from seed or root division, and set plants about 30 cm apart, in light shade. It likes cool to cold winters, regular watering and soil rich in humus. It is unlikely to do well where winters are warm or the air dry for long periods.

ARCTOTHECA POPULIFOLIA SAND DAISY

DESCRIPTION: A South African perennial which is of value in seaside gardens. It grows naturally along the beach forming a carpet of stems and leaves across the sand. The foliage is of more ornamental value than the flowers. The leaves are variable in shape – triangular or lobed, and they have a white to silver covering which is more definite on immature leaves and on plants which do not receive much water.

CULTURE: This plant is recommended for coastal areas not only because of its decorative worth but also because, if thickly planted, it will help to reduce dune erosion. It stands long periods of drought and salt-laden wind.

ARCTOTIS TRAILING ARCTOTIS

DESCRIPTION: There are several decorative species of arctotis to be found growing wild in the drier parts of South Africa. Some of them are annuals, others are perennials. Of the perennial forms the cultivars of *A. acaulis* and *A. stoechadifolia* are amongst the best to use as a ground cover. They produce trailing stems of grey-green leaves with indented margins. These are effective spreading across the ground or spilling over a wall or a dry bank. From late winter to mid-spring, when the flowers appear, they will transform the garden into a kaleidoscope of colour. The daisy-like flowers are 7–10 cm across, and many of them have dazzling bands of different colours which make a strong contrast to the colours of the flowers. Orange flowers may be banded with mahogany; terra-cotta with ochre; lime-yellow with gold; cyclamen with chocolate; lavender with maroon. *A. auriculata* is a charming species with trailing stems of silver-grey leaves and a mass of enchanting flowers in lovely colours, ranging from pastel yellow to ochre and umber.

CULTURE: Although they are perennials, the plants are at their best only for a year or two and, as they grow very readily from seed, it is advisable to raise new plants every other year. Sow seeds in March or make cuttings from established plants in spring. Set plants 40 cm apart. They stand fairly sharp frost and also periods of dryness in summer, but require water in autumn and winter to encourage good flowering. *A. stoechadifolia* is widely used in gardens along the southern coast of Australia.

ARENARIA SANDWORT

DESCRIPTION: Low evergreen plants with moss-like foliage which makes a dense carpet. Pretty little white flowers appear in spring and, under optimum conditions, will make a delightful show. Grow the plants between paving stones or at the front of a border, or to hang over the edge of pots in which other plants are growing. The three species worth trying are: *A. balearica* which has minute glossy leaves scarcely 3 mm long, *A. grandiflora* with pointed bright green leaves and funnel-shaped flowers, and *A. montana* which has greyish-green leaves 10–20 mm in length and flowers which look like miniature morning glories. These plants tend to hug the ground.

CULTURE: *A. balearica* and *A. grandiflora* do best in cool gardens and in partial shade, and require plenty of water. *A. montana* grows in part shade and will do with less water. They tolerate frost but not dryness at the same time. Plant roots about 10 cm apart.

Armeria (*A. caespitosa*) is an ornamental plant for the rock or pebble garden or as a border.

ARMERIA THRIFT, SEA PINK

DESCRIPTION: A hardy evergreen with stiff narrow leaves produced in compact tufts which cover the ground throughout the year. In spring, when the plants bear their flowers, they make a really fine show. The flowers, of pretty shades of pink to deep rose and white, are carried in little globular heads on stems 15–20 cm high. Thrift looks attractive anywhere in the garden – along the edge of a path or border, around beds of roses, or in a rock or pebble garden. The three species worth growing are *A. caespitosa*, *A. corsica* and *A. maritima*. There are also several attractive cultivars of these.

CULTURE: Plant root sections 30 cm apart in autumn or sow seed in late spring or in early summer. They grow in any ordinary garden soil but appear to prefer well-drained soil to a sticky clay. Thrift will survive severe frost and a certain degree of dryness. Shear the flowers off as they fade, to conserve the strength of the plants and to keep them neat. They do well in coastal gardens.

ARTEMISIA SCHMIDTIANA 'Silver Mound' ANGEL'S HAIR

DESCRIPTION: Is an attractive plant of compact habit. It forms a mound of growth reaching a height of 20 cm with a spread of about 30 cm. The foliage is graceful, fernlike and of a delightful silvery-grey hue. Close-planted it is most effective in a pattern-bedding scheme or as an edging or ground cover. The cultivar 'Nana' is similar but somewhat smaller in size.

CULTURE: This is an accommodating plant, tolerant of a wide range of conditions. It grows well even in poor soil and stands both frost and drought. After a few years the plants may become somewhat leggy. Should this happen propagate new ones from cuttings made in spring or summer to replace the old ones.

ASPARAGUS DENSIFLORUS BASKET
(*A. sprengeri*) ASPARAGUS

DESCRIPTION: A shrubby South African plant which has long been popular in many countries of the world for growing in hanging-baskets or pots. It is ornamental also when planted in the garden either between shrubs, such as fuchsias and azaleas, or as a background to low-growing plants. The flowers are of no consequence since they make no show, but the foliage is decorative

Aubrieta is an enchanting picture in late winter and early spring. It likes cool conditions.

throughout the year. The leaves are as small as those of yew and of a delightful mid-green colour. The stems arch over in a graceful fashion and the plant, which spreads across 60–90 cm, may send its stems up to a height of 30–45 cm.

CULTURE: Plant root sections in good soil in shade or part shade. This ornamental asparagus will survive up to 5° of frost, but where winters are cold, it is advisable to mulch the ground over the roots to limit frost damage. Water during dry periods of the year.

ASPERULA ODORATA SWEET WOODRUFF

DESCRIPTION: This little plant is native to the colder parts of Europe. It grows to 20 cm in height and bears whorls of rich green linear leaves on slender stems. Unfortunately the top-growth dies down in winter, but the leaves and flowers make it a worthwhile ground cover for most of the year. In late winter and early spring it carries charming heads of little starry white flowers with a sweet fragrance. It spreads rapidly and could become a nuisance under conditions most favourable to its growth.

CULTURE: Woodruff needs a cool moist place in the shade and is ideal for woodland planting where the soil does not dry out. Severe frost does not harm it but dryness inhibits growth.

ASTERANTHERA OVATA ASTERANTHERA

DESCRIPTION: A climbing plant from Chile recommended only for those gardens where the growing conditions suit it, as this plant is unlikely to adapt and flourish unless planted in the right soil and situation. It is an evergreen with oval leaves of mid-green and flowers of luminous ruby-red which make a splendid show in spring. The flowers are tubular at the base, opening to a starry face. If there is no support to which it can attach itself it will spread out over the ground making a pretty carpet.

CULTURE: Asteranthera requires damp woodland conditions and acid soil. It stands cold but no dryness. For quick cover plant 60 cm apart.

AUBRIETA DELTOIDEA AUBRIETA

DESCRIPTION: A carpeting plant which is at its best in spring when it bears myriads of starry flowers, which are so lovely that, where soil and climate are suitable, it should be grown. It forms

The flowers of Yellow Alyssum (*Aurinia saxatilis*) show up well against its grey-green leaves.

In winter Bergenia becomes gay with flowers which are pretty in the garden and in arrangements.

Bougainvillea can be trimmed and trained to form a colourful ground cover for the large garden.

a mat of small, soft, grey-green leaves which are a perfect background to the mauve, pink, purple or carmine flowers. The plants look splendid draped over a wall, set between rocks or paving stones, as a ground cover along the front of a border, or as an edging to beds of roses. The cultivar 'Aurea' has leaves edged with yellow, and 'Variegata' has leaves edged with white. There are many other cultivars of merit.

CULTURE: Grow from seed sown in early summer, or cuttings made at the same time of the year. Set plants 20–30 cm apart in good soil. Aubrieta does best in regions with cool to cold winters and is not recommended for subtropical gardens. It appears to thrive in alkaline or acid soil. Water this plant throughout the year and particularly well whilst it is producing new shoots and flowers, as dryness in the root area is likely to kill it.

AURINIA SAXATILIS — YELLOW ALYSSUM,
(*Alyssum saxatile*) — BASKET OF GOLD

DESCRIPTION: Should not be confused with the annual white or mauve alyssum. This is a delightful plant to have cascading over a wall, growing along the front of a flower border, as a carpeting plant in a bed of roses, in a rock garden, between the paving stones of a patio or path, or between spring-flowering bulbs. It has grey-green leaves and masses of tiny flowers of daffodil-yellow in spring. The plant spreads forming a mound of leaves, 30–60 cm across and 20 cm high. The cultivar 'Citrinum' has pale lemon flowers, and 'Flore Pleno' is a double form. Interplant them with forget-me-nots or daffodils.

CULTURE: It enjoys frosty conditions and does better in cool gardens than in regions of mild winters. Plant in soil rich in humus and water well during the dry months of the year. Grows in full sun or part shade. New plants can be raised from seed sown in spring or early summer, or from cuttings or root sections. Set plants 30 cm apart for mass effect.

BARLERIA OBTUSA — BARLERIA
DESCRIPTION: Is a scandent African shrub. It has stems which sprawl along the ground rather elegantly, unless it finds a neighbouring shrub to embrace and use as a support. It is evergreen and makes a pretty ground cover in a large garden, massed on a bank or along the front of a shrub border. Trim the plants in winter or early spring

to keep them neat and compact. Its mauve flowers make a fine show in late summer and early autumn.

CULTURE: Grows quickly in any soil and in sun or partial shade. Does well in seaside gardens and stands moderate frost. It looks its best if watered regularly during dry months of the year.

BERBERIS — BERBERIS
DESCRIPTION: The genus includes a wide range of attractive shrubs. Those described here as ground cover plants do not grow very tall, and by pruning in winter they can be kept as low as 30 cm.

CULTURE: Berberis enjoy frost and, once they are established, they endure fairly long periods with little water. They are not recommended for subtropical gardens. Cultivars with coloured leaves should be planted in full sun as they do not colour well in shade. If grown to form a low hedge trim plants in winter.

B. stenophylla 'Nana'
A small compact evergreen which grows to a height of about 40 cm and has a spread of 40–60 cm. If clipped regularly, it makes a neat low hedge, and it is also ornamental as a ground cover or border in front of a shrubbery or around beds of roses. It has pretty golden-yellow flowers in spring.

B. thunbergii 'Atropurpurea Nana'
Is another small form worth growing. Since it is deciduous it does not hide the ground throughout the year, but the tiny leaves of rich burgundy make a fine show for nine months of the year. Set plants 45 cm apart and trim them regularly to make a dense ground cover for a large area. It makes a lovely dwarf hedge. 'Crimson Pygmy' is another splendid cultivar of low bushy growth with colourful leaves – excellent mass-planted, as a ground cover or as a border to a drive. *B. thunbergii* 'Aurea' is recommended for its lime-yellow leaves.

BERGENIA CORDIFOLIA — BERGENIA
DESCRIPTION: Has large and attractive leaves up to 20 cm in length, which are much broader at the apex than the base. They are conspicuously veined and effective as a ground cover throughout the year. The plant is particularly handsome in

late winter and early spring when it bears its oval heads of small candy-pink flowers on thick stems 20–30 cm long. The flowers have the additional merit of being suitable for arrangements. *B. cordifolia* 'Purpurea', B. 'Sunningdale', and B. 'Ballawley' are equally good and worth trying, but these are not readily available from nurseries.

CULTURE: The plants grow from woody rhizomes. Plant them at any time of the year, just below the surface, in good soil, setting them about 30 cm apart. They spread slowly, and look best when planted in clumps. In hot inland gardens grow them in partial shade and water regularly during dry periods of the year. Near the coast they do well in full sun or part shade.

BOUGAINVILLEA BOUGAINVILLEA

DESCRIPTION: Bougainvilleas have been grown as climbers for many, many years, but it is only recently that enterprising horticulturists have experimented and proved that these showy plants can be used to great effect as a ground cover. Because of their vigorous growth they are suitable as ground cover only in the large private garden or public park and for street and roadside planting. When being grown as a ground cover they should be supported just above ground level as the plants do not flower well if the stems are pegged to the ground. A frame can be made by stretching strong wires taughtly between posts projecting 30 to 60 cm above the ground, or by fastening chicken netting onto a frame of galvanised tubing, the same height from the ground. To keep the plants neat and compact train and tie the developing shoots to the wires or netting, and trim them when necessary. A large frame covered by bougainvilleas of different colours is an arresting sight. There are now hundreds of named cultivars from which to make a selection, varying in colour from white through ivory and all shades of pink to rich coral-reds, plum and royal purple.

CULTURE: Bougainvilleas do best in areas where the sunlight is bright and winters are mild. They do well in dry regions, provided they are watered from time to time, and they flourish also in hot humid districts. Established plants will tolerate drops in temperature to −3 °C. Slightly lower temperatures may cut back the newer growth but the roots remain unaffected by moderate frost. For a Persian carpet effect set the plant 2 m apart and interlace some of the stems as they grow, removing the surplus ones at the base.

BRUNNERA MACROPHYLLA BRUNNERA
(*Anchusa myosotidiflora*)

DESCRIPTION: This is a herbaceous plant which dies down for about three months each year. It has round heart-shaped leaves up to 15 cm across which form clumps of green, and in spring it becomes a frothy mass of tiny pure blue flowers – like those of a forget-me-not. Grow it at the front of a shady border of azaleas, fuchsias or hydrangeas, or between bulbs. There is also a lovely but rare variegated form with leaves marked with white.

CULTURE: This plant needs cool, damp, shady conditions and soil rich in leaf mould (humus). It grows from seed sown in spring or late summer and, under optimum conditions, will re-seed itself and increase from year to year. Root sections should be planted in autumn. Set plants 30 cm apart.

BULBINE CAULESCENS BULBINE

DESCRIPTION: A hardy South African plant which makes a thick mat of leaves over the ground, rooting as it spreads. It is, however, not so vigorous as to become a pest. The succulent leaves are short and cylindrical. From mid- to late spring it bears conical heads of dainty, lemon-yellow flowers on stems 30 cm high. It is not a very decorative plant but it is of value in gardens where heat and aridity limit the range of plants which can be grown.

CULTURE: Plant the roots 30 cm apart in autumn. This bulbine grows in any kind of soil, in sun or part shade, and tolerates fairly long periods with little water, and sharp frosts.

CALLUNA VULGARIS SCOTCH HEATHER, LING

DESCRIPTION: Is a bushy evergreen plant which grows to a height of 60 cm with a spread of a little more. It has very small dark green leaves and sprays of tiny flowers which may be white, rosy pink or purple. The flowering time is spring to early summer. There are some charming cultivars of more compact form which are suitable for small gardens. Plant them about 30 cm apart. 'Aurea' has leaves which are yellow in summer and russet in winter; it is grown for its foliage rather than for the purple flowers which are not very pretty. 'Blazeaway', 'Golden Feather' and 'Sunset' are three others worth growing for the colour of the foliage. 'County Wicklow' has leaves of mid-

green and double pink flowers; 'Foxii Nana' has dark green leaves and purple flowers; 'J.H. Hamilton' bears deep green leaves and double pink flowers; 'Mullion' is a compact plant, barely 30 cm across, with mid-green leaves and rosy-purple flowers; 'Nana' is only 20 cm in spread and has dark green leaves and purple flowers.

CULTURE: These heathers, which flourish in poor soil and exposed situations in their native habitat, are tough plants, but they can be grown successfully only where the soil is distinctly acid. Extremes of cold and even dryness for limited periods does not kill them, but lime in the soil will. They are therefore suitable only for gardens where the soil is naturally acid and where the drainage is good. The addition of peat to the soil will encourage growth. Trim plants back in late summer to keep them neat.

CAMPANULA BELLFLOWER

DESCRIPTION: The genus includes many beautiful plants – some tall-growing and others of modest stature. Only four of the low and spreading species are described here. Massed, they make a pretty cover to the ground anywhere in the garden where soil and situation are right for them. They have attractive leaves and delightful flowers in spring.

CULTURE: Plant them 30-45 cm apart in soil rich in humus in partial shade. These plants enjoy cool to cold growing conditions and plenty of moisture. In cold areas the foliage dies down for some weeks, but it is decorative for most of the year. Not recommended for subtropical or dry gardens.

C. carpatica CARPET BELLFLOWER

Has ovate bright green toothed leaves growing in compact tufts, and funnel-shaped flowers o jacaranda-blue on wiry stems 20 cm high. It creates a delightful picture spilling over a bank or wall, or growing in clumps in front of azaleas and fuchsias. It grows readily from seed sown in spring or early summer. There are some fine cultivars which should be propagated by root division or cuttings.

C. garganica

A species from Greece and Italy which grows to 20 cm and spreads across 40 cm. It has soft kidney-shaped leaves with rounded teeth and clusters of starry-faced blue flowers in masses in late spring.

C. portenschlagiana DALMATION BELLFLOWER
(C. muralis)

Grows to about 10 cm in height and makes a billowy ground cover. It creeps along, rooting underground. The leaves are rounded, heart-shaped at the base and deeply toothed. In spring a profusion of lovely lavender-blue flowers hide the leaves. They are bell-shaped and 2–3 cm long. This is a delightful plant for edging a shady bed or for growing between paving stones on a shady terrace.

C. poscharskyana

Is native to Dalmatia, too. It reaches a height of 30 cm and spreads across 60 cm. The rounded, sharply-toothed leaves are of a pretty shade of mid-green. In spring it bears myriads of small starry lavender-blue flowers in dainty sprays. 'Stella' is an exceptionally pretty cultivar.

CARISSA GRANDIFLORA cultivars
DWARF AMATUNGULU

DESCRIPTION: The species is a South African shrub grown in warm coastal gardens in many parts of the world. Recently fine cultivars of dwarf habit have been evolved in the U.S.A. These make good ground covers – particularly for coastal gardens. The cultivars have the characteristic leathery and slightly glossy leaves and white flowers of their progenitor but they grow to only 60 cm in height and tend to spread out laterally. 'Green Carpet' has small leaves on a plant 60 cm in height and a metre across. 'Horizontalis' has trailing stems of densely arranged leaves. 'Prostrata' produces more side than top growth and spreads across a metre.

CULTURE: They do well in seaside gardens and inland where temperatures are never below freezing. They can take a certain amount of salt spray and wind, and do reasonably well in sandy soil, but grow much more quickly in soil to which humus has been added. Established plants are tolerant of fairly long periods with little water. Set plants one metre apart and trim off excessive top-growth to keep them low and spreading.

CARPOBROTUS SOUR FIG AND OTHERS

DESCRIPTION: Five species which grow wild in South Africa are included here. These plants are eminently suitable for large country gardens, or to act as a ground cover to prevent the erosion of

soil along highways and railway embankments, inland or near the coast. They are not recommended for suburban gardens where space is a limiting factor. Carpobrotus have sturdy stems which root as they grow and produce fleshy, succulent cylindrical leaves up to 12 cm in length, often with angled edges. In late winter and early spring the plants bear spectacular flowers. They have slender, scintillating petals with the texture of fine silk, surrounding a central boss of fluffy stamens.

CULTURE: These plants are tough and require no coddling. They root readily from stem sections and will spread rapidly in poor sandy soil and where little water is available. They stand moderate frost. Plant a metre apart in well-drained soil and in full sun.

C. acinaciformis GOUNA OR HOTTENTOT FIG
Has large flowers of rich magenta. The plant spreads quickly and is a good species to use to stop the drift of coastal sand.

C. deliciosus SOUR FIG, GOUKUM
Grows well on coastal dunes. Its fruit was used by early settlers for making a jam or relish. The flowers are magenta to purple.

C. edulis GOUNA
Bears flowers of a rich straw colour. For many years it has been grown in the south of England, where it is known as Sally-my-handsome.

C. muirii
Has smaller leaves which form a compact mass and is therefore a better ground cover than the other species. The flowers, 6 cm across, have glittering amethyst petals.

C. sauerae
Produces huge glistening flowers of cerise or magenta. Its fleshy leaves will cover the bare earth very quickly. A form of this one, with pale pink to straw-coloured flowers is sometimes referred to as *C. quadrifidus*.

CEANOTHUS CEANOTHUS, WILD LILAC
DESCRIPTION: Many gardeners are familiar with the tall-growing shrub known as ceanothus. There are, however, some small, almost prostrate-growing species and cultivars which make a pleasing ground cover in the large garden. In a warm climate they are evergreen but where

Carpobrotus (*C. acinaciformis*). A useful plant for large gardens and the roadside.

This Sour Fig (*Carpobrotus sauerae*) will help to stop erosion and the drift of sand.

The low-growing type of Ceanothus (*C. thyrsiflorus repens*) forms a neat cover to bare ground.

winters are cold they may lose most of their leaves. The dark green leaves are small and neat, and the tiny flowers of shades of blue, mauve or purple, are carried in showy heads.

CULTURE: All of these ceanothus are native to California and they do best in regions which tend to be dry or fairly dry in summer and wet in winter. Where summer rains are heavy they may die off after a couple of years unless the soil is well drained. They are lime-tolerant, do fairly well in coastal gardens, and are hardy to frost. Plant them 40–90 cm apart to form a dense cover.

C. divergens

Grows to about 30 cm in height and spreads across a metre. It forms a hummock of growth of small dark green glossy leaves and has grey-blue flowers.

C. gloriosus

Reaches a height of 30–60 cm and spreads across a metre or more. The small dark green leaves are leathery with spiny margins. In spring it bears clusters of lavender-blue flowers.

C. prostratus SQUAW CARPET
Forms a dense mat of tiny, leathery, dark green, wedge-shaped leaves and bears bright blue flowers in spring.

C. thyrsiflorus repens CREEPING BLUE BLOSSOM
Makes a low mound of dark green across the ground and becomes attractively studded with pale to deep blue flowers in spring.

CENIA SERICEA CENIA
DESCRIPTION: Is a small South African perennial which is charming when young. Old plants tend to become woody. The dainty filigree of soft little leaves forms a most attractive background to the small yellow button-like flowers which stand well above them. Mass-planted it makes a very pretty ground cover, particularly in spring and summer, when it flowers.

CULTURE: This cenia can be found growing wild in regions with cold winters and near the coast. It appears to be tolerant of sharp cold and arid conditions, but the foliage has a more luxuriant appearance if the plants are watered regularly during dry periods of the year. When plants become woody cut them back hard or replace them with new ones. Cenia does well in coastal gardens and inland. Plant 30 cm apart.

CEPHALOPHYLLUM MESEM, ICEPLANT, VYGIE
DESCRIPTION: These showy plants, which are found growing wild in the drier parts of South Africa, are still generally referred to as mesembryanthemums or vygies. They are splendid plants for colour in spring. Plant them along a drive, as a ground cover on a dry bank, in pots or window-boxes in a sunny position, or in a rock garden. The flowers open only when the sun is bright and they do not, therefore, make a good show in shady gardens. The stems and leaves are succulent, slender and cylindrical. The flowers, which appear from late winter to mid-spring, have glistening petals which reflect the sunlight and make a splendid show. The plants root themselves as they grow and require little attention. The following species are worth trying: C. alstonii sprawling, with spectacular rich wine-red flowers; C. anemoniflorum has white flowers edged with blush-pink; C. aureorubrum tufty, with yellow to rose flowers; C. baylissii a compact plant with lavender flowers; C. bredasdorpense is prostrate in growth with flowers of sulphur-yellow; C. ceresianum a prostrate, yellow-flowering species; C. cupreum is low in growth with apricot to copper flowers; C. gracile a mat-forming species with magenta flowers; C. pillansii tufty, with yellow flowers; C. procumbens a low-growing, trailing species with flowers of a delicate shade of yellow; C. spongiosum has long, trailing, fleshy stems and splendid luminous cyclamen flowers with a bright yellow centre; C. subulatoides is almost prostrate with large magenta flowers; C. tricolorum has trailing stems and yellow flowers.

CULTURE: These plants thrive in bright sunlight and in well-drained soil. They can remain quite dry almost throughout the year but produce a better show of flowers if watered occasionally from autumn to spring. Can be grown from seed but much quicker results will be had by rooting pieces of stem during the warmer months of the year. Set plants 40 cm apart.

CERASTIUM TOMENTOSUM
 SNOW-IN-SUMMER
DESCRIPTION: A delightful carpeting plant which is popular in many countries. It romps along happily and a single plant may cover a 30 cm square in a year. Its tiny silver-grey leaves, only 15 mm long, make a dense mat which hides the bare earth, and in spring it becomes studded with

masses of small starry white flowers. Use as a ground cover on level ground, to cover a bank or to spill over a wall. The grey of the leaves shows up beautifully cascading over a red brick wall. It is pretty also in a rock garden or as an edging to paths, rose-beds or driveways, in front of a shrubbery and between paving stones. Although the plant roots as it grows, it is easy to keep under control.

CULTURE: Grows in sun or part shade and in dry ground. Too much water or ill-drained soil may cause root rot. It tolerates frost and heat. Plant root sections at any time of the year 20–30 cm apart. Should it look tatty, shear off the top growth and fertilise with a general garden fertiliser.

CERATOSTIGMA PLUMBAGINOIDES
DWARF PLUMBAGO

DESCRIPTION: A shrublet from China which is useful as a ground cover in front of a group of shrubs, around a bed of roses, or along a drive. It grows to 30 cm in height, and 60–90 cm across. The plant may root as it grows and eventually cover a big area. The wiry stems, loosely clothed with soft green leaves, are at their best in late summer and early autumn when the leaves turn bronze to crimson and little gentian-blue flowers appear. Shear off plants which become straggly to encourage fresh new basal growth, or remove old plants and replace with younger ones which have formed.

CULTURE: It grows well in sun or part shade and, when established, tolerates severe frost and fairly long periods with little water.

CHEIRIDOPSIS

DESCRIPTION: The genus includes decorative plants for desert conditions. They have fleshy cylindrical or angled leaves of ash-grey to pale greyish-green which grow in tufts or mats, and brighten the ground in dry regions, or in areas where the soil is too alkaline for many other plants. The leaves have a pleasing, perky appearance, and in late winter to spring it produces quite sensational flowers with petals as fragile as spun glass, and with a scintillating lustre. *C. candidissima* has pink or yellow flowers; *C. cuprea* bears flowers of coppery tones and *C. turbinata* has flowers of lemon-yellow.

CULTURE: Plant them 30 cm apart in sandy soil and in full sunshine. They stand fairly hard frosts but they will not tolerate wet feet for long periods. They make a pretty show when planted in pots.

CHIRONIA BACCIFERA CHRISTMAS BERRY

DESCRIPTION: A shrubby South African perennial which deserves to be better known and more widely grown. It forms a little mounded bush of soft stems covered with tiny mid-green leaves which make an effective cover to the bare ground. In summer it bears a profusion of small cyclamen to pink flowers. They are followed by showy scarlet berries in autumn. This plant is pretty, massed as a ground cover along the front of a border, on a bank, or in a rock garden.

CULTURE: Can be propagated from seeds, cuttings or by the division of roots. Set plants 30–45 cm apart in well-drained soil. It does better in coastal gardens than in hot dry inland ones, is tolerant of mild frost and grows in full sun or part shade. It is advisable to renew plants every three to four years.

CHLOROPHYTUM COMOSUM 'Variegatum'
HEN AND CHICKENS, SPIDER PLANT

DESCRIPTION: Forms a good ground cover under trees as the variegated leaves show up well in the shade. The leaves are very narrow and tapering, almost grass-like, about 3 cm wide at the base and 30 cm long. They grow in tufts, arching over at the ends. It bears little ivory flowers in summer but these are rather insignificant. The mother plant sends off drooping stems, at the ends of which appear miniature plantlets which can be detached and rooted. The numerous small plants attached to the parent plant no doubt accounts for the common name of Hen and Chickens, and their arrangement in relation to the mother plant, the name of Spider Plant. It is of ornamental value in pots and window boxes as well as in the garden.

CULTURE: Plant the roots at any time of the year in good soil and in a shady place, setting them 30 cm apart. The plants stand drought but look attractive only when watered fairly regularly. They will survive up to 3° of frost.

CINERARIA GROUND COVER CINERARIA

DESCRIPTION: The genus includes two South African perennials which make pleasing ground covers. They look effective in the garden and in containers.

Cephalophyllum (*C. anemoniflorum*). A prostrate plant recommended for gardens in dry regions.

Hen and Chickens or Spider Plant (*Chlorophytum comosum* 'Variegatum') does well in shade.

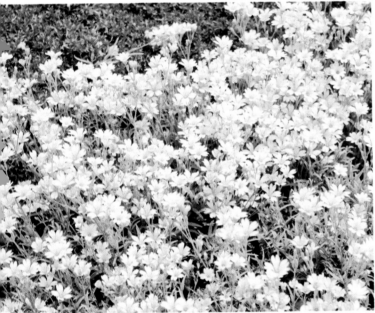

The name Snow-in-Summer aptly describes this plant (*Cerastium tomentosum*) when it flowers.

CULTURE: These plants are not hardy to severe cold and do best where the winters are mild and where they can be watered regularly. Both species are useful for gardens along the seashore as they stand salt-laden wind and will grow in sandy soil.

C. geifolia

Can be found growing in beach sand just above high water mark. The plant sends out trailing stems of leaves which make a pretty carpet over the ground. The leaves, which measure 2–4 cm across, are kidney-shaped with irregularly scalloped edges. They are soft in texture and slightly hairy, and more ornamental than the yellow flowers which appear in winter. Grows in sun or partial shade.

C. saxifraga

Romps along the ground forming a billowy mass of little fan-shaped leaves, soft in texture and bright green in colour. In spring and summer it bears tiny daisy-like flowers, hardly 1 cm across, of daffodil-yellow. This is a pretty and quick-growing ground cover for gardens near the coast and inland where frosts are never more than mild.

CISTUS SUNROSE, ROCKROSE

DESCRIPTION: Although most of the cistus are shrubs too tall to be included under the heading of ground covers, some of them are squat and spreading and therefore useful as a ground cover in large gardens, along a drive, or on a road or railway embankment. The ones described form

A delightful type of vygie or iceplant (*Cheiridopsis candidissima*) which enjoys dry growing conditions.

Lobster Flower (*Coleus neochilus*). Is a quick-growing ground cover for filtered shade.

Conicosia (*C. pugioniformis*) has flowers of fragile beauty and succulent, drought-resistant leaves.

mounds of foliage across the ground and make a pretty show carpeting the ground, or spilling over a wall or bank. Most rockroses have slender leaves and poppy-like flowers in spring. *C. x lusitanicus* 'Decumbens' has dark green leaves and large white flowers with a crimson blotch at the base of each petal. *C. x pulverulentus* (*C. crispus*) has grey-green leaves and bright cerise flowers. There are several cultivars of this species worth trying. *C. salviifolius* is low-growing with sage-green leaves and small white flowers, and 'Prostratus' is a dwarf form.

CULTURE: Rock or sunroses enjoy full sun and well-drained soil. They will endure long periods with little water and 10° of frost. They grow in alkaline soil and do well in seaside gardens as they do not mind wind, sandy soil and a certain degree of salt in the air. To keep plants neat shorten the stems in early summer after they have flowered. Set plants a metre apart. New plants can be grown from cuttings.

Bush Morning Glory (*Convolvulus cneorum*) makes a good ground cover if trimmed to keep it compact.

COLEUS NEOCHILUS

COLEUS, LOBSTER FLOWER

DESCRIPTION: An evergreen South African plant which covers the ground quickly. It can be planted also to hang over a wall or the edges of a large container. The leaves are pale green with serrated edges, and in spring it produces spikes of flowers of mauve to jacaranda-blue. Unfortunately, the plant gives off a pungent smell when touched. Shear off the flowers as they fade and it will produce more in summer.

CULTURE: Does well in shade and will grow right

Plant Ground Morning Glory (*Convolvulus mauritanicus*) to brighten the garden in summer.

up to the bole of fairly large trees. Near the coast it grows in full sun. Plant roots or cuttings 30 cm apart at any season of the year and water until established. Mature plants stand drought and moderate frost.

CONICOSIA PUGIONIFORMIS CONICOSIA
DESCRIPTION: This is a plant for dry gardens. It has succulent pointed, cylindrical leaves about 10 cm long, which come up from near the ground, making tufts of a pleasing mid-green colour. In late winter and early spring it produces numerous yellow flowers on short stems just above the leaves. They are about 4 cm across and made up of very slender pointed segments with a scintillating silky texture. This is a useful and decorative plant for mass effect on a dry rocky bank, or in a rock or pebble garden.
CULTURE: Conicosia grows in sandy or gritty soil with good drainage and tolerates long extended periods of drought and fairly hard frost. It should be watered occasionally in autumn and winter to encourage good flowering. Set plants 30–45 cm apart in full sun. It is easily propagated by root division or by cuttings.

CONVOLVULUS BUSH AND GROUND MORNING GLORY
DESCRIPTION: The name is usually associated with climbers but it embraces two exceptionally lovable plants which are unsurpassed as ground covers when planted in the right places.
CULTURE: They both grow readily in sun or partial shade, at the coast and inland, and they are hardy to moderate frost. Once established they will survive fairly long periods with little water but they look their best only when watered regularly.

C. cneorum BUSH MORNING GLORY
A beautiful shrub with leaves of burnished silver. It is a joy and delight throughout the year and particularly so in spring, when ethereal little white trumpets flushed with pink in the bud, appear above the leaves. Mass-planted in a large garden or park it makes a scintillating ground cover. It can be kept trimmed back to a height of 30 cm, and the spread, which may be a metre or more, can also be controlled by an occasional cutting back. Plant it in good soil to encourage quick growth.

C. mauritanicus GROUND MORNING GLORY
A charming, happy-go-lucky scrambler for gardens large or small. It shows up well as a ground cover on level ground or on steeply sloping banks, and looks attractive tumbling over a wall or the edge of a large container. The slender stems are also pretty when trained up short stakes to create a bushy effect. It has trailing stems which carpet the ground with small, grey-green rounded leaves with a soft texture. Throughout the summer months it is covered with delightful miniature convolvulus flowers of hyacinth-blue. It roots as it grows but is not invasive. Plant 60–90 cm apart.

COPROSMA COPROSMA
DESCRIPTION: A genus of New Zealand shrubs which are well-known and widely planted in gardens where the climate is temperate. They are grown for the beauty of their leaves which are highly glossy, and in some of the cultivars, also attractively variegated. The best of the species are too robust in growth to use as a ground cover but some of the cultivars look effective when grown as such, particularly if the plants are trimmed two or three times a year. *C. repens* (*C. bauerii*) has given rise to pleasing cultivars, the finest of which is probably 'Picturata' which has branches spreading laterally clothed with scintillating leaves of dark green blotched with gold. Peg the stems down to keep the plant prostrate. *C. petriei* is a creeping species which forms a dense mat of leaves along the ground. It is not as attractive as the cultivars of *C. repens* but has the advantage of being hardy to frost. To make a dense cover, peg lateral branches down to the ground and cut out stems which grow erect.
CULTURE: These are decorative and useful plants for coastal gardens as they do not mind wind, sandy soil or salt spray. Where the soil is sandy, add humus to the holes in which they are planted to encourage more rapid growth. At the seaside they do well in full sun but in hot inland gardens they prefer part shade. Set plants a metre apart. The cultivars will stand only moderate frost.

CORNUS CANADENSIS GROUND CORNUS
DESCRIPTION: Is a fast-growing spreading plant with a creeping rootstock. Where winters are cold the top-growth dies down for two or three months and it is therefore advisable to plant it between evergreen plants. It grows to 10 to 20 cm in height

and spreads rapidly across 60 cm or more. The leaves of mid-green are crowded at the top of the stem and make a verdant cover to the ground. In spring the plant is even more attractive when its pure white ovate bracts appear about the tiny purple flowers. Where conditions are congenial these are followed in summer by round red berries. CULTURE: It is native to North America and it enjoys cold frosty conditions, but it does well only in decidedly acid soil which does not dry out. Recommended for a cool, moist woodland garden.

CORONILLA VARIA CROWN VETCH
DESCRIPTION: This is a legume – that is, of the same family as beans and peas. It is a wildly enthusiastic grower and could become a nuisance in time, and under good conditions. It reaches a height of about 20 cm and has pretty fernlike foliage which makes an elegant cover to the ground. In spring, when it bears clusters of blush-pink to pale cyclamen flowers, it is a splendid sight. Recommended for dry banks.
CULTURE: Grows in any kind of soil and stands long periods with little water and severe frost. Plant 30 cm apart. If it shows signs of invading the whole garden, banish it altogether.

COTONEASTER COTONEASTER
DESCRIPTION: Most of the species and cultivars belonging to this genus are tall shrubs. There are, however, some which make a good ground cover for the large garden and for clothing road or railway embankments. The plants have small neat leaves, pretty little white flowers in spring and colourful berries in late summer and autumn. Some are evergreen and some deciduous. The former have the merit of being green throughout the year but the leaves do not turn colour, whereas the deciduous ones are very often most decorative in autumn when the leaves assume fiery autumn tints.
CULTURE: Cotoneasters are hardy plants – tolerant of severe frost and drought. They will grow in any kind of soil – alkaline or acid, but quicker growth will be had from plants set out in ground rich in humus. Space plants 1–2 metres apart.

C. adpressus CREEPING COTONEASTER
Looks effective on a bank or clambering over a wall. Has white flowers tinged with pink. Is showy in autumn when leaves turn crimson and the berries become scarlet.

C. congestus
A pretty evergreen which makes mounds of grey-green leaves, ornamented with white flowers in spring and scarlet berries in autumn.

C. dammeri
(*C. humifusa*)
An evergreen with prostrate stems spreading two metres along the ground. The tiny leaves are densely arranged and show up to perfection the small white flowers which stud the plant in late spring. These are followed by brilliant scarlet berries. 'Lowfast' is a particularly attractive cultivar suitable for the rock garden, as a ground cover along the drive, or arching against a wall with the stems trained up flat against the wall as a climber.

C. horizontalis 'Saxatilis'
A deciduous one which is almost prostrate with fan-like branches coming off the main stems in an angular fashion and tiny leaves which colour in autumn. It will spread across 1–2 m.

C. microphyllus
A ground cover suitable for the large garden or park or for roadside planting. It reaches a height of 30–60 cm and sends out horizontal stems which tend to root as they grow. A single plant will spread across 1–2 m. The leaves are tiny, dark green above and grey beneath. The white flowers which decorate the plant in late spring are followed by fairly large rose-red berries. Cut out stems which tend to grow vertically and peg the others to the ground. *C. microphyllus cochleatus* makes an even better ground cover as it is more prostrate in growth.

C. salicifolius
Is a large upright shrub but two cultivars derived from this are of merit as ground cover. 'Autumn Fire' is an evergreen with stems rising only 15 cm above the ground but spreading to 2 m. It has showy white flowers followed by scarlet berries. 'Repens' is another prostrate one with very narrow little leaves and showy red berries in late summer and autumn.

COTULA SQUALIDA BRASS BUTTONS
DESCRIPTION: A small New Zealand plant which is of decorative value when grown for massed effect. It is an evergreen perennial less than 20 cm in height with soft fern-like leaves of a bronze-

green hue. In late spring tiny button-like flowers of creamy yellow festoon the plant. It looks pleasing growing in the crevices between paving, in the rock garden or massed as a ground cover in sun or part shade. *C. potentillina* and *C. reptans* are two other species similar in habit of growth.

CULTURE: They grow in regions which have cold winters and do quite well in poor soil, but will not thrive unless watered fairly regularly. Plant roots 30–40 cm apart at any time of the year. It roots as it grows.

CRASSULA CRASSULA

DESCRIPTION: The genus includes more than 300 species of succulent perennials and shrubs. They are evergreen and of particular value in dry regions because of their resistance to drought.

CULTURE: They grow in any kind of soil but prefer a well-drained one. The species described grow in sun or part shade and tolerate sharp frost. They also grow well in coastal gardens. Set plants 45 to 60 cm apart.

C. cordifolia

Sprawls along the ground covering it with pliable stems of little leaves hardly 2 cm in length. They are fleshy, heart-shaped and apple-green. In winter tiny starry flowers of palest pink appear. They are too small to show up well in the garden but are useful for miniature arrangements.

C. multicava

Few plants romp along and cover bare earth more quickly than this one, and yet it need not become a nuisance as do many of the rampant spreaders, for it is easy to weed out when it invades sections of the garden where it is not meant to be. It has fleshy stems growing to about 20 cm in height, clothed with rounded succulent leaves which keep the ground covered throughout the year. In winter it produces a frothy mass of small pink flowers in loose clusters. It roots where it touches the ground.

CYTISUS BROOM

DESCRIPTION: The brooms vary from tall robust plants down to prostrate shrublets which are useful for covering the bare ground. They have rush-like stems and bear a profusion of pea-shaped flowers from early to late spring. Their merit lies in their willingness to grow under difficult conditions. Their disadvantage is the fact that the lack of a dense leaf cover may allow too much soil to show through – particularly in winter.

CULTURE: Brooms do best in light, porous soil and in full sun. They are hardy to extremes of cold and most of them are fairly drought-resistant but look better if watered occasionally during dry periods of the year. They grow in alkaline or acid soil and do well in windswept areas near the sea. Not recommended for subtropical gardens. Trim back annually after flowering is over.

C. x beanii

Grows into a hummock about 30 cm high and wide with spiky twigs and a profusion of small yellow flowers.

C. decumbens PROSTRATE BROOM

A prostrate form with bright yellow flowers. It grows to 20 cm in height and spreads across a metre. The round leaves are about 2 cm long.

C. demissus

A carpeting plant from the mountains of Greece. The leaves are tiny and the flowers, which appear early in spring, are yellow marked with mahogany.

C. x kewensis KEW BROOM

Has grey-green leaves on low-growing trailing stems and a profusion of pale yellow flowers in early spring. This is one of the best of the prostrate brooms. It will spread across a metre.

DAMPIERA DIVERSIFOLIA

DESCRIPTION: An evergreen perennial of almost prostrate growth which grows wild in the drier parts of Western Australia. The ovate to obovate leaves are rather sparsely carried on trailing stems. In spring, when the leaves are entirely hidden by a profusion of blue phlox-like flowers, it is indeed a lovely sight. This is a good plant to cover a rough bank or to have clambering between or over rocks in a rock garden, or hanging over a low wall.

CULTURE: Grows in any kind of soil but prefers one with good drainage. In its natural habitat it is generally to be found in sandy or gravelly soils of an acid nature. It endures moderate frost and fairly long periods of drought, but it should be watered in autumn and winter to encourage good flowering. Set plants 30 cm apart.

Some of the low-growing brooms (Cytisus) are splendid plants for covering the bare ground.

DAPHNE CNEORUM GARLAND DAPHNE

DESCRIPTION: This is a plant for those prepared to go to some trouble to provide it with the conditions it likes. It is not easy to grow but most rewarding when it performs well. It is an evergreen with spreading stems of narrow dark green leaves 2–3 cm long. In spring it bears little clusters of fragrant rose-pink flowers. A mature plant is 30 cm tall and 60 cm across. *D. cneorum* 'Eximia' is a splendid cultivar which makes an even brighter show than its parent.

CULTURE: Plant in soil rich in humus and water well during dry periods of the year. They like well-drained soil but not a dry atmosphere and do best in regions where misty conditions prevail for much of the year. Where the sunlight is intense try growing them in filtered shade.

DELOSPERMA MESEM, VYGIE, ICEPLANT

DESCRIPTION: There are many species of delosperma to be found in South Africa. Some are bushy plants whilst others are of creeping habit. They make a good permanent ground cover for a dry garden and, because the roots tend to spread they are useful also for holding the soil on a steep bank. The succulent leaves are cylindrical, often angled along their length, and pointed at the tip. They glisten in the sunlight – this shimmering quality being due to the water-containing cells on the surface, which catch and reflect the sunlight. The flowers, which appear in late winter and early spring, are composed of numerous glossy, slender petals radiating from the centre. They are white, pink, rose, mauve or purple.

CULTURE: They grow very easily from cuttings taken during the warm months of the year. They can also be grown from seed but this takes much longer to produce flowering plants. Plant in full sun 40–60 cm apart and water in winter to encourage good flowering. Where the rainfall is high, plant in sandy ground as they require good drainage. They do well in coastal gardens.

Daphne (*D. cneorum eximia*) is not easy to grow but a most rewarding sight when it does well.

DIANTHUS PINKS

DESCRIPTION: The genus includes more than 300 species and many hybrids which are perennials, biennials and annuals of differing habits of growth. Only four of perennial ornamental value are described. Pinks look attractive planted in masses at the front of a shrub or flower border, around beds of roses, along a path, or in groups

Didelta (*D. carnosa*) flourishes at the coast and does well also in dry gardens inland.

between rocks in a rock garden. Most of them have pretty little flowers with a delightful perfume. The leaves are very slender and pointed and generally emerge from the ground or from the main stems in tufts. The flowers of many different shades appear in spring and summer. They are delightful in the garden and in small arrangements. Where conditions suit them the plants will root themselves and spread to cover the ground.

CULTURE: Pinks do better in a loose friable soil than in a heavy clay, and they prefer limy to acid soil. They will grow in sun or part shade. Cut off the flowers as they fade and propagate new plants when the old ones become leggy. They are easily multiplied by cuttings taken in spring or late summer, by layers, or from seed sown in spring or late summer. The plants are hardy to 10° frost. Space them 20–30 cm apart.

D. arenarius
Has grey-green leaves in tufts only 5 cm high and small white flowers with fringed petals. It does well in partial shade. Plant 20 cm apart for quick cover.

D. deltoides MAIDEN PINK
Bears very small pink, mauve or white flowers which completely hide the leaves in late spring. In good soil it will seed itself and multiply rapidly.

D. gratianopolitanus CHEDDAR PINK
(D. caesius)
Has grassy grey leaves and very fragrant pink flowers. The creeping stems tend to root as they grow. There are now pretty cultivars of this species.

C. plumarius COTTAGE PINK
Has been cultivated for hundreds of years – since before Shakespeare's day. It has loosely arranged grey-green leaves and flowers with a spicy scent. There are numerous charming cultivars worth trying. The following are the names of some of these: 'Excelsior', 'Flashing Light', 'Mrs. Pilkington', 'Paddington', 'Sam Barlow', and 'Mrs. Sinkins'.

DIDELTA CARNOSA DIDELTA
DESCRIPTION: A shrubby plant which can be found in South Africa – sprawling along coastal dunes and in dry inland regions. It is a useful ground cover for maritime areas to help stop the drift of sand, and for large seaside gardens. The leaves which are turned back along their length may be green or heavily felted with grey. In late winter and early spring the plant becomes covered with myriads of gay, bright yellow, daisy-like flowers 5–7 cm in diameter.

CULTURE: It does well in sandy areas near the coast and withstands drought and moderate frost inland. Set plants 40–60 cm apart in a sunny place and keep them rather dry in summer. Didelta can be grown from seed sown in spring or late summer.

DICHONDRA REPENS WONDER LAWN
DESCRIPTION: Dichondra is a small ground-hugging plant which spreads by underground runners which root and make a smooth ground cover of tiny leaves resembling those of a water lily in form. It can be grown as a substitute for a lawn but it is apt to die off if walked upon a great deal.

CULTURE: Can be grown from seed or from runners. Sow in ground to which plenty of humus has been added. Make sure that the ground is free of weeds by forking or spading the compost in, watering, raking and then watering regularly for a month, by which time the weeds should have emerged and can be removed. In hot inland areas wonder lawn does better in partial or light shade than in full sun. It should be watered regularly throughout the year to keep it in good heart. Stands 5° of frost. If top-growth becomes rank shave it off with a lawn mower.

DOROTHEANTHUS BELLIDIFORMIS
BOKBAY VYGIE, LIVINGSTONE DAISY
DESCRIPTION: This delightful plant is an annual and, strictly speaking, should therefore not feature in a book on ground covers, since its value as such is for a period of only 2–3 months. It is, however, so beautiful and so easy to grow that it deserves to be mentioned. The tiny succulent leaves which grow prostrate along the ground scintillate in the sunlight and the flowers make a glorious show in spring. They are not large but appear in their myriads – glittering like a mass of colourful jewels scattered across the soil. Grow it as a quick temporary ground cover on a sunny bank, as an edging to the front of a bed, between paving stones, or in the rose garden or rock garden.

CULTURE: Sow seed in late summer or early autumn and set the plants 15 cm apart. This plant grows in any soil but prefers a sandy soil to heavy clay. It needs an abundance of sunshine to make the flowers open. Hardy to 3° of frost.

DROSANTHEMUM MESEM, VYGIE, ICEPLANT
DESCRIPTION: A South African succulent which is ideal for gardens subject to long periods of drought, or for parks where it is difficult to keep the whole area watered. There are prostrate forms which make a ground-hugging mat of leaves and bushy ones which look fine lining a long drive, growing in a rock garden, on a steep bank, or along highway embankments. The prostrate ones may root where they touch the ground, but the shrubby ones are difficult to propagate. The tiny water-containing cells on the stems and leaves cause them to glisten in the sunlight like frosting – which accounts for the common name of iceplant. The leaves are generally cylindrical and sometimes angled along their length. The scintillating flowers with slender satin petals make a splendid show from early to late-spring. *D. bellum* has white or pink flowers; *D. bicolor* is a bushy plant with sparkling flowers coloured bright yellow at the centre and orange at the ends of the petals; *D. floribundum* is a dainty trailing species with amethyst flowers; *D. hispidum* has shining mauve flowers and *D. speciosum* bears bright flowers of orange or cornelian-red.
CULTURE: The prostrate ones will grow from cuttings made during the warmer months of the year, but the bushy types do not root readily from cuttings and should be grown from seed. Plant them in friable soil in full sunlight and water them occasionally between autumn and flowering time. They are drought-resistant and stand quite severe frost. As the bushy types tend to become straggly, it is advisable to trim them each year after their flowering period is over.

DRYAS OCTOPETALA DRYAS
DESCRIPTION: A little evergreen perennial which sends out growth close to the ground forming a carpet of prostrate woody stems clothed with small lobed leaves, dark green on the upper surface and grey-green on the underside. In late spring and early summer it carries pretty white flowers with eight petals and a bright yellow centrepiece. They are 2–4 cm across and shaped somewhat like an anemone. These are followed in autumn by fluffy seedheads.
CULTURE: Dryas is not easy to grow. It likes cool to cold conditions and resents hot, dry wind. Plant it in acid, humus-rich soil which drains well, in full sun or filtered shade. Water regularly throughout the year and do not move established plants as they are unlikely to survive.

DUCHESNEA INDICA
INDIAN WILD STRAWBERRY
DESCRIPTION: Grows very much like the cultivated strawberry in that it sends out runners which root along the ground. It is an excellent plant for steep banks as it helps to stop erosion of the soil and quickly forms a dense cover. In a garden it should be kept under control as, with its eagerness to grow, it could become a nuisance. The leaves are composed of three bright green leaflets. In spring the plant is highlighted by canary-yellow flowers about 1 cm across. These are followed, in late spring and summer, by small scarlet strawberry-like fruits. They are edible but have an insipid flavour.
CULTURE: This plant grows in sun or partial shade. It stands severe frost and also fairly long periods with little or no water. Plant runners 45 cm apart at any time of the year.

DYMONDIA MARGARETAE DYMONDIA, GREY CARPET
DESCRIPTION: A little evergreen South African plant which is only now becoming known in the gardening world. It deserves to be widely grown as it makes an excellent ground cover between paving stones. Its tiny dove-grey leaves hug the ground and the plant spreads itself neatly across the soil or between paving. The little yellow flowers which appear in spring are of small account as they do not enhance the appearance of the leaf cover.
CULTURE: Dymondia needs well-drained, friable soil and plenty of sunshine. It grows near the coast and inland, and is tolerant of moderate frost and fairly long periods with little water. It grows in alkaline or slightly acid soil. Set plants 20 cm apart for quick cover.

ECHEVERIA ECHEVERIA, HEN AND CHICKENS
DESCRIPTION: There are several different echeverias suitable for use as ground covers. Plant them

Bokbay vygie or Iceplant (*Dorotheanthus bellidiformis*) makes a scintillating carpet of colour.

This erigeron (*E. karvinskianus*) is a pretty little plant which is only too willing to grow.

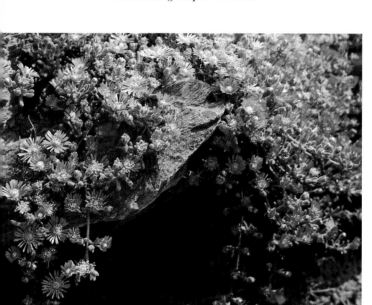

This Iceplant or Vygie (*Drosanthemum floribundum*) is a delightful carpeting plant with dainty flowers.

Erinus (*E. alpinus*). A dainty plant to grow in the crevices of a stone wall or as a carpet.

Dymondia (*D. margaretae*). Grow it between the paving stones of a path or patio.

This Euryops (*E. acraeus*) is a neat South African shrublet which likes cold conditions.

in rows to outline the edges of a formal bed of flowers, or in groups in a rock garden, or as a foreground to a mixed flower border or shrubbery, or for pattern-bedding. These are succulent plants with rosettes of fleshy leaves of a soft green or grey-green hue. The leaves will cover the bare earth throughout the year and in spring and summer their flowers will add to the beauty of the garden. The flowers are bell-shaped on slender stems and usually pink, red or yellow in colour.
CULTURE: Echeveria like well-drained soil and will grow in sun or part shade. They tolerate long periods with little water but not prolonged periods of cold damp conditions. Set plants 30 cm apart.

E. agavoides
Has rosettes about 20 cm across with smooth, very fleshy pointed leaves often tinged with brown at the tips. The dainty red and yellow flowers stand well above the leaves.

E. derenbergii
Is a Mexican plant with small tight rosettes of grey-green leaves 6–10 cm across. It spreads to form a mat of growth, and produces one-sided clusters of yellow or cornelian-red flowers in spring.

E. elegans HEN AND CHICKENS
This is the one commonly used for formal edgings or to make patterns in a formal layout. It has grey rosettes 10–20 cm across which spread freely by offsets. Small pink flowers lined with yellow appear in clusters in early spring.

E. glauca HEN AND CHICKENS
Has grey-green leaves with a purple edge, arranged in rosettes about 10 cm across, and crimson flowers tipped with yellow. The common name of Hen and Chickens is derived from the way in which the baby offsets cluster around the mother plant.

ERICA GROUND ERICA
DESCRIPTION: Although most of the ericas with outstandingly beautiful flowers are native to South Africa it is those from Europe which have been more widely grown as ground covers. This

Wild Strawberry (*Duchesnea indica*) with yellow flowers and red fruits interplanted with Ajuga.

is not only because they are more hardy to frost but also because the habit of growth of some of them is such as to make them a better choice as a ground cover than the South African species. Only those of low, spreading habit are described here. They are all evergreen.

CULTURE: Ericas generally grow only in lime-free soil in which there is plenty of humus. The species named below stand severe frost but produce few flowers in regions subject to dry conditions. Plant them in full sun or light shade. Two of the species and their cultivars can be tried in gardens where the soil is alkaline.

E. carnea

Spreads across the ground forming a carpet of tiny green leaves. In winter it produces small spikes of pink or white flowers. It will grow in soil which is not distinctly acid. This is one of the best to grow as cover to the ground, and some of the cultivars make a splendid show almost throughout the year because of the quality of their foliage. Cultivars of merit are: 'Aurea' (yellow leaves, pink flowers); 'Carnea' (bright pink flowers in winter); 'King George' (compact plant with rose-pink flowers); 'Springwood' (showy white flowers in winter); and 'Winter Beauty' (rich pink flowers). Set plants 45 cm apart.

E. cinerea BELL HEATHER

Grows to about 20 cm in height and spreads across 60 cm. Its flowering time is spring and summer. The purplish-pink flowers are carried in little spikes above the leaves. Cultivars worth growing are: 'Alba Minor' (white); 'Golden Drop' (yellow leaves but few flowers); and 'Rosea' (deep pink flowers). This species and its cultivars must have distinctly acid soil.

E. x darleyensis

Is rather tall and spreading and therefore suitable only for large gardens. It is not as attractive as many other ericas but is included because of its tolerance of lime in the soil. The plant grows to 60 cm in height and spreads across a metre or more. It bears pink, white or purple flowers during winter. 'Arthur Johnson' and 'Molten Silver' are two good cultivars.

ERIGERON ERIGERON

DESCRIPTION: Erigerons were popular many years ago but one now seldom sees them although they are most useful plants for quick cover, and for embellishing a rock garden or edging a path. The two recommended below differ in habit of growth.

CULTURE: E. karvinskianus grows with cheerful abandon in any soil or situation. E. speciosus, which is much more attractive and less likely to become a nuisance, needs good soil and regular watering to promote its growth and spread. Both endure severe frost and both grow well also in seaside gardens. Set plants 20–30 cm apart.

E. karvinskianus TUFTY ERIGERON
(E. mucronatus)

Grows into little mounds of ovate leaves toothed at the tips borne on slender stems. In spring and summer it is covered with minute white daisies which make a pretty show. Plant it as an edging to a bed of flowers but weed out stray plants when they appear as it is very apt to seed itself and spread.

E. speciosus ERIGERON

Produces leaves which hug the ground and form a dense mat. In late spring and early summer it has delightful daisy-like flowers of charming shades of lilac to lavender or pink. They make an attractive show in the garden, as an edging along the front of a border or in groups interplanted with other ground covers of low growth. They are also pretty in small arrangements.

ERINUS ALPINUS ERINUS

DESCRIPTION: A delightful little plant from the mountainous part of south-western Europe. It is charming in effect when growing between stones in a wall or in paving. Mass-planted it will create a carpet of colour when it flowers early in spring. It reaches a height of 10 cm and spreads across 15–20 cm. The stems are soft and pliable and loosely clothed with tufts of mid-green leaves which make a small mound of growth. The tiny, starry flowers show up brilliantly because of their bright carmine to candy-pink colour. The following cultivars are worth trying, too: 'Albus' (white); 'Dr. Hanele' (carmine); and 'Mrs. Charles Boyle' (rose).

CULTURE: Erinus is a plant of great charm which will brave the cold but which is not partial to dry conditions. Plant it in soil rich in humus and see that the plants do not become desiccated during the dry months of the year.

EUONYMUS FORTUNEI CREEPING EUONYMUS
(*E. radicans acuta*)

DESCRIPTION: A hardy evergreen carpeting plant suitable for checking erosion on steep banks or for covering the ground under a large area of trees. The stems root as they progress. The plant is grown for its foliage as the flowers are of no account. It can be trained up against a wall as a climber or allowed to spread itself across the ground. The following cultivars are more suitable for the small garden: 'Coloratus', with purple leaves and 'Kewensis' with minute rich dark green leaves. *E. fortunei radicans* is another trailing or climbing form. It has elliptic or ovate leathery, shallowly-toothed leaves about 4 cm long. A cultivar 'Variegatus' with grey-green leaves outlined with white is more decorative than the species, but it does not grow as vigorously, which could be an advantage in a small garden.

CULTURE: They thrive in almost any type of soil and do well in alkaline ground. Severe cold does not kill the plants but they will not do well unless watered fairly regularly. To encourage speedy spread improve the soil, if it is poor, by the addition of compost. Set plants 30–45 cm apart. In hot inland regions they do better in part shade than in full sun.

EUPHORBIA GATBERGENSIS

PROSTRATE EUPHORBIA

DESCRIPTION: Curious, rather than attractive, this South African plant makes an unusual cover for a rocky bank, where its strangely contorted stems produce a sculptured effect. In spring it is ornamented with little yellow flowers whose fragility seems quite out of keeping with the thick stumpy stems which carry them. Other interesting euphorbias similar in manner of growth are: *E. caput-medusae, E. flanaganii* and *E. tuberculata*.

CULTURE: Plant 45 cm apart in full sunshine in well-drained soil. Once established they stand sharp frost and long periods of drought.

EURYOPS ACRAEUS MOUNTAIN DAISY
(*E. evansii*)

DESCRIPTION: A South African shrublet which forms pleasing mounds of growth. The leaves are small and rather narrow, a pretty shade of silver-grey and neatly arranged on the grey stems. It makes an attractive show along the front of a shrub border, hanging over a wall, or emerging between rocks in a rock garden. In spring it becomes smothered with cheerful daisy-like flowers of canary-yellow, 2–3 cm across.

CULTURE: It stands frost but not long periods of dryness and should therefore be watered regularly throughout the year. Plant in soil rich in humus, spacing plants 45 cm apart. It can be grown from cuttings or the suckers which originate from the base of the plant.

FELICIA BLUE FELICIA, WILD ASTER

DESCRIPTION: There are two South African species which are useful and decorative plants to clothe the ground in a sunny part of the garden. They make a fine show planted in a hollow wall, spreading across the ground in front of shrubs, interplanted with other perennials or in a rock or pebble garden.

CULTURE: They will grow in any kind of soil but spread more quickly in good soil. Plant in full sun and water during winter to encourage spring flowers. They stand about 3° of frost, and they do well in seaside gardens.

F. amelloides BLUE FELICIA

Grows to 45 cm in height and spreads across much more, but it can be kept smaller by trimming once a year. This, done in late spring, will not only encourage new leaf growth and better flowering the following year, but will also ensure that the plants remain within bounds. The soft oval leaves are 2–3 cm long. The flowers, which rise above the leaves on slender stems, make a delightful show in the garden and in arrangements. It flowers most profusely in spring, but if the faded ones are sheared off, it will go on producing more for many months of the year. The flowers are small daisies of clear blue with bright yellow centres.

F. filifolia WILD ASTER
(*Diplopappus filifolius*)

A useful shrublet for large banks, for edging a drive, or to plant in a large rock garden. It grows in a semi-prostrate mounded fashion seldom more than 30 cm high and about 60 cm or more across. The tiny leaves which clothe the stems densely are rather like those of an erica. In late winter and early spring when it becomes covered with its daisy-like flowers, it is a very gay sight. They measure 2–3 cm across and are of a lively mauve colour with golden centres.

The charming flowers of this Felicia (*F. amelloides*) open
from late winter to summer.

This Gazania, hybridised in New Zealand, has decorative
leaves and pretty flowers.

FESTUCA OVINA 'Glauca' BLUE FESCUE GRASS
(*F. glauca*)

DESCRIPTION: An ornamental grass which pro-
duces tufts of slender leaves 25 cm tall, of a delight-
ful blue-grey colour. It does not grow prostrate
like lawn grass and cannot therefore be used as a
substitute for a lawn. Plant it in groups at the
front of a shrub or flower border, or to make
patterns in a formal garden. The flowers appear
above the foliage but, as they are of the same
colour, they do not show up as a contrast. To keep
the plants neat, shear them off a few centimetres
above ground level once a year or when they
become straggly.

CULTURE: Likes well-drained soil but not long
continued dry conditions. Stands severe frost. If
plants become overcrowded shear off the top
growth, dig them up and re-plant small pieces of
the root 30 cm apart. Grows in full sun or light
shade.

FICINIA TRUNCATA FICINIA

DESCRIPTION: An unusual and distinctive South
African plant which deserves to be better known
and more widely grown. It spreads slowly from
an underground rootstock producing little whorls
of slender leaves – each about 10 cm long and
only 2 mm wide, with a rounded tip. They are
dark green with a papery white edging. The
flowers are insignificant but it is well worth plant-
ing for its decorative foliage and habit of growth.
It is ornamental as a ground cover, in pattern
planting, or in a rock or pebble garden.

CULTURE: It develops slowly, forming rounded
mounds or hummocks of growth. Plant 30–45 cm
apart in full sunshine, in well-drained soil, but
water it regularly during dry periods to encourage
growth. It will stand moderate frost and grows in
alkaline or acid soil. It will also grow in coastal
gardens.

FICUS PUMILA CREEPING FIG,
TICKEY CREEPER

DESCRIPTION: An evergreen climber which is a
useful ground cover, particularly where it is
desirable to soften the outline of large bare
expanses of concrete. It has strong rootlets on the
stems and these hold the plant firmly in place,
whether it is climbing up a wall or along the
ground. Although somewhat slow to start, this
plant will cover a large area if it is not cut back

Wild Aster (*Felicia filifolia*) does well at the coast and inland
where frosts are not severe.

Spanish Gorse (*Genista hispanica*) produces a glowing mass of colour in late winter and early spring.

from time to time. It is grown for its foliage which is variable in form. The young leaves are soft, oval or heart-shaped, and the older leaves are somewhat leathery and glossy, oval or ovate and up to 10 cm in length. A cultivar with variegated leaves is more suitable for the small garden as it is unlikely to spread too far and wide.

CULTURE: It grows in sun or partial shade, stands severe frost and, when established, will also endure long periods with little water. Should the top growth become untidy shear it off to encourage the formation of new leaves. If coverage is required on a large bank set the plants a metre apart.

GAULTHERIA PROCUMBENS

PARTRIDGE BERRY

DESCRIPTION: This prostrate evergreen plant native to the U.S.A. forms a pleasing ground cover under optimum conditions. It has dark green glossy oval leaves 3–5 cm long. The tiny flowers

which appear in summer are not as ornamental as the scarlet fruits which follow in autumn.

CULTURE: Likes acid soil and is suitable only for damp woodland gardens where the soil is rich in humus. Stands severe frost. A good ground cover to have under or in front of azaleas. Set the plants 60 cm apart.

GAZANIA

GAZANIA

DESCRIPTION: Gazanias may be divided into two broad groups – those which form clumps and those which are trailing in habit of growth. Both types are excellent to plant as a cover to bare ground – on large steep banks, in a rock garden, in pots, along the front of a flower or shrub border, or in a hollow wall. The tufty types have leaves which are fairly long and often prettily indented – generally dark green on the upper surface and felted grey on the undersides. *G. krebsiana* is an outstanding species. The flowers have velvety

petals of glowing orange with chocolate and cinnamon markings in the centre, rather like those of a peacock's tail. The plants hybridise readily and each year sees the introduction of yet more glamorous ones with burnished petals of glorious colours. In many cases the petals are marked with contrasting bands or patterns of colour which add further to their handsome appearance. They start flowering in late winter and are most prolific up to the end of spring, but if not neglected entirely they will produce some flowers throughout the year. *G. rigens* var. *uniflora* is a trailing form which looks charming hanging over a wall or bank. If clipped, it is a good one to grow for pattern-bedding. It is also useful for stopping erosion on a steep bank as it roots as it spreads. The long, slender leaves are of a silvery colour and the flowers are golden yellow. *G. rigens* var. *rigens* has yellow flowers with a black spot at the base of each ray floret. Another one which makes a splendid carpet in poor soil is *G. rigens* var. *leucolaena*. Its silver leaves are a perfect foil to the yellow flowers. Some fine hybrids have been bred in Australia.

CULTURE: These are plants for sunny gardens, large or small. They enjoy harsh conditions – and give a dazzling display even when planted in poor soil and left dry for many months of the year. It is advisable, however, to water them during the autumn and winter to encourage good flowering. They can be grown from seed or from cuttings or root divisions. Where frosts are very severe, store the roots in pots in a sheltered corner until early spring or cover them with a plastic sheet at night. Plant *G. krebsiana* and related hybrids 30 cm apart. The trailing types can be spaced a metre apart.

GENISTA BROOM, GENISTA

DESCRIPTION: The genus includes species for large gardens and small. Those described are low-growing or can be kept trimmed back to keep them fairly small without spoiling their appearance. They have yellow flowers which make a splendid show from mid-spring to early summer. Although deciduous, they have an overall evergreen appearance even in winter because of their closely packed twigs.

CULTURE: Genista are tolerant of difficult conditions. They stand severe frost and fairly long periods with little water. They like bright sunshine and they put up a good performance in poor and alkaline soil.

G. hispanica SPANISH GORSE

A gay subject to clothe a large bare bank. It grows to 45 cm in height and more in spread but should be clipped after flowering to keep it from becoming untidy and from spreading too far and wide. Its flowers are brilliant yellow and carried in small clusters.

G. lydia

This species is better suited to the large garden than the small, for, although the stems rise only 30 cm high above the ground they spread out to a metre or more. Little sprays of canary-yellow flowers completely hide the grey-green twigs in spring.

G. pilosa procumbens PROSTRATE BROOM

A splendid ground cover which grows flat along the ground moulding itself to the contours. It looks effective on a bank or spilling over a wall. The whip-like shoots may grow laterally to 2 metres but, where space does not allow of such a spread, they can be trimmed back without spoiling the appearance of the plant.

G. tinctoria 'Flore Pleno'

Grows to 30 cm in height and spreads across about 60 cm. The tiny leaves are deep green and completely hidden in mid-spring by a sheet of small double flowers of daffodil-yellow.

GERANIUM GERANIUM, CRANESBILL

DESCRIPTION: The plant most people know and refer to as a geranium is really a pelargonium. Geraniums are different from pelargoniums in leaf and flower. Some geraniums are shrubs whilst others are prostrate or semi-prostrate in habit of growth. There are many species and even more cultivars which can be used effectively to hide the bare earth and to create a verdant picture in the garden. The leaves vary tremendously in form and, on the whole, they are attractive for most months of the year. The flowers which may be small or large, are generally cup- or saucer-shaped with five petals of equal size and of pastel shades or more brilliant tones. Nurseries which specialise in geraniums list species and hybrids of differing habits of growth. *G. incanum* is a very decorative South African species with lacy foliage which carpets the ground, and dainty salver-shaped flowers of a delicate shade of mauve. *G. endressii*, *G. macrorrhizum*, *G. sanguineum* and

G. subcaulescens are four of the many European species of value as carpeting plants. Some fine low-growing cultivars have been bred from these species.

CULTURE: The South African geranium is tender to frost whereas most of the exotic species and cultivars are hardy. Generally, in hot inland gardens they do best in partial shade. Plant 45–60 cm apart in ground enriched with compost, and water well during dry periods of the year to promote good flowering. It is advisable to trim the plants occasionally when they show signs of outgrowing their allotted space. This will keep them neat and tidy in appearance too.

GIBBAEUM PUBESCENS GIBBAEUM

DESCRIPTION: An evergreen succulent plant, native to the dry regions of South Africa, with clusters of fat, stubby finger-like leaves of a delightful blue-grey hue. In spring it bears small shining magenta flowers, but, as they adorn the plant for a very short time, this gibbaeum is worth growing for its form and foliage rather than for floral effect. To make an impact, plant it in clumps, grouped with ground covers with dark green leaves. It looks attractive in a rock or pebble garden, too.

CULTURE: This is a plant for dry gardens. Too much water, particularly in summer, will cause it to rot. Plant 30 cm apart in sandy or gravelly soil and water it occasionally during summer and more often in winter. It is not recommended for regions with a high rainfall.

GYPSOPHILA REPENS

PROSTRATE GYPSOPHILA

DESCRIPTION: Every garden needs plants of light and feathery growth as a contrast to those which are rigid in outline or prostrate in form. This little perennial gypsophila adds grace and elegance to the garden with its slender trailing stems of tiny grey-green leaves and its clouds of pink or white flowers in spring. The plant grows to 20 cm in height and the stems spread across 45 cm. Its only disadvantage is that the top-growth dies down in winter. It looks delightful trailing down over a wall or bank.

CULTURE: Plant it in well-drained soil. It enjoys bright sunlight but should be watered adequately during dry periods of the year. This gypsophila stands severe frost.

HARDENBERGIA COMPTONIANA
AUSTRALIAN PEA VINE, LILAC VINE

DESCRIPTION: An Australian climber which looks attractive as a ground cover allowed to scramble up or down a bank. It has long leaves, heart-shaped at the base, carried on long slender stems. The leaves are of good appearance throughout the year and in late winter and early spring the plant bears spikes of charming little flowers of a delightful shade of mauve. Should the plant become too exuberant trim off some of the stems at the tips in late spring.

CULTURE: It stands rugged conditions – fairly sharp frost and drought. However, to encourage more rapid initial growth and good flowering it is advisable to water regularly until established. Plant 1–2 m apart.

HEBE HEBE, VERONICA

DESCRIPTION: Several species of hebe are grown in gardens in many parts of the world. These attractive evergreen shrubs, native to New Zealand, vary considerably in form. Some are large shrubs whilst others are almost prostrate in habit. Only those of dwarf growth are described here. Plant them as a ground cover in front of a shrub border or in a large rock garden. They look their best in summer when they flower. In addition to the species mentioned there are also some good cultivars.

CULTURE: Plant 60–90 cm apart in soil to which compost has been added and water well during the dry periods of the year. They stand sharp frost but not drought. At the seaside they grow in full sunshine, but inland where the sunlight is intense, they do better in partial shade.

H. albicans
Has small grey-green leaves on plants about 20 cm tall. The plant forms a pleasing mound of growth, and produces spikes of white flowers in late spring and summer.

H. x 'Carl Teschner'
Grows horizontally covering the ground with its tiny dark green leaves. In summer it bears little spikes of mauve flowers.

H. carnosula
(*H. pinguifolia carnosula*)
Is dwarf in habit with tiny glaucous, grey-green leaves and white flowers in summer.

73

Plant this Geranium (*G. incanum*) for its cover of dainty leaves and flowers.

Gibbaeums (*G. pubescens*) flourish in hot dry places and are good ground covers for desert regions.

The starry flowers of the prostrate gypsophila (*G. repens*) will form a colourful carpet.

H. loganioides

A shrublet with minute scale-like leaves growing prostrate along the ground. It has white flowers.

H. pinguifolia 'Pagei'

Has tiny pretty blue-grey leaves and white flowers. It grows to a height of only 20 cm but spreads across almost a metre, and is probably the most widely used hebe as a ground cover.

HEDERA IVY

DESCRIPTION: Ivy has been grown to embellish gardens for centuries – from pre-Christian times. Its merit as a climber or a ground cover under widely diverse conditions is no doubt the reason why it has been popular for so long. As a climber it can be relied on to cling to any surface by means of the strong rootlets on its stems. As a ground cover it is excellent – of great value in gardens large and small, in parks, or along road or railway embankments. It is also an excellent plant to grow to stop soil erosion. Many cultivars of more restrained habit of growth than the species have been introduced recently. These are better plants for the small garden as they are not as rampant in growth as some of the species.

CULTURE: Ivy will grow under adverse conditions, but to encourage quick spread over a large area it is advisable to make holes 20–30 cm wide and deep, about a metre apart, and to fill these with good soil and compost. When the plants have covered their allotted area take the precaution of cutting back any stems which start invading adjacent beds or climbing over neighbouring shrubs. With the passing of years the top growth may become rather high and billowy. When this happens run over the whole area with a rotary lawn mower or clip the leaves and stems off with a pair of hedge shears. The subsequent growth will be neat and compact. Ivy stands severe frost and quite long periods of drought when once it is established. It flourishes in deep shade.

H. canariensis ALGERIAN IVY, CANARY ISLAND IVY

This species has very large leaves not as neatly formed as those of the English ivy. A cultivar, with leaves edged with cream, known as 'Variegata' or 'Gloire de Marengo', is more popular than the species with plain green leaves. This plant is recommended only for very large gardens or for road embankments.

H. helix ENGLISH IVY

Makes a splendid ground cover and can be trimmed to form a neat border, too. The neat glossy dark green leaves have three to five lobes and they remain ornamental throughout the year. There are several cultivars with small leaves – some of plain green and some with leaves marked with white, yellow or cream. The following are recommended for the very small garden. 'Buttercup', 'Glacier', 'Gold Heart', and 'Tricolor'.

HELIANTHEMUM NUMMULARIUM
(*H. chamaecistus*) SUNROSE

DESCRIPTION: A delightful plant to make gardening easy. Plant on a rough bank or to cascade over a wall, in the rock garden, along the drive, or in a container. This little evergreen shrublet is only too anxious to please. It romps along the ground sending its stems of little leaves of green or grey-green to a height of 20 cm. A single plant will cover a square metre in area. There are many hybrids with flowers of different colours – white, cream, yellow, orange, pink, rose and crimson. The flowers, which appear in summer, are cup-shaped and about 3 cm across, and a plant in full flower is a charming sight. Shear the plants back after flowering to keep them neat and compact and encourage the development of autumn flowers too.

CULTURE: Sunroses do best in a light well-drained soil but they grow well also in a heavy one. They are hardy to frost and drought but do not flower well if left dry for very long periods. Set plants 30–60 cm apart.

HELICHRYSUM EVERLASTINGS

DESCRIPTION: There are a few South African everlastings which are well worth growing as ground covers because of their delightful silvery foliage. They have flowers which add to the lustre of the plants but, to keep them attractive, it is wise to cut off the flowers as they fade and to trim the plants back fairly hard after flowering is over. The flowers are useful for long-lasting arrangements or posies. Interplant them with ground covers with green leaves for high contrast. Many of them have aromatic leaves and stems.

CULTURE: Generally they do best in friable, sandy or gravelly soils with good drainage and look their best in bright sunlight. They tolerate moderate frost and they also do well in seaside gardens.

This everlasting (*Helichrysum argyrophyllum*) forms a mound of silvery-grey leaves.

The little sunrose (*Helianthemum*) is a charming plant to grow in any part of the garden.

Should they become woody or die back, propagate new plants from cuttings. Allow 60 cm or more between plants.

H. argenteum

Becomes a spreading mound 30 cm high and 30–50 cm across. The slender silver leaves are highly ornamental for many months of the year and the plant is particularly attractive in spring when it bears its papery, ivory-white flowers with golden centres.

H. argyrophyllum
GOLDEN GUINEA EVERLASTING

Grows prostrate forming a dense covering of small, glossy silver leaves. These are decorative throughout the year and in summer and autumn it is covered with bright button flowers of canary-yellow. In a warm climate be sure to keep it under control. In cold regions frost may cut it back.

H. auriculatum

A charming plant which romps along the ground covering it with slender grey stems rising to about 30 cm. The flowers which appear above the leaves in spring are white, but the main beauty of this species is its small, soft, almost triangular leaves which are dove-grey on the top surface and silver on the reverse. It looks striking near plants with dark green leaves.

H. bellidioides

A New Zealand species which is almost prostrate in growth. It forms a permanent carpet of tiny grey-green leaves and produces a mass of minute white everlastings in summer. Set plants 30 cm apart in a sunny position. It is hardy to severe cold.

H. crassifolium

Is a most useful plant for seaside gardens. It grows along the coastal sand dunes in South Africa just above high water mark and it stands salt-laden wind. The soft silver-grey velvety leaves on ash-grey stems spread over the sand like a carpet. The leaves which are oval or obovate in form look effective interplanted with ground covers with dark green leaves.

H. crispum

A happy-go-lucky plant of tufty habit which has very small crisped grey leaves and straw-coloured flowers in spring and summer. Mass-planted and clipped it is an effective ground cover. This species tolerates salt-laden wind at the coast very well.

H. maritimum

A shrubby plant which makes a fine border or ground cover. It grows to a height of 60 cm and has soft pliable arching stems of slender little leaves only 2 cm long and about 2 mm wide. They are grey-green on the upper surface and grey on the reverse. The flat heads of bright yellow flowers which appear in mid-spring show up well against the grey of the leaves. Cut the flowers off as they fade as otherwise the plant looks untidy. It does very well in coastal sand along the seashore.

H. paniculatum

This is an elegant plant which forms a pretty ground cover when mass-planted. The silver stems arch up from the ground to a height of 30 cm or more, and are sparsely covered with slender pointed silver leaves which tend to hug the stems. Glistening white papery flowers ornament it in mid-spring.

H. petiolatum

A lusty species suitable only for the large garden or park. It grows to a metre in height and spread, and has soft grey leaves ornamental throughout the year. The flowers which are white or ivory are of less ornamental value than the foliage. Cut the plant back hard once a year in late spring to force fresh new attractive growth. A cultivar 'Limelight' has leaves of lime green.

HELLEBORUS
CHRISTMAS ROSE, LENTEN ROSE, HELLEBORE

DESCRIPTION: The genus includes plants to grow as ground cover under trees, between other shade-loving plants or as a border in front of azaleas, hydrangeas or fuchsias. The species described are evergreen perennials worth growing for their decorative leaves, but they have the additional merit of producing entrancing flowers from late winter to mid-spring. The leaves are palmate or fan-shaped – the leaflets being neatly serrated, prettily veined, dark green and somewhat glossy on the upper surface and pale green beneath. The name of Christmas rose and Lenten rose was acquired in Europe and North America where the plants flower at this season of the year. The flowers are bowl-shaped and are carried singly or

in clusters. They are generally green, but may also be white, pink, and rose. In one species the flower changes colour from white to green as it matures. They look pretty in arrangements and last well if the ends of the stems are dipped in boiling water for a few seconds before arranging them in cool water.

CULTURE: Hellebores like soil rich in humus and acid in nature. They prefer shade to sun and cannot tolerate hot dry wind. They enjoy frosty conditions provided they are not left dry at the same time. Not recommended for subtropical gardens. These plants can be grown from seeds but as this takes some time to produce flowering plants, it is better to purchase rooted plants. Set plants 60 cm apart, and each autumn add a top dressing of good compost to the bed. Water well throughout the year.

H. corsicus CORSICAN HELLEBORE
Grows too tall (90 cm) to be regarded as a ground cover but it is a useful perennial for gardens where conditions do not suit the others as it tolerates more heat than they do. It has clusters of chartreuse flowers during winter and early spring.

H. foetidus
Has handsome leathery leaves divided into 7–11 leaflets, and apple-green flowers often with purplish margins. It is not as attractive as the other species but nevertheless worth growing. It grows to 45 cm.

H. niger CHRISTMAS ROSE
A charming species which produces the first of its elegant flowers in mid-winter. The saucer-shaped flowers, 3–5 cm across, are rose or greenish-white, turning pale green as they age. Water this species well throughout the year.

H. orientalis LENTEN ROSE
Is a species from the mountains of Greece, with rich dark green leaves divided into five to eleven leaflets similar to those of *H. niger* but more sharply toothed. Its cream flowers are flushed with rose, and sometimes freckled with mahogany spots. This species stands hot wind better than *H. niger*.

HELXINE SOLEIROLII BABY'S TEARS
DESCRIPTION: An evergreen creeping moss-like plant which makes a velvety carpet with its minute round apple-green leaves. It has a lush and verdant appearance and is a charming ground cover for the small or large garden. It is also a pleasing plant to grow between paving stones, or rocks bordering a pool or around a tree.

CULTURE: It wants damp woodland conditions to promote its best development. Plant 10 cm apart in soil rich in humus and water well during dry periods of the year. It will grow with only morning sun or in complete shade. Under optimum conditions of heat and humidity it can become a nuisance, and is not therefore recommended for tropical gardens.

HERMANNIA VERTICILLATA HERMANNIA
DESCRIPTION: This South African perennial sends out slender pliable stems which spread almost flat along the ground making a pleasing cover. The leaves are rather like a yew or erica in shape, and carried in little tufts. They are soft in texture and mid-green in colour. In winter and spring it produces small cup-shaped flowers of orange-red.

CULTURE: Hermannia is a tough little plant which will tolerate long periods with little water and moderate to sharp frost. Under dry conditions, however, the stems and leaves will not be as pretty as when the plant is watered regularly. Should the plants become woody, trim back the old stems and new growth will take its place. Plants may be set 60 cm or a little more from one another.

HETEROCENTRON ROSEUS HEERIA
(*Heeria rosea*)
DESCRIPTION: This is a delightful little prostrate plant from Mexico. Plant it where it can clamber over rocks in a rock garden, or spread across the ground to form a carpet. Because of its mat-forming habit of growth it is a useful plant to grow in order to stop soil erosion on a bank. The tiny dark green ovate leaves, scarcely 3 cm in length, form a dense ground cover and in summer, and on and off during other seasons, it is embellished with pretty cyclamen flowers with four rounded petals.

CULTURE: It grows in sun or part shade and once established will stand up to 5° of frost and fairly long periods with little water. Although prepared to grow in poor soil, it looks more attractive and makes more rapid growth if planted in good soil and watered regularly during dry seasons. Space plants 30 cm.

HOLCUS MOLLIS 'Variegatus' Mole Grass
DESCRIPTION: The word *Holkos* is the old Greek
name for grass, and the species from which this
variegated form has developed is not recommen-
ded as it could become a pest. The variegated
form has grass-like leaves prettily edged with
white along the length. It is worth growing for the
leaves which remain verdant throughout the year.
They grow in tufts, and close-planted are effective
as a ground cover, particularly between plants
with dark green or grey leaves. It is also a useful
plant for pattern bedding. *M. lanatus albo-variegatus*
is similar but not as ornamental.
CULTURE: To encourage quick spread, plant roots
20 cm apart in good soil and water regularly
during dry periods of the year. They stand severe
frost but not long periods of drought.

HYMENOCYCLUS PURPUREOCROCUS

DESCRIPTION: A succulent plant native to the
south-western part of South Africa where it can
be found growing along the seaside in pure sand,
and often swept by saltspray. The stubby, fleshy,
finger-like leaves are grey-green in colour and
show up the delicately coloured apricot flowers to
perfection.
CULTURE: This is an excellent plant for coastal
gardens but it will grow inland also provided the
soil is sandy or gravelly, and the winters are mild.
It likes dry growing conditions and plenty of
sunlight.

HYPERICUM Dwarf Hypericum
DESCRIPTION: The shrubby hypericums are well
known but one seldom comes across the miniature
or dwarf forms which are useful and decorative
plants to grow as a ground cover or as an edging
to beds of roses or other perennials. These plants
are evergreen except where winters are very
harsh, when they may lose some of their leaves.
The foliage forms a compact cover of soft green
and in mid-summer the plants are a carpet of
golden flowers.
CULTURE: Hypericums grow in sun at the coast
but most species do better in filtered shade
inland. They stand severe frost, and grow in poor
soil, but they increase much more quickly in
humus-rich soil. Set plants 30 cm apart.

H. calycinum
Increases by vigorous underground stems and it is
therefore a good plant to halt erosion. The stems
of leaves rise to about 20 cm and the bright
yellow flowers are 5 cm across. It grows under
trees where many other plants will not do well.
If the top-growth becomes untidy shear it off at
ground level. It can become invasive.

H. olympicum
Is a shrubby little plant from Asia. The soft grey-
green leaves hide the ground throughout the year
and in summer golden-yellow flowers appear in
profusion at the tips of the shoots. Its height and
spread are 30 cm.

H. polyphyllum
Another decorative Asian species which makes a
mound of growth 20 cm high and 30 cm wide. The
grey-green leaves create a good background to the
large yellow flowers in summer.

H. reptans
Is prostrate in habit and has minute leaves along
the soft spreading stems which tend to root as they
grow. It bears large daffodil-yellow flowers in
summer.

H. rhodopeum
Grows prostrate along the ground forming a
carpet with its small downy grey leaves. The
flowers which appear in summer are small but
they are carried in profusion and make a gay
sight.

Heeria (*Heterocentron roseus*) has pretty leaves and charming
little flowers in summer and autumn.

Low-growing plants are invaluable in the garden, to hide
the bare earth or to decorate a bank.

IBERIS SEMPERVIRENS
EVERGREEN CANDYTUFT

DESCRIPTION: Has lax stems which form a neat little shrublet 20–30 cm in height and the same across. Close-planted it forms a good cover of dark green leaves. It can safely be planted between roses to hide the bare ground, and it makes a pretty edging to a shrub or flower border. The snow-white flowers are at their best in late winter and early spring. Some of the cultivars are more prostrate than the species. 'Snowflake' is one which makes an enchanting picture with its carpet of brilliantly white flowers.

CULTURE: Plant perennial candytuft in sun or part shade in good soil and water it regularly. It stands frost but not long periods of hot dry wind. It grows readily from seed or from cuttings. Set plants 30 cm apart.

JUNIPERUS
DWARF JUNIPERS

DESCRIPTION: Many gardeners are familiar with the tree and shrubby junipers, but as yet comparatively little use has been made of the dwarf forms as ground covers, although they are eminently suitable for this purpose, particularly in the large garden. There are several species and cultivars available. They are evergreen plants with needle-like, awl-like, or scale-like foliage.

CULTURE: Some of the evergreen conifers described below are excellent landscape or accent plants as well as being good ground covers. When established they tolerate severe frost and fairly long periods with little water. They grow in sandy soil, clay or gravel, full sun or part shade. They are useful plants for regions with alkaline soil as they are more tolerant of soils with a high lime content than many other plants. To keep them neat and tidy, trim or shape them lightly. Not recommended for subtropical gardens.

J. chinensis 'Japonica'
Is a delightful dwarf juniper with light green prickly leaves closely arranged on elegantly spreading stems. In spring a slight yellow tinge suffuses the new growth. The plant grows to a height of 1 m and spreads across 2 m or more.

J. communis depressa
Is a dwarf carpeting form native to the U.S.A., with a spread of a metre or more but growing to only 60 cm in height. *J. communis depressa* 'Aurea' has young shoots tinged with yellow during spring and summer. *J. communis* 'Repanda' is one of the finest of the mat-forming junipers. It grows vigorously and will cover an area of three metres. The height of a mature plant is about a metre.

J. conferta
A good one for the large garden near the coast. It is native to Japan where it grows along the sea-shore. This species which grows to 30 cm in height and has a spread of 2 metres, has bright green prickly leaves.

J. davurica 'Expansa Variegata'
Grows to a height of a metre and has a spread of 2–3 m. The scale-like leaves are arranged in sprays along the branches. The leaves are mid-green with scattered tinges of creamy white.

J. horizontalis
CREEPING JUNIPER

Is a tough, prostrate plant extending across 2–3 m with green or grey-green leaves. An excellent plant to cover large banks, and to halt soil erosion. There are now many good cultivars. 'Bar Harbor' grows to a height of 30 cm and spreads across 2 m or more, hugging the ground as its stems develop. The leaves are a grey-blue shade in spring and summer and mauve-bronze in winter. 'Glauca' is an excellent ground cover with neatly arranged whipcord branches spreading flat across the ground to a distance of 2–3 m. The closely packed little leaves are steel-blue. 'Montana' is another prostrate form with branches which are very slender at the tips and clothed with scale-like, blue-grey leaves. It will cover 2–3 m. 'Plumosa' (Andorra Juniper) reaches a height of 40 cm and spreads across 2 m. It is a good ground cover with flat branches of feathery grey-green leaves which turn bronze in winter. 'Wiltonii' (Blue Rug) is undoubtedly one of the best cultivars to plant for ground cover, or to drape over a rocky bank. It hugs the ground as it grows, reaching only 20 cm in height and has long trailing stems of silver-blue leaves extending over 2 m.

J. x media 'Pfitzeriana'
PFITZER JUNIPER

A popular juniper for landscape purposes and for large gardens. The branches rise from the central stem and droop attractively at the tips. The cultivar 'Pfitzeriana Aurea' is even more decorative as the foliage is prettily tinted golden-yellow. This cultivar will spread across 2 m when mature.

J. procumbens 'Nana' CREEPING JUNIPER
(*J. chinensis procumbens*)
A dwarf type forming a carpet up to 30 cm in height and spreading across 2–3 m. Its natural habitat is the seashore in Japan. It has bright green awl-shaped leaves.

J. sabina 'Arcadia'
Is a dwarf, slow-growing plant to a height of 60 cm with a spread of 2 m, and strong horizontal branches clothed with light green leaves. *J. sabina tamariscifolia* is similar, with a preponderance of awl-shaped leaves of bright green. It is a good plant to use as ground cover over a bank or in a large rock garden, in a hollow wall or in a large container.

J. virginiana 'Grey Owl'
Makes an elegant mound of growth. It may eventually reach a height of a metre but is seldom more than 40 cm, with a spread across 2 m. Its form and its blue-grey leaves make it a desirable plant for a large garden.

KALANCHOE BLOSSFELDIANA RED POSY
DESCRIPTION: Several different species of kalanchoe are grown as house plants. This particular one is propagated as such for indoor colour during the cold months of the year. Mass-planted out-of-doors it makes a charming show on a dry bank, along a path or drive, or as the border to a bed of flowers. Individual plants are good subjects for the rock garden or for pot culture. It has fleshy, glossy ovate leaves which remain attractive throughout the year. They are 2 cm broad and up to 3 cm long, mid-green in colour with a tinge of red outlining the prettily scalloped margins. In winter the plant is a glorious show when the coral-red flowers carried in profusion almost hide the leaves. The individual flowers, only one centimetre across, are carried in attractive posy-like clusters which are colourful in the garden, in pots indoors or when cut for posies or small arrangements.
CULTURE: Being succulent in nature it grows well in dry areas and in porous soil. Too much rain in a heavy clay may cause the plants to rot. It stands up to 3° of frost. This little plant grows easily from stem cuttings or root division. Set the plants 20–30 cm apart to make a compact ground cover. In cold regions a plastic covering at night will protect plants from frost damage.

Evergreen Candytuft (*Iberis sempervirens*) creates an enchanting picture in late winter and spring.

A Juniper of sculptured form which needs space to expand.
(*J. x media* 'Pfitzeriana Aurea')

Red Posy (*Kalanchoe blossfeldiana*) is easy to grow and gay with flowers in winter and early spring.

KENNEDIA COCCINEA CORAL VINE

DESCRIPTION: An Australian plant generally grown as a climber but which, with a little trimming and training, makes an effective ground cover for the large garden or park. Its trailing stems should be pegged down to hold them against the soil and form a carpet. The plant is evergreen and the leaflets, arranged in threes, are of some ornamental value throughout the year. In spring, when the clusters of coral-red flowers appear, it makes a splendid show.

CULTURE: Plant 1 m apart in full sun in well-drained soil. It stands moderate frost and drought, but, in a harsh climate it is advisable to mulch the ground until the plant is well grown, to conserve ground moisture and minimise the possibility of frost damage.

KLEINIA ACAULIS KLEINIA

DESCRIPTION: This South African succulent is an excellent one to grow for colour contrast because its blue-grey foliage is a fine foil to plants with dark green or wine-coloured leaves. The leaves are cylindrical and pointed at the tips, and arranged to form a hummock of growth. The flowers are insignificant. Plant it as a ground cover at the base of a climber with vivid orange or red flowers, or along a brick path.

CULTURE: Like other succulents, kleinia does best in soil with a gravelly or sandy texture, which does not become water-logged at any time. It is a good plant for dry inland gardens where frosts are not extreme and also for coastal ones. Trim plants if they become woody at the base. Too much watering tends to make the growth sappy and it then loses its attractive glaucous appearance. Allow 60 cm or more between plants.

KOELERIA GLAUCA BUBBLE GRASS

DESCRIPTION: This is a grass-like plant which forms tufts, and is useful for carpet or pattern bedding, or to form a contrast amongst trailing or prostrate ground covers. The clumps reach a height of 20–30 cm and are of a pleasant shade of blue-grey. Plant it in groups beside an ornamental pool, alongside a path, or in a rock or pebble garden.

CULTURE: It grows quickly if planted in good soil and watered regularly. Does well in full sun or in partial shade and is hardy to moderate frost. Set plants 30 cm apart.

LAMIUM LAMIUM

DESCRIPTION: Under optimum conditions lamiums romp along the ground with cheerful abandon. They are however, fairly easy to keep under control and make an excellent ground cover under large trees. They have colourful leaves and flowers on trailing or prostrate stems which root as they grow.

CULTURE: In good soil they will spread and take over large areas very quickly They need shade to bring out the beauty of the leaves. Will grow in poor soil and survive fairly dry conditions and extreme cold. Pieces of root will establish and spread quickly so plants can be set out 30–60 cm apart. They can prove too invasive and may need to be kept under control.

L. galeobdolon 'Variegatum'

Do not be put off by the name. This is a charming ground cover with ovate leaves 3–6 cm long prettily splashed with silver. The trailing stems root as they run along the ground. In spring it produces small hooded canary-yellow flowers which make a gay show.

L. maculatum

Has soft, ovate leaves with a creamy stripe down the middle, and mauve flowers. There are two attractive cultivars of this species – 'Aureum' has leaves flushed with yellow, and 'Roseum' has pink flowers.

LAMPRANTHUS MESEM, ICEPLANT

DESCRIPTION: These succulent evergreen plants are only too ready to grow and make a splendid show in late winter and spring. They are native to the drier regions of South Africa and thrive under the most difficult conditions. Some of them are bushy and some are prostrate in habit. Mass-planted they will not only cover the soil quickly, but they will prevent erosion on steep banks. They are therefore useful plants to grow for this purpose along rail or highway embankments. The bushy types also look effective at the front of a shrub border or along a drive, whilst low-growing ones are decorative as a carpet anywhere in the garden, or spilling over a wall. The fleshy, cylindrical leaves are sometimes angled and pointed. They vary in length quite considerably. The flowers make a brilliant show with their many slender glistening petals radiating from the centre rather like those of a daisy. The name is derived from

two Greek words *lampros* (shining) and *anthos* (flower), which aptly describe the shining quality of the flowers. The range of colours is both rich and varied. *L. aurantiacus, L. aureus, L. explanatus* and *L. glaucus* have flowers of different shades of yellow; *L. blandus, L. compressus, L. comptonii, L. vanputtennii, L. roseus, L. saturatus, L. spectabilis* and *L. stayneri* have pink to cerise flowers; *L. amoenus, L. brachyandrus, L. eximeus, L. formosus, L. haworthii, L. littlewoodii, L. microstigma, L. vredenburgensis* and *L. zeyheri* have mauve to magenta flowers; and *L. watermeyeri* has large white or pink flowers, while *L. coccineus* has crimson ones.
CULTURE: Lampranthus grow best in full sun and in porous soil. They give a good account of themselves in poor soil but spread more rapidly in ground to which some humus has been added.

They are drought-resistant and tolerate 5° of frost. They do well in coastal gardens and in hot inland ones, but do not flower profusely in subtropical regions where humidity is high throughout the year. Allow 60–90 cm between plants.

LANTANA MONTEVIDENSIS

(*L. sellowiana*) CREEPING LANTANA
DESCRIPTION: This is a plant well worth growing, particularly where poor soil and dry heat make it difficult to establish a wide range of plants. It is scrambling in habit of growth and makes a dense cover to a bank, but it also looks effective spilling over a wall or the edges of a large container. The leaves are dark green, 2–3 cm long, and have coarsely toothed margins. In spring its profusion of posy-like heads of mauve flowers makes a fine show for some weeks. Where conditions are congenial this lantana will produce some flowers also during other seasons of the year. Cut the plant back fairly hard in late spring when the first burst of flowering is over, to prevent it from becoming straggly and untidy.
CULTURE: Is not particular as to soil. Grows best in sun and in a temperate climate. Can stand dryness but not more than 5° of frost, and it is not at its best in a hot humid climate. A single plant will cover a metre fairly quickly.

LEPTOSPERMUM HUMIFUSUM

(*L. scoparium prostratum*) PROSTRATE TEA BUSH
DESCRIPTION: The shrubby tea bush is widely grown but this little low-growing species is seldom seen in gardens. It forms a good ground cover and is particularly lovely in spring when it becomes studded with flowers like miniature blossom. It grows almost prostrate, the stems seldom rising more than 30 cm from the ground but spreading across a metre. The dark green leaves are a perfect foil to the snow-white flowers which appear in mid-spring. *L. scoparium* 'Nanum' is a dwarf form of the popular bush which can also be regarded as a ground cover although it grows to 60 cm in height.
CULTURE: Both species are hardy to severe frost provided that they do not become too dry during winter. They do best in a well-drained acid soil.

LEUCOGONES LEONTOPODIUM

NEW ZEALAND EDELWEISS
DESCRIPTION: Forms a low compact mound of growth. The stems are ash-grey and densely clothed with leaves which hug them forming tight whorls. They are spatulate but pointed at the tip and covered with a glistening silver down. The flowers which appear in spring are very like those of the European edelweiss, but larger. They measure 2–4 cm across and have numerous white downy petals emerging from a golden centrepiece.
CULTURE: This plant which is native to the high mountain regions of New Zealand will stand extremes of cold and brilliant sunshine, but not long periods of drought. It is unlikely to thrive in a mild climate.

LEUCOSPERMUM PROSTRATUM

CREEPING PINCUSHION
DESCRIPTION: A South African plant which makes a pretty show in spring, cascading over a wall or carpeting the ground with its pretty flowers. It is prostrate in habit and has small slender leaves. The flowerheads are about 4 cm across and look like little pincushions with pins projecting from them. They are shaded from apricot to terracotta.
CULTURE: Plant in well-drained acid soil about 60 cm apart. It will stand 5° of frost. Water well and regularly throughout autumn and winter to encourage good flowering.

LIMNANTHES DOUGLASII LIMNANTHES

DESCRIPTION: Is an annual and therefore should not appear in a book on ground covers. It is, however, so rewarding for quick cover that it is

Kleinia (*K. acaulis*) with its mound of silvery leaves is a
splendid ground cover for dry gardens.

Lampranthus roseus. To keep the plants neat shear off some of
the top-growth after flowering is over.

Lamium maculatum looks delightful in filtered shade. It
enjoys cold winters.

Lampranthus roseus. Is easy to grow and it produces a glowing
mass of vibrant colour.

Lampranthus glaucus is very quick-growing and creates a
cheerful show of colour.

New Zealand Edelweiss (*Leucogones leontopodium*) requires
cold conditions to encourage good growth.

Creeping Lantana (*L. montevidensis*) is most colourful from late winter to early summer.

Limnanthes forms a billowy mound of lacy leaves and has colourful flowers in early spring.

Plant Lamium (*L. galeobdolon* 'Variegatum') to brighten a shady part of the garden.

included as a plant for temporary effect. It grows to a height of 20–30 cm and as much, or more, across, creating a soft, billowy mound of lacy, pale-green, glossy, deeply-cut leaves, which are in themselves most attractive. In late winter and early spring when the flowers appear it makes an enchanting show. The flowers are funnel- or bowl-shaped, 2–4 cm across, with petals of rich golden-yellow in the centre and white at the tips. Mass it at the front of climbers or shrubs, or around beds of roses.

CULTURE: Sow seeds in late summer and transplant when small to stand 30 cm apart. Soil rich in humus and cool, moist growing conditions suit it best. In gardens subject to brilliant sun during winter, grow it in filtered shade, and water well during dry periods.

LIRIOPE LILY TURF

DESCRIPTION: An evergreen perennial with grass-like leaves generally carried in tufts. It belongs to the lily family but the flowers do not in the least resemble lilies. These are unusual plants for shady corners under trees or in a shady position near a pool, or for pattern-bedding.

CULTURE: They do best in acid soil rich in humus. Although established plants will survive fairly long periods with little water, they do not look attractive unless watered regularly. They are hardy to sharp frost. Should plants become bedraggled, shear off the top-growth in late winter to encourage the development of new shoots. Plant 20–30 cm apart.

L. exiliflora

Spreads by underground stems, producing tufts of leaves 20–30 cm tall. It has spikes of violet-blue flowers in spring.

L. muscari 'Variegata'

Makes a better show than the species as its leaves, edged with creamy-yellow, show up well in the shade. The spikes of violet flowers stand well above the foliage.

L. spicata

Is another species which spreads by means of underground stems to form a fairly dense cover of grassy leaves 20 cm high. It has spikes of lilac or white flowers.

LITHOSPERMUM DIFFUSUM LITHOSPERMUM

DESCRIPTION: Where conditions suit it this is a most attractive plant to have hanging down over a wall, growing along the front of a bed of azaleas, or scrambling over rocks in a rock garden. It is a shrublet of loose, almost prostrate growth with soft stems of light to dark green leaves hardly 3 cm in length. The flowers which appear in late winter or spring are tubular in form opening to a five-lobed starry face of gentian blue. Some of the hybrids have flowers of lighter or darker hue. The plant seldom reaches more than 20 cm in height and covers a metre in spread. Two of the best of the cultivars are: 'Grace Ward' and 'Heavenly Blue'.

CULTURE: Will grow only in acid soil. It is advisable to try it in soil to which peat and acid compost have been added. Near the coast it can be grown in the open but in hot gardens where the sunlight is intense, plant it in shade and keep it well watered. Not recommended for subtropical gardens as it enjoys cold winters.

LONICERA JAPONICA
 JAPANESE HONEYSUCKLE

DESCRIPTION: Is a quick-growing scrambling plant useful for covering large banks or to control erosion over a large area. It is evergreen except in very cold districts where it may lose most of its leaves for a short period. The pliable stems will in time form a dense mound of growth. Fortunately it is easy to keep in control by annual trimming which is best done in late spring or early summer. The oval pointed leaves are arranged in opposite pairs and the sweetly-scented flowers are carried in pairs, too, in the axils of the leaves. They are slender tubes with recurved lips, cream tinged with purple in the bud, turning yellow as they mature. The floral display is not spectacular but the plant is worth growing for the perfume of the flowers. Two cultivars which have merit are: L. japonica 'Aureo-reticulata' which has leaves marked with gold, and L. japonica 'Halliana'. The former is suitable for the garden of average size whilst the latter is so exuberant that it should be grown only in the large garden or park.

CULTURE: These honeysuckles endure severe cold and they will also tolerate fairly long periods of drought, but to promote good initial growth, water them well and regularly. They do better in partial shade than in full sun. Space plants 2 m apart.

LOTUS BERTHELOTII TRAILING LOTUS

DESCRIPTION: An evergreen, trailing perennial which makes a colourful show when in flower. Plant it to cascade down over rocks or a wall. The stems of small, narrow silver-grey leaves spread out to 2 m, hugging the ground as they grow. In spring and early summer it becomes covered with cheerful crimson pea-shaped flowers.

CULTURE: Grows in full sun or part shade. Once established it withstands fairly long periods with little water and about 5° of frost. It does well in sun in coastal gardens provided it is not subject to salt spray. Plant in soil rich in humus. In a cold climate grow it in containers which can be moved to a sheltered corner.

LYSIMACHIA NUMMULARIA
CREEPING JENNY

DESCRIPTION: A carpeting plant with long runners which root at the joints as they progress. It will hold soil on a bank and it looks effective falling over a wall or the edge of a hanging basket. This is an evergreen perennial with a mat of light green rounded leaves. In late spring and summer it produces cup-shaped flowers of canary yellow, 2–3 cm across, just above ground level. The cultivar 'Aurea' which has leaves tinged with yellow is less invasive.

CULTURE: Plant it in humus-rich soil in shade or part shade and water well throughout the year. It stands frost but not dryness. Under ideal conditions it can become too invasive.

MALEPHORA CROCEA COPPER VYGIE
(Hymenocyclus croceus)
DESCRIPTION: Is a tough plant useful for gardens where growing conditions are difficult. It is a succulent which sprawls across the ground covering the bare earth with its fleshy, cylindrical grey-green leaves. In late winter and early spring the plant becomes covered with a mass of sparkling flowers composed of numerous slender cyclamen to copper petals radiating from a golden central disc. It will spread rapidly to cover a metre in area.

CULTURE: This is a plant which needs no encouragement to make it grow. It will thrive in poor, sandy and alkaline soil and endure long periods of drought and considerable cold. It likes bright hot sun and is not recommended for damp shady gardens.

MENTHA REQUIENII JEWEL MINT,
PEPPERMINT MOSS

DESCRIPTION: A Corsican plant which creeps flat along the ground sending out roots as it grows. It has a verdant appearance and gives off a pleasant aromatic scent when crushed underfoot. Plant between paving stones of a path or patio. It has tiny rounded, bright green leaves and mauve flowers in summer.

CULTURE: Grows easily from root sections. Plant roots in sun or part shade at any time of the year, setting them about 15 cm apart to form a quick carpet. It stands frost and a certain amount of dryness. In cold areas the top growth may disappear during the winter months.

MUEHLENBECKIA COMPLEXA WIRE VINE
DESCRIPTION: An unobtrusive evergreen plant with small neat dark green leaves on wiry stems. If it finds a support it will climb up it, otherwise it sprays out over the ground. The flowers are insignificant and the plant is grown purely for its neat leaves and not ungraceful form. Another species M. axillaris (Creeping Vine) is also sometimes planted as a ground cover. It seldom reaches more than 20 cm in height and spreads by means of underground stems. Both species are useful where it is necessary to check erosion.

CULTURE: They grow well in seaside gardens and they stand severe frost. Once the roots are well grown they will survive drought, and they thrive in partial shade.

MYOPORUM PARVIFOLIUM
DESCRIPTION: Is not a very decorative plant but useful where conditions make it difficult to grow a wide range of plants. A native to Australia it is almost prostrate in growth with ivory stems densely covered with small slender leaves 2–3 cm long which quickly clothe the bare ground. In summer it has small honey-scented flowers which are followed by purplish berries in autumn.

CULTURE: It grows in any kind of soil – acid or alkaline – sand, gravel or clay. Once it is rooted it survives long periods with little water and moderate frost. Set plants 30 cm apart.

NEPETA CATMINT, GROUND IVY
DESCRIPTION: Two species are worth planting. Both grow readily but may die out if planted in a

Lithospermum is one of the few ground covers which has blue flowers. It likes cold.

Omphalodes (*O. cappadocica*) needs moist, acid soil and prefers filtered shade to full sun.

heavy soil with poor drainage. They are vigorous plants of the mint family, and, if trimmed, they form a good dense ground cover of leaves. Their flowers add to their attractiveness in late spring and early summer. These are good plants to grow as a border along a drive.

CULTURE: Both species do best in friable, well-drained soil. Plant *N. mussinii* in full sun. *N. hederacea* does best in partial shade. They stand sharp frost and some dryness. Allow 30–45 cm between plants.

N. hederacea GROUND IVY
(*Glechoma hederacea*)

Is a creeping evergreen perennial about 15 cm high, which grows well in the shade. The stems root at the joints and form a carpet. Because of its vigour it can become a weed where growing conditions are good. It has rounded leaves with scalloped edges and light blue flowers. The cultivar 'Variegata' with variegated leaves makes a pretty show in filtered light and is not an invasive plant.

N. mussinii CATMINT

Makes mounds of growth 40–60 cm high and wide but can be trimmed to smaller size. The soft grey-green leaves are aromatic and attractive to cats who like rolling or sleeping in it. In late spring and summer its little spikes of lavender flowers make a pretty display. Set plants 30–45 cm apart for ground cover. *N. faassenii* is a related form of taller growth.

NIEREMBERGIA REPENS WHITE CUP
(*N. rivularis*)

DESCRIPTION: A charming perennial from the Argentine with slender stems which creep along the ground, forming a hummock or prostrate mat of bright green leaves. These are variable in size and oblong or spatulate in shape. In summer it bears a mass of white flowers. They are funnel- or cup-shaped, and approximately 2–3 cm across. It looks attractive spilling over the edge of a container or carpeting the ground. Where winters are very cold the top-growth is likely to die back for a short time.

CULTURE: Plant it in good soil in sun or partial shade and water well during dry periods. Set the plants 30 cm apart and, if they become over-crowded, divide the roots in autumn or winter. It stands moderate frost.

The Trailing Daisy bears its flowers from late winter to mid-spring. (*Osteospermum fruticosum*)

Osteospermum (*O. jucundum*) and its hybrids are vigorous, quick-growing ground covers.

This decorative Sorrel (*Oxalis semiloba*) flowers for many weeks from late winter to summer.

Pelargonium (*P. angulosum*) is a delightful South African species for gardens large or small.

OMPHALODES CAPPADOCICA

OMPHALODES

DESCRIPTION: Plants with clear blue flowers always make an impact in the garden, and this little perennial, native to Turkey and Asia Minor, has flowers of the same colour as forget-me-nots. It grows from a creeping rhizome and sends up loosely arranged soft stems of broadly ovate leaves to a height of about 30 cm. The plant, covered with sprays of flowers, is particularly attractive in spring. Plant it in a rock garden or as a ground cover between azaleas and fuchsias.

CULTURE: Set plants 30–45 cm apart in a shady part of the garden. It will grow only in acid soil and it is advisable to dig in peat and acid compost where it is to be grown. Water well during dry periods of the year. It stands severe frost but not hot dry conditions.

89

OPHIOPOGON JAPONICUS 'Variegatus'
LILY TURF, MONDO GRASS

DESCRIPTION: This plant, like liriope, belongs to the lily family, but there is really no resemblance in its growth to that of a lily. It forms clumps of grass-like leaves with pointed blades, striped green and white. They grow to about 30 cm and arch over at the tips. It spreads slowly from the underground rootstock. The pale mauve flowers which appear in spring have little ornamental value, the plant being grown for its pretty leaves.
CULTURE: Plant 30 cm apart in soil rich in humus and water well to encourage growth. Severe frost may damage the leaves. If this happens shear them off and new growth will emerge in spring. At the coast it grows well in full sun, but elsewhere it does better in shade or partial shade.

ORIGANUM VULGARE 'Aureum'
GOLDEN MARJORAM

DESCRIPTION: Many plants are worth growing solely for foliage effect, and this is one which is particularly striking in spring when the soft little leaves are golden-yellow. The plant forms a thick mat across the ground and, as it is not an invasive grower, it is very suitable for the small garden. It looks charming spilling over the edge of a container or cascading down over a wall, interplanted with other ground covers with grey or green leaves, along the sides of a path, or as an edging to beds of roses.
CULTURE: It grows in sun or partial shade and prefers well-drained soil to sticky clay. The top-growth dies down in winter but the roots survive severe frost. Water well when the new growth emerges in spring. For quick cover set plants 20 cm apart.

OSTEOSPERMUM TRAILING DAISY

DESCRIPTION: The genus includes good ground covers for gardens large and small. They are native to South Africa and, like many other South African plants, they grow even when neglected. The species described below are excellent plants to grow on a dry bank, to cover the bare earth and to stop soil erosion. They also look attractive draped over a wall, edging a drive or along the sidewalk outside the garden. The leaves are mid- to dark green, fairly long and slender with uneven points along the margins. They flower for a long period.

CULTURE: The stems root as they grow along the ground, so it is not necessary to plant them closer than a metre, except where quick cover is required. They grow in any kind of soil, survive long periods of drought, and tolerate frost, but sharp frost may damage the flowers which appear in late winter and early spring. Where frosts are severe, plant them where they are shaded from the early morning sun so that the frost melts before the sunlight catches the plants. They need an abundance of sunshine for their best development but will grow in part shade. Every two to three years it may be necessary to dig up those plants which have spread too far and wide. If not checked these trailing daisies may spread across neighbouring plants, but it is very easy to cut the stems off, when they grow too long, and to root out unwanted plants.

O. fruticosum TRAILING DAISY
(*Dimorphotheca fruticosa*)
Has sprawling stems which cover the ground or clamber up any support near at hand. The daisy-like flowers are glistening white on the upper surface and tinged with mauve on the reverse. The centre is deep lavender to purple.

O. jucundum MAUVE TRAILING DAISY
This species and its hybrids have flowers of shades of mauve to claret. It is a graceful plant – charming covering a bank or spilling over a tub. *O. barberae* has flowers which are similar in every way.

OXALIS SORREL

DESCRIPTION: This is a large genus of over 800 species, many of which produce really pretty little flowers. Unfortunately the plants have a tendency to multiply and spread all over the garden, and for this reason only two species of restrained habit are described below. In both cases the flowers close towards evening.
CULTURE: Sorrel does best in acid soil, but it will grow in regions where the soil is slightly alkaline and in coastal gardens. Where frost is severe cover the plants with a mulch during the winter. Plant in full sun or filtered shade, setting them about 30 cm apart.

O. adenophylla
Is native to Chile. It has grey-green leaves carried in rosettes or whorls just above the ground. These

90

are ornamental for most months of the year. In spring its pink flowers with satin petals make a delightful show. This species grows from a woody rootstock which increases slowly.

O. semiloba PINK SORREL
A South African species with large, bright green, shamrock-like leaves which cover the ground completely. In spring and summer and at other seasons, it bears flowers of bright rose-pink.

PACHYSANDRA TERMINALIS
JAPANESE SPURGE

DESCRIPTION: An evergreen ground cover which spreads by underground runners to form a neat dense carpet only 15 cm above the soil. The ornamental glossy dark green leaves which arise in clusters are 4–8 cm long, and in spring the plant has spikes of tiny white flowers. It has become a popular ground cover in Europe and the U.S.A. and should be used more in cool gardens here. A cultivar named 'Variegata' has leaves edged with silvery-white, which show up well in an area of dense shade.
CULTURE: Grows best in acid soil rich in humus and should be watered fairly regularly. It does well in dense shade or partial shade and is therefore a good ground cover to use under large trees. It is one of the few plants which will grow under pine trees. Set plants 30 cm apart.

PELARGONIUM PELARGONIUM, GERANIUM
DESCRIPTION: It seems a pity that the popular common name for pelargonium should be geranium, because this leads to confusion as there are the true geraniums which are different in appearance from pelargoniums. There are many species of pelargoniums and hundreds of named cultivars. Generally, they are referred to under different type headings. A large group is known as Regal. These are thought to be derived from *P. angulosum* and *P. cucullatum*. The other two popular types are Zonal and Ivy-leafed pelargoniums. All of the species from which the popular hybrids have developed are native to South Africa. Because of the large number of cultivars, gardeners who wish to grow pelargoniums on a large scale should consult the catalogues of nurserymen who specialise in these plants.

Some of the species and cultivars are bushy in growth whilst others have trailing stems which tend to root along the ground. Some have leaves with a fresh lemon scent whilst others have leaves with a scent redolent of roses or apples. The shape and colouring of their leaves vary quite considerably, too. They may be rounded with scalloped edges, similar to those of an ivy, or like a maple. Some are a lustrous pale green; some are dark green whilst others are prettily banded with different colours. In addition to having attractive leaves they also produce outstanding flowers varying in colour from white through many shades of pink to brilliant scarlet, and from palest mauve to purple.

Pelargoniums flower and grow well in pots and, where frosts are severe, plants in pots can be kept in a shed during the worst months of the year. It is a good idea also to have plants growing in pots to use as temporary space fillers anywhere in the garden or on a patio or stoep.
CULTURE: Pelargoniums are very willing to grow, and flower prolifically if given a little attention. Generally, they will grow quite well in poor soil but they do far better in soil to which some leaf mould or compost has been added. They survive long periods with little water and fairly sharp frost. Trim plants back in autumn or winter to encourage the development of new shoots and, if the plants become woody and straggly, make cuttings. They root very easily and old plants should be replaced by new ones every few years.

PENNISETUM SETACEUM FOUNTAIN GRASS
DESCRIPTION: A perennial grass which forms dense clumps. The slender, tapering, arching leaves rise to 45 cm or more and make a graceful ground cover. In summer fuzzy spikes of coppery flowers appear on stalks above the leaves. These look attractive in the garden and in arrangements. 'Cupreum' has mahogany leaves.
CULTURE: This is a good plant for difficult gardens as it stands severe frost, full sun and fairly long periods with little water. Its disadvantage is that the top-growth dies down in winter. Set plants 60 cm apart. If it begins to look straggly after a few years shear the top-growth down to ground level and divide the roots and re-plant.

PHALARIS ARUNDINACEA 'Picta'
RIBBON GRASS

DESCRIPTION: A dainty grass-like plant which grows to a height of 60 cm. It has narrow leaf-

Ribbon Grass (*Phalaris arundinacea* 'Picta') will form a dainty border or ground cover.

The leaves of *Polygonum affine* are decorative and in spring it has handsome flowers.

blades of soft texture, with longitudinal stripes of apple-green and white. The plant forms a fresh-looking and graceful ground cover and looks particularly effective growing in clumps in front of plants with dark green or purple foliage. It multiplies quickly but is easy to keep under control.

CULTURE: Although it will grow in poor soil and tolerate fairly long periods with little water, it looks more verdant and attractive when planted in good soil and watered well and regularly throughout the year. It stands severe frost and grows in partial shade or full sun. Shear the top growth off once a year, in late winter or early spring, and divide the plants after a few years when they appear to be overcrowded. Set plants 30 cm apart.

PHLOX ROCK PHLOX, MOSS PHLOX
DESCRIPTION: These little plants should not be confused with the annual or the tall perennial phlox. They are low-growing types which make a carpet of colour in spring. The two described here are prostrate in growth forming a mat of leaves along the ground. They bear their flowers on short stems just above the leaves. *P. nivalis* has slender leaves and clusters of pink or white flowers.

Phlox subulata is pretty as a ground cover anywhere in the garden. It enjoys cool conditions.

P. subulata has broader leaves and glorious mounds of starry, five-petalled pink, white or lilac flowers.
CULTURE: Plant in soil rich in humus and water regularly during dry periods of the year. Both species like cold winters, and do not grow well in subtropical gardens. Plant 30 cm apart.

PHYLA NODIFLORA LIPPIA, DAISY GRASS
(*Lippia repens*)
DESCRIPTION: Has been popular as a carpeting plant for many years, and is sometimes grown as a lawn substitute. It has tiny leaves, scarcely 2 mm long, carried on ground-hugging stems which make a complete cover. The small rounded heads of lilac to pale pink flowers stud the plants in spring and attract bees from far and wide. In regions with hard winters the top-growth disappears until the weather warms up.
CULTURE: Grows better in a loose sandy soil than in clay, and in part shade rather than in full sun. Fertilise in spring to encourage vigorous new growth, and water regularly. For quick cover plant 10 cm apart.

PLECTRANTHUS SPURFLOWER
DESCRIPTION: The genus includes shrubs and low-growing perennials, four of which are described here. They are very quick-growing plants with soft, spreading stems of leaves with neatly serrated margins. The flowers are tubular, ending in two lips – rather like those of the salvia to which it is related. The leaves when crushed give off a pleasant aromatic scent.
CULTURE: Plant in shade and water during dry periods of the year. Frost will cut back the top-growth but the plants often shoot out again in spring. They are not recommended for dry or very cold gardens.

P. ciliatus
The stems are thickly clothed with rough leaves which are green on the upper surface and purple on the underside. In summer spikes of tiny mauve flowers appear in a foaming profusion. This is too vigorous a plant for the small garden. Space 1 m apart.

P. coleoides marginatus
The other three species of plectranthus described here are native to South Africa, but this one comes from southern India. It is the prettiest and

Polygonum (*P. capitatum*) is a prostrate, quick-growing plant. Here it is trained to form a mound.

Sow portulaca in spring to produce a scintillating mass of colour in summer.

the most suitable for the small garden or for growing in containers. The small leaves are almost triangular in shape, apple-green in colour and have a neatly serrated margin tinged with creamy-yellow. The leaves remain ornamental throughout the year and in late summer and early autumn the plant is enhanced by little spikes of white to palest lavender flowers. It roots from cuttings as readily as the other species. Set plants 30 cm apart.

P. grandidentatus

A quick-growing species which romps along forming a mound of soft, hairy, aromatic leaves of olive-green. In summer it brightens the garden with its ivory flowers. A good plant for the sides of a shady drive. Allow 40 cm between plants.

P. verticillatus

Has much smaller leaves than the two species described above and is, therefore, more suitable for the small garden. They are almost round, fleshy in texture and about 3 cm across. Plant 30 cm apart.

POLYGONUM POLYGONUM

DESCRIPTION: The genus includes plants of widely varied habit of growth. Two of them – *P. aubertii* and *P. baldschuanicum* – are effervescent climbers which can be effectively used as ground cover over a steep bank in a large park, or along a highway embankment. The other two included here differ in appearance and in their growing requirements.
CULTURE: The climbing types and the one known as *P. capitatum* will stand considerable drought and they are not choosy as to soil. *P. affine* is at its best in moist soil rich in humus. All of them grow in full sun or filtered shade and all stand severe frost, but continued cold may kill off the roots of *P. capitatum*.

P. affine

Is a perennial. Where winters are cold the top-growth may die down in winter but the new growth starts again early in spring and the spear-shaped leaves which rise to 30 cm from the ground create an unusual cover. In spring when the flowers appear it is an impressive sight. The individual flowers are small but they are carried in handsome spikes. Two cultivars of merit are 'Darjeeling Red', which has rose-pink spikes 15 cm long in mid- to late spring, and 'Donald

Lowndes' which has larger leaves and paler flowers early in spring. Set plants 45 cm apart.

P. capitatum GROUND POLYGONUM

This plant is more than willing to grow. It will cover not only the ground but neighbouring plants too if not checked. Its trailing stems root as they progress and it is therefore a useful subject to grow on a steep bank to check erosion. It also looks effective spilling over a wall. The leaves are attractively coloured and marked with brick red, and in a cold climate they turn a rich crimson in autumn. Globular heads of closely packed flowers festoon the plant in spring and on and off during the other seasons, too. Although it is a quick spreader it is easy to control as the roots are fairly near the surface. Shear off excessive top and side growth two or three times a year to keep it within bounds.

PORTULACA GRANDIFLORA PORTULACA

DESCRIPTION: Makes a splendid temporary ground cover during the hottest months of the year. It should not be included in a book dealing with permanent ground covers but it makes such a glorious show and is so easy to grow that it deserves to be mentioned. Many home owners with little time to spare wonder how to keep the ground covered whilst the new-planted roses or shrubs are still small. Portulaca will do this magnificently in summer and the Bokbay vygie (Livingstone daisy) will make a carpet of colour in spring. The fleshy little leaves are cylindrical and pointed, and fairly closely packed on the succulent, rose-tinted stems which spread out over the ground. The lustrous flowers are like miniature roses and of lovely shades of pink, cerise, red, yellow, orange and white.
CULTURE: Sow seed as soon as the weather is warm in spring and set the young plants 20 cm apart. They do best in well-drained soil and in full sunshine. Although they tolerate fairly long periods with little water, they will flower better with regular watering. The flowers open freely when the sun is bright.

POTENTILLA CINQUEFOIL, POTENTILLA

DESCRIPTION: The genus includes a wide diversity of plants – evergreen and deciduous perennials and shrubs. The leaves of many of them are attractive, being grey-green or bright green in

colour and divided into small leaflets. The flowers which appear in spring or early summer are rather like small single roses.

CULTURE: Plant in well-drained soil and water during dry months of the year. The evergreen species need regular watering throughout the year, whereas the deciduous ones may be left fairly dry during winter. They stand severe frost but are not happy in hot humid regions. They grow in full sun or partial shade.

P. alba

A deciduous species which makes a charming ground cover for most months of the year. It reaches a height of about 10 cm and spreads 30 cm. The deeply divided leaves are grey-green and the flowers are white with an orange eye.

P. cinerea

An evergreen which forms a carpet on the ground. The leaves are divided into five wedge-shaped grey leaflets notched at the tips. The pale yellow flowers are about 2 cm wide. Set plants 20 cm apart.

P. cuneata

(*P. ambigua*)

Is a deciduous species native to the Himalayas. Each plant will spread across 30 cm. The tiny leaves are dark green on the upper surface and grey-green beneath. The flowers are yellow.

P. fragiformis

A delightful little species which makes a pleasing ground cover when planted about 30 cm apart. It has soft, sage-green palmate leaves which are in themselves attractive. In spring the plant is enhanced by a mass of yellow flowers.

P. nepalensis 'Willmottiae'

Is an evergreen growing to a height of 20 cm and spreading across 45 cm. The decorative leaves are divided fanwise into five green leaflets 2–3 cm long. It bears clusters of shrimp-pink flowers.

P. verna

Is evergreen where frosts are not sharp but may lose its leaves in regions of severe winters. It grows to only 15 cm in height and spreads across 20–30 cm. The leaves are divided into five bright green leaflets which make a pretty show, and in spring the plant is enhanced by its clusters of small yellow flowers.

RAOULIA LUTESCENS RAOULIA

DESCRIPTION: Is a delightful New Zealand plant which forms decorative mounds or mats of minute rounded green or grey-green leaves arranged in compact rosettes. The tiny flowers of bright yellow make a gay show in summer. Grow it in a rock or pebble garden, between paving stones of the path or patio, or massed along the front of a shrub border.

CULTURE: Plant it in friable soil and water during dry periods of the year. It stands frost provided it is not dry at the same time. Grows in sun or part shade. Space plants 60 cm apart.

RHOICISSUS TOMENTOSA WILD GRAPE, MONKEY ROPE

DESCRIPTION: This evergreen South African climber is vigorous in habit and will climb to the tops of tall trees, but it is also decorative when grown as a container plant or as a ground cover. The leaves are large and somewhat like those of a grapevine in shape, but they are more decorative as they have a glossy surface and a rich green colour. Because of its large leaves and robust habit of growth it is not recommended as a ground cover in the small garden but it is an excellent plant to grow to cover large areas of bare earth.

CULTURE: It grows in sun or shade and endures moderate frost but not long periods of drought. Cut the stems back when they begin to encroach on other areas of the garden or when they twine about neighbouring shrubs or trees.

ROSA WICHURAIANA RAMBLER ROSE

DESCRIPTION: The original species from which many rambler roses have been developed is a quick-growing, semi-evergreen plant which has few thorns, masses of dark green glossy leaves and clusters of small white flowers with golden anthers, in late spring and summer. 'Dorothy Perkins' is the name of one of the most decorative of these roses and it is one which makes a splendid ground cover tumbling down over a large bank.

CULTURE: Severe frost may cause these roses to lose most of their leaves but the roots are unaffected by cold. Once they are well grown the plants will survive drought, but regular watering is desirable in the first three to four years. Should the plants become straggly or too big for their allotted space, cut them back in late spring soon after their flowering is over. They are extremely

Plant a rambler rose, such as 'Dorothy Perkins' to cover a large expanse or a steep bank.

Dainty leaves and cascades of little flowers are a characteristic of some of the saxifrages.

resilient and even when hacked back with a sickle they will grow out again with cheerful abandon to flower the following year. To cover a large bank space plants 2 m apart.

ROSMARINUS LAVANDULACEUS
(*R. officinalis prostratus*) DWARF ROSEMARY
DESCRIPTION: Most gardeners know the large shrubby rosemary, but one seldom comes across

96

This little saponaria (*S. ocymoides*) grows across the ground and makes a cheerful show.

the prostrate-growing form, which is a much better plant for small gardens. It spreads across the soil and spills prettily over a wall or bank. The small deep green aromatic leaves cover the stems closely, and in spring the plant is covered with masses of pale lilac flowers which show up well against the dark colour of the foliage.
CULTURE: It does best in gravelly soil with good drainage and in full sunshine. Severe frost may cut back the top-growth, but this is an advantage as in a temperate climate the plant may become rather straggly if some of the older stems are not thinned out each year. Grows well in seaside gardens. Set plants 20–30 cm from one another.

SAGINA IRISH or SCOTCH MOSS
DESCRIPTION: This moss-like plant produces a delightful verdant sward and is admirable for carpeting woodland areas. It is spongy in growth and spreading in habit. It bears tiny white flowers on short stems, but the plant is grown not for the flowers but for the rich green carpet it forms. *S. pilifera* and *S. subulata* are the best-known species. Hybrids of both of these with leaves flushed with yellow are splendid plants for carpet bedding.
CULTURE: Plant 10–20 cm apart in soil rich in

humus, in partial or filtered shade. Water plants well during dry periods of the year. Frost will not damage the plants if they are watered regularly during winter.

SANTOLINA CHAMAECYPARISSUS

(*S. incana*) LAVENDER COTTON

DESCRIPTION: This plant can look delightful or dreadful, depending on how it is treated. It has a height and spread of 60 cm but looks far more attractive if it is clipped once or twice a year, to keep it to 30 cm or less. Trimmed in this fashion it makes a fine show used in carpet bedding or mass-planted over a large area. The stems are densely clothed with little silver-grey leaves which are aromatic, and, in late spring or early summer, it bears buttonlike heads of yellow flowers. The cultivar 'Nana' grows to only 20 cm in height and has a spread of about the same. It is therefore more suitable for the small garden.

CULTURE: Lavender Cotton grows in poor soil and it stands cold and dry conditions. Plants are, however, inclined to become leggy with age and it is advisable to make new plants from cuttings to replace the old ones. If trimmed annually they should keep their neat appearance for at least five years.

This little Sedum (*S. spathulifolium*) is a charming plant to grow anywhere in the garden.

If trimmed, Stoebe (*S. plumosa*) is a useful ground cover for the large garden or park.

SAPONARIA OCYMOIDES ROCK SOAPWORT

DESCRIPTION: A prostrate perennial which covers the ground with a profusion of dark green leaves for many months of the year. In spring and early summer it becomes a mass of phlox-like flowers of rose to shocking-pink. It grows to a height of 15 cm and spreads itself fairly fast. 'Rubra Compacta' is the name of a cultivar which is even more impressive than the species.

CULTURE: Likes cold but not long periods of

97

Sedums are variable in growth. *S. acre* is a small species with neat leaves and dainty flowers.

drought. Plant 30 cm apart in full sun or part shade, in well-drained soil and water during dry periods of the year. Should plants appear to be spreading too far afield, remove the roots around the edges.

SAXIFRAGA SAXIFRAGE, LONDON PRIDE

DESCRIPTION: The genus includes a wide range of plants some of which make a pretty and unusual ground cover if mass-planted. The habit of growth of different types varies considerably and it is perhaps least confusing to consider them under two headings. The 'mossy' ones which make mounds or little cushions of finely divided greenery; and those which form rosettes of leaves. They are recommended for growing in rock or pebble gardens and in cracks between pavingstones, or massed anywhere in the garden where conditions are suitable. They are grown for their leaves rather than the flowers.

CULTURE: Many of them grow naturally on high mountains and like frost provided they are not left dry at the same time. Plant them 30–45 cm apart in soil rich in humus, in shade or partial shade, and water well throughout the year. Not recommended for subtropical gardens.

S. burseriana

Forms masses of tiny rosettes of blue-grey leaves closely packed together. The dainty little white, cup-shaped flowers appear on stems only 5 cm high. 'Sulphurea' is a pretty cultivar with yellow flowers.

S. geranioides

This little one is native to the Pyrenees. It is a mossy type growing to a height of 10 cm and spreading across 25 cm. In spring it has sprays of little ivory-white flowers.

S. x 'Jenkinsae'

Is a dainty little plant making a mound of growth hardly 3 cm above the ground. The plant spreads across 30 cm. The rosettes of leaves have a silvery tinge. In late winter flowers of palest pink cover them completely.

S. paniculata

Produces large clumps of dense, silvery rosettes of leaves with toothed edges and clusters of creamy-white flowers on stems 30 cm high. These appear in spring.

S. x 'Peter Pan'

Is a mossy saxifrage forming low hummocks of bright green leaves. In spring it bears a profusion of deep pink flowers.

S. stolonifera MOTHER OF THOUSANDS
(S. sarmentosa)

A species from China and Japan which is sometimes used as a house plant. It sends out numerous runners which root as they grow – hence the common name. The leaves are almost round, about 8 cm across, have white veins, and are flushed with pink on the underside. The flower stems rise to 30 cm and carry loose clusters of white flowers in spring.

S. umbrosa LONDON PRIDE

Forms spreading mats of rosettes of apple-green, slightly shiny, spathulate leaves with toothed margins. In spring it has starry flowers of blush-pink on stems 20 cm tall.

SEDUM SEDUM, STONECROP

DESCRIPTION: Sedums are grown for the unusual quality of their foliage and for their flowers. These plants vary in height considerably but only those of low or prostrate growth which can be grown as a ground cover, are described here. The leaves are generally fleshy or succulent and the flowers are star-shaped. They may hug the ground or form a hummock of growth. Sedums are effective as cover plants in a rock garden and also in pattern-bedding.

CULTURE: The species described are easy plants to grow. They stand severe frost and fairly long periods with little water, and grow in full sun or partial shade. They root very easily from stem cuttings. With some, even a leaf will root if pushed into the soil a little way. These plants grow best in a well-drained soil.

S. acre GOLDMOSS SEDUM, STONECROP

Grows to 5 cm in height and spreads across 30 cm or more. Forms a mat of pale green closely-clustered leaves and has sprays of cheerful yellow flowers in spring. Stands extremes of frost. The cultivar 'Aureum' has foliage flushed with yellow.

S. album

Is a creeping evergreen 5–10 cm high, with little fleshy cylindrical leaves tinged with red along the margins. In late spring it has a mass of small white starry flowers. Space plants 20 cm.

S. cauticolum

A Japanese sedum about 10 cm in height spreading across 30 cm. It has ovate leaves of a grey-green hue and showy heads of cyclamen flowers in summer and autumn, when few other perennials flower.

S. dasyphyllum

This species from the Mediterranean littoral grows flat along the ground and makes a carpet of tiny blue-green leaves. It has flat clusters of dainty white flowers in spring.

S. lineare

Has trailing stems which root as they grow, making a ground cover of very narrow, fleshy leaves of mid-green, about 2 cm long. In late spring and summer it becomes a carpet of dainty, yellow, star-shaped flowers. 'Variegatum' is a cultivar with leaves striped white.

S. rubrotinctum

(*S. guatemalense*)

A Mexican plant which produces sprawling stems to a height of 15 cm with a spread of 30 cm, covered with fleshy, cylindrical leaves tinged with red. Brick-coloured flowers appear in clusters in spring, and make a gay show for a month or more.

S. sieboldii

A species from Japan which sends out stems up to 20 cm long. It has flat round leaves of silver-grey edged with pink, notched at the ends and loosely arranged in threes. Where winters are cold the leaves turn red and the top-growth dies down until spring. In autumn it bears dense flat clusters of pink flowers. The cultivar 'Variegatum' has leaves striped with white.

S. spathulifolium

Is 10 cm in height and spreads across 20 cm or more. It makes a pleasing mat or hummock of grey-green spathulate leaves carried in crowded rosettes. In late spring flat heads of tiny bright yellow flowers ornament the plant. 'Capa Blanca' is an attractive cultivar.

S. spurium

Is a prostrate plant with a mat of obovate toothed leaves of mid-green, and flat heads of bright pink flowers in spring and early summer. It will spread across 60 cm or more.

SILENE SCHAFTA — MOSS CAMPION

DESCRIPTION: Produces tufts of wiry stems to about 15 cm in height with a spread of 30 cm. The slender leaves are tiny and mid-green in colour, and in late summer and early autumn the plant bears a mass of tiny cyclamen to rose flowers. It makes a pretty show as a border to a bed or a path, spilling over a wall or peeping out from between rocks in the rock garden, or as ground cover between roses.

CULTURE: Set plants about 30 cm apart. It grows best in well-drained soil. Is hardy to frost and may be planted in full sun or in a partially shaded position.

STACHYS OLYMPICA — LAMB'S EAR

(*S. lanata*)

DESCRIPTION: Plant it as a ground cover or edging plant. The leaves emerge at ground level and form a carpet as the plant roots itself along the ground. This is a neat plant with very attractive silver leaves. In summer it carries small spikes of purple flowers. The cultivar 'Silver Carpet' does not bear flowers and is a more ornamental ground cover or edging to beds of shrubs or roses.

CULTURE: Grows in full sun or partial shade. Stands sharp frost and long periods with little water, but is less pleasing in appearance if left dry for a long time. Set plants 20 cm apart.

STOEBE PLUMOSA — STOEBE, SLANGBOS

DESCRIPTION: Plants with grey foliage are invaluable in the garden, and this bushy South African plant is a good one to grow for contrast between shrubs, trees or ground covers with dark green foliage, or as a background to brilliantly coloured flowers. It is variable in habit – sometimes large and sprawling and sometimes neat and compact. It is advisable to trim the plant once a year in autumn or winter to keep it compact and to encourage fresh new basal growth. The entire plant is ash-grey and the leaves which hug the stems are minute. The flowers are insignificant but the stems are decorative in arrangements. They give off a pleasant musky smell when picked.

CULTURE: It grows in sun or partial shade, at the coast and inland where frosts are not severe. Plant 60 cm apart. It does well in gravelly soil and although tolerant of dry conditions it undoubtedly looks better when watered regularly.

SUTERA CORDATA GROUND COVER SUTERA
DESCRIPTION: A delightful ground cover which occurs naturally in the coastal belt of a part of South Africa. It romps along the ground, rooting itself as it progresses, and makes a graceful, billowy but neat carpet of growth close to the soil. The leaves of mid-green, about 1 cm across, are soft in texture, almost triangular in shape with finely serrated edges. In summer and autumn it bears dainty little white funnel-shaped flowers. Grow it as a ground cover or let it tumble over a bank or container.
CULTURE: This is a splendid plant for coastal gardens as it does well in sandy soil. It can, however, be grown inland where winters are mild. It performs fairly well in full sun but the leaves are larger and deeper in colour and the plant generally looks better when grown in partial shade. Water regularly during dry periods of the year. Plant 30 cm apart.

The silver leaves of Lambs Ear (*Stachys olympica*) show up the colours of other flowers.

TANACETUM DENSUM TANACETUM
(*Chrysanthemum haradjani*)
DESCRIPTION: This charming plant is native to north Africa and Anatolia. It forms a rounded plant about 20 cm in height and double this in spread. The filigree of foliage is ornamental throughout the year and it is worth growing for this alone. The leaves are deeply dissected – like a feather – and silver to ash-grey in colour. In spring and summer it produces a mass of tiny yellow flowers in dense clusters. Grow it between plants with dark green leaves or as a foreground to such plants to get the full effect of its pretty foliage.
CULTURE: Tanacetum does best in a gritty soil in full sun. It stands severe frost and dry conditions. Remove fading flowers to keep it neat and attractive.

TAXUS BACCATA 'Repandens'
 SPREADING ENGLISH YEW
DESCRIPTION: Is an evergreen shrubby plant which can be used with great effect to hide bare earth in a large garden or in a park. It grows slowly to a height of about 40 cm and spreads its branches horizontally across 1–2 m. They are gracefully arched and covered with sharp needle-like leaves of shining dark green which make a pleasing show throughout the year. It is an excellent background to beds of colourful flowers. 'Repens Aurea' is a related cultivar, with leaves tinged with creamy yellow.
CULTURE: Grows in any kind of soil – acid or alkaline. As it is slow-growing, it is advisable to give it a good start by planting it in a hole to which plenty of compost has been added. Established plants stand drought but it is advisable to water regularly throughout the year to maintain growth. Enjoys frost and grows in sun or partial shade. Do not plant near a wall which reflects heat. Not recommended for subtropical gardens.

TETRAGONIA DECUMBENS TETRAGONIA
DESCRIPTION: A South African coastal plant, perennial in nature, which forms patches up to 4 m in diameter, from a woody underground stem.

Black-eyed Susan (*Thunbergia alata*). A quick-growing plant, effective as a carpet.

The new growth is soft and pliable and sprawls over the sand dunes just above high water mark. The wedge-shaped leaves are dark green on the upper surface and paler with prominent veins on the underside. The flowers which appear in winter are inconspicuous.

CULTURE: This plant is included not because it is decorative but because it forms a good dense cover to the sand and is therefore of value in arresting wind erosion along the coast where few other plants will grow because of the sand and salt-laden wind. Space plants 90 cm apart.

TEUCRIUM CHAMAEDRYS GERMANDER

DESCRIPTION: This is not an outstanding plant but a useful one to fill in space in a difficult garden. It is an evergreen of dwarf bushy growth and has a creeping rootstock which ensures its spread. The plant reaches a height of 30 cm. The stems are densely clothed with very small, dark green, toothed leaves, rather like those of dwarf box. In summer, when it bears spikes of rose-pink or white flowers, it makes quite a lively show. It takes kindly to clipping whether planted as ground cover or to form a small low hedge. Set plants 40 cm apart as ground cover and 20 cm apart if being grown as a low hedge. 'Prostratum' is similar but it grows almost flat along the ground. *T. pyrenaicum* and *T. rosmarinifolium* are two other species suitable as ground covers.

CULTURE: Plant in a light, well-drained soil in a sunny position. When established they stand both sharp frost and drought.

THUNBERGIA ALATA BLACK-EYED SUSAN

DESCRIPTION: This cheerful South African plant needs little encouragement to make it grow. It wraps itself around any support and will make its way into a tall tree if not checked. Where there is no support handy it will scamper across the ground and make a brilliant display in late spring and early summer, when it bears rich orange flowers marked in the centre with purple-black. The leaves are almost triangular in shape and the flower is made up of a short tube ending in a face of five spreading segments. Hybrids with white, pale cream and yellow flowers are now available.

CULTURE: Black-eyed Susan likes a hot sunny situation. It is tender to frost but it can neverthe-less be grown in cold gardens as it develops rapidly from seed sown in spring and flowers by summer. Set plants a metre apart.

Thyme grows easily. This species (*T. praecox*) is at its best in spring and early summer.

THYMUS THYME

DESCRIPTION: The thyme used in flavouring food is a bushy perennial. Those described here are dwarf or prostrate relations which have some ornamental value as carpeting or edging plants, or to fill cracks between paving stones.

CULTURE: They grow easily and spread themselves out along the ground, rooting further afield from year to year. They grow in poor soil, in sun and part shade, and stand frost and drought. It may be necessary to restrain their growth or keep them tidy by cutting back the stems once or twice a year. For quick cover space the plants 20–60 cm apart.

T. x citriodorus LEMON-SCENTED THYME

Reaches a height of 20 cm and has mid-green leaves with a strong lemon scent when crushed. The pale mauve flowers which appear in summer are of no ornamental value. This thyme is grown for the fresh lemon scent of its leaves. A form of this known as 'Aureus' has golden leaves, and 'Silver Queen' has variegated ones. Set plants 30 cm apart.

T. herba-barona CARAWAY-SCENTED THYME

Comes from Corsica. It grows quickly to form a mat of dark green leaves across the ground. They are only about 1 cm long and have a caraway scent, and can be used for flavouring meat or vegetable dishes. It has little clusters of rose-pink flowers in late spring and early summer. Plant 30–45 cm apart.

T. praecox

This species is native to Austria. It is a hardy plant which grows in alkaline soil. The leaves make a dense mound of growth and in spring the plant is covered with charming heads of cyclamen flowers.

T. serpyllum CREEPING THYME

Forms a carpet of small dark green aromatic leaves. Plant it between the paving stones of a path or patio where it will be trampled on and give off its fragrance. The leaves can be used in seasoning food. It has insignificant purple flowers in summer. Two pretty cultivars are 'Coccineus' and 'Pink Chintz'. Plant 45 cm apart.

T. vulgaris

Grows quickly to a height of 20–30 cm and spreads rapidly. The slender dark green leaves are aromatic. Clusters of tiny mauve flowers appear in summer. The most ornamental cultivars of this species are: 'Aureus' with lime-green leaves and 'Variegatus' which has grey-green leaves edged with white. Set plants 60 cm apart.

TIARELLA CORDIFOLIA FOAM FLOWER

DESCRIPTION: Where it grows well it makes a delightful show, but it is a choosy plant and needs pampering. The leaves are decorative for most of the year. They are maple-like in form and of a pleasing mid-green colour. They rise to 20–30 cm above the ground in a dense mass and form a complete cover. The plant spreads by means of surface runners. In spring it produces a sparkling show when it becomes covered with a foaming mass of tiny white flowers.

CULTURE: This is a plant for cool shady places. It is hardy to frost but stands no dryness and should therefore be watered regularly and well. Plant in soil rich in humus, about 40 cm apart.

TRADESCANTIA FLUMINENSIS

WANDERING JEW

DESCRIPTION: A fast-growing plant which is of practical value as a ground cover under trees. It will grow right up to the bole of a large tree. Care should be exercised, however, to ensure that it does not invade the entire garden. It looks effective spreading over the edges of window boxes, pots or hanging baskets, or indoors as a pot plant. The species has long ovate leaves of a pleasant shade of green, but the cultivar 'Variegata', with leaves striped white and green, is the prettier and more popular one.

CULTURE: This plant needs no encouragement to make it spread, and can become a pest in a warm garden because of its invasive growth. It looks best when grown in shade and watered fairly

regularly. The plant will tolerate mild frost but severe frost may kill the roots as well as the top-growth.

TRIFOLIUM REPENS 'Purpurascens'

COPPER CLOVER

DESCRIPTION: This trifolium, which is a clover, is a fast-growing ground cover. It grows almost prostrate, rooting under the ground as the stems elongate. The flowers, which appear in summer, make a brief show, but the leaves are ornamental for most months of the year. The leaves, like those of the common clover, are divided into three to six rounded leaflets, coloured green and purple. It makes a delightful edging to a bed of gaily coloured flowers.

CULTURE: It grows in sun or part shade and survives frost and fairly long periods with little water. Plant 20 cm apart.

URSINIA URSINIA

DESCRIPTION: Only two of the perennial species of Ursinia are described here. Both are native to South Africa and they both will make a pretty show. As they vary in mode of growth descriptions are given under the species names.

CULTURE: Ursinias grow quickly and stand moderate frost but not long periods of dryness. They do well in seaside gardens. Should plants become straggly or outgrow their space, trim them back at any time of the year and new growth will emerge within a short time.

U. nana DWARF URSINIA

Produces a low mound of feathery foliage, soft in texture and grass-green in colour. In winter and early spring it bears dainty little yellow flowers which are effective for a short time. The plant, which is resistant to mild frost, is grown for the foliage rather than for the flowers. Space plants 30 cm apart.

U. sericea LACELEAF URSINIA

Is bushy in habit but can be trimmed to form a compact ground cover. It is certainly worth growing, for its delightful lacy foliage of silvery-grey makes a splendid contrast to plants with dark green leaves. Untrimmed it grows to a height of 60 cm and has a spread of as much. In spring dainty yellow daisy-like flowers appear on slender stems well above the foliage.

VERBENA Verbena

DESCRIPTION: This name includes annuals and perennials which differ widely in growth. Some are tall and rather bushy, some are tufty in habit, whilst others hug the ground, spreading their stems along the soil, rooting as they grow. These look gay when in flower in the garden, or in window boxes or pots.

CULTURE: Verbenas like a well-drained soil and plenty of sunshine. In clay or in damp shady gardens they will make stem growth but produce few flowers. They stand drought and moderate frost, and will do well near the coast or in the dry interior. Where frosts are severe put some rooted cuttings into pots in a sheltered corner in autumn, and plant them out again in spring. Make sure the roots do not dry out in the pots.

V. hybrida Garden Verbena
(*V. hortensis*)

A perennial, usually treated as an annual, this species sends out trailing stems which spread across 60 cm or more. The leaves are 6–8 cm long and have toothed margins. Its flowers are carried in flat clusters in late spring and early summer. The colours are white, pink, crimson, purple and mauve. If the top-growth becomes untidy shear it off in winter and new growth will take its place.

V. peruviana
(*V. chamaedryfolia*)

A South American plant which grows quickly forming a mat of ovate, toothed, mid-green leaves. In spring and summer a profusion of flat, rounded clusters of flowers decorate the plant. They are pretty shades of pink, red, white and mauve to purple. Set plants 30–45 cm apart for quick cover.

V. rigida
(*V. venosa*)

Forms tufts of growth to 30 cm and roots itself as it grows. The dark green leaves 10 cm long are rough in texture and sharply toothed. It is not an elegant plant but a useful one for hot dry gardens. In spring it bears flowers of cyclamen to purple in cylindrical clusters. Set plants 30 cm apart.

VERONICA Veronica

DESCRIPTION: This genus includes plants which grow close to the ground and others which reach a height of 2 m. Only dwarf or prostrate species are described here. These are suitable to plant as ground cover on banks, in hollow walls, in containers or as edging to a shrub border or beds of roses.

CULTURE: They need good soil to encourage quick cover but will perform well even in poor ground. They stand sharp frost and fairly long periods with little water but to keep them verdant it is advisable to water regularly during dry periods of the year. Allow 30–45 cm between plants.

V. incana

Has slender, lance-shaped, silvery grey leaves which make dense clusters near the ground. In late spring and summer it bears showy spikes of little amethyst flowers. 'Rosea' is the name of a pink cultivar of this one.

V. pectinata

Is a species from North Africa which creeps along the ground, forming a prostrate mat. It has small, toothed leaves of grey-green and little spikes of blue flowers in spring.

V. prostrata
(*V. rupestris*)

Grows to a height of 10 cm and spreads across 30 cm. It forms a mat of very small ovate, toothed, green leaves and has pretty little spikes of blue flowers in spring. Two decorative cultivars are: 'Rosea' with pink flowers, and 'Spode Blue' with china blue ones.

V. teucrium

Forms hummocks of stems to a height of 20 cm and has a spread of 45 cm. It has narrow, toothed, mid-green leaves carried closely along the stems. In summer the plant is festooned with slender spikes of lavender-blue flowers. 'Crater Lake Blue' is the name of a cultivar of this one which makes an even more delightful show than the species.

VINCA MAJOR Periwinkle

DESCRIPTION: An evergreen perennial of trailing habit which roots iself readily and is decorative throughout the year. Plant it as a ground cover on a steep bank or in containers or hanging baskets. It multiplies and spreads with carefree abandon and should therefore be watched and

trimmed, and some of the roots should be removed when they start invading areas reserved for other plants. The bright green, ovate leaves have a silky sheen and are exceptionally pretty. The flowers which appear in quantities in spring, and on and off at other seasons too, make a lovely show in the garden. The flower consists of a slender tube opening to a face of five widely separated segments of a delightful shade of mauve. *V. major* 'Variegata' has leaves prettily margined with creamy white, and 'Maculata' has leaves with a splash of greenish-yellow in the centre. These variegated forms grow more slowly than the species and are not likely to outgrow their allotted space quickly. There is also a dwarf form known as *V. minor*. It is similar to *V. major* but is not as attractive and has smaller leaves and flowers. Cultivars of this have white or wine-coloured flowers.

CULTURE: Vinca will grow in sun but looks its best in shade. It thrives in any kind of soil, grows

in coastal gardens, and survives severe frost and drought. However, unless watered regularly during dry weather, the leaves look sad and dejected, and it may refuse to flower. It is advisable to shear off the top-growth occasionally to keep the plants tidy.

VIOLA VIOLET, AUSTRALIAN VIOLET
DESCRIPTION: The genus includes two well-known old favourites – the sweet-scented violet and the colourful pansy. There are however two other species worth trying as ground cover – *V. hederacea* and *V. cornuta*.

CULTURE: All of them do best in a shady position in soil rich in humus. To encourage good growth water them well during dry periods of the year and add compost to the soil each spring. They stand frost but not long-continued periods of dryness.

V. cornuta
Is a quick ground cover for shade or semi-shade. It has soft oval mid-green leaves with rounded teeth. The flowers which appear in spring are 2–3 cm across, lavender in colour and a cross between a violet and viola in appearance. Two good cultivars are: 'Alba' (white) and 'Jersey Gem' (royal purple). After the flowers fade in spring clip off some of the top-growth and more flowers will appear in summer.

V. hederacea AUSTRALIAN VIOLET
A delicate-looking little plant which spreads rapidly by underground stems. It looks pretty tumbling over the edge of a container or brick wall and as a ground cover. The rounded leaves only 1 cm across are pretty and the small white- or pale blue, violet-like flowers which appear in spring are attractive too. Set plants 30 cm apart. Under congenial conditions it can prove invasive.

V. odorata VIOLET
Is worth growing for the heart-shaped dark green leaves which cover the ground. From late winter to early summer it bears sweetly-scented purple flowers which add to its value in the garden. There are several cultivars with flowers of different colours – white, pink, lilac and cyclamen, but these lack the vigour in growth and the rich perfume of the well-known species. If plants appear to be overcrowded remove some of the roots, and add compost to the empty spaces to promote luxuriant new growth. Plant 45 cm apart.

Verbena. A low-growing species which is particularly decorative in late winter and early spring.

Trifolium is a prostrate plant with coloured leaves – pretty in the garden and in a container.

WALDSTEINIA TERNATA — WALDSTEINIA

DESCRIPTION: This plant from eastern Europe and north Asia is worth planting because of its delightful dark green leaves. It is an evergreen which makes a thick carpet, rooting itself as the stems elongate. The dark green leaves are rather like those of the strawberry in form but thicker and they have a lustrous texture. They are carried on short stems 10 cm above the ground and show up to perfection the little bright yellow bowl-shaped flowers which appear in spring. They are also a perfect foil to grey leaves.

CULTURE: Grow it as a ground cover or as a border to a bed or along a path or drive. Where it is happy it may prove invasive, but excessive growth is easily checked. It grows in full sun and in shade and is not fussy as to soil and climate. Set plants 45 to 60 cm apart.

WEDELIA TRILOBATA — WEDELIA

DESCRIPTION: Is a quick-growing evergreen plant which spreads itself over the surface of the ground rooting itself as it grows, to form a mat or low mound. The leaves, which are sharply indented and dark green in colour, are attractive throughout the year. In spring and early summer it produces cheerful little daisy-flowers of orange-yellow. Grow it in any part of the garden where a dense cover is required.

CULTURE: This is an excellent plant for a temperate climate, suitable for coastal gardens or those inland where winters are not extreme. It does well in full sun or in filtered shade. Water until established, after which it is fairly drought-resistant. Trim when necessary in autumn to spring. Set plants 30–60 cm apart.

ZEBRINA PENDULA — WANDERING JEW

DESCRIPTION: A trailing Mexican plant closely resembling *Tradescantia fluminensis*, which also has the common name of Wandering Jew. The variegated form is the best known. It has slender ovate leaves up to 8 cm long with a green band down the centre and white on both sides. The undersides of the leaves are suffused with purple. A cultivar known as 'Quadricolor' has leaves striped with longitudinal bands of white and purple. The small three-petalled purple flowers are insignificant.

CULTURE: Zebrina is usually grown as a trailing plant indoors but in areas where winters are mild it can be used as a ground cover in a shady part of the garden. It grows very quickly and roots as it spreads, and it therefore needs to be cut back from time to time to keep it within bounds. Plant 60 cm apart.

ZOYSIA TENUIFOLIA — KOREAN GRASS

DESCRIPTION: This grass forms mounds or hummocks and cannot therefore be planted as a substitute for a lawn, but it is an unusual plant for pattern-bedding and as a ground cover anywhere in the garden. It spreads and roots as it grows, and is bright green almost throughout the year. This is a useful plant to grow on a steep slope to help stop erosion.

CULTURE: Zoysia grows in full sun or partial shade and survives severe frost. It will also endure fairly long periods of drought, but to maintain a luxuriant appearance it should be watered regularly. It does well in coastal gardens as well as in those inland and at a higher altitude. Set plants 20 cm apart for a quick cover.

This veronica (*V. prostrata*) produces masses of dainty flowers at ground level.

Wedelia hides the bare earth quickly with its rich deep green leaves and bright flowers.

Index of Common Names

Index of Botanical Names

111